NICHOLAS HAWKSMOOR

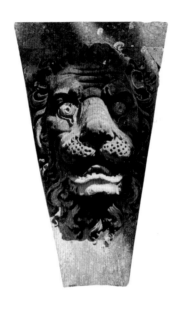

NICHOLAS HAWKSMOOR

REBUILDING ANCIENT WONDERS

VAUGHAN HART

Published for
THE PAUL MELLON CENTRE
FOR STUDIES IN BRITISH ART
by
YALE UNIVERSITY PRESS
NEW HAVEN & LONDON

Designed by Gillian Malpass

Printed in China

Library of Congress Cataloging-in-Publication Data

Hart, Vaughan, 1960–
Nicholas Hawksmoor: rebuilding ancient wonders /
Vaughan Hart.
p. cm.
Includes bibliographical references and index.
ISBN 0-300-09699-2
1. Hawksmoor, Nicholas, 1661–1736 – Criticism and
interpretation. 2. Architecture – England – 18th century.
I. Title.
NA997 .H3 H37 2002
720′ .92 – dc21 2002001025

A catalogue record for this book is available from
The British Library

Page i Keystone to the side doors of the Woodstock arch, Blenheim.

Frontispiece St Anne, Limehouse. Detail of west façade.

1 (*page vi*) St Bride, London. Detail of urn.

To Charlotte and Christopher

Contents

INIGO JONES HAS THE BANQUETING HOUSE and Christopher Wren St Paul's, but there is no single work popularly associated with the name of Nicholas Hawksmoor (1661?–1736). Despite his status as one of England's greatest architects, Hawksmoor to this day remains something of an enigma, neither the classical figure characterized in the bust attributed to Henry Cheere (see Fig. 3) nor the mystic character in Peter Ackroyd's popular novel. Although trained by Wren, the master builder of his age, Hawksmoor had no pupils or contemporary disciples (apart from the self-serving Batty Langley), and following the shift in national taste from Baroque towards Palladianism he sank into obscurity. During the latter part of his life his buildings were publicly dismissed, and after his death were completely ignored.[1] As a symbol of this neglect, Hawksmoor's tombstone in Shenley churchyard in Hertford lay broken and buried until around 1832 when a brick vault was built to receive it. Evidently his name was not completely forgotten, however, for in 1847 a Victorian learned society – the Architectural College of the Freemasons of the Church, promoting the 'recovery' of the 'true principles and practice of architecture' – proposed moving the stone to rest alongside Wren's in St Paul's Cathedral.[2] Interest in Hawksmoor grew with the publication of the twenty volumes of the *Wren Society*, beginning in 1924 and coinciding with the appearance of Goodhart-Rendel's monograph on the architect. Hawksmoor's original place in English architecture was finally recognized with the publication in 1959 of Kerry Downes's monograph, and more recently Ackroyd's novel has made him a household name. Nevertheless, his intentions are in many cases still unclear. In 1959 Downes pointed out the need for a study of Hawksmoor's style and sources, and this book attempts to fill that gap and thereby extend Downes's admirable overview.[3] It coincides with a renewed interest in the Baroque, and in expressive forms derived from classical canonics but moulded to express new, 'Postmodern' imperatives.

The aim of this book is to explain why Hawksmoor's esoteric buildings look the way they do. Why, in other words, he felt compelled to build a fanciful copy of an ancient mausoleum above the rooftops of London, and to ornament his churches with huge decorative keystones. This book therefore examines afresh his surviving, destroyed and unrealized projects, as well as those executed in collaboration with others. Hawksmoor enjoyed a formidable architectural apprenticeship, assisting both Wren and Vanbrugh on many of their most important commissions. But these partnerships have meant that he is often characterized as an assistant rather than as an architect in his own right, despite his fluency in matters of architectural history and theory.[4] Furthermore, while Hawksmoor's solo buildings are now well enough known, the reasons behind their eclectic ornamental details and 'quotations' of ancient architecture remain obscure. The replication of such Wonders of the ancient world as Egyptian pyramids and the Halicarnassus mausoleum was certainly without precedent in English architecture, and the term Baroque hardly seems appropriate as a stylistic description of much of Hawksmoor's work. Nor, clearly, are his buildings conventionally Palladian. Although he relied heavily on antique references that he considered 'licensed' his architectural inventions (from sources including Vitruvius, Herodotus, Pliny and Varro), his buildings often met with contemporary disapproval because they failed to follow Palladian design rules.

Wren wrote five Tracts on architecture, Jones a treatise of sorts (on Stonehenge), but Hawksmoor produced no comparable theoretical study that can be used to 'explain' his unique architecture. This was despite witnessing the enormous influence of such works following the publication of *Vitruvius Britannicus* between 1715 and 1725. His theoretical works are limited to isolated drawings and accompanying notes. The most important of these are his fanciful 'Basilica after the Primitive Christians' (c. 1712), which demonstrates a keen awareness of contemporary theology (as examined by Pierre de la Ruffinière Du Prey in 1989 and 2000), and his hitherto unstudied sketch and notes concerning the east gate of Solomon's Temple (c. 1723). He also provided an historical 'explanation' of a number of sketches for

2 St Anne, Limehouse, 1714–30.

his proposed Blenheim obelisk, which demonstrates his knowledge of Renaissance emblematics. Otherwise, the principal sources are, firstly, Hawksmoor's letters.[5] Of these, most significant are those in which he defends the historical accuracy of his work, at Oxford to George Clarke (on All Souls), at Westminster to Dean Joseph Wilcocks (on the Abbey's west façade) and at Castle Howard to Charles Howard, the third Earl of Carlisle (on the Mausoleum). These letters reveal his concern to synthesize tradition with innovation, or more accurately antiquity with modernity. Moreover, they give valuable insight into what Hawksmoor himself defines as his 'architectonricall method' and what he intriguingly called 'Authentic', that is, 'Historicall and good Architecture'. Added to these sources are his two short publications (one on the Royal Hospital at Greenwich and the other on Westminster Bridge), his sketchbook (1683) and drawings, and the records of his site duties and the catalogue of his library.[6] The last is an important source in understanding the range of Hawksmoor's intellectual interests and theoretical sources, in the absence of a period of foreign travel or university education, and will be used throughout this study. His obituary recorded that he was 'bred a Scholar', and so it can reasonably be assumed that he studied closely the books he collected (a number of which have survived).[7]

What, then, was Hawksmoor's concept of architectural history and theory and how did this inform his work? Some influences are easy to trace. The growing awareness of the monuments of a wide range of cultures, in the wake of increased travel and exploration, helped stimulate the use of Egyptian, Roman, Gothic and even Greek styles by Wren and his contemporaries. The post-Restoration ideology of Whig politics, Church of England theology and the developing rationalism of contemporary science all influenced Hawksmoor's vocabulary of forms, as did the iconography of freemasonry. The influence of Palladianism on his later work, most notable in the Mausoleum at Castle Howard, reflected the change in national taste over his long career. But considering Hawksmoor's work as a whole, it is noticeable that he frequently adopted a variety of styles for buildings coinciding in date, sometimes using forms directly based on antiquity while at other times using highly inventive adaptations. The reasons informing when and where he chose particular styles or ornamental details seem more difficult to explain. His claim to Carlisle that he was 'only for following architectonricall method, and good Reason' was certainly in tune with the priorities of his age and implies a consistency of approach if not outcome. Hawksmoor's own statements therefore encourage an examination of the 'reasons' behind his choice of forms and the 'method' which he used to design them. This book will attempt to explain this approach and the expressive motivations which informed a body of work that ranged from architectural details to ambitious urban plans, and from new parish churches to work on the monument of his age, St Paul's Cathedral.

Acknowledgements

THANKS ARE DUE TO: Dr Timothy Anstey, Professor Andrew Ballantyne, Dr James Campbell, Dr Mario Carpo, Peter Clarkson, Professor Alan Day, Lady Hasketh, Dr Peter Hicks, the Hon. Simon Howard, Professor Neil Leach, Michael McMorrow, Professor Joseph Rykwert, Victor Nierop-Reading, John Sunderland, Professor Robert Tavernor, Dr Richard Tucker, Professor William Vaughan, Professor David Watkin and Mark Wilson Jones. All have helped in either small or large ways with this book. I would also like to thank Margaret Richardson and Steven Astley of the Sir John Soane's Museum in London and the staff of the Heinz Gallery at the R.I.B.A. in London. Professor Lisa Jardine allowed me to read a manuscript copy of her forthcoming book on Wren and shared her insights with me into his travels and work, and Dr Caroline van Eck discussed issues surrounding the theory of decorum of relevance to this book. Drs Ann and Jennifer Nutkins both helped in the book's preparation. Archive visits were funded by the Interbuild Trust (in 1998) and the Arts and Humanities Research Board (in 2000). The Arts and Humanities Research Board also funded the computer models of Hawksmoor's Oxford (in 1999), carried out with Alan Day and Henry Chow in the Centre for Advanced Studies of Architecture (CASA) at Bath University. The Department of Architecture and Civil Engineering at Bath also funded travel associated with the work.

I would also like to thank the Librarians at the following institutions: The British Library, London, particularly the departments of Maps, Manuscripts and Rare Books; Westminster Abbey; Cambridge University Library, particularly the Rare Books department; Bath University Library; Bodleian Library, Oxford; Ashmolean Museum, Oxford; British Museum Print Room, London; Lambeth Palace Library, London; Guildhall Library, London; Sir John Soane's Museum, London; Witt and Conway Libraries, Courtauld Institute, London; Victoria and Albert Museum, London; Blenheim archive; Castle Howard archive; Magdalen College archive, Oxford; All Souls College archive, Oxford.

Gillian Malpass of Yale University Press has been a consistent supporter of the project. Finally my wife, Charlotte, has offered encouragement and borne patiently my many monologues on the subject of Hawksmoor.

Vaughan Hart
University of Bath, 2002

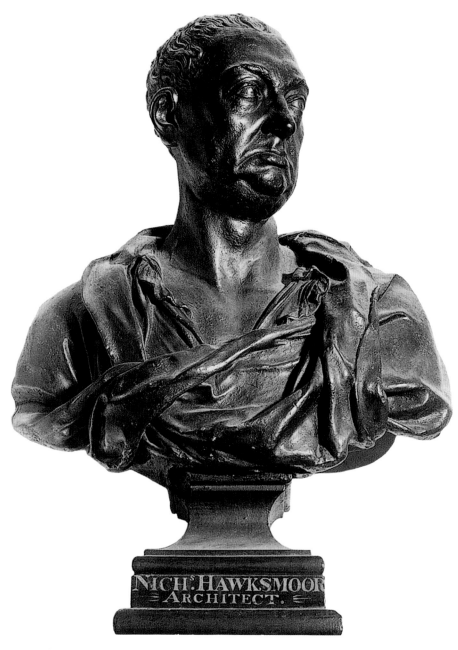

3 Plaster bust of Nicholas Hawksmoor in the Buttery of All Souls College, Oxford, assumed to be by Henry Cheere, c. 1736.

FROM BAROQUE TO PALLADIAN: HAWKSMOOR'S STYLE

'MODESTY AND MERIT':
HAWKSMOOR'S CHARACTER

HAWKSMOOR WAS BORN IN OR AROUND 1661, the year of Charles II's coronation and of Boyle's definition of the chemical elements, and died 'in a very advanced age' (as his obituary put it) in 1736, having worked for most of these seventy-five years. His appearance in old age is recorded in the sole likeness of him, the plaster bust, painted black to imitate bronze, assumed to be by Henry Cheere in the Buttery of All Souls College in Oxford (Fig. 3). This presents him in informal dress (wigless and in casual rather than in Roman attire) but the mouth is turned down as if to reflect the many disappointments of his later years. Something of the more jovial character behind this mask of fortitude can be glimpsed in a number of records. The obituary of the architect by his son-in-law, Nathaniel Blackerby, of 27 March 1736 recorded that 'In his private Life he was a tender Husband, a loving Father, a sincere Friend, and a most agreeable Companion; nor could the most poignant pains of the Gout, which he for many Years laboured under, ever ruffle or discompose his Evenness of Temper'.[8] Gout was the subject of frequent complaint to the Earl of Carlisle in letters written in Hawksmoor's last years – noting on 4 December 1732 for example that 'I am very much afflicted with it, and am forced to keep my bed'.[9]

Hawksmoor's 'evenness of temper' would certainly have assisted his collaborations with Wren and Vanbrugh. He was modest with regard to his contribution to both, especially to Vanbrugh considering the playwright's relative lack of training in architecture. Arthur Maynwaring reported to the Duchess of Marlborough in 1709 that Vanbrugh

has often mentioned a request which he would have me make to you in behalf of Mr Hawkesmore, and I beg you will please to let him tell it you yourself, now they are both together. I would not take this liberty, but that I have often heard you wish for some

opportunity to do him good: which he is the more worthy of because he does not seem to be very solicitous to do it for himself: but has two qualities that are not often joined, modesty and merit.[10]

Later, in 1715, the Duchess herself had occasion to write of Hawksmoor's 'modesty, & great honesty'.[11] This modesty is further attested by the Palladian amateur Sir Thomas Robinson who, on 20 July 1734, noted to Carlisle concerning his conversations on the Mausoleum design with the architect that 'I must say one thing in fav'r of Mr Hawksmoor I never talk'd with a more reasonable man, nor with one so little prejudiced in favour of his own performances'.[12] To some extent this reasonableness was forced on Hawksmoor through the rise of the Palladian movement and amateurs such as Robinson. But as will become evident, Hawksmoor's letters to the Duchess and to the Earl of Carlisle show that he was less than diffident in his own cause when attacked in later life by the Palladians.

THE TRIUMPH OF THE 'ANCIENTS':
HAWKSMOOR AND THE PALLADIANS

Probably Hawksmoor's major misfortune was to live long enough to witness the rise of Palladianism, his correspondence on which helps both to define his principles and to reveal aspects of his character. Due to illness he did not attend the opening of Burlington's York Assembly Rooms, which proved a landmark in the establishment of the new orthodoxy. He wrote to Carlisle on 25 August 1732 that 'I believe you have been very gay at York; and I wish I had bin with you (as I certainly would if I had had my Limbs) to have seen the opening of your Egyptian sal. Pray send me word how it is approved'.[13] As early as 1712 the third Earl of Shaftesbury, in his *Letter concerning the art or science of design* (first circulating in manuscript and then published in 1732) addressed to the Whig Lord Somers, had

predicted the emergence from the 'national taste' of a new British style. Shaftesbury did not define this style – except negatively as anti-French, anti-Wren and anti-Baroque – but it was destined to be supplied by Colen Campbell's *Vitruvius Britannicus* (1715–25). The influence which Campbell's Palladian models enjoyed rendered the so-called Baroque period in England an interlude between the era of Inigo Jones and that of his emulation.

From 1718 onwards Hawksmoor had felt the assault on the Office of Works by the Palladians, under the incompetent amateur William Benson and his successor, Sir Thomas Hewett.[14] Writing to the Duchess on 17 April 1722, he ends by lamenting

4 Brick arcade of the stable court, St James's Palace, London, 1716–17.

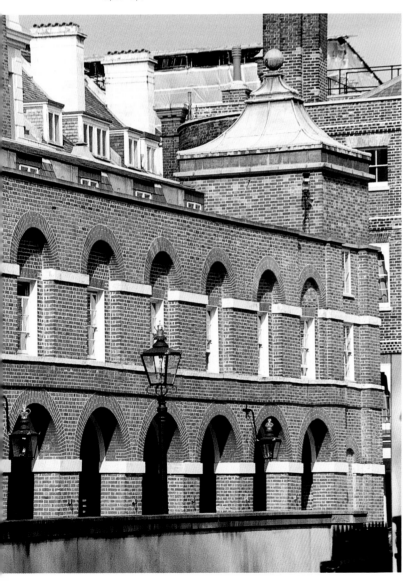

my many misfortunes and hard sufferings under the Tyranny occasiond by the Late Surveyor Benson; who cruelly turned me out of my employment to make Roome for his Brother after I had served near 40 years in a lower office at a small allowance. I have been also very ill Treated by some persons that I have raisd in y[e] Works, in return for the great favours I bestowd upon them. I did think them honest, but I have found them very ingratefull knaves.[15]

Hawksmoor's correspondence with Carlisle between 1725 and 1726, addressed to the Earl as the 'best patron I have',[16] records at some length his distress at being rejected as Secretary to the Board of Works and his subsequent battle for reinstatement. His letters are written in an obvious mood of self-pity at 'y[e] Losses that has lessen'd my fortune and made it very Scanty – The miserys of y[e] Gout, and other misfortunes'.[17] In the first letter, written in the summer of 1725, he gives 'a short acct of my hard usage in y[e] Office of Workes'. He charts his own progress from his early years with Wren on St Paul's and the City churches, following which 'Sr Christ Wren appointed me Clerk of y[e] Workes at y[e] kings house at Kensington, which small post I kept till his present Majesty came to y[e] Throne'. A year after the accession of George I in 1714, Lord Halifax had freed Hawksmoor from this responsibility under Wren for Kensington Palace – converted from Nottingham House – and appointed him Clerk of Works at Whitehall, as well as at the palaces of Westminster and St James's in succession to William Dickinson. At St James's in 1716–17 he designed and built the brick arcade to the stable court (Fig. 4).[18] In the same year as taking charge of work at St James's and as a direct result of 'being then Clerk of y[e] Works at Whitehall',[19] he was appointed by Carlisle to the newly created role of Secretary to the Board with an annual allowance of £100. Carlisle was Chancellor of the Exchequer, and followed advice from Vanbrugh as the Comptroller.[20] It was the specific duty of the Secretary to take minutes at the meetings, which had hitherto gone unrecorded.

However, only three years passed before the Royal Works were reorganized again, in 1718, and Hawksmoor was replaced in his posts under the new Surveyor, the Whig William Benson. Hawksmoor commented bitterly that 'William B-N Esqr in extreem Need of an employment . . . disguising himself under the pretence of an Architect, got himself made Surveyor Generall', turning out the elderly Wren and other officers 'and me in particular'[21] – thereby removing Hawksmoor's £100 per annum. To add insult to injury, Benson made his brother Benjamin – derided by

Hawksmoor as 'a very young man' – the new Secretary, as well as Clerk of Works at the palaces of Whitehall, Westminster and St James's. Both men, however, were destined to be dismissed after about a year for what Hawksmoor calls 'Sundry famous Reasons'.[22] In fact Benson had condemned the House of Lords and the adjoining buildings as unsafe, having them shorn up, but an enquiry established that they were stable while the scaffolding was not. Benson's folly, corruptly motivated by a personal ambition to design the new building,[23] became popularized in Daniel Defoe's *A Tour Through the Whole Island of Great Britain* of 1725. Defoe notes that Benson's work at the House of Lords 'was directed so ill, or understood so little, that some thought he was more likely to throw the old fabrick down, than to set it to rights, for which ignorance and vanity, 'tis said, some have not fared as they deserv'd'.[24] Hawksmoor was certainly one of these. After Benson's dismissal, Hewett – described by Hawksmoor as 'that Reptile Knight'[25] – took over and held the Surveyorship from 1719 until his long-awaited death in April 1726.

Following the death of Vanbrugh on 26 March 1726 the Comptrollership became vacant, and two days later Hawksmoor, eager for advancement, wrote to Carlisle 'with Modesty' concerning his 'Long attendance, and the experience I have had, both in publick and private Buildings'.[26] Modesty aside, he mentions the 'integrity and regard' with which he had executed his duties. Then on 6 April he complained that 'there is prodigeous pressing Sr R. Walpole; by my Ld Devonshire Ld Burlington, and many other's, for painters, poets and other virtuosos to Suceed Sr John Vanbrugh'.[27] Hawksmoor's own lobbying had an effect, for he relinquished the job of Deputy Comptroller, a post he had held from July 1721, and regained that of Secretary to the Board (a post he occupied until his death). Nevertheless he did not regain the Clerkship at Whitehall (which under Burlington's influence went to Henry Flitcroft), nor was he appointed Surveyor or indeed Comptroller. His description of fellow officers at the Board, sent to Carlisle on 28 May after his reappointment, is telling:

> vizt Mr Arundell surveyour
>
> Mr Ripley Controller, late carpenter
>
> Mr Dartiquenave (Late paymastr to yᵉ Workes) is Surveyour of yᵉ Gardens and water's a place (your Lordship knows) was made for Sr John V –
>
> Mr Kent, painter, is to represent his Majtys Master Carpenter
>
> One Howard a painter is to be yᵉ paymaster in Mr Dartiquenaves Roome,

> and
>
> Monsieur Dubois Sometimes (I think) a French Ingeneer, is to stand still [having been appointed in 1719] for his Maj's master mason, as we call'em.
>
> And I have yᵉ honor to be the Secretary to this honble Board.

Flitcroft, Ripley, Kent and Dubois were all Palladians, as was the new Surveyor of Greenwich Hospital in succession to Vanbrugh, Colen Campbell. Hawksmoor had advised the Admiralty 'to sink, (as useless)' this post since everyone concerned 'knew that I had carried on, and finished so much as was done of that fabrick; for little more than one hundred pds p annm'.[28] In his role as Wren's clerk he had prepared drawings in 1696–7 for the hall, chapel and colonnades at Greenwich, and he served as Assistant Surveyor there from 1705 to 1729. However, as he put it, 'Mr Colin Campell Author of a book calld Vitruius Britanicus. Smelling this out, in spite of all yᵉ Lords of yᵉ Admiralty could doe; got yᵉ place Sr John, had made at Greenwich hotell. with all yᵉ allowances thereof. So that in that place we are handsomly saddled'.[29] Unfortunately it was Hawksmoor's post as Assistant Surveyor at Greenwich that was destined to be abolished, following Campbell's death in 1729 and his replacement by Thomas Ripley. In 1733 Ripley conspired with Walpole to dismiss Hawksmoor from his last remaining post at Greenwich, that of Clerk of Works.

Hawksmoor was to feel the influence of the Palladian hold over architectural tastes even more directly. In 1732 Burlington openly criticized his proposed spacing of the columns of the Mausoleum at Castle Howard, making what Hawksmoor ominously called some 'Observations on our Performance'.[30] This direct attack led to a display by Hawksmoor of pedantic self-justification and a further show of pride in his knowledge and experience as a 'professional' architect – as opposed to what he dismisses as amateurs such as 'my Ld Burlington with yᵉ other virtuosi'.[31] He had previously complained to Carlisle, on 7 January 1724, that 'I would not mention Authors and Antiquity, but that we have so many conceited Gentlemen full of this science, ready to knock you down, unless you have some old father to stand by you'. The Palladian pedantry of these loathed 'virtuosi' threatened Hawksmoor's right to invent forms – that is, as Vanbrugh put it, his architectural 'ingenuity'.[32] In his short book on Greenwich Hospital of 1728 Hawksmoor observed sarcastically concerning the prevailing tyranny of 'Taste' that 'so many of our Noblemen and Persons of Distinction are not only

Patrons of Building, but also great Professors of that Science, from whom we may expect speedily to be converted to Truth, and have also our Taste rectified and made sensible: This is mention'd with all imaginable Regard to the Connoisseurs and Criticks'.[33] Implicit is Hawksmoor's recognition that his work transcended the 'sensible' – that is, that which was strictly justifiable with respect to the 'rules' – in its imaginative use of form.

Resentment against leading Palladians and their alternative, stricter interpretation of antique models thus came to characterize Hawksmoor's later life. He was among the most prominent victims of the change in official style brought about by Burlington and his circle, a change most clearly represented in the transformation of the Office of Works into a Palladian stronghold.[34] He went to his grave with this feeling of injustice. On 15 September 1735 he complained to Carlisle following his recent dismissal at Greenwich that 'I am confoundedly used for my services to y^e publick', and on 17 February 1736, just before his death, he added that 'I have had a sad Winter, and the more so because the Worthy Squire Rip-y has had power from his great Friends to Destroy me at Greenwch: Hospitall. and the H. of Commons. have suspended our fund for Repairing the Abbey, so that adding the Loss of my Limbs to my Misfortunes I am in a fine situation. And the World is determined to starve me. for my good services'. Under Ripley and other new Palladian officers of the Works, Greenwich Hospital in his eyes sank from a noble 'public Building' to a 'deformed Barrac'.[35] The overall picture of Hawksmoor is thus of a character by turn melancholic and yet agreeable, bold and yet modest – qualities rather similar, perhaps, to the stylistic range which is so intriguing in his buildings.

HAWKSMOOR AND THE QUESTION OF ARCHITECTURAL STYLE

Debates concerning architectural style were thus sharply defined in Britain in the early eighteenth century. Hawksmoor was keenly aware in his battle with the Palladian pedants that at stake was the architect's right to adapt and adjust ancient models to fit contemporary practical and expressive needs. His inventiveness with ornament and form in certain situations and his contrasting canonic approach elsewhere have caused him to assume differing significance for the historians of style. In 1979 Anthony Blunt, assisted by others, defined Hawksmoor and Vanbrugh as the 'two greatest wholly Baroque English architects',[36] while a year later Christian Norberg-Schulz concluded his

study *Late Baroque and Rococo Architecture* (1980) with Hawksmoor's churches, albeit presented as products of a uniquely English 'stylistic pluralism'. Howard Colvin's *Biographical Dictionary of British Architects* describes Hawksmoor as 'one of the great masters of the English baroque',[37] while Kerry Downes, the leading historian of the English Baroque, recently defined him in the *Dictionary of Art* as having 'used a rich, eclectic, scholarly and often unconventional vocabulary of detail'. Downes adds that, as an assistant to Wren and Vanbrugh, 'together these three architects were the greatest exponents of the Baroque in England'.[38]

Despite this frequently repeated Baroque classification, however, certain elements of Hawksmoor's work have defied categorization. In his fundamental study of Hawksmoor, first published in 1959, Downes balked at accepting certain eclectic elements at face value. Concerning the steeple for St John, Horselydown, he notes that 'it is unpleasant to suggest that Hawksmoor would take this sort of liberty with the Ionic order. Yet he had considered putting other transplanted objects on steeples . . . It therefore seems reasonable to think that he might have drawn such a steeple; it does not seem reasonable to think that he would willingly have let it be built. Second thoughts were very important in Hawksmoor's work'.[39] Downes echoed this judgement in 1966 when he speculated that 'had the Commission allowed its architects as much time, money and freedom in 1730 as in 1714, second thoughts would have produced more complex and more successful results'.[40] Later he observed in passing that the steeples in general 'may be considered bizarre', repeating that those of St John, Horselydown and St Luke, Old Street, 'show Hawksmoor's liking for evocative incongruity to extremes that . . . he would surely have wished to temper'.[41] Colvin, too, passed a similar judgement in 1962 when observing of the Ionic steeple of St John that 'it is perhaps one of the most striking examples of the rather fantastic and even *outré* element which one has to reckon with in Hawksmoor's architecture. . . . There was certainly something which was at times rather strange and unpredictable in his work'.[42] Nor has Downes accepted at face value Hawksmoor's more neo-Palladian work. Concerning the elevations of Worcester College, Oxford, he notes that 'One might almost suggest that Hawksmoor acted the Palladian with his tongue in his cheek . . . Here is the same flippancy about a serious façade as in the west front of Christ Church, Spitalfields'.[43]

In contrast, despite Hawksmoor's own antipathy to leading figures in the Palladian movement and to their over-pedantic strictures, Giles Worsley has presented the architect as essentially a neo-Palladian, due to his

undoubted borrowings from sources in Andrea Palladio and Inigo Jones. This portrait is presented most completely in Worsley's *Classical Architecture in Britain: The Heroic Age* (1995).[44] Here the ancient sources for Hawksmoor's canonic, *all'antica* work (the Mausoleum and the triumphal gate to Blenheim, for example) are emphasized, while the Stepney churches (work without apparent progeny) are traced to prints of imaginary Roman temples by Androuet du Cerceau.[45] Emphasizing Hawksmoor's use of Jones and Palladio does not necessarily paint a true picture of his stylistic motivations, however, since he borrowed from many sources, nor does it explain the meaning behind his use of certain Palladian motifs (which in any case often have an equal source in the treatise by Sebastiano Serlio).

In this way the more eccentric examples of Hawksmoor's work – that is, those which most departed from using the basic grammar of classical architecture, with its emphasis on the proportions and mouldings of the five Orders – have either defied classification or been linked to sources of undisputed Renaissance pedigree. Due to the stylistic range of his work, at least two very different 'Hawksmoors' thus emerge from the pages of the studies by contemporary historians of style. Colvin, for one, recently concluded that Hawksmoor was something of a stylistic schizophrenic, commenting that 'although it is the fantastical side of baroque that is apparent in so many of his unexecuted designs, he could also be gravely classical, as in the Clarendon Building, St George's Bloomsbury, or the Mausoleum at Castle Howard'.[46] However, little attempt has been made to explain why he was capable of these stylistic mood swings and what these 'fantastical' and 'grave' styles might mean. This book will examine Hawksmoor's work less as a problem of categorization in this or that architectural style, defined by movements and common tastes, than as a product of specific contexts and particular circumstances. His work will be understood as necessarily evolving over time and as responsive to the individual locations in which it is situated. For, rather than produce any consistent 'style',[47] Hawksmoor attempted to evolve a language of ornament and form which was responsive to the variables of a particular location, patron and building type. Take his various proposals for All Souls College, for example, which some have seen as demonstrating a 'nonchalant' attitude to style.[48] These schemes will be seen to represent attempts to satisfy – either in Gothic or in mixed styles (Gothic with what he calls 'Grecian') – the spirit of the college's foundation as expressed by the existing Gothic fabric, and by the chapel in particular. Such departures from the classical canon must have been heartfelt, for clearly it would have been far easier for Hawksmoor, in terms of his employment with the Royal Works, to have followed the Palladian canon throughout his work.

That Hawksmoor's architecture for the most part looks very different from that of Inigo Jones – which clearly influenced the young Hawksmoor[49] – is hardly surprising. He had grown up during a period when the Neoplatonic cosmology that had been dominant throughout the Renaissance and had animated Jones's practice,[50] was gradually replaced by modes of thought compatible with modern science. The loss of faith in the Platonic conception of the cosmos and in the validity of the national magical legends that underpinned Stuart monarchy had been paralleled by the challenge to absolutism and the consequent decline in the actual power of the king. The latter had been initiated by the Civil War and confirmed by the advent of constitutional monarchy after 1688. Concepts of history, science and state were no longer to be understood as servants of the royal image but were pursued along increasingly independent scientific or philosophical lines, an approach institutionalized by the foundation of the Royal Society in London in 1662. In poetry, Alexander Pope's *Rape of the Lock* (1714) expressed the loss of the monarch's magical powers through presenting Queen Anne, a sun goddess and second Elizabeth (as the last of the Stuart blood) shorn of her golden hair.[51] This shift in priorities was also evident in architecture. The emphasis of Neoplatonism on perfect numbers and human proportions had found expression in, and apparently confirmed the truth of, the proportions and forms of *all'antica* architecture. The questioning of antique wisdom and the rejection of the microcosm–macrocosm analogy by Hawksmoor's contemporaries (particularly by Wren) led to a much freer approach to antique authority which might be seen reflected in the greater licence – indeed 'licentiousness' – adopted by Hawksmoor in the use of ornament and forms. For before the rise of Palladianism affected his work, Hawksmoor sought justification for design not through strict adherence to canonical rules found in the Roman text of Vitruvius but through qualities of invention and, following Wren, through optical composition based on variety. Indeed an examination of the books in Hawksmoor's library shows him to be a keen student of contemporary works that questioned antique authority, in the sciences as well as in architecture. In the absence of any foreign travel, these works must have fundamentally informed his visual vocabulary and search for an architectural grandeur appropriate to his age.

★ ★ ★

Having thus posed the 'problem' of Hawksmoor's eclectic style, this book is divided into two interdependent sections, the content of which for the most part moves from theory to practice. The first looks at the influences which shaped Hawksmoor's understanding of ornament, while the second section focuses on his major solo projects. The first part follows the list of his interests and influences recorded in his obituary. This paints a picture of a mature, sophisticated artist, very different from the image of the practically minded clerk, somewhat unversed in theory, suggested by many of his surviving letters. The obituary records that 'He was perfectly skill'd in the History of Architecture, and could give an exact Account of all the famous Buildings, both Antient and Modern, in every Part of the World; to which his excellent Memory, that never fail'd him to the very last, greatly contributed. Nor was Architecture the only Science he was Master of. He was bred a Scholar, and knew as well the Learned as the Modern tongues. He was a very Skilful Mathematician, Geographer, and Geometrican'.[52] Hence at the start of this book Hawksmoor's formative collaboration with Wren and the influence, through him, of the natural sciences encouraged by the Royal Society is considered. Next, the growing contemporary awareness of exotic structures at home and abroad is shown to account for his use of a wide variety of historical models, including native Gothic forms at All Souls and Westminster Abbey. This is followed by a study of Hawksmoor's method of 'authenticating' his designs with reference to ancient and, in some cases, modern archetypes and models.[53] For the production of what he calls 'Authentic' and 'Historicall' (and therefore 'good Architecture') is evidently of much concern to him. In particular, his neglected study of the archetypal Temple built by Solomon will be examined in the context of contemporary freemasonry.

The second section of this book traces Hawksmoor's method of adapting an appropriate historical model, or models, and his selection of the Orders, to fit local circumstance (such as site, patron and dedication) in a building or group of buildings. This section begins with his domestic architecture, at Easton Neston, Castle Howard and Blenheim, examining the influence of the ancient architectural principles of decorum and of Vanbrugh's more modern theatrical conception of architectural heraldry. As an aspect of his search for an authentic architectural vocabulary, Hawksmoor's highly original use of an imaginary early Christian 'basilica' and of elemental funereal forms – mausoleums, obelisks and urns – is next outlined with particular reference to his London church steeples. His equally original

ornamentation of these churches to create a range of moods, from sombre to triumphant, is then examined with regard to the various locations of these buildings. Next Hawksmoor's dream of urban renewal modelled on Baroque Rome, with its vistas and walks, combined with more ancient planning devices of forums, axes and triumphal routes, will be shown to have informed his urban layouts for Oxford and Cambridge. Here the archetypes of Pliny's villa, the Roman house and Solomon's Temple will be traced in his individual college schemes. Following this, Hawksmoor's dream of reconstituting London as an imperial mercantile capital will be shown to lie behind his unrealized plans for Westminster and Greenwich, evidenced by his two pamphlets describing these schemes. And finally the influence of emerging Whig ideals and the use of the Doric 'type' are considered in relation to the Mausoleum at Castle Howard, Hawksmoor's last design. The apparent eclecticism in Hawksmoor's oeuvre will be shown to have been, rather, a disciplined and regulated response to a variety of local circumstances and national ambitions. No attempt is made here to discuss at any length his practical work as a building clerk or as a draughtsman of details for buildings attributed to others, work that more often than not owed little to theoretical matters and is covered elsewhere.[54] Although Hawksmoor earned a consistent living from such practicalities – for example moving conduits and securing water supplies at Greenwich – his beliefs and dreams, as expressed through his buildings, are the focus of this book.

Hawksmoor's moulding of the traditional vocabulary of classicism into highly original ornamental forms testifies, as graphically as would any inscription, to his willingness to transcend and even abuse antiquity. This was in the wake of a world picture that had expanded to embrace far-flung exotic cultures unknown to the early Renaissance masters but widely represented in books that Hawksmoor collected. In common with Wren, he was well aware that ancient architects had themselves frequently used the Orders in a more arbitrary way than the Renaissance treatises allowed. He was aware, too, that the more modern functional needs – what was 'Convenient' as he put it[55] – became defined, the less antique models could be imitated *per se*. The following chapters will demonstrate that in thus widening the application and range of historical architectural models and ornamental styles, while still clearly recalling the archetypes of architectural history, Hawksmoor sought a timeless architecture reflecting what he saw as the contemporary virtues of Reason, Monarchy and Faith.

5 (*facing page*) William Hogarth's *Gin Lane*. Detail of Fig. 235; and 6 (*following page*) North elevation of St George-in-the-East, looking west.

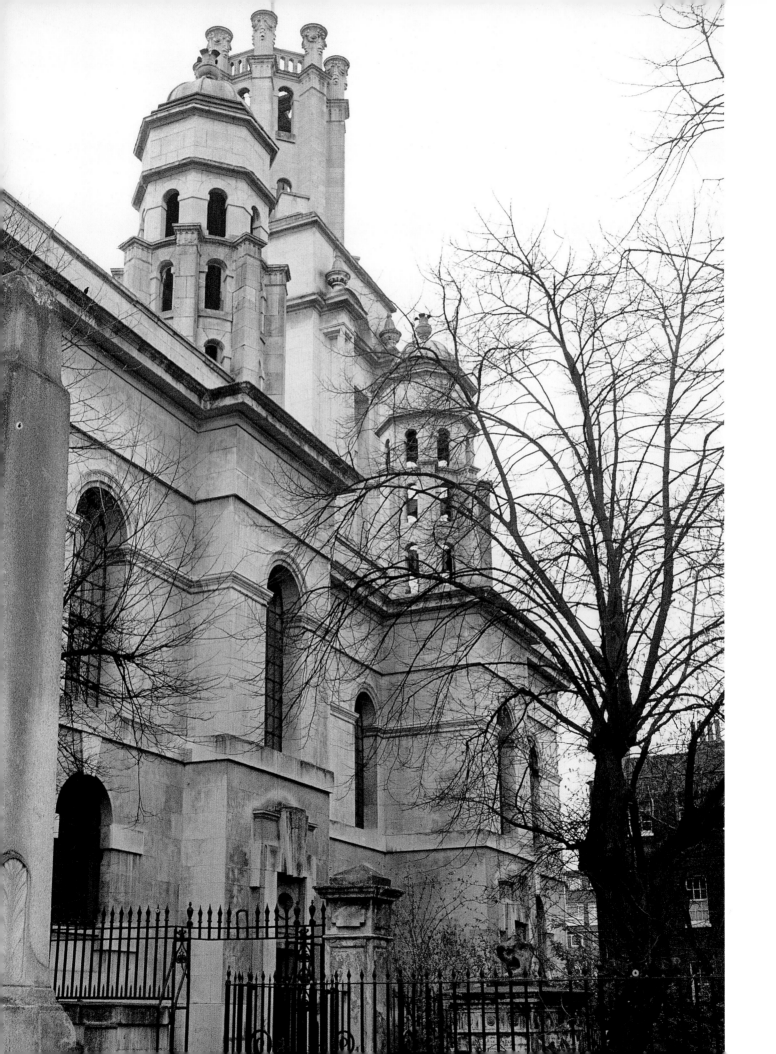

'BRED A SCHOLAR': HAWKSMOOR'S STUDIES

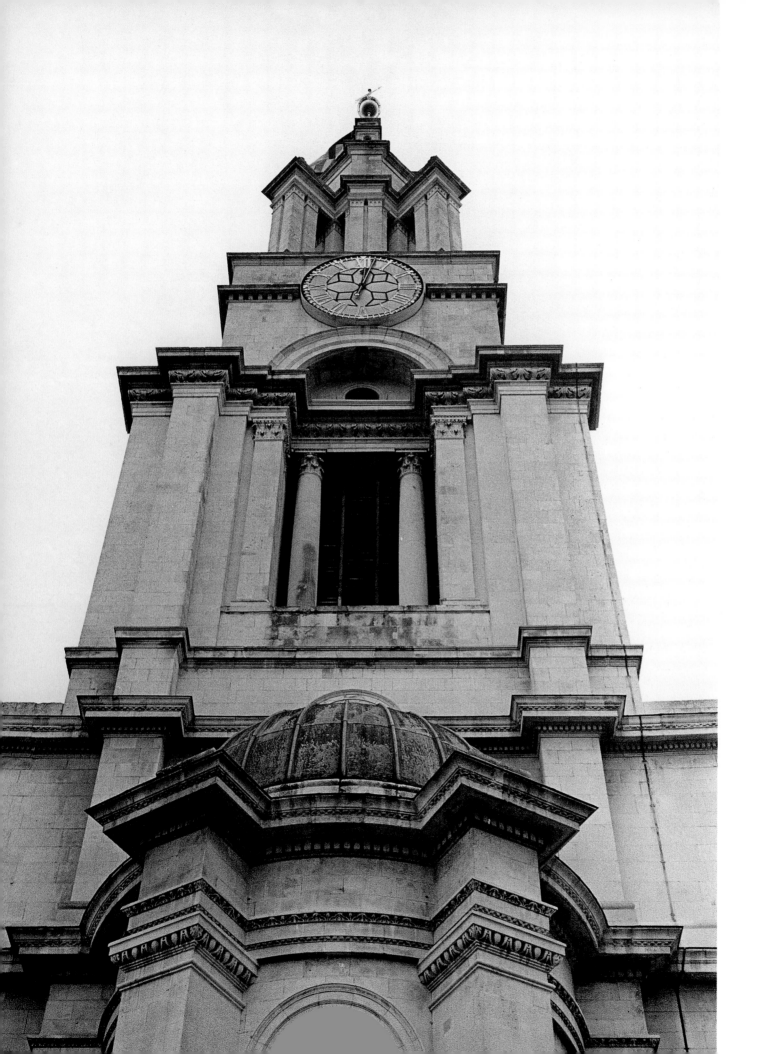

'A VERY SKILFUL MATHEMATICIAN': HAWKSMOOR AND THE NATURAL SCIENCES

EVEN THOUGH HAWKSMOOR'S WORK is more sombre than triumphant, he made full use of ornamental and plan forms commonplace to continental Baroque architecture. The giant court and chapel proposed at Greenwich Hospital, the proposed oval chapel at the Queen's College in Oxford, or the broken pediments at St George-in-the-East and at Blenheim, owe little to antiquity and rival anything by the Baroque masters (Figs 8–11). This and the next chapter will attempt to illustrate that these forms were a product of the gradual decline in faith in antique practices brought about by the rise of science and global exploration. The empirical methods and discoveries of seventeenth-century science led to a general questioning of the authority of antiquity that naturally undermined the classical canon, including *all'antica* architecture as codified by Vitruvius and the Renaissance treatises. Vitruvius's *De Architectura* owed its status to the fact that it was the only surviving record of antique building practices, necessarily centred on Rome and her monuments. But design models that reflected its principles were increasingly being replaced by forms without antique precedent, including the Gothic, and by familiar forms used in unprecedented ways.

Hawksmoor's outlook was influenced by this new world-picture, and his interests were by no means limited to architecture alone. He was well aware of the discoveries of his age, and his eclecticism with regard to antique ornament can be seen as a product, if not a direct representation, of this emerging modernity. Blackerby's obituary of Hawksmoor in March 1736 claimed that 'Nor was Architecture the only Science he was Master of . . . He was a very Skilful Mathematician, Geographer, and Geometrican'. Echoing the priorities of his age, Hawksmoor was at pains to emphasize that his approach to design – what he called his 'architectonricall method' – was founded on 'good Reason'. He consequently praised Lord Carlisle for not being 'superstitious' concerning the design of the Mausoleum at Castle Howard, and tellingly corrected himself when

commenting that 'if any thing is not agreeable to My Tast (I mean my Reason,) for when tast is without Reason both Tast and Fashion are out of Doors. I can . . . easyly add what is wanted'.[1] Despite the modern fictional view of Hawksmoor as a somewhat anti-rational, even demonic figure, his faith in the supremacy of human reason underpinned all aspects of his taste and judgement. No matter how strange his buildings may seem today, he clearly saw them as reflecting this rational approach.

NATURAL SCIENCE AND THE 'VITRUVIAN MAN'

For early Renaissance architects, the effectiveness of *all'antica* architecture lay in its ability to embody their view of an animistic, interconnected natural world in which the human body was at the centre and the ultimate 'pattern'.[2] Such a view famously informs the outstretched 'Vitruvian man' drawn by Leonardo, and the wonderland described in the *Hypnerotomachia Poliphili* (1499). The proportional systems adopted by Renaissance architects had sought to unite the Platonic harmony of a finite macrocosmos of concentrically orbiting planets with the human form described as a microcosmos by Plato, Vitruvius and the Bible. The gradual replacement of this magical view of nature by Cartesian concepts, from the mid-sixteenth century onwards,[3] was paralleled by, and even helped stimulate, the equally gradual rise throughout Europe of an architecture no longer dependent on models offered by either the human body or ancient Rome. The emerging anatomical understanding of the human body – illustrated in anatomy books and prints in Hawksmoor's collection[4] – together with the concept of mind–body dualism advanced by René Descartes – whose works Hawksmoor also collected[5] – inevitably demoted the importance of the 'Vitruvian man' pictured at the core of the Renaissance architectural treatises (Fig. 12).[6] This

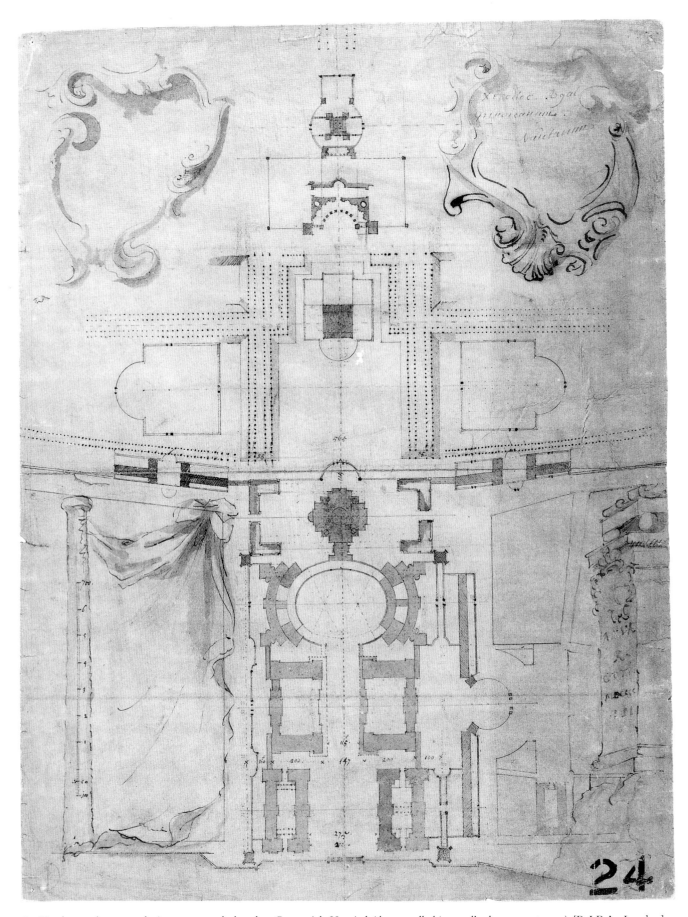

8 Hawksmoor's proposed giant court and chapel at Greenwich Hospital (the so-called 'second' scheme, post-1705) [R.I.B.A., London].

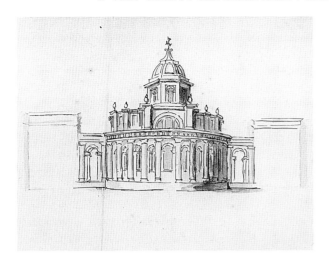

9 (*left*) Hawksmoor's proposed oval chapel at the Queen's College, Oxford, c. 1708–9 [Queen's College, Oxford].

10 (*below left*) Broken pediment on the front façade of St George-in-the-East.

11 (*below right*) Broken pediment on the front façade of Blenheim Palace.

12 (*bottom*) 'Vitruvian man', from Cesare Cesariano's *Vitruvius* (1521).

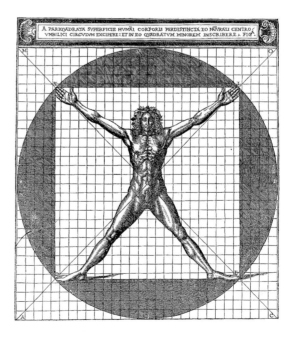

decline was underlined by the establishment of geometry as a science, independent of any reference to human form as its source, as well as by the increasing presence after 1550 of freer, Mannerist forms – oval plans and broken pediments – and by the complete absence after 1615 of any new Vitruvian treatises.[7]

Stimulated by the inventive, 'licentious' ornamental models of Sebastiano Serlio's *Libro Extraordinario* (1551) and the work of Michelangelo in Italy, the use of these Mannerist forms coincided with, and gained momentum from, early developments in scientific thinking of which anatomy was only one aspect. At first the preference for the oval (a distortion of the Platonic circle) and for broken antique forms reflected and even dramatized, as it were, the humanist re-evaluation of the canonical role of antiquity in favour of modern learning and discoveries. For these forms appeared in the

wake of shocks such as the discovery around 1500 of a New World beyond the limits of the old one,[8] and the disturbance of the progress of the High Renaissance centred on Rome by the Sack of the city in 1527. As others have pointed out, the oval was used in architecture long before the elliptical astronomy of Kepler and Newton that is frequently presented as inspiring its use.[9] Nevertheless following the publication in 1609 of Kepler's new elliptical planetary motion (in the *Astronomia nova*), the growing use of oval plans by Baroque architects clearly assumed new authority in coming more literally still to embody modern learning. Equally the Baroque emphasis on infinite space through axial planning came, in some English minds at least, to reflect the new open, infinite universe. For here, if not abroad, the development of Newtonian physics and the first use of Baroque forms and axes neatly coincide. This coincidence is most clear, as will shortly be seen, within Wren's work in both fields, but it is also found in the work of Robert Hooke. Hooke was the Royal Society's Secretary and Curator of Experiments, served as Gresham College's Professor of Geometry, as well as being architect of a number of the post-1666 Great Fire churches in London.[10] He also worked alongside Hawksmoor for Wren, running the work on the churches inside the Surveyor's office at Scotland Yard and then in the second office next to St Paul's Cathedral.[11]

In accepting the Newtonian view of the universe (and the anatomical view of the human body),[12] Wren was obliged to reject the Platonic idea of the human body as a model both of the cosmos and of architectural proportion as outlined by Vitruvius. He proposed the tree as the model for the column – as he put it, 'the more natural Comparison, than that to the Body of a Man, in which there is little Resemblance of a cylindrical Body'.[13] The column here followed natural laws for practical as opposed to symbolic reasons, prefiguring the arguments in Marc-Antoine Laugier's famous *Essai sur l'Architecture* published over half a century later, in 1753. A sign of this rationalization is that the canonic column types preoccupied Wren much less than they had Renaissance commentators on architecture. Wren went on to echo the French architect Claude Perrault – who was, significantly enough, also an anatomist – in rejecting the idea of 'perfect' Pythagorean bodily proportions for the Orders. Wren observed that proportions were 'more arbitrarily used than they care to acknowledge', and that these had been reduced 'into Rules, too strict and pedantick, and so as not to be transgressed, without the Crime of Barbarity'.[14] As Wren's student and, as will be seen, having himself studied the latest experiments of the

Royal Society as well as the writings of Perrault, Hawksmoor was clearly influenced by this shift. He seems to have preferred tangible qualities such as structural strength and visual effect – what he defined as 'L'Utile–La Perpetuita–La Bellezza'[15] – to overly abstract, traditional models of beauty based on the body and the cosmos, implicit in the treatise of Alberti and the more immediate Neoplatonism of Inigo Jones.[16] In defending his Doric colonnade on the Mausoleum at Castle Howard in his famous letters to Carlisle, Hawksmoor's more earth-bound thinking echoes in his acceptance that 'there is scarce any thing so perfect, but some faults may be found and Justly, in some particulars'.[17] Proportional perfection was, by implication, impossible and therefore, in the case of the Mausoleum at least, somewhat irrelevant when competing with structural necessities determined by available materials. His elongated pilasters on St Anne, Limehouse, and St George-in-the-East (Figs 14, 15), clearly owe little to traditional models of male and female forms for the column types, while other classical elements such as keystones are enlarged far beyond their traditional human scale (Fig. 13). In these cases his architecture might literally be described as 'disembodied'.

Indeed Hawksmoor saw the human body as a model of visual diversity rather than as a pattern of proportional harmony. He noted that at Castle Howard

> tho y[e] South front is Rusticated in the Basement yet the order upon it is plain, but divided into a per-

13 Keystone, St George, Bloomsbury.

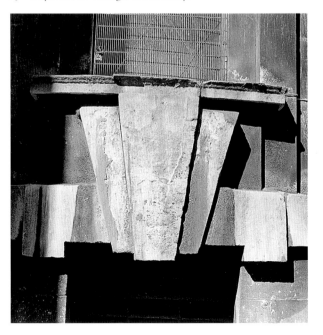

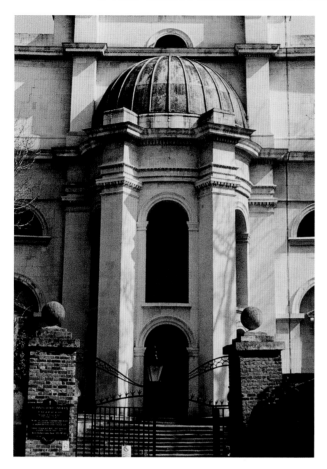

14 Pilasters at St Anne, Limehouse.

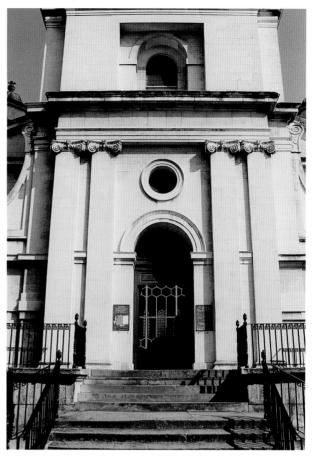

15 Pilasters at St George-in-the-East.

petuall Arcade, supported with a Range of pilasters, by which the contrast and dispar[ity], between the Basement and the order, become more visibly remarkable. and it is most certain, that when a machine is composed of different parts, Limbs, or members, one would not have them, blend and melt into one mass, so as not to be able, to distinguish ye Noble parts from the inferior, the Basement, from the order, that rest upon it. or as in human bodies, the Trunk from the Limbs.[18]

His words serve to underline the process whereby the visual had been privileged over other, more ontological factors, a development traceable to the invention of linear perspective in the early Renaissance.[19] Indeed, as his obituary implies and as a study of his library proves, Hawksmoor was well aware of such developments influenced by the rise of science.

★ ★ ★

THE ROYAL SOCIETY AND HAWKSMOOR'S LIBRARY

In 1671 Jean Baptiste Colbert, Louis XIV's chief minister, had founded the Académie Royale d'Architecture in Paris, the first institution to teach architectural theory and practice in a systematic way. To date England had no equivalent, and John Evelyn in his 1707 'Account of Architects and Architecture' appended to his translation of the French theorist Roland Fréart de Chambray's *Parallèle de l'architecture antique et de la moderne* (lots 89 and 108)[20] included this appeal:

> Great Pitty then I say it is, that amongst the *Professors* of *Humanity* (as they call it) there should not be some *Lectures* and *Schools* endowed and furnish'd with *Books, Instruments, Plots, Types* and *Modells* of the most excellent Fabricks both in *Civil* and *Military Architecture*, where these most Noble and Necessary *Arts* might be Taught in the *English* and Vulgar Tongue.[21]

As someone who had received training in both the theory and the practice of architecture, under Wren in the Office of Works, Hawksmoor was thus a rarity

in early eighteenth-century England.[22] This fact was underlined by the continuing predominance of the artist-, craftsman-, or gentleman-architect. Richard Boyle, third Earl of Burlington, was one of the last mentioned, while his associate William Kent was of the artist type. Not surprisingly Hawksmoor drew attention to the distinction between himself and those of his age who acted as mere critics, as he saw them. In a letter to the Dean of Westminster he observed sarcastically concerning his critics that 'I wish I had the honor to know, whether they are Gentlemen – Connoissieus, Criticks or Workmen advanc'd to the degree of Architects'.[23] Only John Webb preceded Hawksmoor in having received an apprenticeship. Wren had started out as an astronomer before becoming Surveyor General, although his background in the natural sciences, especially in geometry and mathematics, would have provided him with a good foundation in both structural and optical matters.[24] Vanbrugh was untrained as an architect, and Hawksmoor's later collaboration with him would have been as a professional with an untrained partner.

In the absence of a period of foreign travel or university study, Hawksmoor's education in technical subjects including architecture was informed by his wide-ranging collection of books.[25] The treatises had traditionally provided aspiring architects with their main source for the *all'antica* design rules. Hawksmoor owned the famous editions of *Vitruvius* by Barbaro and Perrault (lots III and 70),[26] as well as the treatises by Alberti (lots 42 and 114), Serlio (lot 102), Du Cerceau (lot 144), Palladio (lots 40, 68 and 123), Scamozzi (much referred to in the book on Westminster Bridge) and Carlo Cesare Osio (lot 61).[27] His letters to Carlisle concerning the Mausoleum make clear his reliance on these books when designing.[28] He evidently also found inspiration from his study of such antique authors as Pliny the Elder (lots 84 and 99), Tacitus (lot 82), Caesar (lots 48 and 135), Plutarch (lot 55) and Juvenal (lot 76), for on one of his drawings for the Belvedere at Castle Howard, Hawksmoor refers to Pliny (probably the Younger), Herodotus and Varro (Fig. 16).[29] He equally collected the leading architectural publications by native Palladians, including the works by Campbell (lot 131) and Kent (lot 116), and was even a subscriber to that by Gibbs (lot 136). Alternatively, his collection of amply illustrated books on Baroque Rome would have inspired his inventiveness, in the absence of first-hand experience of the city.[30] These books included works by Domenico and Carlo Fontana, Giovanni Giacomo de Rossi, Giovanni Battista Falda and Domenico de Rossi.[31] He also had general works on Baroque orna-

ment by Serlio, Giovanni Battista Montano, Hendrick de Keyser and Alexandre Francini.[32]

A notable characteristic of Hawksmoor's library is that it reflected the programme and interests of the Royal Society, as might be expected of someone apprenticed to Wren, a President of the Society from 1681 to 1683. Most notably, Hawksmoor owned a three-volume set of the Society's transactions to 1700, edited by John Lowthorp (lot 35).[33] He also owned editions of works by leading Fellows of the Society, including Robert Boyle, Robert Plot, Isaac Barrow and his pupil Isaac Newton.[34] Equally represented were studies sponsored by the three recently founded royal academies in Paris – of science (1666), architecture (1671) and music (1672): alongside Perrault's famous translation of Vitruvius (lot III) were works on geometric patterns by Dominique Douat (lot 37),[35] on the application of geometry to stonecutting by Gerard Desargues (lot 8)[36] and on the proportions of the Roman monuments by Antoine Desgodets (lot 109). As well as the works by Descartes and the natural scientist and atomist Pierre Gassendi (lot 2),[37] Hawksmoor owned works on logic, law, metaphysics, mechanics, mathematics, medicine, natural history and geography (lots 5, 6, 20, 55 and 65). The Royal Society's particular interest in natural history, as part of its Baconian programme, was reflected in the presence of works by Plot and by Aylett Sammes (lot 86).[38] Hawksmoor's interest in the emerging science of civil engineering is evident in his close study of the works on bridge design by Henri and Hubert Gautier, which he referred to in arguing for his bridge at Westminster.[39] His obituary emphasized his engineering prowess in the repair of Beverley Minster, where, in the spirit of Wren's mechanical experiments for the Royal Society, he corrected a leaning wall 'by Means of a Machine of his own Invention' (in fact devised by William Thornton). He admired contemporary feats of engineering, noting in his book on Greenwich Hospital that, compared to memorials, 'the most useful Undertakings are still more to be commended, such as mending and making Roads, Bridges, Rivers Navigable, and many other public Works, which cannot be reckoned among the vain Projects'. This engineering work encouraged him in his wish for the contemporary advancement of what he went on to term 'the Science of Architecture'.[40]

Hawksmoor's interest in the emerging science of husbandry and gardening – subjects again promoted by the fledgling Royal Society – is evident in his ownership of John Evelyn's *Sylva, or a Discourse of Forest-Trees, and the Propagation of Timber in His Majesties Dominions* (1664; lot 64).[41] This work was undertaken by a number

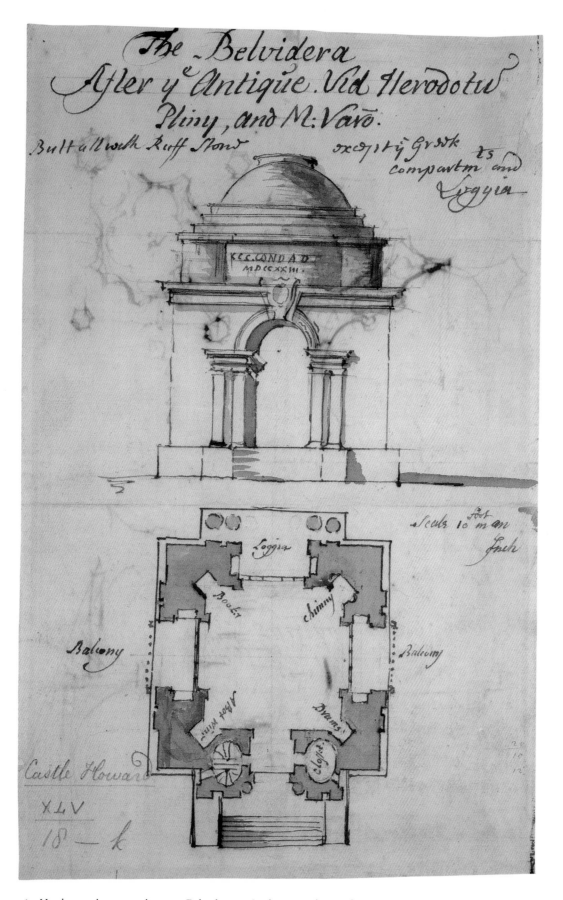

16 Hawksmoor's proposed square Belvedere at Castle Howard, 1723 [British Library, London].

of the Fellows of the Society and was perhaps the most successful of the various projects which Evelyn directed on their behalf. It represented a major part of the Society's claim to have achieved progress in practical matters. One such, architecture, was also assisted by Evelyn, this time through his popular translation of Fréart that appeared in the same year and whose title-page boasted of Evelyn as a 'Fellow of the Royal Society'.[42] Hawksmoor would also have seen illustrated one of the leading experimental gardens of the day, at Wadham College, Oxford, in his copy of David Loggan's *Oxonia Illustrata* (1675; lot 119).[43] He owned other works on the subject by Leonard Meager and the natural scientist Richard Bradley,[44] as well as John James's 1712 English translation of the Parisian savant, naturalist and collector Antoine-Joseph Dézallier D'Argenville's *La théorie et la pratique du jardinage* (1709; lot 45). This last, on the formal French garden 'commonly called pleasure-gardens' (as James's title has it) conceived by André Le Nôtre, became the most influential French work on the subject in the eighteenth century. As will be seen in Chapter 8, Hawksmoor admired Le Nôtre's axes and employed the vista as a key device in his plans. Like Evelyn, who had published a translation of De Bonnefons's *The French Gardiner* in 1658, James tried to introduce rational French practices into English garden design just as he attempted to do with architecture through his translation of Perrault's *Ordonnance* (lot 126). Hawksmoor knew James well, because both men served as surveyors to the Commission for Fifty New Churches and collaborated on two of them – the eclectic St Luke, Old Street, and St John, Horselydown. Perhaps Hawksmoor's interest in the emerging science of gardening was nurtured on the Castle Howard estate through his involvement in the laying out of the Wilderness and Ray Wood (c. 1705–10); both were cut into paths and 'cabinets' which he would have seen illustrated by James (Fig. 17; and see Fig. 160).[45]

Thus rather than reflecting the outdated Neoplatonic cosmology and mythology cultivated in the era of Inigo Jones, with its arcane superstitions, Hawksmoor's collection of books for the most part recorded contemporary advances in scientific theory. This interest and, as will be seen in the next chapter, his concern with newly discovered cultures chronicled in travel books, indicates why, like Wren, Hawksmoor would have felt particularly justified in transcending antique precedent in inventing the architectural forms and ornamental mixtures so prominent on his buildings. Moreover his need to stress to Carlisle that he followed what he called an 'architectonricall method' when designing, reflected the priorities – in etymological, if not in

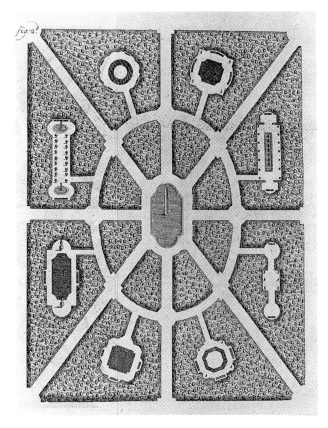

17 Paths and 'cabinets', from John James's 1712 English translation of Antoine-Joseph Dézallier D'Argenville's *La théorie et la pratique du jardinage* (1709).

actual, terms – of the experimental methodology emerging in the sciences. In this process the rules of the ancients were not rejected but used as a rational starting point to underpin invention. Hence Vanbrugh's proposal for the Belvedere (the 'Temple of the Four Winds') at Castle Howard (Fig. 18) was, according to Hawksmoor, 'founded upon yᵉ Rules of yᵉ Ancients. I mean by that upon Strong Reason and Good Fancy, joyn'd with Experience and Tryalls'.[46] The 'Good Fancy' referred to here was not capriciousness but rather echoed Thomas Hobbes's definition of it as the faculty that formed images at the moment of perception, that is the imagination.[47] Thus true to scientific method, Hawksmoor combined the use of imagination with 'Strong Reason' in recommending a design that was to be tested, like in any worthwhile experiment, by 'Experience and Tryalls'.

★ ★ ★

18 Vanbrugh's 'Temple of the Four Winds' (Belvedere) at Castle Howard.

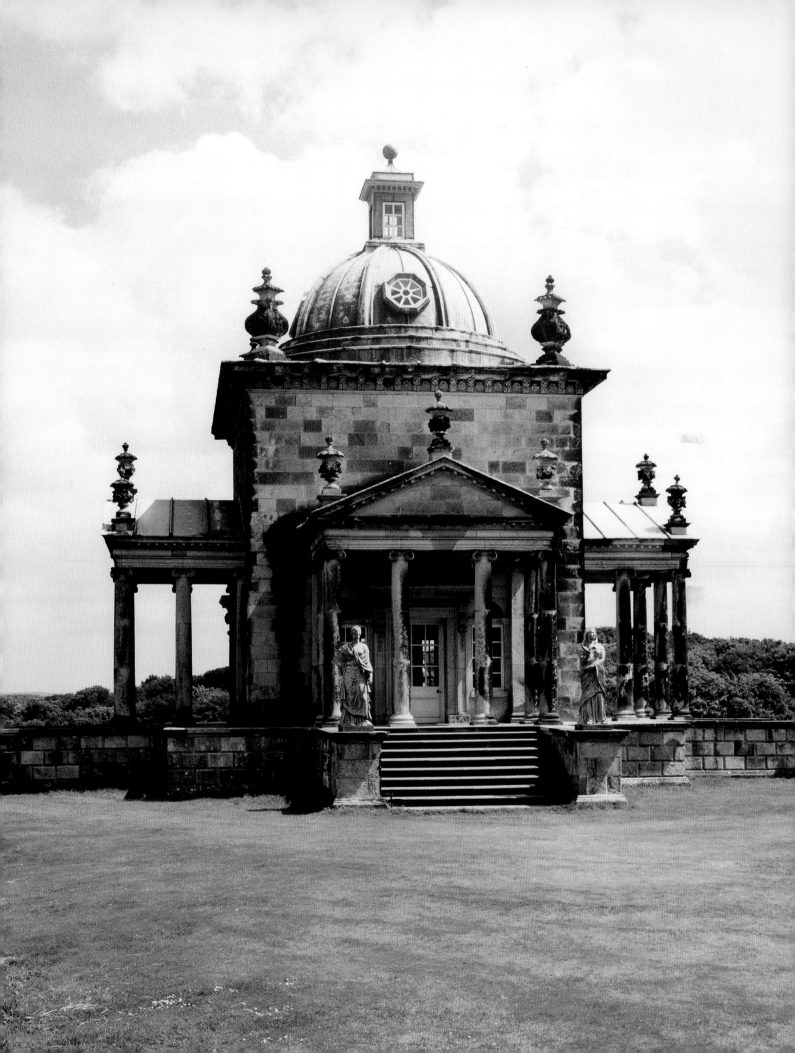

'EVILL CUSTOM, AND PERNICIOUS PRACTICE': WREN'S VIEW OF THE NATURAL SCIENCES IN PRACTICE

The various English translations of French architectural and gardening treatises indicate the modernity of France in matters of architectural theory. Indeed by the middle of the seventeenth century, France could claim to rival Italy as the European centre for architectural debate. This claim was maintained despite the absence of antique remains on the scale of those in Rome, whose monumental presence helped preserve the city's central status as a tourist attraction. Wren never went to Italy, famously studying the new architecture of Paris at first hand instead.[48] Contemporary French debate centred on the primacy of established authority in questions of architectural beauty, stimulated as in England by claims for modern progress and scientific scepticism towards the absolute truth of aspects of antique theory and ancient sources. Of fundamental importance in this debate was the search for a new

19 Portico at All Saints' church, Northampton, c. 1683, attributed to Hawksmoor.

architecture of classical authenticity. On one side were the 'Ancients' – the academic architects represented by Roland Fréart de Chambray and François Nicolas Blondel. Condemning the 'licentious' use of the Orders by modern architects and citing Greek monuments as the source for architectural principles, Fréart proposed the Greek Doric, Ionic and (particularly) the Corinthian Orders as the ultimate models of beauty in architecture (and hence had little time for the Roman Tuscan or Composite). Blondel for his part emphasized traditional Vitruvian sources in promoting the concept of a universal, immutable architectural beauty.[49] Hawksmoor owned not one but two copies of Blondel's treatise.[50]

Opposed to this group were the 'Moderns' – represented by Perrault, the most extreme exponent of their cause – who rejected the Renaissance canon of absolute beauty reflected in perfect proportions and instead cited custom and habit as determinants of a changeable beauty in architecture. Hawksmoor was well aware of Perrault's ideas, quoting from his *Vitruvius* (lot III) when defending the Mausoleum to Carlisle, and his sympathy with Perrault's position is suggested by his numbering among the subscribers to James's translation of the French theorist's *Ordonnance* (lot 126). Moreover Evelyn drew his reader's attention to the French debate in his second, 1707 expanded 'Account of Architects and Architecture'.[51] Hawksmoor studied this work, making direct reference to 'Mr. Evelyn in his addition to the Paralell of Monsr. Chambray' in his Mausoleum defence.[52] The fact that he owned both editions of Evelyn's translation – the first of 1664 and this second of 1707 (lots 89 and 108) – strongly suggests that he was interested in the additional material in the second edition, especially since it was dedicated to Wren. Certainly Hawksmoor's awareness of this French debate, and his probable conditional sympathy with the freedom to experiment as advocated by the 'Moderns', could only have further undermined the absolute authority of ancient rules that many of his eccentric details so clearly flaunt.

It was through Wren's influence, however, that much of the thinking of the 'Moderns', not just on the questioning of canonic proportions, would have been introduced to Hawksmoor. His obituary claims that 'His early Skill in, and Genius for this noble Science recommended him, when about 18 years of Age, to the Favour and Esteem of his great Master and Predecessor, Sir Christopher Wren, under whom, during his life, and for himself since his Death, he was concerned in the erecting more publick Edifices, than any one Life, among the Moderns at least, can boast of . . . under [Wren] he was assisting, from the Beginning

20 Orangery, Kensington Palace, London, 1704–5.

to the Finishing of that grand and noble Edifice the Cathedral of St. Paul's'. Hawksmoor was introduced to Wren by the plaster worker Edward Gouge. He was initially taken on as the Surveyor General's personal clerk, probably some time around 1684 following a period of extensive travel in England recorded in a topographical sketchbook (now at the R.I.B.A.).[53] This was not therefore 'from the Beginning' of the Cathedral design, in following the great model of 1673 and the Warrant design of 1674–5. His first recorded work for Wren was at the new palace at Winchester, from 1684 until work stopped in February 1685 on the death of Charles II. It has recently been speculated that around 1683 Hawksmoor was engaged in the design of the portico at All Saints' church, Northampton (modelled after Inigo Jones's portico to old St Paul's) – a work independent from Wren which Hawksmoor recorded in his sketchbook (Fig. 19).[54] By 1685 he was being employed at Whitehall at two shillings a day, while in 1687 in his new role as clerk he was 'finding Ink, paper, bookes, wafers, pens and other Necessarys'[55] for the office in charge of Wren's City churches. Between 1687 and 1692 he was paid at Chelsea for 'drawing designes for yᵉ Hospitall'.[56] When in 1689 the

king bought Nottingham House as the nucleus of Kensington Palace, Hawksmoor was appointed Clerk of Works there (until 1715) and in 1704–5 the Orangery was built for Queen Anne under his direction (although possibly not designed by him) (Fig. 20). During this period he also received a daily wage as Wren's clerk at Hampton Court, designing details himself.[57] A perspective sketch attributed to Hawksmoor is of a monumental oval bowling green for the palace (Fig. 21).[58]

It was during the 1690s that Hawksmoor worked as Wren's draughtsman and clerk on the City churches – and latterly on their steeples – as well as on St Paul's Cathedral, where he was paid consistently from 1691 to 1712 for copying and draughting designs. The consistent nature of this employment is recorded in the Cathedral building accounts. They note, for example, that Hawksmoor was paid £2.3.4 in March 1691 'for assisting the Surveyor in drawing [which is altered in the next entry, perhaps significantly, to 'copying'] Designes and other necessary business for the Service of this work'. Eleven years later, the entry in July 1702 tellingly adds 'and Giving Directions to the Masons, &c'.[59] This work for Wren at St Paul's would have taught Hawksmoor not only about such practical

21 Sketch attributed to Hawksmoor of a monumental oval bowling green for Hampton Court, c. 1689–91 [Yale University Center for British Art, New Haven, Paul Mellon Collection].

matters but also introduced him to his master's theories concerning architecture. For the Cathedral must have represented a lesson in stone, in which Wren sought to apply his ideas with Hawksmoor's practical assistance. It is thus worth looking at exactly how the Cathedral represented Wren's ideas in order to understand something of Hawksmoor's training in principles of architectural beauty.

Wren outlined his theory of architecture in five Tracts, the first four published posthumously by his grandson in *Parentalia: or, Memoirs of the Family of the Wrens* (1750) but written from the mid-1670s – that is, the period when Hawksmoor served as Wren's pupil and clerk.[60] The last Tract, a 'Discourse on Architecture', is bound in the R.I.B.A. 'Heirloom' MS copy of *Parentalia* and, following Wren's description of the Halicarnassus mausoleum in Tract IV, includes a drawing by Hawksmoor of that monument (Fig. 22).[61] It is therefore perfectly possible that both master and pupil worked on the Tracts together, and, as will be seen in the next chapter, their influence on Hawksmoor is

confirmed by his direct references to Wren's historical models. In shifting his attention from the study of astronomical and geometric theory to architectural history and practice, Wren sought in these Tracts to define architectural laws in the spirit of the new 'experimental' philosophy. Not surprisingly, the Tracts reflect the priorities of the Royal Society – and of Perrault – in re-examining antiquity based on new observations and more rational criteria. Wren introduced the first Tract by echoing the Vitruvian design triad of strength, utility and grace (*firmitas, utilitas, venustas*; I.iii.2), although redefined using the epistemology of seventeenth-century science: now 'Beauty, Firmness, and Convenience, are the Principles; the two first depend upon geometrical Reasons of *Opticks* and *Staticks*; the third only makes the Variety'.[62] For Wren as a geometrician, the natural guarantors of firmness, or structural integrity, were Euclidean principles. When discussing the structure of the old Cathedral he emphasized the shift from the established design practices of Renaissance architects to those based on geometry,

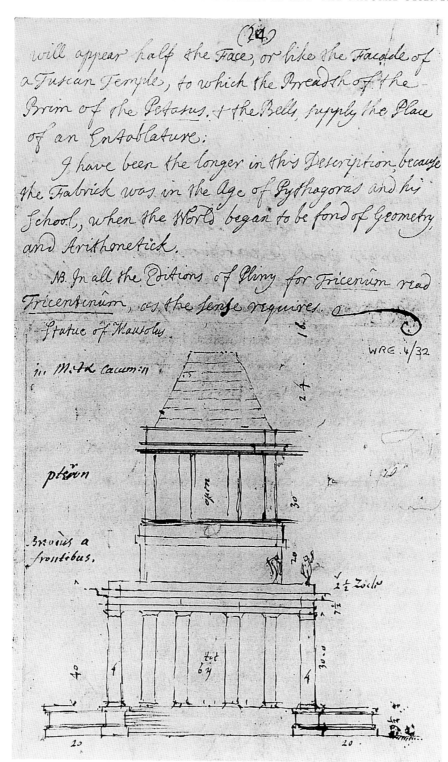

22 Hawksmoor's drawing of the Halicarnassus mausoleum bound with Wren's 'Discourse on Architecture' in the R.I.B.A. "Heirloom" MS copy of *Parentalia* (1750) [R.I.B.A., London].

noting that 'This also may be safely affirm'd, not only by an architect, taking his Measures from the Precepts and Examples of the Antients, but by a Geometrician, (this part being liable to a Demonstration) that the Roof is, and ever was, too heavy for its Butment'.[63]

While Wren attempted to establish geometric laws based on statics for the firmness of structure, without which 'a fine Design will fail',[64] he considered that the first criterion of design – that is, beauty – was less an intrinsic structural quality than an optical 'effect' or

appearance of geometric purity which worked on the senses of the observer. This natural, or geometric, beauty – although still based on the primacy of regular, Platonic forms – was no longer justified through its reflection of the microcosmic model of the human body, nor was it dependent on the innate harmony of an object's form. Rather, it had to do with the object's outer appearance of harmony as perceived by the viewer. Consequently in the first Tract Wren recognized two causes of beauty:

> Beauty is a Harmony of Objects, begetting Pleasure by the Eye. There are two Causes of Beauty, natural and customary. Natural is from *Geometry*, consisting in Uniformity (that is Equality) and Proportion. Customary Beauty is begotten by the Use of our Senses to those Objects which are usually pleasing to us for other Causes, as Familiarity or particular Inclination breeds a Love of Things not in themselves lovely. Here lies the great Occasion of Errors; here is tried the Architect's judgement: but always the true Test is natural or geometrical Beauty.[65]

For Wren there were thus two causes, but only one type, of beauty. The first cause, based on the appearance of geometry, included the property of symmetry (defined as 'equality'), while the second was, for Wren, erroneously based on familiarity or custom. Hawksmoor echoed this prejudice against customary beauty when proclaiming to Carlisle that he was 'only for following architectonricall method, and good Reason, in Spite of evill Custom, and pernicious practice'.[66] Although this re-evaluation of the basis of architectural beauty by master and pupil echoed Perrault's rationally inspired aims, their rejection of customary practices strongly contrasted with the Frenchman's conclusions.[67] Perrault considered that there was not one but two types of beauty, the 'positive' or absolute and the 'arbitrary' or customary. Having rejected the Renaissance canon of absolute beauty based on human form, he controversially included proportion in the second, arbitrary category. Even though good taste was founded on knowledge of both types, for Perrault judgements in the latter alone 'distinguishes true Architects'.[68] For Wren, however, custom was the 'great Occasion of Errors'. Customary causes were outside influences that disturbed the intellect, leading to the apprehension of beauty in objects that had no intrinsic geometric qualities. Reason was overruled by familiarity and the imagination worked without rules; certain physical aspects were perceived as beautiful, although they were only 'Modes and Fashions' which formed the 'Tastes' of a particular age and led to the variations in style which history recorded. This no

doubt justified Hawksmoor in his view of Palladianism as one such passing fashion.

Wren considered architecture to be a mathematical science, and the Cathedral, with its strong clarity of geometric forms, should be viewed as an attempt to represent this concept of natural beauty following the ancient examples studied in the Tracts. On the Temple of Mars Ultor, for example (Fig. 23), Wren commented that the 'Squares in the Wall of the *Cella* opposite to the Inter-columnations, tell us how extremely the Ancients were addicted to square and geometric Figures, the only natural Foundation of Beauty'.[69] From the court of the temple Wren concluded that 'certainly no Enclosure looks so gracefully as the Circular: 'tis the Circle that equally bounds the Eye, and is every where uniform to itself . . . a Semicircular joining to an Oblong, as in the Tribunal at the End of this Temple, is a graceful Composition'.[70] This preference lies behind Wren's eastern apse and semi-circular porticoes on the transept façades at St Paul's (Figs 24, 25). Indeed, in its embodiment of pure forms, the Cathedral design clearly followed Wren's hierarchy of geometric beauty, for

> Geometrical Figures are naturally more beautiful than other irregular; in this all consent as to a Law of Nature. Of geometrical Figures, the Square and the Circle are most beautiful; next, the Parallelogram and the Oval. Strait Lines are more beautiful than curve; next to strait Lines, equal and geometrical Flexures; an Object elevated in the Middle is more beautiful than depressed.[71]

It is against the last 'Law of Nature' that the Cathedral's west front, with its elevated central portico and pediment, should be understood (Fig. 26) – and indeed the central dome, since Wren adds in Tract 1 that 'The Ancients elevated the Middle with a Tympan, and statue, or a Dome'.[72]

In his obituary of Hawksmoor, Blackerby praises the architect as 'a very Skilful . . . Geometrician' (a fundamental virtue to a freemason such as Blackerby).[73] Clearly this skill as a geometrician would have been fully employed in creating such geometric beauty at St Paul's. For in working closely with Wren on the Cathedral, entering his service around 1684 during the time when the Tracts are thought to have been written, Hawksmoor could not have failed to be influenced by his master's strictures – especially since he helped illustrate them. Wren's suspicion of customary beauty would certainly have opened the way for the originality of form and ornament, often based on geometric shapes, which characterizes Hawksmoor's work.[74] Following Wren's advice that the expression of geometric purity was nothing less than the 'true Test' of good architec-

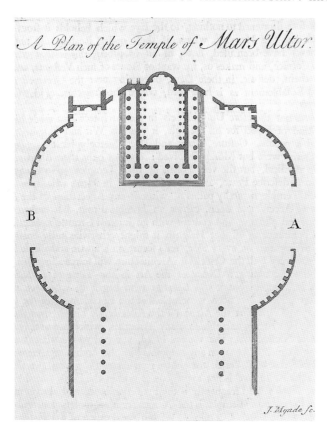

23 Wren's plan of the Roman temple of Mars Ultor, from *Parentalia* (1750).

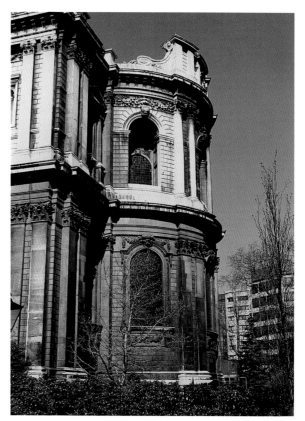

24 Eastern apse of St Paul's.

25 Semi-circular portico on the south transept of St Paul's.

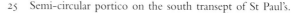

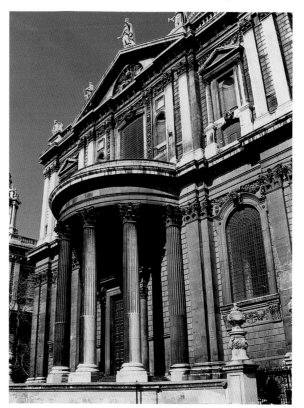

ture, Hawksmoor's spires are composed for the most part of octagons and pyramids, for example, while his Castle Howard Mausoleum is a triumphant perfection of form. At Christ Church, Spitalfields, the walls are continued as parapets to conceal the sloping aisle roofs and thereby create the external effect of a purity of form (Fig. 27). This reflects St Paul's, where a non-structural covering to the dome, concealing the conical structure supporting the lantern, and false walls to the sides, concealing the flying buttresses, are used to give the effect of geometrical clarity (Figs 28, 29). In Hawksmoor's work the pediment invariably conceals the roofline that heavy cornices also frequently help disguise; indeed Wren advised in the first of his Tracts that 'no Roofs almost but spherick raised to be visible, except in the Front, where the Lines answer', and that 'No Roof can have Dignity enough to appear above a Cornice, but the circular'.[75]

Despite Wren's reformulation of beauty from its metaphysical reflection of the macrocosm towards an apparently more rational basis in geometry and optics, his conception thus rested on much more empirical judgements of human perception now based, as in science and archaeology, on direct observation. On

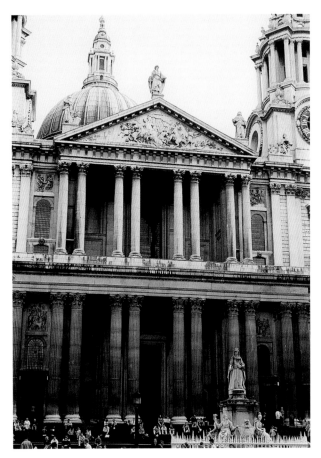

26 West front of St Paul's.

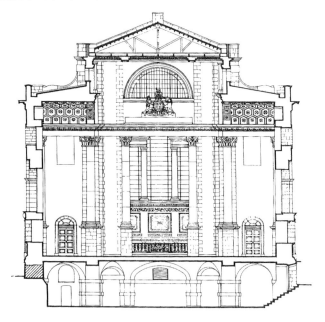

27 Section through Christ Church, Spitalfields [author].

the truth of the natural sciences and the 'Elliptical Astronomy', Wren concluded that 'natural Philosophy [has] of late been order'd into a geometrical Way of reasoning from ocular Experiment, that it might prove a real Science of Nature, not an Hypothesis of what Nature might be'.[76] The priority he gave geometric beauty relied on the supposed inherent human preference for visually balanced, regular forms. In order to respond to this preference, according to Wren, the architect needed to use perspective views, and take into account surrounding buildings and viewing distances. By way of justification he noted in Tract IV that 'The *Romans* guided themselves by Perspective in all their Fabricks'.[77] St Paul's was evidently designed from such perspective views, as well as from the models made for the early schemes. For in Tract I Wren specifies that

> The Architect ought, above all Things, to be well skilled in Perspective; for every thing that appears well in the Orthography, may not be good in the Model, especially where there are many Angles and Projectures; and every thing is good in Model, may not be so when built; because a Model is seen from other Stations and Distances than the Eye sees the

Building: but this will hold universally true, that whatsoever is good in Perspective, and will hold so in all the principal Views, whether direct or oblique, will be as good in great, if this only Caution be observed, that Regard be had to the Distance of the Eye in the principal stations.[78]

Accordingly, in elements seen together, such as within the simply arranged two-storey ordered block comprising the Cathedral's west front, 'much Variety makes Confusion'. In elements that are seen separately, however, 'great Variety is commendable, provided this Variety transgresses not the Rules of *Opticks* and *Geometry*'.[79] An indication that the plain side walls of the Cathedral were designed to be viewed in perspective – that is, along their length and in total – is to be found in Wren's first Tract. Here he notes that

> In Buildings where the View is sideways, as in Streets . . . every thing [should be] strait, equal and uniform. Breaks in the Cornice, Projectures of the upright Members, Variety, Inequality in the Parts, various Heights of the Roof, serve only to confound the Perspective, and make it deformed, while the Breaches and Projectures are cast one upon another, and obscure all Symmetry.[80]

The 'strait, equal and uniform' might easily describe the Cathedral's side walls, and reads as a triumph of visual simplicity over the distorted forms of Baroque ornamentation. Indeed the unbroken symmetrical street frontages of Hawksmoor's Oxford college schemes on the whole seem to follow Wren's advice, in forming

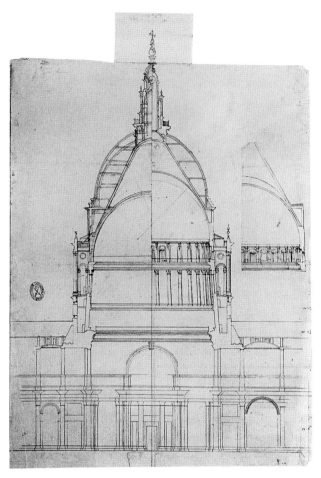

28 Section through the dome of St Paul's, from Wren's office, undated [Guildhall Library, London].

29 Section through vault and screen wall of St Paul's, from Wren's office, undated [Guildhall Library, London].

part of a plan where the vista was all important, as will be seen in Chapter 8.

Hawksmoor certainly followed his master in considering perspective views an important tool in the design process; his views have survived of schemes for All Souls and for the Temple of Venus at Castle Howard (Figs 30, 108).[81] He owned two editions of Joseph Moxon's practical treatise on perspective drawing (lots 71 and 73) and a copy of Newton's revolutionary work on the principles of optics (lot 34). He also owned a copy of the English translation by John James of Andrea Pozzo's leading Baroque painter's manual, concerning how to merge real and painted space in a continuum (lot 93). Together with Wren and Vanbrugh, Hawksmoor went so far as to endorse this book on perspective illusion as 'a Work that deserves Encouragement, and very proper for Instruction in the Art'.[82]

Furthermore Hawksmoor seems to have agreed with Wren that beauty was an optical 'effect', rather than an abstract quality defined by reference to cosmic relationships. In reflecting the experimental method of trial

and error, he frequently insisted on the use of models – for the London churches for example – and of other 'tryalls, so that we are assured of ye good effect of it'.[83] Concerning some additional piers on the Mausoleum he recommended 'Your Lordship sees whether it has a good effect, or a bad one'.[84] Indeed beyond the subjective appreciation of visual beauty, Hawksmoor can be seen to have followed objective seventeenth-century theories of perception in clearly evoking a range of such 'effects' and moods in his work, including those of solemnity and even fear. Descartes for one – whose works were noted earlier as present in Hawksmoor's collection – had stressed the effects produced in the mind through the apprehension of colour and light: Hawksmoor's sketches emphasize the contrasts between light and shade as a matter of principle.[85] His Stepney churches in particular are famous for their brooding sense of foreboding, manipulated through massive quoins and over-scaled keystones and doors combined with ponderous projections and dark recesses (Fig. 7). The evocation of melancholy had been studied in Robert Burton's *The Anatomy of Melancholy*, which first appeared in 1621 with a title-page illustrating the link between mood and shadowy settings.[86] In this spirit Evelyn, for example, described Gothic buildings as 'Congestions of Heavy, Dark, Melancholy and *Monkish Piles*'.[87] The accent on the visual and sensory aspects of a design, defined by trial and error, also paralleled the growing importance in the natural sciences of observation over 'evill' customary practices necessarily remote from particular contexts.[88] Indeed, as will be seen, rather than universally apply a customary style derived from antiquity (such as Palladianism), Hawksmoor was

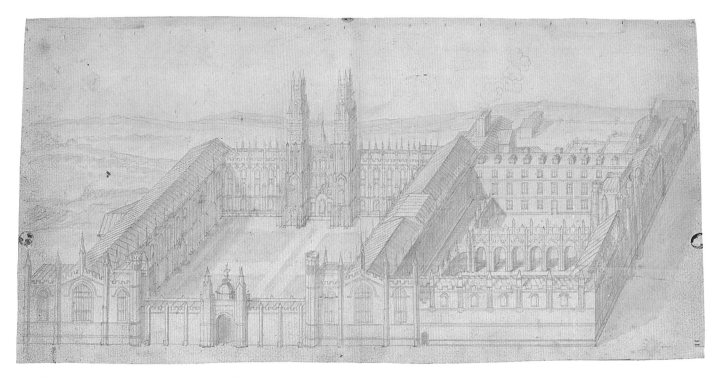

30 Hawksmoor's perspective of scheme for All Souls, Oxford, probably c. 1717–18 [Worcester College, Oxford].

particularly sensitive to the relationship between the appearance of his buildings and their local context.

In the first of his Tracts Wren advised the architect in general – and it might reasonably be supposed his pupil in particular – 'to think his judges, as well those that are to live five Centuries after him, as those of his own Time'.[89] His work attempted to cast in stone an enduring, absolute standard of architectural beauty and taste, and thereby, it was implied, establish a new national style. In the event Wren's principles and architectural models were developed by Hawksmoor in such a way that his work became inimitable – defined as it was by time and place – but he too wished to build in an enduring manner.[90] Alongside 'Convenience', 'Decency' and 'Beauty', one of his principles outlined to Carlisle is that architecture should be 'Lasting',[91] and like Wren he sees the use of reason as a guard against fashion. He wrote on 3 October 1732 that 'Men have generally different ways of thinking and the Opinion of the Professours of Arts are exceeding various, so that if you will not agree to this Maxim, that all Rules should proceed, from Reason Experience and necessity, (as well as Laws) then we must Submit to the many Caprices of the World' and 'quit our Reasons and intentions'.[92] In following Wren's ambition to establish a timeless architecture through reference to first principles, Hawksmoor here once again endorsed human reason and the experimental method championed by contemporary science. Prompted by these sentiments, this book will be concerned with the 'reasons' and 'Laws' which Hawksmoor clearly implied lay behind his use of a puzzlingly wide range of ornamental styles and forms.

'A BOOK OF PRINTS BY SALVATOR ROSA': ILLUSION AND THE SUPERNATURAL

The Baroque emphasized its modernity through being aggressively anti-classical, breaking the bonds with tradition by actively abusing the classical language of architecture. Its outwardly irrational, illusionistic and supernatural qualities also served to emphasize this modernity by using contemporary techniques of perspective to represent the concept of infinity, and of construction to achieve an apparently impossible plasticity. The stonecutting science of stereotomy – as employed by Guarino Guarini for example – used geometry as never before to build vaults that seemed to defy the very forces of nature. Supernatural or occult natural forces thereby appeared to be tamed. Although Hawksmoor's work is less flamboyant structurally than Guarini's, and is less indulgent in its use of flowing curves easily associated in the Protestant mind with the Baroque churches of the Counter-Reformation, he was

31 Salvator Rosa, *Scene of Witchcraft* [Cleveland Museum of Art].

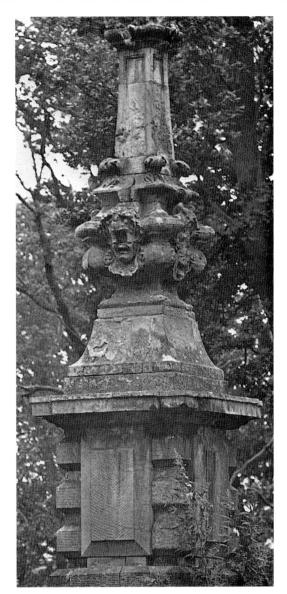

33 'Four Faces' miniature obelisk at Castle Howard.

perfectly well aware of the Baroque's illusionistic qualities, as his endorsement of Pozzo proves. He was also aware of the untamed, irrational side of nature – as depicted in the wild and supernatural landscapes of Salvator Rosa which he collected (lots 181 and 36) (Fig. 31) – and on occasion he employed the traditional grotesque symbols for the supernatural world. St Bride in London has urns with demon faces, and Easton Neston has a human face in the form of a shell; at Castle Howard there is an enigmatic 'Four Faces' miniature obelisk and for the Belvedere he proposed a sphinx

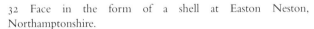

32 Face in the form of a shell at Easton Neston, Northamptonshire.

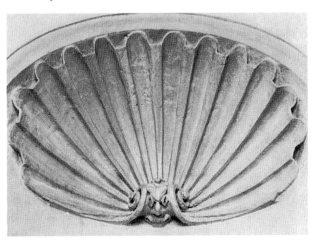

and painted Terms after those by Annibale Carracci (Figs 32–4; see also Fig. 90).[93] Capricious creatures are also prominent in works with which Hawksmoor was associated, such as the 'Satyr Gate' at Castle Howard (see Fig. 102), and the satyr masks under the buttresses of the dome and the sea monsters on the outside of the Painted Hall at Greenwich (Figs 36, 37). The strange masks in the keystones of Kensington Orangery also make visible a hidden world of nature here tamed, as it were, by art (Fig. 35).[94] Hawksmoor was, after all, against the purely 'sensible' (which he identified with Palladianism),[95] and it is tempting to see this supernatural, less rational world as equally symbolized by his

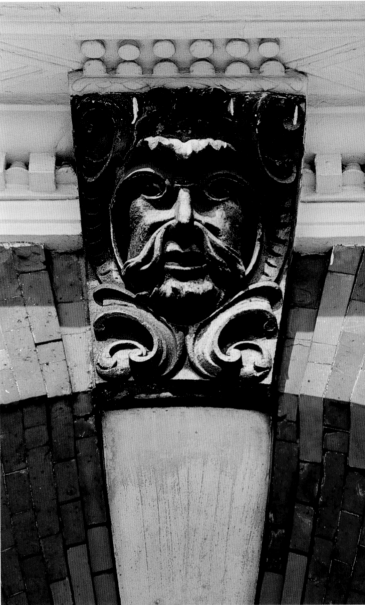

34 (*above left*) Demon-faced urns at St Bride, London.

35 (*above right*) Mask in a keystone of the Orangery at Kensington Palace.

36 (*left*) and 37 (*facing page*) Satyr masks under the buttresses of the dome, and sea monsters on the west façade of the Painted Hall at Greenwich Hospital.

trademark giant keystones and sacrificial altars on his churches – the natural place, after all, for such allusions.

And so although Hawksmoor does not mention any supernatural interests in surviving records and professes to be against superstition, it should not be concluded that his sole purpose was to express the increasingly rational world of his peers – the influence of which was all too evident in his library, his correspondence and his association with Wren. For one of the main reasons for the enduring appeal of Hawksmoor's architecture – as the following chapters will amply illustrate – is that it appears to bridge our current void between the worlds of human rationality and of sensory experience.

'PERFECTLY SKILL'D IN THE HISTORY OF ARCHITECTURE... IN EVERY PART OF THE WORLD': HAWKSMOOR AND EXOTIC ARCHITECTURE

THIS CHAPTER EXAMINES HAWKSMOOR'S USE of historical models drawn from a variety of cultures and periods, in the context of the advancement by the 'Moderns' of the pluralistic view of the past known as historicism.[1] According to this view, monuments of contrasting cultures were reduced to competing models that architects could combine and mix at will on the basis of symbolic need and aesthetic value. The modern practice further undermined the notion of a continuity of absolute principles (based on Vitruvius) and the supremacy of antiquity (as reflected, say, in Serlio's third book of 1540 with its frontispiece inscription: 'How great Rome was, the Ruins themselves Reveal' (Fig. 39)). This pluralistic view was famously reflected in the architectural reconstructions by Johann Bernhard Fischer von Erlach (1656–1723), a copy of whose *Entwurff einer historischen Architectur* (1721) Hawksmoor owned (lot 106). The work was a radical departure from the Vitruvian-style treatises, grounded as it was in comparative studies of the monuments of a wide range of cultures. Here Assyrian, Egyptian, Phoenician, Persian, Arabian, Turkish and Chinese buildings were imaginatively reconstructed and placed on an equal footing with those of classical antiquity, particularly the Seven Wonders of the antique world with which the book opens (Figs 41, 42). It thus embraced newly discovered historical types – from pagodas to mosques – against which new forms and iconography were explained and justified in addition to, and rivalry with, the antique. Fischer von Erlach visited London in 1704, a year before commencing the *Entwurff* and, in his role as architect to Emperor Leopold I, almost certainly met Wren and probably Hawksmoor – an almost exact contemporary – in his role as assistant in the Royal Works.[2] In fact the aim of Wren's 'Discourse on Architecture' (Tract v) – 'to reform the Generality to a truer taste in Architecture by giving a larger Idea of the whole Art, beginning with the reasons and progress of it from the most remote Antiquity' – is very similar to that of the *Entwurff*.[3]

Through the account of travellers to the New World and the Near and Far East and, closer to home, antiquarian investigations into enigmatic monuments such as Stonehenge, the Royal Society in particular became increasingly aware of buildings with antique attributes that seemed outside the accepted historical development of architecture centred on Roman antiquity. Members of the Society turned their attention to the Near Eastern ruins at Palmyra and Baalbek, to the North African ones at Leptis Magna and to the Parthenon and the Temple of Diana at Ephesus in the Greek world.[4] These recent discoveries only served to illustrate the diversity of ancient practices, and the 'Moderns' were therefore encouraged to reassess further the role of Vitruvius as the source for architectural principles. Such expanded horizons provided the context for Hawksmoor's eclecticism, in using a broad range of historical design models and ornamental forms.

THE INFLUENCE OF EXOTIC ARCHITECTURE

The increased awareness of hitherto unexplored ancient cultures existing beyond the limits of the classical world, advances in scientific archaeology and the apparent relativism of the rules of architectural proportion once held as absolute were all factors which led, from the 1670s onwards, to a spate of new surveys and published reconstructions of the neglected ruins not only of classical but also of Near and Far Eastern antiquity.[5] Some of these studies appeared to be astonishingly accurate; the most famous was that of Roman monuments by Antoine Babuty Desgodets (1653–1728) prepared for the French Academy of Architecture, which

39 Frontispiece of Sebastiano Serlio's *Terzo Libro* (1540).

illustrated the errors of earlier masters and the diversity, rather than consistency, of ancient proportional schemes (Fig. 40). Desgodets's study became a key text on the side of the 'Moderns' – notably assisting Perrault – in their battle with the 'Ancients'.[6] Hawksmoor owned a first edition of the work, published in 1682 (lot 109). In the wake of these new explorations, the status of Rome as the principal embodiment of architectural magnificence was increasingly questioned, with architectural history being reformulated to embrace Greek, Persian, Turkish, Egyptian and Chinese monuments, alongside the traditional Roman antiquities. Architecture from these cultures was closely studied by the Royal Society, and even found limited expression in Wren's work: in his Warrant design for St Paul's, for example, the steeple appears to be based on the exotic model of a Chinese pagoda (Fig. 43).[7]

Hawksmoor never travelled abroad, as far as is known, yet the obituary by Blackerby records that he 'was perfectly skill'd in the History of Architecture, and could give an exact Account of all the famous Buildings, both Ancient and Modern, in every Part of the World'. It adds that Hawksmoor 'was bred a Scholar, and knew as well the Learned as the Modern tongues'.[8] Indeed he owned books in a variety of European languages and his Italian, Spanish, Greek, Latin, French and Dutch dictionaries and grammar books testify to his

40 Arch of Constantine, from Antoine Babuty Desgodets's *Les Edifices Antiques de Rome Dessinés et Mesurés tres Exactement* (1682).

41 Halicarnassus mausoleum, one of the 'Seven Wonders' of the ancient world, from Johann Bernhard Fischer von
Erlach's *Entwurff einer historischen Architectur* (1721).

42 Pagoda, from Fischer von Erlach's *Entwurff einer historischen Architectur* (1721).

keen interest in understanding their texts.[9] His knowledge of history is born out by his defences of his work, in letters to Carlisle – citing ancient and modern temples and sepulchres – and to the Dean of Westminster, Joseph Wilcocks – citing the development of Gothic architecture.[10] His book on Westminster Bridge of 1736 refers to the medieval bridges of England, France and Prague, the ancient ones in Rome (illustrated by Serlio), Trajan's legendary Danube bridge (described by Palladio) and the Rialto in Venice (from Scamozzi). The source for this knowledge of buildings 'in every Part of the World' can be easily traced to the books and prints in Hawksmoor's library, which show a wide cultural awareness. The glory of ancient and modern Rome was an obvious focus of attention: the splendour of Baroque Rome was all too evident in the works in his collection by Domenico and Carlo Fontana, Giovanni Giacomo de Rossi, Giovanni Battista Falda and Domenico de Rossi.[11] Hawksmoor sketched from these sources, drawing the Piazza Navona for example (lot 295).[12] His collection included works on Dutch ornament and culture reflecting the court of William of Orange (William III), which would have

emphasized traditional Dutch (non-antique) decorative forms.[13] Hawksmoor was clearly interested in Chinese costumes for his sale catalogue includes prints of '4 Chinese Figures' by François Boucher and 'Two Books of Chinese Figures by Bouche' (lots 101 and 242). Also listed are contemporary geographical and cartographical works by Nicolas Sanson and Bernard Varen (lots 28 and as translated by Richard Blome, lot 65) as well as works on America (lots 19 and 133) and the Ottoman Empire (Richard Knolles's *The Generall Historie of the Turkes*, 1603; lot 57). Hawksmoor was equally well aware of contemporary studies of national 'antiquities' and exotic structures. He owned Aylett Sammes's *Britannia Antiqua Illustrata* (1676), with its influential illustrations of Stonehenge and of Saxon ancestry (lot 86).[14] This interest in exotic cultures was further represented by his ownership of travel books by John Struys (covering Persia, Greece, East India and Japan, lot 21) and Le Brun (Asia Minor and Syria, lot 98; and, among the prints, lot 114 'The four Parts of the World by Le Brun'). Hawksmoor also studied the Moorish architecture of Spain – and the Alhambra in particular – through travel accounts, noting to the Dean of

43 South elevation of Wren's Warrant design for St Paul's, 1675 [All Souls, Oxford].

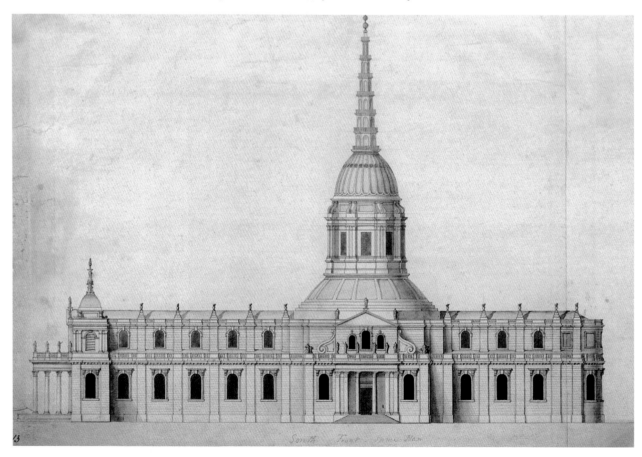

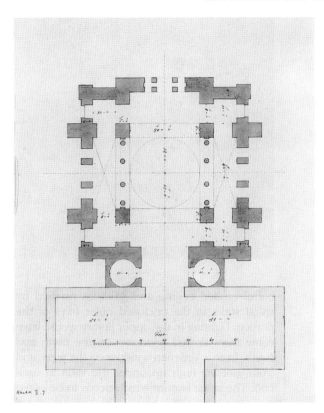

44 Hawksmoor's design (Project II) for the Radcliffe Library in Oxford, c. 1712 [Ashmolean Museum, Oxford].

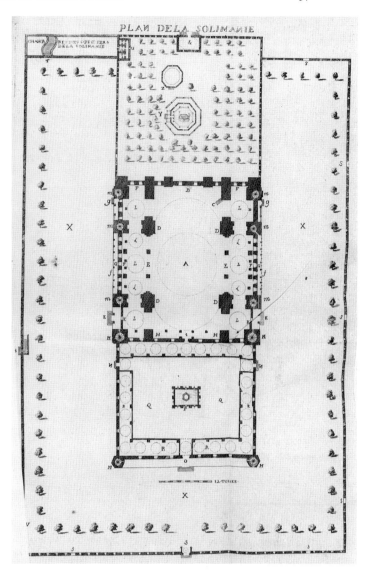

45 Plan of Suleiman's mosque in Constantinople, from Guillaume-Joseph Grelot's *Relation nouvelle d'un voyage de Constantinople* (1680).

Westminster that 'our unskillfull travellers call the Morisco Buildings in Spain Gothick, as at Sevill, Granada, &c'.[15] Wren too had relied on travel reports in his reformulation of architectural history within the Tracts. For example in Tract III he footnoted Le Brun on Pompey's Pillar, in Tract IV he referred to 'Modern Travellers' – probably Jacob Spon and George Wheler (a Royal Society Fellow) – on the Temple of Diana at Ephesus, while in Tract V he acknowledged, concerning the 'Pillar' of Absalom, 'what I have learnt from Travellers who have seen it'. He added in Tract IV that the statue of Diana was 'of as odd a Figure as any *Indian Pagod*'.[16]

Hawksmoor used travel literature as a source of inspiration for his designs. For example, his planned road under the grand chapel at Greenwich Hospital was termed a 'Pausilippo', and his general plan of central Oxford includes a 'New Gate into New Coll Garden, and thro' y^e Mount by a Pausilyp'.[17] His knowledge of the Roman grotto of Posillipo quite possibly derived from George Sandys's *A Relation of a Journey Begun Anno Domini 1610* (1615), with its description of the grotto 'which passes under the mountaine for the space of six hundred paces (some say of a mile) affording a delightfull passage to such as passe betweene Naples and

Putzol'. More exotic architecture described by travellers clearly also influenced Hawksmoor: for instance, he is thought to have adopted the plan of Suleiman's mosque in Constantinople in an early design for the Radcliffe Library in Oxford (both buildings conceived as memorials to their founder's name) (Fig. 44).[18] This followed illustrations of the mosque in Guillaume-Joseph Grelot's *Relation nouvelle d'un voyage de Constantinople* (1680), a copy of the 1683 English edition of which was owned by Wren (Fig. 45).[19] Hagia Sophia (which started life as a church of the venerable early Christians) may have influenced Hawksmoor in his use of galleries in his London churches, again by way of Grelot.[20] Hawksmoor certainly studied these Islamic buildings, for when discussing a flat system of founda-

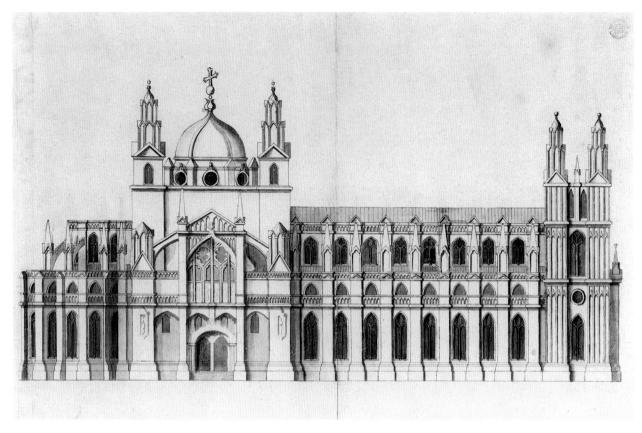

46 Hawksmoor's scheme for the completion of Westminster Abbey, c. 1724 [Westminster Archive Centre].

tion, with regard to his proposed Westminster Bridge, he noted that 'And *Dragnet Reys* did the same at *Constantinople*, at the stately Mosque he built in the Sea'.[21] Indeed his proposal for the completion of Westminster Abbey is strangely reminiscent of a mosque, with its ogee dome and minaret-like towers (Fig. 46).[22] The ogee dome also features in his scheme for St Mary in Warwick (c. 1694) (Fig. 47).[23]

Here again, this interest reflected that of Wren. Relying once more on the accounts of Grelot and other travellers,[24] Wren had commended structural techniques drawn from Byzantine architecture in Tract II when advising 'you may build upon that Circle an upright Wall, which may bear a Cupola again above, as is done at *St Sophia*'. Referring to 'that Example, in all the Mosques and Cloysters of the *Dervises*, and every where at present in the *East*', he added on this structure that 'I question not but those at *Constantinople* had it from the *Greeks* before them, it is so natural'. Wren here felt the need to credit (falsely, as it happens) Greek antiquity with favoured methods derived from newly discovered sources. In comparing the Gothic arch with this 'eastern Way of Vaulting by Hemispheres', he made clear his use of the latter system 'in the vaulting of the Church of *St Paul's*'.[25] Hooke records in his dairy on

14 November 1677: 'To Sir Chr Wr. At Mans with him and Mr. Smith, a description of Sta Sophia';[26] this was in reference to Thomas Smith, a Fellow of the Royal Society who had lived in Constantinople for two years from 1699. Studies of Hagia Sophia in plan and section,

47 Hawksmoor's scheme for St Mary in Warwick, c. 1694 [All Souls, Oxford].

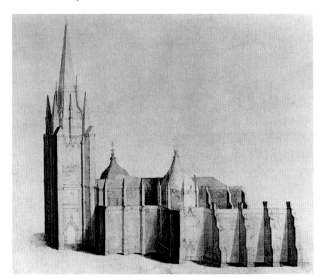

attributed to Wren but possibly by Hawksmoor, have recently come to light.[27] Contemporary scientific and theological interests thus merged in focussing on the Near Eastern structures of early Christianity.

It was noted earlier that Hawksmoor owned a three-volume set of the Royal Society's transactions to 1700, edited by John Lowthorp (lot 35).[28] As part of the Society's natural and mechanical history programme, the transactions contained reports and travel accounts of all types of architecture.[29] Illustrated in Lowthorp's edition are the ruins of the palace of Persepolis in Persia, for example, with 'licentious' column forms and, more particularly, post and lintel monoliths – known to Hooke and Wren[30] – very similar to the stripped-down post and lintel frames around doors and tower niches on Hawksmoor's churches (Figs 48, 49, 50; see Fig. 66). Hawksmoor's reading of Herodotus, with his history of Persia, would certainly have stimulated the architect's curiosity concerning such remains, and in 1686 the Frenchman John Chardin described, and in 1711 published drawings of, Persepolis that Hawksmoor could also easily have studied.[31] Such unorthodox antiquity, as recorded in his edition of the Society's transactions, would certainly have licensed Hawksmoor's own experiments in all'antica stone detailing, as well as stimulating his keen interest in Egyptian obelisk inscriptions, evident at Blenheim, of the type which Lowthorp's collection recorded in subsequent chapters.[32]

Once again, modern fieldwork reports played their part in encouraging knowledge of exotic wonders. One of the first students of Egyptology was the mathematician and antiquary John Greaves, whose accurate survey of obelisks and pyramids based on direct experience appeared in 1646 as Pyramidographia: or a description of the pyramids in Egypt. Greaves illustrated the pyramidal tomb of Porsenna, a structure that, as will be seen, fascinated Wren, Hooke and Hawksmoor (Fig. 51). The monuments of ancient Egypt had featured in Serlio's third book, again based on contemporary travel reports supplemented by Pliny, and so although not Roman in origin they were part of the Renaissance repertoire of forms and emblems. Obelisks played a key part in Sixtus V's urban vision for Rome in 1588, for example, as Hawksmoor would have seen in his copy of Fontana's Oblesco Vaticano of 1590 (lot 104). In the early eighteenth-century climate of new worlds and expanding horizons, however, Egyptian antiquities assumed new significance as additional evidence to undermine the Rome-centred view of history found in the Vitruvian treatises. To such contemporary groups as the freemasons, Egyptian forms featured in a revised view of architectural history which identified the birth of their craft with Egyptian masonry and the building of

the temple in Jerusalem long before Rome held sway, thereby further transcending the limits of Vitruvian imagery.[33] Egyptian Pyramids and obelisks were prominent features of Hawksmoor's church iconography and his landscape at Castle Howard, the meaning behind which will be examined in Chapters 5 and 6. Not surprisingly, the negative influence of exotic architecture on antique values was fully recognized in Vitruvius Britannicus, or the British Architect of 1715 (lot 131). Here Colen Campbell suggested that it was indiscriminate and uncritical foreign travel that had led 'so many of the British Quality' to 'have so mean an Opinion of what is performed in our own Country'. This was despite the fact that, with all'antica buildings such as the Banqueting House, 'perhaps, in most we equal, and in some Things we surpass, our Neighbours'.[34]

HAWKSMOOR'S RECONSTRUCTION OF THE TEMPLE OF BACCHUS AT BAALBEK

Compelling evidence of Hawksmoor's fascination with newly charted architecture, following the concerns of Society Fellows, is represented by his reconstruction of the (Roman) Temple of Bacchus at Baalbek (Heliopolis) published in the third edition of Henry Maundrell's Journey from Aleppo to Jerusalem at Easter, A.D. 1697 (1714) (Fig. 52). In his letters to Carlisle defending his Mausoleum colonnade, Hawksmoor cites the Bacchus temple as a design model: 'The Famous Temple of Heliopolis, in Syria call'd I think in the Arabeck tongue (Baalbec) most of it now standing entire, is of the disposition Picnostyle (as our is) . . . The Cell of this Temple was 60 foot wide within and 120 foot long it was a stupenduous structure'.[35] Having never actually seen the temple, he once again bases himself on travel reports and verbal accounts. Hawksmoor discussed the temple with Maundrell directly, for on the cella he adds: 'Dr. Lisle told me he measur'd it so did Dr. Mandrell'. Henry Maundrell and Edward Lisle had both been chaplains to the Levant Company, whose opening up of trade routes had encouraged such increased awareness of more remote and exotic antiquities. Vanbrugh was employed by the East India Company between 1683 and 1685, and was influenced in his subsequent proposals for out-of-town cemeteries not by antique practices but by his youthful study of the English cemetery at Surat (Fig. 53).[36]

Hawksmoor's reconstruction of the Bacchus temple was also clearly indebted to Jean Marot's Baalbek study to be found in Le grand oeuvre d'architecture de Jean Marot (c. 1665; 'le Grand Marot'). Marot considered Baalbek

48 Columns and post and lintel monoliths of the Persian palace of Persepolis, from John Lowthorp's *The Philosophical Transactions and Collections* (1705; from *Transactions*, first published in 1694), Fig. 72, plate 6.

49 Post and lintel frame round the south-west door of St George-in-the-East.

50 Post and lintel frame around the north-east door of St Anne, Limehouse.

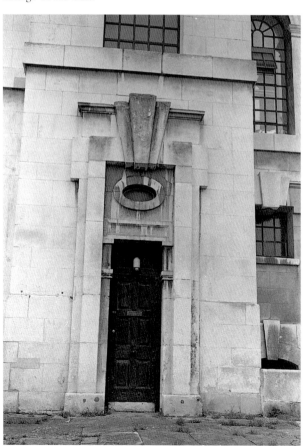

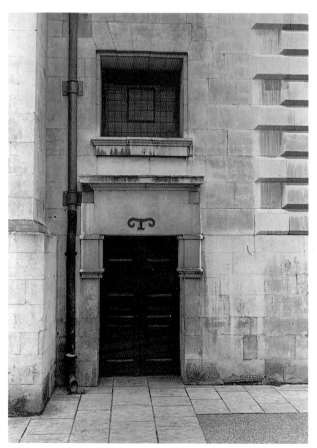

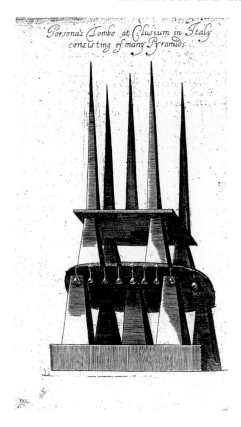

to be 'en Grèce', perhaps because Syria had been part of the Hellenistic world.[37] Hawksmoor may well have followed Marot and have seen himself as producing a reconstruction of a Greek, and not a Roman, antiquity.[38] At this time actual examples of Greek architecture were still relatively unknown. Even the Parthenon had only recently been illustrated for the first time – initially in Spon's edited work, *Relation de l'Etat présent de la Ville d'Athènes Capitale de la Grèce* (1674), and subsequently in his account of his travels with Wheler entitled *Voyage d'Italie, de Dalmatie, de Grèce, et du Levant, fait aux années 1675 & 1676* (1678).[39] Although Hawksmoor is vague as to what type of architecture he understood by the term 'Greek', he would have known something of Greek architecture through John Struys's account of his travels through Greece (lot 21).[40]

51 Pyramidal tomb of Porsenna, from John Greaves's *Pyramidographia: or a description of the pyramids in Egypt* (1646).

52 (*below*) Hawksmoor's reconstruction of the (Roman) Temple of Bacchus at Baalbek (Heliopolis), from the third edition of Henry Maundrell's *Journey from Aleppo to Jerusalem at Easter, A.D. 1697* (1714).

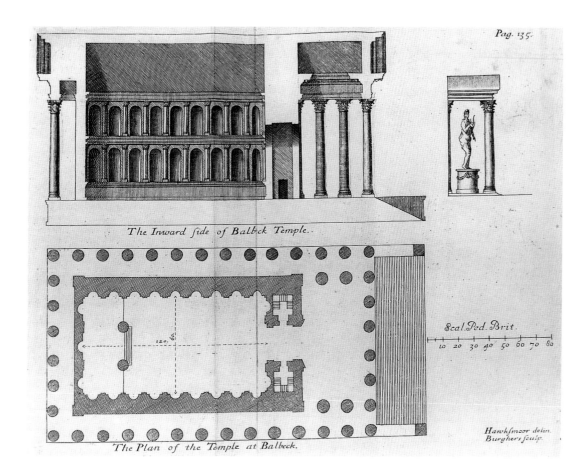

53 Vanbrugh's sketch of the English cemetery at Surat, 1711 [Bodleian Library, Oxford].

Hawksmoor certainly took what he considered to be Greek monuments as models in his work. He used the Tower of Andromachus at Athens (the Tower of the Winds)[41] as a model for a chapel bell tower at Worcester College in Oxford, in his intermediate design for the lantern at St Anne, Limehouse, and in his first lantern design at St George-in-the-East (see Figs 227–32). He also considered the Halicarnassus mausoleum, used as a model for his steeple at St George in Bloomsbury, as Greek (Persian in fact).[42] There is evidence that he considered the colonnade a Greek element, possibly following Serlio's single illustration of a Greek structure in his third book (Fig. 54).[43] For this structure, composed of one hundred Corinthian columns, may well have inspired Hawksmoor's 'Cloister of all S[ouls]. after the Greek', with its four-deep Corinthian columns, while the earlier elevation for this west front of All Souls facing Radcliffe Square similarly labeled 'after y[e] Greek manner' also had a giant colonnade – here of the Ionic Order (Figs 55, 56).

54 Greek structure of one hundred columns, from Sebastiano Serlio's *Terzo Libro* (1540), pp. C–CI.

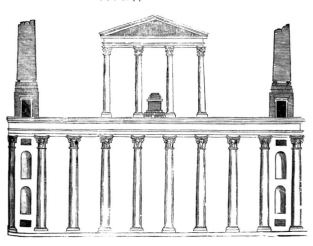

It was noted that the Greek origins of these Orders was spelt out by Roland Fréart in his *Parallèle de l'architecture antique et de la moderne* (1650), which Hawksmoor would have seen in his copies of the English translation by John Evelyn (lots 89 and 108). Whether or not he considered the temple at Baalbek as Greek, it was none the less a fine example of the Corinthian style.

Greek antiquities gained in significance through the contemporary interest of Wheler and other theologians in the Greek Orthodox Church as the descendant of the first, or 'primitive', Christians.[44] Once again, this interest formed part of the wider antiquarian study of cultures which physically or chronologically transcended Roman antiquity; following Wheler's illustration of a fanciful 'primitive' church, Hawksmoor himself produced a reconstruction in 1711–12 of what he termed a 'Basilica after the Primitive Christians' (Figs 57, 58, 60).[45] No doubt as part of this interest in the forms of Christian worship, Hawksmoor's plates in Maundrell's book include illustrations of Inigo Jones's church at Covent Garden (Fig. 59). The Tuscan simplicity of Inigo Jones's church – famously styled a 'handsome barn' by Jones – would certainly have appealed to the primitive Christian sensibilities of many of the more theologically minded of Maundrell's readers, especially since a similar, Stuart view of 'primitive' British Church history had informed Jones's 'temple' design.[46] In Hawksmoor's plates the ancient and modern temples are even 'compared upon y[e] same scale'.[47] In thus offering a speculative reconstruction of an antique monument together with a modern example – and comparing Pagan with Christian, Ancient with Modern, Greek (Corinthian) with Roman (Tuscan) – Hawksmoor's plates are a striking precursor to the historicism of Fisher von Erlach, whose work, as noted, Hawksmoor owned (lot 106). In Hawksmoor's comparative study, both temples are

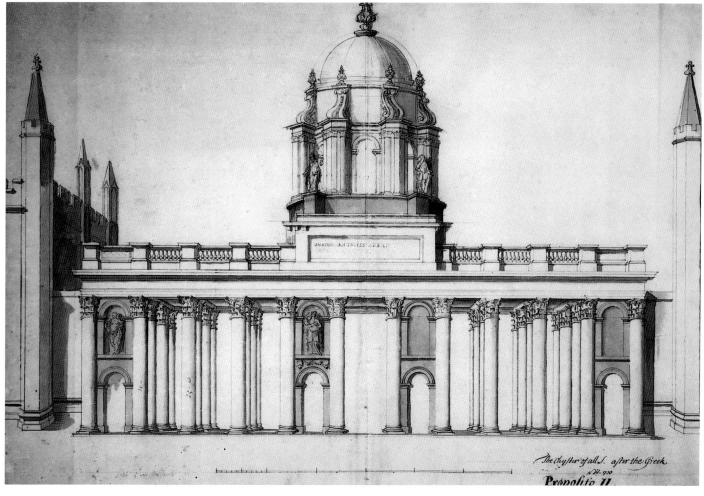

55 Hawksmoor's cloister for All Souls 'after the Greek', with its four-deep Corinthian columns, 1720 [Worcester College, Oxford].

56 Hawksmoor's west front of All Souls facing Radcliffe Square, similarly annotated as 'after yᵉ Greek manner', 1714 [Worcester College, Oxford].

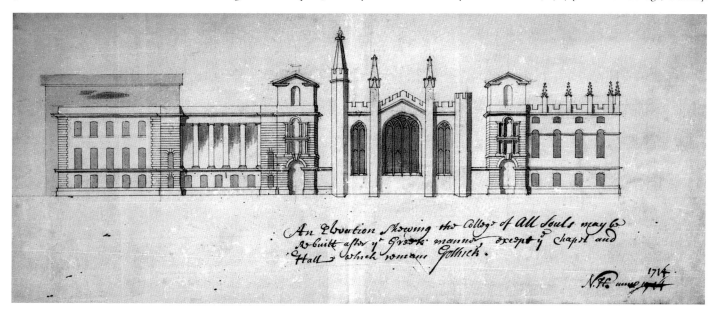

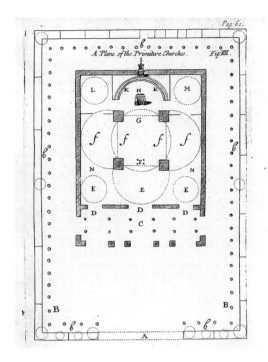

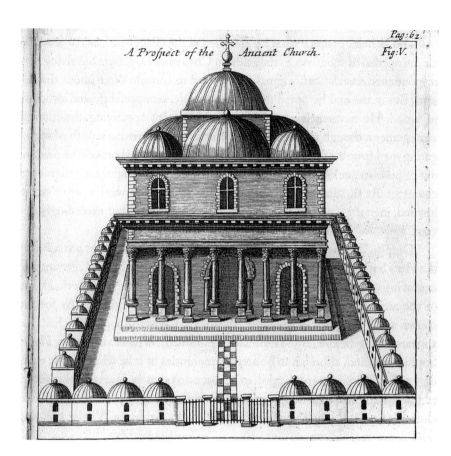

57 and 58 Model primitive church, in plan and perspective, from George Wheler's *An Account of the Churches, or Places of Assembly, of the Primitive Christians* (1689).

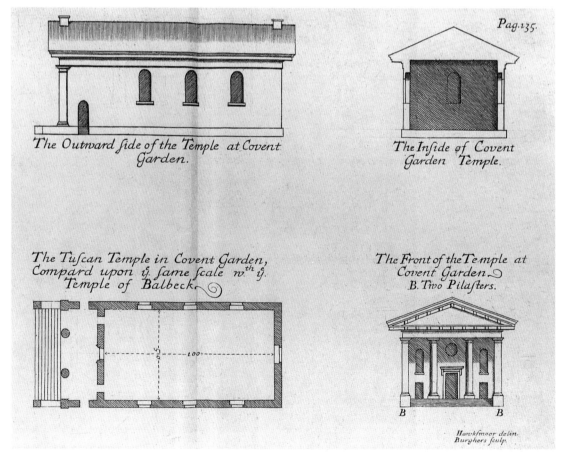

59 Inigo Jones's church at Covent Garden, from the third edition of Henry Maundrell's *Journey from Aleppo to Jerusalem at Easter, A.D. 1697* (1714).

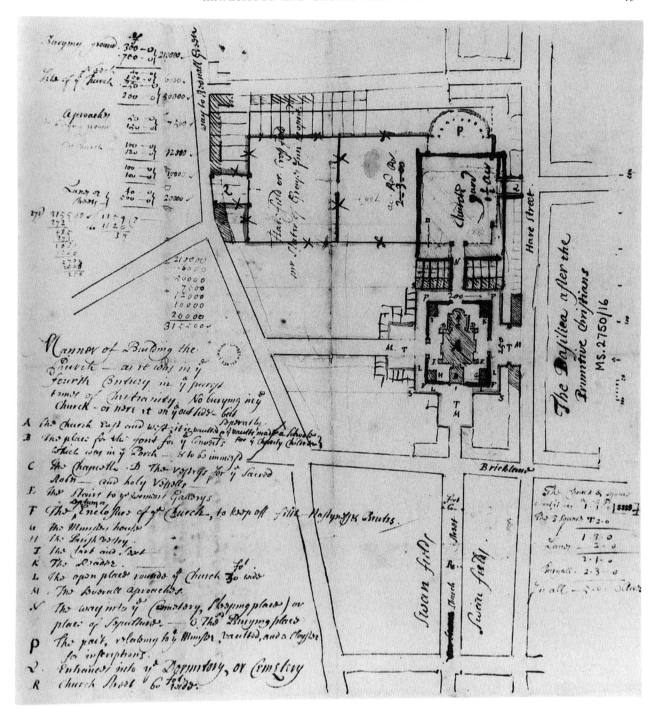

60 Hawksmoor's plan entitled 'Basilica after the Primitive Christians', 1711–12 [Lambeth Palace Library, London].

matched in their simplicity of proportion and form (both are twice as long as they are wide). As such they would have provided ready ancient and modern models – combining architectural and theological virtues – both for Hawksmoor's primitive Christian aisle- and chancel-less 'basilica' reconstruction and for the slightly more developed basilica plans of his actual churches

begun around the same time, in 1714. As has been seen, later he cited the Baalbek temple as a model for his Mausoleum column spacing, and the circular temple of Venus at Baalbek may have served as a model for his second Belvedere design at Castle Howard, also a circular building with concave walls (see Fig. 129b).[48] Indeed this use of newly discovered models was

probably perfectly evident to contemporaries, since William Stukeley reported that, despite differences between the two designs, the giant Corinthian portico of St George in Bloomsbury, begun in 1716 (Figs 61, 62), was designed by Hawksmoor 'in imitation, and the size, of that at Balbeck'.[49]

WREN'S VIEW OF ARCHITECTURAL HISTORY IN PRACTICE

Hawksmoor was deeply indebted to Wren for his understanding of architectural history, and it was noted in the previous chapter that he may well have helped with Wren's Tracts on architecture, which read like instructions to a pupil. For it was here that Wren attempted to outline the universal 'principles' or 'Grounds of Architecture' which were central to his and his pupil's collaborative projects, most notably at Greenwich Hospital and St Paul's. Indeed in assisting Wren on these projects it would have been impossible for Hawksmoor not to have been influenced by many of his master's principles, a fact which his reference to identical historical models appears to confirm. In particular it was noted in the previous chapter that Hawksmoor produced a drawing of the Halicarnassus mausoleum to illustrate Wren's description of the monument in Tract IV (see Fig. 22).[50] He cites Wren's views concerning the ancient mausoleum when later defending his own Mausoleum design to Carlisle: 'The whole work according to Pliny was 140 foot high, Sr. Christopher Wren, contemplated this Fabrick with great exactness according to the measures given by Pliny, and declared, by his calculation; it could be nothing but the Dorick Sistyle'.[51] The form and structure of such ancient and modern monuments, both mythical and actual, fascinated Wren and Hooke as part of their Royal Society investigations, and Hawksmoor's drawing arose from their attempt to reconstruct these works on supposedly objective grounds.

The attempt by Wren to return to first principles in his definition of beauty and study of nature, outlined in the previous chapter, also prompted him to re-evaluate the antique mythology that underpinned Renaissance architecture. Echoing the 'Moderns', he observed 'how much the Mathematical Wits of this Age have excell'd the Ancients, (who pierc'd but the Bark and Outside of Things) in handling particular Disquisitions of Nature', adding that a vital part of this process lay 'in clearing up History, and fixing Chronology'.[52] This ambition foreshadowed Newton's *Chronology of the Ancient Kingdoms Amended* (1728), and found expression in the Tracts and the Discourse's

62 View inside the Corinthian portico of St George, Bloomsbury.

'larger Idea of the whole Art, beginning with the reasons and progress of it from the most remote Antiquity'. Despite its rational intent, however, Wren's historical scheme was still dependent on the most important sources for architectural history as formulated in the Renaissance – the Bible and Josephus for Old Testament buildings and Pliny the Elder, Herodotus

61 Corinthian portico of St George, Bloomsbury.

and Vitruvius for the Wonders of the ancient world. As a Christian, Wren accepted the notion that, alongside nature, Scripture revealed divine laws, and in amending it and Vitruvius to produce one coherent history he rejected the Renaissance architectural theories that most reflected the old cosmology. In particular, it was noted that in Tract I Wren identified the origin of the Orders with Vitruvius's description of primitive man's construction of huts from branches (II.i.2–7), and in so doing rejected the Roman author's subsequent more explicit analogy of the Orders to human proportions (IV.i.6–8). According to Wren, 'in the hot Countries, where Civility first began, they desired to exclude the Sun only, and admit all possible Air for Coolness and Health: this brought in naturally the Use of

64 Paired columns on the colonnade of the east front of the Louvre, Paris.

63 Hawksmoor's project for a precinct and colonnade around St Paul's, c. 1710 [Guildhall Library, London].

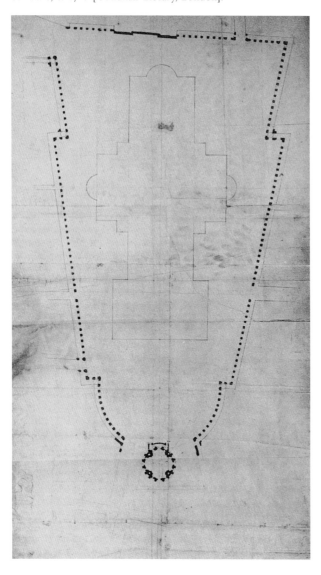

Porticoes, or Roofs for Shade, set upon Pillars'. In this, as the previous chapter noted, 'we see they imitated Nature, most Trees in their Prime . . . This I think the more natural Comparison, than that to the Body of a Man, in which there is little Resemblance of a cylindrical Body'.[53]

Since Wren's Tracts represent a rewriting of the Renaissance view of history to justify, from apparently first principles, the use of historical models in his own work, Hawksmoor would obviously have had to apply this teaching at St Paul's from about 1684 onwards. For example in Tract II Wren noted that trees had provided shade around the first cellas, forming groves, and that 'when the Temples were brought into Cities, the like Walks were represented with Stone Pillars'.[54] Hawksmoor's project for a precinct with a colonnade around St Paul's can be seen as an attempt to imitate this primitive model, albeit on a grand scale (Fig. 63).[55] For Wren adds that such colonnades were 'the true Original of Colonades environing the Temples in single or double Ailes'. Wren adds in Tract III that in designing Alexandria, Dinocrates 'drew a long Street with Porticoes on both Sides', after which the citizens 'soon

65 Paired columns on the west front of St Mary Woolnoth, London.

filled the Quarters between the Porticoes with private and publick Buildings. Thus were Cities suddenly raised'.[56] This rational account of the rise of antique cities through the device of the 'Greek' colonnade would have agreed with Hawksmoor's own understanding of the colonnade as a 'Greek' element, the likelihood of which was noted earlier, and legitimized his use of colonnaded walks in urban designs at Oxford, Cambridge and Westminster. At Westminster, linked to his plan for a new bridge, he projected a new street half a mile long from New Palace Yard to the Royal Mews, with what Thomas Lediard described as a 'Colonnade on each side of the way, in the Nature of that at Covent-Garden'.[57]

Wren continues in his second Tract that 'these Avenues were afterwards, as Cities grew more wealthy, reformed into Porticoes of Marble', although as the paired columns on the portico at St Paul's suggest, the original trees were 'not equally growing' in their spacing.[58] The unprecedented, modern use of paired columns – famously by Perrault on the Louvre colonnade and later by Hawksmoor on the west front of St Mary Woolnoth for example (Figs 64, 65) – could thus be justified by reference to a natural (if not antique) prototype.[59] Wren called the first primitive timber column the 'Tyrian', or Phoenician Order, following its supposed use by builders from Tyre, a city in Phoenicia, in the construction of the Temple of Solomon. Early structures such as the Temple needed to be Tyrian in order to show a logical development to and through Greek and Roman architecture: Wren consequently regards the idea of a Solomonic Corinthian Order, famously put forward by the Jesuit Juan Bautista Villalpando in 1604, as 'a fine romantick Piece'.[60] Wren adds that, 'from these *Phoenicians* I derive, as well the Arts, as the Letters of the *Grecians*, though it may be the *Tyrians* were Imitators of the *Babylonians*, and they of the *Egyptians*'.[61] In embracing pre-classical antiquity, this progression in refinement from Tyrian timber column to the Orders of Greek antiquity gave the columns a wider, more primitive antiquity than the Greek Doric archetype recorded by Vitruvius, and apparently accounted for such primitive stone monuments as Stonehenge. Hawksmoor's later use of simplified, 'primitive' pilasters – without their capitals – on his towers at Christ Church, Spitalfields and St George-in-the-East would have found legitimacy as antique forms through this historical

66 Capital-less pilaster forms on the tower at Christ Church, Spitalfields.

67 Capital-less pilaster forms on the tower at St George-in-the-East.

development (Figs 66, 67). For as a consequence of this account and in the spirit of Baroque experiment, Wren undermined the Renaissance canon of five Orders. Accordingly there had been many legitimate types of Orders, since 'The *Orders* are not only *Roman* and *Greek*, but *Phoenician*, *Hebrew*, and *Assyrian*' and as such were 'founded upon the Experience of all Ages'.[62] Wren also accepted Gothic as a further legitimate style (the 'Saracen'), an acceptance which Hawksmoor noted in his history of Gothic architecture, outlined shortly.

In his Tracts Wren extended the scope of his historical enquiry beyond the ancient Roman world to include biblical buildings that had been neglected by all but biblical commentators (most notably the Jesuit polymaths Villalpando and Athanasius Kircher).[63] As

with the Orders, he considered the development of architecture chronologically, beginning with its origins in timber structures and then proposing a logical form, plan and structure for ancient buildings constructed during Old Testament times. These were set up as models which, as was noted, Hawksmoor also sought to use in practice. From Genesis Wren took the first city of Enos, proceeding in Tract v to Noah's Ark, the Tower of Babel and the pyramids of Egypt. He cited examples of Tyrian monuments: the Temple of Dagon destroyed by Samson was considered against structural principles in Tract iv, together with the sepulchre of the son of David, Absalom, which reappeared with the Temple of Solomon in Tract v. The 'Pillar' of Absalom was illustrated in Le Brun's *Voyage au Levant* (first pub-

68 'Pillar' of Absalom, from Corneille Le Brun's *Voyage au Levant* (first published in Delft in 1700 and republished in London in 1702).

and Greaves's illustration of the tomb in *Pyramidographia* (1646) (see Fig. 51).

Just as the Tyrian structures are prototypes for the most simple of the Roman Orders, namely the Tuscan, each of the Greek Orders is identified with an historical model in Wren's fourth Tract. The Halicarnassus mausoleum (after Pliny) forms the model for the Doric, the temple of Diana at Ephesus (again after Pliny) represents the first building to employ the Ionic, while the Roman Temple of Mars Ultor (after Palladio) forms the preferred model for the Corinthian (Figs 71a,b; see Fig. 23). Thus the Greek Orders are identified with some of the most magnificent buildings of antiquity – two of them among the legendary Seven Wonders of the ancient world – in a progression that required the Temple of Solomon to be a simple Tyrian, rather than

69 Wren's wooden catafalque for Mary II, containing her body as she lay in state at Westminster Abbey on 5 March 1695 [from an undated print by J. Mynde in the Library of Westminster Abbey].

lished in Delft in 1700 and republished in London in 1702) (Fig. 68), which it was noted was in Hawksmoor's library (lot 98). Wren then studied buildings dating from early antiquity. For example, the Tyrian sepulchre of the Etruscan king Porsenna, as described by Pliny (quoting Varro) and Alberti, is outlined at the end of Tract V as a proto-Tuscan model.[64] Wren explains why he considered the tomb exemplary by observing that it was built 'in the Age of Pythagoras and his School, when the World began to be fond of Geometry and Arithmetick'.[65] He discussed the Porsenna tomb with Robert Hooke in October 1677, apparently in preparation for designing a mausoleum to commemorate Charles I.[66] His wooden catafalque for Mary II, containing her body as she lay in state at Westminster Abbey on 5 March 1695, was also based on this tomb (Fig. 69)[67] – Hawksmoor having been paid £5 'for his extraordinary paines in copying designes by the direction of Sir Christopher Wren for the Mausoleum in the Abbey'.[68] Indeed this ancient tomb equally fascinated Hawksmoor, since the sale catalogue records twenty-eight designs by him 'of the Tomb of Parsenna' (lot 153). He commended it in a letter to Carlisle in 1726, noting that while the Halicarnassus mausoleum was the most famous tomb among the Greeks, 'That which was the most famous in Italy was the Monument of Porsenna yᵉ king of Tuscany, if I may be allowed to call it among the Latins, being in yᵉ Early days of Rome however it was in Italy'.[69] A year later he sent Carlisle 'A Mosoleum like the Tomb of King Porsenna'.[70] There is a clear resemblance between the pyramidal forms on Hawksmoor's Carrmire Gate at Castle Howard (Fig. 70)

The Mausoleum Erected in Westminster Abbey, at the Funeral Obsequies of QUEEN MARY II.

70 Carrmire Gate at Castle Howard.

a Corinthian, structure. And just as the Porsenna tomb was identified by Wren with the age of Pythagoras, the Halicarnassus mausoleum was identified as 'contemporary with the School of *Plato*', a fact explaining its 'harmonick Disposition'.[71]

As might be expected, these models too influenced Hawksmoor's work. The statue of Queen Caroline in the circular tempietto over the gate at Queen's College, Oxford (Fig. 38), built following Hawksmoor's designs, is based on Wren's reconstruction of the shrine to Diana at Ephesus as illustrated in *Parentalia*.[72] Following Wren, Hawksmoor also saw this temple as the first Ionic building, observing to Carlisle that the Halicarnassus mausoleum 'was Built in the 2d Year of the Hundreth Olimpiade, which was before the Temple of Diana at Ephesus was built, and in consequence before the Ionick Order was used. so that they had only the Corinthian and Dorick. This was also before Alexander the Great's time'.[73] As noted above, he praised the mausoleum as a model of Doric practice in this letter to Carlisle concerning his own Mausoleum at Castle Howard. After his collaborative drawing with Wren of

the mausoleum, it became the model for his tower at St George, Bloomsbury (Fig. 72). Fischer von Erlach had illustrated the mausoleum in his *Entwurff*, which Hawksmoor would have seen in his copy of the work (lot 106; see Fig. 41). This may have been the original, 1721 German edition or the 1730 English translation, but if it was the former then there was ample opportunity for it to have influenced the Bloomsbury design.[74] The ancient tomb with its quadriga also formed the model in four elevational schemes (one closely resembling Christ Church, Spitalfields) in drawings now held at All Souls in Oxford (Figs 73–6).[75] Here again, Hawksmoor follows his master, since in Wren's Great Model for St Paul's of 1673 the lantern was based on the Halicarnassus mausoleum (Fig. 77).[76] Clearly, through replicating the ancient 'Wonder', both architects hoped to build a modern one.

Hawksmoor also drew on Wren's historical models in other aspects of his work. Both architects, for example, adapted the ancient basilica plan in their churches. Wren's ideal model for this plan was the Temple of Peace (Basilica of Maxentius/Constantine)

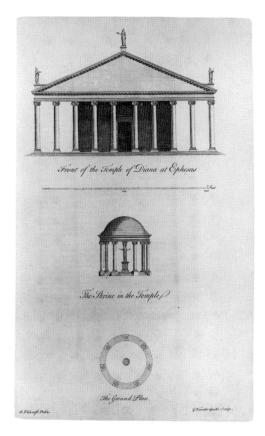

Front of the Temple of Diana at Ephesus

The Shrine in the Temple

The Ground Plan.

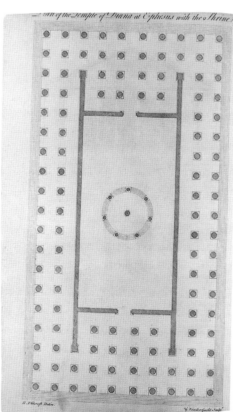

71 a and b Wren's reconstruction of the temple of Diana at Ephesus, from *Parentalia* (1750).

which he followed Pliny in placing alongside the Pantheon as 'the most remarkable Works of *Rome*'.[77] Indeed in his fourth Tract he identified the Temple of Peace as the prototype of the Roman basilica, an antiquity further enhanced through associations with the archetypal biblical temple. For the Temple of Peace had been seen by Palladio and other Renaissance commentators as the supposed repository for, as Wren put it, 'the Spoils of the *Jewish* Temple, and the Records of *Rome*, the most sacred for Antiquity'.[78] On a more practical level, the form of the Temple of Peace was of particular importance in Wren's development of a three-aisle plan, of use for churches conceived as auditories given the emphasis on preaching in the

72 The tower of St George, Bloomsbury (originally the tower had statues of unicorns and lions).

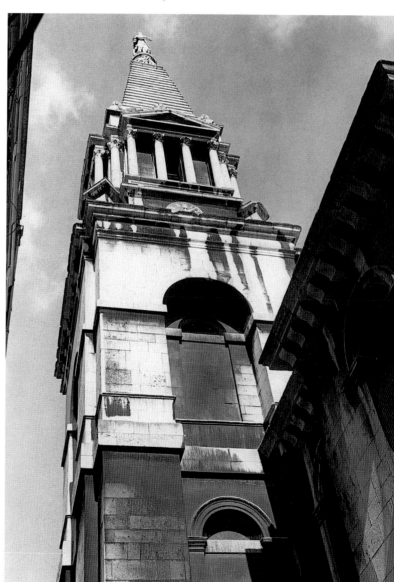

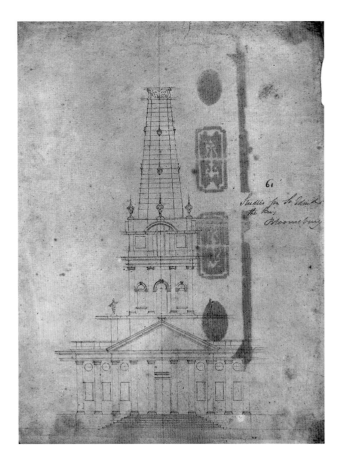

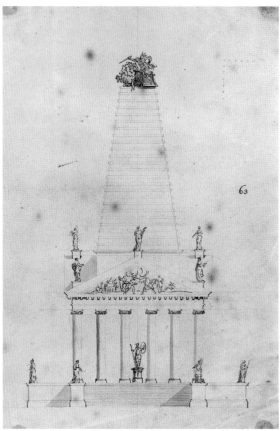

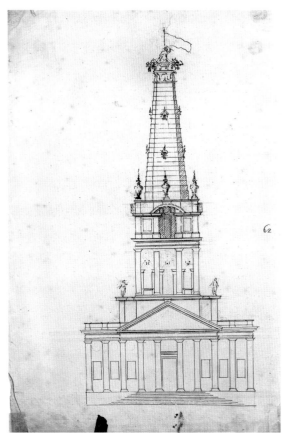

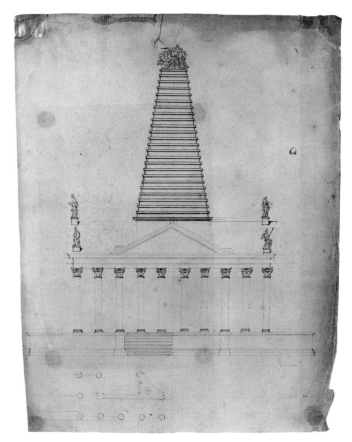

73–6 Four elevational schemes (bottom left resembling Christ Church, Spitalfields) by Hawksmoor modelled after the Halicarnassus mausoleum, undated [All Souls, Oxford].

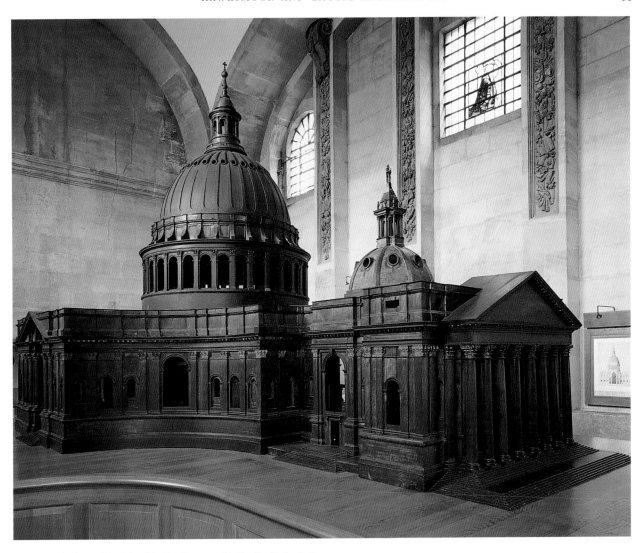

77 Wren's Great Model of St Paul's, 1673 [St Paul's Cathedral].

Protestant service.[79] In Wren's advice drafted in 1711 to the Commission considering the general design of Protestant churches, he noted that 'in our reformed Religion, it should seem vain to make a *Parish-church larger*, than that all who are present can both hear and see'. He added that while for Catholics, 'it is enough if they hear the Murmur of the Mass, and see the Elevation of the Host', English churches 'are to be fitted for Auditories'.[80] This emphasis plainly influenced Hawksmoor in his adaptation of the basilica plan in his London churches, following the specific model of the Temple of Peace (with its portico, aisles and apse). In particular, the form adopted at Christ Church, Spitalfields – of free-standing Composite columns supporting a broken (longitudinal) entablature and arches (fronting barrel-vaulted bays) with clerestory windows above – is an obvious variant of the Temple of Peace as illustrated by both Serlio and Palladio (Figs

78, 79).[81] Hawksmoor was well aware of this arrangement since Wren's acknowledged model for the form and ornament of the nave and chancel at St Paul's was the Temple of Peace.[82]

From this re-evaluation of history Wren aimed to identify architectural principles with an eternal validity, akin to those of the mathematical sciences. Consequently St Paul's was intended to celebrate the conclusion of the historical development of the Orders, from the primitive hut through Solomon's 'Tyrian' Order to the great Corinthian temple in London. Following his French visit, he reacted against what he saw as the feminine excess of Baroque ornamentation in noting that 'Works of Filgrand, and little Knacks are in great Vogue; but Building certainly ought to have the Attribute of eternal'.[83] Later, in the first of his Tracts, he elaborated that 'Architecture aims at Eternity; and therefore the only Thing uncapable of Modes

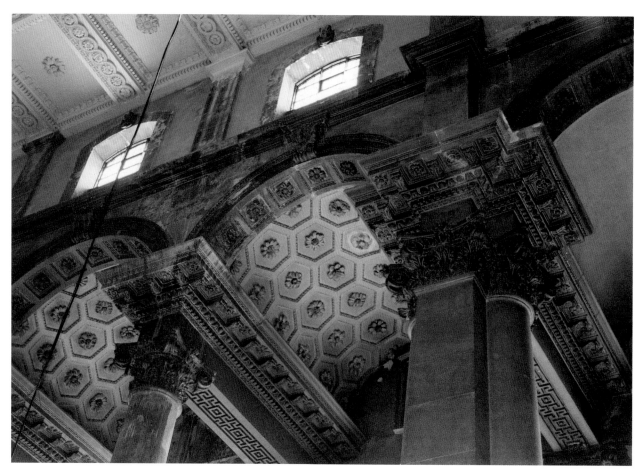

78 Interior of Christ Church, Spitalfields.

79 Temple of
Peace (Basilica
of Maxentius/
Constantine), from
Sebastiano Serlio's
Terzo Libro (1540),
pp. XXIII–XXIV.

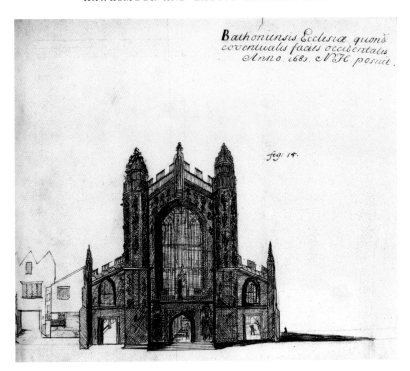

Bathoniensis Ecclesiæ quonð
coventualis facies occidentalis
Anno 1683. NH posuit.

fig: 15.

80 Hawksmoor's sketch of
Bath Abbey, from his
Topographical Sketchbook of
1680–83 [R.I.B.A., London].

and Fashions in its Principles, [are] the *Orders*.[84]
Hawksmoor expressed a similar dislike of excessive
ornamental freedom, as the next chapter will outline,
but he nevertheless went beyond Wren in developing
non-canonic column forms and in using outsized
antique elements, most notably triglyphs and keystones,
in unusual positions for symbolic rather than structural
reasons. Hawksmoor's Stepney churches in particular
are certainly much more licentious (and therefore
Baroque) than were Wren's churches – even though the
inspiration behind their novelty can be traced to his
master's historical scheme – and the possible meaning
behind this distortion of historical models will be
further examined in the following chapters.

'THE MANNER OF BUILDING . . . AMONG THE FIRST CHRISTIANS': HAWKSMOOR'S HISTORY OF GOTHIC ARCHITECTURE AND WESTMINSTER ABBEY

An important symptom of the breakdown of the
Vitruvian canon, and of the emerging historicism of the
'Moderns', was the growing acceptance of the Gothic
as an approved style of architecture. This was certainly
how the Gothic was interpreted by the Palladians, who
not surprisingly considered the years between the fall
of the Roman Empire and the Renaissance as the
lowest point in architectural history. They praised the

subsequent '*Restorers* of Architecture', as Campbell put
it, who had '*greatly help'd raise this Noble Art from the ruins
of Barbarity*'.[85] The rise during the early eighteenth
century of the freemasons, with their celebration of
medieval masonry, particularly encouraged the accept-
ance of Gothic. Batty Langley, for example, was an
enthusiastic freemason and advocate of 'British' Gothic
in his publications.[86] Interest in Gothic monuments
also reflected the more objective, antiquarian concerns
of the Royal Society. Hawksmoor would have seen
such antiquarianism amply illustrated in his copy of
John Slezer's *Theatrum Scotiae: containing the prospects of
his Majesties Castles and Pallaces . . . the ruins of many
ancient abbeys, churches, monasteries and convents within the
said kingdom* (1693; lot 92). In praising Greenwich
Hospital and the historic role of the navy in 1728, he
appeals to all that have read British history, 'from the
Invasion of the *Romans* to this Day thro' all the Series
of her Annals'.[87] Hawksmoor's later book proposing a
new bridge for Westminster records that he had studied
the chronicles of William of Malmesbury and Stow.[88]
In this work he observes that 'The North of *England*
was notably stored with many magnificent Castles,
Churches, Stone Bridges, and other publick Buildings.
And so was *Scotland* the same; for they are plentifully
supply'd with excellent Free-stone, and good Artists, as
may be seen in the two principal cities, *Edinbrugh* and
Glasgow, where are many Fabricks worth Attention'.[89]
In his youth Hawksmoor had sketched a number of
cathedrals and churches, including Bath Abbey (Fig. 80)

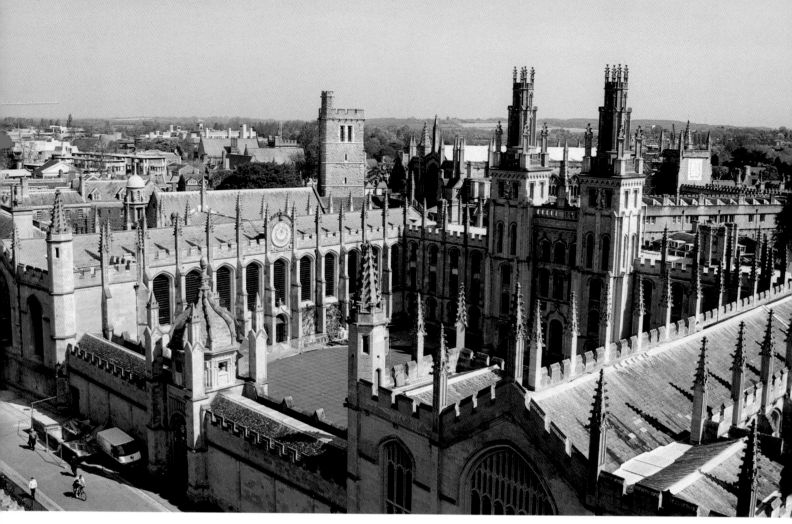

81 All Souls, Oxford, 1708–30.

and All Saints' in Northampton (see Fig. 19), and later drew the south front of Welbeck Abbey in Nottingham for Vanbrugh.[90] In 1721 he went to the trouble of engraving a view of 'the Ancient Temple' of St Albans.[91] He recorded his love of English cathedrals in a letter to Dean Wilcocks of 18 March 1735, citing in particular those at Lincoln, Lichfield, Ripon, Durham, Beverley and York. Indeed he describes Beverley Minster, 'fully repaired' by him, as 'surpriseingly beautifull',[92] and in January 1736 he requested permission to send the Dean 'the Prints of some Gothick Buildings, & in particular by that of Beverly Minster you will see how we finished the Middle Lantern . . . and covered it in form of a Gothic Cupola'.[93]

Hawksmoor adopted the Gothic style most notably for new work at All Souls in Oxford (c. 1708–30), where he at first experimented with *all'antica* schemes, and for his new west gable and towers at Westminster Abbey (1734–45) (Figs 81, 82).[94] Wren had carried out repairs to the Abbey between 1698 and 1722, and Hawksmoor followed his master's intentions closely. In

1713 Wren had reported that 'the two West-towers were left imperfect, . . . one much higher than the other, though still too low for Bells . . . they ought certainly to be carried to an equal Height, one storey above the Ridge of the Roof, still continuing the *Gothick* Manner, in the Stone-work, and Tracery'.[95] In a letter to Dean Wilcocks of 1734/5, Hawksmoor defended his work on the Abbey against unnamed critics who had commented that 'the new works and repairs are not conformable and pursuant to the old at the West front of the Abby church'.[96] In this letter he emphasizes his pluralistic approach to architectural style by providing a history and justification of Gothic, in its various manifestations, as one of the legitimate Christian 'Styles of Building' – a style which, by implication, would serve as a virtuous alternative to the columns of the Renaissance treatises. Once again, Hawksmoor self-consciously followed Wren's historical scheme. He notes to the Dean concerning the 'sharp pointed Arches' of the Abbey that 'this manner of Building Mr Evelyn, Sr Chrisr: Wren and other regular Artists, beleiv'd was

82 West gable and towers at Westminster Abbey, 1734–45.

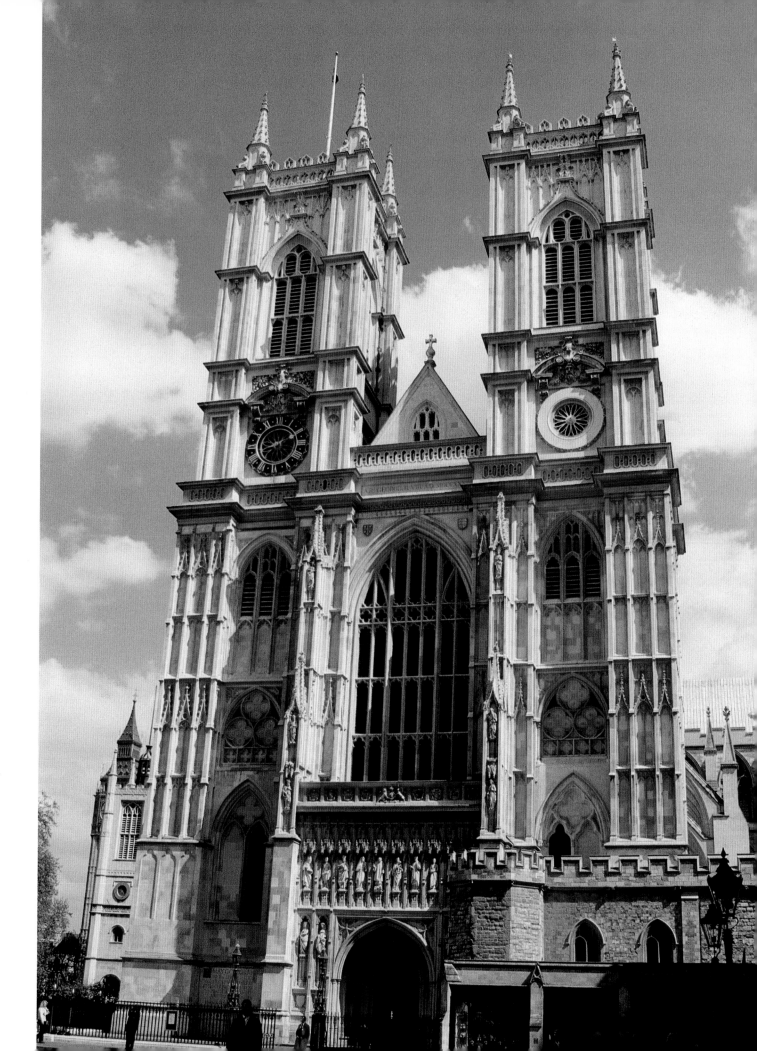

83 Hawksmoor's Gothic design for the High Street façade of All Souls, 1708–9 [Worcester College, Oxford].

brought from ye Saracens (in the holy war) by some of the Curious of the time'.[97] (Hawksmoor is at pains to point out that his own work was 'in a more Modern Style'). However whereas Wren's account of Gothic was, on balance, negative (although less hostile than Evelyn's), Hawksmoor's was positive.[98] Hawksmoor's justification of Gothic as an authentic Christian style is in the face of its rejection by his Palladian critics who approved of only the 'Greek & Latin Style'. He singles out one of their number, James Ralph, who in attacking the Stepney churches had made 'use of the word Gothick to signifye every thing that displeases him'.[99] Hawksmoor's conception of the Gothic as a developed 'style' equal to the Orders would clearly have justified the apparent stylistic interchangeability of his early proposals at All Souls (Fig. 83; and see Figs 30, 92, 317). Indeed he would have seen the mixture of Gothic and *all'antica* forms in his copy of Androuet du Cerceau's *Livre d'architecture* (first published in 1559; lot 144), and

he too mixed both styles in single designs (as proposed in Oxford at All Souls and Magdalen, and in London on the Stepney churches). In fact Hawksmoor's Gothic work is overtly classical. At All Souls, for example, there is a consistent use of symmetry and preference for round-headed windows over the pointed arch. In the case of schemes for Windsor Castle, where the drawings for the south range (of 1698) are attributed to Hawksmoor (although the overall scheme was by Wren),[100] an astylar *all'antica* palace front is flanked by symmetrical Gothic wings (Fig. 84). The wing on the left (west) is new work made to match the existing, medieval-style work on the right. Here Vitruvian principles of symmetry and harmony govern the whole composition, through alignments of height and repetition of (round-headed) windows and tower forms. Once again, Hawksmoor followed his master. In Tom Tower at Christ Church, Oxford and in all of his Gothic designs, Wren had fully utilized primary

84 Drawing for the south range of Windsor Castle, 1698, attributed to Hawksmoor [All Souls, Oxford].

85 (*facing page*) Wren's Tom Tower at Christ Church, Oxford.

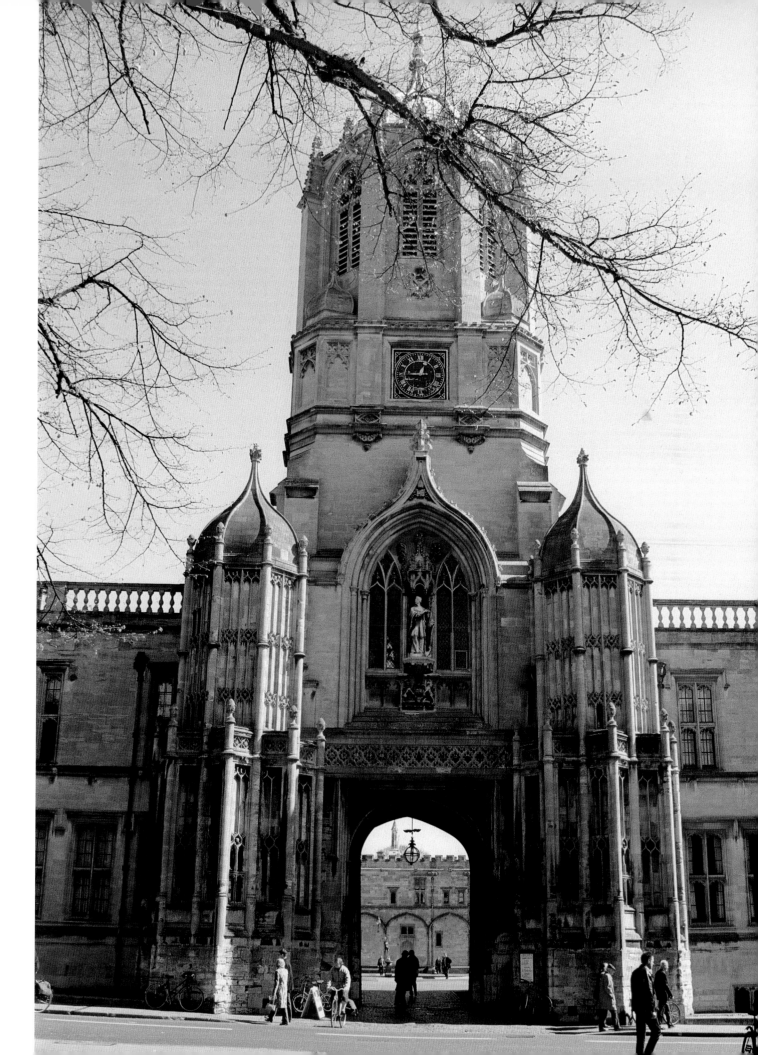

geometries and their proportions, as well as symmetry and uniformity, as the natural causes of beauty (Fig. 85).[101] And in commending a crenellated scheme for Kimbolton which is described as having 'Something of the Castle Air', Vanbrugh cautions 'tho' at the Same time to make it regular'.[102]

At the Abbey Hawksmoor's west towers are each symmetrical, with classical additions (volutes and cornicing most notable over the clock).[103] Indeed his letter defending the Gothic 'style' owed its existence to the fact that critics had noticed a misfit between this work and the original Gothic ('not conformable and pursuant to the old'). Perhaps most telling concerning his identification of the Gothic style with *all'antica* forms is the fact that he refers to the Abbey's western gable, designed by him in 1735, as a 'pediment', while the old pillars inside the Abbey were apparently 'dress'd with small Torus's'. His inscription on a drawing for the gate to the north quadrangle of All Souls notes the presence of 'Crockets (or Calceoli)',[104] and to the Westminster Dean he reports that 'As soon as the mason can get stone he will put on the Crocketts (or Calceoli) at the West end. on the pediment'. This has been seen to imply a connection in Hawksmoor's mind between Gothic crockets and the acanthus leaves (*caulcoles*) of the Corinthian capital.[105] Indeed his 'explanation' of his All Souls design in 'y^e Gothick manner' sent to George Clarke in 1715 had also appropriated terms from Vitruvian theory.[106] Phrases such as 'for y^e better Ornament', '2 other Arches of y^e Like nature on y^e right hand & Left', 'preserve a Reasonable uniformity' and 'y^e Order & beauty of y^e Compartment' are resonant of Vitruvian concepts of symmetry, order, harmony and decorum which, behind its outward style, Hawksmoor's design clearly reflected. The Gothic was thus seen as a style or ornamental vocabulary that was easily equatable to the classical. It had a series of details with *all'antica* equivalents – gable (pediment), pinnacle (pyramid), semi-circular vault (Roman and Romanesque arch), buttress (pilaster), crenellation (cornice) and what Hawksmoor calls a 'Gothic Cupola'[107] (dome) – which were to be 'applied' to a given façade using Vitruvian principles. The most obvious examples of the equality between Gothic and antique forms are the obelisk and triumphal column used as spires on Hawksmoor and James's two collaborative churches (see Figs 184–6).

This conception was perfectly compatible with Hawksmoor's understanding of Gothic architecture as originating, or growing out of, the fragments of classical antiquity, for according to him the early Christians had first built with antique *bricolage*. Du Prey has seen this view as fundamental to Hawksmoor's church designs, with their 'assemblage' of forms reminiscent of both pagan and medieval building traditions.[108] Hawksmoor observed to the Dean that 'What is vulgarly meant by this Term Gothick, is, the manner of Building, so different from the Greek & Latin Style, which came in at the fall of the Roman Empire, and among the first Christians'. He rejected this popular early dating for the Gothic, however, since its practice was a matter for those 'skill'd in masonry, and the Styles of Building' and this early time was not a sophisticated era. The very first Christians had made 'use of some of the Basilica's for Churches, as, St. John Lateran, and St. Mary Major, at Rome, and the Emperour Constantine built the Basilica of St. Peter in the Vatican, from the Ruins of severall other Buildings, but in a very unskillfull manner'. Nevertheless, evidently the early Christians quickly evolved their own model church plan, which Hawksmoor reconstructed around 1711–12 in the form of his basilica 'after the Primitive Christians' (see Fig. 60); tellingly, he understood this to be drawn 'as it was in y^e fourth Century in y^e purest times of Christianity'.[109] In echoing works on the primitive Christians by the likes of the Rev. George Hickes and Père J.-L. de Cordemoy,[110] Hawksmoor's period of architectural and theological virtue thus followed Constantine's acceptance, in the 320s, of Christianity as a religion fit for the Roman Empire. This period also marked the rise of Gothic. According to his account, 'Gothic' had been the first real architecture of the early Christians, since

> Learning, Arts and Sciences still declining. After ages, whether Goths, Vandalls, Saracens or the Monks, afterwards, in Building Churches (no matter) partly out of necessity or partly humor. They made use of a different sort of Building with stones of less dimensions, and what they could easily transport or raise upon their fabricks, and sometimes patch'd up aukward Buildings, out of the Ruins of Old Magnificent Structures. This was what was afterwards calld Gothick. At first they built with large round pillars of five Diamr in height, and the Arches half round, wth Narrow Lights haveing half round heads, or semicircular a top. and this is the most Antient style in the Gothick or Monastick manner, as they call'd it.

Thus for Hawksmoor the origins of Gothic lay not in medieval pointed-arch construction but in earlier, post-Constantine building of the first millennium. Given the underlying classicism of his Gothic, this dating is natural enough since architecture from this period (whether Early Christian, Byzantine or Romanesque) had adapted and re-used Roman forms

(most notably in using round arches rather than pointed ones). This was also consistent with George Wheler who, as was noted, in 1689 identified the legacy of Constantine's primitive Church in the contemporary practices of Greek Orthodoxy, and in drawing a model primitive Church adapted a Byzantine building complete with arched openings and multiple domes (see Figs 57–8). Hawksmoor's views on the origins of Gothic thus reflected these quests by contemporary theologians for Near Eastern models of primitive Church building, untainted by Catholic corruption and superfluity, as a basis for Protestant Church ritual, iconography and architecture.

According to Hawksmoor, the Abbey itself boasted an early example of Gothic work (our 'Norman'), for 'your Lordsp. may see a specimen of this way of Building behind the little Cloyter, by Mr. Davys Lodgings'. In identifying this 'specimen' Hawksmoor echoed the methods of classification introduced by the Royal Society, and he followed the antiquarian studies of Wren and Aubrey in particular in dividing the subsequent development of the Gothic 'style' in England into distinct historical periods, each with its own unique character.[111] He goes on to make clear that the (more antique-looking) round-arched form of Gothic was the native style, in contrast to the later imported Gothic comprising 'sharp pointed Arches' built during the reign of Henry III (our 'Early English'). The latter style lacked the same authentic Christian origins for Hawksmoor, being, as quoted earlier, a 'manner of Building... brought from y^e Saracens (in the holy war) by some of the Curious of the time'. This work developed into the 'Tracery' style (our 'Decorated'), and thence into the work found in 'The Chappell built, by Henry the seventh' which 'the Artists beyond sea call Filigrane' (our 'Perpendicular'). Since according to Hawksmoor the 'Tracery' was the style of the existing west front of the Abbey, he concludes 'this sort of Building we are now upon, in the Abby, has been consider'd pursuant to the Gothick Tracery, or Monastic Style'. But when not compelled to match existing work, Hawksmoor consistently favoured the older, native round 'arched' style of Gothic over the pointed 'Saracen' or subsequent 'Tracery'. The bell-stage of his tower for St Michael, Cornhill (1718–24), has round-headed windows in preference to pointed arches (with additional Romanesque corbel tables as used at All Souls) (Fig. 86).[112] Under Hawksmoor's direction, as Clerk of Works at Westminster, the former Jewel Tower was repaired with parapets replacing battlements and with round-headed windows and Portland stone surrounds replacing the medieval windows.[113]

86 Bell-stage of the tower of St Michael, Cornhill, London, 1718–24.

Hawksmoor's letter to the Dean thus offers a unique insight into his understanding of the validity and virtuous origins of his 'Gothic' style, with its preference for round-headed windows, applied *all'antica* and Romanesque details and symmetrical arrangements. For this was a style supposedly rooted in the early architecture (rather than mere building) of primitive Christianity as it developed from Roman practices. In one particular work in his library Hawksmoor would have found a persuasive authority for the equality and interchangeability of classical and Gothic architecture.[114] This was the appendix, issued with continuous pagination, of Jean-François Félibien's translation of the younger Pliny's description of Roman villas (first published in Paris in 1699, and then in Amsterdam in 1706

and in London in 1707).[115] Hawksmoor's sale catalogue included a copy, most probably of the first, octavo Paris edition ('Maisons de Pline', lot 8).[116] According to Félibien, following the decline of Vitruvian practices after the fall of the Roman Empire, people had become 'accustomed for many centuries' to Gothic, another way of building which was 'light, delicate, & daring work capable of giving astonishment', and still admired by the 'best architects' for good construction and 'some general proportions'.[117] Like antique works, these Gothic buildings drew their qualities of 'massiveness' and 'grossness', as opposed just to 'lightness', from the origin of building in nature, Félibien citing the use of bunched shafts to support vaulting 'in the better manner of taste'.[118] Félibien's scarcely concealed admiration for Gothic prompts him to consider the 'progress of a new theory among the learned', the new 'dream of Poliphilo', which should 'open the eyes . . . to all the sensible characters of reason'. Parity was underlined when Félibien compared the imitation by antique columns of tree-trunks as equal to the 'flexible branches of Gothic works',[119] suitable for garden bowers and tents – and not all that out of place in a book on the gardens of Pliny. Through emphasizing the common origin in timber construction of the antique column and Gothic arch, in Félibien's appendix Hawksmoor would have found perfect justification for marrying his *all'antica* Radcliffe Library designs to the Gothic Old Schools in Oxford (see Figs 282, 283),[120] and for his outright fusion of the two national styles in his churches. Here, rising majestically from antique temples, medieval towers are ornamented with proto-Doric buttresses, and traditional spires are transformed into antique columns and obelisks (see Figs 179–86). (An early scheme for the Abbey by Hawksmoor even had spires topped by Corinthian capitals.)

Hawksmoor's famous tower at Bloomsbury probably stands as the best example of his historicist approach to the use of historical models, in combining a 'Greek' mausoleum with a Roman altar and contemporary royal insignia to form an element of Gothic origin – a spire (see Fig. 72). As with Fisher von Erlach's Karlskirche in Vienna, an eclectic collection of elements is here brought together to redefine the contemporary architecture of the crown. The landscape at Castle Howard perfectly reflected this cultural eclecticism, with the monuments being described by Carlisle's daughter, Anne, Viscountess Irwin, in a poem of around 1733 as '*Grecian, Roman* and *Egyptian*'.[121] Faced with this growing choice in architectural styles and models, Hawksmoor will be shown in the following chapter to have had criteria for selecting which ones to use where.

Chapter 3

'ARCHITECTONRICALL METHOD, AND GOOD REASON': HAWKSMOOR ON IMITATION AND INVENTION

THE MORE INVENTIVE OF HAWKSMOOR's ornamental forms, such as his over-scaled keystones and triglyphs, did not escape the censure of his Palladian contemporaries, whose criticisms echoed the link between ornamental and moral 'licentiousness' first outlined by Sebastiano Serlio in print and developed into a Protestant aesthetic by early English architects and writers. It is perhaps telling that 'licentious' ornament is most apparent on some, but not all, of Hawksmoor's churches (see Figs 66–7, 239–41). The wide variations in ornamental style from one Hawksmoor building to another – from the 'plain' Mausoleum to the 'decorative' St George in Bloomsbury through to the 'licentious' Stepney towers – do not necessarily mean that Hawksmoor was inconsistent in his use of ornament, that is, in when and where various styles should be used. That Hawksmoor followed what he considered to be a method when designing is evident from his comments to Carlisle that he was 'only for following architectonricall method, and good Reason, in Spite of evil Custom, and pernicious practice'.[1] 'Architectonricall' is an Aristotelian term meaning the systematization of knowledge compatible with the universal or, in Hawksmoor's case, the absolute virtue of 'good Reason'.[2] What did Hawksmoor consider as his universal or absolute principles defining his 'method' of design? Concerning his Mausoleum he makes clear that he wished to build, when precedents existed, 'according to the practise of yᵉ ancients'; on the colonnade for example he notes that 'being a Monumentall Temple, I cannot avoid having recourse, to Vitruvius himself, on this Occasion'.[3] But as his emphasis on using Vitruvius 'on this Occasion' and his buildings themselves indicate, such fidelity to ancient authority varied according to circumstance. Indeed as forms such as the Bloomsbury tower clearly demonstrate, Hawksmoor frequently remodelled and 'rationalized' antique forms to fit particular contexts and contemporary objectives. This chapter will examine the meaning behind the more

'licentious' of his forms, and will go on to outline his 'universal' rules governing when *all'antica* imitation was preferable to modern invention, and when the reverse was true – outline, in other words, his 'architectonricall method'.

'EGYPTIAN CHARACTERS, REPRESENTING MORALS & POLITICKS &C.': HAWKSMOOR'S STYLISTIC RANGE AND SERLIO'S LICENTIOUS GATES

The first English architectural treatises, by John Shute (1563) and Henry Wotton (1624), presented the five Orders as a form of emblematics whose pictorial language of virtues and vices was thought to date back to Egyptian hieroglyphics.[4] Hawksmoor was certainly well aware of the traditional moral purpose behind emblems. He notes in the 'explanation' of his Blenheim obelisks celebrating the Duke of Marlborough's victories that 'The Inscriptions generally put upon yᵉ Ancient Obelisks by great Men were in Egyptian Characters, representing Morals & Politicks &c. The Virtues and Actions of great & illustrious Men, &c'.[5] Concerning the Orders, a distinction had emerged in moral terms between their canonic forms, especially the plainer types, and the more decorative and even the 'licentious' ones (as Serlio termed them). Inigo Jones had made a clear distinction between what he called 'composed ornaments . . . brought in by Michill Angell and his followers' and the virtues of 'sollid Architecture' which, like a 'wyse ma[n]' who 'carrieth a graviti in Publicke Places', ought 'to be Sollid, proporsionable according to the rulles, masculine and unaffected'.[6] The former forms were certainly controversial. Ignoring the common enough examples of ancient 'licentious' practices, Palladio had rejected Mannerist ornament as 'abuses' with respect to ancient models, as

87 Composite Order as Pandora, from John Shute's *The First and Chief Groundes of Architecture* (1563).

Born just after the Civil War, Hawksmoor would have been acutely aware of the religiosity of ornament. All too recent was the iconoclastic battle between the Laudians, with their vision of beauty in holiness, and the Puritans, with their distaste for rich ornament.[10] Hawksmoor was clearly well versed in the history of this conflict, for his library included John Foxe's 'Book of Martyrs, 2 vol.' (lot 53), 'Salmon's Abridgment of the State Trials' (lots 55 and 57), 'Laud against Fisher' (lot 56), 'Dugdale's View of the Troubles' (lot 58) and 'Clarendon's History, 6 vols' (lot 15).[11] His subscription to William Kent's *Designs of Inigo Jones* (1727; lot 116) furnished him with a plate of one of the finest architectural achievements of William Laud's Church – Inigo Jones's Corinthian portico to old St Paul's, defaced by angry Puritans during the Civil War as a symbol of Laudian ostentation (Fig. 88).[12] He would have seen the Puritan aversion to the outward display of luxury outlined at source in his copy of John Calvin's *Christianæ religionis Institutio* (1536; lot 57).[13] That Hawksmoor was 'bred a Scholar' suggests that he would have studied carefully the folio editions of Plutarch (the *Lives*) and Juvenal in his collection (lots 55 and 76), and noted their emphasis on moral character and condemnation of luxury for its own sake. More significantly, he would have seen similar firm,

88 Inigo Jones's Corinthian portico to old St Paul's, from William Kent's *Designs of Inigo Jones* (1727).

Hawksmoor would have seen in his copies of the Italian's treatise (lots 40, 68 and 123).[7] Shute and Wotton condemned as licentious and capriciously showy the most decorative of the five Orders, the Composite, despite its pedigree in the treatises of the Renaissance masters and in antiquity itself (Fig. 87). Emphasizing the emblematic characteristics of the Orders, Wotton even extended his moral disapproval to the Corinthian, describing it as 'laciviously decked like a Curtezane' in preferring the homely honesty of simple Tuscan and Doric.[8] John Evelyn echoed this in 1707 in his 'Account of Architects and Architecture' when observing that the Corinthian was 'trick'd up and adorn'd like the Wanton Sex', adding that the Composite was '*Gay* and *Wanton*'.[9] Such sentiments appealed to long-standing Puritan prejudices concerning the idolatrous nature of certain decorative forms of the visual arts.

moralistic strictures linked to ornamental display in a much more immediate work, namely Campbell's introduction to the first volume of *Vitruvius Britannicus* (1715; lot 131). Here, taking his lead from Palladio, hardly surprisingly Campbell condemned the 'affected and licentious' works of Bernini and Fontana, and the 'widely Extravagant' designs of Borromini, 'who has endeavour'd to debauch Mankind with his odd and chimerical Beauties'.[14]

Chapter 1 outlined how, with the rise of the Baroque in continental Europe, the preference for ornamental invention over *all'antica* imitation had inevitably led to the decline in importance of generally accepted rules governing architectural imitation, Vitruvian or otherwise, and of the treatise genre which sought to record them. This was marked by the rise of pattern books, with little or no theoretical explication. The presence in Hawksmoor's library of well-known Baroque pattern books, noted in Chapter 1, underlines the spread of this questioning of Vitruvian authority. For example Alexandre Francini's *Livre d'architecture* (1640), listed in Hawksmoor's sale catalogue as a 'Book of Embellishments' (lot 91), combined traditional French motifs with heavily rusticated Mannerist forms producing a licentious style that, at least in England, was never popular (Fig. 89). Hawksmoor's enthusiasm, in certain instances, for licentious and monstrous forms – the traditional grotesque symbols for the supernatural world – was also noted in Chapter 1 (see Figs 32–7). To take but one design suitable for such treatment, the Belvedere at Castle Howard, he toys in his letters to Carlisle with the idea of placing a sphinx at the building's base (Fig. 90).[15] Concerning the interior, he refers to the famous Terms painted by Carracci in the Palazzo Farnese in Rome, which he would have seen illustrated in his copy of the 'Galeria Farnesianæ per Jacob Rubies – Rome 1643' (lot 113) and 'The Gallery of Carrach by Cessinas' (lot 162). He observes that the 'Gallery of Farnese has examples enough to follow but if your Lordship has not all them designs we should endeavour to gett the Book and in it we cannot fail of sufficient examples'.[16] This is indicative of Hawksmoor's practice of making continual reference to archetypal models and historical examples drawn from his collections. His sale catalogue also refers to 'Termes des Aulmanz 42 prints Italian' (lot 43), whilst Terms and other licentious forms used on the Louvre were illustrated in Du Cerceau's *Livre d'architecture* (lot 144). He would also have seen Raphael's famous painting of bestial forms (grotesques) illustrated in the unspecified work in his collection on the 'Loggia Vatican' (lot 157).

Hawksmoor's flirtation with heraldic monsters, demons, terms and sphinxes in sculpture and decora-

89 Model gate design, from Alexandre Francini's *Livre d'architecture* (1640).

tion also reflected decorative models of bestial and licentious forms illustrated in one of the first and most influential of the Mannerist treatises, that by Sebastiano Serlio.[17] In his *Libro Extraordinario* ('Extraordinary Book of Doors'; 1551) Serlio presented a series of model gate designs on which the Orders were simplified or embellished so as to explore the limits of ornamental invention, rather as Hawksmoor did most prominently on his church towers. Serlio's treatise might be identified as a source for a number of the more inventive of Hawksmoor's forms, and possibly, by extension, as a source for their meaning. Indeed it was noted that his edition of Serlio was the 1663 Italian–Latin folio version of Books I–V published in Venice (lot 102; Wren also owned this edition),[18] which included the 'Extraordinary Book', mislabelled as 'Book Six', in a somewhat reduced form from the original. This comprised Serlio's opening explanatory letter to the readers and eleven of the fifty original plates – eight Rustic and three Delicate gates with their accompanying text (a selection which thereby emphasized licentious

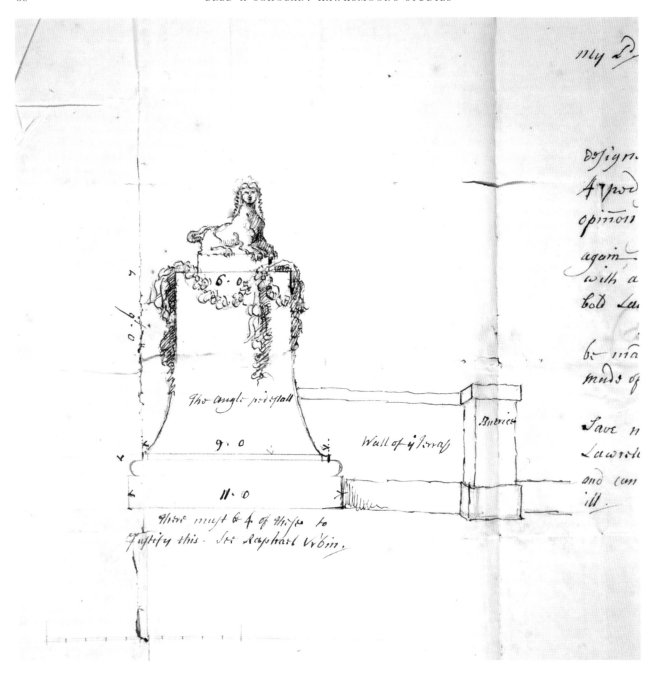

90 Hawksmoor's sketch of a sphinx, for the base of Vanbrugh's 'Temple of the Four Winds' at Castle Howard, from his letter to Carlisle of 11 April 1730 [From the Castle Howard Collection, Yorkshire].

forms).[19] Hawksmoor clearly studied the third book of Serlio's treatise closely because he refers to it in the course of his book proposing a new bridge at Westminster.[20] George Clarke, Hawksmoor's patron for much of the Oxford work, also owned a copy of Serlio and attentively studied it.[21] Given Hawksmoor's experience with the design of gates, he must surely have looked at Serlio's models in some detail, especially since the ornamental vocabulary of which he was fond was

fully explored in the gates illustrated by the Italian. Examples of staple 'Serlian' forms in Hawksmoor's work include the rustic bands in the Easton Neston gate (Fig. 91), the mixture of stone and brick voussoirs on the Carrmire Gate (see Fig. 70), the over-scaled yet 'delicate' keystone and pilastrade to the gallery doors in St George-in-the-East (see Fig. 49), and the rustic gates in an elevation for the Fellows' building at All Souls (Fig. 92).[22] More specific examples of Serlio's influence

are the banded columns and giant scrolls in the East (Hensington) gate at Blenheim (as in Serlio's Rustic gates XIX, XXI, XXIV or XXIX, and Delicate gate XV), the giant keystones and recesses on the basement to St Mary Woolnoth (Rustic gate XIX), the satyrs in the 'Satyr Gate' at Castle Howard (carved by Samuel Carpenter; Rustic gate VIII) and the lion heads in the keystones to the side doors to the Woodstock gate (the monsters in Rustic gate XXIX) (Figs 93–102).

Commentators have acknowledged the influence of Serlio's *all'antica* and Mannerist models on Hawksmoor's work.[23] Indeed as Downes points out, that most Hawksmoorian of details, the triple keystone motif, 'must have reached England through the intermediacy of designs such as the book of gateways published as *Libro Extraordinario* in the most influential sixteenth-century Italian architectural manual, that of Sebastiano Serlio'.[24] But Serlio's book was more than a 'manual'; his gates represented an almost unique set of theoretical studies explaining the meaning behind licentious ornament which Hawksmoor – 'bred a Scholar' as he was – would have easily understood when studying their forms. Here he would have seen the concept of ornamental 'licentiousness' explained and illustrated through the duality which structures the 'Extraordinary Book', in which Rusticated, capricious forms ('*ordine Rustico*') on the gates in the first part are

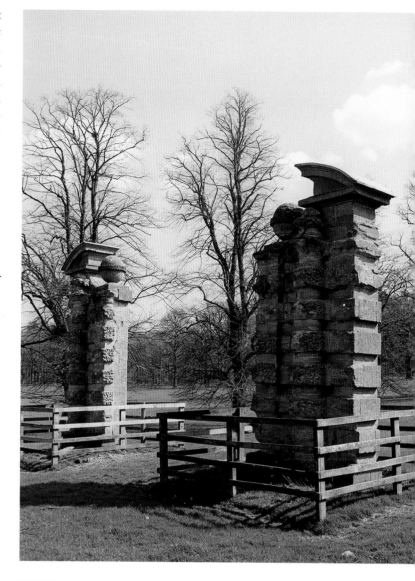

91 Old gate at Easton Neston.

92 (*below*) Hawksmoor's elevation for the Fellows' building at All Souls, Oxford, 1708–9 [Worcester College, Oxford].

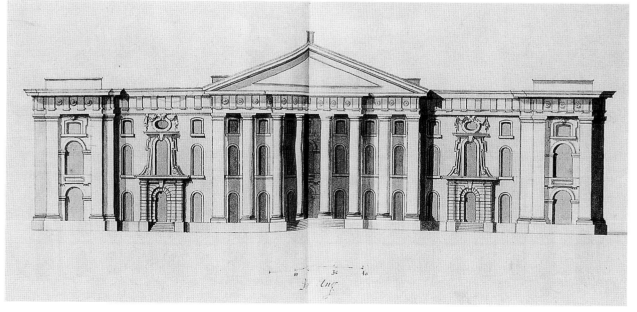

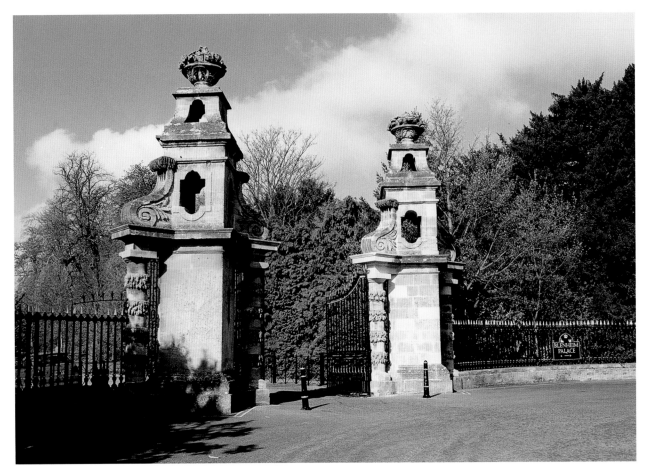

93 Banded columns and giant scrolls in the East (Hensington) gate at Blenheim.

94–6 Rustic gates xxi and xxiv (banded columns) and Delicate gate xv (scrolls), from Sebastiano Serlio's *Libro Extraordinario* (1551).

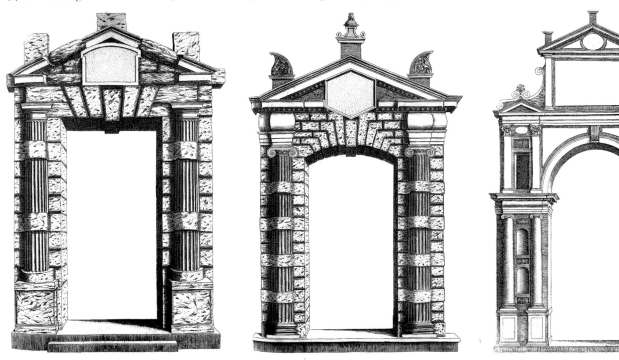

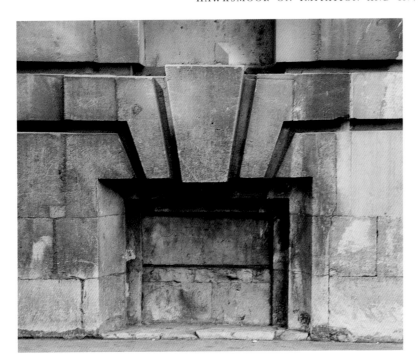

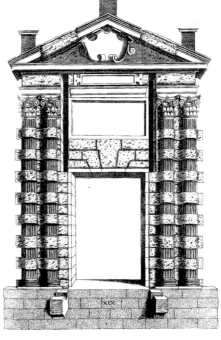

97 Giant keystone and recess on the basement to St Mary Woolnoth.

98 Serlio's Rustic gate XIX.

contrasted with refined, orthodox forms ('*ordine gentile*') on those in the second.[25] As his use of the word 'licentious' suggests, Serlio identified moral qualities with these forms, associating virtues with Vitruvian forms and vices with Mannerist ones. This dichotomy is made explicit through his terminology, which contrasts the opening 'bestial', 'capricious', 'bastard' and 'vicious' (non-Vitruvian) ornaments with the later 'delicate' (Vitruvian) ones.[26] In light of the subsequent preoccupation of English theorists with the morality of ornament, Hawksmoor would clearly have found these associations familiar enough. Similar contrasts in ornamental display, between rustication and refinement and between modern licentiousness and classical orthodoxy, are, appropriately enough, particularly evident on his churches. Observe, as but one example, the juxtaposition between the heavy rustication and the 'delicate' Ionic columns on the north side of St Mary Woolnoth (see Fig. 261).

Through his licentious ornament Serlio aimed to test the qualities he most admired in the good architect, namely judgement and inventiveness, a challenge that Hawksmoor fully acknowledged when combining 'Strong Reason' with 'Good Fancy'. The delicate balance between dogmatic imitation on the one hand, and the artist's freedom to invent on the other, was a fundamental theme of the Renaissance treatises and animated the debate between the 'Ancients' and the 'Moderns'. While, at least for the 'Moderns', mere imitation would fail to reflect the spirit of the modern age, everyone (including Perrault) agreed that complete freedom from antique rules would represent an irrational departure from the still fundamental values of antiquity. For Serlio, the ultimate test of the architect's judgement and sign of originality was the appropriate use of monstrous imagery of the type Hawksmoor was earlier seen to have studied. When illustrating such 'bestialized' forms in the 'Extraordinary Book' Serlio cites the traditional Vitruvian reference point in nature. On one Rustic gate (XXIX), present in the 1663 edition, he offers the excuse that 'since there are some rocks made by nature which have the form of beasts, Bestial work [*ordine bestiale*] exists' (fol. 17r; see Fig. 100). Such work was so licentious that it transcended the range of human morality, from virtue to capriciousness, and instead became a work of pure nature, resembling a beast or monster outside human moral constraints. These forms signified the bestial, darker forces of nature that, as was noted at the end of Chapter 1, might readily be identified in Hawksmoor's demon-faced urns, strange keystoned doorways leading to subterranean rooms and lofty altars open to the sky. Indeed the sense of the *terribilità*, which derived from Michelangelo and which Serlio's Rustic gates popularized, is particularly apparent in Hawksmoor's Stepney churches and in Vanbrugh's preference for temples

99 (*right*) Satyrs in Serlio's Rustic gate VIII.

100 (*far right*) Monsters in Serlio's Rustic gate XXIX.

102 (*facing page*) Satyrs in the 'Satyr Gate' at Castle Howard by Hawksmoor and Vanbrugh (carved by Samuel Carpenter), 1705.

101 (*below*) Lion head in the keystone to the side doors of the Woodstock triumphal arch, Blenheim.

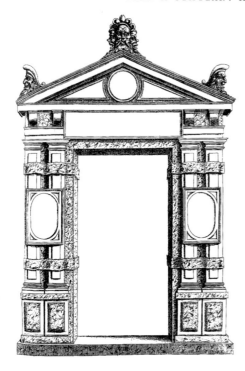

with what he calls 'the most Solemn and Awfull Appearance'.[27] Serlio therefore offered a source for more than a mere vocabulary of forms. Just as Félibien would have provided a justification of Gothic ornament in classical terms, so first Serlio and later Shute provided an all-important rational theory justifying licentious ornament – as a form of moral emblem to be used as a warning when the situation called for it.[28] And there could surely be no more appropriate situation than on the towers to the Stepney churches, whose pared-down 'licentious' pilasters lift urns and sacrificial altars skywards as if to warn that the day of judgement is never far away.

'A MEAN, BETWEEN THE GREEK AND GOTHIQUE ARCHITECTURE': PROTESTANT RESTRAINT AND HAWKSMOOR'S LONDON CHURCHES

In the introduction to *Vitruvius Britannicus* of 1715 (lot 131), Campbell observed that 'the *Italians* can no more now relish the Antique Simplicity, but are entirely employed in capricious Ornaments, which must at last end in the *Gothick*'.[29] Not surprisingly perhaps, Hawksmoor rejects this obsessive Palladian taste for 'correctness', over-simplicity and lack of experiment, complaining to the Dean of Westminster in 1734/5 that, 'where they fancy too much liberty is taken . . . they call it Gothick'.[30] This was in particular

103 Ornate style of Wendel Dietterlin, from *Architectura von Ausstheilung, Symmetria und Proportion der fünff Seulen* (1593–4).

reference to James Ralph's criticism of his Stepney churches as 'mere Gothique heaps of Stone, without form or order'.[31] What were perceived of as 'liberties' in the design of the Castle Howard Mausoleum had brought Hawksmoor into direct opposition with Burlington and his fellow Palladians – referred to in the Carlisle letters as 'virtuosi'.[32] Hawksmoor echoed this dig near the end of his life when boasting patriotically that Castle Howard 'claims more Regard, than one of Palladios humble Villas in y^e Vicentine, or Veronese'.[33] In a letter to Carlisle on 7 January 1724, having discussed various designs for the Belvedere, Hawksmoor makes clear his attitude to Palladian pedants and to antique imitation: 'I wou'd not mention Authors and Antiquity, but that we have so many conceited Gentlemen full of this science, ready to knock you down, unless you have some old father to stand by you. I dont mean that one need to Coppy them, but to be upon y^e Same principalls'.[34]

Not surprisingly, therefore, Hawksmoor also disapproves of the excessive ornamental licentiousness practised on the continent. Wren had earlier warned of the 'Curiosities of Ornaments' and 'Works of Filgrand, and

little Knacks' evident at Versailles;[35] Hawksmoor echoed these sentiments when defending his work on the Abbey and complaining to the Dean of the 'liberty' taken by 'Modern Italians . . . especially Boromini and others'.[36] He also complains of the wildly ornate style of Wendel Dietterlin (Fig. 103), once to Carlisle in reference to the design of Wollaton (in fact influenced by Dietterlin's Mannerist forerunner, De Vries),[37] and again to the Dean where he notes that Dietterlin 'put the whole disposition of Antient building into Masquarade. Your Lordsp. may see some of this Taste in the West front of Northumberland house. This Burlesque Style of Building, is still called Ditterlyn, but not imitated'.[38] Thus despite his own use of licentious forms, albeit much plainer ones than Dietterlin's, Hawksmoor was careful to distance himself from being associated with ornamental models that were too fanciful. In so doing he wished to defend his own Gothic work at the Abbey from accusations of capriciousness (especially of a foreign variety) and associations with immorality to which Dean Wilcocks would have been particularly sensitive. Hawksmoor's approach to design, in combining the use of imagination (or 'Good Fancy') with antique rules, was meant to guarantee ornamental propriety. It was noted that, when writing to Carlisle in 1724 on Vanbrugh's proposed Belvedere 'Temple', he observed:

> What Sr. John proposes is very well, and founded upon y^e Rules of y^e Ancients I mean upon Strong Reason and Good Fancy, Joyn'd with experience and tryalls, so that we are assured of y^e good effect of it, and thats what we mean by following y^e Antients, if we contrive or invent otherwise, we doe but dress things in Masquerade which only pleases the Idle part of mankind, for a short time.[39]

Here again, ornamental 'masquerade' is linked by Hawksmoor to the morally reprehensible, fashion-conscious tastes of the 'idle' – in other words those of his critics.

Hawksmoor was a patriotic Englishman, a fact that will be further illustrated in Chapter 9 concerning his remarks on Greenwich Hospital. He might thus be expected to have been suspicious of anyone relying too heavily on the work of foreign masters, especially the Counter-Reformation Baroque of 'Modern Italians', but also, when it came to domestic architecture, the work of Palladio. It has been seen that his history of Gothic emphasized the long-established nature of the style in England, tracing its forms from early Christianity past the Crusades to his own work on the Abbey. His Stepney churches, built as they were in the Protestant cause, reflect the Calvinist aversion to

rich display in favoring, as Ralph pointed out, somewhat stark, primitive forms evoking national Gothic church traditions of spires, lanterns and buttresses. Daniel Defoe echoes Calvin in noting in his *A Tour Through the Whole Island of Great Britain* of 1725 that, taken together, the new London churches being built by the Commission 'are rather convenient than fine, not adorned with pomp and pageantry as in Popish countries; but, like the true Protestant plainness, they have made very little of ornament either within them or without, nor, excepting a few, are they famous for handsome steeples'.[40] Hawksmoor's churches in Bloomsbury and Stepney, with their dramatic towers, were however singled out for praise by Defoe, thereby implying that they had avoided the extremes of continental excess (or 'pomp') and native austerity (or 'Protestant plainness').[41] Irrespective of their differences in mood, one from another, these designs neither 'Coppy' nor take 'too much liberty' with antiquity. For it was noted that unlike 'Modern Italians . . . especially Boromini', Hawksmoor was much less indulgent in his use of plastic forms such as flowing curves, easily associated in the Protestant mind with the Baroque churches of the Counter-Reformation, and that his licentious forms were of the simplified variety, not the embellished.

The desire to temper extremes, whether moral or ornamental – evident in Hawksmoor's approach to design and his general attitude to ornament – stemmed from Aristotle's work on ethics. Drawing on this ancient source, Daniele Barbaro in his 1567 commentary on *Vitruvius* – a work much studied by Hawksmoor (lot 111) – explained that mixing contrasting forms using reason 'can result in a beautiful median form'.[42] This notion had earlier influenced Calvin's quest for the 'middle way' in Protestant aesthetics.[43] The Protestant theologians of Hawksmoor's day clearly identified a Calvinist 'middle way' in the decoration of the setting of primitive, and therefore their own, worship. This licensed ornate Gibbons carving internally but demanded a more austere exterior, in emulation of past models such as Inigo Jones's churches. William Cave for example observed that 'the Christians of those [primitive] times spared no convenient cost in founding and adorning public places for the worship of God, yet they were careful to keep a decent mean between a sordid slovenliness and a too curious and over-nice superstition . . . so far as consisted with the ability and simplicity of those days'.[44] Perhaps a similar aim for an overall Protestant 'balance' lies behind the contrasting qualities also evident, to a greater or lesser degree, in Hawksmoor's churches – such as the mixture of smooth and rusticated blocks and of canonic and licentious

decoration (necessary, Serlio implies, to represent equivalent moral contrasts). Indeed in Chapter 1 Hawksmoor was quoted admiring such ornamental 'contrast and dispar[ity]' at Castle Howard, while Wren had emphasized that it was the 'Variety of Uniformities' which 'makes the Mean'.[45] Certainly for at least one contemporary, Batty Langley, Hawksmoor was the first in England to combine the apparent stylistic opposites of 'Greek' (or antique) and Gothic, as well as (or so it is implied) the Pagan and national Christian virtues which both styles represented. For Langley observes in the *Grub Street Journal* of 11 July 1734: 'That stile or mode, after which the churches at *Limehouse* and *Ratcliff* are built, is a mean, between the Greek and Gothique architecture'.[46]

'MAKE YE FABRICK MORE FIRM AND MASCULINE': DECORUM AND STYLE

Hawksmoor was thus perfectly capable of being restrained in his use of the more decorative of the canonic Orders – and in his invention of licentious variants – when the patron, function or context demanded it. Notable in this regard are his Doric Mausoleum, the astylar school buildings at Christ's Hospital and at Kensington, and the so-called Office of Works' 'utility style' employed in his proposal for Ravensdowne Barracks in Berwick-upon-Tweed, later built with some simplifications (Figs 104–7).[47] In the case of the Mausoleum Hawksmoor himself records that, under the watchful eye of the Palladian Sir Thomas Robinson, 'it was offerd, to stick close to ye Imitation of ye Antique, whereupon we agreed to keep the outside as plain as possible'.[48] And he was often most indulgent in his decoration and most licentious in his ornament when freed of such restraints, Protestant or otherwise. Most notable in this respect are the church steeples, lacking as they did any obvious antique precedent or, as will be seen in Chapter 6, client regulation. It was noted that Hawksmoor confirmed his circumstantial approach to Vitruvian canonics when commenting on the Mausoleum colonnade design that he needed to have 'recourse, to Vitruvius himself, *on this Occasion*' (my emphasis). When choosing which style to use where, from plain to ornate through to licentious, he followed in the footsteps of Inigo Jones in drawing on the ancient principles of 'appropriateness' or decorum, as outlined by Vitruvius and developed to suit modern practices by Serlio.[49]

Having specified the gender of the three Greek columns – which ranged from the 'masculine' Doric and 'matronly' Ionic to 'maidenly' Corinthian –

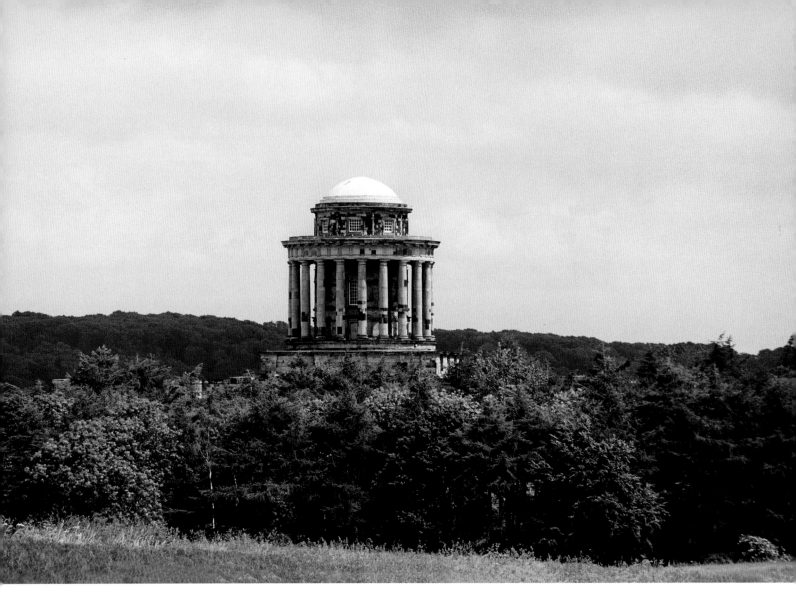

104 Mausoleum at Castle Howard.

Vitruvius had related these human types to the character, or 'decorum', of temples dedicated to particular gods. Hence the Doric Order was appropriate for Minerva, Mars and Hercules because 'of their might'; Ionic for Juno, Diana and Bacchus taking account 'of their middle quality'; and Corinthian for Venus, Proserpine and Flora 'on account of their gentleness'. In his fourth book of 1537 Serlio developed this ornamental range to include the two Roman Orders – Tuscan and Composite – and to take account of modern building functions, types of patron and Christian dedications. By the turn of the eighteenth century the individual characteristics of the five canonic Orders were widely understood in England. Freemasons, for example, identified the Doric Order with strength, the Ionic with wisdom and the Corinthian with beauty.[50] Defoe's *Tour* of 1725 praises St Paul's Cathedral by quoting lines from John Dryden: 'Strong Doric pillars form the base, / Corinthian fills

the upper space; / So all below is strength, and all above is grace'.[51] Evelyn, in both editions of his 'Account' (1664 and 1707), defined decorum as 'where a *Building*, and particularly the *Ornaments* thereof, become the *station*, and *occasion*, as *Vitruvius* expresly shews in appropriating the several *Orders* to their natural affections; so as he would not have set a *Corinthian Column* at the Entrance of a *Prison*, nor a *Tuscan* before the *Portico* of a *Church*, as some have done among us with no great regard to the *decorum*'.[52] Vanbrugh reflected this attitude to ornamental propriety when distinguishing between 'a plain, but Just and Noble Stile' for the new London churches, and what he called 'such Gayety of Ornaments as may be proper to a Luxurious Palace'.[53] The possibility of such a range in ornamental display, matched to building type, has been linked by Christian Norberg-Schulz to a native freedom of artistic and political expression which contrasted with continental shows of absolutism and dogmatic religion that tended

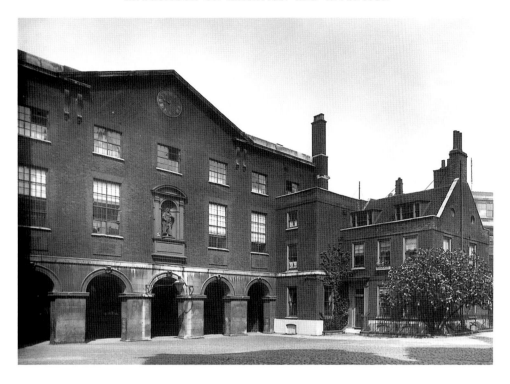

105 (*above*) Writing School at Christ's Hospital, 1692–5 (demolished).

106 Kensington Charity School, 1711–12 (demolished).

towards stylistic uniformity. He suggests that the 'aim of Vanbrugh, instead, must have been to achieve a "democratic" architecture wherein every building is given a character appropriate to its use'.[54] The principles of decorum, among other Vitruvian virtues, were certainly presented as of importance to national well-being. For when dedicating his translation of Fréart to Sir John Denham (Surveyor of the King's Works), Evelyn had lamented that 'it is from the *asymmetrie* of our *Buildings*, want of *decorum* and proportion in our *Houses*, that the irregularity of our *humors* and *affections* may be shrewdly discern'd'. Hawksmoor would have seen this warning, and the definition of decorum, in his own copies of Evelyn's work (lots 89 and 108).

Hawksmoor evidently studied the treatises closely concerning the classical canons, or 'yᵉ Rules of yᵉ Ancients' as he put it. Kerry Downes has observed that the 'theory of propriety, that the style of a building should be related to its purpose, is common in Renaissance architectural literature. It underlies much of the eclecticism of Hawksmoor's architecture as well as a number of statements in his surviving letters'.[55] On rejecting the Ionic Order for the Mausoleum colonnade, for example, Hawksmoor wrote to Carlisle on 19 April 1729 that the Doric 'will make yᵉ fabrick more

107　Hawksmoor's proposal for Ravensdowne Barracks in Berwick-upon-Tweed, 1717 [Wiltshire Records Office].

firm and masculine', recalling later that 'I esteem'd the Dorick most suitable to the Masculin strength we wanted'.[56] Concerning the octagonal Temple of Venus at Castle Howard he observed on 4 January 1732 'that the 8 pillars may be Rusticated as I have hinted to you, in y^e drawing, for the more firm and masculin they appear, the better they will suit our Rurall, Sylvan, Situation. Without the Rusticks they will be too feminin (*trop Megre*) as the French call it'. (The temple is destroyed, but a surviving sketch shows a 'Serlian' effect similar to the rustic blocks in the columns of the East (Hensington) gate at Blenheim (Fig. 108; see Fig. 93).[57]) Here again Hawksmoor expresses the idea that ornament might reflect contrasting qualities – in these cases the timeless ones of masculine and feminine characteristics. Most tellingly of all, in defending his choice of the Doric for the Mausoleum he followed the prejudices of Wotton and Fréart in observing: 'As for the order call'd Composite, I look upon it as a mongrell and no true Species'.[58] This makes clear his interest in the individual, metaphoric meaning of the

canonic Orders, as codified by the architectural treatises. The application of the classical principles of decorum was evidently a vital part of the 'architectonricall method, and good Reason' which Hawksmoor recommends to Carlisle as the design method to be followed for the Mausoleum. Judging from these comments, the rules of architectural decorum gave him an all-important rational basis upon which to select which Order to use where, a basis which Inigo Jones had termed 'Varying with reason' in his copy of Palladio (in notes which Hawksmoor could easily have read).[59]

By bearing in mind the rules of architectural decorum, apparent contradictions in Hawksmoor's attitude to the use of particular forms of ornament can be explained. Take, for example, his comment when defending his choice of the Doric for the Mausoleum colonnade that the Composite was 'a mongrell and no true Species'. From this he would seem to have become somewhat puritan in his tastes, here even disapproving of a canonic column 'type' despite having used it and

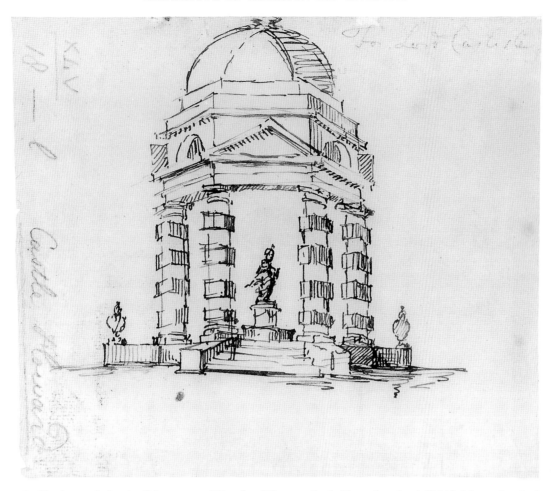

108 Hawksmoor's sketch of the octagonal Temple of Venus at Castle Howard, undated [British Library, London].

even 'mongrel species' of his own invention elsewhere on earlier work. This apparent paradox points to the influence of relative factors such as building context and type in the selection of ornament. For the Composite was perhaps the least appropriate Order for a Mausoleum exterior, bearing in mind its decorative 'superfluity' (as related by Shute and Wotton), its temporal triumphalism (as related by Serlio)[60] and the absence of antique Composite funerary precedents. Although Hawksmoor was evidently perfectly happy to entertain the use of the Composite for the Mausoleum interior, modelled on the arch of Titus,[61] in the finished building the pilasters were amended to Corinthian. As a Greek capital whose form was based on a funerary basket according to Vitruvius, the Corinthian was, like the Doric colonnade, more suitable to both the building's function and its 'Greek' character as requested by Carlisle.[62] Chapter 5 will outline how Hawksmoor 'personalized' the Composite Order at Easton Neston to relate to the character of the patron. In both these cases, true to the principles

of decorum, his selection of the individual Orders was based on their appropriateness to particular physical and symbolic contexts.

The principles of decorum also guided Hawksmoor in his choice of Gothic as the ornamental system. For as a style supposedly rooted in the early architecture of primitive Christianity, he appears to have seen it as especially appropriate to ecclesiastical and semi-ecclesiastical architecture (such as colleges), rather than, say, country houses (a building type of which he was certainly experienced). Castle Howard is not, despite its name, an obviously Gothic-style building – that is, with 'Something of the Castle Air' as Vanbrugh put it concerning his proposals at Kimbolton – while in contrast, at All Souls Hawksmoor's drawing for a Gothic west gate is labelled 'after yᵉ Monastick Maner' (Fig. 109).[63] Indeed in his letter to Dean Wilcocks of 1734/5, it was noted that he described Gothic – both the 'Ancient', or semi-circular, and the 'Modern', or pointed – as the 'Monastic style'.[64] This expression seems to have been coined to convey the style's

109 Hawksmoor's drawing for a Gothic west gate to All Souls, Oxford, 1720 [Worcester College, Oxford].

'explanation' of his designs sent to Clarke in 1715, he notes

> I must ask leave to say something in favour of y^e Old quadrangle, built by your most Revd. founder for although it may have some faults yet it is not without its virtues . . . and I am confident that much convenience and beauty may be added to it, whereas utterly destroying or barbarously altering or mangling it wou'd be using y^e founder cruelly, and a Loss to y^e present possessours . . . [67]

These sentiments again echoed those of Wren, who had justified his 'Gothic' Tom Tower at Christ Church in Oxford (see Fig. 85) in a letter of 1681 by noting that 'I resolved it ought to be gothic to agree with the Founders worke'.[68] Thus both architects considered that Gothic was not merely a visual style but, at least in the context of an Oxford college, symbolized the ancient virtues of a building's foundation. Hawksmoor's letter to Clarke also demonstrates that, certainly in the case of All Souls, he considered all new work should, as a basic objective, provide a decorous 'match' to existing work. Nevertheless, Hawksmoor's experiments with alternative, *all'antica* designs for elements at All Souls (such as the west gate) indicate that he entertained the possibility, in certain instances, of achieving this match in mood through using a different style. After all, rather than merely 'Coppy' an ancient design, of whatever style, new work should 'be upon y^e Same principalls', and it was noted in the previous chapter that his description of Gothic work emphasized its underlying compatibility with the classical.

The idea that the choice of style and level of decoration should respond to circumstantial qualities such as setting, function, or patron's character, was thus clearly applied by Hawksmoor at Castle Howard and Oxford – and, as will be demonstrated throughout the second part of this book, in other instances also. In fact Hawksmoor can be seen to have drawn on the principles of decorum in his very first work, independent of Wren. Take the early design of the Writing School at Christ's Hospital in London (now demolished), where he seems to have had a certain freedom from Wren (see Fig. 105).[69] Although still executed through Wren, and under his name, this project was designed and built by Hawksmoor between 1692 and 1695. It had an astylar façade comprising an arcade, a central niche and a broken-based pediment possibly deriving from Palladio's Villa Pogliana.[70] Order is here achieved not through columns and pilasters but through qualities of symmetry and a minimum of ornament, perfectly appropriate, perhaps, to a humble schoolhouse with no neighbouring style to relate to. His later design for

associative, rather than its formal, qualities – an understanding of Hawksmoor's conception of style which will be further examined in Chapter 5. As if to emphasize this association, he proudly related to the Dean that he 'built that noble Tower of St Michaels Cornhill' and 'Repair'd the Minster at Beverly, a fine old Monastick Fabrick', using this style.

In subsequent books (to his fourth) Serlio had linked the selection of ornamental style to a building's physical circumstances, as will be seen in some detail in Chapter 7, and based on these circumstances he indicated when and where licentious ornament was acceptable. Hawksmoor's reference to 'our Rurall, Sylvan, Situation' at Castle Howard and his defence to Dean Wilcocks that his Abbey towers were, despite criticisms, 'conformable and pursuant to the old' indicate that physical context also played a significant part in determining the style of his buildings. Using contextualism as his argument, Wren had advised in 1713 that to add classical details in the repair of the Abbey would only lead to 'a disagreeable Mixture, which no Person of a good Taste could relish'. The intention here was 'to make the Whole of a Piece', even though the classical had the greatest beauty based on the natural causes.[65] Equally, when Vanbrugh wrote to the Earl of Manchester on 18 July 1707 proposing a crenellated façade for Kimbolton, he added with a nod to the principles of decorum and dramatic effect that, 'to have built a Front with Pillasters, and what the Orders require cou'd never have been born with the Rest of the Castle: I'm sure this will make a very Noble and Masculine Shew'.[66] Hawksmoor's own Gothic ranges for the north quadrangle of All Souls (from 1716) were consciously designed in response to the style of the fifteenth-century chapel (see Figs 30, 317). In his

110 North end loggia in the courtyard of the Queen Anne Building, Greenwich Hospital, 1716–17.

111 and 112 Conduit head and the Standard Reservoir of 1710–11 in Greenwich Park, erected under Hawksmoor's supervision.

the Kensington Charity School, built in 1711–12 (also demolished), once again had an astylar brick façade whose order was implied by simple stone string courses, keystones and a broken-based pediment this time on a tower (see Fig. 106). In these designs the *all'antica* system is reduced to a show of what Downes calls a 'utilitarian plainness',[71] which is reliant, in the absence of columns, on subsidiary parts – string courses and pillars – to make ornamental distinctions of storeys and roofs. Similar astylar façades were designed elsewhere by Hawksmoor, notably for St James's Palace Stable Yard (see Fig. 4) and for the end loggias in the courtyard to the Queen Anne Building at Greenwich (apart from internal details, his only documented designs to be built at the Hospital) (Fig. 110), both of

1716–17.[72] Even though these buildings are of a higher status than the schoolhouses, here the astylar character is perfectly appropriate to the function as 'backs' or service quarters. Elsewhere at Greenwich, actual utilitarian features such as conduit heads erected under Hawksmoor's supervision are, appropriately enough, made to resemble Roman engineering works with their brick arches and piers (Figs 111, 112).[73] The sophistication of Hawksmoor's early designs, in using a minimal ornamental vocabulary at a stage when it would be tempting for any young architect to use the Orders, can be seen as a sign of his early awareness of the formalities of architectural decorum.

★ ★ ★

'WHAT I HAVE SENT YOU IS
AUTHENTIC . . . HISTORICALL AND
GOOD ARCHITECTURE': ARCHETYPES
AND MODELS

Although it would have been impossible for
Hawksmoor to escape the priority given by Wren to
natural beauty, the efficacy of regular, geometric figures
seems to have concerned him less than it had Wren. It
has been seen that rather than the dogmatic appearance
of geometric uniformity (Wren's 'Harmony of Objects,
begetting Pleasure by the Eye'), contrasts in ornament
and form in single bodies were compositional qualities
frequently admired by Hawksmoor.[74] And whereas
Wren held that in architecture 'the only Thing unca-
pable of Modes and Fashions in its Principals' was the
column, on certain unprecedented forms (particularly
the church towers) Hawksmoor evidently felt at liberty
to adapt their canonic forms and even to invent a variety
of novel capital types, no doubt in the spirit of 'Good
Fancy' (see Figs 66–7, 239–41). This was despite Wren's
warning that 'An Architect ought to be jealous of
Novelties, in which Fancy blinds the Judgment'.[75]
Indeed Hawksmoor's pronouncements on his work –
most notably on Castle Howard where there is the
clearest record of his 'architectonricall method' in
practice – fail to mention geometry as a source of
beauty. Wren's preference for the expression of architec-
tural beauty based on universal, geometric qualities was
replaced, at least in Hawksmoor's statements on matters
of architectural principle, by the need to represent
more relativistic qualities concerning the character of a
building's location, together with that of its patron and
its function.

Part Two of this book will outline how these cir-
cumstantial factors determined not only the selection
but also the variation of canonic forms and models –
historical, geometrical and ornamental – from which a
particular Hawksmoor building was to be composed.
This distinction between the visual priorities of master
and pupil can be illustrated by a comparison, say, of
Hawksmoor's churches, with their eclectic ornament
and unusual assemblage of tower forms, and Wren's St
Paul's, with its geometric regularity and (for the most
part) canonic ornamentation. The undeniable range in
mood of Hawksmoor's churches – despite their being
built for the same patron and at more or less the same
time – testifies to his disbelief in the efficacy of one,
absolute criterion of beauty. This range, from sombre to
triumphant, suggests that for him the empathetic
and symbolic nature of certain ornamental forms,
defined by custom and memory, carried more weight
in the manipulation of the observer's senses and mood

than did the use of geometry or canonic proportions
to give, as Wren put it, 'Pleasure by the Eye'. Moreover
Hawksmoor's use of distorted and monstrous forms
– such as the demon faces on the urns at St Bride
(see Fig. 34) – indicates that, in the tradition of the
grotesque, he was interested in a range of emotions and
'effects' evoked by ornament, not just 'pleasure'.

Instead of emphasizing geometry as a source of
beauty in his letters to Carlisle, it was noted that
Hawksmoor stressed the importance of visual effect
and, as a symbolic imperative, a use of the antique
Orders appropriate to their individual characters. He
also emphasized the fitting yet imaginative use of a
wide range of historical models that, although custo-
mized, remain recognizable. Hawksmoor's comments to
Carlisle of 10 November 1727, on three alternatives for
the Mausoleum, encapsulate his design priorities: 'What
I have sent you is Authentic and what is According
to the practice of yᵉ antients. / and what is Historicall
/ and good Architecture / Convenient, Lasting, Decent,
and Beautifull'.[76] These last four paraphrase Vitruvius's
time-honored *firmitatis* ('Lasting'), *utilitatis* ('Conve-
nient') and *venustatis* ('Decent and Beautiful') outlined
following the discussion of architectural decorum in
the opening book (I.iii.2). Indeed 'decent' architec-
ture would certainly be 'decorous' in nature. The way
to achieve this 'good Architecture', judging from the
preceding part of the quote, is to be true to 'what is
Historicall'. Hawksmoor's use of historical models and
forms, on the Mausoleum and elsewhere, seems to be
the key to understanding what he saw as making his
architecture 'authentic' and timeless, in avoiding what
he later defined as 'the many Caprices of the World'.[77]
He would have seen the inspirational role of antique
ornamental and typological models – not least the
five canonic Orders – outlined in the treatises, and
especially in Serlio's third book with its woodcuts
cataloguing the different 'types' of antique architecture.
As Chapter 2 noted, to this classical repertoire had
been added more recently discovered 'Wonders' which
Hawksmoor also studied and to which contemporaries
such as William Stukeley referred in seeking to account
for his buildings – in Stukeley's case to explain the
source for the giant portico in Bloomsbury.

The importance of historical models to Hawksmoor
– not as an antiquarian but as a designer of buildings
– is perhaps at its clearest in the cases where he was
compelled, through lack of physical remains, to offer his
own speculative reconstructions of legendary buildings,
based on oral and literary sources, which were then
adapted in his work. This process has been seen to be
the case with his reconstructions of the Baalbek temple
and the Halicarnassus mausoleum, as with his lost draw-

ings of the tomb of Porsenna and his reconstruction of the primitive Christian 'basilica'. As the next chapter will show, this was also true of his notes and plan of the gate to Solomon's Temple. Indeed the practical role of his idealized 'basilica' plan and, more generally, the importance of archetypal models, are confirmed by the minutes of the Commission charged with building the London churches. For the meeting on 16 July 1712, in drawing up the principles Hawksmoor was to be required to follow, resolved 'that one general design, or Forme ['Modell' crossed out], be agreed upon for all the fifty new intended Churches'.[78] Concerning the practical nature of such ideal models, the meeting's chairman, Rev. George Smalridge, observed in a sermon that 'an able and skillful artist, before he undertakes any curious work . . . doth in the first place form in his mind a model of what he intends, according to which he shapes his work, and gives it all its proper dimensions and proportions'.[79] Not surprisingly, perhaps, here he echoed his surveyor Nicholas Hawksmoor's design method of archetypal selection and adaptation perfectly.

Guiding the identification of what was 'Historicall' and 'Authentic' in any given design was Hawksmoor's, and his patron's, understanding of the original or common, indeed customary, use of particular models 'According to the practice of ye antients'. For as might be expected, ancient models were not chosen at random. Their 'correct' use in contemporary designs obviously served to confirm Hawksmoor's scholarship and professionalism in the face of what he considered the amateur or 'virtuosi'. According to his obituary he was, after all, 'Perfectly skill'd in the History of Architecture', and this knowledge must have helped him to determine which model to use where. It was noted that Hawksmoor echoed the etymological developments in the natural sciences in classifying Gothic into historical periods and by thinking in terms of column 'species'.[80] Dividing buildings into 'types' – or the 'nature of fabrick' as he puts it concerning mausoleum precedents[81] – was equally common: John Evelyn was quoted in Chapter 1 calling for schools of architecture to teach '*Types* and *Modells* of the most excellent Fabricks'.[82] It follows that Hawksmoor considered that the 'type' or 'species' of a particular design – its unique character as a mausoleum, theatre, church, college – was expressed by the appropriate use and adaptation not only of ornament, following the principles of decorum, but of historical models as well.

Despite the apparent difference in priorities between master and pupil, Hawksmoor's adaptation of specific historical models clearly followed Wren, as has already been seen with the use of various models common to

the work of both in the design of St Paul's. Perhaps most literally, recognizable behind Wren's designs for the Sheldonian Theatre in Oxford and Pembroke College chapel in Cambridge (to take but two examples) are, respectively, the Roman 'types' of theatre and temple (possibly both taken from Serlio).[83] However, unlike Hawksmoor, Wren in his use of ancient precedent 'did not hesitate to disregard or manipulate it without regard to the meaning or formal integrity of the original source', according to Lydia Soo.[84] This would be compatible with his distrust of custom. Famously in the case of the centralized Great Model design for St Paul's, abstract ideals of natural beauty based on geometric regularity were preferred to customary associations between form and religious symbolism, in this case ones latent in the traditional model of a Latin cross. Whereas for Wren the appropriateness of this or that model, established by its original meaning and customary usage, had given way to the expression through geometric forms of universal, natural laws, for Hawksmoor the former aspects remained a priority. This may account for his use of a far more eclectic range of historical models and ornamental forms than Wren, and his greater willingness to invent new forms based on them.

The most revealing example of Hawksmoor's concern with the 'correct' models relates to Carlisle's initial suggestion to use a Greek temple-form for his Mausoleum, which Hawksmoor answered in his letter of 3 September 1726.[85] Informing Carlisle that the designs of ancient mausoleums 'are published in ye Books of Antiquity, that your Lordship may see at pleasure', Hawksmoor called on his knowledge of the actual uses of ancient temples in Greece and of mausoleums in Greece and Rome, built, appropriately enough, 'to ye Memory of illustrious persons'. While the Greeks had 'Magnificent piles for Sepulture', he warns that they never 'built their tombs in the form of any temple dedicated to divine honours'. He continues: 'I therefore humbly Advise that we may take the form of one of ye Greek or Latin Examples, for such a Structure as your Lordship speaks of', adding that 'I know your Lord'p is not Supestitious' (presumably with regard to modelling the new Mausoleum on an ancient pagan tomb). As has been seen, he goes on to offer the Halicarnassus tomb as a suitable 'Greek' model and that of Porsenna as an Italian one. He observes that the 'manner, and form, of either of these fabricks, may be imitated, in Little, as well as at great Expence, and I will draw up a Scheme for your Lordship accordingly'. Here at least the authenticity of the new building's symbolic meaning – especially one whose primary purpose was commemorative – appears to be largely dependent on

113 Andrea Palladio's Villa Rotunda, near Vicenza.

114 Andrea Palladio's fanciful reconstruction of the Temple of Fortuna Primigenia at Praeneste (Palestrina) [R.I.B.A., London].

its imitating, whenever possible, an appropriate antique prototype. Hawksmoor makes clear in the letter that this approach to the use of models defines what he suggestively calls his 'architectonricall method' – a method further demonstrated in a letter to Carlisle of October 1732 justifying the intercolumniation of the Mausoleum colonnade with reference to various antique examples.[86]

Hawksmoor implies that to use a Greek temple-form for the Mausoleum numbered among the kind of 'evill Custom, and pernicious practice', as he puts it in this letter, which he and Wren opposed. This reference may have been a further, ironic dig at the Palladians given their supposed cultivation of antique 'correctness'. For Palladio had famously adapted the antique temple portico to secular buildings following a belief that the portico had been used on the ancient house, as illustrated by him in Barbaro's *Vitruvius* and his own *Quattro Libri* (see Figs 305a,b). The most notable expression of this view is his Villa Rotunda, whose four porticoes recall his fanciful reconstruction of the Temple of Fortuna Primigenia at Praeneste (Figs 113, 114). Palladio's four-porticoed designs – and, appropriately enough, very possibly his temple at Praeneste – formed the model for Vanbrugh's 'Temple to the Four Winds' at Castle Howard[87] (which Hawksmoor mentions at the start of his letter on the antique models for the Mausoleum – being careful to describe Vanbrugh's porticoed design as 'the Temple'; see Fig. 18). Following Palladio's lead, Hawksmoor's own use of the portico on secular designs – at Oxford and Ockham Park for example – can also be seen to have been sanctioned by the ancient

house which he would have seen in his copies of Vitruvius and Palladio.[88] These designs emphasize the entrance portico, however, following the ancient house model and unlike Palladio's four-sided adaptations.[89] The Clarendon Building (conceived of as a kind of 'temple' to the muses)[90] has free-standing columns to the front and pilasters to the rear, to make a distinction between public and private (see Figs 274–5). And on drawings for Ockham the front portico is labelled 'Principall Portico', indicating its distinction from the inset ones to the side (Fig. 115).[91] The fact that Hawksmoor had studied, and in some way disapproved of, Palladio's 'temple' villas is evident from his later boast to Carlisle that Castle Howard 'claims more Regard, than one of Palladios humble Villas in yᵉ Vicentine, or Veronese'. In these appeals for the use of appropriate models and scale, Hawksmoor again echoes the time-honored Vitruvian and Aristotelian ideals of decorum and magnificence that he evidently saw the domestic designs of Palladio, and of his eighteenth-century followers, as having transgressed. This is further implied

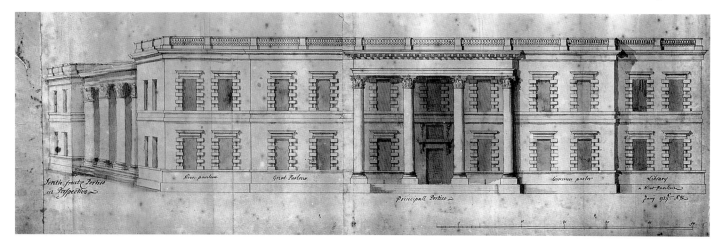

115 Hawksmoor's scheme for Ockham Park, Surrey, 1727 [Canadian Center for Architecture, Montreal].

in his observation to the Dean of Westminster that 'I am certain our famous pretenders have not been long from Building Country Cottages, who are now Great Artists, preferred in great posts in their way'.[92]

As Chapter 2 outlined, in examining Hawksmoor's work it becomes clear that the preferred model need not be antique: it might be by a Renaissance master or a more exotic one only recently illustrated (such as Hagia Sophia which possibly influenced the galleried section of the London churches). Moreover forms from different models were quite often combined in one work, as with the Carrmire Gate which mixes the Rustic motifs of Serlio's gates with the pyramids of Porsenna's tomb – a reminder of the funerary imagery which was ever present in Hawksmoor's work (see Figs 51, 70). One model might guide the plan while another the form: in the case of the churches, his primitive Christian 'basilica' lies behind their plans while a variety of antique memorial forms shape their towers.[93] In a number of cases Hawksmoor reveals his models. His annotations on façade designs for Worcester College record that various details were based on a range of Imperial Roman and Renaissance buildings (Fig. 116; and see Figs 197, 228).[94] He relates in a letter that his first Belvedere design at Castle Howard (1723; see Fig. 16), proposed in place of Vanbrugh's 'Temple', was based in its form on Vignola's church of Sant' Andrea on the Flaminian Way outside Rome, and was further justified on the drawing as 'After yᵉ antique' with particular reference to 'Herodotus, Pliny, and M:Varo'.[95] Given the Belvedere's purpose for drinking and reading, annotated on the drawing, this citation probably drew from Bernard de Montfaucon's *L'antiquité expliquée* (1719) with, as Downes points out, its matching references to Herodotus and to 'a singular parlour for eating' belonging to Varro.[96] The second,

circular 'temple' seems to have been developed from a study of the east gatehouse of the archetypal temple, that of Solomon, which accompanies the scheme and is examined in the next chapter.

In practice Hawksmoor inevitably adapted models to satisfy contemporary requirements of utility (or

116 Hawksmoor's annotated details of cornices and other mouldings for Worcester College, Oxford, c. 1717 [Worcester College, Oxford].

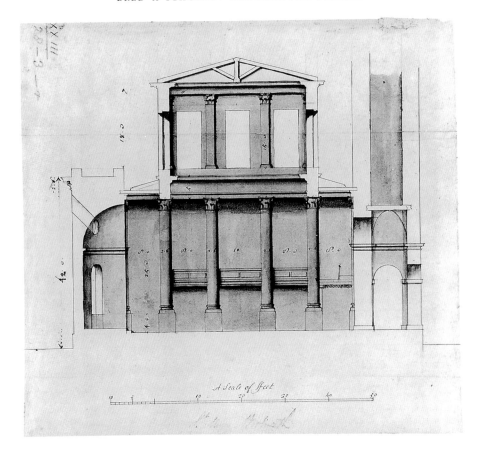

A Scale of feet

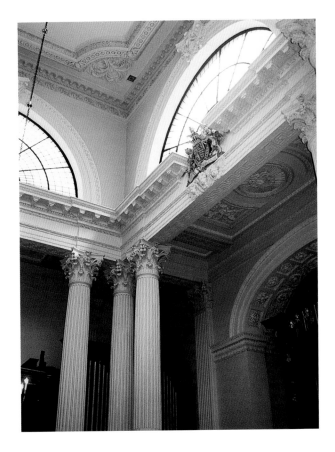

'commodity' as he puts it) defined by function and situation. Thus he refers in a letter to Carlisle of 3 June 1728 to sending a 'Drawing of the Mausoleum' as soon as he (and Carlisle's son, Lord Morpeth) 'can adjust it'. This adaptation is all too evident in the plans and forms of his churches, where for the most part the site restrictions inhibited the full realization of the ideal basilica plan. In some cases the model was transformed pretty much beyond recognition, as with St Mary Woolnoth, for example. Here the internal section was initially (in the 1716 design (Fig. 117)) based on the Vitruvian Egyptian Hall (an obvious antique model for an assembly hall, as he acknowledged at York).[97] The church as built, although still novel, groups the internal columns at the corners to create a more convenient centralized plan (Fig. 118). Hawksmoor's willingness to adapt not just ornament but historical models to express a particular aspect of his patron's character is shown, as but one example, by a design for the Blenheim obelisk (Fig. 119). Here the four river gods that had symbolized the continents of the known world on his model – the obelisk fountain in the Piazza Navona (which he sketched from copies)[98] – are limited to European rivers (Danube, Thames, Rhine and Seine) since Marlborough had not fought beyond the continent of Europe.[99]

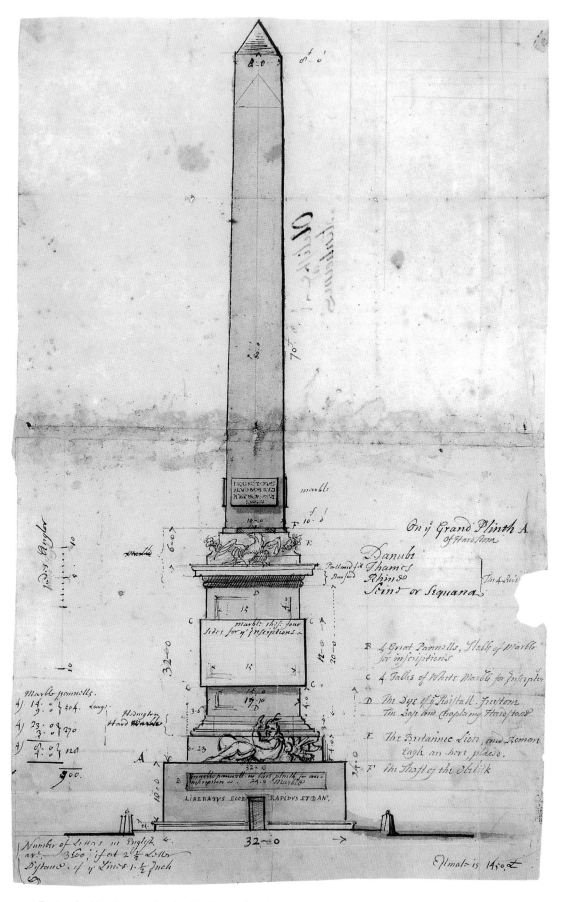

119 Design by Hawksmoor for the Blenheim obelisk, c. 1724 [Bodleian Library, Oxford].

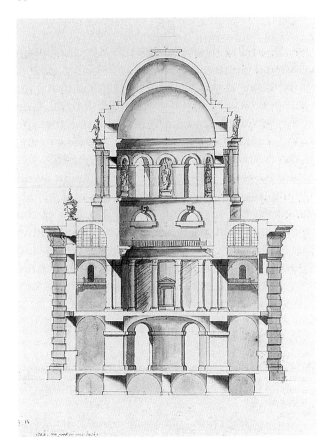
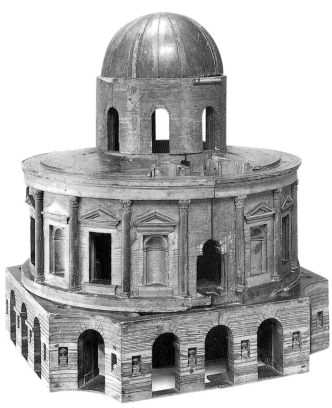

120 and 121 Two of Hawksmoor's alternative designs for the Radcliffe Library in Oxford, both with urns [Section of Project IV, c. 1712–13: Ashmolean Museum, Oxford. Model of Project VII, 1734 or 1735: Bodleian Library, Oxford].

Modern or even post-antique building types such as libraries, colleges and hospitals, and essentially Gothic elements such as steeples and lanterns, called for a flexible approach to the use of ancient models. In the case of Hawksmoor's rotunda schemes for the Radcliffe Library in Oxford – which were produced after some experiments with square forms – the library's symbolic role as a memorial to its founder seems to have validated Hawksmoor's adaptation, once again, of commemorative and mausoleum prototypes.[100] This understanding of the building is enhanced by the embellishment of some of the schemes with flaming urns symbolizing life after death (Figs 120, 121).[101] This prototype was not lost on contemporaries, for Thomas Salmon commented in 1748 on the rotunda as built by Gibbs that 'a great many People [are] of Opinion, that he [Radcliffe] intended to perpetuate his Memory by it; and therefore give it the Name of *Radcliff's Mausoleum*'.[102] The use of a rotunda scheme was at the obvious expense of practicality and in the absence of any free-standing, centralized library precedents. Even Hawksmoor's Gothic work on the great English cathedrals and at All Souls was validated with reference to appropriate historical prototypes, as his letters to his patrons make clear.[103] When it came to designing church and chapel lanterns, medieval in origin but now used as part of a basically 'classical' ensemble, Hawksmoor developed forms that were based, appropriately enough, on the octagonal Greek Tower of the Winds (a structure described by Vitruvius) (see Fig. 227).[104] The Greek tower provides the basic form which, in the case of his churches, is then embellished with square piers carrying unorthodox Doric 'triglyph' capitals. Antique elements are thus adapted to produce a simple 'effect' of masonry piers, appropriate to elements seen at a long distance. As Chapter 6 will demonstrate, for his steeples Hawksmoor chose triumphal columns, obelisks and tombs which were seen as appropriate to the memorial function of the spires. Here again, the most obvious example of this is the tower at Bloomsbury, where the pyramid form of the Halicarnassus mausoleum as described by Pliny becomes a spire commemorating George I, in supporting a statue of the king (see Fig. 72). Clearly of less importance to Hawksmoor in signifying this memorial meaning was the historically accurate location of a par-

ticular element – since tombs, obelisks, columns and
sacrificial altars crowning towers are not self-evidently
historically 'correct'.[105] Nevertheless, august precedents
certainly existed for Hawksmoor's strange spires. The
Halicarnassus mausoleum had been illustrated as a
tower structure in Cesariano's 1521 *Vitruvius*, for
example, while an obelisk rising from a fanciful pyram-
idal monument similar to the steeple-forms of St Luke,
Old Street, and St John, Horselydown, was illustrated
in Colonna's *Hypnerotomachia Poliphili* (1499; Fig. 122;
and see Figs 219, 220).[106] These were clearly fitting
models, given that the Halicarnassus mausoleum was
one of the 'Seven Wonders' of the ancient world that
Colonna describes his obelisk tower as rivalling.

Hawksmoor's design method might thus be summa-
rized as follows. Rather than start with a preference
for regular geometry, following Wren at St Paul's,
Hawksmoor appears to have first selected an archetypal
model or models that reflected, wherever possible, the
required symbolic and functional character of the build-
ing 'type' in question. He then 'adjusted' these models
during the design process, to fit the practical and sym-
bolic needs of the building, and sometimes changed
their ornamental style – perhaps up- or down-grading
the Order of column, perhaps transforming the
columns into a giant order or into licentious work, or
even choosing Gothic forms. The aim behind such
adaptations was to produce a form and style of orna-
ment which not only represented the building's or
patron's character, reflecting the principles of decorum,
but also where appropriate – such as on city sites – that
of its context. In this way canonic ornaments – that is,
the Orders – and antique and Renaissance archetypal
structures – the ancient house and mausoleum,
Solomon's Temple and Christian basilica – were adapted
in his work to suit relative qualities such as visual effect
and relationship to context.

Hawksmoor records his faith in the timeless rele-
vance of these archetypal monuments of architectural
history in his book on Greenwich. He notes that

> The great Men of the World heretofore, to perpet-
> uate their own Memories, and their great Actions,
> among other Things had recourse to the liberal Arts;
> particularly to that of Architecture; sometimes by
> erecting useful Structures for the Good and Benefit
> of Mankind, and sometimes for their Grandeur only.
> Such as the Pyramides, the Monumental Pillar of
> *Trajan*, the great Tomb of *Porsenna* King of *Tuscany*,
> and infinite others.[107]

Each great era thus had its own quintessential monu-
ment that reflected the glory of monarchy, just as
Hawksmoor saw himself as providing for his own era

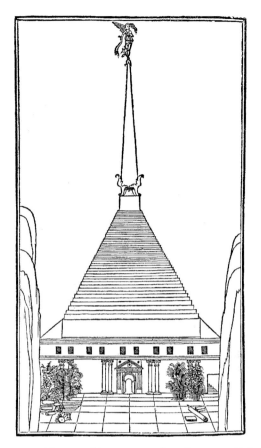

122 A fanciful pyramidal monument from Francesco Colonna's
Hypnerotomachia Poliphili (1499).

through his reference to historical models – for these
monuments 'long remain'd Historical to Posterity' and
'drew Crowds of Strangers to see them'. Indeed on the
benefit of these monuments as tourist attractions he
continues,

> we may instance *Rome* for Example, and many other
> Cities; for tho' there are many Devices to draw in
> Foreigners, yet their admirable and stupendous
> Buildings have no small Share in captivating the
> Attention of Strangers, to the great Advantage of the
> Inhabitants, and greatly owing to the Encouragement
> of Arts and Architecture, for their (so many) eminent
> Fabricks.

It follows that through using the same archetypal struc-
tures of architectural (and masonic) history in his work,
as adaptable models, Hawksmoor intended to establish
and 'authenticate' his buildings as equivalent national
architectural 'Wonders' of the modern era. There was
surely no clearer emblem of this intention than his
'Halicarnassus' steeple at Bloomsbury. Indeed he con-
tinues that if Wren's plan for London had been realized
'The City would then have been built in such a

Manner, as to have stood foremost at this Day amongst the Wonders of the World'. Greenwich Hospital, about whose completion these remarks were directed, was clearly also conceived by Hawksmoor as one such modern 'Wonder'. Furthermore as the Bloomsbury steeple again makes clear, he saw the royal authority of his own day as 'authentically' represented by the pyramid, column, mausoleum and arch, given their historical role as archetypes of monarchal, sometimes absolutist, power. His championing of this authority was in line with his admiration for the regulating architecture of Louis XIV, made equally clear in this explanation of his Greenwich work.[108]

Encouraged by the sombre mood of the Stepney churches, popular wisdom has presented Hawksmoor's concerns as less rational, or more fanciful, than those of Wren. It has been seen that when commenting on Vanbrugh's design for the Belvedere 'Temple' at Castle Howard, Hawksmoor paired 'Strong Reason' with what he termed 'Good Fancy' as twin aids to the architect's judgement. Both were to be 'joyn'd with experience and tryalls, so that we are assured of y^e good effect of it'.[109] Evidently he did not feel the need to echo Wren's warning that architects 'ought to be jealous of Novelties, in which Fancy blinds the Judgment'.

But, as Hawksmoor was often at pains to point out, he was not irrational or capricious. 'Good Fancy', in reflecting Hobbes's materialist philosophy, emphasized the role of the disciplined imagination in adapting universal models to particular circumstances ('good' here meaning informed). Not surprisingly Hawksmoor identified a similar application of reason, imagination and empirical testing in the designs of antiquity, and in what he called 'the Rules of the Ancients'. This was seen as a timeless combination, one that ensured the durability of his vision for, as was noted, 'if we contrive or invent otherways, we doe but dress things in Masquerade which only pleases the Idle part of mankind, for a Short Time'. He saw his design method as proceeding in a reasoned or logical manner. For 'architectonricall method, and good Reason' was to be used to adapt Euclidean and ornamental forms to create, through trial and error, a range of 'effects' which appealed to the senses, and to adapt historical models which, through the power of memory, appealed to the intellect. The forthcoming chapters will therefore be concerned with retracing not only the historical models used by Hawksmoor in a particular design but also his motives for their adaptation in a given situation.

Chapter 4

'AUTHENTIC . . . AND GOOD ARCHITECTURE': FREEMASONRY AND HAWKSMOOR'S STUDY OF SOLOMON'S TEMPLE

HAWKSMOOR LIVED IN AN AGE that actively sought to reconcile aspects of faith and science, when many applied biblical archetypes – the Garden, the Ark, the Tower and the Temple – as models for the reform of traditional practices and for the foundation of new institutions.[1] This relationship famously existed between Athanasius Kircher's rationalistic studies of the Ark of Noah and the Tower of Babel and his establishment in Rome of a museum of the known world, the Kircherianum, as also between Solomon's 'House of Wisdom' and the foundation in London of the Royal Society.[2] The biblical archetypes became rationalized through this process, with Kircher and Wren concentrating on their physical properties and the technical requirements of their construction.[3] In also relying on historical models and archetypes – notably the pagan tomb, the Christian basilica and the ancient house – to 'authenticate' his projects, Hawksmoor was particularly interested in reconstructing the plan of Solomon's Temple, perhaps the greatest of the physical structures recorded in the Bible.

'ESTEEMD 'EM PROPHANE': HAWKSMOOR AND THE PAGAN ORDERS

Hawksmoor's need to 'authenticate' his designs, often through utilizing pagan architectural models and archetypes, together with his interest in matters of Church history and liturgy, led him to follow the Renaissance theorists in questioning the origins and validity in the Christian building tradition of the Orders. His letter to the Dean of Westminster praising the Gothic work at the Abbey makes clear his awareness of the traditional problem concerning the pagan origins of the Orders, and of the antique buildings which they ornamented. He points out that during the first period of Christianity, Roman temples of a suitable size were either demolished or the early Christians 'then esteemd 'em prophane'. The Orders were not part of the building practices of these early Christians, for 'they cou'd not or wou'd not, go to the expence at that time, To build in the Antient way'.[4] Successive early English architectural theorists (first Dee and Shute under Elizabeth I and then Wotton under James I) had sought to overcome this stain of pagan ancestry by 'Christianizing' the columns and by describing their meaning in terms acceptable to Protestant tastes and moral values.[5] Both Joseph Moxon (in his 1655 edition of Vignola) and Balthazar Gerbier (in his 1664 Vitruvian 'discourse') sought divine authorship for the rules of the Orders through reference to Solomon's Temple. The most notable continental attempt at this was by Villalpando, whose sixteenth-century published reconstructions of the Temple of Solomon as an *all'antica* building with Corinthian pilasters on its façades achieved wide-spread fame (Figs 123, 124).[6] Hawksmoor would have seen Villalpando's proposition concerning the Solomonic Corinthian Order illustrated in what was noted were his much consulted copies of Evelyn's translation of Fréart (lots 89 and 108). Villalpando's images inspired Wenceslaus Hollar's views of the Temple of around 1660, which Du Prey speculates were among Hawksmoor's large collection of Hollar engravings, and also inspired a large wooden model of the Temple by Johann Jakob Erasmus exhibited in Britain before 1720 which Hawksmoor may well have seen.[7]

Of course Hawksmoor would also have been aware of Wren's dismissal, on chronological grounds, of Villalpando's claims for a Solomonic Corinthian Order as 'a fine romantick Piece' and 'mere Fancy'; for the Corinthian 'in that Age, was not used by any; for the early Ages used much grosser Pillars than the *Dorick*'.[8] Since according to Wren the Temple was built using the simple timber 'Tyrian' Order, and the Tyrian was a prototype of the Greek Orders, his history gave the columns a divine origin. It was for this reason that

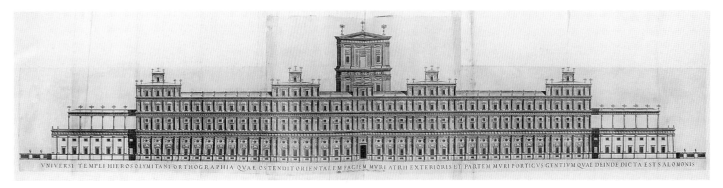

123 and 124 (*below*) Reconstruction and plan of the Temple of Solomon, from Juan Bautista Villalpando's *In Ezechielem Explanationes et Apparatus Urbis ac Templi Hierosolymitani* (1596–1604).

Wren credited the Orders in the opening Tract as 'the only Thing uncapable of Modes and Fashions' in architecture.[9] Their eternal validity was due to the fact that their canonic forms were, he continues, 'founded upon the Experience of all Ages, promoted by the vast Treasures of all the great Monarchs, and Skill of the greatest Artists and Geometricians, every one emulating each other'. Thus there still could be no more powerful union than that of the laws of nature, the

experience of the greatest ancient civilizations, and the truth of Scripture. Hawksmoor's interest in the canonic Orders as 'true species' and his use of these and simplified column forms on his London churches indicate that, despite his awareness of their problematic origins, he too accepted the Orders as valid Christian iconography. Indeed his conception of *all'antica* architecture as expressive of antique moral virtues and civil decorum – noting to the Dean of Westminster that 'the Greeks and Romans calld every Nation Barbarous, that, were not in their way of Police and Education'[10] – necessarily legitimized his use of Roman (pagan) models. This lack of superstition concerning pagan models was seen reflected in his letters to Carlisle concerning the appropriate antique precedent for his Mausoleum.

Hawksmoor may well have been helped in his acceptance of the Orders and of other pagan forms by the beliefs of the biblical scholar and architect Henry Aldrich. Like Villalpando and Wren, Aldrich maintained that the columns had been used on the Temple of Solomon, studies of which were presented in his *Elementorum Architecturae Civilis* printed in limited numbers in Oxford around 1708.[11] Aldrich had formidable credentials, with his publications including commentaries on the ancient Roman Jewish historian Flavius Josephus.[12] Hawksmoor and Aldrich certainly knew each other, and perhaps first met through the fact that Aldrich was a friend of Hawksmoor's Oxford patron, Dr George Clarke. Hawksmoor even provided a tower design completing Aldrich's All Saints church in Oxford (Aldrich's Corinthian pilasters presumably drawing their validity from the Solomonic originals illustrated in his study) (Figs 125, 221–6). Indeed the plan of Aldrich's church is inked-in on Hawksmoor's masterplan for Oxford in such a way as to suggest its integral role in his scheme (see Fig. 276).[13] Moreover Hawksmoor had followed other works by Aldrich: the Dean's illustrations of the temple at Baalbek for his 1703

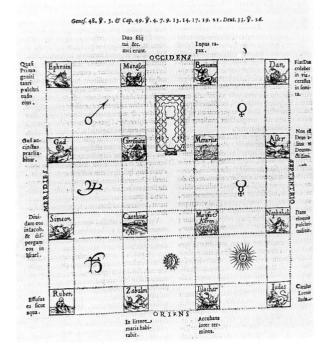

EORVNDEM
CASTRORVM
DISPOSITIO, MVNDVM
referens, & Templum.

Oxford edition of Maundrell's *Journey* set the tone for Hawksmoor's own plates of the same, discussed in Chapter 2. Aldrich's study of the Orders used on Solomon's Temple was published at Oxford at the same time as Hawksmoor's early work at All Souls, and so he cannot have failed to have seen a copy of the work – not least because his patron, Clarke, had been presented with one.[14] Along with imaginative views such as Hollar's, it may also have helped stimulate his own study of the Temple, examined next.

HAWKSMOOR'S STUDY OF SOLOMON'S TEMPLE AND THE BELVEDERE 'TEMPLE' AT CASTLE HOWARD

Hawksmoor's interest in drawing on antique and biblical archetypes as a means to 'authenticate' his work can also be seen to lie behind his own overlooked study of the ultimate 'authentic' model, Solomon's Temple – or more precisely of a gateway to the Temple. For in common with contemporary theologians such as Aldrich and more esoteric groups such as speculative freemasons, who cultivated Solomon as their patron, Hawksmoor closely studied the description in Ezekiel of the east gate and inner court of the original Temple. Wren had set the challenge of reconstructing the plan of the Temple in Tract IV (repeated in Tract V) by noting, 'What the Architecture was that *Solomon* used, we know but little of, though holy Writ hath given us the general Dimensions of the Temple, by which we may, in some measure, collect the Plan, but not of all the Courts'.[15] In the 'Discourse' (Tract V) he follows I Kings (6:21–2), 2 Chronicles (3:5–7) and Josephus in noting that 'The Body of the first Temple was gilt upon Bitumen, which is good Size for gilding and will preserve the timber. The Roof, and Cedar Wainscot within being carv'd with Knotts was gilded all over with a thick leaf'. He adds that 'The Doors might be plated over and naild, and the Hinges and Bars, call'd *Chains*, might be solid for these were afterwards stripp'd when the Egyptians pillaged the Temple in the Reign of Rehoboam'. In arguing for a Solomonic Tyrian Order, Wren speculated on the form of the pillars to the Gate of the Gentiles leading into the later Temple standing at the time of Christ. He observes that 'Herod built the *Atrium Gentium* . . . a Triple Portico [with] thick Pillars of the groser Proportions . . . being whole stones of an incredible Bulk'.[16] This refers to the legend of the 'Beautiful Gate' and its famous twisting columns.[17] Hawksmoor uses two such twisting columns to frame the altar in St Mary Woolnoth, taking as his model

125 Henry Aldrich's All Saints church in Oxford, tower built adapting Hawksmoor's design (see Figs 225, 226).

Bernini's famous baldacchino in St Peter's (his collection of prints included those of the inside of St Peter's; lot 108) (Fig. 126). And he was paid £5 for drawing a twisted column of the Corinthian Order to serve as the model for those in the wooden altarpiece at St John's, Smith Square.[18] The Solomonic origin of this column form was well known in Hawksmoor's day, since columns of this type had been depicted by Raphael in his 1515 cartoon of Christ in the Temple entitled *The Healing of the Lame Man* (Fig. 127). This, along with the other six cartoons, had been purchased by Charles I and housed in a new gallery at Hampton Court

126 Twisting columns framing the altar in St Mary Woolnoth.

prepared by Wren. Perhaps copies of these were what Hawksmoor's sale catalogue lists as 'The Cartoons of Raphael, 8 prints' and 'A sett of Raphael's Cartoons' (lots 133 and 252). Clarke also had copies and Sir James Thornhill made full-size versions.[19] As Hawksmoor would certainly have seen, twisting columns based on these cartoons feature in the painting by Rubens representing James I as Solomon on the Banqueting House ceiling (Fig. 128).

As with Hawksmoor's reconstructions of the Halicarnassus and Porsenna tombs, his interest in the original and later Solomonic temples was thus probably first stimulated by Wren's (and Hooke's) Royal

127 Raphael's cartoon of Christ in the Temple entitled *The Healing of the Lame Man*, 1515, distemper on paper, 342 × 536 cm [Victoria and Albert Museum, London].

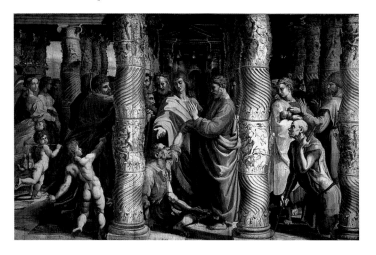

Society studies.[20] The copy of the Society's *Transactions* in Hawksmoor's library (lot 35) records a report on, and illustration of, the ruined city of Tadmar (Palmyra or Thadamora) which identifies the remains with Solomon's desert city as recorded in both Josephus and the Bible (1 Kings 9:19 and 2 Chronicles 8:4).[21] However the probable date of late 1723 for Hawksmoor's notes and sketch of the Temple gate – the same year as Wren's death – makes it highly likely that the study was his work alone. It is consistent with his earlier interest in primitive Christianity and, as will be seen, the growing influence of freemasonry. Perhaps consulting his modern French folio Bible (lot 100),

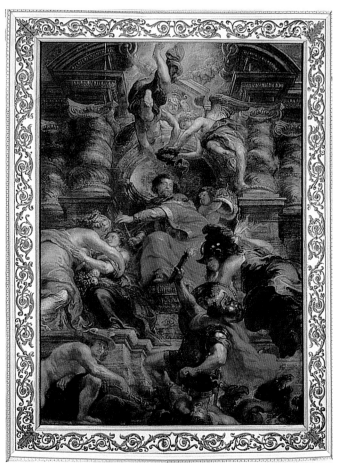

128 Rubens's painting of James I as Solomon between twisting columns, 1634, on the Banqueting House ceiling, London.

Hawksmoor made detailed notes from Ezekiel (40:5–19) on the reverse of his preliminary plan for a circular Belvedere as an alternative to Vanbrugh's 'Temple' at Castle Howard, notes now held in the British Library (Figs 129a,b).[22] This plan was drawn some time near the end of 1723, judging from an inscription on the

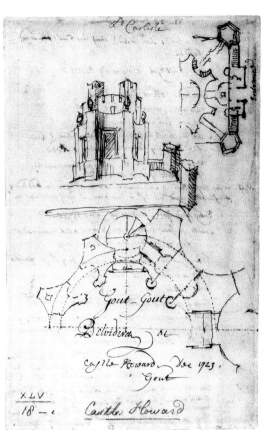

129 a and b Hawksmoor's detailed notes from Ezekiel on the reverse of a preliminary plan for a circular Belvedere at Castle Howard, 1723 [British Library, London].

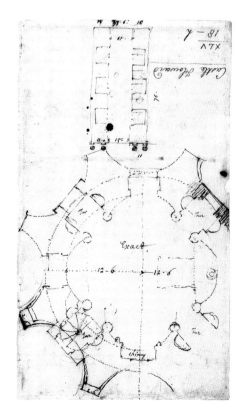

130 (*far left*) A companion sheet to Fig. 129, with a sketch of a rectangular layout that matches the notes from Ezekiel, 1723 [British Library, London].

131 Hawksmoor's sketch of the siting of his Belvedere at Castle Howard, 1723 [British Library, London].

alternative, square Belvedere proposal ('MDCCXXIII') and from Hawksmoor's letter of January 1724 sent with the presentation designs (and still at Castle Howard).[23] Indeed on a companion sheet, above a further sketch of the plan of the circular Belvedere, there is a sketch, to a much smaller scale, of a rectangular layout that matches these notes from Ezekiel (Fig. 130).[24] For example, where Ezekiel records 'And the lodges of the gate eastward were three on this side, and three on that side; they three were of one measure', Hawksmoor repeats 'N.B. in this East Gate, ye Little chambers were in No 3 on this hand and 3 on ye other hand all sqd in dimension – and ye parts were ='. The plan shows these three square chambers either side of the passageway. Again copying Ezekiel, Hawksmoor notes that 'The mesure from ye Roof of 1 Little Chamb to ye Roofe of another was in breadth 25 cub door agt Door'. Various dimensions are also recorded on this plan, which appear to convert the cubit dimensions of the notes into English feet. If a cubit is taken to equal one and a half feet, the 25 cubit width would agree with the '37.6' (feet) on the plan, annotated above the rear entrance. The passageway is '15' (feet) wide (which, following Ezekiel, Hawksmoor's notes have as 10 cubits), with an additional '11' (feet) either side of what appears to be the main door (with its paired columns) and '10' (feet) either side of the rear entrance. Indeed again copying Ezekiel the notes record 'From ye face of ye entrance, unto ye inward face – was 50 cub' and the front to back dimension is annotated as '75' (feet).

As was noted, below this plan Hawksmoor has sketched the plan of his Belvedere. The proximity of both plans and the conversion of biblical cubits into English feet might reasonably suggest that Hawksmoor had the gate of the biblical Temple in mind when designing his own 'temple' at Castle Howard. Although circular and recalling in external form the Temple of Venus at Baalbek, it shares certain features with its Solomonic companion – most obviously, three 'chambers', framed by columns, either side of the main axis. It was noted that Hawksmoor also prepared a square version based on Vignola's church of Sant'Andrea (again showing his dependence on Christian temples and, with a reference to 'Herodotus, Pliny, and M:Varo', to ancient literary sources).[25] Moreover in the circular Belvedere, the maximum internal diameter marked on the plan is twice '12.6', that is 25 feet; perhaps the cubit dimensions of the temple gate inspire, if not literally translate as, the diameter of Hawksmoor's 'temple'. In his notes from Ezekiel, Hawksmoor concludes that 'ye Lower pavement over against ye Length of ye Gates . . . mesures from ye (East Gate front) to ye out front of the inner Court 100 cub, and ye same ye other way, so this Court was 100cb square'. A small sketch shows that his own 'temple' was to sit (this time centrally) on a square pavement approached, like the biblical Temple gate, via steps (Fig. 131). Perhaps Vanbrugh's preference for 'a Temple of smooth freestone with a portico each way' (as Hawksmoor's letter accompanying his proposals described it), and to which his 'common Wall stone' designs were offered as an alternative in finish if not in intention, encouraged the use of a pavilion drawn from the archetypal Temple as a model. Such a source would obviously have served to confer a biblical authenticity on his 'temple', given his awareness of the pagan problems of all'antica design. It would also have reflected his reference to antique garden 'paradises' (in Pliny and Varro), and the wider association of the Castle Howard garden with the biblical paradise. Lady Irwin's poem, for example, refers to 'this young Eden', 'the promis'd Land', and to the Belvedere 'Temple' as 'paradise'.[26] Like the gate to the archetypal Temple, the Belvedere is situated on the edge of the walled 'paradise' at Castle Howard.

Irrespective of Hawksmoor's possible use of plan and iconographic details drawn from Solomon's Temple in his work, these notes confirm his keen interest in the layout and cubit dimensions of Ezekiel's visionary building (which had, after all, supposedly been dictated by God). It is possible that he intended to produce, or (given that many of his designs are now lost) actually completed, a reconstruction of the Temple along the lines of his primitive Christian 'basilica', for which these notes are preparation. Their survival might well be due to their location on the reverse of an identifiable design. Together with the primitive Christian 'basilica', they are of enormous significance in understanding Hawksmoor's purpose. Theologians studied Solomon's Temple as a prototype of the early primitive Christian Church, from whose 'basilica' Hawksmoor's own London churches drew their inspiration. And St Mary Woolnoth's twisting columns confirm the Solomonic influence on these churches, rising in the 'New Jerusalem' by the Thames.[27]

HAWKSMOOR AND FREEMASONRY

It hardly needs emphasizing that Hawksmoor was close to the masons he directed, as can be seen from the affectionate terms of his letters to Henry Joynes.[28] He enthusiastically related the history of English operative masonry in the course of defending his own masonry work on the Abbey to the Dean of Westminster, and he described the 'prodigy house' of Wollaton as 'an admirable piece of Masonry' when defending his

132 Signed plan of Greenwich Hospital, from Hawksmoor's *Remarks on the founding and carrying on the buildings of the Royal Hospital at Greenwich* (1728).

Mausoleum colonnade to Carlisle.[29] His stone churches clearly represented a practical celebration of the mason's craft through their accentuated masonry details and tower forms.[30] The redundant – that is, non-structural – nature of his giant keystones suggests that these details were intended to perform an iconographic role, perhaps in symbolizing the skill of operative masonry, as masons working on them such as Edward Strong and Edward Tufnell would surely have recognised.[31] Something of

this symbolic intention may also be reflected in the curious fact that on Hawksmoor's signed plan of Greenwich Hospital, published in his book of 1728, St Alfege is labelled 'Lapide quadrato', or 'stone square' (Fig. 132). This must be a symbolic description, not a practical one, for the church is obviously rectangular (with projecting bays). Masonry lore identified the archetypal Temple of Solomon with a cube stone through its having been modelled on the 'cubic'

133 St Mary Woolnoth's cubic form [axonometric by Alison Shepherd].

celestial temple of Revelation (21:16), and the corner-stone laid by masons in foundation rituals was thus by tradition cubic.[32] As others have observed, of Hawksmoor's churches St Mary Woolnoth most closely resembles a stone cube, with its rusticated walls and perfect cubic form (Fig. 133).[33] In the context of masonry lore, Solomonic associations between the church's form and its two twisting columns framing the altar would surely have been unmistakable. Wren, who was shown to have closely studied the form of Solomon's Temple, noted in Tract IV concerning the Romans that 'not only their Altars and Sacrifices were mystical, but the very Forms of their Temples'.[34]

Hawksmoor was obviously well aware of the symbolic importance of the primitive Christian 'basilica' used as a basis for the plan of his churches, especially follow-ing the clergy's insistence on a Latin cross for St Paul's.

Like the Royal Society Fellows, non-operative masons (or 'freemasons') were also fascinated with the form and physical dimensions of Solomon's Temple.[35] It may seem paradoxical that, despite the early eigh-teenth century's appeal to 'reason', this was also the period of rapid growth in freemasonry as an institution, whose attraction lay in its apparent mystery, ritual, secrecy and quest for hidden truth. Nevertheless behind this cultivation of ancient mysteries and signs lay a rational approach to religion based on the non-sectarian theology of Deism.[36] James Anderson for one called on his brother freemasons to 'love God above all things' for 'this is the true, primitive, catholic and uni-versal religion agreed to be so in all times and ages'.[37] This forward-looking non-sectarianism was comple-mented by a view of architectural history largely in tune with the logical chronology advanced by Wren and Newton. Freemasons traced the origins of masonry past the Greeks and Romans to the building of the Solomonic temple, where it was supposed that the Egyptian secrets of geometry had been taught to the masons. Hence part of their initiation ritual involved the question 'where was the first lodge?', to which the apprentice replied 'in the porch of Solomon's Temple', and this legendary Lodge informed the layout and orientation of its eighteenth-century counterpart.[38] As has just been seen, curiously enough Hawksmoor made detailed notes and sketched the layout of the east gate to the Temple that can be dated to around the end of 1723. Equally, his interest in Egyptology – expressed through his study of hieroglyphic inscriptions and his proposed and actual use of pyramids, sphinxes, obelisks and sacrificial altars – was also perfectly compatible with the esoteric concerns of the fraternity.[39]

Although there is no earlier record of Hawksmoor's membership of the freemasons, in a general list of Lodges active in 1730 the name of one 'Nicholas Hawkesmore, Esqr.' appears as a member of the Lodge meeting at the Oxford Arms in Ludgate Street (near St Paul's).[40] This spelling of his (uncommon) family name is to be found in correspondence, in the minutes of the Commission for building fifty new churches, and in his will.[41] What is more, only the more eminent members of the Lodge were given the 'Esquire' rather than the plain title 'Mr'. The Lodge had the prominent anti-quarian and topographer Richard Rawlinson as its Master and included the engraver George Bickham (either father or son). Hawksmoor was clearly on friendly terms with prominent freemasons, most

notably Nathaniel Blackerby, Deputy Grand Master of the Grand Lodge between 1728 and 1730 – that is, when it appears Hawksmoor is first listed as a member.[42] From January 1722 onwards Blackerby had been treasurer to the Commission building the new churches, working alongside Hawksmoor, and eventually (in 1735) became the architect's son-in-law and, as was noted, his obituarist. They were close friends well before they became related, with Blackerby describing the architect – spelling his name 'Hawksmore' – as 'a tender Husband, a loving Father, a sincere Friend, and a most agreeable Companion'. It was Blackerby who paid for mason's work done to Hawksmoor's house in 1727–9, and for the inscription on his tomb.[43] In 1731, the year after Blackerby stood down as Deputy Grand Master, both men toured England together, visiting Blenheim, Easton Neston and Castle Howard where they were entertained by Carlisle.[44] It is inconceivable that the former Deputy Grand Master did not talk of freemasonry to his architect friend on their long journey together. Perhaps Blackerby personally initiated Hawksmoor into the brotherhood of freemasons, some time after 1722 – that is, just after the architect's demotion at the hands of the rising Burlington establishment, when he needed friends most, and just before his study of Solomon's gate. This was, after all, the period of most rapid growth in new Lodges following the establishment of the Grand Lodge in February 1717 and the publication in 1723 of James Anderson's *Constitutions of the Free-Masons, Containing the History, Charges, Regulations, etc., of that Most Ancient . . . Fraternity*.[45] Hawksmoor's particular skill as a geometrican and his knowledge of architectural history – both virtues attested by Blackerby – as well as his interest in Solomon's Temple, would clearly have readily qualified him for membership.

From the earliest days Hawksmoor also enjoyed a professional relationship with Sir James Thornhill (Grand Warden under Blackerby and an erstwhile architect), as well as with Thornhill's son-in-law and prominent freemason William Hogarth. Both were allies with Hawksmoor in the artistic war against Burlington.[46] Hawksmoor may well have come into contact with Dr John Théophilus Desaguliers when in 1715 the latter advised the Board of Works on the ventilation of the House of Commons.[47] Desaguliers was an ardent Deist, Fellow of the Royal Society and one of the two leading founders of the Grand Lodge and a Grand Master in 1719 (becoming Deputy Grand Master in 1722–3). Both men lived in neighbouring parts of Westminster, Desaguliers holding popular experiments in his house, and both were involved in the project for a new Westminster Bridge.[48] Hawksmoor also lived close to

his admirer and prominent freemason, Batty Langley (also a close friend of Blackerby's, both living in Parliament Stairs in Westminster).[49] Hawksmoor may have associated with the sculptor Louis-François Roubiliac (especially when Roubiliac worked for Henry Cheere), who in 1730 was listed as a member of the White Bear Masonic Lodge in King Street, Golden Square.[50] Of most significance, perhaps, Wren also appears to have become a freemason in May 1691 (according to John Aubrey), and subsequently to have become Grand Master of his London Lodge (although like Hawksmoor he does not record the fact himself).[51] The foundation ceremony at St Paul's, performed in 1675 and attended by Wren, inevitably recalled the legendary rituals cultivated by freemasons.[52] Perhaps the difference in style between Wren and Hawksmoor was less to do with the supposed geometric priorities of the former and the eclectic interests of the latter, than with the mythical lore of the fledgling freemasonry movement exerting more consistent influence on the pupil than on the older master.

Moreover given that Carlisle was influenced by Deism and that this may well have found expression in the design of his Mausoleum,[53] a knowledge of Deism and even shared sympathies in that direction may lie behind Hawksmoor's statement to the Earl in 1726 about adopting a rational, unsuperstitious attitude to the use of pagan models. Indeed the 'purist times of Christianity' symbolized by his model primitive Christian 'basilica' were clearly non-sectarian ones. Hawksmoor's letters do not betray any strong religious feelings. Despite frequently complaining of Gout or 'Quarrys of Chalke', for example, he makes no superstitious appeals to God – even in his letters to the Dean of Westminster – trusting instead in medical remedies including, at one point, 'falling under ye Surgeons' hands' for the 'Issue of my distemper'.[54] Among the many personal qualities attributed to the architect by Blackerby, the Deputy Grand Master curiously fails to mention the conventional one of Protestant piety.[55] Such an omission is surely of significance given Blackerby's certain knowledge (as the Commission treasurer from January 1722) of Hawksmoor's intentions behind his church designs. The pagan and primitive forms of these churches, examined further in Chapter 6, might easily have been intended to express a nonsuperstitious masonic, or Deist, spiritual outlook, later explored in the Castle Howard Mausoleum. And as with the Mausoleum, Deist sympathies would certainly account for the striking absence, for the most part, of traditional Christian symbols on these churches: for example, the Bloomsbury tower is topped not by a cross but by a monarch.[56] (Inside the church, the keystone

over the eastern apse – the original position of the altar – is decorated with a triangular plaque bearing the Hebrew name for God and surrounded by a sunburst, a symbol that would become a prominent freemasons' sign.)

In 1717 John James became Hawksmoor's co-surveyor on the London churches and later collaborated with him on St Luke, Old Street, and St John, Horselydown. James was also a freemason, belonging to the Lodge that met at the Swan in East Street, Greenwich, where he had been employed on the Hospital as assistant Clerk of Works under Hawksmoor since 1705.[57] The two co-designed churches should be considered as a pair – approved by the Commission on the same day (23 June 1727) and built concurrently (1727–33) – and both were given their strange, if misunderstood, spires (see Figs 219, 220). St John had a fluted Ionic column and St Luke has a fluted obelisk resembling, as was noted in the previous chapter, Colonna's fanciful antique wonder. Given that both architects were freemasons, at least by the time these

spires were on the drawing board, it is perfectly possible that they intended to express through these forms the solar and lunar pairing commonplace in masonic iconography. Hawksmoor was well aware of the traditional use of obelisks as solar icons. In his 'Explanation of the Obelisk' proposed for Blenheim he notes that, following Constantine's obelisk in Rome, 'On the Apex (or Top) of the Shaft, may be placed a Star', adding that, 'The French Set up an Obelisk at Arles in ffrance to the Late Lewis the 14th ... On the Top was placed the Sun'.[58] In his first proposal for an obelisk at Ripon of 1702, the needle rose from a sunburst canopy (Fig. 134).[59] If the St Luke obelisk thus takes on a solar meaning, then the tapering column of St John's, with its applied Ionic capital, might assume a lunar one. For Hawksmoor could reasonably have associated the Ionic, following Wren's fourth Tract, with the Order's origin in the legendary temple to Diana at Ephesus, where Wren records that the arrangement of the Ionic columns represented the moon's 'Period' and 'menstrual Course'.[60] It was noted in Chapter 2 that Hawksmoor

134 Hawksmoor's proposal for the obelisk at Ripon, 1702 [Leeds City Archives].

135 Emblems of the sun and moon surmounting free-standing columns, from Batty Langley's *The Builder's Jewel* (1741).

drew on this study when designing the tempietto containing the statue of Queen Caroline above the High Street gate at Queen's College, Oxford. Thus perhaps these strange steeples can be further explained with reference to the timeless pairing of the sun with the moon – openly publicized by Batty Langley in 1741 as freemasonry symbols (Fig. 135).[61]

As Commission treasurer, Blackerby can be expected to have been particularly sympathetic to the cultivation of a 'primitive' antiquity for the Church of England through Hawksmoor's use of Egyptian masonic forms such as pyramids and obelisks, sacrificial altars and indeed mausoleums with statues of George I. Curiously enough Langley erected a domed temple for Blackerby, probably in his garden in Parliament Stairs close to Hawksmoor's house in Millbank, in 1734–5 – about the time of Blackerby's marriage to Hawksmoor's daughter. This structure contained busts of William III and George I, together with 'five gentlemen of the club of liberty', and outside 'an eagle on the vertex of its dome, with sphynxes on its entablature, and with wolves at the extremes of its base'.[62] The two kings signified support for the Protestant Succession, while sphinxes had obvious associations with the legendary Egyptian

origins of freemasonry. Despite the pagan associations of such esoteric symbols, their use was validated through the masons' Deist creed. Given Hawksmoor's own use of statues of George I and of other, more esoteric forms – including proposing a sphinx for the base of Vanbrugh's Belvedere (see Fig. 90) – his approval for his new son-in-law's masonic garden folly might well be imagined. It would thus have been nearly impossible for Hawksmoor not to have understood the masonic significance of certain of his church forms. Indeed contemporaries reading Langley's public defence of Hawksmoor's churches in the *Grub Street Journal* of 11 July 1734, following their condemnation by the Palladian critic James Ralph, would have seen these strange buildings celebrated by none other than the archetypal mason himself. For Langley wrote his defence in the guise of 'Hiram', the legendary architect of Solomon's Temple.[63] It is surely as masonic versions of the archetypal temple that the grandest of Grand Masters, the Duke of Montagu, who was appointed a vestry man of St George in Bloomsbury in 1731,[64] would have seen these churches, and no doubt how they should also be understood today.

136 (*following page*) One of the three niches in the north façade of St Mary Woolnoth.

THE TOWER, THE TEMPLE
AND THE TOMB

Chapter 5

'TRAVELLERS . . . WILL THEN READ THE DUKE OF MARLBOROUGH IN STORY': EASTON NESTON, CASTLE HOWARD AND BLENHEIM

IN HIS DOMESTIC DESIGNS HAWKSMOOR followed the conventions of architectural decorum in using ornament to convey particular characteristics of his patrons and their achievements. In this work – both on his own account and later in collaboration with John Vanbrugh – Hawksmoor reflected Renaissance associations between ornamental forms and emblematics, and more particularly between the Orders and the quintessential art of family identity, heraldry.

EARLY SOLO WORK AT EASTON NESTON

By the end of 1694 Hawksmoor was actively concerned with a country house at Easton Neston in Northamptonshire, whose owner, Sir William Fermor, first Baron Leominster ('Lord Lempster'), was related to Wren by marriage (Figs 137, 138, 142).[1] Building work had begun in the early 1680s, and Hawksmoor and Wren first became involved with either the house or garden around 1686. The initial design for the house is thought to be by Wren, but was substantially altered by Hawksmoor over a number of schemes. In his letter to Carlisle of 4 October 1731, Hawksmoor writes that he and Blackerby

> went to my Ld pontfracts. The Body of ye House has some virtues, but is not quite finished, the Wings are good for nothing. I had the honor to be concerned in ye body of ye house, it is beautifully and strongly built with durable stone, The State and the Conveniencys are as much as can well be in soe small a pavilion. One can hardly avoy'd loveing ones owne children.[2]

The first volume of Campbell's *Vitruvius Britannicus* (1715) closed with the house, illustrating Hawksmoor's design for remodelling and enlarging it with wings, a forecourt and other additions that were never built

(Fig. 143).[3] Built mostly between 1695 and 1702, the main house was limited by the location of the two service wings, constructed about ten years earlier to an anonymous design. Hawksmoor managed to include, within one block, four big rooms on each of the two floors, a two-storey hall, a grand staircase and a novel gallery across the centre of the upper floor. For Easton Neston was designed as much for show as for comfort, since its owner had bought the collection of antique sculpture formed in the early seventeenth century by Thomas Howard, second Earl of Arundel and Surrey.[4] It is this conception of the house, as a showcase for its owner's taste and recently acquired nobility, which might account for a hitherto unexplained change in the design of its façade.

Easton Neston is ornamented on its façades with giant Composite pilasters and columns. But an undated model and rough drawings (by Thomas Colepeper) survive of an earlier design for the house, in which the façades are astylar: only the doorway has columns, reflecting an even earlier Wren drawing thought to be for the house (Figs 139–41); the question must be asked why these pilasters were added, and why Hawksmoor chose the Composite Order – albeit in modified form – especially given his later distaste for its use elsewhere.[5] There were clear enough precedents for the use of the Composite as a giant order: Serlio, for one, used the Composite on his grander country houses illustrated in Book VII.[6] But more to the point, the embellishment of the façade was perfectly compatible with the recent ennoblement of the patron, Lord Leominster, in 1692. Indeed this context is suggested by the fact that a lion's head (signifying *Leo*minster) replaces the 'canonic' rosette between the volutes in the Composite capitals at Easton Neston (Fig. 144). Leominster's nobility is similarly represented elsewhere on the front façade by arms above the two columns that frame the door and by statues of lions above two of the pilasters, ornaments which are also absent from the model. That

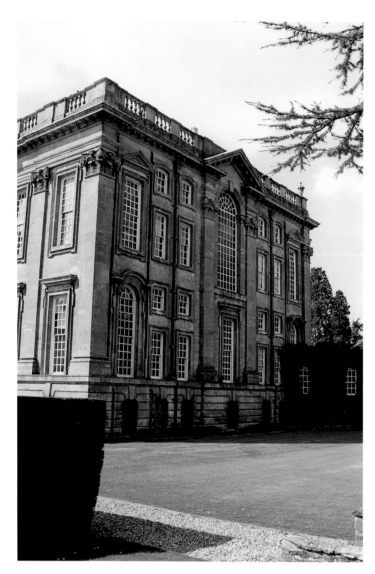

139 Rough drawing of Easton Neston by Thomas Colepeper, undated [British Library, London].

138 North façade of Easton Neston.

140 Drawing by Christopher Wren thought to be for Easton Neston, undated [All Souls, Oxford].

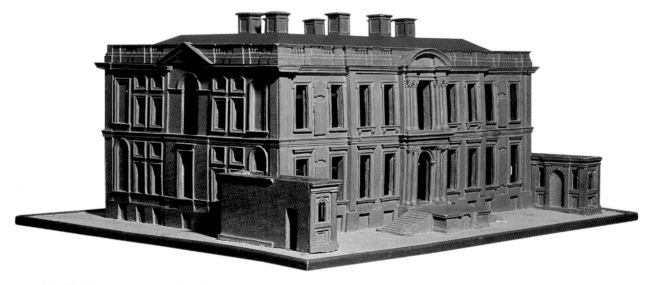

141 Model of Easton Neston, undated [Lord Hasketh collection].

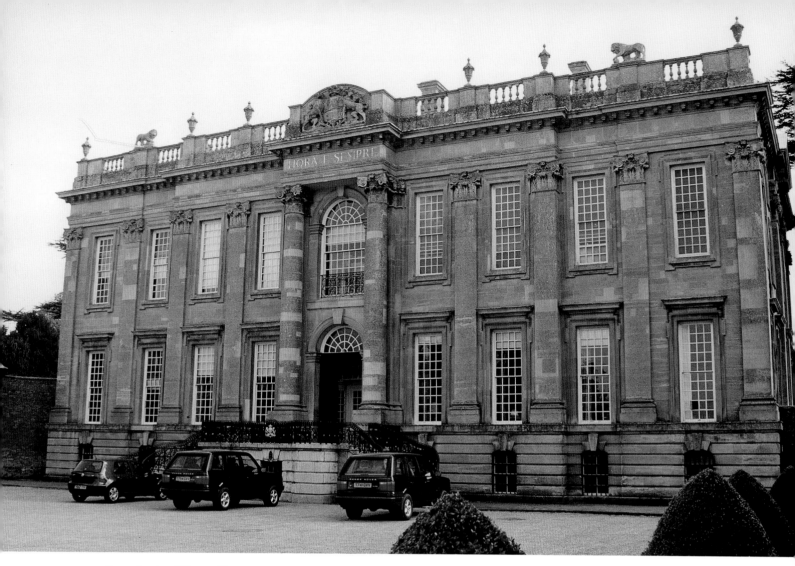

142 Front façade of Easton Neston.

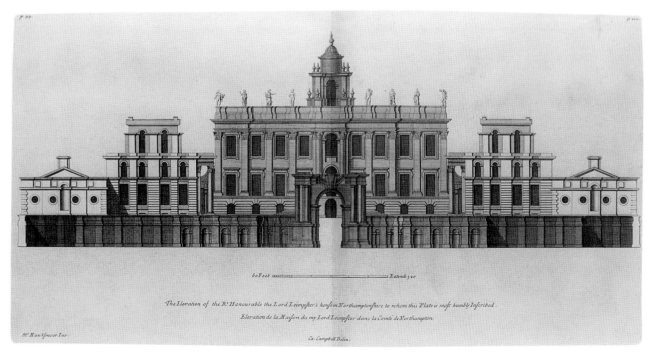

143 Easton Neston, from the first volume of Colen Campbell's *Vitruvius Britannicus* (1715).

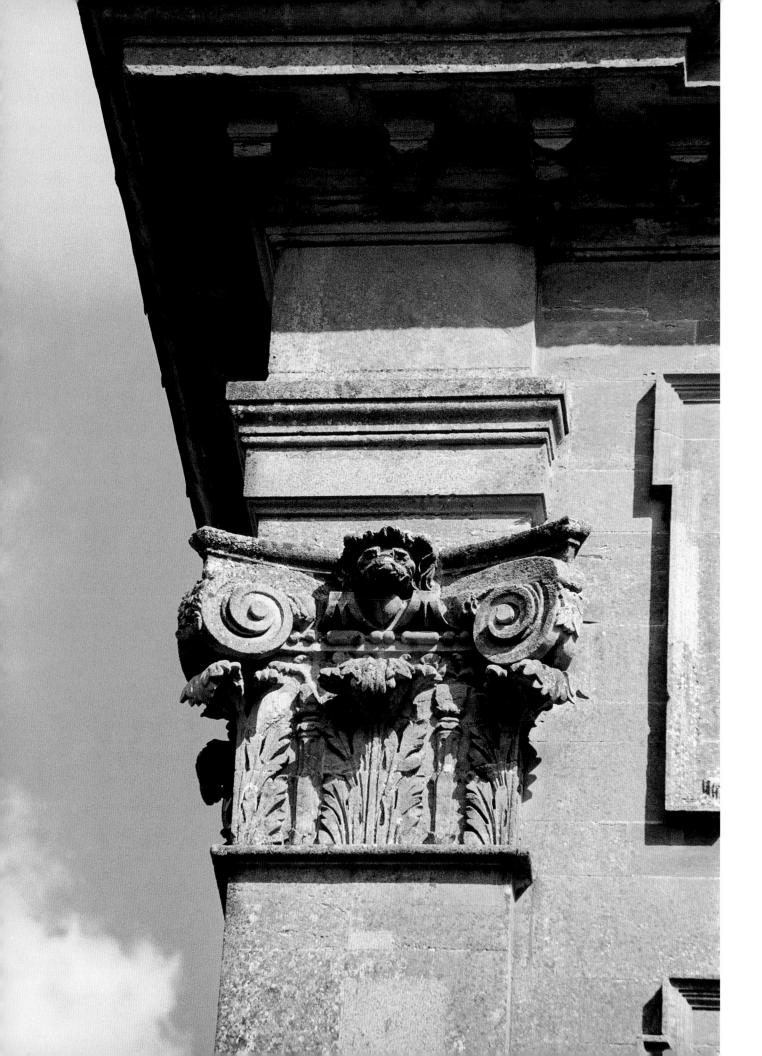

145 Capital forms from Giovanni Battista Montano's *Cinque libri di architettura* (1636).

Hawksmoor felt at liberty at this early stage in his career to 'personalize' the Composite Order – and perhaps less so the other, more canonic capital forms – is indicated by his subsequent somewhat blunt view of the Order as a 'mongrell and no true Species'.[7] In applying the principles of decorum, it would be expected that the character of the patron was reflected in some way by the character of the selected Order. Here this principle is almost literally interpreted, for Hawksmoor alters the capitals from their canonic form to become a type of heraldic emblem, and in so doing provides a visual clue to the meaning of the ornamental scheme as a whole.

In fact the Orders had long been associated with the native medieval art of heraldry.[8] Henry Wotton in his *Elements of Architecture* (1624), in explaining the 'masculine Aspect' of the Doric Order, comments:

> His ranke or degree, is the lowest by all Congruity, as being more massie than the other three, and consequently abler to support . . . To descerne him, will bee a peece rather of good *Heraldry*, than of *Architecture*: For he is best knowne by his place, when he is in company, and by the peculiar ornament of his Frize, . . . when he is alone.[9]

Just as a range of human characteristics were attributed to, and expressed by, a particular Order according to the principles of decorum, so similar characteristics were marshalled in a shield or coat of arms according to the

146 Claude Perrault's famous 'Gallick Order', invented in 1671 and illustrated in the frontispiece to his French translation of *Vitruvius* (1684).

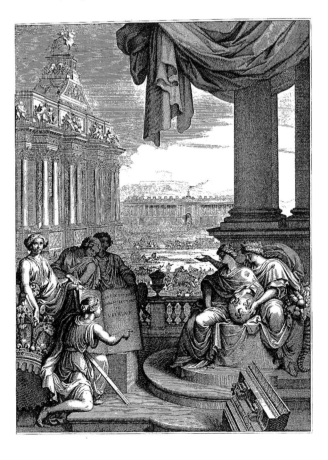

144 Detail of a Composite capital on the pilasters at Easton Neston.

147 Festoons with shellfish on the four Ionic capitals on the east front of the King William Building at Greenwich Hospital of 1702.

principles of heraldry. Hawksmoor might well have understood this similarity through his use of heraldry in his work, most famously placing at his own instigation the royal arms – including statues of the unicorn and lion – in the Bloomsbury tower (see Fig. 5).[10] Other contemporary houses bear similar witness to the association between the Orders and heraldry. At Drayton Hall, built according to designs by William Talman, as part of a general conception of the ornamentation as heraldic, eagles were carved into Corinthian capitals erected around this time or slightly later (c. 1700).[11] Hawksmoor would have seen similar experiments with capital forms in his copy of Montano's *Cinque libri di architettura* of 1636 (lot 96; Fig. 145) – it was following these examples that John Webb had invented a number of heraldic Composite capitals.[12] He would also have seen Claude Perrault's famous 'Gallick Order', invented in 1671 and illustrated in his *Vitruvius* frontispiece of 1684 (lot III), which comprised a Corinthian capital with fleurs-de-lys

instead of acanthus (and which Wren and Evelyn condemned; Fig. 146).[13] At Greenwich Hospital the four Ionic capitals on the east front of the King William Building of 1702, possibly designed by Hawksmoor, are customized through the addition of festoons with shellfish to signify the association of the building with the Navy (Fig. 147).[14]

The dates of the surviving model and 'Colepeper' drawings of Easton Neston are unknown, but it is perfectly possible that these two astylar schemes predate, or just post-date, Leominster's ennoblement in 1692 since the house itself was not begun until 1695 or soon after. Downes dated the model to probably no earlier than 1691, from the date of the purchase of the statues that would have necessitated the wide hall present in the model.[15] He also notes that the spacing of the pilasters on the main fronts of the house as built reinforces 'the slight departures from an even rhythm' of the bays – or, in other words, emphasizes the superimposition of these pilasters as, effectively,

an afterthought.[16] For irrespective of whether the model narrowly pre- or post-dated the ennobling of Leominster, the ornament as built certainly followed this event and was a significant addition to the scheme represented by the model. Given the heraldic nature of the new capitals, their very presence might reasonably be explained by the recent change in social status of the patron. Such 'upgrading' in ornamental style was in line with Hawksmoor's decorum-based principle of 'decency',[17] and followed the social conventions of Renaissance domestic design that linked opulence to status, as particularly developed in France by Serlio's sixth book and Androuet du Cerceau's *Livre d'architecture* (1559).

Indeed Easton Neston represents a clear adaptation by Hawksmoor, in this the first of his solo works, of French domestic traditions in opulence and planning as illustrated in the treatises of Serlio and De Cerceau. The drawing by Wren thought to be for an early version of Easton Neston is particularly French in character, with its mansard roofs (see Fig. 140). Having never visited France, unlike Wren, Hawksmoor relied on sources in his collection of books and prints, which not surprisingly lists 'Andronet's French Houses' (lot 144). At Easton Neston this influence is most apparent in his arrangement of the sculpture gallery, which reflects the *galerie* in French châteaux.[18] As Hawksmoor himself implies in his observations to Carlisle concerning the house, quoted above, he clearly attempted in this early solo work to balance ancient (Italian) ornamental notions of decorum or 'decency' and more modern (Northern European) expectations of commodity or 'convenience'. Examples of the latter are large windows, fireplaces and service rooms – the 'Conveniencys' mentioned to Carlisle – which often inhibited the decorum of a design, as at Easton Neston where mezzanine windows produce an unorthodox arrangement on the side elevations (see Fig. 138).

In an age of country-house building, Easton Neston is an almost unique example of the genre in Hawksmoor's built work – excepting, that is, his work with John Vanbrugh. Only Panton Hall in Lincolnshire of around 1720 and Colby House in Kensington some two years later were designed and built by him (both now demolished). In addition he carried out work at Ockham Park in Surrey and Vanbrugh Castle in Greenwich, the first between 1723 and 1725 and again in 1729, and the second between 1733 and 1734 (see Fig. 115).[19] His designs for Wotton House in Surrey (?1713) and for stables at Thirkleby Park in Yorkshire (1704) remained unbuilt,[20] while the drawings of his designs for a gate, pavilion and obelisk for the Duke of Kent's garden at Wrest Park in Bedfordshire have

survived.[21] Hawksmoor's readiness both to select and customize particular canonic ornamental models (in this case the Orders) to suit specific circumstances (in this case the upgraded status of the patron) is fully apparent in his work at Easton Neston. His conception of the Orders as heraldic, which this work explored, reached its full expression, however, in collaboration with Vanbrugh at Castle Howard and Blenheim.

COLLABORATION WITH JOHN VANBRUGH AT CASTLE HOWARD: ARCHITECTURAL HERALDRY AND EMBLEMATICS

Hawksmoor came into contact with John Vanbrugh, the playwright turned architect, in 1699. In the same year Vanbrugh started to design Castle Howard in Yorkshire for the Earl of Carlisle, with Hawksmoor as his assistant and principal draughtsman.[22] The relationship continued until Vanbrugh's death in 1726, after which Hawksmoor designed and built the Pyramid, Carrmire Gate, Temple of Venus and, most famously, the Mausoleum (Fig. 148; and see Figs 70, 104, 108). The division of labour at Castle Howard has been studied by Charles Saumarez Smith, who concluded that where

> Vanbrugh took responsibility for everything that happened at Castle Howard, Hawksmoor occupied himself with practicalities, regulating the quality of workmanship, surveying the foundations, drawing up future instructions for the workmen . . . Vanbrugh was entirely and exclusively responsible for the first ideas for the house . . . He took the project through to the stages of preparing the model in wood. At this point he realized that he would need the professional assistance of someone with more experience of the everyday practicalities of building. So he decided to employ Nicholas Hawksmoor in this capacity . . . If one single person is to be attributed with the quality of the building of Castle Howard, then it must be Vanbrugh, working within a matrix which was essentially collaborative.[23]

The impossibility of determining individual responsibility for the work at Castle Howard makes attribution of specific ideas to Hawksmoor unreliable. But given the character of his earlier work at Easton Neston, he would surely have found affinity with the heraldic nature of Vanbrugh's style. He must also have been influenced, in emphasizing the 'effect' of various details, by Vanbrugh's scenographic manipulation of mood through ornament and form – qualities especially evident at Castle Howard.[24] After all, both these

148 Pyramid at Castle Howard.

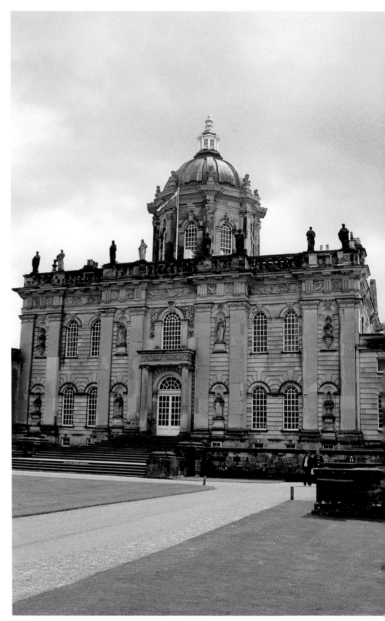

149 Front façade of Castle Howard.

characteristics had a source in the ancient principles of architectural decorum later employed by Hawksmoor when choosing the ornamental style for his Mausoleum and Temple of Venus, as Chapter 10 will demonstrate.

Rather like stage scenery, the buildings at Castle Howard evoke particular moods in the onlooker through their various ornamental styles and features. The Doric Mausoleum, for example, in its isolated setting is plainly intended to evoke the mood of solemnity in the face of death. This is much like the purpose behind the brooding forms on most, if not all, of Hawksmoor's churches, in reflecting Vanbrugh's mood-orientated recommendation to observe 'the Reverend

look of a Temple it self; which shou'd ever have the most Solemn and Awfull Appearance both within and without'.[25] The simple austerity and antique fidelity of the Mausoleum contrasts with the more ornate character of the house façades, as might be expected with regard to the expression of the purpose of both buildings (Figs 149, 150). Vanbrugh certainly approved of such distinctions in ornament and therefore mood, writing that the new London churches should be built 'in a plain but Just and Noble Stile', without recourse to 'such Gayety of Ornaments as may be proper to a Luxurious Palace'.[26] As might be expected, a 'Gayety of Ornaments' is indeed to be found on the 'Luxurious

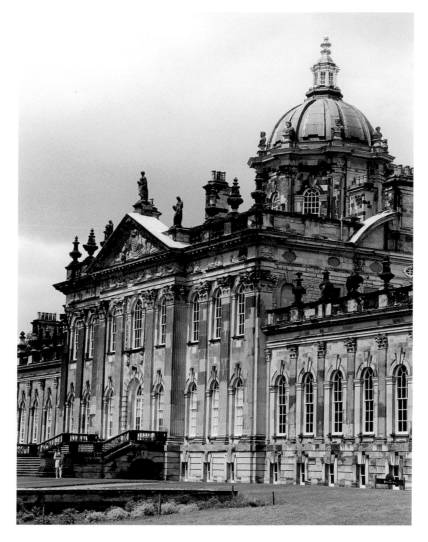

150 Rear, garden façade of Castle Howard.

151 Rear, garden façade of Blenheim.

Palace' of Castle Howard, especially facing the garden, as well as on the garden façade of Blenheim (Fig. 151). In contrast, the crenellated walls, towers and fortress-style Carrmire Gate encountered on approaching Castle Howard can be seen as an exercise in evoking the feelings of fear and wonder in the visitor (Fig. 152). Vanbrugh boasted to the Duke of Newcastle concerning these walls that 'I think all that come here, are Supris'd at their Magnificent Effect'.[27]

In line with Hawksmoor's description of Gothic as the 'Monastic style' – coined to convey the style's associative, rather than its formal, qualities – Vanbrugh's and Hawksmoor's architecture can be seen as more a matter of allusion than of illusion in the Baroque manner. Drawing on a variety of customary emblems and architectural styles at Castle Howard, they attempted to symbolize distinct virtues such as 'strength' (Doric Order), 'British history' (crenellated walls), 'classical mythology' (statues), 'philosophy' (busts), 'luxury' (fruit), 'naturalness' (seahorses), 'victory' (trophies of arms), 'nobility'

152 Crenellated wall and a tower at Castle Howard.

153 Water tower on Kensington Palace Green (demolished), from the *Gentleman's Magazine* (1821).

(heraldry) and so on. The outworks, for example, have the appearance of medieval fortifications to most observers, although they were possibly also conceived of as 'Roman' in spirit.[28] Rather than serving any actual function of protection against imminent attack, however, they helped confirm the new estate in the noble traditions of British history – recalled by its 'castle' name and heraldic character – especially in the wake of the destruction of the parish church and old house.[29] In the same semantic spirit of association, it was noted that in 1707 Vanbrugh and Hawksmoor proposed a crenellated façade for Kimbolton that the former described as having 'Something of the Castle Air' – adding with a nod to the principles of decorum that 'to have built a Front with Pillasters, and what the Orders require cou'd never have been born with the Rest of the Castle: I'm sure this will make a very Noble and Masculine Shew'.[30] The 'Castle Air' was thus not only masculine but necessarily astylar. It derived its character not from antique columns but rather from evoking associations with the English domestic archetype – the castle – through using once functional but now decorative elements. Vanbrugh had been a soldier in earlier years, and the imagery of his architecture frequently reflected this experience.[31] For he evidently saw medieval castle forms – novel in contemporary works – as particularly appropriate for buildings of a military or functional typology. An example of this is his (or Hawksmoor's) water tower on Kensington Palace Green (now demolished), which was in the form of a medieval tower with a projecting corbel table common in Florentine palazzi (Fig. 153). Vanbrugh most probably influenced the use of defensive forms at Chatham Dockyard on the great store and gate, and used them at Eastbury on the west arch of the north court, at Blenheim on functional buildings such as the kitchen court, and at Woolwich Arsenal on the Old Board of Ordnance with its (predictably enough) astylar façade (Figs 154–7). On these buildings the elemental forms of fortification are manipulated to signify 'strength' and 'functionality' (commodity), given that such forms had lost any practical purpose long ago. The corbel table performs the same symbolic, or emblematic, role on Hawksmoor's towers at All Souls (forming a kind of Gothic 'cornice'), as do the crenellations on the quadrangle walls (see Fig. 81).

Vanbrugh would have been introduced to the idea of using ornamental styles and historical forms to symbolize particular virtues and types – of people, in order to 'typecast', as well as of buildings – through his stage work. Drury Lane Theatre, in which he staged his work, was said to be the first public theatre in London to use elaborate scenery.[32] Stage design followed

154 and 155 Great store and gate at Chatham Dockyard (demolished), possibly by Vanbrugh.

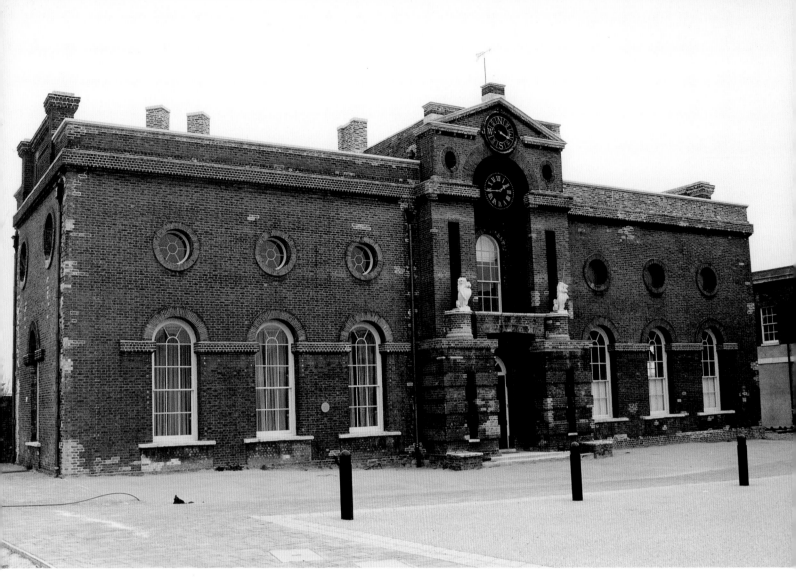

156 Front façade of the Old Board of Ordnance (1718–20) at Woolwich Arsenal, possibly by Vanbrugh and Hawksmoor.

emblematic conventions for Tragic, Comic and Satiric drama illustrated by Serlio in a series of famous wood-cuts and introduced into Britain in the masques of Inigo Jones. Costume design involved the recognizable, and therefore customary, characterization of a variety of occupations, classes, and virtues and vices, often based on Renaissance conventions established by catalogues of moral emblems and hieroglyphs. It was noted in Chapter 3 that Hawksmoor observed in the 'explana-tion' of his Blenheim obelisk celebrating the Duke's victories that 'The Inscriptions generally put upon yᵉ Ancient Obelisks by great Men were in Egyptian Characters, representing Morals & Politicks &c. The Virtues and Actions of great & illustrious Men, &c'.[33] He could have studied hieroglyphics in his copy of Lowthorp's collected Royal Society transactions or in Domenico Fontana's *Oblesco Vaticano* (1590; lots 35 and 104).[34] Wren also makes clear his familiarity with this tradition when noting in Tract IV that, in Roman times,

'Each Deity had a peculiar Gesture, Face, and Dress hieroglyphically proper to it; as their Stories were but Morals involved'.[35] He owned a copy of Joannes Georgius Herwart's *Thesaurus hieroglyphicorum* (1610), with its folio illustrations of Egyptian characters that Hawksmoor could also easily have studied, and of Quintus Horatius Flaccus's *Q Horatii Flacci emblemata* (1682).[36] An edition of the most famous emblem book of all, Cesare Ripa's *Iconologia, or, Moral Emblems*, was published in England in 1709 and was used in the internal scheme of the great hall at Castle Howard.[37] Here again, through working with painters, Vanbrugh, Hawksmoor and Wren would have come into contact with emblematic conventions governing the represen-tation of character and type very similar to the rules of heraldic and architectural decorum.

The appropriate display of the five Orders, with their various 'characters' as outlined by Vitruvius and his Renaissance followers, would also have been readily

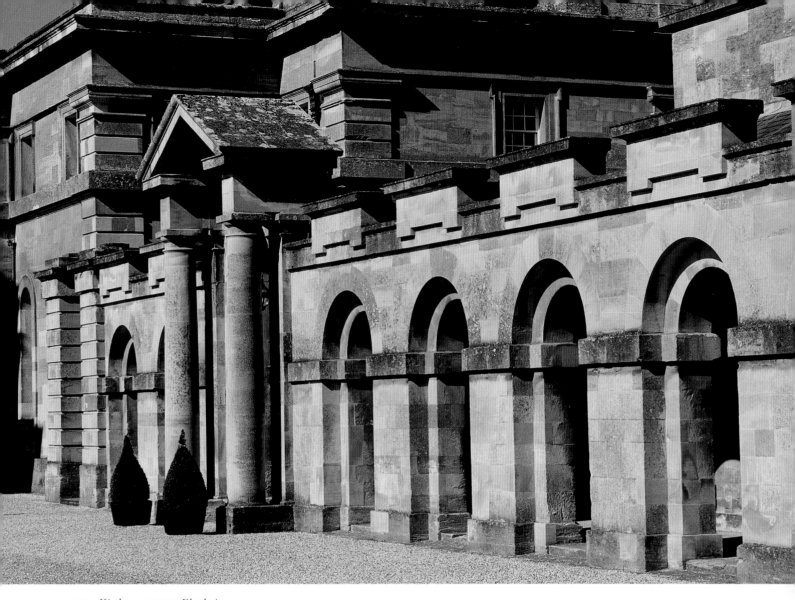

157 Kitchen court at Blenheim.

comprehended by an 'amateur' like Vanbrugh in the context of the native art of heraldry, with which it was noted the Orders had long been associated. For he must have been well aware of this link since he was both an architect and a herald. On Vanbrugh's installation by the Earl of Carlisle in the revived office of Carlisle Herald in March 1703, as a reward for the early work at Castle Howard and as a prelude to becoming Clarenceux King of Arms, Jonathan Swift commented 'Now Van will be able to build houses'.[38] In *Vanbrug's House* (c. 1703) Swift again observed: 'Van, (for 'tis fit the Reader know it) / Is both a Herald and a Poet; / No wonder then, if nicely skill'd / In each capacity to Build'. Swift thus played on the obvious analogies between heraldry and architecture, as arts governed by principles of decorum and order, and it might reasonably be supposed that both Vanbrugh and Hawksmoor were fully aware of this analogy at the outset of building work at Castle Howard.

Carlisle was himself interested in heraldry. Among the Earl's private papers is the manuscript title-page of 'A Book of Coates & Crestes' by him, dated 1699, and in 1701 he had become acting Earl Marshal responsible for organizing all aspects of Court ceremonial.[39] This interest was despite – or perhaps because of – the 'newness' of the Carlisle line. Although the 'house' of Carlisle was an old title (of the Hay family), it had been re-established in the seventeenth century by the first Earl, Charles Howard (?1628/9–85). Carlisle was thus not naturally part of the landed class: a hostile manifesto issued on 10 December 1701 noted sarcastically 'wee the Gentlemen of Ancient Families & substantiall Freeholders of the County of Cumberland . . . First and princily we commend our dying Liberties, Properties, Priviledges, and Immunities into the hands of the Noble Peer the Lord C[arlisle] to be disposed of according to his discretion for ye supporting & Maintaining his Grandeur at Court'.[40] In this light the

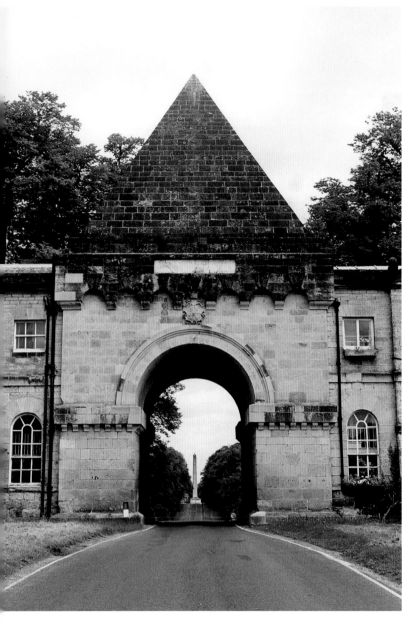

158 Pyramid gate at Castle Howard, designed by Vanbrugh and completed in 1717.

159 Obelisk at Castle Howard celebrating Marlborough's victories, designed by Vanbrugh in 1714.

austere Mausoleum might be seen as a conscious attempt to overcome the lack of ancient roots, in associating the Howard line with antiquity – symbolized in particular by the use of the most august of the Orders, the Doric, and through the strict application of ancient precedent. Even though the *all'antica* style was freely adapted elsewhere, notably on the main house, a more rigid application of the style was clearly appropriate to this the most heraldic of buildings. Moreover in the light of the associations between Vanbrugh's roles as herald and architect, and between heraldry and architecture, the main house might itself be seen as a vast

exercise in heraldry in order to legitimize a title of relatively recent origin, built as it was to celebrate the 'house' of Carlisle. After all, rather like this 'heraldic house', Castle Howard was raised on the site of the ruins of an older house, called Henderskelfe Castle. This heraldic purpose would surely have been emphasized by the use, once again, of the Doric Order, given its explicit heraldic characteristics introduced by Wotton in 1624, and by Carlisle's cipher – 'CCC' for 'Carolus Comes Carleolensis' – on the central keystone of the front façade and by his arms in the pediment to the rear (see Figs 149, 150).

In fact a notable distinction is made at Castle Howard between the style of the front, with its military character, and that of the rear, garden façade, with its Corinthian pilasters. It is often claimed that this contrast in the ornamentation of a single building produces a poor dichotomy,[41] and Hawksmoor was well aware that such contrasts could be criticized. In defending Vanbrugh's design to Carlisle, he pointed out the importance of optics, for 'The South side, and the North front of your Ldships house cannot be seen together at the same Time, nor at any time upon the Diagonall (or angular view)'.[42] He echoes Wren's view that the geometry of parts not seen together need not coincide, a principle that informs the divergent internal and external form of St Paul's (see Fig. 29).[43] If the pilasters and accompanying ornament were indeed used, like heraldic emblems, to express the identity of Carlisle and his house, then the reason for this contrast may lie in the split nature of Castle Howard. For the house was conceived of as both a castle imposed on the landscape, implicit in its title, and a domestic palace belonging to its garden. Hawksmoor himself pointed out this dichotomy – and his interest in building 'types' – in his comment to Carlisle on 12 October 1734 concerning the house, that 'It is the seat of one of chief nobles of Britain, it is both a Castle and Pallace conjoyn'd'.[44]

Castle Howard was given the identity of a military building through a variety of means. The approach to the house is marked by ever more refined martial and heraldic elements, in the form of the rustic Carrmire Gate and crenellated walls, the slightly more refined pyramid gate followed by the inscribed obelisk celebrating Marlborough's victories (both designed by Vanbrugh (Figs 158, 159)). Judging from the famous idealized view of the house published in the third volume of *Vitruvius Britannicus* (1725), triumphal arches were to have marked the entrance to the forecourt (Fig. 160). The ornamentation of the north face of the house continues this martial theme, as a concluding backdrop to, and final refinement of, the landscape elements on the approach side. As was noted, the façade

160 Idealized view of Castle Howard, from the third volume of Colen Campbell's *Vitruvius Britannicus* (1725).

Castle Howard in Yorkshire the Seat of the Right Honourable the Earl of Carlisle &c :

161 Hawksmoor's early drawing of the north (entrance) front of Castle Howard, undated [Victoria and Albert Museum, London].

has giant pilasters of the Doric Order (and which replaced Corinthian pilasters of an early scheme); Hawksmoor certainly worked on the façades, since early drawings are in his hand (Fig. 161).[45] As an austere 'masculine' Order, the Doric was particularly suited to the character of soldiers according to Serlio, whose citation of St George as an example would have given the Order a special relevance to his British readers.[46] Appropriately enough, Wren chose the Doric for his colonnades at Greenwich Hospital for retired seamen,[47] the drawings for which were prepared by Hawksmoor in 1696–7, and at Chelsea Hospital for retired soldiers, the façades of which were intended to carry reliefs of trophies of arms making the military theme explicit (Figs 162, 163).[48] The conception of the Doric pilasters at Castle Howard as a form of heraldic ensign is emphasized by accompanying martial trophies in the form of flags, breastplate and cannon (symbols absent on the

earlier designs). The pilasters are set against walls with incised joints that result in a form of smooth-faced rustication particularly suitable, according to Serlio, to castles.[49] This lent a further 'masculine' character to the façade, following Hawksmoor's remarks concerning the pillars on the Temple of Venus that 'Without the Rusticks they will be too feminin (trop Megre) as the French call it'.[50] Moreover the façade rests on a basement which, according to Hawksmoor, 'is plain and represents (or intended so to do) a grand entire plinth made out of one solid Rock of Stone', thereby signifying 'Strength'.[51] Here again he refers to the decorum-based concept of ornament and texture symbolizing particular qualities.

This work is in strong contrast to the delicate (feminine) ornamentation of the private, south façade, which celebrates the contrasting ideal of the house conceived as a palace set in nature tamed by art. This

façade faces the garden and its parterre, lake, wilderness and temples to the Four Winds (Belvedere) and to Venus. Here giant pilasters, this time of the Corinthian Order – the feminine Order most appropriate to Venus and Flora according to Vitruvius (I.ii.5) – are accompanied by leaf motifs, boys blowing conch shells at seahorses and a general ornamental flamboyance. Appropriately, the pediment serves as a plinth to statues of Pallas Athene (Minerva), Flora with a cornucopia of flowers and Ceres with a sheaf of corn. Again appropriately, a large relief of Diana on the east end of the garden wing faces Ray Wood, which is described as the goddess's 'fav'rite Grove' in the poem of around 1733 by Carlisle's daughter, Lady Anne Irwin (Fig. 164).[52] This poem opens with a quote from Virgil's *Georgics* in celebrating Castle Howard as a product of a new Golden Age, that is, 'happy Plenty, the Effect of Peace'. Slightly later, Thomas Gent's *Pater Patriae: Being, An Elegiac Pastoral Dialogue occasioned by the most lamented Death of the Late Rt. Honble and Illustrious Charles Howard* (1738), grieved 'Ah, me! dear Strephon! Is my Lord then dead! / That God-like Soul, with Astraeal

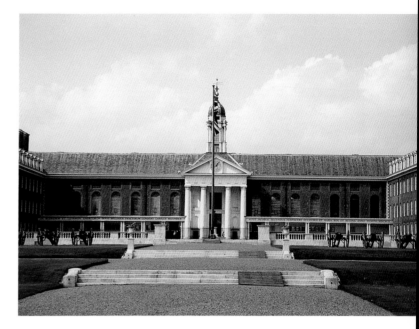

163 Wren's Doric colonnades at Chelsea Hospital for retired soldiers.

162 Wren's Doric colonnades at Greenwich Hospital for retired seamen.

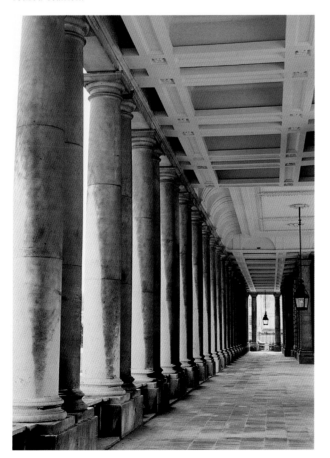

164 East end of the garden wing at Castle Howard.

Virtues, fled!' According to Virgil, the age of iron and war gave way to that of gold and peace under the rule of the legendary virgin, Astraea. A woodcut used to illustrate Gent's poem pictures the house and landscape at Castle Howard in this Arcadian light (Fig. 165).

Thus a form of integrated symbolic (or emblematic) programme can be suggested for Castle Howard, compatible with Hawksmoor's reference to the house as

165 Woodcut illustrating the Castle Howard landscape as an arcadia, from
Thomas Gent's *Pater Patriae* (1738).

both a castle and a palace.[53] Clearly conceived as a form
of 'gateway' to the garden beyond, the house marks the
physical boundary between two opposing 'realms'. Just
as the north (public) face is masculine in character, dra-
matically triumphing over the forces of human conflict
and mortality, the south (private) front is feminine in
character and celebrates, through traditional Golden
Age imagery, the ideals of peace and a renewed
harmony with nature. Encircling the dome, busts of
antique philosophers – including Seneca, Socrates,
Cicero, and Plato[54] – look down from all sides of their
'heaven' on this timeless narrative of war giving way, as
it were, to peace. Certainly the idea of the façades as
ornamental 'opposites' was emphasized by Hawksmoor
when noting that whereas 'The South Front is Smooth
in ye upper order, with, a continuall arcade, and The
Basement Rusticated, per Contrà The North ffront is
Rusticated in the order, and so is the Wing, and the
Basement, Like a sollid rock quit plain'.[55] This narra-
tive may account for the otherwise inexplicable change
in the style of the north front, from the Corinthian of
the early schemes to the Doric of the built façade. For
as time went on, the project came increasingly to cel-
ebrate the military glory of Whig rule evident from
Anne's succession in 1702 – eventually explicitly com-
memorated by the obelisk – and the new age of peace
and plenty expected in its wake. The massive crenel-
lated walls enclosing the estate also play their part in
this scheme. Paradise had, after all, been surrounded
and defined by walls and it was noted that the Castle
Howard walls were primarily symbolic structures.
Located on a remote hilltop well outside this enclosure,
the Mausoleum represented a permanent reminder of
human mortality visible from, but not physically con-
tained within, this 'ideal' realm. This was mirrored by
the memorial Pyramid to the founder of the Carlisle
line, also designed by Hawksmoor, on the borders of

the estate outside the garden boundary. The landscape
perfectly reflects the classical paradox famously repre-
sented by the 'Et in Arcadia Ego' tomb inscription as
depicted in *Arcadian Shepherds* by Poussin – examples
of whose work were in Hawksmoor's collection (lots
87, 246, 270, 277 and 173). Castle Howard might thus
be seen as a setting designed to dramatize the eternal,
cyclical theme of temporal glory, mortality and natural
rejuvenation.

COLLABORATION WITH VANBRUGH AT
BLENHEIM: A *VIA TRIUMPHALIS*

Vanbrugh was appointed Comptroller of Works – the
second highest office – in 1702 in place of William
Talman, and this led to his appointment as architect of
Blenheim in 1705, the foundation stone of which was
laid that year. Hawksmoor again served as his assistant,
since the work was (in principle) paid for by the gov-
ernment and was therefore within the scope, if not the
direct responsibility, of the Office of Works. Writing to
the Duchess of Marlborough on 27 May 1710, Vanbrugh
justified his additional remuneration for work on
Blenheim by defining his responsibilities, observing that
'I am *here Surveyor*, which Relates to the Designing and
Direction of the Building'.[56] In contrast Hawksmoor
later wrote to the Duchess, on 2 September 1725, that
'when the Building began, all of them (the Builders)
put-together, could not stir an inch without me' –
although here again this fact was never recognized, as
part of the 'ill luck that follows me'.[57] In 1716 Vanbrugh
had quarrelled with the Duchess and resigned, taking
Hawksmoor with him. But in 1722 Hawksmoor was
re-engaged to help complete the palace, designing the
decorations for the Long Library or Gallery along the
west side,[58] the Woodstock triumphal arch and various
unbuilt versions of an obelisk or column (see Fig. 119;
Fig. 166). Writing to the Duchess on 17 April 1722,
he pointed out that he had 'had the honour to see
the first Stone layed', and considered his concern for
Blenheim as 'like a loving nurse that almost thinks
the Child her own'.[59] Here again the impossibility of
determining individual responsibility for the work
before 1722 makes attribution of specific ideas to
Hawksmoor unreliable, but his supervisory role is at
least clearly recorded in his letter of 1725 and other
unpublished correspondence (now in the British
Library) between himself and his residential assistant,
Henry Joynes.[60]

Both Marlborough and his architect wisely con-
sidered the house a public memorial to the deed (the
Duke's defeat of the French in 1704), not the doer. In

Sir Godfrey Kneller's sketch of 1708 for a painting celebrating the reward of the house to the Duke, the Queen presents a drawing of Blenheim not to Marlborough but to a figure representing 'Military Merit'.[61] Shaftesbury had attacked opulent palace-building by the nobility – with Blenheim and Castle Howard in mind – in moralistic terms, noting in 1712 that such building was performed 'at a vast expense' and represented 'a false and counter-feit Piece of Magnificence' which could be 'justly arraign'd for its Deformity'.[62] The Aristotelian ethical concept of 'magnificence' (magnificentia) had been used by architectural writers from Alberti onwards to justify expenditure on large-scale public works and, as a matter of architectural decorum, to distinguish appropriate public and charitable displays of magnificence from inappropriate ones of luxury.[63] It was noted in Chapter 3 that Hawksmoor drew on this concept, albeit with a differing interpretation from Shaftesbury's, when boasting to Carlisle that Castle Howard 'claims more Regard, than one of Palladios humble Villas in y^e Vicentine, or Veronese'. Vanbrugh, too, reflected this concept when defining the role of Blenheim as that of a public memorial in his letter to the Duchess of 27 May 1710. There he observed that 'This Building, tho ordered to be a Dwelling house for the Duke of Marlborough, and his posterity, is at the Same time *by all the World esteemed, and looked on as a Publick Edifice*, raised for a Monument of the Queen's Glory through his great Services. Which (I desire leave by the way to observe) is a most ample justification of the great Expence, which has been made for the beauty, Magnificence and Duration of the shell'.[64] After the Duke's death in 1722, however, his widow altered the meaning of the house with Hawksmoor's assistance to a personal memorial to the Duke.

From the Woodstock entrance, what had become established as the main approach to the house became conceived of in imperial terms by Hawksmoor.[65] For this route to the palace of the victorious general was, not surprisingly perhaps, characterized in the archetypal form of a *via triumphalis* entered through the triumphal arch and, if Hawksmoor had had his way, further marked by the obelisk. His 'explanation' of his obelisk designs, of around 1724, made clear the link between the two elements as symbols of military glory:[66] he proposed that the 'Inscription upon the Gate by the Town, says that the (Reader) or Traveler will know more by the Column (or Obelisk) Set up at y^e Entrance, for that the Said Inscription on the Gate, points the Obelisk to be somewhat near in y^e Neighbourhood or at or near the Entrance. Now these things Considered it should not be placed out of Sight, or at a Mile Distance'. Although he put forward a variety of locations for this

obelisk, all on axes relating to the house, two alternatives were favoured. These were firstly, 'at the Entrance into y^e Grand Avenue next the North End of the Bridge' – that is on axis with the house where the column by Lord Herbert was eventually built. Or secondly, a point 'where your Grace mentioned' on the route from the arch, 'in the View, from the New Arch, where it meets wth the Line from the East Entrance of the House or Water Tower'. True to their traditional roles, both arch and obelisk were here to function as sequential mnemonic emblems in recalling the story of the Duke's victory in the cause of British 'liberty'. It has even been speculated that the magnificent, if somewhat useless, bridge was built to 'recall' the Duke's crossing of the Nebel that had preceded victory near the village of Blenheim.[67]

In his letter to the Duchess on 17 April 1722 concerning the completion of the 'remaining things of the Approach', Hawksmoor hoped that 'your Grace will not omit to use proper Inscription to shew the Succeeding Ages to Whom they were obliged for defending their liberties, and put them in mind (if possible) of their gratitude'.[68] It was pointed out that he echoed the Renaissance tradition of emblematics when observing in his obelisk 'explanation' that ancient inscriptions on such forms were in Egyptian characters. Hawksmoor evidently referred to Domenico Fontana's *Oblesco Vaticano* (1590; lots 104 and 118) to provide models for his obelisk designs, noting 'I have sent 2 designes, one much Like that set up in y^e Piazza Navona, by Cavalier *Fontana*, or Bernini'.[69] These designs were also considered emblematically. On the solar heraldry of Marlborough's defeated opponent, the sun king Louis XIV, he notes that just as 'that (parhelion) or false Sun, was forced, to Leave Shineing by the Influence of a British Starr, the brightest Europe has yet at any time, ever Seen – The Emblem of a Starr may not be improperly placed on the Top of this obelisk'. An alternative design was to be surmounted by Roman eagles and other 'proper Emblems' which Marlborough was entitled to use.[70] Once again Hawksmoor's purpose is to use iconography 'properly', not simply for visual effect but as a symbol to convey an appropriate meaning. Rather like at Easton Neston, antique ornament is here adapted through the addition of heraldry and, as Chapter 3 noted, specific statuary (of river gods) to reflect the character of the patron. True to his 'architectonricall method', Hawksmoor demonstrates his concern to understand the original, historical meaning and symbolic purpose behind his vocabulary of forms.

In referring to 'the Column (or Obelisk)', the 'explanation' implies an alternative model for the victory

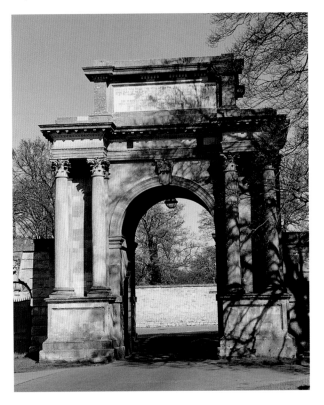

166 Woodstock triumphal arch, Blenheim.

167 Arch of Titus, from Sebastiano Serlio's *Terzo Libro* (1540), p. CV.

memorial and at some point Hawksmoor also provided a design for a fluted column surmounted by a statue of Marlborough.[71] In a letter to the Duchess of 2 September 1725 he mentions the stone necessary for what he now calls the 'Historicall pillar', and three months later, on 23 December, he makes clear his model in noting 'I hope your Grace has not forgot y^e Column of Trajan'.[72] Here again, the Doric character of this antique column echoed the well established notions concerning that Order's appropriateness to soldiers like Marlborough, a propriety which Hawksmoor cannot have failed to appreciate. As noted above, the Palladian amateur Lord Herbert ultimately designed the victory memorial placed in the park to the north of the bridge (1727–31), copying Hawksmoor's idea for a Doric column with the Duke's statue on top. The Woodstock arch was built in 1723 to Hawksmoor's design, modelled appropriately enough on the arch of the Emperor Titus as illustrated by Serlio but transformed from Composite to Corinthian,[73] and was indeed inscribed in the Duke's honour (Figs 166, 167). As will be seen in Chapter 8, the vision of a triumphal route orchestrated around arches and columns, axes and vistas, had also informed Hawksmoor's plan for nearby Oxford. As part of the shift in meaning at Blenheim initiated by the Duchess, the recurrence of the idea here at

Blenheim might thus be seen as Hawksmoor's own particular contribution to the landscape.

Much like at Castle Howard, the ornament and forms used at Blenheim were conceived in heraldic terms to emphasize British military glory. The house, with its trophies and ensigns, was seen as the triumphant conclusion to the landscape narrative (Fig. 168). For once inside the great court, the visitor passes Vanbrugh's side gates to the kitchen court and stables, with their giant pared-down Doric columns (without triglyphs) and rustic bands recalling in style Giulio Romano's 'porta Cittadella' in Mantua and Serlio's fortified gates in his Book VII (Figs 169, 170). Heraldic beasts in the form of the British lion savaging the French cockerel surmount these gates. Progressing towards the house, the square towers are crowned by giant finials of upside-down French fleurs-de-lys supported by cannon balls: Hawksmoor may well have been solely responsible for the design of this triumphalist heraldry (Fig. 171).[74] This mood is continued by the giant Corinthian portico to the house, either side of which are fictive arcades of Doric pilasters which sweep out as if to form the apse of a Roman forum. In fact the portico was also originally intended to be of the Doric Order, as might be expected given the Order's associations with martial and masculine strength

made explicit at Castle Howard. But the style was changed to the Corinthian during construction (in the winter of 1706–7) – that is after the column diameters had been fixed – due to a need to increase the height of the portico and, in following the canonic proportions of the columns, thereby use a more slender Order.[75] The Duke's heraldry is blazoned in the tympanum and the pediment is surmounted by a statue of Pallas Athene (here in her war-like guise) together with those of chained captives on the broken pediment above (recalling the iconography of imperial Rome).[76] The overall arrangement of the front façade – with its curved wings, statues, heavy cornice and giant Corinthian portico – bears a striking similarity to that of the temple of Mars Ultor as illustrated in Palladio and discussed and illustrated in plan by Wren (Fig. 172; see also Fig. 23).[77] It was observed in Chapter 4 that Wren understood the form of ancient temples as expressive of their dedication. He thus notes in Tract IV that 'As studiously as the Aspect of the Temple of *Peace* was contrived in Allusion to Peace and its Attributes, so is this of *Mars* appropriated to War: a strong and stately Temple shews itself forward'. Indeed much like at Blenheim, Wren records that this temple

front was built 'to muster up at once a terrible Front of Trophies and Statues, which stand here in double Ranks . . . Thus stands the Temple like the *Phalanx*, whilst the Walls represent the Wings of a *Battalia*'. It is tempting to imagine Marlborough viewing his Blenheim façade in a similar way, with the legion of Doric and Corinthian columns deployed like military ensigns, surmounted as these columns were by statues and trophies of war.

Again as at Castle Howard, the archetype of the medieval castle was recalled semantically at Blenheim through the Office of Works' reference to the palace as 'Blenheim Castle' – an association reinforced through the cannon balls and other trophies of arms, the fortress-style gates and the battlements to the kitchen court (see Fig. 157).[78] But unlike at Castle Howard, the triumphalism of the front extends to the rear at Blenheim (see Fig. 151). Here the Doric pilasters of the earliest known design, of 1704–5, were again modified to a more regal fluted Corinthian portico in the built solution, above the cornice of which is an actual trophy of victory: drawings in Hawksmoor's hand record the original Doric theme of this south façade (Fig. 173).[79] The engraving of this garden front

168 Front façade of Blenheim.

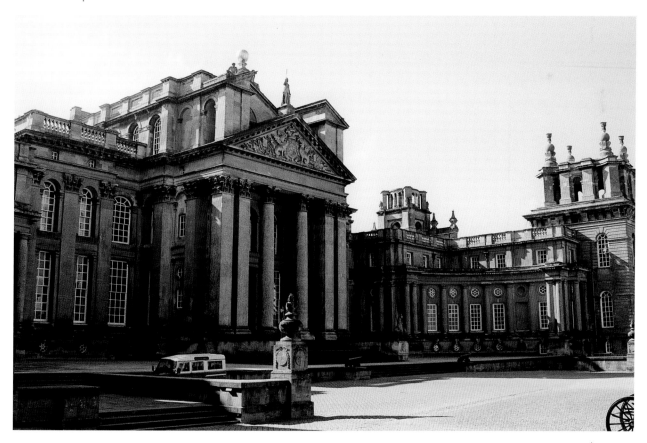

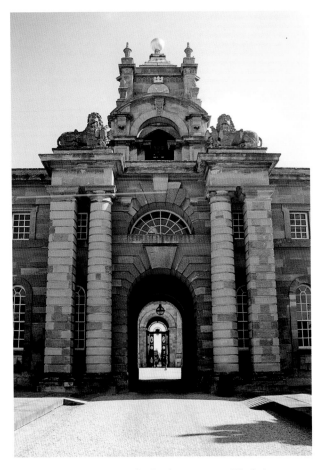

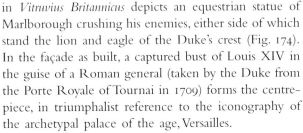

169 Vanbrugh's gate to the kitchen court at Blenheim.

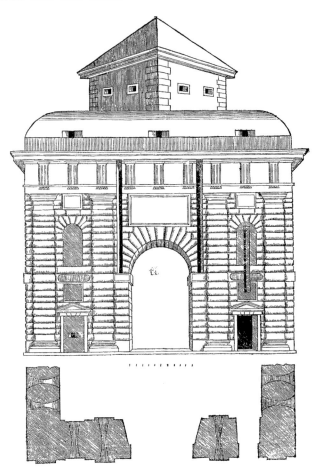

170 A fortified gate from Sebastiano Serlio's *Settimo Libro* (1575), p. 95.

in *Vitruvius Britannicus* depicts an equestrian statue of Marlborough crushing his enemies, either side of which stand the lion and eagle of the Duke's crest (Fig. 174). In the façade as built, a captured bust of Louis XIV in the guise of a Roman general (taken by the Duke from the Porte Royale of Tournai in 1709) forms the centrepiece, in triumphalist reference to the iconography of the archetypal palace of the age, Versailles.

In 1709 Vanbrugh famously argued for the preservation of the ruins of the existing house on the site, Woodstock Manor, and the old house even became something of a model.[80] True to the spirit of contextual decorum, he later assured the Duchess that 'the homely simplicity of the Ancient Manor' was in his 'constant thoughts for a guide in what remains to be done, in all the inferior Buildings'.[81] The astylar, crenellated arcade and simple monumentality of the kitchen court at Blenheim are the result. Underlining the influence of different forms of architecture on the onlooker's mood, such ancient buildings may, according to Vanbrugh in his letter of 1709, 'move more lively & pleasing reflections (than History without their aid can

do) on the Persons who have Inhabited them'. In going on to make explicit the emblematic, memorial role of the new house which Hawksmoor later sought to embellish with his landscape monuments, Vanbrugh added that 'I believe it cannot be doubted, but if Travellers many ages hence, shall be shewn the very House in which so great a man dwelt, as they will then read the Duke of Marlborough in Story . . . they will find Wonder enough in the Story to make 'em pleas'd w^th y^e Sight of it'. Both Castle Howard and Blenheim should thus be viewed as giant emblematic compositions narrating the victory of British 'liberty' under the Whigs, and the dawning of a new, particularly British Golden Age.

THE WHIG GOLDEN AGE

Many 'Moderns' at the turn of the eighteenth century thus saw their era as a renewal of – indeed as having surpassed – the Golden Age of antiquity. In his column project for example Hawksmoor idealized the Duke

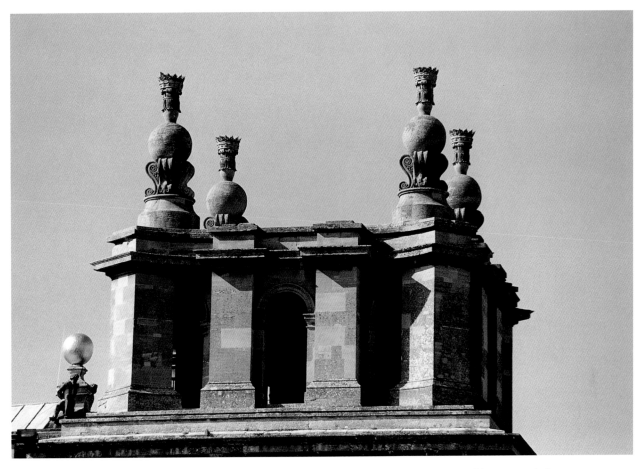

171 Towers at Blenheim crowned by giant finials of upside-down French fleurs-de-lys supported by cannon balls.

of Marlborough as a worthy successor to Trajan, in describing him as 'a British Starr, the brightest Europe has yet at any time, ever Seen'. Such belief in a reborn Golden Age appeared to be supported by the new knowledge flowing from the Royal Society,[82] the increase in trade facilitated by peace and exploration, the restored and reformed constitutional monarchy and the revived Church of England (ultimately symbolized by Hawksmoor's London churches). The Treaty of Ryswick of September 1697 had marked the albeit temporary end of hostilities between France and England, and increasingly liberal conditions of trade enhanced the wealth of the new Whig aristocracy.[83] John Sturt's dedication to Queen Anne of John James's 1707 English translation of Pozzo's *Perspectiva pictorum et architectorum* (1693) celebrated an expected artistic supremacy under Anne which would match the military glories under Marlborough. It was noted in Chapter 1 that together with Wren and Vanbrugh, Hawksmoor endorsed the book, which was to be found in his library (lot 93). It might be reasonable to suppose that both he and James saw their collaboration on the London churches, after 1717, as part of this artistic

172 Temple of Mars Ultor, from the fourth book of Andrea Palladio's *I quattro libri dell'architettura* (1570), ch. vii, p. 16.

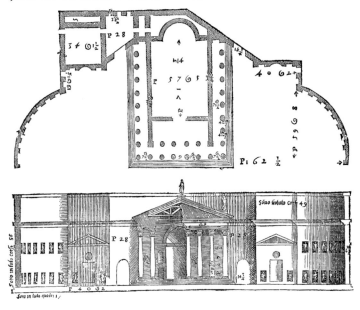

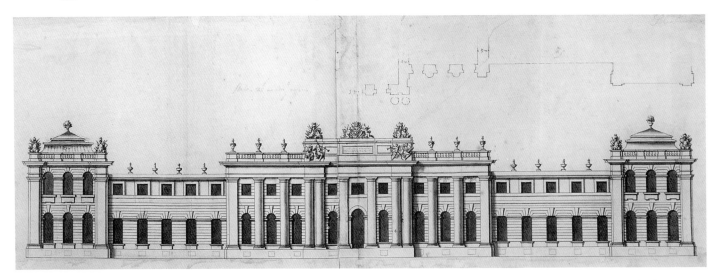

173 Hawksmoor's drawing illustrating the original Doric theme of the south façade of Blenheim, c. 1704–5 [Bodleian Library, Oxford].

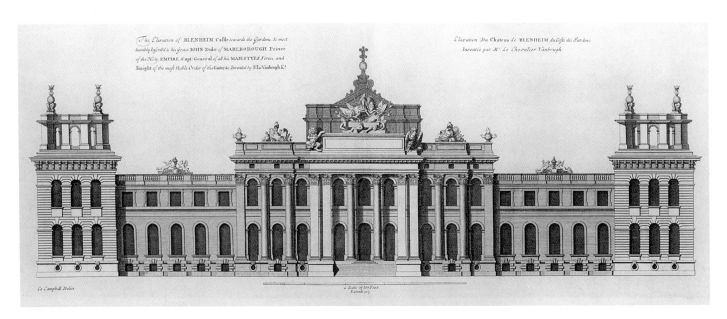

174 Garden front of Blenheim, from the first volume of Colen Campbell's *Vitruvius Britannicus* (1715).

rebirth. Indeed Sturt's dedication had expressed a hope that 'Whitehall is to be Raised from its ruins', having noted 'The Great Dispatch lately given to those Noble Fabricks of St Pauls, Greenwich-Hospital, and Blenheim'. Of these, Blenheim was perhaps the most provocative symbol of Whig ambitions, built as it was at vast expense by the State to glorify the recently ennobled Whig Duke. For with its crowning statue of Pallas Athene – the embodiment of the warrior-artist – the house openly celebrated the harmony between military and artistic glory.

This marriage has also been seen expressed at Castle Howard – equally a product of Whig culture. Carlisle

was an ardent campaigning Whig,[84] and like Vanbrugh he was a prominent member of the Kit-Cat Club that flourished during the time the house was being built, around 1705.[85] Vanbrugh was chosen as architect precisely because of his Whig affiliations, and evidently discussed the design of the house with fellow Kit-Cat members.[86] The internal decoration of the house can be seen to celebrate the Whig triumph in classical, emblematic terms: the dome of the hall was painted by Gianantonio Pellegrini with a scene depicting the 'Fall of Phaeton' which had followed Apollo's permission to drive the chariot of the sun (Fig. 175). Contemporary observers could not fail to identify the replacement

of French ambitions towards absolutism with Whig ones towards liberty.[87] Moreover, the Whig's confidence in their age might equally be seen reflected in Hawksmoor's garden monuments – the Temple, Pyramid and Mausoleum – recalling as they do the great eras of history here, as it were, revived and renewed. Lady Irwin followed her description of these monuments as 'Grecian, Roman and Egyptian' by proudly heralding the modernity of her father's Mausoleum through its having emulated, and even rivalled, its ancient Halicarnassus namesake: 'Tho' that a Wonder was by Ancients deem'd, / This by the Moderns is not less esteem'd'.[88]

Ornamentation and landscaping also played their part in the expression of the Whig cause.[89] Whig country houses – such as Blenheim and Castle Howard, Chatsworth and Lowther Castle – ostentatiously sought to celebrate the possibility of men born in a free society (that is, ruled by a constitutional monarchy) to surpass in grandeur the established Tory nobility.[90] While by tradition the country house had represented the quintessential Tory means to express political power, Tory landowners had sought to build unpretentious houses in harmony with their formalized gardens, not dominating their landscape as at Blenheim and Castle Howard.[91] This restraint was celebrated in Ben Jonson's 'To Penshurst': 'Thou art not, Penshurst, built to envious show / Of touch or marble, nor canst boast a row / Of polish'd Pillars, or a Roof of Gold'. Contemporaries reacted to the new Whig houses by echoing the links between ornamental and moral licentiousness debated since Shute. Roger North, for example, in his Notes of Building (1698) wrote that 'Pomp and ornament are but fancy and chimera of the imagination, and lean on pride, ambition, and envyous comparison'.[92] Most famously of all, the Tory poets Swift and Pope, both on the side of the 'Ancients', clearly identified Vanbrugh's domestic architecture with the over-scaled, vulgar claims of the 'Moderns'.[93] In comparison to the formal restraint characterizing the gardens of Tory landowners, the Whigs favoured a more natural – that is, less formalized – style of garden. This ideal has often been compared with the more natural, post-Glorious Revolution form of constitutional government under the Whigs.[94] The great Whig Prime Minister Sir Robert Walpole advised that 'Loose groves' should be planted to crown 'an easy eminence' with 'happy ornament', and statues and buildings should be positioned to decorate the horizon.[95] During the 1720s he had sought to put these ideas into practice at

175 Dome of the hall at Castle Howard, painted by Gianantonio Pellegrini with a scene depicting the Fall of Phaeton (destroyed).

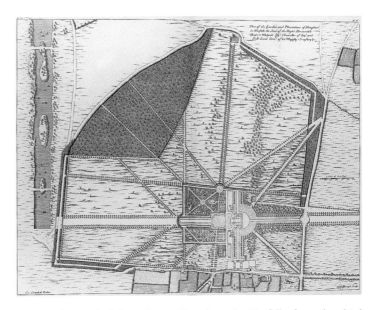

176 Robert Walpole's garden at Houghton in Norfolk, from the third volume of Colen Campbell's Vitruvius Britannicus (1725).

Houghton in Norfolk, which Hawksmoor would have seen illustrated in what the sale catalogue records was 'A Book of Sir Robert Walpole's House at Houghton Hall' (lot 161; Fig. 176). The siting of the Mausoleum at Castle Howard, much like one of Walpole's 'Loose groves', can here again be seen to reflect perfectly the new Whig Golden Age.

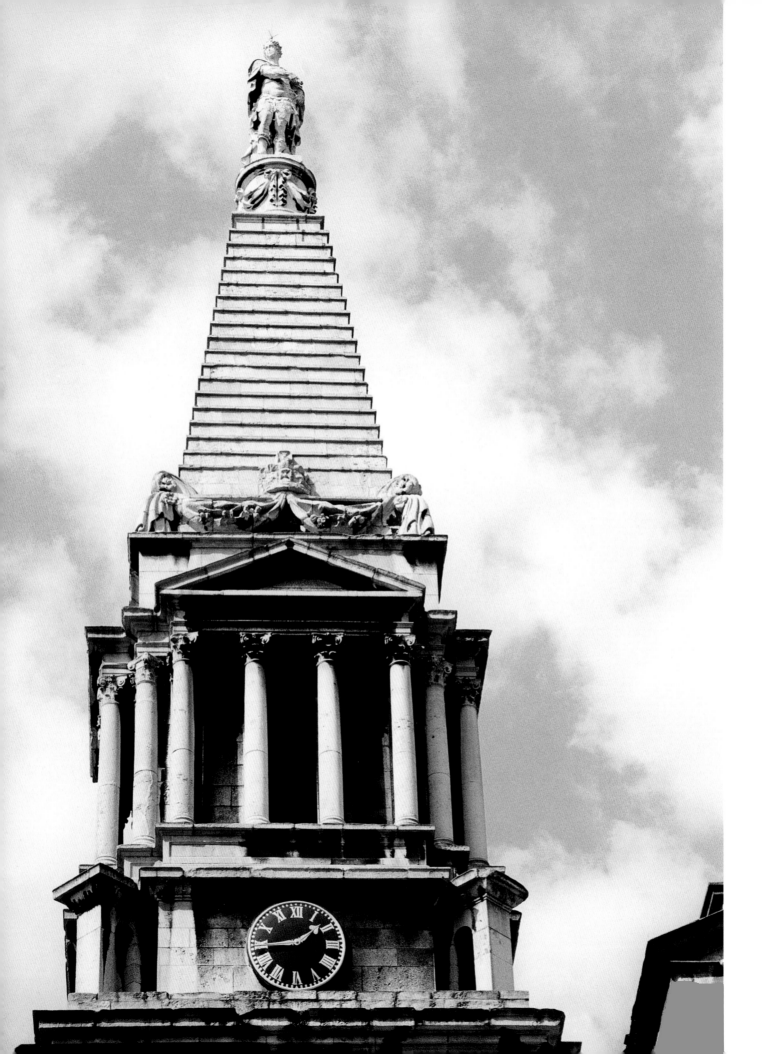

Chapter 6

'A STEEPLE IN THE FORME OF A PILLAR': THE MEMORIAL TOWERS ON THE LONDON CHURCHES

HAWKSMOOR'S SKETCH PLAN OF THE EAST GATE of Solomon's Temple, if dated around 1724, was preceded more than a decade earlier by a similar investigation into the plan of an archetypal temple drawn from architectural and ecclesiastical history, in the form of the hypothetical 'Basilica after the Primitive Christians' (see Fig. 60). In this case the relationship between a Christian archetype and Hawksmoor's actual buildings is obvious, given that the 'basilica' was put forward as the Commission's 'General Modell', requested in 1712, and that it prefigured the planning of a number, if not all (due to site restrictions), of his six London churches. These churches are probably Hawksmoor's best-known buildings. They are St Alfege in Greenwich (1712–18), St Anne in Limehouse (1714–30), St George-in-the-East in Wapping, Stepney (1714–29, gutted in 1941),[1] Christ Church in Spitalfields (1714–29, the rectory of 1726), St Mary Woolnoth in the City (1716–24) and St George in Bloomsbury (1716–31, the demolished rectory of 1726–8) (Figs 178–83). The very names of these buildings celebrated the institutions they collectively sought to monumentalize: St Anne, the Queen; Christ Church, the High Church of the Tories; St George and St George-in-the-East, the new King and the patron saint of England. Added to this list should be the two churches Hawksmoor designed in partnership with John James – St Luke, Old Street in Finsbury (1727–33) and St John, Horselydown in Bermondsey (1727–33, demolished above the plinth in 1970 although the vestry and parsonage of 1733–5 survive) (Figs 184–8). Hawksmoor also prepared a scheme for remodelling and refacing St Giles-in-the-Fields in north Soho (1730) that remained on the drawing board (Figs 189–91).[2]

These unusual buildings, with their giant keystones and triglyphs, broken pediments and monumental towers, formed part of an ambitious and largely unrealized plan for fifty new churches in London. They were paid for from the coal tax initially levied to fund the rebuilding of churches after the fire of 1666, and were guided by a series of Commissions, the first of which was set up by the new Tory government in 1711. The first Commission was comprised of Church of England divines (mostly High Churchmen), elected officials (mostly Tories) and architects in the pay of the crown. This last group comprised Wren as Surveyor of the Royal Works, his son and clerk (also Christopher), Vanbrugh as the Work's Comptroller and Thomas Archer as Groom Porter in the royal household and amateur architect of note. Vanbrugh's involvement led to his recommendations to the Commission concerning the appropriate appearance of the new churches, quoted earlier, and he went on to submit his own designs, but none was accepted.[3] On 10 October 1711 Hawksmoor was appointed one of the two salaried surveyors serving the Commission, alongside another Wren pupil, William Dickinson (c. 1671–1725). Both men had been involved in the rebuilding of the City churches after the Great Fire, when the young Hawksmoor worked on the steeples.[4] Hawksmoor served right up to the Commission's dissolution in 1733, whilst Dickinson was destined to be followed in the post first by Gibbs, in 1713, and then from 1717 onwards by James. Apart from direct responsibility for the churches being built to his designs, Hawksmoor's duties covered practical aspects of all the Queen Anne churches. For example, on 14 January 1721 the Commission minutes record that 'Mr Hawksmoor layd before the Board, Estimates of finishing the Strand and Deptford Churches, covering Spitlefields Church, and Securing the other Churches from weather'.[5] He was even instrumental in establishing the new parishes, for on 29 June 1724 he 'laid before yᵉ Board a Draught of yᵉ Division of yᵉ Parish of Deptford, with a District of yᵉ new Parish'.

Quakers, Presbyterians, Anabaptists and other dissenters from the Church of England had grown in number under the relaxed Protestant atmosphere which marked the policy of successive Whig governments

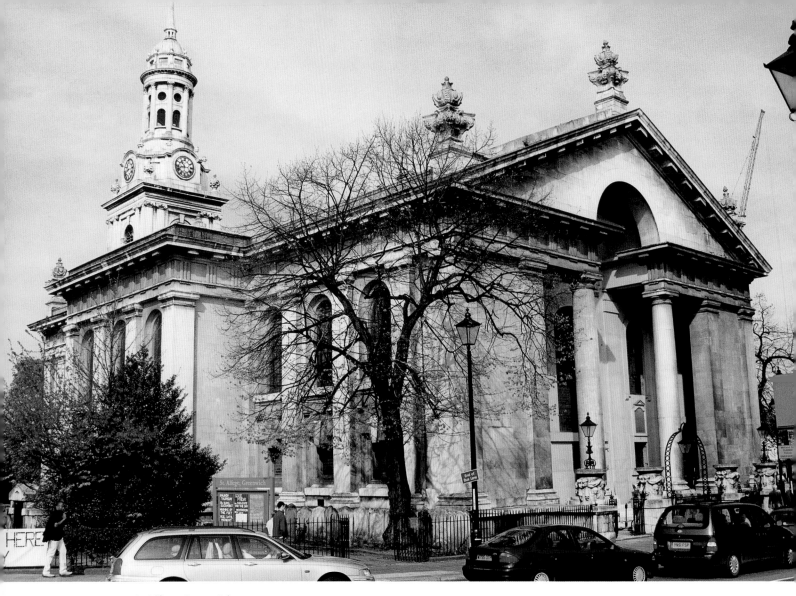

178 St Alfege, Greenwich, 1712–18.

under William and Mary. High Churchmen opposed any accommodation with the dissenters and, together with the Tories (their natural political allies), they held that the state religion under the pious reign of Queen Anne (from 1704) needed renewed support. When the Tories came to power in 1710 the High Church part enjoyed a complete (if short-lived) revival, of which the fifty new churches were to have been a tangible expression. However when Anne died in 1714 the Tories lost power and were replaced by Whigs on a new, third Commission of 2 December 1715. Work continued on the churches because the increase in London's suburban population had left existing parish churches unable to cope. In 1725 Daniel Defoe estimated that in Spitalfields alone 350 acres of meadow had been covered with buildings 'which are all now close built, and well inhabited with an Infinite Number of people, I say, all these have been built new from the Ground, since the Year 1666'.[6] One of the most urgent cases

for the Commission's attention was St Alfege at Greenwich, the roof of which had collapsed in November 1710, while the neighbouring parish of Deptford also pressed its case in Parliament for a new church. In addition to Greenwich, a total of forty potential sites were allocated to various parishes, including five (the largest single share) to the parish of St Dunstan in Stepney.[7] One such site was Hare Field in the hamlet of Bethnal Green, which was surveyed in November 1711 and provided the location for Hawksmoor's model 'basilica' embodying what he saw as the 'Manner of Building the Church as it was in y[e] fourth Century in y[e] purest times of Christianity'.[8]

179 (*facing page*) St Anne, Limehouse, 1714–30.

180 (*page 134*) St George-in-the-East, Wapping, Stepney, 1714–29 (gutted in 1941).

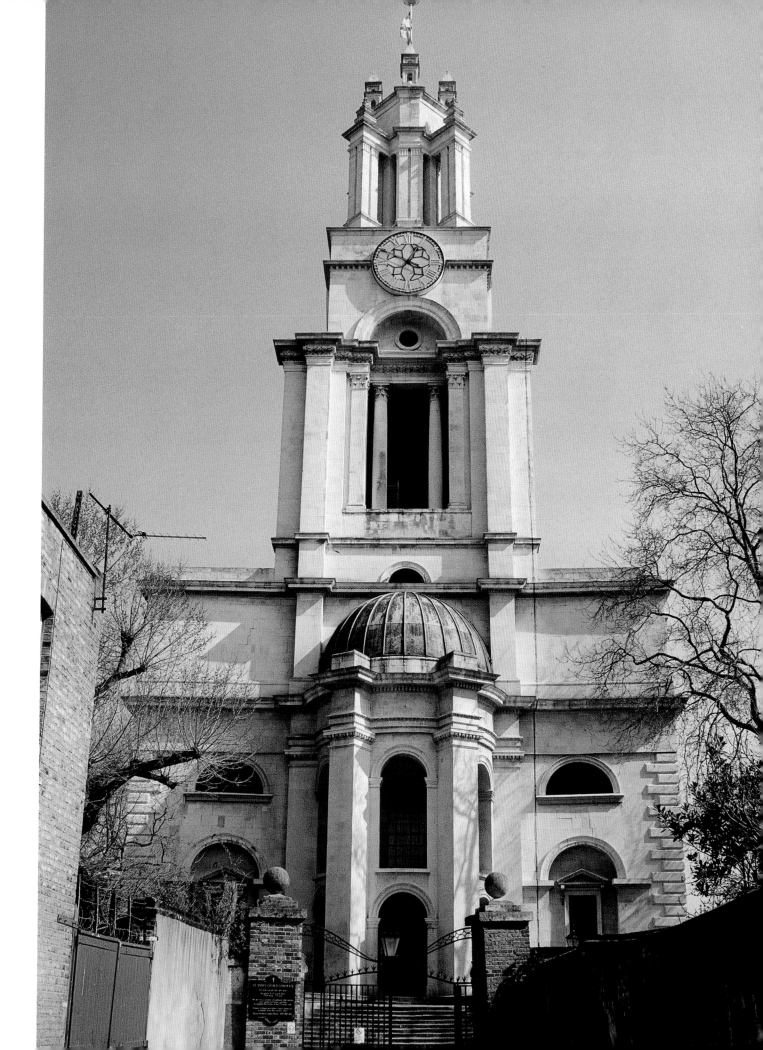

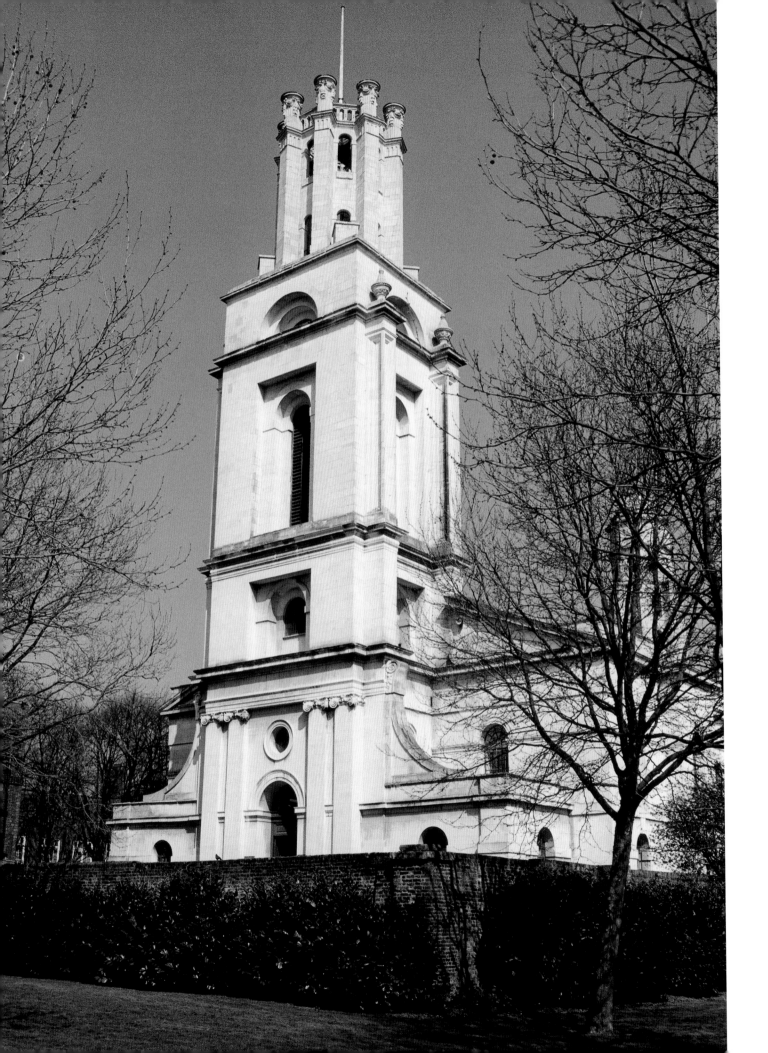

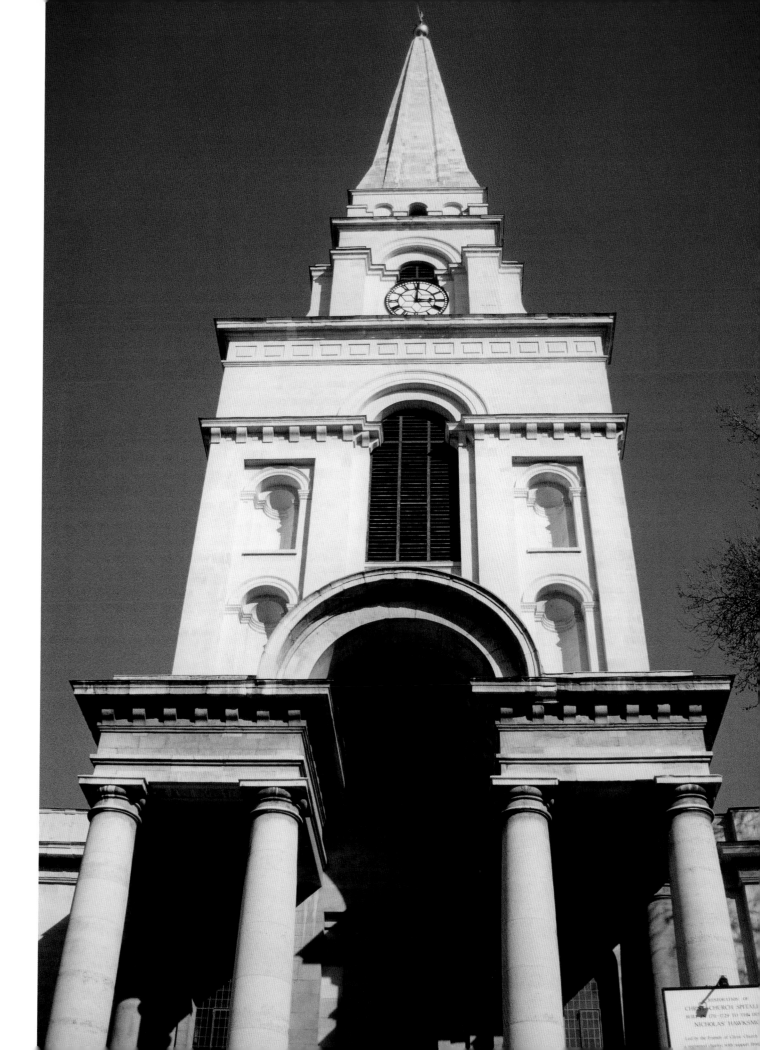

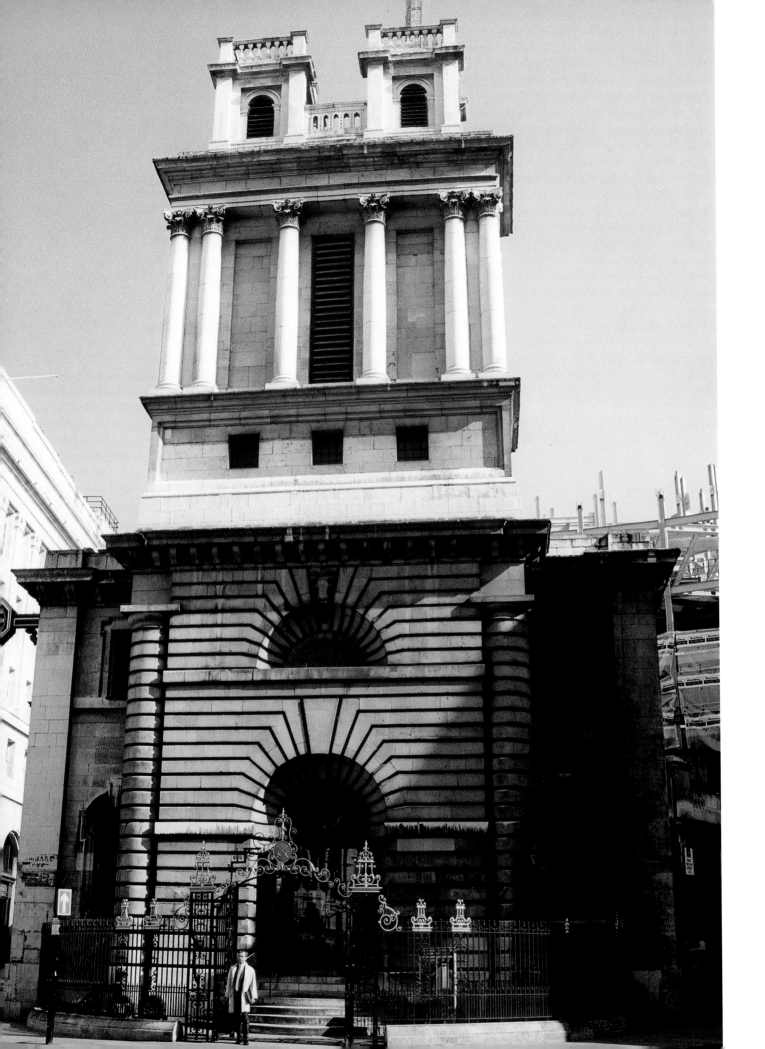

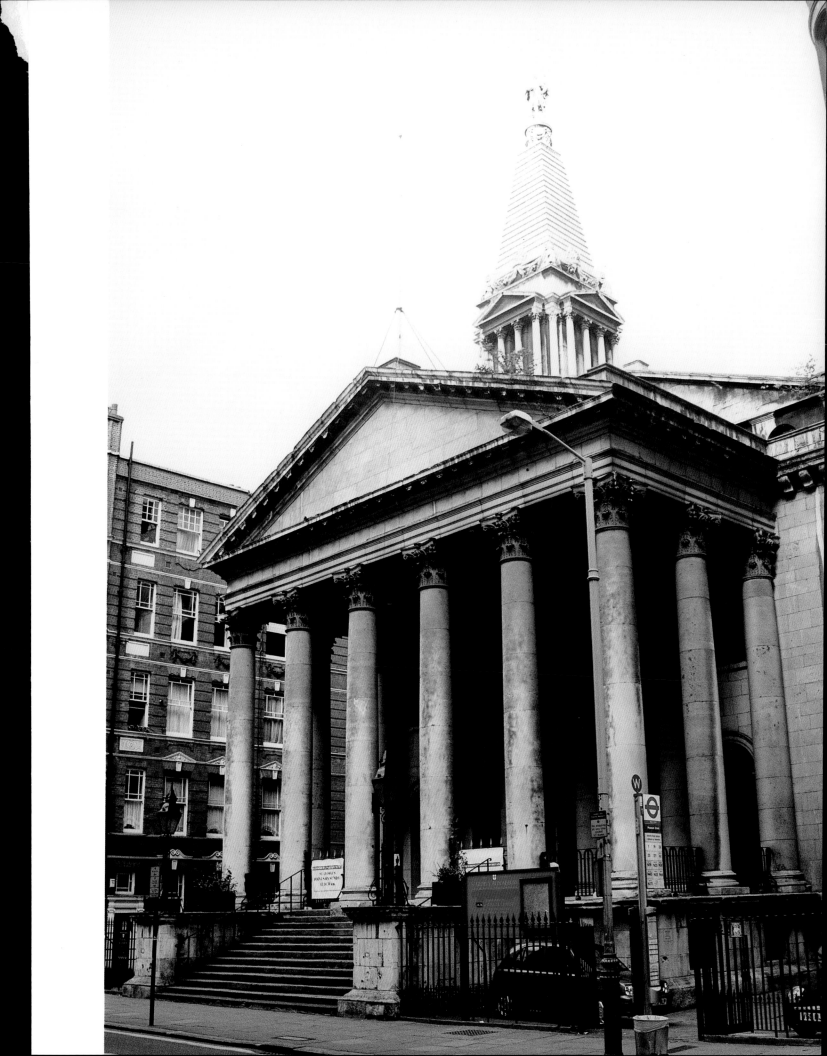

184　Engraving by T. Lester
of St Luke, Old Street,
1727–33, before damage
during the Second World War
[British Library, London].

185 (*right*)　The tower of St
Luke, Old Street.

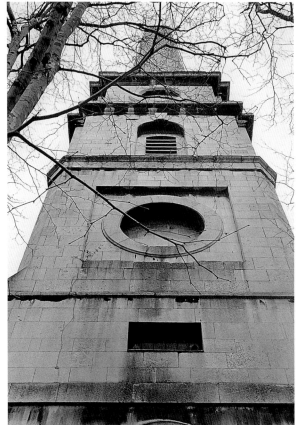

181 (*page 135*)　Christ
Church, Spitalfields, 1714–29.

182 (*page 136*)　St Mary
Woolnoth, City of London,
1716–24.

183 (*previous page*)　St George,
Bloomsbury, 1716–31.

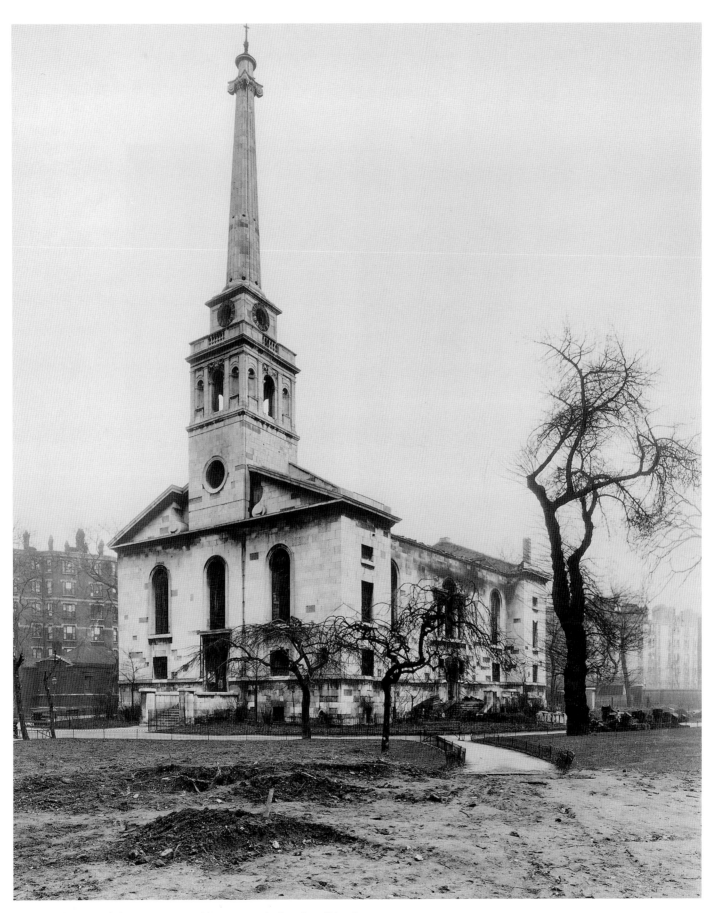

186 St John, Horselydown in Bermondsey, 1727–33, before demolition in 1970.

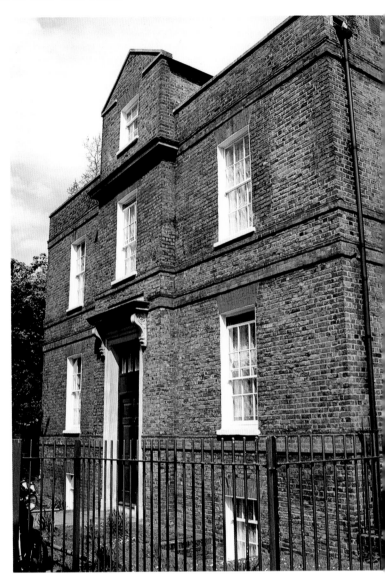

187 Vestry at St John, Horselydown, 1733–5.

188 Parsonage at St John, Horselydown, 1733–5.

'BASILICA AFTER THE PRIMITIVE CHRISTIANS': PRIMITIVE CHRISTIANITY AND HAWKSMOOR'S CHURCHES

Hawksmoor collected a large number of works by leading English Protestant theologians, perhaps most notable among which, with regard to his interest in primitive Christianity, was that by Edward Stillingfleet.[9] Stillingfleet concerned himself with the supposed origins of Anglicanism in the early, 'primitive' Christian Church. The so-called primitive Christians had been described by Eusebius and Zonaras and, as the first practitioners of Christianity, were regarded by contemporary theologians (and by High Churchmen in particular) as having practised Christianity in its purist form. Not surprisingly, they became identified with the unadulterated virtues first represented in stone by Solomon's Temple.[10] With its use of the Greek language, the contemporary Orthodox Church of the Near East was considered by many – including George Wheler – to be the primitive Church's least corrupted descendant.[11] As Chapter 2 outlined, the consequent recourse to early Christian architecture in Greece and the Near East allowed theologians effectively to bypass the Italian peninsula, with all its pagan and Catholic connotations, as a further symptom of the decline in canonic status of Classical antiquity promoted by the 'Moderns'. Early Christian architecture recalled a time, at first under Constantine and later under the Byzantine emperors,

The West Front.

(1)

The Spire

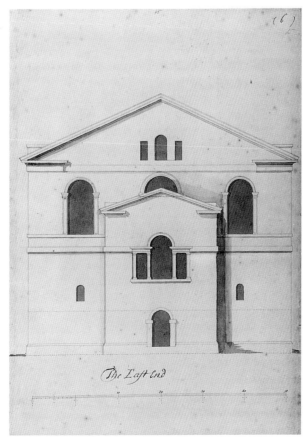

(6)

The East End

189–91 Hawksmoor's scheme
for St Giles-in-the-Fields,
north Soho, 1730 [British
Library, London].

when Church and State were united – a union that the Church of England hoped it had finally achieved under Queen Anne.

The 'basilica' designed by Hawksmoor reflected this contemporary interest in particular ways. Clearly it is not a prototypical Roman basilica (with colonnaded aisles and apse), theologians having made clear that the term 'basilica' traditionally referred to a church in the general sense.[12] Nor does it reflect any actual early Christian church. As has been seen, Hawksmoor was dismissive of their remains, observing to the Dean of Westminster that Constantine had built the Basilica of St Peter's 'in a very unskillfull manner'.[13] Rather, it reflected current idealizations of primitive churches through shared features such as galleries for women, houses for church officials and charity schools. There is an obvious parallel between his plan and that of Wheler's, for example, published in *An Account of the Churches, or Places of Assembly, of the Primitive Christians* (1689), recalling his travels in the Levant discussed in Chapter 2 (see Figs 57, 58).[14] Also influential was Peter King's *An Enquiry into the Constitution, Discipline, Unity, and Worship of the Primitive Church* (1691), since King served as one of the Commissioners. So too was the third volume of Joseph Bingham's *Origines Ecclesiasticae: or, the Antiquities of the Christian Church* (1711), both directly through an engraved plan of an ancient church that Hawksmoor had evidently studied, and indirectly through 'observations' made to the Commission by the theologian George Hickes concerning Vanbrugh's recommendations.[15] Drawing on Bingham, Hickes wanted to place a baptistery at the west end of the new churches with a font 'large and deep enough for immersion'.[16] Following this – and reflecting Guillaume-Joseph Grelot's description of the narthex of Hagia Sophia[17] – the porch in Hawksmoor's 'basilica' was annotated 'The place for the font for yᵉ Converts which was in yᵉ Porch – & to be immers'd'.[18] Hickes agreed with Vanbrugh 'not to make churches burying places, but to purchase Coemetaries in the skirts of the town', and then place the bodies in 'large Cloysters, wᶜʰ would serve for a shelter in all ill wether for the people, and render the walls of wᶜʰ monuments may be built . . . or monumental tables of inscriptions fixed in them'. Hawksmoor echoed these prescriptions by noting on his 'basilica' plan that there would be 'No burying in yᵉ Church . . . but Separatly', and by including a vaulted hemicycle 'and a Cloyster for inscriptions'.

It was pointed out that in forming the Commission's 'General Modell' of 1712, Hawksmoor's paper 'basilica' influenced his subsequent stone churches – a relationship made clear by the fact that it was planned for an

actual site. Its detached tower and projecting bays are very similar to the more orthodox basilica forms of St Alfege in Greenwich and St George-in-the-East for example. Preliminary drawings of the latter show its development from the model plan (Figs 192, 193).[19] Elsewhere, site restrictions obviously limited Hawksmoor's ability to implement his model – such as at St George in Bloomsbury with its southern entrance – but the Stepney churches may have been intended to evoke a primitive Christian presence through being 'basilican' in flavour if not in archaeological fact.[20] Indeed, as the Bloomsbury tower makes abundantly clear, Hawksmoor also used other, more admonitory 'primitive' forms, this time pagan in origin, in his churches. These elements are all the more striking in their unprecedented location silhouetted against the sky, although Hawksmoor's intentions behind these rooftop elements have particularly puzzled historians.[21]

'THE STEEPLES OR TOWERS EXCEPTED': HAWKSMOOR'S MEMORIAL TOWERS

While the Commission thus controlled much of the arrangement and form of the churches, the towers and steeples were not seen as part of the model plan which was to be determined by them. On 16 July 1712, following the sub-committee meeting five days earlier under George Smalridge, the full Commission – with Wren and Vanbrugh in attendance – endorsed the earlier minutes 'that one general design, or Forme ['Modell' crossed out], be agreed upon for all the fifty new intended Churches'. The only addition to the earlier minutes was the note: 'the Steeples or Towers excepted'.[22] Hawksmoor evidently took this distinction to heart, for on 12 November 1725 he was reprimanded by the Commission for ordering the (now destroyed) heraldic sculpture on the Bloomsbury tower to be carried out (by Edward Strong junior) 'with out their directions or Privity' (see Fig. 5). While acknowledging that 'some sort of Decorations were necessary in these Places', the Commission admonished 'Mʳ Hawksmore to be more carefull for the future how he Engages the Board in any such Expence without their Directions and consent on pain of bearing the charges thereof himself'.[23] The towers might thus be seen as particularly expressive of Hawksmoor's unfettered vision. For here he drew less on primitive Christian models cultivated by contemporary theologians than on pagan ones close to his heart.

Following Alberti's advice in his eighth book that towers 'provide an excellent ornament, if sited in a

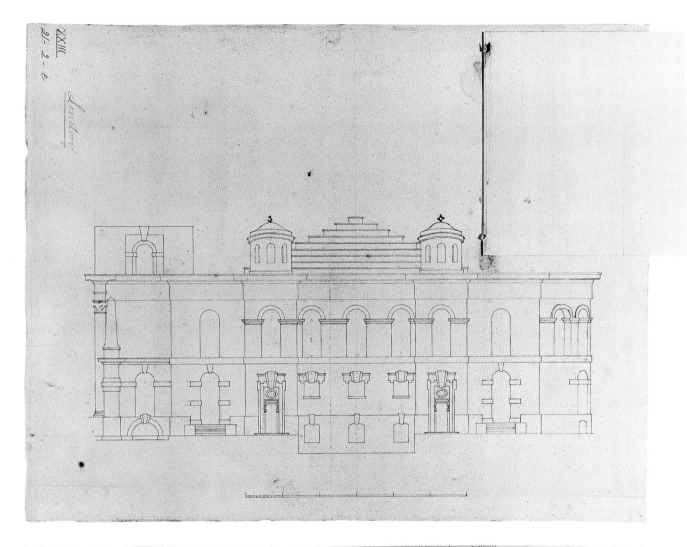

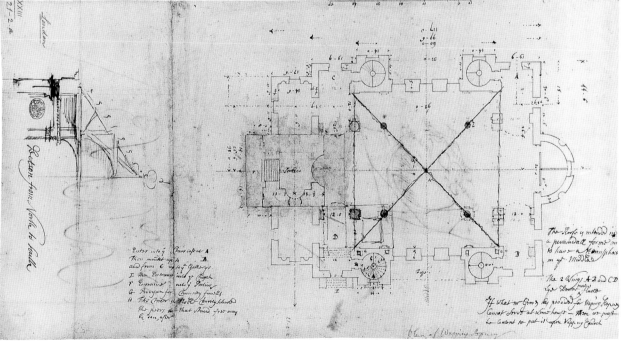

192 and 193 Hawksmoor's preliminary south elevation and plan for St George-in-the-East, post-June 1714 [British Library, London].

suitable position and built on appropriate lines',[24] Wren
had considered the design of the steeple an important
opportunity for the architect to display his powers of
invention. His general advice to a 'friend' on the Com-
mission recommended that

> Such Fronts as shall happen to lie most open in View
> should be adorned with Porticoes, both for Beauty
> and Convenience; which, together with handsome
> Spires, or Lanterns, rising in good Proportion above
> the neighboring Houses . . . may be of sufficient
> Ornament to the Town, without a great Expence
> for enriching the outward Walls of the Churches, in
> which Plainness and Duration ought principally, if
> not wholly, to be studied.[25]

It was noted that his 'Warrant' design for St Paul's had
included a steeple after the exotic model of a Chinese
pagoda (see Fig. 43). Equally, Vanbrugh followed Wren
when advising that, 'for the Ornament of the Towne,
and to shew at a distance what regard there is in it
to Religious Worship; every Church (as the Act of
Parliament has provided) may have a Tower'.[26] These
towers were to be 'High and Bold Structures, and so
form'd as not to be subject to Ruin by fire'.

Hawksmoor was particularly concerned with the
rooftops of his buildings – famously describing the
statues and other rooftop elements at Blenheim as 'emi-
nencies'[27] – and his church towers became the subject
of separate drawings and detailed study.[28] For Gothic-
style churches he was happy to adapt either a spire or
a tower form. In his letter to Dean Wilcocks of 18
March 1735 he admires a number of cathedral spires,[29]
and he used medieval tower forms in his designs for
the west end of the Abbey and for the bell-stage and
pinnacles of St Michael, Cornhill (see Figs 82, 86).
In both these cases existing work clearly dictated
the style of new work. Elsewhere Hawksmoor freely
interpreted traditional forms, as at St Mary Woolnoth
where the tower of the demolished church was recalled
through the twin-towered arrangement of the new
building – a characteristic medieval church form,
as Hawksmoor acknowledges concerning the Abbey
(see Fig. 65).[30] In situations where the design was
all'antica, antique temple architecture did not provide
any immediate models for church towers or steeples.[31]
Moreover contemporary reconstructions of pri-
mitive Christian churches were without spires. As
Hawksmoor's Bloomsbury tower, with its origins in the
Halicarnassus mausoleum, and his and James's obelisk
and column spires indicate, he turned in this vacuum
to older, pagan funereal and memorial monuments –
quite a number of which were in the form of towers.[32]

Hawksmoor's close interest in funereal architecture
is attested by the sale catalogue of his drawings, which
records a (now lost) collection of 'sixty-two designs for
mausoleums' (lot 79). In addition to the Mausoleum for
Carlisle, he produced surviving but unrealized designs
of mausoleums for William III and (most probably)
for the Duchess of Kent (Figs 194, 195).[33] The latter
amalgamates features drawn from archetypal examples
– notably the stone covering Christ's tomb and the
reclining figures of Day and Night from Michelangelo's
Medici tombs. Hawksmoor collected copies of the
main Renaissance and Baroque pattern books on
ancient and modern sepulchres – including publications
by Montano, Bartoli, Rossi and Fontana – which no
doubt comprised 'yᵉ Books of Antiquity' mentioned
in his letter to Carlisle concerning appropriate
Mausoleum models.[34] These books must have been
closely studied by Hawksmoor since, as Chapter 2
noted, both Wren and his assistant identified various
mausoleums as prototypes for the first use of the
Orders. According to Wren the tomb of Porsenna was

194 Hawksmoor's design for a mausoleum for William III,
c. 1702 [Victoria and Albert Museum, London].

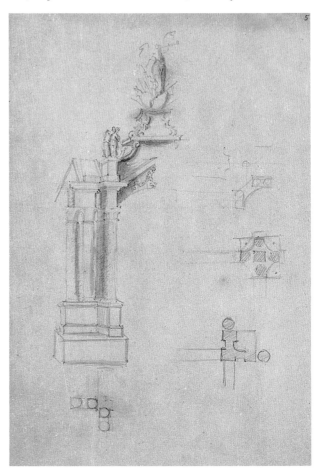

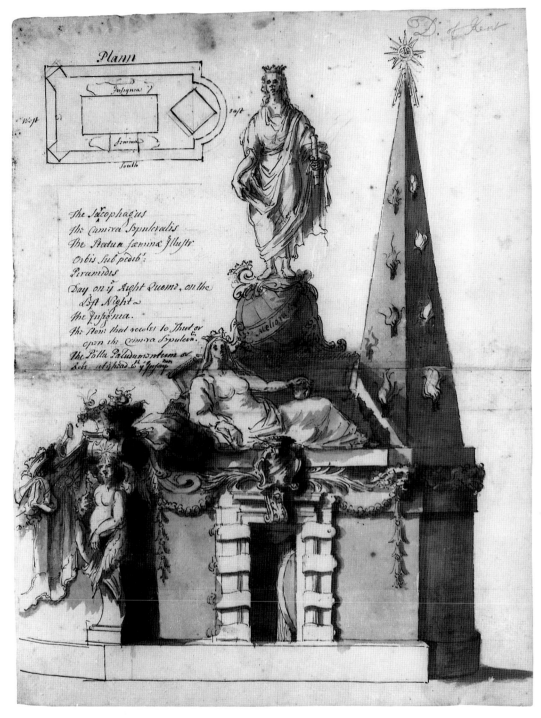

195 Hawksmoor's design for a mausoleum possibly for the Duchess of Kent, undated [Bodleian Library, Oxford].

a 'Stupenious Fabrick . . . of Tyrian Architecture', while the Halicarnassus mausoleum was 'the exactest form of Doric'. This was not the first time that funereal monuments were identified as fundamental models indicative of the origins of *all'antica* architecture. François Blondel's *Cours d'Architecture* (1683) – which Hawksmoor owned (lots 90, 124 and 146) – included an opening plate, entitled 'L'Origine des Chapiteaux des Colonnes', illustrating Vitruvius's story of the origin of the Corinthian capital in a funereal basket atop acanthus, as first sketched by the Greek sculptor Callimachus (Fig. 196).[35] Wren, in Tract II, makes plain

196 'L'Origine des Chapiteaux des Colonnes', from François Blondel's *Cours d'Architecture* (1683).

his faith in this story, over the more modern, Solomonic claims for the capital.[36] Blondel's plate also depicts Doric columns used as grave stelae surmounted by urns; the Ionic capital is also illustrated, wreathed with flowers.[37] A funereal landscape is littered with pyramids, tombs, towers and obelisks all carrying urns. Clearly Hawksmoor would have found Blondel an important Vitruvian source for his – and Wren's – ideas concerning the origins of the architectural Orders traced to funereal forms. Indeed one of Blondel's stelae, a coffered proto-Doric column surmounted by an urn, is almost identical to the apparently unprecedented urn-topped pilasters on the tower of St George-in-the-East – Blondel's work on Vitruvius effectively licensing their non-canonic form (see Fig. 67). On occasions Hawksmoor reveals his source for funereal forms used in his work. In one of his designs for the library at Worcester College, for example, the spandrels of the upper storey have reliefs of urns that he notes were modelled on those from 'the antiquity at Bordeaux' (Fig. 197).[38] This was in reference to the 'Edifice des Tuteles', a Roman structure described and illustrated in Perrault's *Vitruvius* (lot III) (Fig. 198).[39] To an architect of Hawksmoor's obvious preferences, Perrault's

Bordeaux model must have given further legitimacy to burial urns as an essential part of the Vitruvian ornamental language.

While Hawksmoor's use of such novel forms as the proto-Doric column and Halicarnassus tomb on his church towers could thus be validated by reference to antique ornamental prototypes with memorial functions, his forms were designed to serve a more contemporary commemorative purpose. The Bloomsbury 'mausoleum' is surmounted by a Roman altar that forms a pedestal for a statue of George I, who is here canonized by association, via the church's dedication, with St George. The original tomb was crowned with the triumphal chariot of Mausolus, to make clear the memorial purpose of the building, and so the British King also stands in, as it were, for the ancient monarch.[40] Placing a triumphant statue of George I on an altar and tomb had the effect of emphasizing the apotheosis of the King (especially after 1727, the year of his death). Lower down, the Bloomsbury 'mausoleum' was once decorated with the British royal heraldry unilaterally ordered by Hawksmoor, comprising a life-sized lion and unicorn fighting for the crown on the north and south faces, but only the festoons and

crowns remain. Here again general models have been altered by Hawksmoor to reflect local circumstance, following Wren who when using the Halicarnassus mausoleum as the model for the lantern in the Great Model for St Paul's of 1673, Christianized it this time with a crowning statue of St Paul (see Fig. 77).[41] Indeed Wren's designs for funereal monuments to British monarchy based on antique models, discussed in Chapter 2, would have provided an immediate precedent for Hawksmoor's towers with the same memorial purpose.

The hitherto overlooked source of the idea for this memorial tower at Bloomsbury, and for the strange column-steeple at Horselydown, can in fact be traced to the Commission minutes. For on 25 June 1713 it was resolved that 'a statue of her majesty Queen Anne made by the best hands be set up in the most conspicuous & convenient parts of each of the 50 new intended Churches'.[42] Then, somewhat remarkably, on 29 April 1714 it was 'Resolv'd that instead of the statues design'd to be put upon the 50 new Churches, a Steeple in Form of a pillar be built at the West End of the Church to be Erected near the Maypole in the Strand; w^th the Queens Statue on the top of it, w^th Bases capable of Inscriptions, to perpetuate the memory of the building the 50 New Churches' (Item 5). It was 'Orderd that the surveyors Draw and lay before the Comissioners, Designes of such a Steeple in the forme of a pillar' (Item 6). Obviously the Commissioners had in mind the great memorial columns of Rome, with their statues of Roman emperors (which Sixtus V had replaced with the Apostles), of which Hawksmoor was well aware through books in his collection and, most obviously, via Wren's Fire Monument (Figs 199–200).[43] This is crowned with a flaming urn, symbolizing the city's resurrection; but Wren's preference had been for a fifteen-foot high statue of Charles II in Roman costume, described in *Parentalia* (1750) as 'a *Coloss* Statue in Brass gilt, of *King Charles the Second*, as Founder of the new City; in the Manner of the *Roman* Pillars, which terminated with the Statues of their *Caesars*'.[44] On 6 July the sub-committee of the Commission specified the style of their own Strand pillar-steeple as Corinthian, with lions at the base, and by 8 July it had become a free-standing column built 'near the Maypole in y^e Strand'. By 15 July it was recorded that 'Her majesty was of opinion, that the said pillar ought to stand about 50 foot from the Church, and not directly against Somerset House Gate'. This wish clearly stimulated Hawksmoor's unbuilt design for a triumphal column in honour of Queen Anne of the same year, a stimulus unnoted before (Fig. 201).[45] The column is Doric rather than Corinthian, in imitation

197 Hawksmoor's design for the library of Worcester College, Oxford, c. 1717 [Worcester College, Oxford].

198 'Edifice des Tuteles', from Claude Perrault's *Vitruvius* (1684 ed.).

of Wren's Monument and its prototype, Trajan's Column – thus overruling the patron in favour of antique 'correctness'. In conceiving their idea for a column-steeple, the Commission obviously hoped that

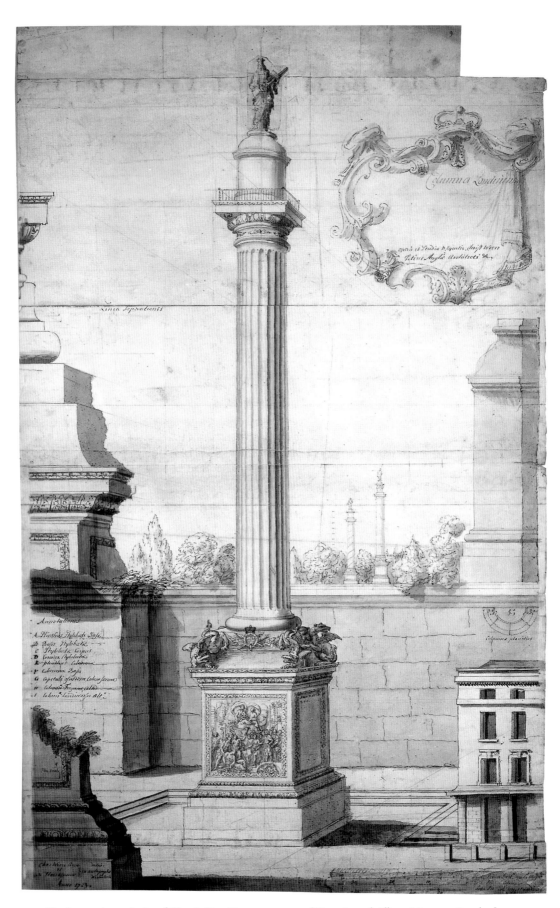

199 Hawksmoor's capriccio of Wren's Fire Monument, 1723 [Victoria and Albert Museum, London].

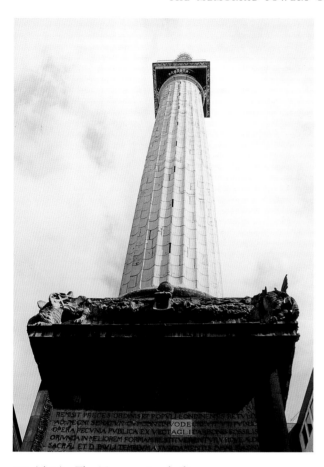

200 (*above*) The Monument as built.

201 Hawksmoor's design for a triumphal column in honour of Queen Anne, 1714 [Prints and Drawings, British Museum, London].

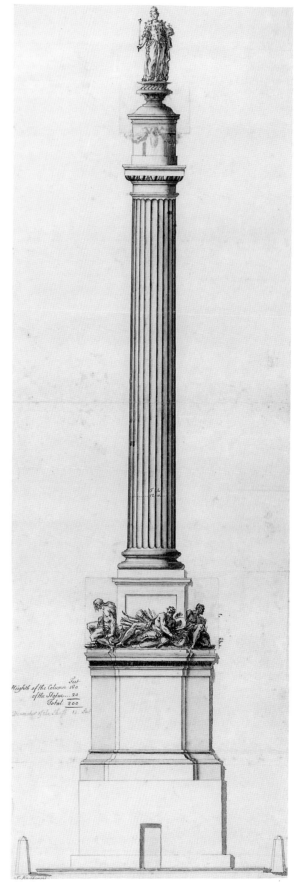

such lofty memorials to royal munificence would help reconstitute London as an imperial, Christian capital, in the spirit of Sixtus V's vision for Rome.

These memorial intentions equally account for why it was originally proposed that the east façade of St Anne, Limehouse, should have a statue of Anne flanked by two pyramids, while at one stage the west tower was also to have a statue, again probably of the pious queen (Figs 202, 203).[46] An engraving of the east elevation of St Alfege by Jan Kip, dated 1714 (the year of the queen's death), depicts a statue of Anne above the central window, flanked on the pediment by urns (Fig. 204).[47] Hawksmoor's correspondence with the Commission records his enthusiasm for these statues,[48] although significantly enough none was ever put in place. Nor were any planned after Anne's death and the succession of a Hanoverian monarch that may well have rendered difficult any sculptural celebrations of the old queen, as the Bloomsbury tower – with its statue of George

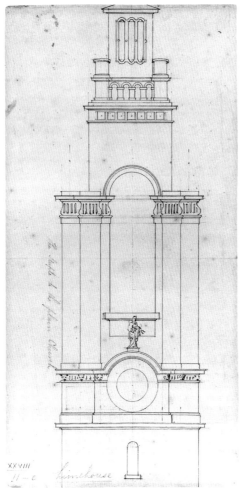

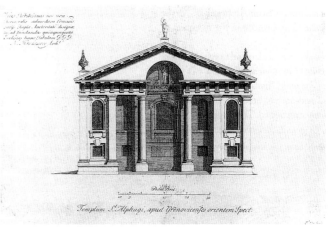

204 (*above*) Engraving of the east elevation of St Alfege by Jan Kip, 1714.

202 (*top*) Hawksmoor's preliminary drawing for the east façade of St Anne, Limehouse, ?early 1714 [British Library, London].

203 Hawksmoor's preliminary drawing for the west façade of the tower of St Anne, Limehouse, ?early 1714 [British Library, London].

rather than Anne – seems to confirm.[49] However, the memorial meaning behind Hawksmoor's church iconography could not have been made more obvious to contemporaries, especially to the Commission, even in the absence of statues. For this meaning was signified above the cornice through a variety of funereal forms which Hawksmoor understood, following Blondel and Wren, as antique ornamental prototypes commemorating the memory of their royal builders.

MAUSOLEUMS, OBELISKS AND URNS: HAWKSMOOR'S ROOFTOP 'GARDEN OF REMEMBRANCE'

Hawksmoor would have been well aware of the memorial origin and meaning of the forms he used on his churches. Alberti observed in his eighth book that the Romans had placed upon their tombs 'a column, pyramid, cairn, or similar large structure, whose primary function was not to preserve the body but to preserve the name for posterity'.[50] Serlio recorded in his third book that, concerning the obelisk placed by Domenico Fontana in front of St Peter's, 'it is of Egyptian stone and in its apex are said to be the ashes of Gaius Caesar'.[51] The memorial purpose of the Mausoleum at Castle Howard was underlined by Hawksmoor when noting to Carlisle that 'There are many forms of this nature of fabrick, built to yᵉ Memory of illustrious persons'.[52] And he did the same when justifying Greenwich Hospital by observing:

> The great Men of the World heretofore, to perpetuate their own Memories, and their great Actions, among other Things had recourse to the liberal Arts; particularly to that of Architecture; sometimes by erecting useful Structures for the Good and Benefit of Mankind, and sometimes for their Grandeur only. Such as the Pyramides, the Monumental Pillar of *Trajan*, the great Tomb of *Porsenna* King of *Tuscany*, and infinite others.[53]

Hawksmoor's churches – with their royal patron and elevated pyramids, monumental pillars and (empty) mausoleums – could only have been projected by their architect as the latest manifestation of this tradition. Indeed the vitality of these forms as memorial structures is attested by the Blenheim obelisk, and by his use of them in mausoleum designs for Dr Radcliffe (c. 1715) (Fig. 205) and that thought to be for the Duchess of Kent (see Fig. 195).[54] When asked in 1728 to design a memorial at Castle Howard to Lord William Howard, Carlisle's ancestor, Hawksmoor built a pyramid (see Fig. 148) described in Lady Irwin's poem as 'Sacred to Piety

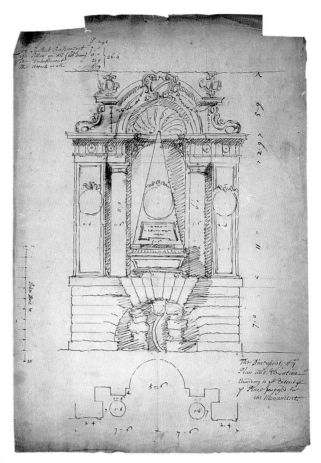

205 Hawksmoor's design for a mausoleum for Dr Radcliffe, c. 1715 [Ashmolean Museum, Oxford].

and filial Tears'.[55] Evidently the pyramids proposed for St Anne, Limehouse, in recalling the most ancient form of royal tombs, must also have been understood as funereal iconography (see Fig. 202).[56] In the event only the giant tomb-like bases were actually built at Limehouse, perhaps due to cost, but the presence of these pyramids on the drawings represents a further reflection of the memorial purpose behind the iconography of the new churches as conceived by the Commission.

Hawksmoor developed his vocabulary of memorial forms when working on Wren's city of London churches, where the spires in particular served as 'prototypes' in the development of his 'style'.[57] However while the funereal forms on his later, Commission churches clearly had a specific association with the intended role of the towers and steeples as royal memorials, on the Wren churches they serve as more general Christian symbols of death and resurrection – appropriately enough given their rooftop location. Wren's St Bride in Fleet Street for example has flaming urns (here again symbolizing resurrection) which

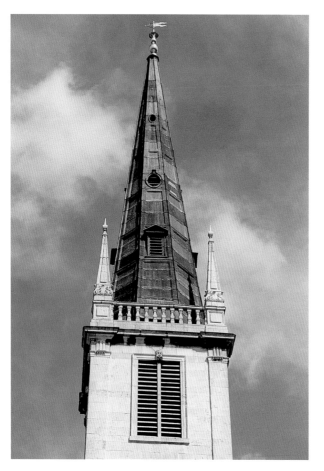

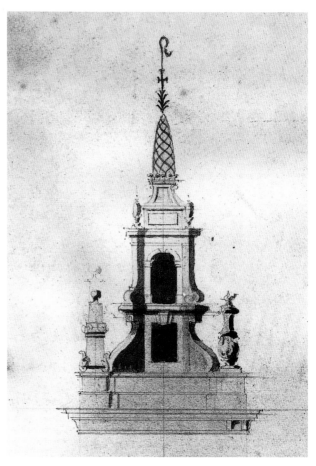

206 Steeple of St Margaret Pattens, London.

207 Hawksmoor's project for a steeple to Wren's St Augustine Old Change in Watling Street, London, c. 1695 [All Souls, Oxford].

208 Urns represented as giant banded eggs in Hawksmoor's elevation of the Fellows' building at All Souls, 1708–9 [Worcester College, Oxford].

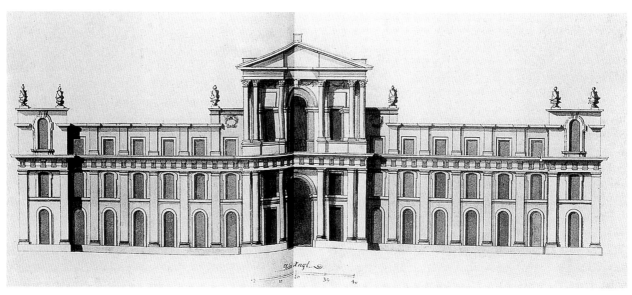

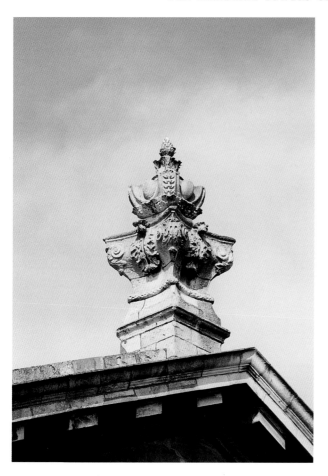

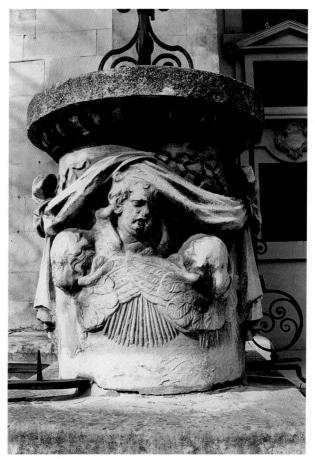

209 Monumental urns at St Alfege.

210 Roman altars at St Alfege.

Hawksmoor probably designed – given that they have the 'four faces' motif, comprising gargoyle-like demons, also embellishing a miniature obelisk at Castle Howard (see Figs 33, 34). The steeples at All Hallows, Bread Street, and at St Margaret Pattens were given balustrades with corner plinths and obelisks designed by Hawksmoor (Fig. 206).[58] Hawksmoor's project of around 1695 for a steeple to Wren's St Augustine Old Change in Watling Street comprised a giant pineapple-like form (Fig. 207).[59] The parapet of the spire of St Edmund-the-King carries a mixture of pineapples and urns, while at St Anne, Limehouse, the lantern urns have what the Work's Book describes as 'pine apples' on their lids.[60] The pineapple, used as a finial, clearly had funereal (or resurrectional) associations for Hawksmoor, since one surmounted his (now lost) first design for the Mausoleum at Castle Howard.[61] Follow-ing the use of urns on Roman tomb structures (as at Petra) and, more generally, in Wren's work, the urn became one of Hawksmoor's favorite elements above the cornices of all types of building – as if he conceived the skyline as the proper place to remind everyone of

their fate.[62] Indeed more often than not urns are the only form of ornament on Hawksmoor's church towers. It was noted that he used urns for a memorial purpose in his designs for the Radcliffe Library, forming part of the conception of the building as a kind of mausoleum (see Figs 120, 121).[63] On some of his All Souls elevations too, urns are represented as giant banded eggs, symbolizing the breaking of the bonds of death at the Last Judgement – appropriate to a college dedicated to 'All Souls' (Fig. 208).[64] (A further elevation has a crowning tempietto that Downes sees as 'another stage in the sequence of circular memorial or funereal buildings which for him culminated in the Mausoleum'.[65])

The commemorative role of the Bloomsbury mausoleum and the unbuilt Limehouse pyramids, both accompanied by their memorial statues of British monarchs, has already been discussed in some detail. In fact above the cornice of his churches Hawksmoor proposed to use the full range of antique funereal iconography – statues and pyramids, obelisks and pillars, mausoleums and stelae, altars and terms, and pineapples

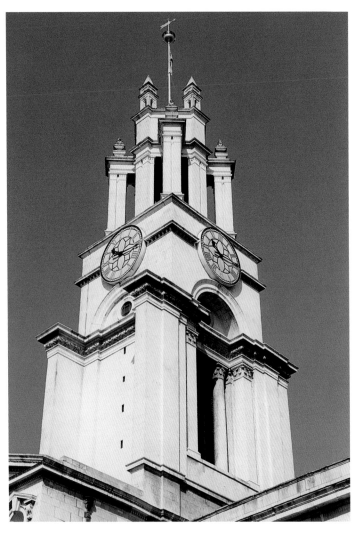

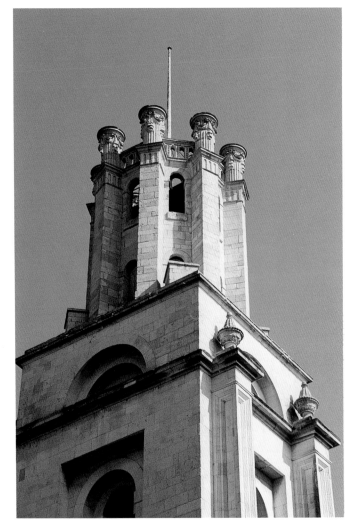

211 Lantern of St Anne, Limehouse.

212 Lantern of St George-in-the-East.

and urns. For in reflecting the Commission's desire for commemorative statues and steeples, these churches were conceived of as forming a monumental rooftop 'garden of remembrance'. At St Alfege the front of the church is ornamented with monumental urns above the cornice, while at the entrance four Roman altars carved with cherubim fuse pagan forms with Christian imagery (Figs 209, 210). Like urns, altars were well enough understood by contemporaries as bound up in ancient rituals of death and resurrection – it was noted that Wren observed concerning the Romans that, 'not only their Altars and Sacrifices were mystical, but the very Forms of their Temples'.[66] At St Anne, along with the eastern pyramids and royal statue, the lantern on the western tower was to have been of a tomb-like form with similar altars at its corners (see Fig. 203).[67] On the finished building the lantern is embellished with columns surmounted by urns and pinnacles with mini-

pyramids (perhaps once again to reflect those on the tomb of Porsenna) (Fig. 211). Langley described the tower as 'a most magnificent pile, exhibiting the most solemn reverend aspect when viewed in front'.[68] At St George-in-the-East, Roman altars crown the top of each of the lantern's corner pilasters, positioned as if to make a sacrificial offering to the sky (Fig. 212).[69] Here Langley felt that the 'tower is of more solemn aspect than that of *Lime-house*, being crown'd with a group of square columns affix'd to a cylinder, each supporting an ornament in manner of an altar, on which the ancients made their offerings'.[70] Below this octagonal lantern are the urn-topped pilasters similar to Blondel's stelae (see Fig. 67). In the first and intermediate designs Hawksmoor placed two obelisks at the edges of the cornice on the west end (Figs 213, 214).[71] The roof was to have resembled an Egyptian stepped pyramid, Hawksmoor noting on a preliminary plan

that: 'The Roofe is intended in a piramidall forme and to have a Hemisphere in ye Middle' (see Figs 192, 193).[72] At Christ Church he used an obelisk – or rather four combined – with a similar 'Hemisphere' or golden ball finial to form a traditional spire rising from a quasi-Doric 'podium'.[73] The funereal conception of the spire is evident from the fact that its form probably evolved from a model church design, with a steeple pyramid and urns, based on the tomb of Mausolus (see Figs 73–6).[74] Urns once ran up the spire's face – three are shown on each side in the final scheme drawing (Fig. 215)[75] – further signalling its funereal associations. They were perhaps intended to recall the large Roman cinerary urn that had been famously discovered in Spitalfields, which Wren presented to the Royal Society and John Aubrey drew (Fig. 216).[76] At St Mary Woolnoth the original intention at the western end was for obelisks at the lower level and two urn lids (with festoons) and a wreathed term at the apex (Fig. 217).[77]

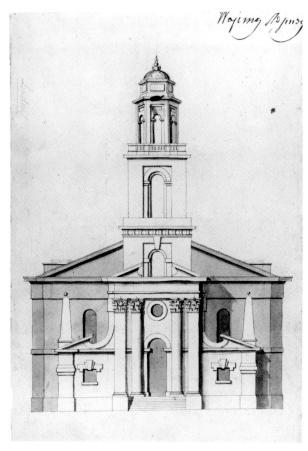

213 Hawksmoor's initial (narrower) design for St George-in-the-East, pre-June 1714 [British Library, London].

214 (below) Hawksmoor's intermediate design for St George-in-the-East, August 1714 [British Library, London].

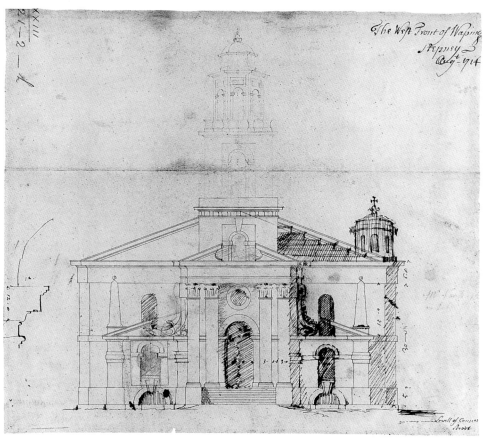

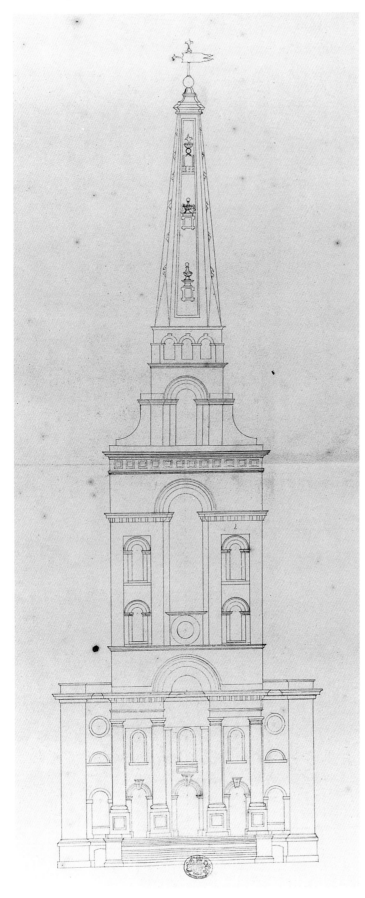

215 Christ Church, Spitalfields, west façade showing spire as originally built, undated [British Library, London].

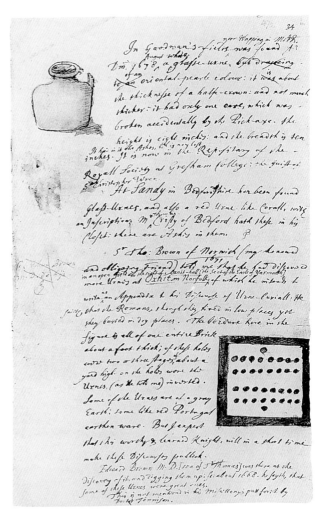

216 Large Roman cinerary urn famously discovered in Spitalfields, drawing by John Aubrey, undated [Bodleian Library, Oxford].

In the built scheme the west front became crowned with two mini-towers reminiscent in their form and details of Roman tombs (Fig. 218; and see Fig. 65).[78] The north front as built has a scrolled *acroterium* (here split in two by a balustrade) such as is often found on the sides or ends of antique sarcophagi (see Fig. 133).[79] Finally, perhaps the most dramatic of these memorial forms are the fluted obelisk emerging from a square base at St Luke and the apparently unprecedented tapering Ionic column at St John (Figs 219, 220). The solar and lunar themes associated with these forms, discussed in Chapter 4, were linked with the iconography of death in Hawksmoor's tomb design most likely for the Duchess of Kent, with its figures of Night and Day (see Fig. 195). Hawksmoor prepared a number of detailed drawings for a tower again surmounted with an obelisk in the course of designing his unrealized scheme for St Giles-in-the-Fields (1730) (see Figs 189–91).[80]

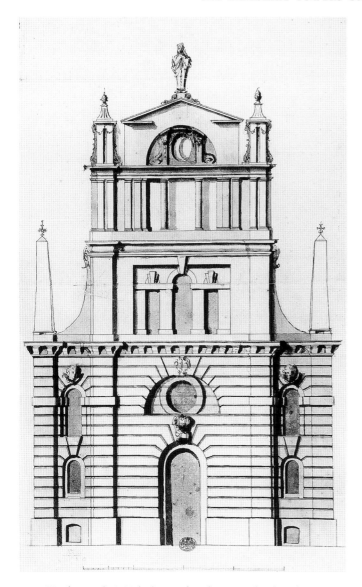

217 Hawksmoor's initial design for the west façade of St Mary Woolnoth, 1716 [British Library, London].

One further church tower built more or less after a design by Hawksmoor was possibly based on an antique funereal monument. For at All Saints in Oxford (c. 1713–20), the square tower with its arched windows and Corinthian tempietto perched above – that is, below the spire – bears an unmistakable likeness (as Lang points out) to the Roman tomb of the Julii at Saint-Rémy in Provence (Figs 125, 221–2).[81] One of the most elaborate antique tower tombs to have survived, this building had been pictured within an imaginary necropolis in the frontispiece of Jacob Spon's *Recherches curieuses d'antiquité* (1683; Fig. 223). Perhaps in Oxford the urns were added to make the reference to the antique tomb more explicit. Indeed in Hawksmoor's surviving design drawing, the tower's resemblance to

the Saint-Rémy tomb is even greater than as built (without a spire and with statues next to the Corinthian columns; Figs 225, 226).[82] Anonymous design drawings for the Oxford tower, very possibly also by Hawksmoor, play with combinations of tempietto, urns and obelisks and point to the consistency of the funereal theme.[83] In the case of this Oxford tower, Hawksmoor's design may have been intended as a specific memorial to Aldrich, as the promoter and architect of the body of the church; whereas in the case of his funereal iconography on the London towers, the nature of the memorial was clearly monarchical.

Thus Hawksmoor's sombre forms reflected Vanbrugh's mood-orientated recommendations to the Commission, when advising that the

> Grace that [church] architecture can produce . . . shou'd generally be express'd in a plain but Just and Noble Stile, without running into those many divisions and breaks which other buildings for Variety of uses may require; or such Gayety of Ornaments as may be proper to a Luxurious palace . . . That for the lights, there may be no more than what are necessary for meer use . . . They likewise take off very

218 Mini-towers at St Mary Woolnoth.

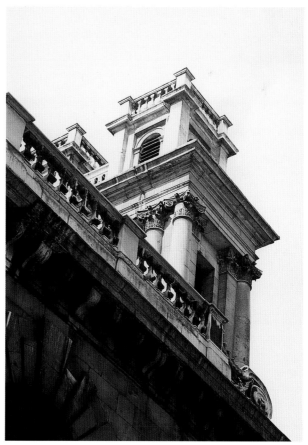

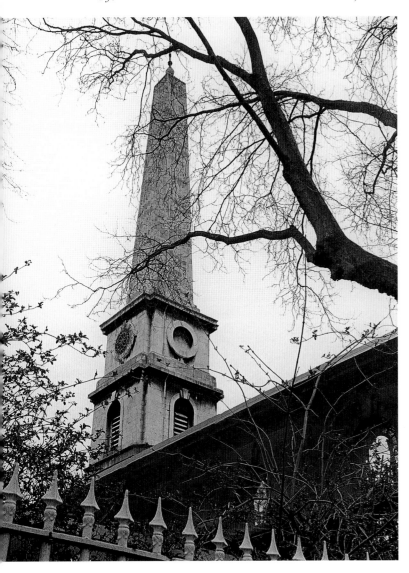

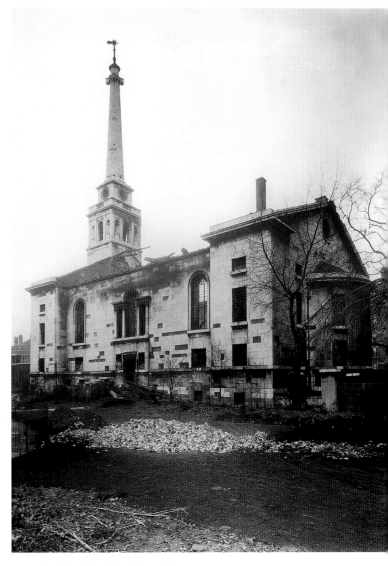

219 Steeple of St Luke, Old Street.

220 Steeple of St John, Horselydown.

much, both from the Appearance and reality of strength of the Fabrick; giving it more the Air of a Gay Lanthorn to be set on the Top of a Temple, than the Reverend look of a Temple it self; which shou'd ever have the most Solemn and Awfull Appearance both within and without.[84]

Indeed just as Hawksmoor's towers reflected this somber sense of decorum, they were contrasted in some instances by more open lanterns. As has been noted, for these essentially functionless elements he again chose a suitable enough antique model – namely the octagonal tower of Andromachus at Athens, known as the Tower of the Winds (Fig. 227).[85] Hawksmoor cites this as his source for the proposed bell tower to his chapel at

Worcester College in Oxford (Fig. 228), a design which is practically identical to his preliminary lantern schemes for St Alfege, St Anne, Christ Church and St George-in-the-East (the last-mentioned modified into a structure resembling the lantern of Ely Cathedral) (Figs 229–32).[86] His consistent use of this octagonal tower as the initial model for his lanterns, irrespective of their ultimate appearance, and his preference for the use of appropriate models, suggests that it held some particular significance for him. Given Wren's link between form and symbolic meaning, this relevance may well have rested with its octagonal shape, which Hawksmoor is careful to preserve in all his lanterns. The octagon had long been associated in the Christian tradition with the *octava dies* or 'eighth day' – the time

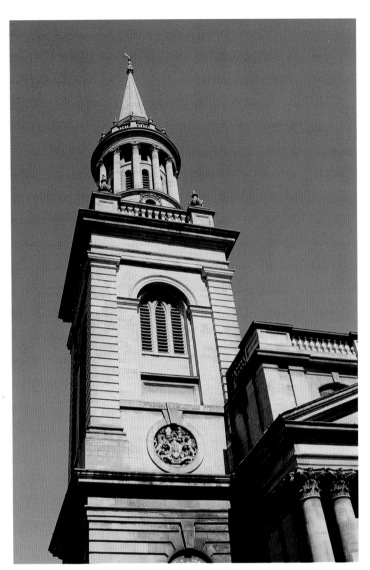

221 (*above left*) All Saints, Oxford.

222 (*above right*) Tower of All Saints, Oxford, built adapting Hawksmoor's design.

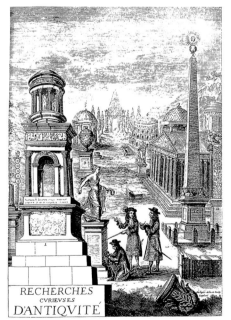

223 (*left*) Roman tomb of the Julii at Saint-Rémy in Provence, France, from the frontispiece of Jacob Spon's *Recherches curieuses d'antiquité* (1683).

224 (*far left*) Elevation of the tomb of the Julii.

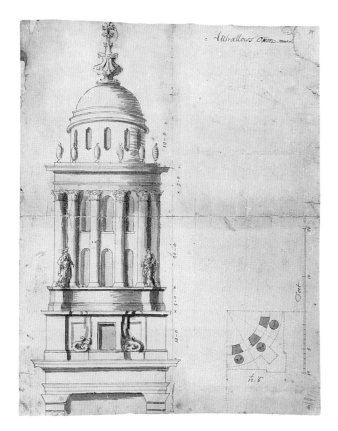

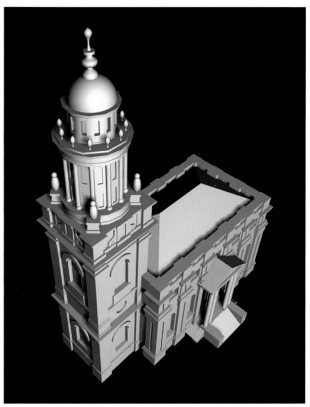

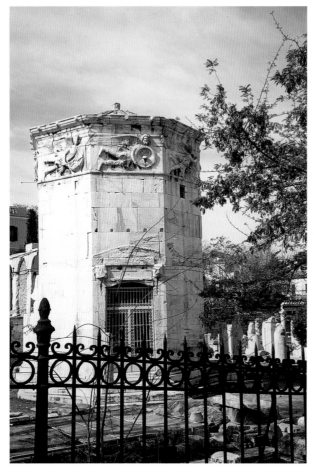

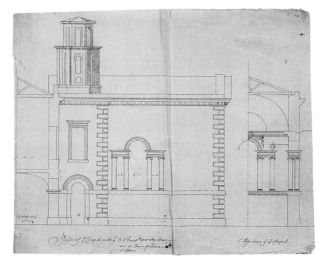

228 (*above*) Hawksmoor's proposed bell tower to the chapel of Worcester College, Oxford, c. 1717 [Worcester College, Oxford].

225 (*top left*) Hawksmoor's drawing for the tower of All Saints, Oxford, undated [Bodleian Library, Oxford].

226 (*top right*) Computer model of Hawksmoor's proposed tower for All Saints [author].

227 (*left*) Octagonal tower of Andromachus at Athens, known as the Tower of the Winds.

230 Hawksmoor's preliminary scheme for the lantern of St George-in-the-East [British Library, London].

229 (*below*) Hawksmoor's preliminary scheme for the lantern of St Alfege (as recorded in Jan Kip's engraving of the north façade design of 1714).

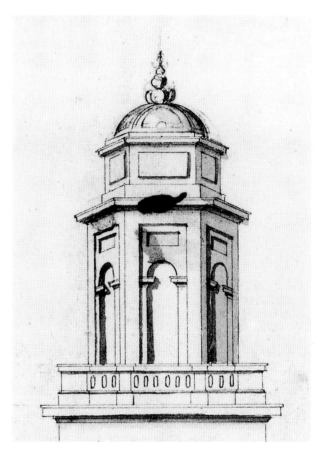

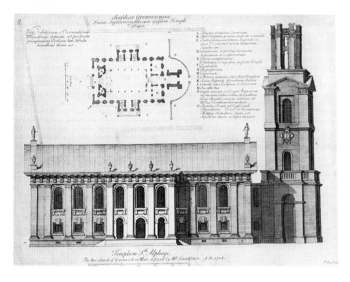

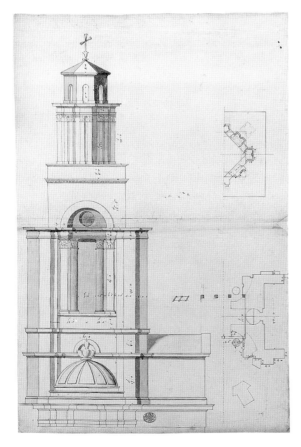

232 (*above*) Hawksmoor's preliminary scheme for the lantern of Christ Church [British Library, London].

231 Hawksmoor's preliminary scheme for the lantern of St Anne [British Library, London].

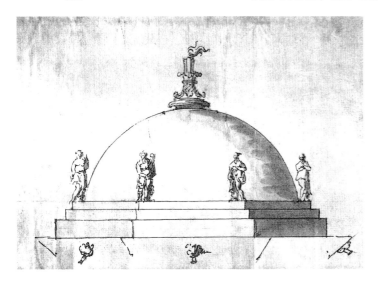

233 Hawksmoor's sketch of the cupola of the octagonal Temple of Venus at Castle Howard, in a letter to William Etty of 25 August 1732 [The Castle Howard Collection, Yorkshire].

of the risen Christ from the tomb, beyond the earthly cycle of seven days (St John 20:26) – and was consequently widely used for martyria and baptisteries.[87] Downes has pointed out Hawksmoor's growing concern with 'a historical sequence of circular buildings associated with death, baptism and eternity – concepts which are mystically related – extending from Antiquity to his own time'.[88] Christian associations between resurrection and the octagon were, at the very least, perfectly compatible with the use for open church lanterns of an octagonal model, especially one connected with wind (or *spiritus*).[89] Indeed at St George-in-the-East the eight lantern piers are capped by altars while the four octagonal staircase turrets are capped by bronze flaming urns, in both cases making this 'life-after-death' theme even more explicit.[90] Significantly, perhaps, Hawksmoor used the octagonal Tower of the Winds as a model only on ecclesiastical projects,[91] although he again chose the octagonal form for the open 'turret',[92] or temple, in the grounds of Castle Howard (see Fig. 108; Fig. 233). This also had a flaming torch pinnacle detailed in one sketch and as part of the general landscape thematic of mortality and natural renewal became dedicated to Venus, Roman goddess of spring and rejuvenation. Hawksmoor's open lanterns thus rise from their closed, funereal towers, much like George I on his altar, to celebrate the truth of the Resurrection from the most visible part of the church.

★ ★ ★

THE EMPTY TOMB: HAWKSMOOR'S DEATH AND RESURRECTION SYMBOLISM

By drawing on Greek, Egyptian and Gothic forms when designing his churches, Hawksmoor reflected the emerging cultural diversity of architectural sources beyond the buildings of ancient Rome. In effect he proclaimed at rooftop level the reformed view of architectural history newly embracing the great eras of antiquity and the Middle Ages. At St George-in-the-East for example Grecian urns sit on proto-Doric pilaster 'buttresses' below an octagonal lantern which was based on the Greek Tower of the Winds but in its finished form recalls the Gothic lantern at Ely.[93] In this spirit it is tempting to trace a connecting line from Perrault's rejection of canonic proportions for the antique columns – as translated into English by James – through the historicism of Fischer von Erlach to the licentious Ionic steeple at Horselydown designed in honour of the crown by the freemasons James and Hawksmoor.

In using memorial forms on his towers and steeples to create what Langley described as a 'most solemn reverend aspect', Hawksmoor clearly intended to imbue his churches with architectural and spiritual authenticity – a virtue that much concerned him when defining his 'architectonricall method'. Blondel had, after all, illustrated funereal monuments as the very prototypes of antique ornament. This 'authenticity' was enhanced by the fact that some of these ornamental forms appeared to possess a local antiquity. At St Paul's Wren found 'The most remarkable *Roman* Urns, Lamps, Lacrymatories, and Fragments of Sacrificing-vessels', for example, while in Cannon Street he even found the remains of a Roman column or 'Pillar'.[94] The primitive, archetypal nature of these forms – many of them unidentifiable with any particular classical period – might be linked, as with Hawksmoor's 'basilica' church plan, to contemporary ideas concerning the authenticity of primitive Christianity. The primitivism (even paganism in the case of his Roman altars) of these forms is made all the more apparent by the relative absence on the exterior of the churches of traditional Christian symbolism (and of the cross in particular, the traditional sign of death and resurrection). As the relationship between Hawksmoor's idealized 'basilica' plan and an actual site suggests, his churches might even be seen as reconstructions of imaginary ancient temples to British Christianity, albeit modified, following the principles of decorum, to fit the particular circumstances of time and place.[95] As such these eclectic buildings represented an attempt to formulate a new icono-

graphy for Anglican churches, Hawksmoor's academic interest in which is demonstrated by his study of the first such church, St Paul's in Covent Garden (see Fig. 59).[96]

Less 'authentic' and more novel was the location of this funereal and memorial iconography, often used as it was in unorthodox ways – as towers and spires – and stripped of its traditional function enshrining a physical body or ashes (as at Castle Howard). Similarly the altars symbolize but, unlike their internal counterparts, do not form 'platforms' for the ritualistic celebration of sacrifice and resurrection. The symbolic nature of this iconography was enhanced by the intention for there to be no actual tombs in and around the new churches.[97] Following the advice of Vanbrugh and Hickes, the Commission had recommended burial take place in large cemeteries on the outskirts of town – albeit filled, as Vanbrugh advised, with 'Lofty and Noble Mausoleums' – unprecedented in England. Vanbrugh illustrated his proposals with a sketch of obelisks, columns and pyramid mausoleums at the English cemetery at Surat that he had visited when in India – here again, a funereal landscape becoming a model for one of Hawksmoor's teachers and collaborators (see Fig. 53).[98] In the absence of any actual tombs – in theory if not in practice[99] – Hawksmoor's 'Lofty and Noble' memorial forms would have taken on the traditional symbolic role of churchyard tombs, namely to serve as pious reminders of human mortality here conveyed through the most visible part of the church. The sombre ornamental details used at basement level on the churches only reinforced this melancholy mood. The combination of funereal forms and oversized, ornamental keystones to the crypt doors (in signifying the presence of an 'underworld') – together with the austerity of the ornamentation used on the Stepney churches in particular – clearly helped realize Vanbrugh's wish for churches of 'Solemn and Awfull Appearance both within and without'.[100] The use of this ornament was no doubt intended to provoke a mood of solemnity and awe – even a sense of *terribilità* – in the onlooker. For as Vanbrugh made clear, judging the 'effect' of ornamental details – something it was noted Hawksmoor frequently recommends – was not merely based on aesthetic criteria but also on the subconscious association of certain customary forms and ornamental styles with certain emotions.[101] The psychological power of funereal forms was certainly well understood by contemporaries. John Breval in his *Remarks on several Parts of Europe* (1726) observed that 'Most of the considerable Avenues to Rome . . . are cover'd with the Vestiges of these Tombs; which, in their entire State must have spread an Air of Horrour and Melancholy over the Places they took in'.[102] Concerning ancient temples Wren, too, noted their effect on the onlooker, observing in Tract II that 'a Grove was necessary not only to shade the Devout, but, from the Darkness of the Place, to strike some Terror and Recollection in their Approachers'.[103]

A further context for the presence of funereal iconography on the Queen Anne churches can be found in contemporary preoccupations with death. The Queen was widowed in 1708, and her constant experience with infant mortality not surprisingly led to a morbid tendency in her character and devotion that may well have influenced the symbolism behind her churches in the years before her own death in 1714.[104] Added to this were the general health fears of a populace more aware than society today of the frailty of life.[105] In 1720 there had been widespread fears concerning the return of the plague, an anxiety frequently cast in biblical terms by clerics.[106] Hawksmoor observed to Carlisle in October 1729 that 'in London and all about it, almost, (8 in 10) persons are ill; of a sort of epidemicall fever, but I hope it is not fatall if timly care be taken'. Having commended the tomb of Metella as 'durable' to Carlisle in July 1728, Hawksmoor's morbid frame of mind is reflected in his afterthought 'if anything can be sayd to be so in this world'.[107] This outlook was no doubt reinforced by a continual affliction with gout in his later years.[108] William Hogarth's *Gin Lane* (1750/1) pictured the lofty Bloomsbury tower in the background of a scene of death and decay that characterized the streets around Drury Lane (Fig. 235). The central position of the tower 'crowning' this scene of moral and physical decay cannot be accidental: directly below, a body is being lowered into a coffin and a neglected baby falls to its death. The city has been transformed from Hogarth's preceding engraving, *Beer Street*, in which a scene of merriment, pre-dating the drinking of gin, has a distant obelisk steeple recalling the form of St Luke's (Fig. 234). Hogarth's engravings thus represent an ironic comment on the beneficial intention behind the fifty new churches in general, and their towers in particular, to consolidate the established social hierarchy and provide a symbol of the pious duty of the parishioners to their king and God. Hawksmoor's Stepney towers were erected in some of London's poorest and most squalid of parishes, described by Swift as full of 'the Vilest People, Highwaymen, House-Breakers, Felons of all Degrees, Impudent Women, and Persons Disaffected to His Majesty's Government'.[109]

Vanbrugh had opened his advice to the Commission by wishing that 'the fifty new Churches the Queen has gloriously promoted the Building of' should 'remain

BEER STREET.

Beer, happy Produce of our Isle
Can sinewy Strength impart
And wearied with Fatigue and Toil
Can chear each manly Heart.

Labour and Art upheld by Thee
Successfully advance,
We quaff Thy balmy Juice with Glee
And Water leave to France.

Genius of Health, thy grateful Taste
Rivals the Cup of Jove,
And warms each English generous Breast
With Liberty and Love.

GIN LANE.

Gin cursed Fiend, with Fury fraught,
Makes human Race a Prey,
It enters by a deadly Draught
And steals our Life away.

Virtue and Truth driv'n to Despair,
Its Rage compells to fly,
But cherishes with hellish Care,
Theft, Murder, Perjury.

Damn'd Cup! that on the Vitals preys,
That liquid Fire contains,
Which Madness to the Heart conveys,
And rolls it thro' the Veins.

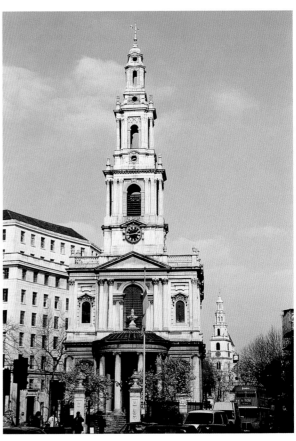

Monuments to Posterity of Her Piety & Grandure'.[110] Hawksmoor's use of funereal iconography to help fulfill this wish mirrored such contemporary royalist propaganda as Lewis Theobald's *The Mausoleum: A poem sacred to the Memory of her late Majesty Queen Anne* (1714). This described an imaginary 'Regal tow'r' dedicated to the queen's memory with its own 'Pompous Arch' similar in spirit, perhaps, to the triumphal arches on the towers at Christ Church, St John and St Mary Woolnoth. In the case of the new church in the Strand, St Mary's,

for which the Commission had first conceived the idea of a memorial steeple, engravings of James Gibbs's design for the church of around 1713 show a statue of Anne above the porch (Figs 236, 237).[111] Following the queen's death this statue was replaced in the design by the monumental urn that is present on the church today, a substitution that illustrates perfectly the particular memorial meaning behind the funereal ornament on these unique buildings.

234 and 235 (*facing page top*) William Hogarth's *Beer Street* and *Gin Lane* (1750/1), engravings, both 36 × 30.5 cm [British Museum, London].

236 (*facing page bottom left*) Engraving by John Harris of James Gibbs's design for St Mary's in the Strand, of c. 1713 [British Library, London].

237 (*facing page bottom right*) St Mary's in the Strand as built.

Chapter 7

'THE BETTER THEY WILL SUIT OUR . . . SITUATION': THE ORNAMENTATION OF THE LONDON CHURCHES

IN THE COURSE OF DISCUSSING ORNAMENT IN HIS SIXTH BOOK, Alberti observed that 'in the whole art of building the column is the principal ornament without any doubt', a sentiment repeatedly emphasized by Serlio and later theorists.[1] Hawksmoor would have read this in his own Italian and English copies of Alberti (lots 42 and 114) when forming his opinion on the relative importance and metaphorical meaning of the five canonic Orders (the 'true Species'), outlined to Carlisle concerning the Mausoleum.[2] It was noted that, following the principles of decorum, the appropriate use of any one of these styles, and whether it was to be designed in a canonic form or a licentious one, was dependent on a number of factors. These included the position of the column on the building, as well as that building's location, its patron and its dedication – the clear influence of the latter two on the ornamentation of St George in Bloomsbury is an obvious case in point.

Ever since the construction of Hawksmoor's London churches, the reasons behind the stylistic range and strangeness of their ornamentation have been the subject of much speculation (Figs 239–44). The focus by Wren and Vanbrugh on the appearance of these buildings when advising the Commission indicates that ornament should be seen as an important aspect of their design. Examining this ornament against the principles of decorum – a well established theory of ornamental selection that Hawksmoor clearly studied, judging from the books he owned and the statements he made – a pattern emerges. A rationale might be expected to lie behind his ornamentation of these buildings, and his deployment of the Orders, given his frequent call to 'reason' and 'method' when justifying his designs.[3] For the contrasting locations of these churches can account for their disparate wall treatments, ranging from the extremely plain to the heavily articulated, as well as the presence or otherwise of particular canonic ornamental styles, ranging from the simple to the decorative. Indeed consistent with Hawksmoor's context-dependent

attitude towards the adaptation of these styles – implicit in his statement concerning the Mausoleum that he had had 'recourse, to Vitruvius himself, on this Occasion' – location also determined when and where non-Vitruvian, or licentious, details were used on these churches.

THE LOCATIONS OF HAWKSMOOR'S CHURCHES AND THEIR ORNAMENTATION

Since the publication of Serlio's fourth book in 1537, it had become common to rank the five Orders in order of the richness of their details, from plain Tuscan to ornate Composite, and to identify this range with the social hierarchy, a notion articulated most notably in England by Henry Wotton.[4] While Wotton associated the Tuscan with a 'sturdy well-limmed Labourer', the Corinthian becomes 'laciviously decked like a Curtezane' as a result of national Puritan tastes, discussed in Chapter 3. A particular Order might thus be matched to the social rank of a patron, to his or her building's type, from 'robust' fortress to 'delicate' convent, or to its location. Location in particular affected the ornamentation on a given building type. For while ornament must always be appropriate to the rank of the patron, in the centre of towns this decoration should, for Serlio, be 'solemn and modest', whereas in more open places in the city and in the country 'a certain license can be taken'.[5] Serlio notes in his letter 'to the Readers' in the 'Extraordinary Book of Doors', present in Hawksmoor's 1663 edition: 'you, O architects grounded in the doctrine of Vitruvius (whom I praise to the highest and from whom I do not intend to stray far), please excuse all these ornaments, all these tablets, all these scrolls, volutes and all these superfluities, and bear in mind the country where I am living, you yourselves filling in where I have been lacking' (fol. 2r).[6] Here again, context – in this case France – played its

238 North elevation of St George-in-the-East, looking east.

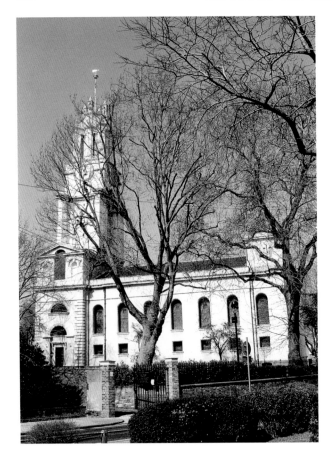

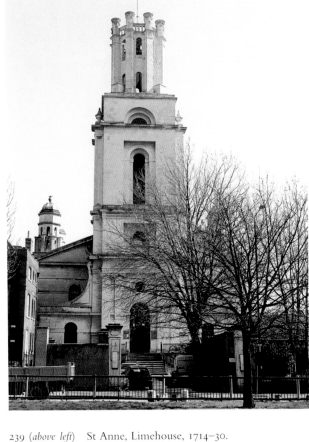

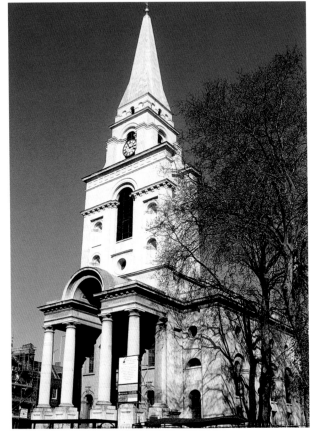

239 (*above left*)　St Anne, Limehouse, 1714–30.

240 (*above right*)　St George-in-the-East, Wapping, Stepney, 1714–29 (gutted in 1941).

241 (*left*)　Christ Church, Spitalfields, 1714–29.

242 (*facing page top left*)　St Mary Woolnoth, City of London, 1716–24.

part in determining the degree of fidelity to Vitruvian forms, linked to prevailing moral norms and acceptable licences. It was noted in Chapter 3 that John Evelyn, in both editions of his 'Account' (1664 and 1707; lots 89 and 108), defined decorum as 'where a *Building*, and particularly the *Ornaments* thereof, become the *station*, and *occasion*, as *Vitruvius* expresly shews in appropriating the several *Orders* to their natural affections'.[7] In 1734, two years before Hawksmoor's death, Robert Morris in his *Lectures on Architecture* emphasized that a building's setting, or 'situation', was the external determinant of its character and therefore of the choice of the proper ornamental style.[8] It has been seen that Hawksmoor was sensitive to this match between style and location – noting on the rusticated pillars of the octagonal temple to Venus at Castle Howard that 'the more firm and masculin they appear, the better they

243 St Alfege, Greenwich, 1712–18.

244 St George, Bloomsbury, 1716–31.

will suit our Rurall, Sylvan, Situation'.[9] And it has also been seen that this contextualism even led him to choose Gothic in preference to *all'antica* details for All Souls and later Westminster Abbey, to match the founder's work.[10]

Given that Hawksmoor's London churches were identical in their function, patrons (Anne and George I) and denomination (and even in some cases, identical in dedication), their striking stylistic distinctions – in ornament, form and character – can surely only have been intended to relate to their varying contexts. For although Hawksmoor respected the established Protestant rule of using 'richer' ornament (that is, decoratively and therefore socially) on the inside than on the outside of churches – a differentiation first preached by Inigo Jones and echoed by the theologians of primitive Christianity – his churches have distinct characteristics. As commentators have noted, the austere and licentious ornamentation and overall character of the three churches in Stepney – a poor suburban district in which the Established Church was weak and noncon-formists were active[11] – strongly contrasts with the richer and more canonic ornament and character of the other three church exteriors.[12] The latter trio were in well-to-do neighbourhoods, one bordering the Royal

precincts and the newly built Naval Hospital in Greenwich (St Alfege, with its royal pew), one in the mercantile centre near the Bank of England (St Mary Woolnoth, traditionally the Lord Mayor's church), and the other close to it in the Russell Estate centred on Bloomsbury Square (St George). While St George is described as 'near Bloomsbury Square' in the minutes of the Commission (13 June 1716), the churches in

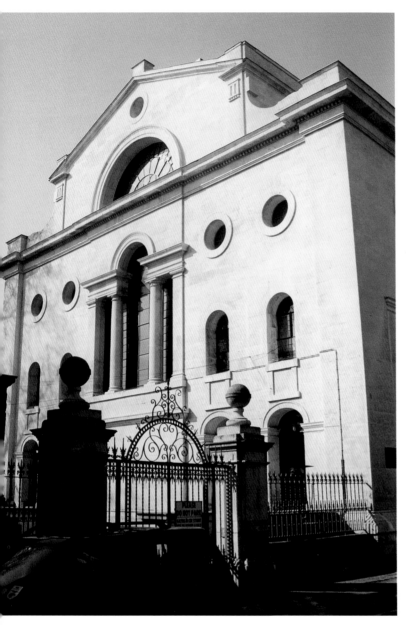

245 East façade of Christ Church.

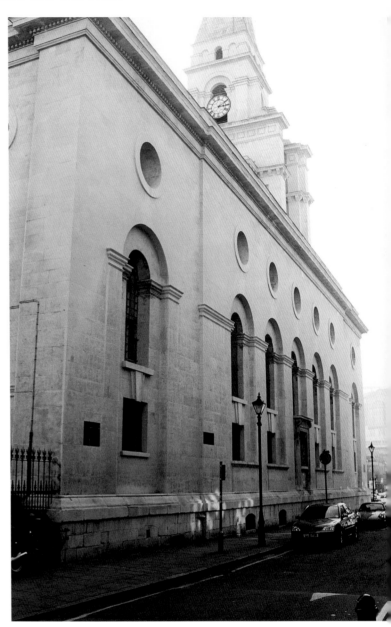

246 Plain (astylar) side walls of Christ Church.

Spitalfields, Wapping and Limehouse are situated in 'hamlets' (29 April 1714). Spitalfields was crowded with poor weavers' houses beyond the City's jurisdiction,[13] while the new churches in Limehouse and Wapping served the riverside sprawl of sailors' and shipwrights' chambers. The three new churches in these poor areas were clearly intended to stand as beacons of Christian morality, their huge white stone forms strongly contrasting with the adjacent crowded brick terraces. Their sombre mood is conveyed not only through funereal forms common to all the towers but also through the general ornamental austerity of these particular churches.

The Stepney trio were all begun in the same year, 1714, and might be examined first. At Christ Church, Spitalfields, a Tuscan portico in the form of a Serliana fronts plain (astylar) side walls (Figs 241, 246). Hawksmoor's use of Wotton's 'labourer' Tuscan Order clearly fits the location and follows the model of Inigo Jones's tetrastyle Tuscan portico on the first Protestant church, at Covent Garden (illustrated by Hawksmoor in 1714). At the east end the columns are restricted to ornamenting the most important element – namely the window over the altar which is once again, as commonly in Hawksmoor's churches, in the form of a Serliana (Fig. 245). Here the columns are of a simplified

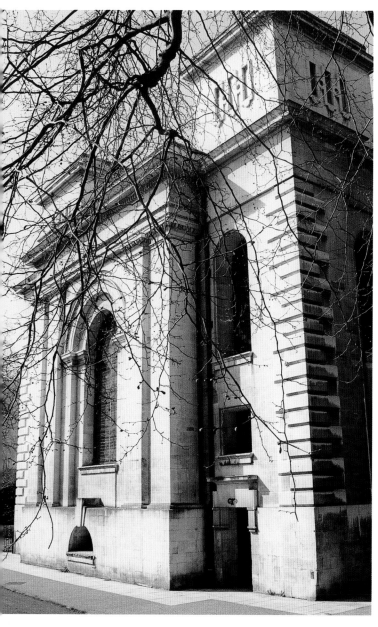

247 East façade of St Anne.

248 Plain (astylar) side walls of St Anne.

Doric – with their upper torus but without triglyphs in the frieze. Instead, two giant triglyphs are used higher up as corbels – that is, as part of the wall – emphasizing the pared-down character of the ornament on this façade.[14] At St Anne, Limehouse, giant elongated Doric pilasters (baseless and with no triglyphs but with egg-and-dart mouldings) frame the west door and the east window, but the side walls are again astylar and extremely stark (Figs 239, 247, 248). The window mouldings are restricted to sills and the windows are, as Downes puts it, 'simply punched out of the massive walls'.[15] This treatment is much simplified from an earlier, generalized scheme of 1713 possibly intended for the site, with its Doric portico and columnar side entrances (Fig. 249).[16] Hawksmoor's design for St Anne was submitted to the Commission at the same time as that for St George-in-the-East, on 1 July 1714, and both were considered together.[17] On the latter church the external use of the Orders is restricted to elongated Ionic pilasters, without entasis or flutes, either side of the west door (Figs 240, 250, 252). These smooth pilasters are again pared down, and have been 'down-graded' from the Corinthian ones of the (more ornate) original façade design (see Fig. 213).[18] The side walls are once again astylar, as is the east elevation. Even the side doors (to the gallery staircases) have extremely

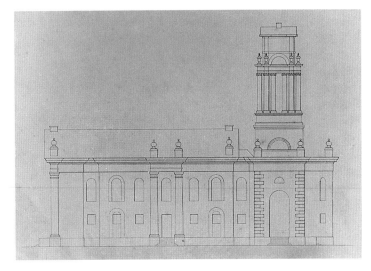

249 Measured drawing of a (now lost) model possibly of Hawksmoor's 1713 scheme for St Anne, by C. R. Cockerell, 1826 [Victoria and Albert Museum, London].

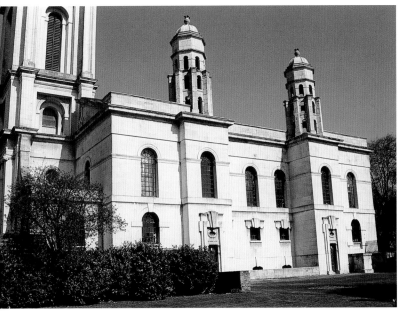

250 Plain (astylar) side walls of St George-in-the-East.

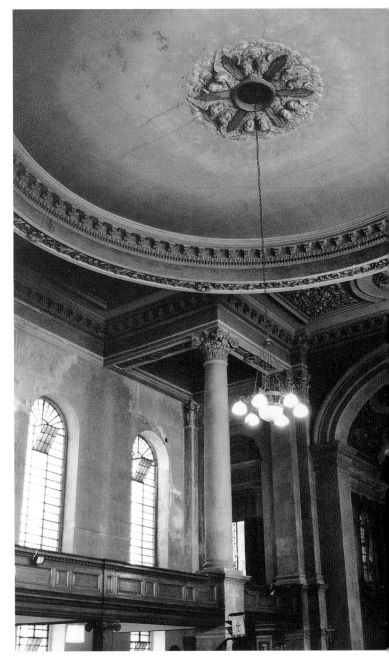

251 Interior of St Anne, Limehouse.

plain, elongated pilastrades reminiscent, as was noted in Chapter 2, of the post and lintel monoliths of the palace of Persepolis in Persia (see Figs 48–9). The only purely decorative feature is the giant masonry keystone, a structural element used for ornamental 'effect', since the keystone is structurally redundant. The result is to create a superhuman door as if to induce humility and even Vanbrugian 'awe' on the part of the onlooker, feelings surely enhanced by the presence of the 'all-seeing' oval oculus above; this 'divine' scale is also emphasized

through the giant pilasters at the entrance and the basement keystones.[19] On all three Stepney churches, conventional mouldings round doors and windows – sills, architraves and cornices – are pared down to a minimum, ornate tabernacles are nowhere to be seen, and the side walls are at no time articulated with pilasters. Here blocks of masonry and massive walls, emphasized at the corners by piers and quoins – modelled, appropriately enough, on Inigo Jones's chapel at St James's Palace[20] – are preferred to the classical Orders

252 East façade of St George-in-the-East.

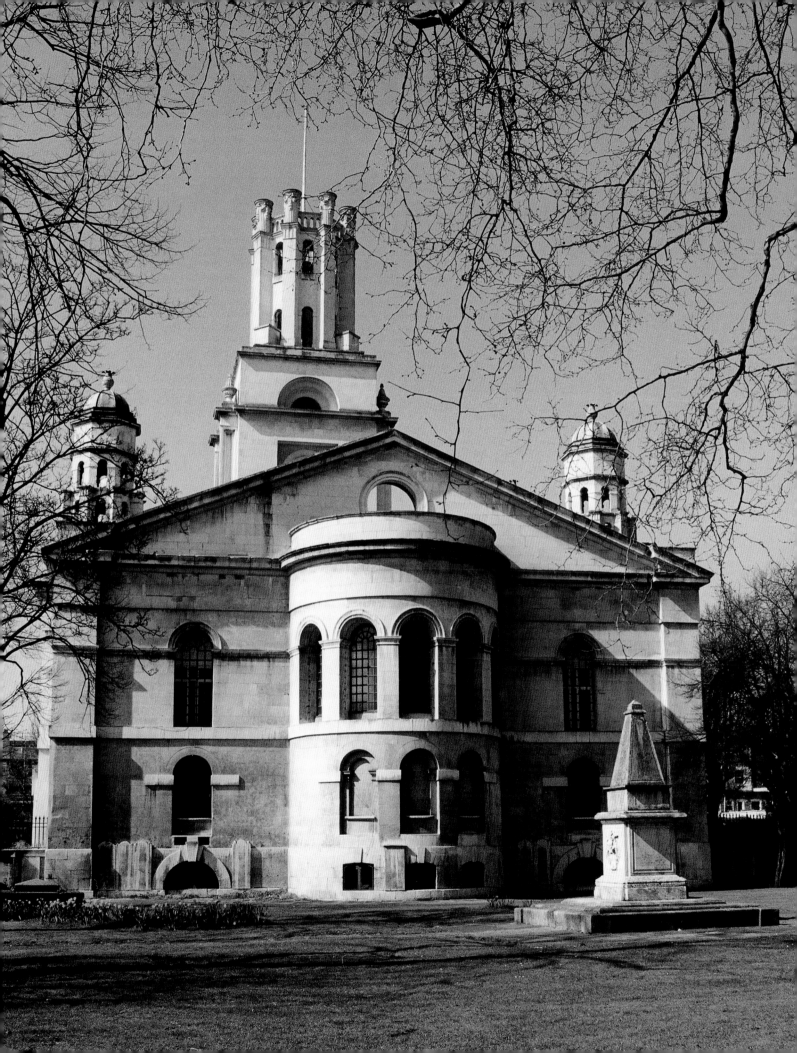

253 West façade of St Luke, Old Street.

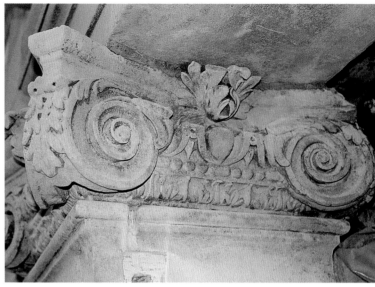

254 Capital on the east window of St Luke, Old Street.

as the real essential elements of architecture. This external austerity is all the more striking in comparison with the interiors of these churches, with their rich ceiling work and Composite columns (at St Anne and Christ Church) or Doric columns with triglyphs (at St George-in-the-East) (Fig. 251; see Fig. 78).

Furthermore St Luke in Old Street and St John in Horselydown – in the poor areas of Finsbury, near Clerkenwell, and Bermondsey, south of the Thames

– both had extremely plain, astylar side walls (see Figs 184–6, 220).[21] At St Luke, as on the Stepney churches, the *all'antica* decoration is restricted to the two most important elements, namely the western door – here with Doric pilasters – and the eastern window – once again in the form of a Serliana here embellished with Ionic capitals (Figs 253, 254). Even the usually exaggerated decorative keystones have been scaled down on the west façade to more domestic proportions (Fig. 255). St John has been demolished and today only the plinth remains, but the front was plain and astylar with a pediment form broken by the base of the column-spire. To the side, the columns were restricted to a central Serliana and the west wall was also plain with a further broken-based pediment. Hawksmoor's brick parsonage survives, however, and is equally astylar and plain, perfectly reflecting its domestic status (the vestry, in Fair Street, carries his trademark heavy keystones; see Figs 187, 188).[22] The other church in Southwark funded by the Commission, St George-the-Martyr of 1734–6 by John Price, is also extremely plain and astylar on its side walls (Fig. 256),[23] as was Hawksmoor's unexecuted design for altering and refacing St Giles-in-the-Fields, in north Soho (see Figs 189–91).[24] Here the conservative mix of quasi-Gothic tower with obelisk steeple, and stark walls with ponderous mouldings – in strong contrast to the gilded *all'antica* interior[25] – was surely once again intended to suit the church's location. This was among insalubrious dwellings bordering a commercial region south of the more affluent Bloomsbury (with its Corinthian church of St George). The scene in Hogarth's *Gin Lane* was set

255 Decorative keystone on the west façade of St Luke, Old Street.

256 St George-the-Martyr, Southwark, by John Price, 1734–6.

257 Cherubim at St Mary Woolnoth.

in the parish of St Giles (see Fig. 235), and by the end of the century St Giles' Rookery was destined to have achieved a reputation as the worst of all London's slums.[26]

The simplified ornamental character and general austerity of these churches is in strong contrast to the character of Hawksmoor's three other London churches. At St Mary Woolnoth the west front has giant Tuscan columns with incised joints framing a heavily articulated central doorway of incised stonework (which Hawksmoor calls 'Rusticks') (see Fig. 242).[27] The composition closely resembles the kitchen-court gates at Blenheim, in using the language of fortification for decorative effect (see Figs 169, 170). The doors either side of the columns are ornamented with three richly carved cherubim, resembling those on St Paul's, next to which two giant triglyphs are used as corbels for the window sills (Fig. 257). The Mannerist origin of this ornament is apparent from an earlier design for this elevation, which in its silhouette and iconography (especially the winged cherubim) is redolent of Roman Catholic churches in Italy (resembling Jesuit churches such as the Gesù in Rome and San Ambrogio in Genoa) (see Fig. 217).[28] In place of this Jesuit silhouette, the façade as built above the rustic 'gate' has a regal triumphal arch made up of six canonically formed

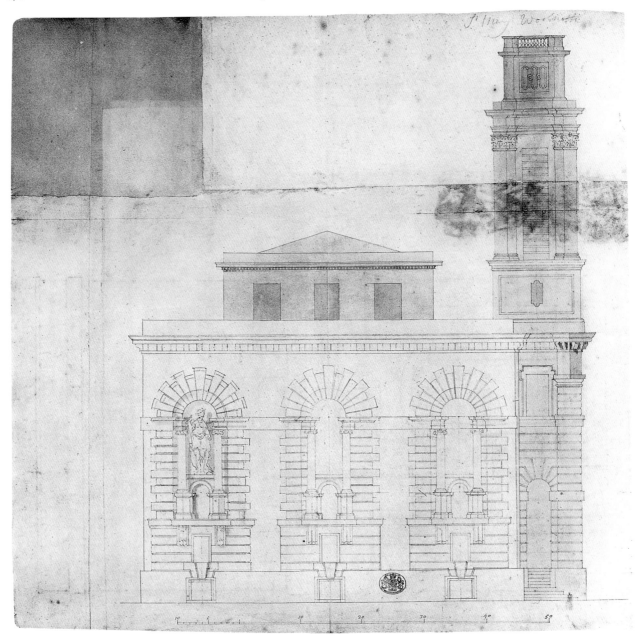

258 Hawksmoor's drawing for the north façade of St Mary Woolnoth, undated (post-1716) [British Library, London].

Composite columns – possibly used to emphasize the tower's role as 'entrance'. The use of this more tradi-tional tower form, complete with its 'tomb' lanterns, produces a design better suited to the church's location and Protestant denomination – on whose churches the tower was a traditional element. For, as noted in the previous chapter, the local memory of the medieval church and tower, demolished to make way for Hawksmoor's design, might well have influenced these design changes. The articulation of the western wall surface is continued on the north façade, where three empty, ornamental niches are framed by heavy quoins

and fully formed Ionic columns and entablature (Fig. 261). One of the detailed drawings of this façade includes a female statue sketched within the most easterly niche (possibly of St Mary), as a late flirtation with High Church decoration (Fig. 258).[29] (The south side was originally obscured by surrounding buildings, only visible in steep foreshortening and was left plain as a consequence, as was the east wall.[30]) Thus at St Mary Woolnoth, unlike the churches examined so far, ornamentation is used to articulate the wall for deco-rative effect rather than to single out the most impor-tant basic elements of west door and east window.

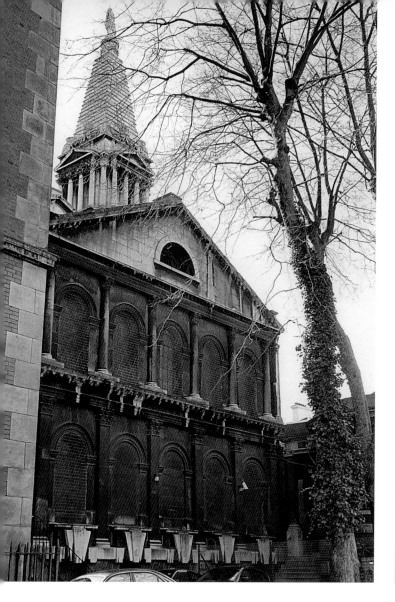

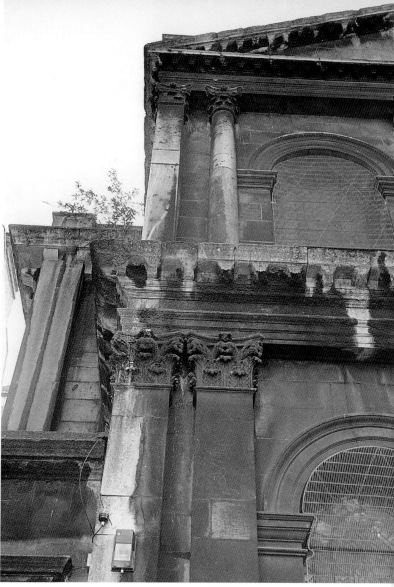

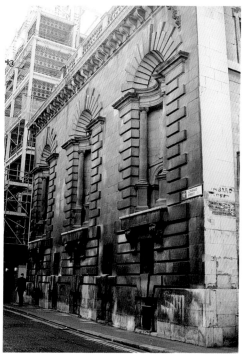

259 and 260 (*above*) North façade of St George.

261 Niches in the north façade of St Mary Woolnoth.

While the Jesuit origins of the projected west façade were downplayed in its final form, Hawksmoor's ornamental intentions for this church are clear from the outset. The ornament as built has even been 'upgraded' from the original design, which is without the Composite triumphal arch and Ionic columns.

At St George in Bloomsbury, the giant Corinthian portico on the (south) front is matched on the north by Corinthian and Composite pilasters which form a blind arcade divided by a huge Composite entablature (Figs 244, 259, 260).[31] (Both the western tower base and eastern apse are tightly enclosed and are plain in consequence; Figs 262, 263.) This church is consistently Corinthian throughout the design revisions.[32] Du Prey points out the appropriate nature of the Corinthian Order, given its 'associations with rulership stretching

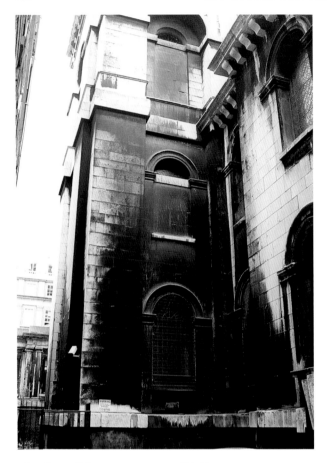
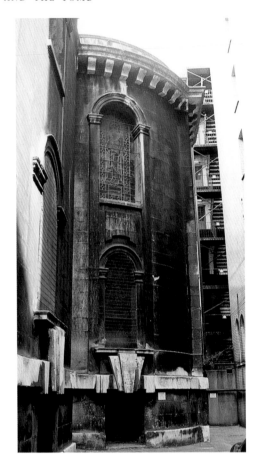

262 Base of the western tower of St George. 263 Eastern apse of St George.

back to antiquity',[33] on a church dedicated to St George (and by implication George I). Hawksmoor's use of a different, 'lower' style of Order (a simplified form of Ionic) on his other church dedicated to St George, at Wapping, can therefore have been due only to the different character of its location. Whether or not the deeply projecting portico at Bloomsbury was modelled on that at Baalbek, as William Stukeley supposed, the church as a whole seems to have owed its initial form to the majestic model of the Pantheon (which a preliminary scheme closely resembles; Fig. 264).[34] Classical models also inspired the form of St Alfege in Greenwich – again appropriately given its location (see Fig. 243). Here a portico composed of canonically formed Doric columns is matched by Doric pilasters and full entablature on the side walls. These pilasters were possibly intended to imitate the colonnade around the *cella* in the Greek temple – a canonic Doric model deliberately recalled at St Alfege through the pedimented front and pagan altars.[35] Indeed, that Hawksmoor conceived of this church as an 'antique' Doric temple is suggested by his plan of the Hospital of 1723, and by the signed version in his book of 1728 concerning the work at

Greenwich (see Fig. 132).[36] On this 1728 plan, for example, attention is drawn to the church's classical, canonic status as a 'Templum novû[s] Grenovicanû . . . / Dorico Extructû Magnifi'. On both plans, the new road (Romney Road, on the southern boundary of the Hospital) is positioned to lead directly to the portico and, as a *Via Regia*, is clearly conceived of as a triumphal route. This suggests that when designing St Alfege a decade earlier, Hawksmoor had conceived it as forming an integral part of the future (ideal) layout of the Hospital – albeit further distorting its already focus-less plan – and that he had chosen the form and ornament of the church accordingly. For the hitherto unrecognized conception of a *via triumphalis* cutting through the Hospital (in the position of the *via larga* in the Roman military camp)[37] clearly explains the unorthodox sacrificial altars and eastern portico to St Alfege. To preserve the profile of the 'antique' temple façade – appropriate as the conclusion to the route – the obligatory tower was envisaged as sitting on the rear, west side, on the site of the medieval tower (which was later refaced by James). As such it no longer marks the front entrance – a function it serves in Hawksmoor's other churches and in his

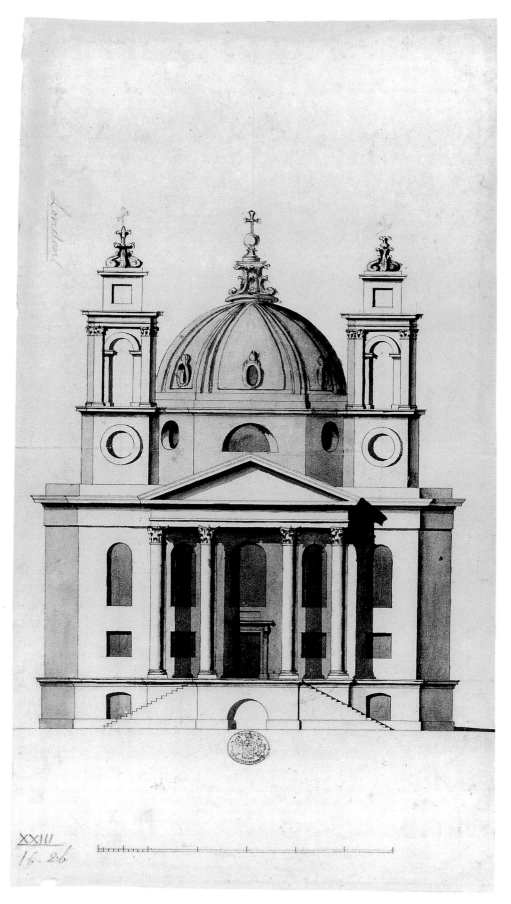

264 Hawksmoor's preliminary design for St George, undated [British Library, London].

model 'basilica' plan. Indeed the perversity of this arrangement and of the church's pagan symbolism demonstrates just how important the *Via Regia* idea was to the design of St Alfege. In the event Romney Road was built slightly closer to the river, leaving the church and its 'triumphalist' altars isolated from the Hospital plan.

Residents of the more affluent areas could be expected to be much more familiar with the classical language of architecture, and consequently less suspicious of Doric and Corinthian pagan temple-forms perhaps thought inappropriate to the poorer regions where the residents were accustomed to astylar, medieval churches with towers on their fronts.[38] On churches located in these poor areas, plain or simplified Orders on the front façades (which in final form are never Corinthian or Composite) are combined with extremely austere, astylar side walls. Ornament is reserved for the most important basic elements of west door and east window, in striking contrast to the richer and much more canonic decoration used internally. In affluent areas, however, the churches have front façades of much richer ornament, comprising Composite columns with heavily articulated Tuscan rustication, Corinthian porticoes or, at the very minimum, a full Doric portico complete with triglyphs in the frieze. In all three cases, columns or pilasters (sometimes of a 'lower' Order than on the front) are introduced to articulate the side and/or rear walls for decorative effect. These distinctions in ornamental character between the two groups of churches were made all the more apparent as their designs progressed. Such revisions, in being consistent with the principles of decorum, might be seen as examples of what Hawksmoor calls his 'architectonricall method' in action. This would certainly explain his 'upgrading' of the columns on the Bloomsbury tower from those of its model. For here Hawksmoor uses the Composite in preference to the Doric of the Halicarnassus tomb and of his own 'model' church design based on it (possibly intended for Spitalfields, for which the Doric would have been suitable; see Figs 73–6).[39] This adaptation was clearly in line with the role of the Bloomsbury tower as a form of royal heraldry – which called for a 'high' Order – as well as better matching its city (that is, non-rural) location. (It should be remembered that Hawksmoor considered the contrasting 'firm and masculine' as reflecting a 'Rurall, Sylvan, Situation'.) Hawksmoor's selection of particular ornamental forms – and his willingness to adapt these forms through the addition of heraldry – to reflect the character of the patron is clearly evident at Easton Neston and at Blenheim.[40] The substitution at Bloomsbury of the fabled chariot

of King Mausolus with the statue of King George, to honour the church's dedication and patron, and the embellishment of its tower with British royal heraldry, here again perfectly illustrates the effect of local circumstance on archetypal models in Hawksmoor's design process.

Comments by Hawksmoor on other, unexecuted churches confirm his desire to match them to their surroundings. In his 'Report conc^g sev^l sites for churches in St Andrews, St Giles delivered to the Committee October 23 1711' he observes that 'The other good situation is at the Lower End of hatton Garden . . . A Church thus placed at the End of one of the best streets in London, would stand most ornamentally & be very convenient for that part of the Parish'. Concerning the proposal for a new church (St Mary's) in the affluent Lincoln's Inn Fields – his design of 1711 for which is lost – Hawksmoor adds that this 'situation . . . wants only a Church for its convenience & ornament, to make it Equal any Piazza in Christendome'.[41] Finally, it should be noted that the most important ecclesiastical building which Hawksmoor worked on, St Paul's Cathedral in the heart of the mercantile City, is articulated with impressive, canonically formed Corinthian and Composite pilasters and columns[42] – here again perfectly befitting its status and location.

'TOO MUCH LIBERTY IS TAKEN': CANONICAL WALLS AND LICENTIOUS TOWERS

A similar distinction can be identified in Hawksmoor's use on his churches of a range of capital types, from canonic to licentious, which is once again location-dependent. Serlio in his seventh book (1575) had developed the idea that the five canonic Orders, and the façades that they ornamented, could be made more 'delicate' by additional carving in the form of intaglios.[43] A range of column forms resulted, from canonic to licentious, whose use was dependent on context and building type. It has been seen that Hawksmoor had greatest freedom with regard to ancient practice in the design of his towers, lacking as they did any obvious antique model and exempted as they were from the Commission's 'Generall Model'. This freedom evidently licensed, in certain situations, his use of a variety of highly original, non-canonic capital forms to ornament his towers, as well as his outright omission of the capital on some pilasters. Church towers and steeples served as parish landmarks and, as the Bloomsbury tower suggests, their ornamentation might be expected to be more affected by their

265 Delicate gate II, from Sebastiano Serlio's *Libro Extraordinario* (1551).

location and dedication than by the influence of any particular general model.

Examining the churches, a pattern once again emerges in that licentious capital types are only used in the 'poorer' parishes and, in these cases, only above the main body of the church as part of the tower/lantern. The best example of this licentiousness is of course the Ionic column in the form of an obelisk spire at St John. But also notable in this regard are the 'Doric' details used on the lanterns of St George-in-the-East, St Anne and on the unexecuted lantern for St Alfege, where triglyph forms appear as 'capitals' to square columns or piers (see Figs 211, 212, 229).[44] As the previous chapter noted, the tower at St George-in-the-East has the proto-Doric urn-topped pilasters that resemble the grave stelae illustrated by Blondel as the origin of the antique capital forms (see Figs 67, 196).[45] The coffered detailing on these pilasters is similar to that found on the licentious gates in Serlio's 'Extraordinary Book' (Fig. 265). The Ionic capitals at the entrance to the church are canonic however. At St Anne the tower openings have a pair of columns with hybrid

Corinthian-Doric capitals – two rows of leaves described by the Work's Book as of 'a Composed Doric'.[46] In an earlier design Hawksmoor even proposed using 'Egyptian' capitals in the tower (together with the pyramids above the east façade) (see Fig. 203).[47] Below, the Doric capitals (with ovolo mouldings) at the entrance and on the east end are once again canonic (that is, following models in Serlio's fourth book).[48] On the Christ Church tower, the 'pilasters' that form a triumphal arch are without capitals and are capped instead by a corbelled cornice; the Tuscan portico below, however, has capitals that are canonic.

Thus in contrast to the novel capitals used on the towers and lanterns of these churches, the capitals on their main walls, where the design was more strictly regulated by patron and ancient precedent, are all composed of orthodox Vitruvian forms. Such a distinction does not exist in Wren's city churches, where the towers are ornamented with canonical Orders.[49] Contemporaries certainly commented on the austere and licentious nature of the ornamentation on these Stepney churches. It was noted that the Palladian critic James Ralph observed that, together with St John, they 'are mere Gothique heaps of Stone, without form or order'.[50] And that Hawksmoor responded to the Westminster Dean by noting that 'the critics go further beyond sea, and here at home also; where they fancy too much liberty is taken (as the Modern Italians have done, especially Boromini and others) they call it Gothick'.[51] In thus defending his churches (and by implication the licentiousness of their towers) as within the bounds of acceptable invention, it was observed that Hawksmoor underlined his awareness of, but limited taste for, Italian licentious forms and his belief in Vitruvian rules as a rational starting point.[52]

It was noted in Chapter 4 that Batty Langley publicly defended the Stepney churches against Ralph's attack when writing in the *Grub Street Journal* on 11 July 1734 in the masonic guise of 'Hiram'. In pointing out the 'solemn solidity' and 'simple beauty' of St Anne, Langley recognized Hawksmoor's use and abuse of antique forms in particular locations on the church. For the church's east, chancel end 'is of the Doric order, strictly executed after the antique manner, without any other base to the pillars, than the square basement of building', and 'is certainly in the most august taste', while the tower openings have 'a pair of Composite columns, with their intablatures, whose capitals consist of acanthus leaves, as with the Corinthian Order, but instead of having their abacus after the Ionic manner (as has always been the practice) they have Doric abacus's'. Langley approves of this inventiveness, for the Doric mouldings 'express the Composite order much

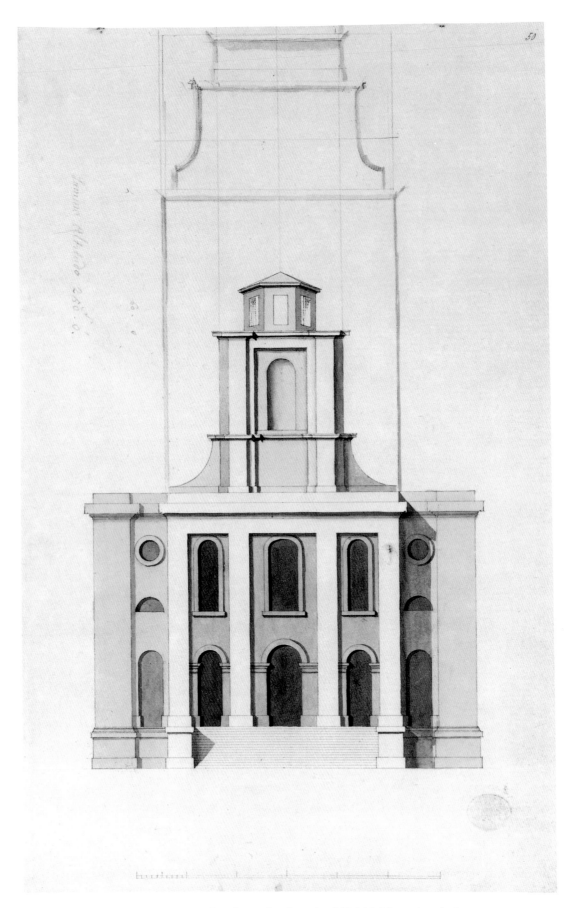

266 Hawksmoor's preliminary design for Christ Church, undated [British Library, London].

better, than has been yet done'. The licentious nature of these tower capitals is here justified by optics, for 'at a considerable distance, the volutes in the Corinthian and Composite capitals of all other architects, are not to be distinguished from each other, but by those who are very conversant with them'. Langley also praises the orthodox nature of the pilasters used on the entrance to St George-in-the-East, for the 'frontispiece to this tower is of the Ionic order, consisting of four pilasters supporting their entablature; wherein simplicity and grandeur are as well connected together, as I have yet seen in any composition of the ancients'. At St John, Langley recognized the column-spire's antique source but found the new column wanting. He observed that 'instead of a square tower, enriched with battlements, or pinnacles, which was the *Gothic* manner of finishing such structures, there is an insulate column erected, in manner of that of TRAJAN, which had it been larger and higher (as the beauty and magnificence of such columns consists in their largeness) would have had a more glorious effect'.

The spire at St John and the Stepney towers represent a unique set, since elsewhere Hawksmoor is much more restrained in his use of corrupt capital forms.[53] The licentious ornament on these towers is in most striking contrast to the ornamentation of the other three church towers in wealthier parishes. At St George the Corinthian columns forming the portico and the Composite ones of the 'mausoleum' tower have canonically formed capitals. The propriety of this tower ornamentation is emphasized by the presence of the royal statue and heraldry. At St Mary Woolnoth the richly articulated rusticated Tuscan ground storey is of a canonic form (that is, in following 'Rustic Tuscan' models illustrated in Serlio's fourth book). So too are the fully formed Composite columns above, on the tower's triumphal arch. And while canonic models once again shape the Doric columns and pilasters on the walls at St Alfege, the development of its tower design conforms to this contextual distinction between the church towers. For the original lantern illustrated by Kip, with its triglyph capitals, was replaced in the built version by a tempietto with canonic Corinthian columns (designed by James); lower down on the tower, fatter triglyph capitals were replaced in the built tower by paired Ionic capitals again based on canonic forms. Licentiousness was here abandoned in favour of canonical models, and a simpler (proto-Doric) Order was replaced with more decorative (Ionic and Corinthian) styles, consistent with the church's location in a wealthy parish. Elsewhere, the initial west façade design at Christ Church had licentious, capital-less 'pilasters' in place of the (canonic) Tuscan columns (Fig. 266);[54]

at some point these 'pilasters' were moved up the tower to form the triumphal arch above the portico, thereby maintaining the distinction between walls and towers. Both these developments are in keeping with the pattern of 'contextual decorum' evident when Hawksmoor's churches are considered as a group.

'THE MOST SOLEMN AND AWFULL APPEARANCE': MOOD AND LOCATION

Consistent with the principles of decorum, Hawksmoor thus seems to have preferred to use richer, canonic ornamentation in affluent parishes and plainer ornamentation, or no ornament at all, in poorer ones. In the latter case the ornamentation could be simplified to the point of licentiousness, although even here licentious capital forms are restricted to the least 'antique', most 'Gothic', element – the tower. The expressive demands of location and building type explain Hawksmoor's apparently paradoxical attitude to ornament – in describing the Composite at Castle Howard as a 'mongrel species' yet using it, together with new 'species' of antique column (in spirit much like those of the loathed Dietterlin), here on the churches. In fact although triglyphs, corbels and keystones are used as isolated details in unusual locations and at magnified scales, these details are never mixed with elements from different Orders, an inherent quality of the Composite capital and of Dietterlin's forms. Nor do Hawksmoor's churches come anywhere near mirroring the ornamental excesses of continental Baroque. It was noted in Chapter 3 that Daniel Defoe echoed Calvinist preferences when observing in his *Tour* of 1725 that the new London churches 'are rather convenient than fine, not adorned with pomp and pageantry as in Popish countries; but, like the true Protestant plainness, they have made very little of ornament either within them or without, nor, excepting a few, are they famous for handsome steeples'.[55] He continues that 'a great many of them are very mean, and some that seem adorned, are rather deform'd than beautified by the heads that contrived, or by the hands that built them'.[56] One such 'deformity' was evidently Thomas Archer's church in Smith Square, Westminster (Figs 267, 268), described by Defoe as 'very curious, especially the roof'.[57] The clear distinctions between these churches in their use of ornament was certainly an issue from the earliest days, for Hawksmoor's churches appear to have satisfied Defoe's critical eye. He describes the Bloomsbury church as 'very handsome',[58] and then commends 'several very fine new churches, being part of the fifty churches appointed by Act of Parliament,

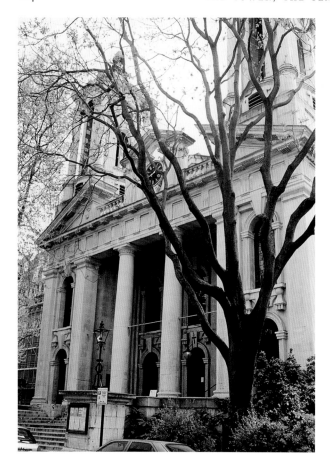

267 and 268 St John's, Smith Square, Westminster, by Thomas Archer, 1713–29.

viz. One in Spittlefields, one in Radcliff-High-way, one in Old-Street, one at Limehouse, with a very beautiful tower, and one in Bloomsbury'.[59]

It seems that Defoe's preference was for the 'middle way' in ornamentation, an approach befitting Protestant buildings and which he saw Hawksmoor's churches as reflecting. Defoe defends the Orders at St Paul's as canonical and contrasts the internal treatment with the opulence of St Peter's. For 'the church of St. Peter's in Rome, which is owned to be the most finished piece in the world, only exceeds St. Paul's in the magnificence of its inside work; the paintings, the altars, the oratories, and the variety of its imagery; things, which, in a Protestant church, however ornamental, are not allowed of'. Concerning St Paul's, he continues:

> If all the square columns, the great pillasters, and the flat pannel work, as well within as without, which they now alledge are too heavy and look too gross, were filled with pictures, adorned with carved work and gilding, and crowded with adorable images of the saints and angels, the kneeling crowd would not

complain of the grossness of the work; but 'tis the Protestant plainness, that divesting those columns, &c. of their ornaments, makes the work, which in itself is not so large and gross as that of St. Peter's, be called gross and heavy; whereas, neither by the rules of order, or by the necessity of the building, to be proportioned and sufficient to the height and weight of the work, could have been less, or any otherwise than they are.[60]

In searching for a Protestant, or 'primitive Christian', plain style for his London churches, Hawksmoor also frequently 'divests' his columns of their 'ornaments' – in preference to embellishing them in the Baroque manner. However in going well beyond the limited licentiousness found on St Paul's (largely restricted to the simplified Doric Order on the dome), the boldness of Hawksmoor's simplifications is underlined by Defoe's citation of the 'rules of order' as appropriate aesthetic criteria for Protestant architecture. Later writers showed less enthusiasm towards those more classically formed, and ornamental, of the churches by Wren and

Hawksmoor. Echoing the by now well established links between ornament and morality, James Cawthorn in 1756 observed that:

One might expect a sanctity of style
August and manly in a holy pile,
And think an architect extremely odd,
To build a playhouse for the church of God;
Yet half our churches, such the mode that reigns,
Are Roman theatres, or Grecian Fanes;
. . .
Where, in luxury of wanton pride,
Corinthian columns languish side by side,
Clos'd by an altar exquisitely fine,
Loose and lascivious as a Cyprian shrine.[61]

In reflecting the Baroque emphasis on sensory effect and drawing directly on the situational theories of Robert Morris, Langley in his *Ancient Masonry* (1734–6) matched the three Greek Orders to various moods, noting that ancient 'Decorum was always just in every Representation, whether *serious, jovial*, or *charming*'. Hence the 'Dorian modus' was applied to 'all things *Majestick, grave,* and *serious*', the Ionic to 'riant uses' while the Corinthian or effeminate 'Lydian modus' was used for '*Palaces, Triumphal Arches,* and *Houses of Pleasure*'.[62] He might well have seen the churches of his hero, Hawksmoor, as examples of these modes, since in the same year as the first part of *Ancient Masonry* appeared, Langley described these buildings as 'truly strong and magnificent and at the same time light and genteel'.[63] It can now be seen that such contrasts in mood are related to location – ranging from Corinthian magnificence at St George, Bloomsbury, to astylar sombreness at St George-in-the-East. While both churches are of the same dedication, it is the latter which most clearly reflects Vanbrugh's stricture for 'a plain, but Just and Noble Stile', eschewing 'such Gayety of Ornaments as may be proper to a Luxurious Palace' in favour of 'the most Solemn and Awfull Appearance both within and without'.[64] Equally clearly Hawksmoor did not follow on every occasion Wren's advice to avoid 'enriching the outward Walls of the Churches, in which Plainness and Duration ought principally, if not wholly, to be studied',[65] or Hickes's for 'as stately, and beautiful porticos, battlements, and pinnacles without, as the new modelles can be'.[66] His departure, in certain churches but not others, from these general rules can surely only reflect their different contexts.

Hawksmoor was clearly sensitive when ornamenting his churches to the vagaries of worldly circumstance, from poverty to riches. But he equally sought to express more universal qualities through the dramatic manner in which these buildings touch both earth and sky. For while brooding masonry keystones point towards the earth, funereal iconography hovers above ponderous, corbelled cornices – modelled after such forbidding Roman temples as that to Mars and, again appropriately enough, the most 'universal' of buildings, the Pantheon.[67] Hawksmoor rooted his churches to their sites less through the classical device of rustication than through the sombre character of their doors and windows, and by the crypts and other subterranean rooms whose presence these elements often signify. At Bloomsbury the theme of triumphant resurrection symbolized by the crowning statue of George I rising from his altar and tomb, and by the giant Corinthian portico to the fore, only serves to emphasize the ominous presence of the heavy ornamental keystones at basement level. It is as if Hawksmoor wished to celebrate the eternal opposites of sky and earth and thus, it might be inferred, of heaven and hell. In reflecting Serlio's contrast between 'licentious' and canonic ornament, presented as a form of moral emblem warning the onlooker, Hawksmoor's esoteric churches can here again be viewed as sermons in stone.

Chapter 8

'A PLEASANT VISTA': THE LOST CITIES OF OXFORD AND CAMBRIDGE

IN 1723 HAWKSMOOR PRODUCED A PERSPECTIVE, intended for engraving, of Wren's preferred design for the Fire Monument, in which the column is pictured set in a landscape of triumphal pillars and ruined classical mouldings that dwarf the ordinary foreground buildings and lend a fictive antiquity to the scene (see Fig. 199).[1] This remarkable capriccio provides a glimpse of Hawksmoor's vision of an ideal city based on Roman models, of special significance since his own urban plans were designed with such models in mind. Drawing most notably on the *via triumphalis* and the civic forum, at Ripon he placed a new obelisk at the centre of the market square to create a 'forum populi' (see Fig. 134), while at Oxford and Cambridge he produced plans to reorganize their academic centres around new forums and triumphal routes.[2] His use of Roman urban models for academic assembly reflected a fundamental belief in classical antiquity as the cradle of civilization: he observed to the Dean of Westminster for example that 'the Greeks and Romans calld every Nation Barbarous, that, were not in their way of Police and Education'.[3] In line with the status of Oxford and Cambridge as ancient seats of learning still dominated by the study of the Classics, Hawksmoor's plans for these towns represent a coherent, if largely frustrated, ambition to glorify them in antique – and more notably in Roman – terms. In Cambridge his plans came to nothing, but in Oxford he had more success. There he proposed two new forums, one civic and the other academic, as well as drawing on appropriate antique models in projects to rebuild the colleges of Queen's (c. 1708–9), All Souls (c. 1708–30), Brasenose (1720–34) and Magdalen (1724). While the last two were unrealized, at Queen's College Hawksmoor's High Street screen (1733–6) was built with alterations by the mason William Townesend, and at All Souls he built the 'Gothic' north quadrangle (with Townesend serving as mason) comprising the hall, buttery, Codrington Library, towers and colonnade (1716–35) (Figs 269, 270; see Figs 38, 81). Hawksmoor also proposed the refacing of the High Street front to University College (c. 1711, unrealized) (Figs 271–2), and produced designs for the hall, chapel and library to the newly founded Worcester College (c. 1717–20) (see Figs 116, 197, 228); they were unrealized but influenced the eventual buildings by Townesend. In addition, the Clarendon Building (1712–13) was constructed to his design (again by Townesend) (Figs 274–5), his projected Radcliffe Library and University forum were adapted by James Gibbs to form the Radcliffe Camera and Square, and Hawksmoor's tower design for All Saints church was amended during its construction from 1718 (see Figs 221, 222, 225, 226).[4]

Hawksmoor's vision for central Oxford, uniting these schemes, is recorded on his surviving urban plans – a detail entitled 'Environs of the Schooles and Publick Buildi[n]gs of ye University next the new Forum Augt 1713' and a much larger drawing of around the same period, or a little later, entitled (in self-conscious Latin) 'Regio Prima Aecademia Oxoniesis amplificata et exornata' (Principal Quarter of Academic Oxford enlarged and embellished) (Figs 273, 276).[5] The latter title may well imply Hawksmoor's intention for further developments to the west of this area, of which his projects for Worcester College formed a part. This grand plan was probably stimulated by his initial scheme for Brasenose, a plan for which was produced by him around this time and included neighbouring projects for a new Radcliffe Library and public square.[6]

The forceful patron and occasional guiding hand behind many of Hawksmoor's college projects, and his urban ambitions for Oxford as a whole, was a graduate of Brasenose, Fellow of All Souls and Tory MP for the University, Dr George Clarke (1661–1736, an exact contemporary of Hawksmoor). It is to Clarke's devotion to architecture that the preservation at Worcester College of Inigo Jones's library is owed. Clarke was Joint Secretary (1702–5) and later Lord of the Admiralty (1710–14), and probably met Hawksmoor concerning Greenwich Hospital some time after 1702.

270 Hawksmoor's engraved plan of his All Souls scheme, c. 1717.

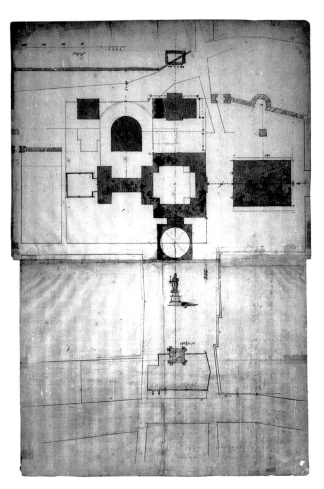

273 (*above*) Hawksmoor's drawing entitled 'Environs of the Schooles and Publick Buildi[n]gs of yᶜ University next the new Forum Augt 1713' [Ashmolean Museum, Oxford].

271 (*above left*) Hawksmoor's scheme to reface the High Street façade of University College, Oxford, c. 1711 [Worcester College, Oxford].

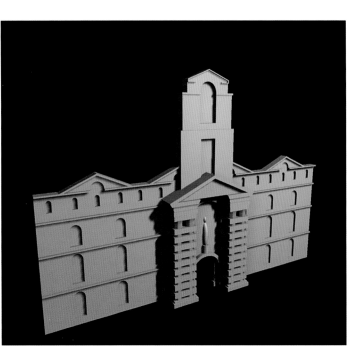

272 Computer model of the proposed façade of University College, Oxford. [author].

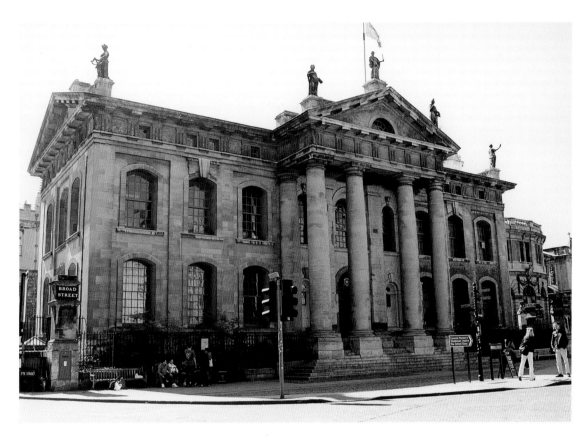

274 Front façade of the Clarendon Building, Oxford.

275 Rear façade of the Clarendon Building, Oxford.

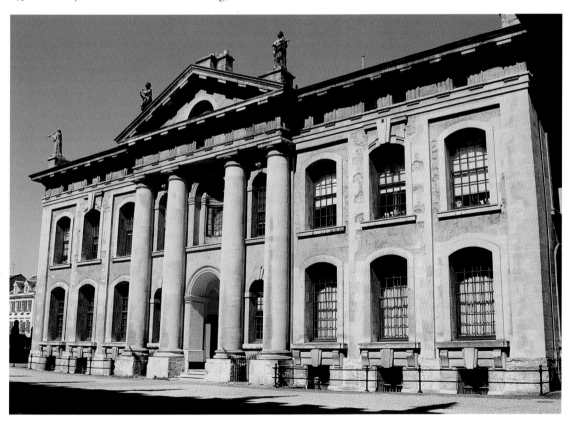

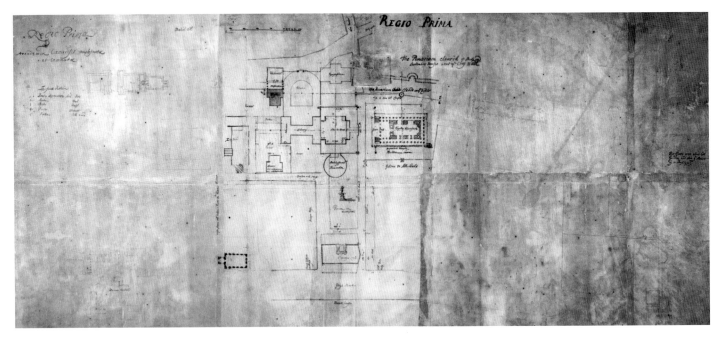

276 Hawksmoor's drawing entitled, 'Regio Prima Aecademia Oxoniesis amplificata et exornata', c. 1713–14 [Bodleian Library, Oxford].

277 Detail of above figure.

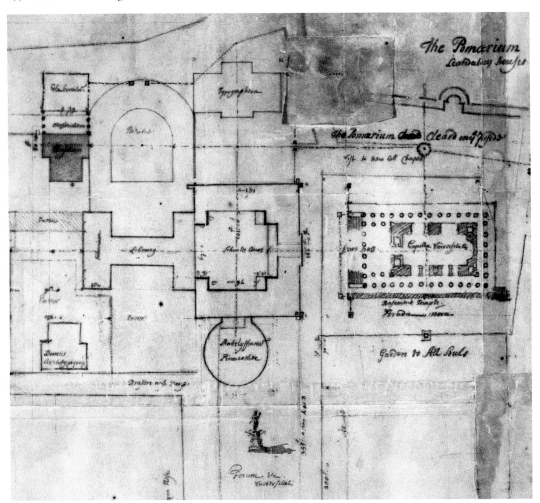

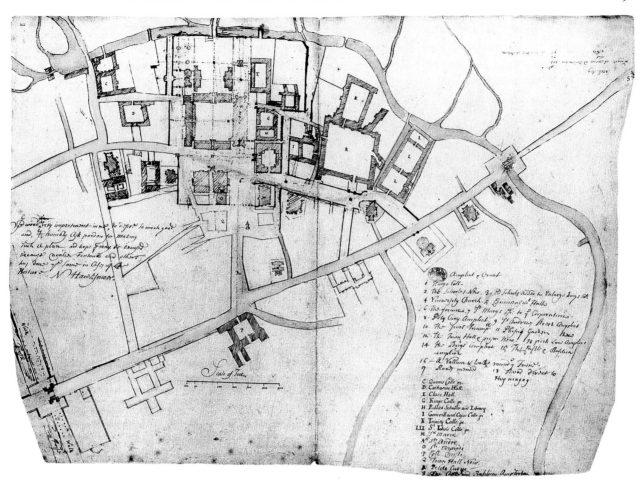

278 Hawksmoor's plan for Cambridge, 1712 [British Library, London].

Following the start of work at Blenheim three years later, Hawksmoor would have passed through Oxford on a regular basis. Clarke was involved with Hawksmoor's projects for Queen's, Brasenose, Worcester and University colleges, as well as the Clarendon Building and his work at All Souls. In Hawksmoor's 'explanation' of his Gothic scheme for All Souls, sent to Clarke in February 1715 (two years or so after drawing the 'Regio Prima' plan), the architect even credits Clarke with the idea for the Radcliffe square. He notes 'I am much delighted with your proposall for y[e] Piazza and Library next y[e] Schools'.[7] Clarke also played a leading role in the new library at Christ Church and the Radcliffe quadrangle at University College, both built by Townesend, and the north range of the quadrangle at Magdalen built by Edward Holdsworth (1733–4).

Hawksmoor's attempt to reorder the medieval fabric of Oxford into a unified whole, and thereby provide a legibility to the central college buildings which by tradition were conceived of as independent and insular institutions, was echoed in his equally ambitious plan for Cambridge of about the same time (1712) (Fig. 278).[8] However there his plan is centred on the rebuilding of a single college, King's. For the most part the medieval fabric of both towns had to be respected and worked within – unlike in post-fire London but equally the case within individual colleges, as at All Souls. Consequently Hawksmoor proposed remodelling existing streets and buildings either to enhance or subdue their importance in his new city structure. This planned reordering did, however, envisage the demolition of parts of the domestic fabric. In Oxford this was to open up the area around the city walls and to create Radcliffe Square, as well as to build the Clarendon Building and a University church on the site of Hart Hall; and in Cambridge buildings would have been demolished to create new streets.[9] Hawksmoor's largely frustrated attempt to give medieval Oxford and Cambridge coherence – as towns as well as universities – stood in the face of the traditional dualities represented by college and university, and by university and town.

In both towns – particularly Cambridge – existing streets were to be centred on forums and buildings transformed into axial focal points following the precedent of Baroque Rome, especially the Rome of Sixtus V.

'CAVALIER FONTANA AND OTHERS HAVE DONE Y[E] SAME': FONTANA'S ROME AND WREN'S LONDON

Chapter 6 pointed out that the obelisks and triumphal columns proposed for the skyline of Hawksmoor's churches were intended to help reinvigorate London as a Christian capital, just as Sixtus V had employed Domenico Fontana to do in relocating obelisks at key points in Rome during the 1580s. Hawksmoor was well aware of this axial model of city reordering and acknowledged it as a major precedent for his own urban schemes. Annotated in his hand on the Cambridge plan is the apology, 'It would [be] very impertinent in me, to desire so much good and, I humbly Ask pardon for Making Such a plan, and hope I may be excused because Cavalier Fontana and others has done y[e] same in Cases of Like Nature. N. Hawksmoor'.[10] Among Inigo Jones's books purchased by Clarke (up to 1712) was a copy of Giovanni Bordino's *De Rebus Praeclare Gestis a Sixto V Pont. Max* (1588), with its diagrammatic plan illustrating the axial concept behind this reordering of Rome around new obelisks and existing monuments (Fig. 279). With their Oxford remodelling in mind, Clarke and Hawksmoor must surely have studied this book (which draws attention to itself through Edmund Bolton's now famous inscription to Jones). More significantly, perhaps, Hawksmoor owned a copy of Domenico's *Della trasportatione dell'obelisco Vaticano et delle fabriche di Nostro Signore Papa Sisto V* (1590; lot 104), republished as the third book of his nephew Carlo Fontana's *Templum Vaticanum* (1694), which Hawksmoor also owned (lot 118). These books directly informed his work, for in his 'explanation' of the proposed Blenheim obelisk he refers to Domenico's obelisk in St John Lateran: 'Sixtus Quintus the Pope Set it up again where it Still remains in the Piazza of St. Jno Lateran', adding that one of his own obelisk designs was 'Like that set up in y[e] Piazza Navona, by Cavalier *Fontana*, or Bernini'.[11] The Baroque replanning of Rome had been equally amply illustrated by Giovanni Giacomo de Rossi, Giovanni Battista Falda and Domenico de Rossi in works that Hawksmoor collected.[12] In Falda's *Il nuovo teatro delle fabriche et edificii in prospettiva di Roma moderna* (1665– ; lot 155), for example, Hawksmoor could have

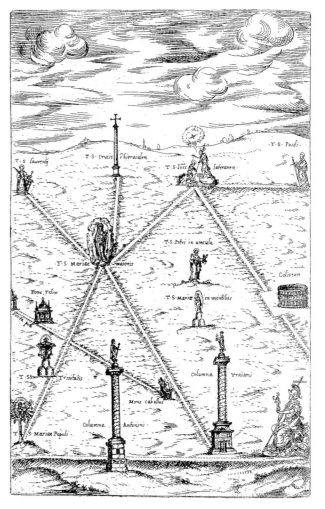

279 Diagrammatic plan of Sixtus V's reordering of Rome, from Giovanni Bordino's *De Rebus Praeclare Gestis a Sixto V Pont. Max* (1588).

read the short captions pointing out Alexander VII's urban interventions – streets widened and straightened and squares enlarged.[13]

Hawksmoor would also have been familiar with Sixtus V's plan through its influence on Wren's proposals for rebuilding the City of London after the Great Fire of 1666 (Fig. 280). Wren's plan monumentalized civic buildings – such as the halls of the City Companies, the Customs House, the New Exchange and, most significantly, the Cathedral – by placing them at the focus of radial streets. This was not only for visual reasons, however, for first Wren and later Hawksmoor sought to emphasize the social value of public buildings through their enhanced prominence. Wren made this ambition clear when observing patriotically in the opening of his first Tract that 'ARCHITECTURE has its political Use; public Buildings being the Ornament of a Country; it establishes a Nation, draws People and

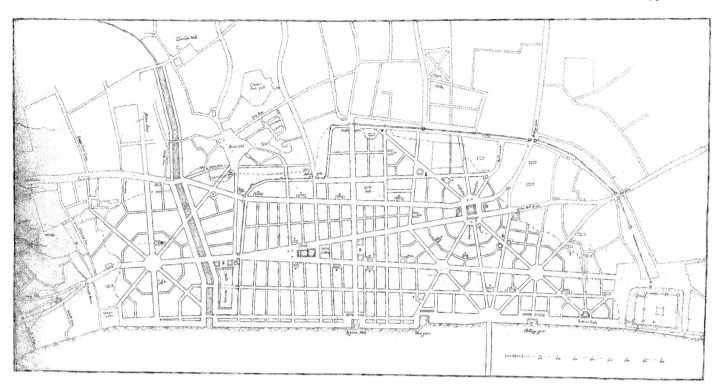

280 Wren's plan for London after the Great Fire of 1666 [All Souls, Oxford].

Commerce; makes the people love their native Country, which Passion is the Original of all great Actions in a Common-wealth'.[14]

In his role as Wren's assistant, Hawksmoor had experienced at first hand – albeit belatedly – the failure to implement the London plan, and regarded this as a missed opportunity not to be repeated at Oxford. For he links the two plans in his 'explanation' of his All Souls designs, offering Clarke some observations 'by way of encouragement towards Generall Design [and] proper forcast in this Affair Architectionicall that may regard both old and new Erections'.[15] These prescriptions throw valuable light on the wider social ambitions (the universal or 'architectionicall' values) behind Hawksmoor's designs for private institutions – especially his schemes for the particular subject of the 'explanation', All Souls – and behind his arrangement of their façades around new forums and vistas. He observes that following the fire in London one might have expected

a Convenient regular well built Citty, excellent, Skillfull, honest-Artificers Made by yᵉ greatness & Quantity of yᵉ Worke in rebuilding Such a Capital. But instead of these, we have noe City, nor Streets, nor Houses, but a Chaos of Dirty Rotten Sheds, allways Tumbling or takeing fire, with winding Crooked passages (Scarse practicable) Lakes of Mud and Rills of Stinking Mire Runing through them.

Just as London's 'crooked' passages symbolized and facilitated the equally 'crooked' nature of their inhabitants, so Hawksmoor evidently expected a new, more 'regular' architectural order of axes and vistas to stimulate a new public order of 'honest' citizenship. For he echoes Wren in underlining the civic benefits of architecture, further lamenting that the government, 'when they had so favourable an opportunity to Rebuild London yᵉ Most August Towne in yᵉ World', ought 'for yᵉ Publick good to have Guided it into a Regular and Commodious form, and not have Sufferd it to Run into an ugly inconvenient Self destroying unweildy Monster'. From Augustan regularity would have flowed 'Many other publick benefits of like nature'. This link between architectural and public order forms the foundation of Hawksmoor's plea to Clarke to support his urban plan for Oxford:

Now to Apply this Argument by looking back we See yᵉ Misfortunes of London in Rebuilding as well as Augmenting it, by not haveing Generall Draughts, and Regular Schemes . . . let us returne to Oxford and Looke forward upon yᵉ hopes we may have in yᵉ Universitys of doing as much good as we can and

Avoiding y^e Ills that May hapen by omiting a little previous Care.

Written with his All Souls schemes in mind, these remarks make clear that Hawksmoor saw his individual college projects not in isolation but rather as an opportunity to emulate Wren's ambition towards a wider civic unity – this time centred on private academic institutions and public university spaces.

THE VISTA AND THE AXIS: VISUALIZING HAWKSMOOR'S OXFORD

Building on the intentions behind Wren's Sheldonian Theatre (Fig. 281), in his 'Regio Prima' plan Hawksmoor attempted to mould a coherent city from the institutions and public spaces required by a modern, eighteenth-century university. This involved moving away from the medieval college-based structure. He proposed a new university library, church, print house and central square or 'Forum Universitatis', as well as an 'Elaboratori[um]', thereby reflecting the Royal Society's preference for experiment and underlining the modernity of his intentions.[16] Hawksmoor follows his principle that 'Churches & other Publick Buildings should always be Insulate'[17] by inserting these new buildings, much as had Sixtus V, into the existing fabric. The more or less regular, rectangular boundary of Hawksmoor's 'principal region' is defined to the north and to the east by the medieval city wall that is shown

terminated by what is obviously a triumphal arch straddling the High Street (on the site of the old east gate).[18] This existing street forms the southern boundary, with the triumphal arch at the eastern end matched by a new colonnaded 'Forum Civitatis' at the western extremity. The colonnade, probably intended to surround the forum and embrace the (now demolished) church of St Martin, judging from the hazy pencil lines, extended an existing Doric colonnade built in 1710–13 at the south-east corner of the junction.[19] The church is also given a new portico, while the forum has a central column with spiral decoration here again recalling that of Trajan.[20] This forum serves as the civic 'gateway' to the university precinct – thus defined at its edges and marked at its centre by the university forum with its own central feature in the form of a female statue, possibly (given the plan's date) of Queen Anne.

The northern boundary, defined by the existing walls, is consolidated by two gates: the 'Bocardo' – which utilizes part of St Michael's church and remodels an existing gate, on axis with the civic forum – and the 'Turl' – which is on axis with All Saints tower. Hawksmoor lists these gates in a key on the 'Regio Prima' plan, indicating their importance to his conception of the area as a defined 'precinct'. The Clarendon Building is positioned on this boundary and is balanced, on the other side of the Sheldonian, by the laboratory (which in the near-contemporary 'Brasenose' plan is of the same shape). The orientation of the Sheldonian – with its main processional entrance on the 'inner', southern façade, to the rear of the gate onto the public thoroughfare – is rationalized in Hawksmoor's plan through the presence of the university forum which establishes a new focus to the south. Prefiguring Gibbs's design, this forum is monumentalized by the new Radcliffe Library that takes the form of a drum on axis with the Clarendon Building and the tower to St Mary's (rather than with the existing Schools façade to which it is joined). An alternative position is also indicated, attached to the west (Selden) end of the Bodleian (the position first suggested, but later altered to the more prominent southern location, by the library's benefactor Dr John Radcliffe).[21] To the west of the forum lies Hawksmoor's proposed new façade to Brasenose, to the east the new screen to All Souls and on the north-eastern corner a new university church or 'Capella Universitatis' with its campanile. This church – in the form of a temple complete with portico and colonnade – lies directly opposite the Old Schools and is positioned on axis with the existing gate of the five Orders, on the site of Hart Hall (now Hertford College).

281 Wren's Sheldonian Theatre, Oxford.

282 and 283 Computer model reconstructing Hawksmoor's Oxford [author].

Hawksmoor's Clarendon Building thus stands today as a 'fragment' of a far more ambitious urban vision, in being conceived as a boundary building and monumental gateway to the Old School's Quadrangle and university forum to the south. His 'lost city' can however be visualized in model form by using the 'Regio Prima' plan and his surviving drawings for the individual colleges which, as has been seen, formed part of his wider urban ambitions (Figs 282, 283).[22] The computer model highlights the structure of Hawksmoor's 'academic Oxford': a series of boundary buildings, two forums (civic and university) and the use of major and minor axes. Much like Sixtus V, Hawksmoor either created new axes or enhanced existing ones by using vistas – frequently focussed on religious structures – to link new and existing institutions (or elements of them, such as gateways). The consideration of vistas often formed part of his concern to make a project relate to its context. His early sketch of Bath Abbey (1683) shows the view through the doors (see Fig. 80),[23] and it is known that Hawksmoor replanned Oxford with particular vistas in mind because on a drawing by him for the north elevation of the Clarendon Building the vista through to the central gate of the Schools has been sketched in (Fig. 284).[24] Furthermore on the 'Regio Prima' plan he noted: 'Vist[a] to New Coll Chapell' and 'Vist[a] from Hallows Tower to Queens Tower' – both of which have been modelled to show what Hawksmoor had in mind (Figs 285, 286). His new tower to All Saints ('Hallows Tower') was clearly conceived of not as an isolated design but as part of this axis to, or beyond, his new 'Turl' gate. As Chapter 4 noted, All Saints is inked-in on the 'Regio Prima' plan, unlike St Mary's, confirming that it was considered by Hawksmoor a part of his overall scheme. 'Queens Tower' may be 'Turl' gate or possibly indicates a new gate to Trinity College – perhaps, much like at Queen's College and the London churches – dedicated to the queen. David Loggan's *Oxonia Illustrata* (1675) records that Trinity was set back from the road with no main public front (just like today). Indeed the 'Regio Prima' plan shows the edge of a building and the faint pencil annotation 'Trinity Tower' in line with All Saints.

Thus Hawksmoor designed his front façades not as flat elevations but to frame and provide focal points for new and existing vistas. The addition of statues, heraldry and monumental towers to these façades helped signify their identity when viewed from afar. This is most notable at Queen's – with its proposed gate tower and the realized tempietto and statue (of Queen Caroline) – at All Souls – with its proposed tower, busts and urns (literally of 'All Souls') – and at the Clarendon Building – with its proposed university coat of arms and the realized statues of the muses. Hawksmoor had studied the prospect of the city in 1683, when aged about twenty-two (Fig. 287), and the skyline of spires and college towers would surely have left its mark on someone who, although never attending university himself, was none the less 'bred a Scholar'.[25]

'WALKE ROUND Y[E] TOWNE': HAWKSMOOR AT CAMBRIDGE

Hawksmoor's parallel plan for Cambridge can be dated to 1712, about the same time, or a little earlier, than his Oxford scheme. It was noted that the reference on this plan to 'Cavalier Fontana' makes explicit his principal model, here combining the Rome of Sixtus V with defensive ideas drawn from Roman military planning.[26] Evidence that Hawksmoor studied the latter is provided by the presence on the southern boundary of this Cambridge plan of a 'Vallum & Walke round y[e] towne'. For a vallum was a rampart enclosing, or radiating from, the Roman camp – a meaning reinforced in the Cambridge plan by its alignment with the existing ditch here relabelled with the defensive term 'fosse'. As in Oxford where the existing city walls are emphasized, in Cambridge the presence of this 'vallum' and 'fosse' signifies the town's notional enclosure and, like Vanbrugh, Hawksmoor's fondness for defensive features. These features are drawn on the bottom left-hand corner of the plan and disappear off the page, but when extended would have linked – along the line of the existing ditch – the two flanks of the river as it loops round Cambridge so as to form the promised perimeter walk.

284 Drawing by Hawksmoor for the north elevation of the Clarendon Building, c. 1709–10 [Worcester College, Oxford].

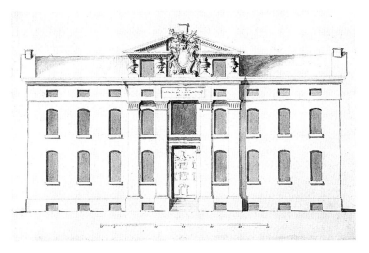

285 (*top*) Computer model of the 'Vist[a] to New Coll Chapell' [author].

286 Computer model of the 'Vist[a] from Hallows Tower to Queens Tower' [author].

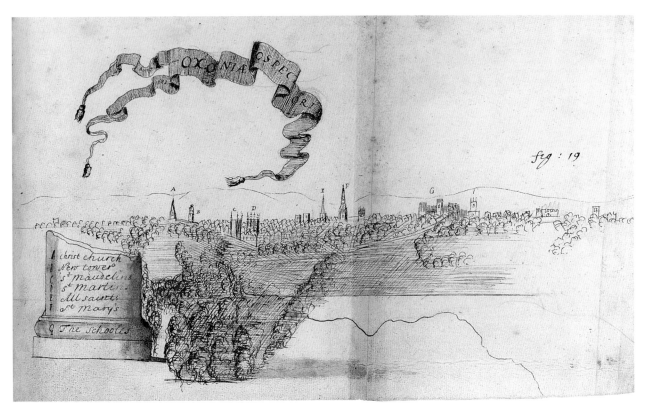

287 Hawksmoor's sketch of the Oxford skyline, from his Topographical Sketchbook of 1680–83 [R.I.B.A., London].

288 Reconstruction of Hawksmoor's Cambridge plan [author].

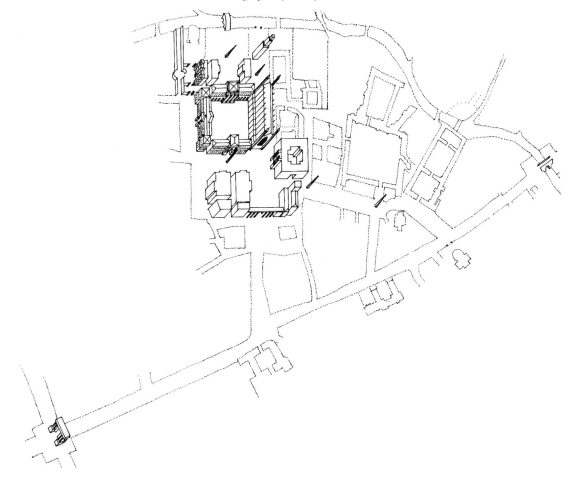

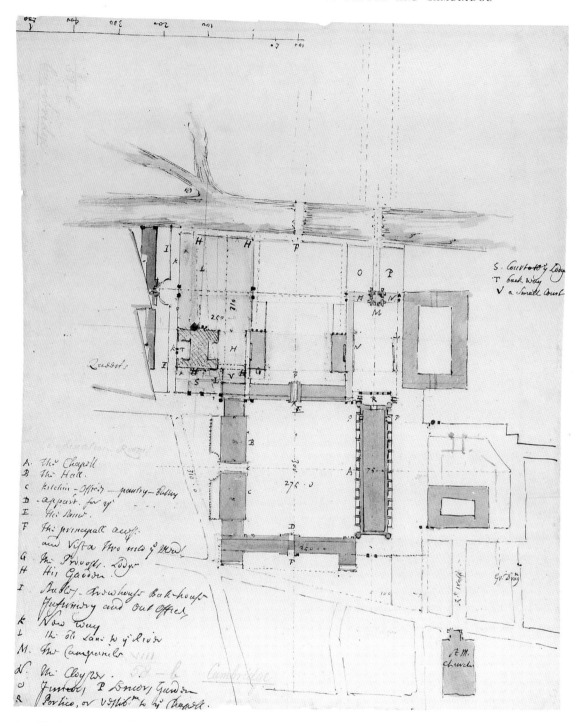

289 Hawksmoor's plan for King's College, Cambridge, 1712–13 [British Library, London].

At Cambridge Hawksmoor envisages two new squares, one with a triumphal arch at the London end of St Andrew's Street and the other surrounding the existing bridge in Magdalene Bridge Street (Fig. 288).[27] A central 'forum' (item 6 on the key) is placed off to one side of this main route, as at Oxford. Here at Cambridge the plan is more open, however, and the city's remodelling is to be achieved principally through the rebuilding of a single college, King's.[28] In a design dated 1712–13, King's was to be rebuilt with linked blocks arranged round a quadrangle where the existing chapel formed the northern face, and with open wings extending towards the river (Fig. 289).[29] These wings formed the Provost's Lodging to the south and, to the

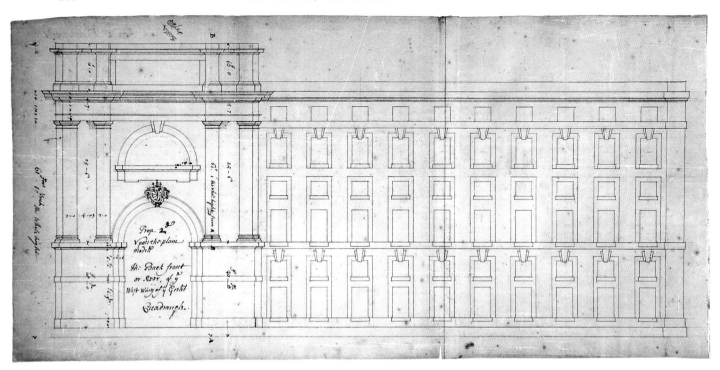

290 Hawksmoor's revised design 'upon the plain modell' for the western block facing the front courtyard of King's College, Cambridge, 1713 [Bodleian Library, Oxford].

north, a cloistered court fronted by the chapel's western face (which is given a portico), Clare College and a new campanile similar to that planned for Oxford. The major college axis runs through an existing bridge to the west (now removed) to new university buildings beyond the front of the college to the east. The plan of 1712–13 makes Hawksmoor's strategy explicit in describing this route as 'The principall axis and Vista'.[30] King's thus structures the new university buildings and civic spaces of the town: an existing route (Petty Cury) is transformed into the central forum on axis with King's Chapel and the existing gate of Christ's – an axis further marked by the new campanile beyond the Chapel to the west. Hawksmoor's plan for King's is more open than are those of his Oxford college schemes, with their tight sites and private courts, and in which university (not college) buildings structure the space (as objects in it). As in Oxford, however, the existing buildings at King's – in this case the Chapel – influenced the style of the new buildings, although not to the extent of dictating the use of Gothic. Whereas the existing buildings at All Souls evidently represented a compelling contextual argument for the use of Gothic, at King's a decorous response to context was supposed to be achieved in the new work through a match of mood rather than style. For after a meeting with Hawksmoor in March 1713 concerning the initial

design, the Provost, Dr John Adams, noted that a 'plainness' in the style of the new western block would be 'more answerable to y^e Chappel', and he 'desird all Ornaments might be avoided'.[31] This request was implemented by Hawksmoor in the subsequent austere design for the western block, annotated as 'upon the plain modell', in which a frontispiece of Doric pilasters (with a plain entablature) replaces an earlier triumphal arch comprising columns of the Corinthian or, in an alternative version, full Doric Order (this time with triglyphs) (Fig. 290).[32]

Hawksmoor had similar grand, if more tentative, ideas for St John's College. In 1698 he had proposed a bridge on the site of the present Bridge of Sighs, on axis with the college's three courtyards, which he described as giving 'a pleasant Vista and entrance thro' the body of y^e whole fabrick'.[33] This area is the subject of a surviving survey drawing.[34] Most intriguingly the bridge is also sketched on the overall town plan where, since its crossing led nowhere, Hawksmoor draws – in faint pencil dots possibly indicating columns – a giant hemicycle, its open centre on axis with the bridge (Fig. 291). It is impossible to say what function this landscape feature would have served, apart from extending the all-important vista, but at Magdalen in Oxford, as will be seen shortly, Hawksmoor labelled the same form a 'Theatrum'.

291 Detail of Hawksmoor's plan for Cambridge, with dots indicating a giant hemicycle (see Fig. 278).

As the reference to Fontana indicates, in Hawksmoor's Cambridge plan existing features (such as gates and bridges) are emphasized through their forming axes for new college, university and public buildings and spaces (see Fig. 288). These axes are marked by objects – very probably obelisks – which are placed in the centre of the new spaces. Two are placed on the main, east–west axis of the new King's buildings – one in the area of the forum in front of the College and the other to the rear in the open court – and one on the long axis of the chapel in the centre of the new courtyard. The rear obelisk also works from north to south in aligning with the new campanile, while that to the front in the forum aligns with new university buildings to the north and east. These include a new university church and Senate (Commencement) House, since items 4 and 5 on the key (but unmarked on the plan) refer to a 'University Church' and a 'Commencement Hall' respectively.[35] Hawksmoor's sale catalogue lists 'Twenty Designs for the Commencement-house at Cambridge' (lot 93) which may have been by him or, more possibly, was Wren's scheme for a Senate House that had been conceived in rivalry to the Sheldonian.[36] Unlike Hawksmoor's Oxford plan, however, in Cambridge the civic administration is accommodated through the presence of a new town hall and public offices.[37]

Taking a cue from the perimeter 'Walke round yᵉ towne', a walk might be taken round the rest of Hawksmoor's Cambridge plan to the north. Leading off the north-western corner of the forum is a Roman circus formed from a widened Trinity Street, with objects – again possibly obelisks – placed on axes with Senate House passage at one end and, at the other, Trinity gate and a new street to Sidney Sussex gate. This arrangement strongly resembled the model of the Piazza Navona in Rome, with Bernini's obelisk in the centre, of which Hawksmoor was seen to have been well aware. In forming this circus, the colleges of Caius and Trinity as well as St Michael's church are left intact, while the tower of All Saints church (now demolished) closes the vista to the north. Passing through to St John's Street, the view is terminated by the Round Church of the Holy Sepulchre. Moving back to the forum, between Great St Mary's and St Edward's, a new colonnade screens the forum from the widened Petty Cury link to St Andrew's Street and Christ's gate. Here again, college gates and public churches are made into focal points for new vistas, following Sistine Rome. As Regent Street gives way to St Andrew's Street and then Sidney Street, vistas open into the new spaces – with views from Christ's gate to the new forum, from Sidney Sussex gate to Trinity gate and obelisk, and from the Round Church to All Saints.

Hence while antiquity provided Hawksmoor with his principal urban forms, in the arrangement of these forms he followed the more modern, 'rational' emphasis of the Baroque masters, on axes, vistas and light. For his use of unified façades and vistas to create major and minor axes leading to important centres – ideas first promoted by Sixtus V – reflected the work of Fisher von Erlach in Vienna and of Carlo Fontana and Bernini in Rome. A more immediate model would have been provided by Wren's use of vistas in his plan for London, a plan that Hawksmoor himself connects with his Oxford work. However, Wren's vistas radiated from monuments rather than lying on axis with them, as in Oxford and Cambridge, and as a consequence are more defined than in Hawksmoor's plans. According to Wren's son, the street pattern of the post-fire London plan radiated 'like so many Rays', Wren having been influenced by the optical theory of light as outlined by Kepler and developed later by Newton.[38] It was noted in Chapter 1 that as part of his interest in the work of the Royal Society, Hawksmoor could have studied this theory at first hand in his copy of 'Newton's Opticks' (lot 33), as too Descartes' theories concerning sight lines (lot 22). The vistas at Versailles must have made an equally strong impression, prints of which were also in his collection (lot 287). At Greenwich Hawksmoor

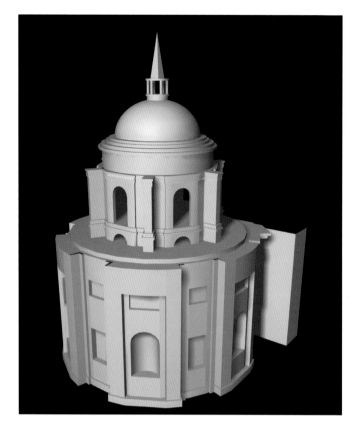

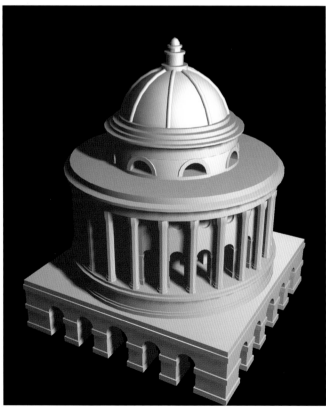

292 and 293 Computer models reconstructing two of the rotunda schemes for the Radcliffe Library, Oxford (Projects IV and VII) [author].

praises the 'Esplanades, Walkes, Vistas, Plantations, and Lines of that beautiful Park' which he thought were also designed by 'that most admirable Person', André Le Nôtre.[39] (Given the importance of the central axis in the Greenwich Hospital plan, Hawksmoor cannot have been unaware that his siting of the tower for St Anne, Limehouse, exactly aligned with it, a relationship visible from Observatory Hill.[40])

Kerry Downes pointed out in 1970 that, in the case of the Oxford plan, 'It is obviously impossible to experience fully from drawings the spatial effect of either the random appearance or the underlying order'.[41] The computer model of Oxford shows for the first time just how effective Hawksmoor's façades would have been as three-dimensional compositions when viewed as part of these planned vistas. It also visualizes two of the rotunda versions of the Radcliffe Library in their alternative locations attached to the Bodleian and the Schools (Figs 292, 293; see Figs 282, 283). Indeed since for Hawksmoor issues of ornamental style and arrangement were dictated by local context as much as by archetypal precedent (a fact his Gothic All Souls designs clearly demonstrate), it is obviously important to visualize his proposed university buildings next to each other in their planned context. The model shows the coherence of his urban vision of Oxford as a 'Roman' city and his sensitivity to issues of situation, scale and decorum.

THE CLOISTER AND THE ATRIUM: HAWKSMOOR'S OXFORD COLLEGE MODELS

The 'open' character of Hawksmoor's new public spaces and buildings in Oxford – where none of the institutional buildings has or helps make a closed courtyard – is in strong contrast to the colleges, whose traditional courtyard plan and enclosed character Hawksmoor's schemes did not attempt to reform. Colleges are by convention a combination of palace (with their porter's lodge and master's quarters) and monastery (with their cloister, communal dining hall and dormitory). Alberti for one had emphasized that monasteries were a form of 'priestly camp', 'where scholars apply their minds to the pursuit of humane or religious studies'.[42] Both monastery and palace have chapels and libraries, like colleges, and in the absence of any antique college precedent, Hawksmoor developed these types, or key parts from them, in his various college plans. Something of his conception of the Oxbridge college as a type of palace is reflected in his reference to St John's in Cambridge as 'so noble a house'.[43] And in clear reference to the monastic type, his proposal for Magdalen

in Oxford included a 'Grand Cloyster', his plan for All Souls of 1714 labelled the Fellows' rooms a 'Grand Dormitory' while one for Queen's (proposition 'v') labelled the hall a 'Refectoir'. For expressive reasons All Souls was built in what he described (on a scheme for the west, Radcliffe gate) as 'after yᵉ Monastick Maner'[44] (see Fig. 109) and, as was noted in Chapter 3, his 'explanation' recorded that this style was used to match the work of the college's 'most Revd. founder'.

It is natural therefore that Hawksmoor's college plans reflected, to varying degrees, important features of the archetypal models of monastery and palace – namely Solomon's Temple recorded by Ezekiel and the Roman house described by Vitruvius, Hawksmoor's interest in which has already been noted. His propositions for Queen's ('A' and 'II'), like that for Brasenose, had a central rectangular chapel between two courts – moved north to create one large quadrangle in a further plan ('v') and replaced by a (central) oval chapel and 'Grand courte' in another ('VI') (Figs 294–8; and see Fig. 9). This arrangement clearly resembles, albeit in simplified

294 (*left*) and 295 (*below left*) Hawksmoor's plans for Queen's College, Oxford, c. 1708–9 ('A' and 'II') [Queen's College, Oxford].

296 (*below*) Hawksmoor's initial plan for Brasenose College, Oxford, 1720 [Worcester College, Oxford].

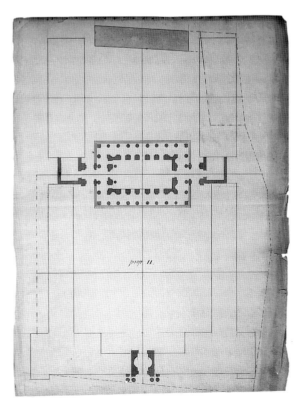

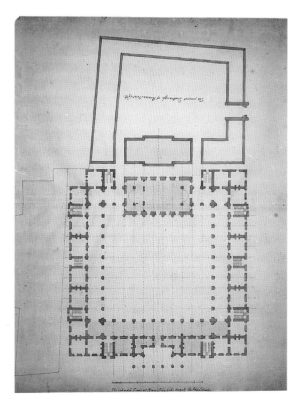

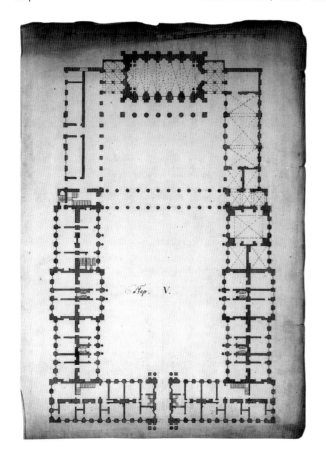 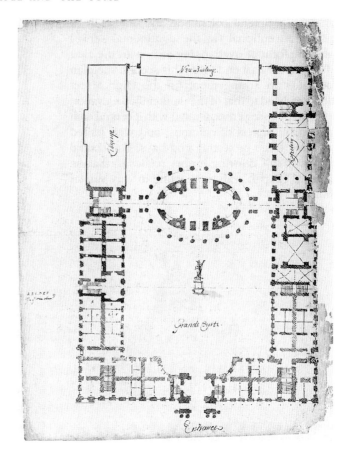

297 and 298 Hawksmoor's plans for Queen's College, Oxford, c. 1708–9 ('v' and 'vi') [Queen's College, Oxford].

form, the general disposition of Solomon's Temple as famously reconstructed as an *all'antica* palace by Villalpando and realized in the palace/monastery in Madrid called the Escorial and later in the Hôtel des Invalides in Paris (Figs 299–301; see Figs 123, 124). It was shown earlier that at some stage Hawksmoor carefully studied the description of the layout of the visionary temple in Ezekiel, while his interest in the Escorial is shown by his ownership of Francisco de los Santos' *Descripción del Real Monasterio de San Lorenzo del Escorial* (1681; lot 74). It is unlikely that Wren failed to discuss Villalpando's reconstruction of the Temple's giant courtyards with his assistant when proposing the proto-Tuscan Tyrian, in preference to Villalpando's Corinthian, as the Order used on the Temple.[45] As noted in Chapter 4, Hawksmoor would have seen Villalpando referred to in his much consulted copies of Evelyn's translation of Fréart (lots 89 and 108). Indeed Villalpando's plates had been re-engraved by Hollar for Bishop Walton's *Biblia Sacra Polygotta* in 1657 and again in John Ogilby's Bible of 1660. It was also noted that plates from these may well have numbered among those by Hollar that Hawksmoor avidly collected.[46]

Villalpando's plates were known in Oxford circles in the 1700s through the studies of Henry Aldrich, who approved of much of what he saw, and his own thoughts on aspects of the Temple – specifically the use of the Orders – were presented to Hawksmoor's patron, Dr Clarke.[47]

The feature of a free-standing chapel in the centre of a giant court (linked only by a colonnade), as proposed at Queen's, was unprecedented in Oxford college plans.[48] Ezekiel's description of the archetypal monastery-cum-temple, as reconstructed by Villalpando, would have provided an obvious model (and biblical legitimacy) for such an arrangement while reflecting Aldrich's contemporary studies and Hawksmoor's own interest in the free-standing primitive Christian 'basilica', set in its own court, of about the same time (see Fig. 60). Indeed Oxford was the centre for theological studies into primitive Christianity, by Joseph Bingham and his followers Francis Atterbury and George Smalridge. Aldrich had been succeeded as Dean of Christ Church first by Atterbury (from 1711 to 1713) and then by Smalridge (from 1713 to 1719), and Hawksmoor would have known both through their

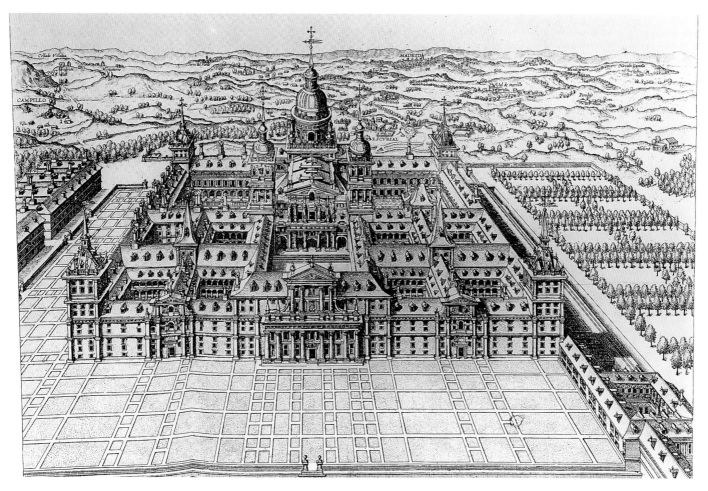

299 The Escorial, Madrid, based on the seventh print of Juan de Herrera's *Estampas* (1589).

300 (*right*) The
Dome of the Hôtel
des Invalides, Paris.

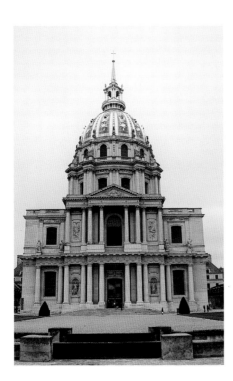

301 (*far right*) Plan
of the Hôtel des
Invalides, from
Gabriel Louis
Calabre-Pérau's
*Description historique
de l'hôtel Royal des
Invalides* (1756).

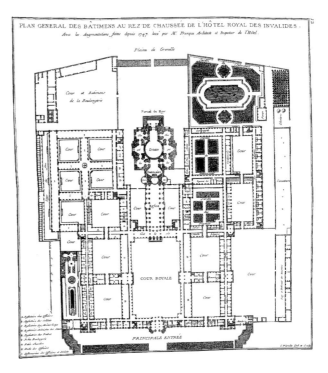

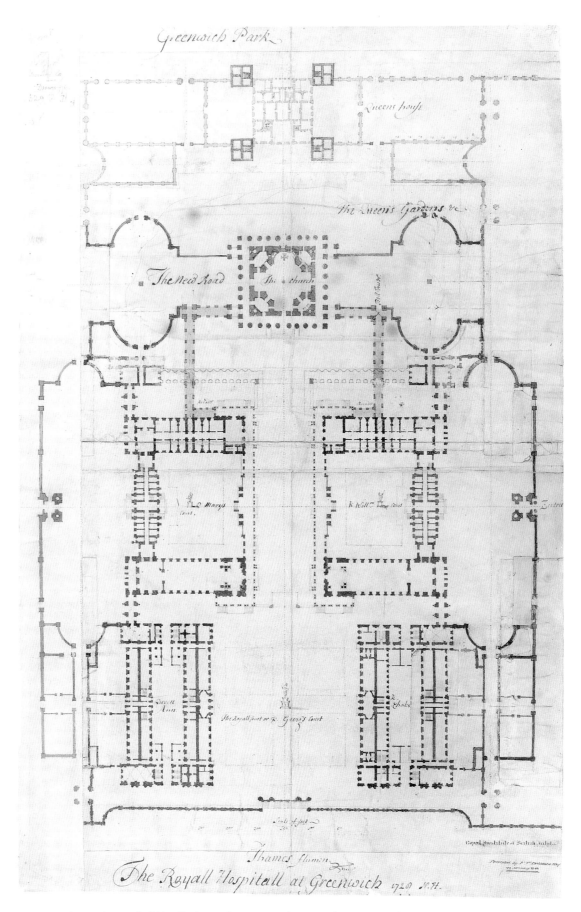

Greenwich Park

Queens house

The Queens Gardens &c.

The New Road

The church

R. Marys Court

K. Will. Court

Entra

The Royall Court or S. Georg's Court

Scale of feet

Thames flumin

The Royall Hospitall at Greenwich 1728 N.H.

302 Hawksmoor's so-called 'third' scheme for Greenwich Hospital, a version of 1728 [R.I.B.A., London].

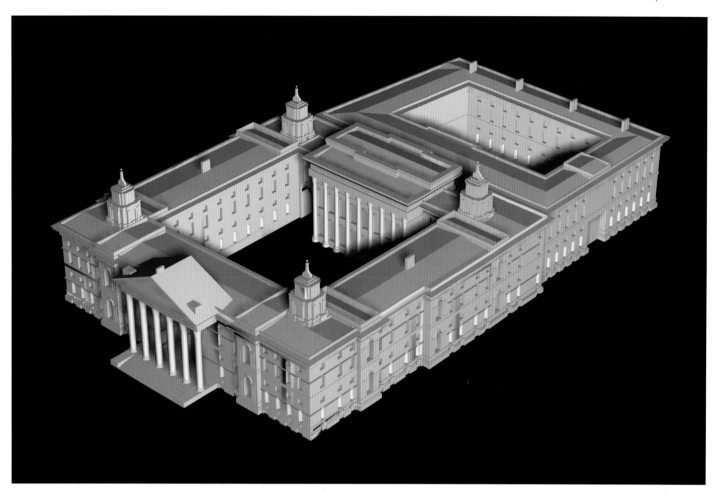

303 Computer model reconstructing Hawksmoor's Brasenose design of 1720 [author].

service on the first Commission guiding the fifty new churches.[49] For such men the temptation would surely have proved irresistible to see Solomon's Temple – a closed community with its gates, residences and courts centred on a private chapel – as a type of the academic college. In stylistic terms this connection had already been implied by one of their number, John Lightfoot, through his crenellated reconstruction of the Temple of 1684.[50]

Moreover Clarke also numbered among the Tories on the second group of Church Commissioners (1712–14),[51] and so the temple archetypes of Solomon and primitive Christianity, based on courtyards and free-standing chapels, might well have influenced Clarke in his work at Oxford and Greenwich, at least from 1712. For between 1705 and 1728 various schemes for Greenwich were produced with a central chapel terminating the axis, even though the land and the Queen's House (which this chapel either obscured or replaced) were not owned by the Hospital (Fig. 302; and see Fig. 8). Drawings for these schemes have been

attributed to Hawksmoor, following ideas from Wren and later Vanbrugh (as Surveyor at Greenwich).[52] The impracticality of these Hospital plans serves to underline the ideal status of their arrangement – the contemporary precedent for which was Libéral Bruant's hospital in Paris, the Hôtel des Invalides, whose monastic dining refectories, shared dormitories, giant courtyards and centrally placed chapel were again inspired by the Escorial.[53] Directly or indirectly, therefore, Solomon's Temple also lay behind this French plan.

Clarke's involvement with the second Church Commission dates from about the same time as Hawksmoor's first interest, around 1712–13, in rebuilding Brasenose with two regular courtyards, a plan which clearly informed his grandiose 'Solomonic' design of around 1720 with its centrally placed chapel (Fig. 303).[54] The Solomonic influence on this design may have been both direct and indirect. For Worsley has pointed out that, as an *all'antica* palace with a giant Corinthian portico, it closely followed palace designs by Jones and Webb in Clarke's collection[55] – designs

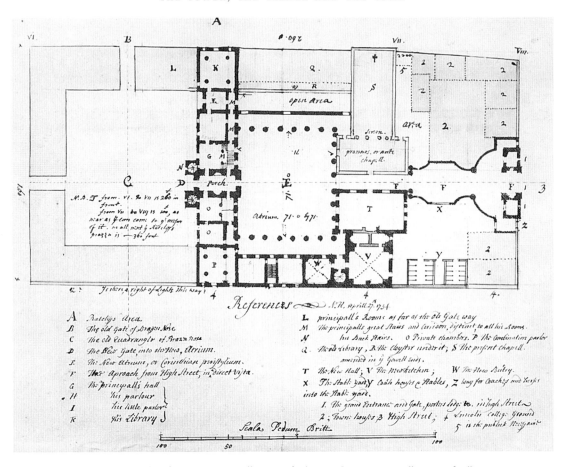

304 Hawksmoor's revised plan for Brasenose College, Oxford, 1734 [Worcester College, Oxford].

which had also been influenced by the Escorial and Villalpando (an influence most notable on the Whitehall palace scheme).[56] Hawksmoor certainly took inspiration from the Stuart master in the course of his Oxford work because his chapel design for Worcester College was modelled on Jones's chapel at St James's Palace. This is made explicit by a reference on some details to 'the Rustics according to Mr Jones, at St James Chappell'.[57] The idealized nature of this Brasenose scheme is underlined by the fact that it too involved total demolition of the existing buildings. Not surprisingly it was superseded in 1734 by a new plan by Hawksmoor which, largely for economic reasons, retained much of the existing fabric at the front (including the off-centre chapel) and reduced the scale of the front courtyard (Fig. 304). Hawksmoor's reference to having followed 'the Antique disposition' in the covering letter to this revised plan has led to the suggestion that the archetype he had in mind was the Roman house described by Vitruvius in his sixth book and first reconstructed by Palladio (Figs 305a,b).[58] Hawksmoor's plan has what is labelled as a 'New atrium, or Corinthian peristylium' – the Latin itself

suggestive of a Roman source – approached on axis via an (open) vestibule, both of which are prominent features of the Roman house (the Greek house has no vestibule). One of the advantages of this model was that its essential spaces of vestibule and atrium could be easily moulded round existing fabric, as Hawksmoor's plan demonstrates. Indeed the earlier, 1720 'palace' façade closely resembles the main elevation of the ancient house as drawn by Palladio, both having a Corinthian portico and statues between wings (see Fig. 314). Elsewhere, Hawksmoor's project to remodel Ockham Park of 1727 included a tetrastyle hall (described as a 'Sall de quatre colonnes') modelled on that in the ancient house, most probably after the illustration by Perrault.[59] In Chapter 3 it was noted that Hawksmoor would have seen Palladio's reconstruction of this house illustrated in his copy of Daniel Barbaro's Latin edition of Vitruvius of 1567 (lot 70) and in Palladio's own Quattro Libri (lots 40, 68 and 123), both of which he studied closely. Both for example are cited in his letter to Carlisle of 3 October 1732.[60] These sources had informed Webb's reconstruction of the Roman house, which Clarke purchased with the other

Jones drawings around 1703 and must have studied.[61] Interest in Palladio's studies of Roman architectural models would have been heightened in Oxford after Charles Fairfax's Latin translation of Palladio's *L'Antichita di Roma*, with its description of Nero's Golden House, was published in 1709 by the Clarendon Press through the encouragement of Aldrich.[62] The second book of Aldrich's unfinished treatise, circulating in Oxford, also dealt with private houses of the ancients.

It was pointed out that the city walls were an important conceptual boundary in defining Hawksmoor's 'Regio Prima'. Their physical presence and symbolic significance was consolidated through the new triumphal arch envisaged on the old east gate site, and by the proposed clearance of the sheds 'next yᵉ Citty wall' north of the planned campanile, as noted on the 'Regio Prima', to create a 'pomaerium' (open ground next to the walls of ancient cities). If Hawksmoor did indeed see the colleges within these walls as types of Roman town house, or Renaissance urban palace, then it follows that its counterpart, the *villa suburbana* or *casa rustica*, might have informed his layout of colleges outside the city walls. In the case of Worcester College, Clarke rather than Hawksmoor determined the

unprecedented open 'U' arrangement for the hall, library and chapel.[63] However Magdalen, also outside the walls, was the subject of a plan by Hawksmoor. The picturesque location of the college, just outside the walls next to the River Cherwell, and its setting in extensive walled grounds (in comparison to the High Street colleges), further isolating it from the town, would certainly have suggested this villa prototype. In 1724 Hawksmoor sent Clarke a plan and bird's-eye view of the college rebuilt, in which the river and college wall are both prominent landscape features: indeed on the plan he is careful to label the presence of the gardens (Figs 306–8). In this scheme the old college has been demolished except for the bell tower that becomes the setting out point for a new axis. The hall and chapel either side are rebuilt in contextual Gothic, while beyond is a large colonnaded hemicycle and a 'Great Cloyster' whose *all'antica* architectural style is evident from its central portico – a stylistic switch no doubt due to the fact that Hawksmoor had predominantly antique models in mind. Indeed in his accompanying letter to Clarke he remarks (somewhat sarcastically) that if his sketch 'was drawne fair, it woud shew the beauty of yᵉ ancient Building (as Col. Campell says in his

305 a and b Palladio's reconstruction of the Roman house, from Daniel Barbaro's Latin edition of *Vitruvius* (1567).

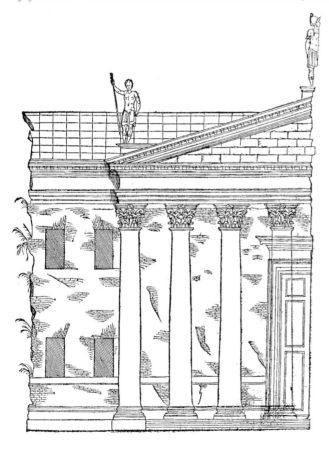
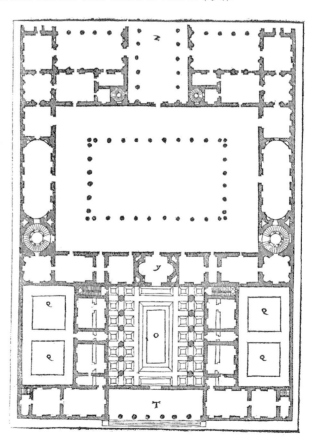

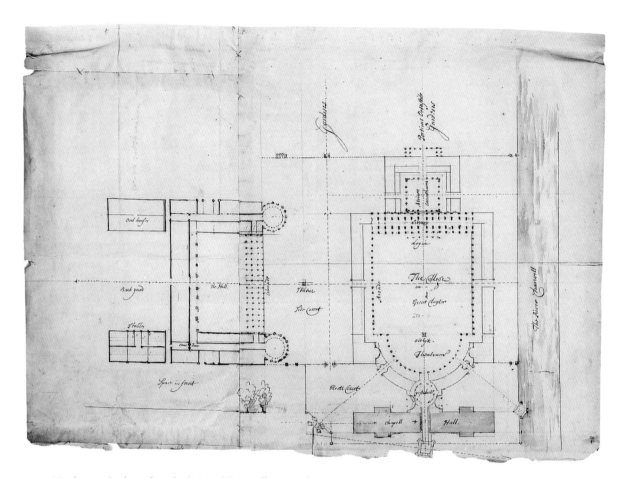

306 Hawksmoor's plan of a rebuilt Magdalen College, Oxford, 1724 [Worcester College, Oxford].

307 Hawksmoor's bird's-eye view of a rebuilt Magdalen College, Oxford, 1724 [Worcester College, Oxford].

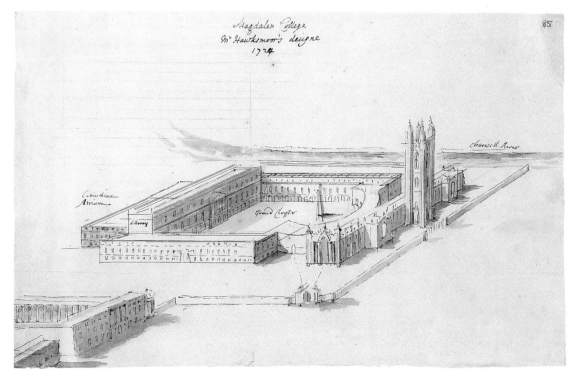

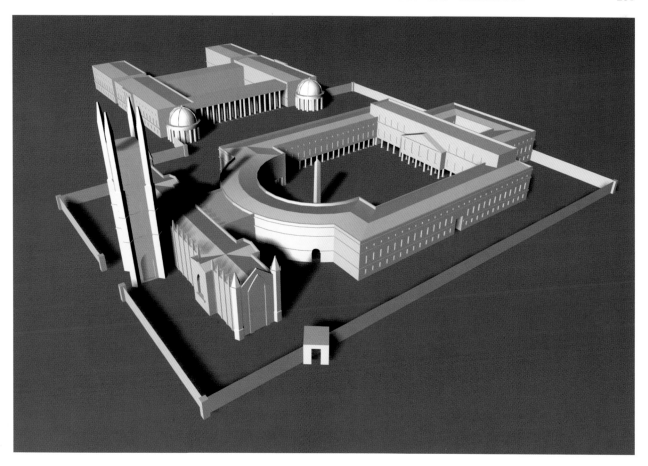

308 Computer model of Hawksmoor's Magdalen design [author].

Workes) in yᵉ Vitruvian style'.⁶⁴ In connecting spaces that are again highly suggestive of the Roman house, the axis starts with a circular chamber labelled a 'vestibule', and ends with a further quadrangle labelled, once more in self-conscious Latin, 'Atrium Corinthium'.

The most important record of suburban domestic architecture in Roman times, widely studied in Hawksmoor's day, was that by Pliny the Younger of his villas at Laurentia and Tuscanum. These villas represented perfectly appropriate antique prototypes for a large complex of rooms, in a landscape setting, with analogous functions to a college (dining hall, dormitory and so on). Hawksmoor certainly studied Pliny's villas since, as Chapter 2 noted, his sale catalogue lists 'Maisons de Pline' in octavo (lot 8), a reference to Félibien's *Les plans et les descriptions de deux des plus belles maisons de campagne de Pline le Consul* (1699). Félibien's account was partly based on Scamozzi, who had included a reconstruction of Pliny's Laurentia villa in his architectural treatise – a work that Hawksmoor also studied.⁶⁵ His use of Pliny (most probably the Younger)

as a source of inspiration is proved by his square Belvedere design at Castle Howard (1723), with its annotation: 'The Belvidera After yᵉ antique. Vid Herodotus, Pliny, and M:Varo'.⁶⁶ Hawksmoor had obviously also read Varro's account of the *villa rustica*, although possibly he studied this indirectly via De Montfaucon's *L'antiquité expliquée* of 1719 (an English translation of which was published in 1722), with its sections on ancient country houses based on both Pliny and Varro.⁶⁷ Pliny and Varro would therefore have been fresh in his mind when he sketched Magdalen in 1724, for this scheme was produced less than a year after he used both authors in his Belvedere design.

It was noted in Chapter 2 that Félibien would have provided authority for the mixing of Gothic and *all'antica* styles, as in this scheme for Magdalen. Moreover a variety of the formal elements proposed by Hawksmoor for Magdalen can be identified in Félibien's plates of Pliny's villas (Figs 309, 310). The Laurentia villa has a circular chamber with colonnade similar to the two in Hawksmoor's western block – which itself closely resembles Félibien's Tuscanum plan. The Tuscanum

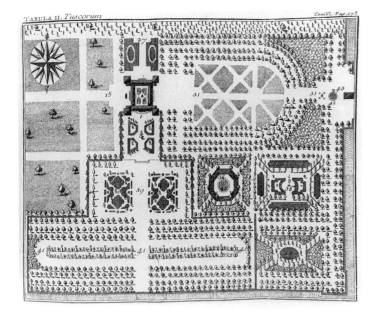

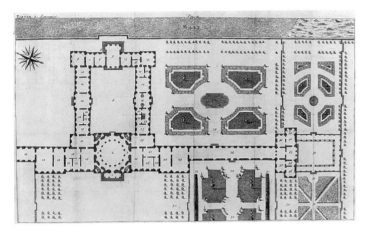

invited Hawksmoor to amend. Again drawing on Roman models, he added a novel circular 'Ampitheatre' at the western entrance (Fig. 311).[70] However only the north range of Holdsworth's proposed quadrangle was completed and, as with so many of Hawksmoor's Oxford schemes, his Roman-inspired vision was lost to the city.

Hawksmoor's method of using biblical and antique models to shape and authenticate his work is perhaps at its clearest in these Oxford schemes, no doubt following in the footsteps of Wren and his use of the

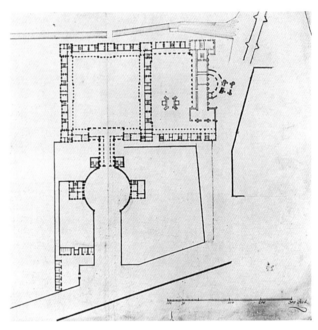

309 and 310 Plans of Pliny's villas, from Jean-François Félibien's *Les plans et les descriptions de deux des plus belles maisons de campagne de Pline le Consul* (1699).

311 Hawksmoor's amended plan of a scheme for Magdalen College by Edward Holdsworth, 1734 [Magdalen College, Oxford].

landscape includes a hemicycle, a form which Pliny describes as reflecting the passage of the sun and which became a prominent feature of Hawksmoor's main *all'antica* college building.[68] His colonnaded hemicycle is labelled 'Theatrum' (again in suggestive Latin) and is focussed on an obelisk, much like counterparts in such Pliny-inspired Renaissance gardens as the Boboli in Florence. Moreover Pliny's description of a *cryptoporticum* or long gallery for walking with openings on both sides, a feature without Vitruvian authority,[69] might well have inspired Hawksmoor's unusual multiple portico-cum-colonnade facing the garden (which certainly followed no obvious Palladian model). The college eventually adopted a Palladian scheme by Edward Holdsworth, a former Fellow, which Clarke

Roman theatre as the model for the Sheldonian. This approach is most obvious in the 'Regio Prima' plan, with its forums and street of Roman 'palaces' bounded at either end by a triumphal column and arch. In this drawing, perhaps not surprisingly, the plan of the university church, or 'Capella Universitatis', was clearly based on Hawksmoor's (inaccurate) reconstruction of the Temple of Bacchus at Baalbek (see Fig. 52), published in Oxford in Maundrell's *Journey* (1714) at the same time as he was drawing the town plan. Both temples have octastyle porticoes flanked by a colonnade of fourteen columns,[71] with identical stair chambers in the *cella* and the same overall proportions. The proposal for a new university temple in Oxford might explain the specific motivation behind Hawksmoor's scholarly

study of the Baalbek temple, for inclusion in a book published in the city, following the earlier Oxford-based studies of Baalbek by Aldrich.[72] This previously unnoted connection between Hawksmoor's two temples is strongly supported by the fact that he sent a 'proof' drawing of his Baalbek reconstruction to none other than Dr Clarke.[73] Although the Oxford temple remained on paper, according to contemporary report the Baalbek temple became Hawksmoor's model for the portico for St George in Bloomsbury, as noted earlier.[74]

HAWKSMOOR'S *VIA TRIUMPHALIS* THROUGH OXFORD

Hawksmoor thus attempted to modernize the institutions of Oxford University, following the intentions behind Wren's Sheldonian. But having been inspired by the public and private Roman archetypes illustrated in the treatises of Serlio, Palladio, Blondel and Desgodets,[75] Hawksmoor's urban vision of Oxford was as a Roman imperial city complete with forums, triumphal arch and column. In keeping with these intentions, the High Street was elevated to a triumphal route (or *via triumphalis*) by the insertion of the monumental arch and column and by the new college façades that lay between the two (Figs 282, 283). The individual colleges with which Hawksmoor was involved for the most part bordered this street, and new front façades were a prominent feature of his schemes for Queen's, Brasenose and All Souls. It was evidently even proposed, albeit fleetingly, that University College might be refaced since a sketch of a scheme for this survives in Hawksmoor's hand, possibly of around 1711 (see Fig. 271).[76] His new steeple to All Saints church, modelled on the Roman tower tomb of the Julii, should also be seen as part of this monumental conception of the High Street.[77]

The monumental character of Hawksmoor's High Street façades indicates the importance of this street as a civic realm. For the academic processions that passed down it displaying the authority of the colleges and university (especially at graduation) would have had these façades as their backdrop. Traditionally a variety of processions progressed from the college gates fronting the High Street to St Mary's (the old University Church replaced as such in Hawksmoor's plan) or, more recently, to Wren's Sheldonian Theatre. The Sheldonian had become the new chamber for such annual events as the graduation ceremony and university commemoration (the *Encaenia*), as well as disputations, public lectures and the like. These events were

preceded by a procession that frequently included the University Verger, Beadle, Librarian and, as their chief, the Chancellor. Such processions emphasized the identity of the university over that of the colleges, much as Hawksmoor was attempting through his town plan. The construction of the Sheldonian had already given these university processions a new prominence as well as focus, and Hawksmoor sought to add dignity to them through his façades lining their route and through consolidating the new ceremonial centre. (The importance to Hawksmoor of this region around the Sheldonian is emphasized by the fact that he produced his detailed plan of the area (see Fig. 273).[78]) In his copy of Loggan (lot 119) Hawksmoor would have seen two views of the Sheldonian (plates VIII–IX) followed by one of a procession of officials in their academic robes which is labelled, yet again in self-conscious Latin, 'Habitus Academici' (plate X) (Fig. 312). Classical associations are enhanced by the presence of an official with the Roman title 'procurator' (a treasury officer in an imperial province).[79] Moreover in William Williams's *Oxonia Depicta* (1732–3), a copy of which was owned by Clarke,[80] a similar processional group is now pictured in a line fronting the Sheldonian and Clarendon Building (Fig. 313). The ceremonial function of Hawksmoor's architecture is also amply illustrated in the annual Oxford Almanacs. That for 1723, for example, even illustrates his unbuilt Brasenose project of 1720 as a backdrop to a procession of the college's founders – Charles I, Bishop Smyth of Lincoln and Sir Richard Sutton – watched over by Apollo, as master of the muses (Fig. 314).[81]

To arrive at the Sheldonian, college processions would thus exit via Hawksmoor's new monumental gateways onto the High Street and progress through his new university forum, passing the new Radcliffe Library on one side and All Souls gate and university church on the other. Hawksmoor's 'explanation' to Clarke concerning All Souls makes clear that this side 'Portico and gate' was initially intended to have been 'after y^e Roman Order', perhaps in recognition of its ceremonial importance given that it was designed with what he refers to as the 'Great Piazza' in mind.[82] Indeed the subsequent 'Greek' and 'Gothic' schemes were no less monumental, even though ostensibly for a side gate (see Figs 55–6, 109).[83] Processions from Magdalen would pass directly under the new High Street arch, while those from Worcester College would enter via the new civic forum with its dignified colonnade, church and central column. Processions from colleges to the rear of the replanned precinct (such as Trinity) would have made their entry via the new northern town gates. It is not surprising, therefore, that at various

312 Procession of officials, from David Loggan's *Oxonia Illustrata* (1675), plate x.

313 View of the Sheldonian, from William Williams's *Oxonia Depicta* (1732–3).

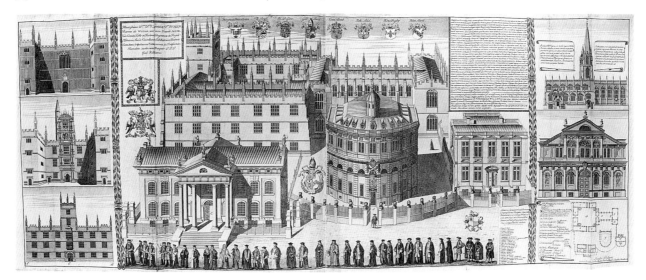

stages Hawksmoor designed the main gate to the indi-
vidual colleges as a triumphal arch or, in the case of
Brasenose, a grand portico.[84] A triumphal arch is used
in three designs in his hand for the High Street front
to Queen's College (in one a regal female statue, pos-
sibly Queen Anne, surmounts a trophy of arms, under-
lining the triumphalist theme) (Fig. 316).[85] An arch also
features in Hawksmoor's initial, *all'antica* design for the
High Street façade to All Souls – in contrast to the
portico he used for the Fellows' building (or 'Grand
Dormitory') (Fig. 317; see Fig. 92).[86] In an alternative
design probably in the hand of Clarke (as a college
Fellow), an arch based on Inigo Jones's design for
Temple Bar in London – in turn based on the Arch of
Constantine – is somewhat incongruously inserted
between two Gothic flanks (Fig. 315).[87] This scheme
indicates that he too considered the High Street in
Roman, or 'Imperial', terms, and demonstrates the
importance of the triumphal arch archetype to the con-
ception of the college gateways (although a more con-
textual Gothic solution ultimately seems to have been
preferred).[88] Indeed the Vice-Chancellor in 1706–10

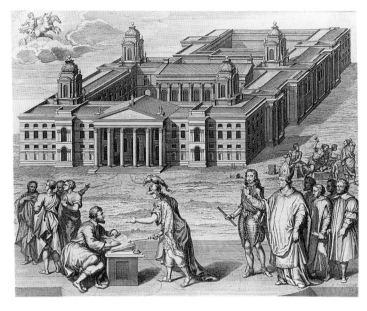

314 Oxford Almanac for 1723 [Ashmolean Museum, Oxford].

315 (*below*) Scheme possibly by George Clarke for the High
Street façade to All Souls, undated [Worcester College, Oxford].

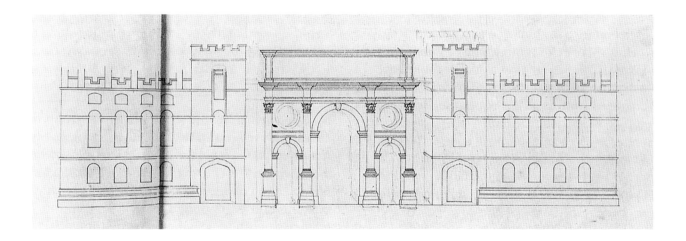

was the Provost of Queen's College, William Lancaster,
whose role and status Hawksmoor's schemes for the
college sought to accommodate – one proposition is
labelled: 'The side of the Quadrangle containing the
Vicechancellours Lodgings'.[89] Lancaster would surely
also have approved of the vision of enhancing univer-
sity processions through architecture, and in particular
through Hawksmoor's projects for Queen's – with their
triumphal gateways – and for the Clarendon Building,
with which he was directly involved. Then in 1711
the Warden of All Souls (between 1702–26), Bernard
Gardiner, became Vice-Chancellor; he too must have
been sympathetic to this wider, triumphal urban vision

for his college buildings and their gateways, irrespective
of their style.

Hawksmoor was clearly interested in triumphs and
processions and collected illustrations of them through-
out his life. His sale catalogue lists 'King William's
Arrival in 14 Sheets' (lot 42) – which evidently repre-
sented William III with his Dutch soldiers entering
Torbay on 5 November 1688 – and possibly concern-
ing William's mother, Mary, 'Five Prints of the Entry of
the Queen Mother at the Hague' (lot 43). Also listed is
'The Polish ambassadors Entry into Rome, by Della
Bella, 6 Sheets' (lot 232): measuring a total of eight feet,
this series by Stefano della Bella depicted the entry into

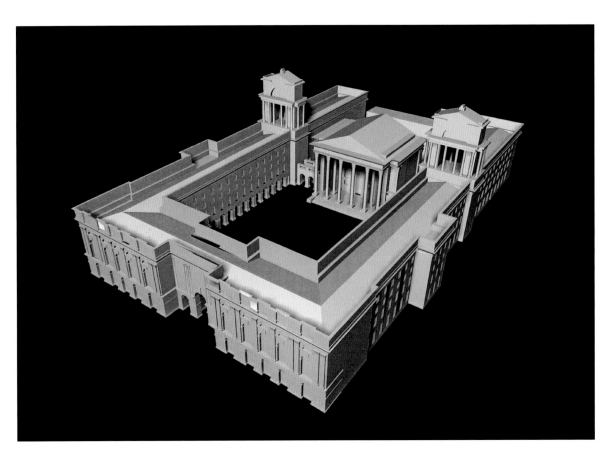

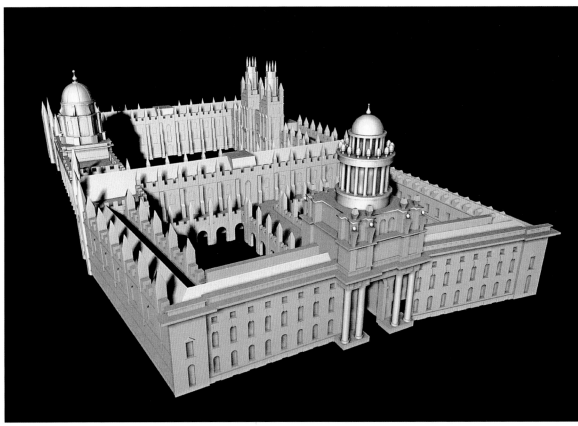

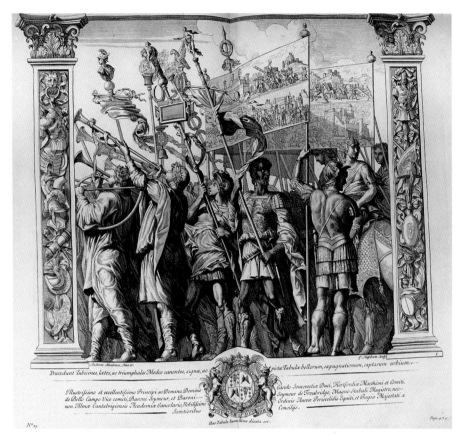

316 (*facing page top*) Computer model reconstructing Hawksmoor's scheme (Proposition 'A') for Queen's College, Oxford [author].

317 (*facing page bottom*) Computer model reconstructing Hawksmoor's scheme for All Souls, Oxford, applying his *all'antica* design for the High Street façade with its triumphal arch [author].

318 Andrea Mantegna's *The Triumphs of Caesar*, as engraved in Samuel Clarke's *C. Julii Caesaris, Quae Extant . . .* (1712).

Rome on 27 November 1633 of George Ossolinsky, the ambassador of King Ladislaus IV of Poland.[90] More general interest in ceremonial processions is indicated by his 'Thirty Prints of the Travels of K. James II' (lot 73). But most notable in this regard, perhaps, is the fact that Hawksmoor owned a copy of Samuel Clarke's Latin edition of Julius Caesar's commentaries on his wars in Gaul, Spain and Britain (lot 135).[91] This beautifully illustrated book (published in 1712 and thus after most of Hawksmoor's college schemes but, significantly enough, coinciding with the 'Regio Prima' plan of around 1713), closed with a series of nine engraved plates illustrating Mantegna's *The Triumphs of Caesar* (Fig. 318). (Hawksmoor may well have seen this work at first hand when as a young man he worked at Hampton Court – where it hung after its purchase by Charles I – or have seen Pellegrini's version of it of around 1711 at Kimbolton.[92]) With its opening portrait of, and dedication to, the Duke of Marlborough and its closing plate of Caesar before a triumphal arch, Clarke's book was intended to inspire his own age. Turning the pages and studying the folio engravings, with their fortified camps and cities populated by forums and basilicas, Hawksmoor would have seen illustrated the spirit behind his remodelled Oxford, and he would

surely also have understood the book's focus on the triumph as the principal celebration of antique civilization.

Hawksmoor did actually realize a design for a *via triumphalis* close to Oxford. At Blenheim the approach to the palace of the victorious general was also conceived by him as a triumphal route, marked by an arch. And in Greenwich he conceived his temple church of St Alfege – with its Doric portico and sacrificial altars – as terminating a *Via Regia*. In Oxford, Hawksmoor's somewhat unrealistic scheme to reface the High Street façade of University College – adding a tower and giant portico (of banded Corinthian columns) without altering the existing building to the rear – surely indicates the ceremonial importance of the High Street and, perhaps, the priorities of Clarke's Oxford vision. Hawksmoor's initial schemes for Brasenose, All Souls, University and Queen's colleges were, unlike later versions, all designed without regard to the need to match in style any existing medieval buildings. If he had been allowed to build these initial schemes, the High Street would have been fronted by a series of Roman palaces complete with giant porticoes and triumphal gateways, natural backdrops to the *via triumphalis* with its monumental arch and column at either end.

319 James Gibbs's Radcliffe Camera, Oxford.

320 Schools Quadrangle, from David Loggan's *Oxonia Illustrata* (1675), plate v.

expense but clearly influenced the layout of the college buildings on the site today, while at Oxford his urban ideas gave a powerful lead to Gibbs's Radcliffe Camera (Fig. 319). Here the Clarendon Building was the only one of his proposed institutional buildings for the university to be realized, and clearly embodies his conception of the town and its 'Learned Body'.[93] For reflecting the popular self-image of the city that he would have seen promoted by Loggan's plates (lot 119),[94] Hawksmoor eulogizes Oxford – or rather the

321 Drawing by James Thornhill for the Oxford Almanac for 1720 [Worcester College, Oxford].

Following Fontana's example in Rome, Hawksmoor in Oxford and Cambridge thus rose to the challenge of designing architecture suitable for England's own pre-eminent ceremonial cities. However his wider urban ambitions depended in part on the realization of individual college schemes – and in the case of Cambridge on one scheme in particular – and, perhaps inevitably, they remained on paper. Nevertheless his vision was not completely lost. At Cambridge the King's College scheme was dismissed on grounds of

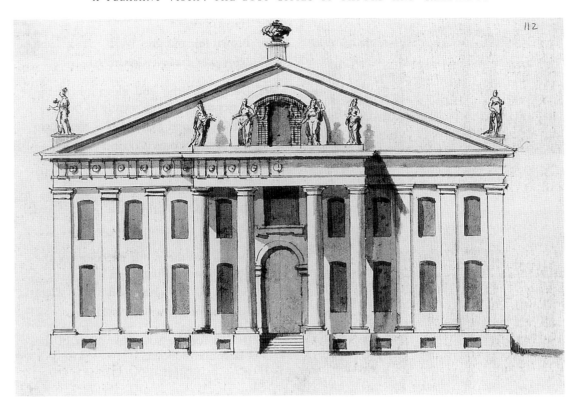

322 Drawing by Hawksmoor for an alternative north elevation for the Clarendon Building, c. 1709–10 (see Fig. 284) [Worcester College, Oxford].

'Aecademia Oxoniesis' envisaged in his 'Regio Prima' plan – as 'this Seat of yᵉ Muses Admired at home and Renowned abroad'.[95] Following one of his schemes for the north elevation of the Clarendon Building, which included a line of female statues representing six of the nine muses (Fig. 322),[96] Sir James Thornhill was commissioned by Clarke to design the lead statues of the muses which were placed above the cornice in 1717.[97] As the new home of the University Press and source for public 'enlightenment', and with its somewhat unusual role as a public passageway, the building was evidently also conceived of as a porticoed entrance to the Schools Quadrangle and Bodleian as a 'palace of learning' (Fig. 320). Indeed the giant portico surmounted by statues and the central vestibule purposefully on axis with the facing entrance to the Schools Quadrangle (appropriately with its gate of the five Orders) clearly reflect the portico, vestibule, large- and small-court sequence of the Roman house – albeit with a plainer portico than Palladio's antique model (where the portico is Corinthian) to take account, perhaps, of its function as a 'Print house'.[98] (Since the alternative designs, by James and Townesend, were also Doric, this Order may well have been stipulated by Clarke as an essential characteristic of the new building, which all of Hawksmoor's schemes respected.) One of Hawksmoor's

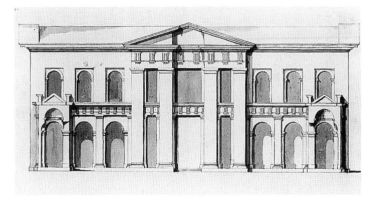

323 Hawksmoor's scheme connecting the Schools to the Clarendon Building via colonnaded cloisters either side of the court, c. 1709–10 [Worcester College, Oxford].

designs even connected the Schools to the Clarendon Building via colonnaded cloisters either side of the court (Fig. 323),[99] while in the 'Regio Prima' plan walls serve the same linking function. On completion, the building was illustrated by Thornhill as a backdrop to Apollo and the muses in the Oxford Almanac of 1720 (Fig. 321),[100] as if heralding Hawksmoor's walled 'principal region' of Oxford as the new Parnassus.

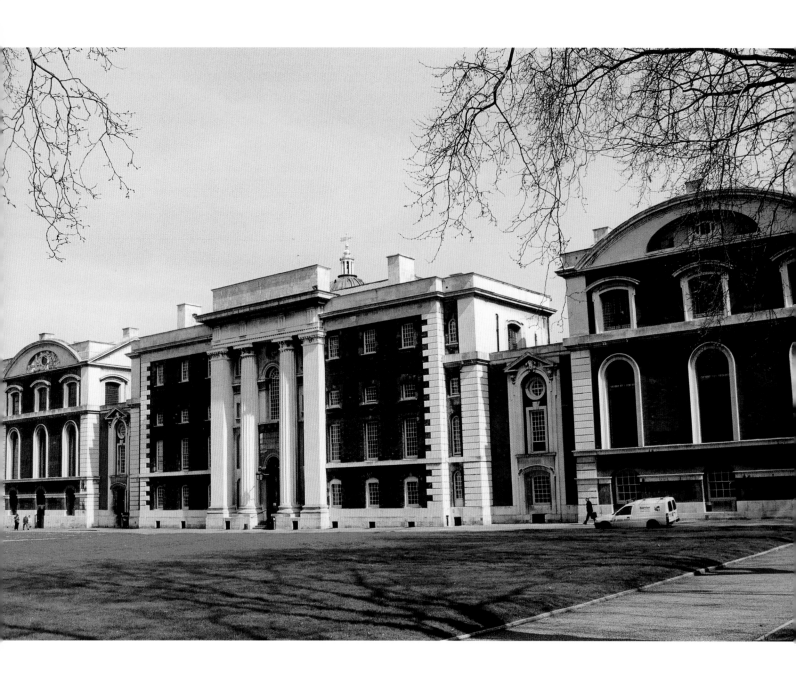

Chapter 9

'THE GRAND EMPORIUM':
THE GREENWICH AND WESTMINSTER PROJECTS

THROUGHOUT HIS LIFE HAWKSMOOR lamented the decay and the lack of civil and architectural order of post-fire London, a state of affairs made all the more poignant in comparison with Wren's masterplan for the city. Born just before the fire, Hawksmoor had witnessed much of the rebuilding and expansion of the city at first hand. Defoe's *Tour* of 1725 even compared this growth to that of ancient Rome, with 'New Squares, and new streets rising up every day to such a prodigy of buildings, that nothing in the world does, or ever did, equal it, except old Rome in Trajan's time, when the walls were fifty miles in compass, and the number of inhabitants six million eight hundred thousand souls'.[1] Like Wren, Hawksmoor dreamed of rebuilding London in a manner recalling the grandeur of Augustan Rome, befitting its status as a leading trading capital ruled by an enlightened monarchy. Having grown up in a yeoman farming family during the reign of the absolutist Stuart kings, Hawksmoor was a deeply patriotic monarchist. As his Bloomsbury steeple suggests, he believed in the timeless duty of monarchy to express its power through architecture, following the heroic biblical examples of Solomon and Absalom and the antique ones of Augustus and Trajan – and even for that matter the modern one of Louis XIV. This view was increasingly unfashionable in the emerging era of constitutional government, but from his London church towers to the various schemes for grand courtyards at Greenwich, his designs were a perfect reflection of this belief in the glory of kingship, not least of the British line.

'POLICE ARCHITECTONICAL': HAWKSMOOR AT GREENWICH

John Evelyn had conceived the idea of a hospital for seamen, and Queen Mary eventually adopted the project. In 1694 land was granted by King William and soon after a commission was established to attend to it, with Evelyn as Treasurer and Wren as Surveyor. Hawksmoor was connected with Greenwich from the very start of work in 1696, first as Wren's clerk and then, from 1698, as the Clerk of Works (a post held until shortly before his death in 1736); he also served as Assistant Surveyor from 1705 until 1729. As Chapter 3 noted, apart from internal details his only documented designs that were built here are the austere end loggias to the courtyard in the Queen Anne Building of 1716–17 (see Fig. 110).[2] He may have been personally responsible for designing the east range of this building, begun in 1699, and the façades of the King William Building, begun in 1698, but this cannot be absolutely proved (Figs 324, 325).[3] His design for an infirmary comprising three wings grouped round a 'Great Esplanade' and a hemicycle – a disembodied feature from the ancient theatre that resembled Magdalen's 'Theatrum' – remained unbuilt (Fig. 326).[4]

At first Wren tried to ignore the existing features of the site – namely the King Charles Building and Inigo Jones's Queen's House – and produced a design for a building with four north–south ranges linked by two east–west wings, situated to the east of the avenue from the Queen's House to the river (Fig. 327). Wren next proposed a large courtyard terminated by a hemicycle and a domed building, but this scheme blocked the view to and from the Queen's House (Fig. 328). Wren's subsequent proposal, for a pair of domed buildings with an avenue in between terminated by a view to the Queen's House, was devised by 1696 and adopted (Fig. 329). Nevertheless the perceived need for a chapel rather than the Queen's House as the central focus of the vista prompted further efforts to re-plan the site. The previous chapter noted that between 1705 and 1728 – therefore extending well beyond Wren's active involvement in the project – various schemes were produced with a central chapel terminating the axis, which have been attributed to Hawksmoor and amply discussed by Downes.[5] The first scheme places a rectangular chapel in front of the Queen's House, as the

324 West front of the west range of the King William Building, begun in 1701.

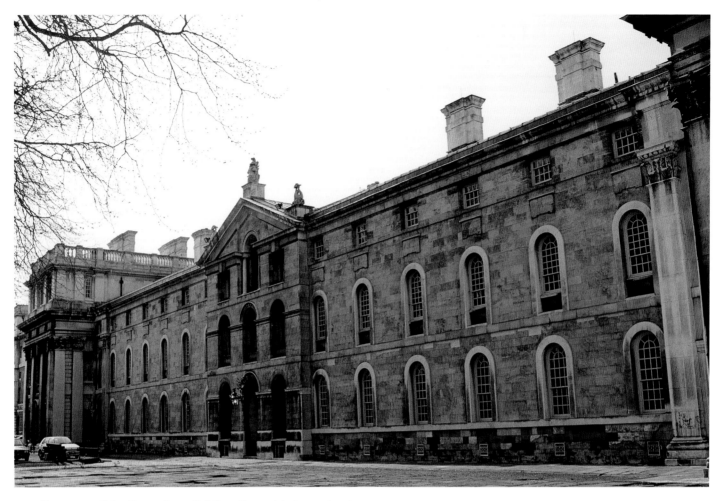

325 East range of the Queen Anne Building, Greenwich, begun in 1699.

new focus of the perspective.[6] The second scheme has a giant oval court fronting a monumental chapel on the site of the Queen's House – which is relocated to the rear.[7] Hawksmoor drew a plan of this scheme with an ornamental frame comprising a curtain, giant pedestal and a shield, probably for engraving (see Fig. 8).[8] A third scheme was also prepared, some time in 1711, which revised the first in placing a chapel – this time a square surrounded by a colonnade – in front of the Queen's House (Fig. 302).[9] A further revised plan by Hawksmoor, of 1723 – the year of Wren's death – restored the first, rectangular chapel (now called a 'temple') and located the new Romney Road (conceived of as a royal route) to lead to the recently built St Alfege. As the previous chapter pointed out, the unrealistic nature of these proposals, especially the second, serves to underline their status as ideal solutions – in following the French fashion for axial arrangements and vistas with strong focal points, and the Solomonic model of central free-standing chapels. After all, John Webb's design for the royal bedchamber at

Greenwich of 1666 was clearly based on Villalpando's illustrations of the altar chamber in Solomon's Temple.[10] And such Solomonic associations were eventually made explicit through the great gates to the Hospital, placed in position in 1751 under the Surveyor, Thomas Ripley (Fig. 330). These carry two globes which, as John Bold points out, combined 'ideas of both imperial and religious dominion, informed by speculative sixteenth-century reconstructions of the pillars of the Temple of Solomon (which bears on eighteenth-century freemasonry)'.[11]

A record of what Hawksmoor saw as being achieved at Greenwich through these ideal schemes, and the actual built work, is to be found in his *Remarks on the founding and carrying on the buildings of the Royal Hospital at Greenwich* (1728). This short work represents one of only two instances where he felt compelled to explain his intentions in print (the other being on Westminster Bridge, examined shortly). As has been noted, the book includes yet another revised plan of the entire Hospital, complete with a *Via Regia* although

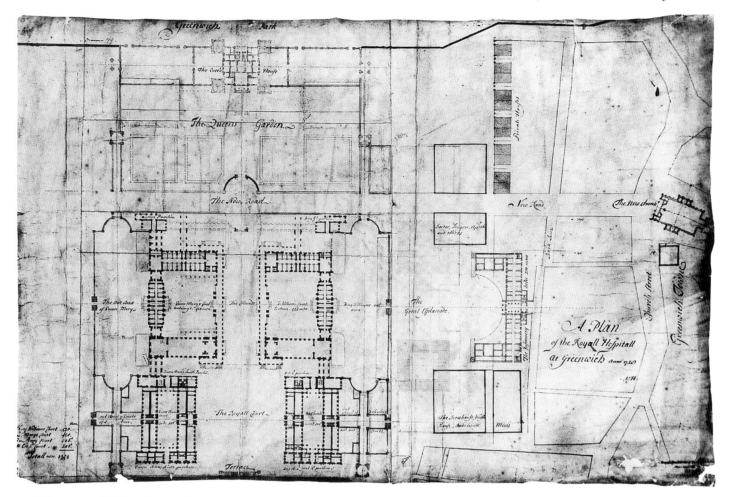

326 Hawksmoor's design for an infirmary comprising three wings grouped around a 'Great Esplanade', 1728 [R.I.B.A., London].

327 Wren's design for a hospital, situated to the east of the avenue from the Queen's House to the river at Greenwich, c. 1695 [All Souls, Oxford].

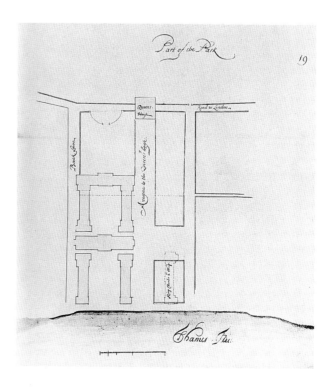

this time omitting the unrealistic grand chapel (see Fig. 132). The text pleads for the work to be finished on the scale originally intended, and was delivered by Hawksmoor to the Lords of the Admiralty on 15 December 1727 following the formation of a new Commission for completing the buildings. Hawksmoor here spells out his fundamental belief in the political role of architecture in monumentalizing royal power together with the institutions of government, and in consolidating public order in general. With the role of the Hospital as a military facility in mind, he opens by noting that 'Among the sundry good and great Qualities of Princes, their Establishment of Arts and Arms, was always esteem'd as Branches of Honour and Security to them'.[12] The history of this patronage is then outlined in two important digressions – the fact that

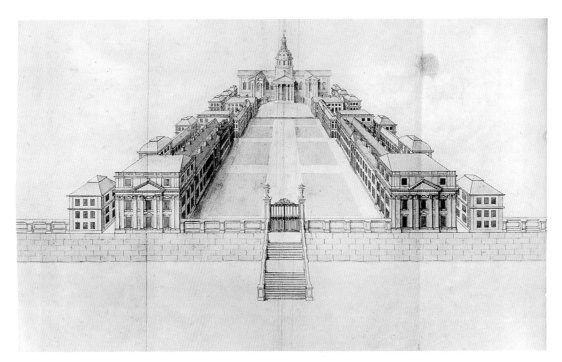

328 Wren's design for a large courtyard terminated by a hemicycle and domed building, undated [Sir John Soane's Museum, London].

329 Plan of Wren's proposal for narrowing courts terminated by a view to the Queen's House, drawn by Hawksmoor, undated [Lambeth Palace Library, London].

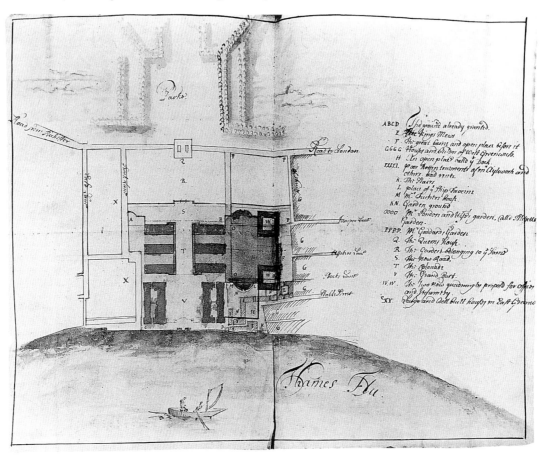

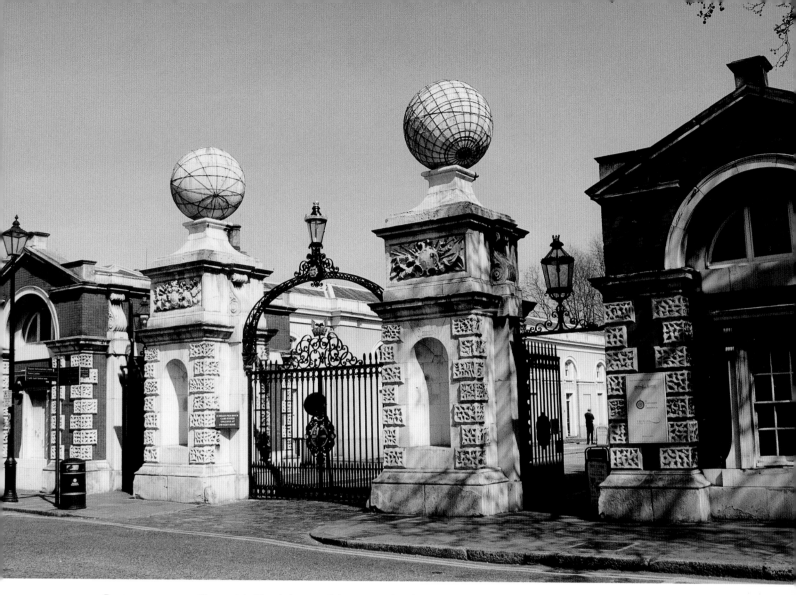

330 Great west gates to Greenwich Hospital, erected in 1751 under the Surveyor, Thomas Ripley (originally located close to the King Charles and King William Buildings).

he is tempted to make them shows their importance (although they are omitted from the Wren Society transcription).[13] One is a patriotic eulogy on British naval power, while the other extols, as emblems of monarchy, such archetypal structures of architectural (and masonic) history as arches, columns and tombs. The latter was first quoted when discussing Hawksmoor's design method, and then again concerning his churches, since throughout this study the recollection of ancient architectural wonders has been seen as fundamental to his desire to 'authenticate' his work.[14]

In turning to contemporary exemplars, Hawksmoor praises the absolutist monarch Louis XIV – ironically enough, Marlborough's opponent – as a 'Royal *Mecaenas*' and, not surprisingly given his purpose, he singles out 'the founding and finishing the Hospital of the Invalids for Veteran Soldiers' (see Figs 300, 301). Libéral Bruant's Hôtel des Invalides had served as a contemporary model for the Royal Hospital at Chelsea

(1682–91) and, as noted in the previous chapter, Hawksmoor's ideal plans for Greenwich also clearly sought to emulate this French absolutist project – along with that of another great monarch, Solomon. The buildings of Louis XIV were viewed by Wren on his visit to Paris in 1665 and had become firmly established as models during the reign of Charles II, in reflecting the traditional English rivalry with France.[15] André Le Nôtre, the designer of the archetypal example of axial planning at Versailles, even made a plan for the (now destroyed) parterre in Greenwich Park that Hawksmoor considered to have formed the basis for its layout.[16] He consequently relates that the King Charles block 'was placed to answer the regular Designs of that most admirable Person *Monsieur Le Notre*, in the Esplanades, Walkes, Vistas, Plantations, and Lines of that beautiful Park'.

Hawksmoor praises Louis for 'rectifying the irregular and ill Management of the Police of great Cities',

and notes concerning the link between arts and arms that 'These two Articles of Police were eminently advanced by the late *French* King, and by the Influence of his admirable Minister Monsieur *Colbert* and others; and they produced many and singular good Effects to his Country'. The term 'police' here means the general organization of the state, which for Hawksmoor was a hallmark of antique civilization – made clear in his observation to the Dean of Westminster that 'the Greeks and Romans calld every Nation Barbarous, that, were not in their way of Police and Education'.[17] Here again he echoes Wren's comments on the political function of architecture, quoted in the previous chapter, which had been graphically illustrated to Wren when visiting Paris at the outset of the Restoration. By 1728, however, such arguments in favour of the benign effects of absolute monarchy were obviously somewhat anachronistic in the context of all-too recent English constitutional reforms, especially since Jean-Baptiste Colbert had been dead for some forty-five years. One such 'good effect' resulting from Louis XIV's public policy (or 'Police') had been the sponsorship of Perrault's *Vitruvius* and his *Ordonnance*, both of which had attempted to regulate French architectural production along the lines of Colbert's legal *Ordonnances* (the *Ordonnance civile* of 1667 and the *Ordonnance criminelle* of 1670).[18] Given that Hawksmoor owned copies of both Perrault works, he would, judging from his comments on Greenwich, have endorsed their mission for civil regulation and rational methods (highly compatible, after all, with his own 'architectonricall method'). Indeed Vanbrugh, in a letter to William Watkins in 1721 concerning Hawksmoor's need for preferment, observed 'What wou'd Monsr: Colbert of France have given for Such a Man? I don't Speak as to his Architecture alone, but the Aids he cou'd have given him, in almost all his brave Designs for the Police'.[19] Hawksmoor's deep sympathy with law and order must have been established in his youth since, according to George Virtue, his first job had been as a 'clerck to Justice Mellust in Yorkshire'.[20]

In his book on Greenwich Hawksmoor encapsulates this relationship between public architecture and the rule of law in his phrase 'Police Architectonical'; the importance of this concept to his work has never received the attention it deserves. Links between civil order and decorum and architectural order and decorum (which the antique Orders traditionally 'ornamented') had existed in England since the first use of the antique column in the Stuart period, to express the legal 'body' of the king.[21] This association is natural enough since the English translations of architectural terms central to the Vitruvian canon reflect notions

of good government based on law: proportion and harmony, order and decorum, symmetry and balance, licentiousness and the rule, scale and measure. Hawksmoor would have seen Daniel Barbaro explain the concept of architectural proportion through citing those of 'equity' and 'justice' in his introduction to the fourth book of *Vitruvius* (lot 70).[22] Indeed in his book on Greenwich, Hawksmoor describes Vitruvian virtues of 'Symmetry, Commodiousness, and Duration' as perfectly reflected in a regular-planned city such as Wren's, with its absolutist vistas, and in strong contrast to 'the irregular and ill Management of the Police of great Cities'. He echoes Perrault's Vitruvian-based absolutism in repeating his earlier comments to Dr Clarke concerning the lawless, or 'confused' and 'irregular', manner of London as built: 'And all this had been prevented, had the Police Architectonical been supported'. Such ills had been rectified by Louis XIV but not by the English authorities where 'the Houses commonly built by the *London* Workmen' are 'often burning, and frequently tumbling down'. It is clear that in Hawksmoor's mind a surfeit of public freedom, or at the very least a lack of regulation, has produced the chaos of London as rebuilt after the fire and in so doing deprived the country of one of the 'Wonders of the World'. Achieving the 'Police Architectonical' was not dependent on expenditure, for Wren's city would have been built 'at much less Expense than the Citizens have been at, in the Rebuilding it in the confused, irregular, and perishable Manner 'tis now left in'. Clearly for Hawksmoor a completed Greenwich Hospital would stand as a beacon of such public order in London just as the Hôtel des Invalides did in Paris.

One of the principal purposes behind Hawksmoor's explanation of his work at the Hospital was to answer criticisms as to its layout, and the problematic retention of the Queen's House. In so doing he emphasized Queen Anne's influence on the design, noting 'her Majesty's absolute Determination to preserve the Wing built by her Uncle King *Charles* II; to keep the Queen's House and the Approach to it'. But the use of the palace 'type' as a hospital, in the absence of a suitable antique precedent, needed a more theoretical justification. In recalling the principles of appropriate display and type that had guided him throughout his work, he asks rhetorically 'is there no Distinction to be made between a private Alms-house, and an Hospital built by the State?' He justifies this distinction by reference to modern precedent (the Hôtel des Invalides) and, as at Blenheim, to the Aristotelian moral concept of 'magnificence' that stressed the expenditure and ostentation appropriate for public works.[23] For Hawksmoor notes that Queen Anne commanded that the 'Fabrick' be

built 'with great Magnificence and Order', later repeating her 'fixed Intention for Magnificence'. And as further contextual justification for the use of the palace 'type', he stresses Greenwich's 'noble Situation in the Sight of (the Grand Emporium) *London*'.

No doubt in response to the enhanced physical circumstances of the Queen's House, emphasised by its new focal role, Hawksmoor's design of 1711 for re-fronting this once isolated astylar lodge proposes a new ornamental surface of giant Corinthian pilasters (thus here again reflecting the contextual demands of architectural decorum; Fig. 331).[24] Above the cornice in unmistakeable Hawksmoorian style are trophies of arms and a central tower with urns. On the rear of the drawing is a contextual interpretation of the scheme in the hand of George Clarke: 'The manner in wch the front of the Queen's House at Greenwich may be altered and made more of a piece W[th] the hospital'. Moreover this Corinthian embellishment may well have also been considered necessary because the Queen's House was no longer to function merely as an occasional rural retreat. Rather, according to Hawksmoor, it was to serve Anne 'as a Royal *Villa . . .* from whence Embassadors, or publick Ministers might make their Entry into LONDON'.[25]

However, here again Hawksmoor was disappointed. In 1734 he lamented to Carlisle that 'imperiall Mischief' had been done to the Hospital and, in a final defence of his grandiose palace vision, added 'I once thought it wou'd have been a publick Building but it will sink into a deformed Barrac'.[26]

'GOOD REGULATIONS IN ALL BRANCHES OF THE GOVERNMENT': HAWKSMOOR AT WESTMINSTER

Hawksmoor's patriotic conception of London as a mercantile world capital, or 'Grand Emporium', lies behind his final project – an ambitious scheme for a new bridge at Westminster. No fewer than 'Four Designs of Westminster-Bridge by Mr. Hawksmoor' (lot 288) are listed in his sale catalogue. This was a popular idea: Defoe in his *Tour* of 1725 had called for a new bridge over the Thames, and Alexander Pope alludes to it in the concluding remarks on public works in his *Epistle to the Right Honourable Richard Earl of Burlington* (1731). Within two years of this poem, an Act for building a bridge was passed through both Parliamentary Houses.[27] The work was left to Hawksmoor's great enemy, Thomas Ripley, who as a former carpenter proposed a wooden bridge. Hawksmoor comments to Carlisle on 17 February 1736 that 'I have been

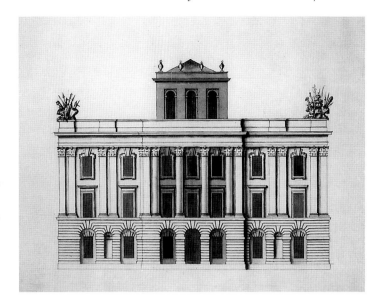

331 Hawksmoor's design for re-fronting the Queen's House, 1711 [Worcester College, Oxford].

extreamly busy about getting a stone Bridge for Westminster to Lambeth Marsh. and they have agreed to have a bridg from New palace yard, and Orderd a Bill to be brought in', adding sarcastically that 'We are striveing to have it stone. but there are some Wooden headed fellows are endeavouring to have a wooden one; I hope we shall get y[e] better of 'em'.[28] Later in the same year he solicited the services of Carlisle, noting 'I must then entreat your Lordship recommendations to your friends, that I may be employd in Some Shape or other if I shall be alive in Building the Bridge I have taken so much pains for'.[29] But he also went out of his way to gain support from the king and the public for his plans. For once again there exists a rare published record of his intentions, in the form of his *A Short Historical Account of London Bridge; with a Proposition for a New Stone-Bridge at Westminster. As Also an Account of some Remarkable Stone-Bridges Abroad, and what the best Authors have said and directed concerning the methods of Building them. Illustrated with proper cuts* (published in the year of his death, 1736).

As this title suggests, Hawksmoor adopted an historicist, comparative method – similar to that used on Baalbek – when illustrating and describing his bridge alongside some 'remarkable' ones of various ages, such as the Rialto and that of Rimini (Fig. 332). His bridge is shown unadorned, without such superfluities as niches and columns, befitting its role as a modern piece of engineering – or what he terms a 'Machine'. Although they may represent Hawksmoor's final scheme, these plates are not, however, the only record of his thoughts on the bridge's appearance and

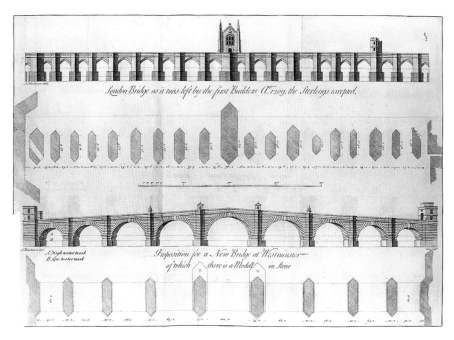

332 Hawksmoor's Westminster Bridge design, from his *A Short Historical Account of London Bridge* (1736).

333 Hawksmoor's drawing of the central arch of his Westminster Bridge, 1736 [R.I.B.A., London].

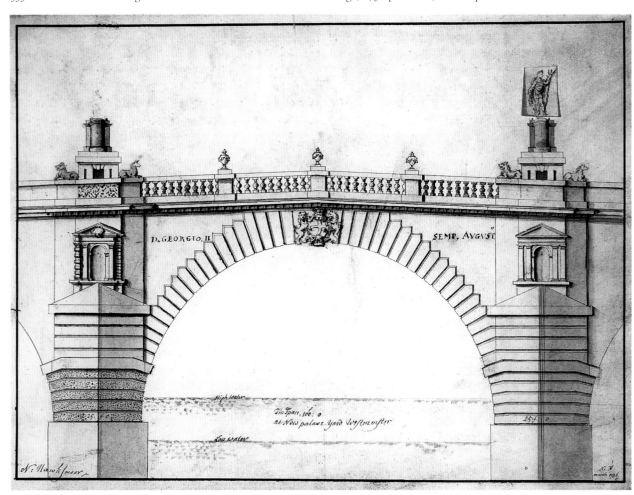

therefore on its meaning – aspects that he evidently considered in some detail. For a surviving drawing in his hand of the elevation of the central arch includes a statue holding a trident, probably of Neptune in signifying the British claim to rule the seas celebrated by Hawksmoor in his Greenwich book (Fig. 333).[30] Hawksmoor no doubt considered this as appropriate embellishment, given that naval supremacy was the basis of the country's trading wealth that the bridge was supposed to symbolize and enhance. Also ornamenting the bridge is the royal coat of arms and motto – 'D. GEORGIO. II SEMP. AUGUSTO' – alluding to the traditional identification of the British monarchy with Augustus and his legendary architectural works (for as Hawksmoor himself puts it, none other than the great Vitruvius 'had the Command' of the 'Treasure of Augustus').[31] Since the days of James I it had been a royal ambition to reshape London on the model of Rome rebuilt under Augustus, as a sign of a new Golden Age of British arts and sciences. This vision, discussed in Chapter 5, was particularly strong in the early years of the Royal Society, and it was during this time that Evelyn, in his English edition of the *Parallèle*, compared Charles II with Augustus (as Hawksmoor would have seen in his two copies, lots 89 and 108).[32] It was hoped by many – especially Royal Society Fellows such as Evelyn and Sprat – that this Golden Age of Stuart monarchy would lead England to challenge the supremacy of Louis XIV's France, not only in science but also in architecture. Hawksmoor's nationalistic call for architectural glory – particularly evident, as has been seen, in his book on Greenwich Hospital – was a legacy of this rivalry with France cultivated by Wren and his circle. The Paris of Louis XIV had been projected as the capital of Europe, and not surprisingly Hawksmoor saw London as its successor. His new bridge, in enhancing trade, lay at the heart of this rival vision of London as 'that fam'd Metropolis, and universal Emporium of *Europe*' flourishing under the new Augustus, George II.[33] Just as the bridges in Rome depicted by Serlio – which Hawksmoor lists – had become symbols of Roman glory, so a new bridge at Westminster was seen by him as a vital part of 'reformed' London, and a symbol of the metropolis as a whole.[34] On his title-page Hawksmoor quotes Pope's praise in his *Epistle* (1731) for public engineering works such as new roads, harbours and river defences, which concludes: 'These Honours, Peace to happy BRITAIN brings / These are Imperial Works, and worthy Kings'. According to Hawksmoor, new bridges even lead to 'Good Regulations in all Branches of the Government', while for the king, a 'Bridge of Stone built over the *Thames* in his Reign, for the Good of his People, will

be (among his other Glories) an everlasting Trophy to his Honour and Memory in times to come'.[35] Once again he sees his work as serving as a memorial to royal magnificence.

Hawksmoor's plan of Whitehall published in his *Historical Account* envisages extensive reordering in the vicinity of the new bridge, and indicates five possible crossing positions (Fig. 334).[36] The 'slaughter house' site (labelled 'B') involved widening College Street (which in those days ran to the river), for example, and the plan as a whole indicates large-scale demolition around the Abbey to establish a new piazza (or forum) whose perimeter is represented by a dotted line. Hawksmoor's scheme for the bridge thus sought to increase the prominence of the Abbey and particularly his own new west front, since the piazza is widened opposite it. For consistent with his principle of 'Police Architectonical', Hawksmoor through this work on the Abbey had reinvigorated the seat of local government in Westminster, which Defoe records was 'by a high bailiff, constituted by the Dean and Chapter, to whom the civil administrations is so far committed'.[37]

As Hawksmoor frequently lamented, London's expansion had largely gone unregulated and his other schemes for Westminster would have formed part of this ambition for a well-ordered core to the metropolis. It had long been the dream, as Defoe observed in his *Tour* of 1725, to transform neighbouring Whitehall Palace into a worthy rival of Versailles, especially after the fire at the palace in 1698.[38] Wren had envisaged a magnificent new palace that extended into the park, sketches for which are possibly in Hawksmoor's hand.[39] Hawksmoor's vision for the area included designs for new Houses of Parliament, after a plan by Wren for a new debating chamber between Westminster Hall and Whitehall Palace. A total of forty-three drawings for the 'Parliament House by Mr. Hawksmoor' are recorded in his sale catalogue (lots 78, 192 and 196), which are now lost, and his obituary lists among his achievements 'his Design of a new Parliament-House, after the Thought of Sir Christopher Wren'.[40] On 2 March 1732 Hawksmoor reported to Carlisle that 'We talk here very much of a new Building for yᵉ Cotton Library and a Fabrick for yᵉ Reception of parliament, I hope they'l stick to their resolution'.[41] The *Grub Street Journal* announced somewhat ominously in the same month that 'The plan for building the new parliament house is the design of Nicholas Hawksmoor Esq., one of the surveyors of his Majesty's Works, which is said to be very grand and beautiful, and is now under the inspection of the right hon. the Earl of Burlington, for his approbation'.[42] Not surprisingly, a year later Burlington produced a design

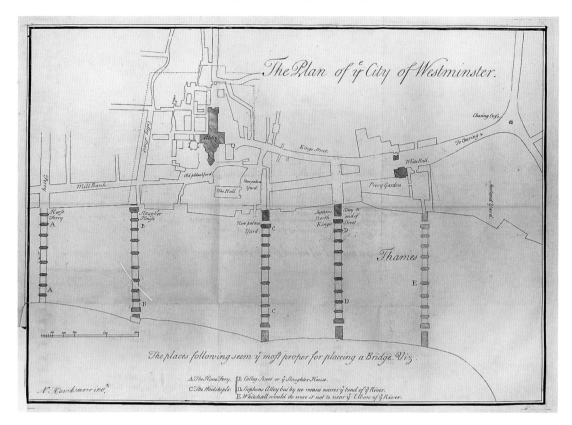

334 Hawksmoor's plan of Whitehall, from his *A Short Historical Account of London Bridge* (1736).

of his own.[43] But in a letter to Carlisle of 14 July 1733, Hawksmoor revealed that – even now, at the age of seventy-two – he continued to harbour hopes of realizing the project: 'I promised a scetch of y^e Parliam^t house to S^r Tho Robinson proposed by S^r C. Wren . . . I will send it to y^r Lordship, only for your amusement'.[44] A clue to Hawksmoor's model for this 'grand and beautiful' project lies in a sketch of what he termed an 'Atrium Corinthium' to serve as a southern vestibule for Westminster Hall, positioned in the angle between the Hall and St Stephen's Chapel (Fig. 335).[45] Possibly directly related to his larger Parliament scheme, this sketch suggests that once again the idea of the Roman house served, perhaps appropriately enough, as an initial inspiration for his new 'Houses' of Parliament.

The most dramatic of Hawksmoor's schemes for Whitehall was his plan for a new Parliament Street stretching the half mile from New Palace Yard to the Royal Mews, which, like his streets in Oxford, would have served a ceremonial as well as a practical purpose. Chapter 2 noted that this street was to have been 110 feet wide and, according to Thomas Lediard's sole surviving record, to have had a 'Colonnade on each side of the way, in the Nature of that at Covent-Garden'.[46] It was also pointed out that Wren's rational account of

the rise of antique urban planning through the device of the colonnade might have inspired Hawksmoor's use of colonnades here and elsewhere – in his town plans for Oxford and Cambridge for example. He certainly echoed Wren in considering that these colonnades served to enhance trade. For in reference to Palladio's scheme for a bridge across the Grand Canal in Venice he notes, 'it is adorned with porticoes, Logias, and Colonades, covered over on each side, and accommodated for the Reception of a Concourse of people, Like a *Forum* or *Exchange* . . . This was designed for the most populus Trading City in *Italy*'.[47] Such a bridge if built in Bristol would, he adds, 'bring Profit, Convenience, Ornament, and Honour, to such a wealthy and noble city'.[48]

Hawksmoor clearly hoped that through his new bridge, forum and colonnaded street, the City of Westminster would be encouraged as a trading centre in emulation and rivalry with the City of London. But he also saw these antique urban forms as powerful symbols of a superior ancient Roman civilization which, in striking contrast to the immorality of his own day, had emphasized magnificence, public morality and what in re-planning Greenwich he called the 'Police Architectonical'. His Parliament scheme obviously

served as the most tangible expression of this conception of public architecture, lying at the very heart of the expanding capital, while the Tory aim of imposing order and morality throughout the unruly areas of London was given expression through the sombre dignity of his new churches. Moreover as has been seen, Hawksmoor considered that the disorganized character of the streets of post-fire London symbolized its moral corruption, an association made plain in the language of his letter to Clarke in describing London's 'Crooked passages' and 'Scoundrell Streets'.[49] In contrast, axial planning of the type pioneered in this country by Wren and used by Hawksmoor in his Parliament Street and elsewhere made manifest good morality and public order.

Thus through a set of projects at Westminster, Hawksmoor sought to reaffirm and invigorate the national institutions of Church, Government and Monarchy. Elsewhere, his abundant faith in these institutions had stimulated his designs for, and supervisory work at, such important national sites as St Paul's, Blenheim, Greenwich and Windsor (the seat of the Order of the Garter).[50] However, as his enthusiasm for the absolutist architecture of Louis XIV indicates, in an age of constitutional government he was increasingly out of step. Following the criticisms of satirists and politicians concerning the public expense of royally commissioned architecture (Tories in particular attacked Blenheim), Hawksmoor evidently felt the need to justify his various schemes in the capital.[51] His two publications were intended to remind the authorities of Wren's remarks concerning the political uses of architecture, although that on Greenwich Hospital – published five years after his master's death – only served to underline his increasing isolation. For here he laments that 'we alone shall not deny the Benefit accruing to the Publick from Foundations and Buildings of this Nature, when all the World is against us in

335 Hawksmoor's sketch of an 'Atrium Corinthium' to serve as a southern vestibule for Westminster Hall, undated [Victoria and Albert Museum, London].

the Practice of them. Their Productions are lasting Memorials of the care and Industry, as well as the evident Marks of a Polite Government'. Following the Glorious Revolution of 1688, the artistic prerogatives of monarchy had passed, together with the political ones, to the Whig nobility. Consequently as Hawksmoor was well aware, at Greenwich the ceiling of the Painted Hall by James Thornhill honours not autocratic monarchy but the triumph of 'Peace' and 'Liberty', while the colonnaded *Via Regia* from the Royal Mews to Parliament was destined to remain on paper.

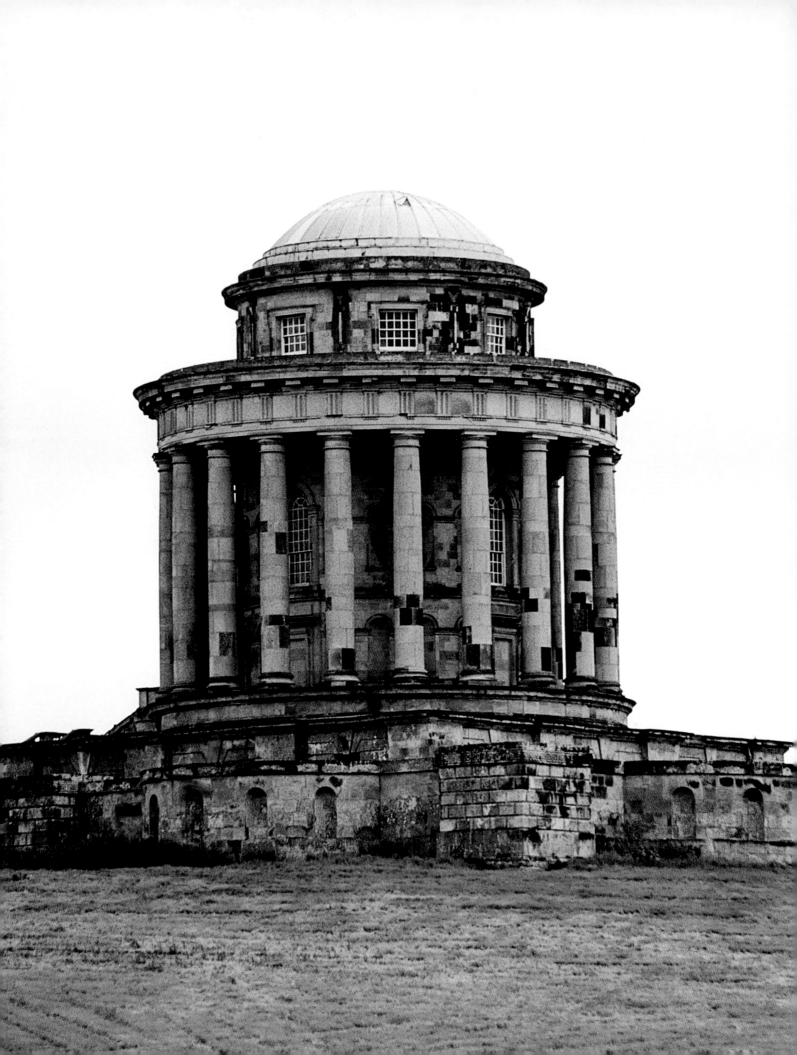

Chapter 10

'IN THE FORM OF A GREEK TEMPLE': THE MAUSOLEUM AT CASTLE HOWARD

ON A HILL OVERLOOKING THE ESTATE at Castle Howard stands the first *all'antica* mausoleum to be built in England and the last of Nicholas Hawksmoor's buildings (Fig. 336). In its design he felt compelled by circumstance to follow what he at least considered were antique rules, in having 'recourse, to Vitruvius himself, on this Occasion'. The resulting building is, in its simplicity of detail and plainness of style, in strong contrast to the flamboyance of the main house, the design of which is accepted as by Vanbrugh with Hawksmoor's assistance in site supervision and in detailing.[1] The Mausoleum was designed by Hawksmoor alone, however, albeit with interference and scrutiny by others. It was noted in Chapter 3 that his correspondence with his patron, Lord Carlisle, concerning its design provides a clear record of his 'architectonricall method' in action, here defined as such for the first time, and of his fundamental belief in using appropriate historical models as a starting point. Hawksmoor embellished his mausoleum 'model' by adding a Doric colonnade, defending his reasons for selecting both model and embellishment in his letters. Indeed his failure to find an adequate antique model for a circular colonnade of the Doric Order at such narrow intercolumniations, in the wake of some high-profile criticism, suggests that his overriding concern was to use this Order above all others.

In investigating the possible reasons for this mixture of antique canonics and modern inventiveness in the design of the Mausoleum, this chapter will examine the political values reflected in its conception and final form. Hawksmoor's concept of 'Police Architectonical', outlined in the previous chapter, shows that he was well aware of the political value of architecture, following Wren's comments at the outset of his Tracts. Of Hawksmoor's two masters, Wren leaned towards the Tories (as a passionate Royalist) while Vanbrugh was a committed Whig.[2] The ardent Tory Jonathan Swift famously interpreted the domestic work of Vanbrugh, and by implication of Hawksmoor, as Whig-inspired.[3]

Indeed Chapter 5 concluded that the landscape and house at Castle Howard can be seen to embody the Whig vision of a new Golden Age. It has been seen that Hawksmoor worked for Tory and Whig patrons alike, giving expression through stylistic shifts to the conflicting political and social values of his time. The Tories had even cut supplies for the building of Blenheim at the same time as commissioning his work on the new churches. As has also been seen, in designing these churches from the early 1710s through the 1720s Hawksmoor drew on primitive (sometimes licentious) forms and column types to give unique expression to the 'primitive' theology of the Tory-aligned High Church party and to Tory political ideals of conformity and order. But in designing the Mausoleum under the scrutiny of Burlington and other Palladians in the 1730s, Hawksmoor sought through a purity of form, Doric style and self-conscious adherence to ancient practice to memorialize Whig aspirations and, more particularly, their nonconformist ideals advocated by his patron, Lord Carlisle.

'BEFORE PRIESTCRAFT GOT POOR CARCASSES INTO THEIR KEEPING': THE MAUSOLEUM AND WHIG NONCONFORMITY

The memorial intentions behind Hawksmoor's Pyramid and Mausoleum at Castle Howard are clear from his previously quoted observation that

> The great Men of the World heretofore, to perpetuate their own Memories, and their great Actions, among other Things had recourse to the liberal Arts; particularly to that of Architecture; sometimes by erecting useful Structures for the Good and Benefit of Mankind, and sometimes for their Grandeur only. Such as the Pyramides, the Monumental Pillar of *Trajan*, the great Tomb of *Porsenna* King of *Tuscany*, and infinite others.[4]

336 Mausoleum at Castle Howard.

While on the London churches such forms had served as royal memorials, as part of a movement towards 'primitive' Anglicanism, in the Castle Howard landscape they celebrated more private values associated with the past and future glories of the Whig 'house' of Carlisle. The Pyramid contains a bust of Lord William Howard, founder of the Howard line, and the Mausoleum was intended for the body not just of the third Earl but of his heirs. As a personal memorial, its design was clearly intended to reflect the beliefs of the Earl, and the ideology of the Whig party to which he belonged.

The term 'Whig' connoted nonconformity in religious and state affairs, and particularly applied to those who championed limited constitutional monarchy – following the ideals of the Glorious Revolution of 1688 – rather than the Divine-Right absolutism of Charles II and James II, favoured by Tories. Whigs thus stressed the value of individual freedom and included among their number nonconformists such as Quakers and Deists. Nonconformists considered the history of organized Christianity to be the story of the triumph of superstition over reason, symbolized by the Church's execution of Galileo and opposition to early science. Lord Shaftesbury, a zealous Whig, was nonconformist in religious matters, appearing to argue that there was no necessity for fixed religious doctrine since a tendency to virtue existed naturally in men.[5] Carlisle's own religious sympathies were latitudinarian (that is, indifferent to the particular creeds and government of the English Church), and there is strong evidence for the influence on him of Deist and Quaker beliefs.[6] His manuscript entitled an 'Essay on God and his Prophets' identifies the source of theological corruption with the priesthood and rejects their superstitious practices as first cultivated by Moses.[7] According to Carlisle, revelations should be subjected to the test of reason, 'which must always direct Man in y^e judgment he makes in these, & in all other cases whatsoever'. Reflecting the materialist philosophy found in Thomas Hobbes's *Leviathan* (1651), mankind is here urged to rely on reason and social utility in the wake of human weakness and brutishness. Carlisle also echoes the contemporary cultivation of primitive Christianity and its 'authentic' forms in observing to the Quaker Thomas Story that 'whatever is invented and imposed by Man, in Matters of Religion, more than what was ordained by CHRIST, and taught by him and his Apostles, is vicious, and ought not to be regarded'.[8] That Hawksmoor mentions Carlisle's lack of superstition in the same breath as stressing his own rationalism suggests that the architect was well aware of his patron's religious preferences when designing the Mausoleum:

indeed he may have had his own Deist sympathies, via freemasonry, as noted in Chapter 4.

True to his Whig affiliation Vanbrugh lampooned the clergy in his plays and, concerning the idea for a mausoleum at Castle Howard, wrote to Carlisle that this form of burial was what 'has been practic'd by the most polite peoples before Priestcraft got poor Carcasses into their keeping, to make a little money of'.[9] Carlisle's quintessentially Whiggish nonconformity in religious matters was therefore seen by some at least to have influenced his novel choice of a pagan mausoleum, in preference to a Christian parish church, as his place of burial. The absence of the chapel that would have formed the (unbuilt) western flank of the main house at Castle Howard only serves to emphasize this apparent rejection of the established Church. The Mausoleum chapel is devoid, both externally and internally, of the standard Baroque crucifixes, sunbursts and baldacchinos that Hawksmoor was obviously perfectly capable of designing, when the occasion demanded it.[10] To Deists, the Greeks had practised a rational form of nature worship seen as compatible with the Christian emphasis on God as creator. Inside the Mausoleum it is perhaps significant that, apart from the sprouting Corinthian columns, the main decoration takes the form of sheaves of wheat in the pedestals and interlocking vegetation in the frieze (Fig. 337). Moreover the pagan Orders – especially the Greek Doric and Corinthian – would surely have been equally acceptable to Deists as rational 'signs', given their basis in natural forms. In the same way Hawksmoor considered his use of a Greek tomb, as a model, as less a matter of 'superstition' than of 'good Reason'. The Mausoleum's form, a Doric rotunda, can also be seen to reflect the rational simplicity – even austerity – of Carlisle's religious philosophy. A rotunda had been used as an emblem of the new age and its 'improved', rational view of nature in the frontispiece of Henry Pemberton's *A View of Sir Isaac Newton's Philosophy* (1728),[11] for example, a work in Hawksmoor's collection (lot 52) (Fig. 338). These sentiments can be identified with the Mausoleum since it was not just any building but one intensely expressive of Carlisle and his dynastic 'house', to whom modern Whiggish values of religious nonconformity were so clearly central. It was noted that Lady Irwin proudly heralded the modernity of her father's Mausoleum through its having emulated, and indeed rivalled, its ancient namesake at Halicarnassus: 'Tho' that a Wonder was by Ancients deem'd, / This by the Moderns is not less esteem'd'.[12]

Earlier it was seen that in his letters concerning the Mausoleum, Hawksmoor reflects – even at one point celebrates – the contemporary shift in priorities from

337 Interior of the Mausoleum at Castle Howard (the cross is a later addition).

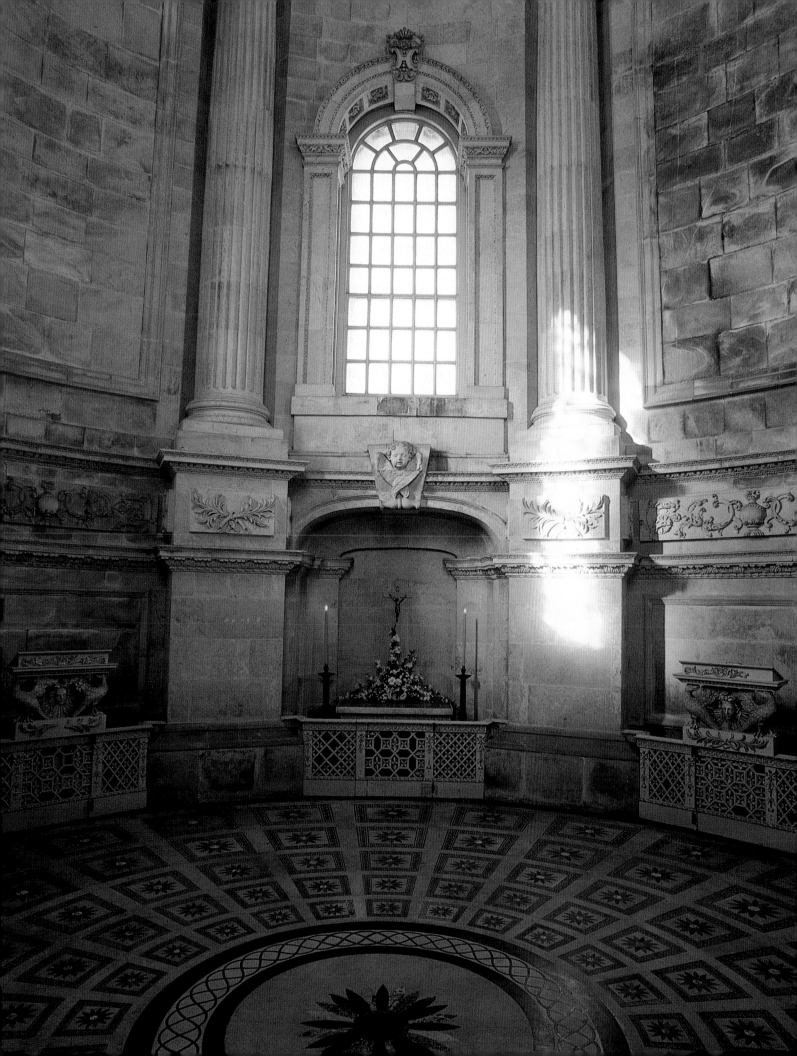

338 Frontispiece of Henry Pemberton's *A View of Sir Isaac Newton's Philosophy* (1728).

Renaissance cosmology, with its superstitions and customs, towards a more rational approach to matters of history and optics. It was also pointed out that a large number of books on contemporary science were in his library, especially those concerning the Royal Society. The experimental philosophy of analysis by first principles and apparent 'reason' – a word Hawksmoor is extremely fond of – also influenced Carlisle given that he was, as Hawksmoor observed, 'not Supestitious'. In his search for a rational basis for design, devoid of superstition, Hawksmoor sought to understand Vitruvian principles but to apply them in new ways. The variations in the style of his churches, between the use of canonic and licentious ornament, have been seen to follow a pattern that can be explained with reference to the Vitruvian theory of decorum or 'appropriateness'. His application of this theory can be further demonstrated in the Mausoleum design, where to achieve expressive requirements in the face of structural realities he had to amend antique examples.

'REASONS AND INTENTIONS': THE MAUSOLEUM AND THE DORIC IMPERATIVE

In Chapter 3 it was pointed out that Hawksmoor's letters to Carlisle concerning the Mausoleum make clear the importance of selecting appropriate antique models. His letter of 11 July 1728 records that the initial design for the Mausoleum was modelled neither on Halicarnassus nor Porsenna but on the Roman tomb known as the Capo di Bove (Cecili Metella), a rustic edifice without columns. He informs Carlisle that Metella was 'a Noble person of Rome' and underlines

the suitability of the model by adding 'And indeed it was a Noble Monument, and durable (if anything can be sayd to be so in this world)'. He continues that 'it was also great, for y^e Square Basement, in which was y^e Sepulcral chamber was on each side (if we are rightly informed) 100 fo^t English and the round part or Tamburo. 90 foot. the whole hight was, 100 foot. I have followed the proportion as near as possible'. Hawksmoor's design reflecting this model can be tentatively reconstructed (see Appendix 1). His knowledge of this Roman tomb on the Appian Way was based on illustrations in Pietro Santi Bartoli's *Gli antichi sepolchri, overo mausolei romani et etruschi* (1697), for in the same letter to Carlisle he quotes from Bartoli's text concerning the tomb's subsequent use as a fortress (Fig. 339). The tomb's form – a cylinder on a square base – was also adapted as the model for what can be identified as a pair of 'cenotaphs', complete with urns, in the garden at Castle Howard (Fig. 340).[13] However the Mausoleum as built, with its colonnade, more closely resembles Bartoli's conjectural reconstruction of another tomb on the Via Appia, known as the Tomb of Gallienus (mistaken for the Temple of Domitian by Bartoli) as published in Domenico de Rossi's *Romanæ*

339 Capo di Bove (Cecili Metella), from Pietro Santi Bartoli's *Gli antichi sepolchri, overo mausolei romani et etruschi* (1697).

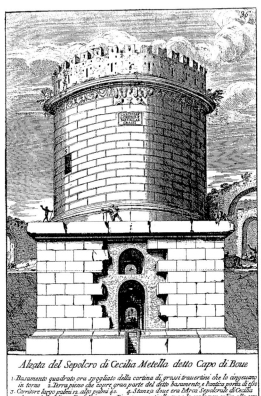

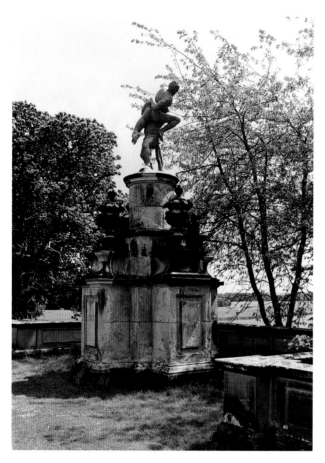

magnitudinis monumenta of 1699 (Fig. 341).[14] Significantly, the one major difference between this model and the eventual building was that Hawksmoor rejected the Corinthian Order used in the ancient colonnade – as well as the astylar arcade he at first proposed (Figs 345, 346) – in favour of the more austere Doric. In doing so he emphasized the importance of the Doric Order to both his and Carlisle's conception of the Mausoleum.

This difference between model and building might be seen as another example of Hawksmoor's 'architectonricall method' in practice. It has been seen that, consistent with the principles of decorum, this method involved the adaptation of antique models according to such variables as character and context. In his Mausoleum design Hawksmoor sought expression for Carlisle's character – for the Earl's desire for antique propriety (in line, as will be seen, with advice from Lord Burlington) and for unsuperstitious, 'rational' forms befitting his religious outlook – preferring for this memorial building plainer external ornament than

340 'Cenotaph' in the garden at Castle Howard.

341 (*below*) Tomb of Gallienus, from Domenico de Rossi's *Romanæ magnitudinis monumenta* (1699).

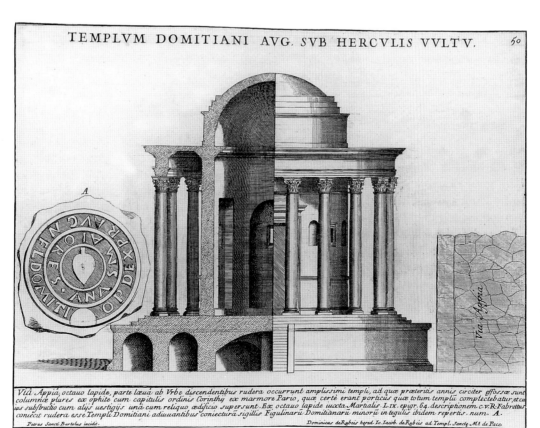

TEMPLVM DOMITIANI AVG. SVB HERCVLIS VVLTV. 50

that used on the main house. Hawksmoor flirted with the Ionic Order for the Mausoleum but quickly rejected it in favour of the Doric, noting on 19 April 1729 that the Doric Order 'will make y⁰ fabrick more firm and masculine'. Some three years later he again observed that 'I esteem'd the Dorick most suitable to the Masculin strength we wanted'.[15] Here, true to the metaphorical meaning of the Orders codified by Vitruvius and his Renaissance successors, the qualities of strength and firmness are emphasized in terms of appearance rather than actual structural force. In this most heraldic of buildings, Hawksmoor clearly wanted to symbolize masculine qualities perhaps thought appropriate to a male line. Consequently the columns are left plain, despite pressure in 1729 from Lord Morpeth (Carlisle's son) to flute them, and the basement is rusticated.[16]

Hawksmoor evidently also saw the Doric as a particularly appropriate Order for the necessarily sombre character of mausoleums, drawing inspiration once again from ancient precedent. As Chapter 2 noted, following Wren he understood the Halicarnassus mausoleum as a model Doric structure. He illustrated the ancient monument as such in his reconstruction for Wren's 'Discourse' and reported to Carlisle on 3 October 1732 that 'The famous Mausoleum Built by Artemisia the Queen according to Pliny was beautified and Sustained by 36 Dorick Columns, 6, upon each Front' (see Fig. 22).[17] In fact, as Hawksmoor could easily have checked in his own copies of Pliny (lots 84 and 99), the Roman author had merely noted that the 'building rises to a height of 25 cubits and is enclosed by 36 columns'.[18] Hawksmoor justifies his interpretation by reference to empirical methods, continuing (as quoted in Chapter 2) that

> The whole work according to Pliny was 140 foot high, Sr. Christopher Wren, contemplated this Fabrick with great exactness according to the measures given by Pliny, and declared, by his calculation; it could be nothing but the Dorick Sistyle. And one Trigliff over each Vacuum. Which is the same as the Picnostyle Disposition of Pillars and considering the vast weight the Substruction, had to support. and from the numbers above-mentioned It could be nor other.

Evidently Hawksmoor was not deterred from moulding this Doric mausoleum into the Composite steeple at Bloomsbury, however, underlining the need to match the ornamentation of a building to its function and location – Doric for hilltop mausoleums, Composite for royal steeples in the city.

Hawksmoor's concern in this letter to emphasize that the intercolumniation of the ancient mausoleum was pycnostyle – comprising a diameter and a half – is due to the fact that this was the somewhat narrow spacing of his own colonnade.[19] He was prompted to send Carlisle this defensive explanation of his sources in reply to criticisms from none other than Lord Burlington, who had objected that there was no antique precedent for such a Doric intercolumniation. Carlisle's son-in-law, Sir Thomas Robinson (a convinced Palladian and an acquaintance of Burlington),[20] in a letter to the Earl of 25 October 1732, wrote that he had 'talk'd with Ld. Burlington about the intercolumniation of the Mausoleum, he all'd. a Diameter & a half had been practised in sqr. Buildings but no instance of a Circular Colonade of that proportion in the Dorick order'.[21] On 18 November Robinson went on to explain: 'The reason Ld B – gave why a Diameter & half for the Dorick order, was not proper in a round Building, because from the Nature of a Circular Colonade the Columns must appear to stand closer, let the Spectator examine it from what point of view he will, then they wou'd do in a Square building'.[22] In his reply of 3 October Hawksmoor does not deal with these optical considerations, sticking to a defence of the Doric as an appropriate Order for mausoleums (which in fact had never been questioned), for the required masculine character and, more controversially, for a pycnostyle intercolumniation. His stubborn refusal to change from the Doric style in the face of such criticisms underlines its importance to his Mausoleum design – and in particular to his decorum-based priorities.

In linking the Doric Order to the pycnostyle intercolumniation, Hawksmoor's principal authority was Daniel Barbaro's 1567 Latin edition of *Vitruvius* (lot 70). He quotes two lines from the third chapter of the fourth book on the disposition of Doric temples, and refers to two illustrations in the following chapter of a rectangular Doric temple with the pycnostyle intercolumniation, which he evidently sent to Carlisle (Fig. 342).[23] Barbaro's Latin edition was however somewhat unusual (although more correct) in citing the pycnostyle at this point – even the text in his Italian edition of the same year has in its place the more common reference to a 'systyle' spacing (two diameters or modules). Other theorists including Palladio had proposed a much wider intercolumniation for Doric colonnades, following a regime for the five Orders in which the widest column spacing (eustyle) is matched to the 'stocky' Tuscan and the narrowest (pycnostyle) to the 'slender' Composite.[24] Hawksmoor himself acknowledged that

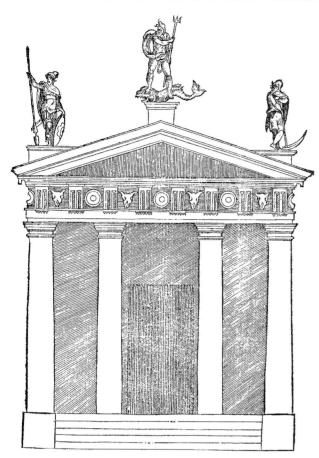

342 Doric temple with pycnostyle intercolumniation, from Daniel Barbaro's Latin edition of *Vitruvius* (1567).

his principal modern Doric precedent, Bramante's famous tempietto, was in fact built not with a pycnostyle spacing but with one slightly greater than two and a half modules (approaching diastyle at three diameters). Referring to Palladio, similar anomalies arose: for 'tho' in his Dorick proposition he offers, the Dyastyle in a direct rang; yet all his 17 Examples of the Ancient Temples, are Picnostyle, tho' they are most of the Corinthian Order'.[25] Hawksmoor somewhat meekly added that Palladio, 'no where forbids the Doric Order being used in the Picnostyle Disposition'. Hence it is no surprise that, following Palladio, it was evidently the diastyle that Burlington had recommended for the Doric colonnade (revealed at one point in Hawksmoor's aside: 'as my Lord would now have it'). Despite his best defences, Hawksmoor thus reversed the more authoritative Palladian scheme in following Barbaro's unusual Latin text (which in any case concerned straight, not round, colonnades).

Hawksmoor's defence to Carlisle implies a scheme of fixed (canonic) column proportions and spacing, even though this had been questioned by one of the authorities cited by him in his own defence, namely Perrault (twice referred to by name). It follows that, having matched pycnostyle with Doric supposedly after Barbaro, an adjustment in spacing would have required the use of a different Order on the Mausoleum. In fact Burlington had been concerned less with style than with optics, and if granted the diastyle he might well have been perfectly content with the Doric, which would then have conformed to the Palladian model. But whether justifiably or not, Hawksmoor understood Burlington's recommendation for diastyle as implying a change in Order. For in a dig at his 'amateur' critic (and ironically, the priority of visual criteria over 'reason'), Hawksmoor appealed to Carlisle that 'If your Lordship doubts of what I have said; then we must to please the inclinations of the Virtuosi; quit our Reasons and intentions, and by adding another Diameter make the Colonade Corinthian, but let them do it that will, it shall never be, by my consent'. With these words in mind, an investigation into the 'reasons and intentions' behind the Mausoleum design hardly seems misplaced.

At one point Hawksmoor concedes to Carlisle that 'Mr. Evelyn in his addition to the Paralell of Monsr. Chambray doth not forbid the Dorick Order, to the Picnostyle disposition; but he says the Dyastile Disposition is most Natural, and perhaps we might have humour'd him, if we could have found such Blocks, of Stone, as are in yᵉ Quarrys at Carara'. Two days later, on 5 October 1732, he once again felt the need to write to the Earl, now concentrating on this practical justification for the narrow intercolumniations. He observes: 'what a sad sight it would be to see the Entablement crack and settle by the large spaces of the intercolumniations'. This was no invented excuse, since the problem of finding stones large enough to span a wider spacing had been in his mind from the time, over three years earlier, that he had rejected an arcade in favour of a colonnade.[26] Irrespective of antique precedents, spurious or otherwise, this shortage of stone was the most probable reason for the close intercolumniations and, together with the extra expense, for Hawksmoor's refusal to enlarge them. Indeed the building work was by this stage quite far advanced, and it is possible that only the style, and not the spacing, of the columns could have been changed without incurring additional expense.

Given that Hawksmoor was evidently stuck with the pycnostyle span, he might well have opted to 'upgrade' the Order of the colonnade, as Vanbrugh had been forced to do with the portico at Blenheim.[27] He could

have chosen Composite, say, in line with Palladian theory concerning (straight) pycnostyle colonnades, and thereby answered Burlington in terms of stylistic canonics if not of optical perception. But it was noted earlier that he also rejected the Composite for the Mausoleum as 'a mongrell and no true Species'. Evidently while this Order was acceptable elsewhere, it was considered too 'inauthentic', or even 'unreasonable', for the exterior of a mausoleum.[28] The fact that Hawksmoor was stuck with a narrower than usual intercolumniation and that he chose to distort Palladian norms in the face of these practical constraints, only serves to highlight his evident priority for the Doric Order as part of the 'reasons and intentions' behind his design – intentions which the use of another Order would have involved 'quitting'. Indeed this priority is further underlined by his having modified the colonnade of his model, the Tomb of Gallienus, which is Corinthian. Since for Hawksmoor the Mausoleum was 'Monumentall, and therefore should be lasting',[29] and since it commemorated a male patron and his 'house', the ancient principles of decorum evidently dictated the choice, not of female Corinthian or Composite, but of Doric columns as signifiers of 'Masculin strength'. As the ensuing controversy amply demonstrates, this was despite the lack of antique precedents for their use at such close intervals.

Moreover the Doric Order was clearly preferred by Hawksmoor to its rival in masculine simplicity, the Roman Tuscan. For he explains that 'As to the project of Omitting the Triglyphs and other Dressings of the Dorick order, and making it plain like the Tuscan I am afraid will add nothing to its Grandeur but rather mutilate and maim, the whole, and make it of no order at all'.[30] But evidently he was perfectly happy to use the Tuscan at Spitalfields, for example, and so he was clearly not rejecting the Order's use in other situations. In arguing for the Doric in this case he obviously wanted to signify something more than masculine strength and somber simplicity, qualities equally represented by the Tuscan. For the Doric, with its origins in Greek antiquity, may well have been considered particularly appropriate as a reflection of the Whig cause.

'STICK CLOSE TO Y[E] IMITATION OF Y[E]
ANTIQUE': A 'GREEK' MAUSOLEUM IN
A WHIG LANDSCAPE

Following the epic poetry of John Milton, in the early eighteenth century the ancient Greeks were cultivated as the originators of democracy and of the arts, particularly architecture, and as such were identified with the Whig cause.[31] Shaftesbury for example made connections between liberty and the arts and hence the Greeks in 'Miscellaneous Reflections' published in his *Characteristicks* (1711).[32] To add to this virtue, it was noted earlier that the Greek Orthodox Church was identified (by George Wheler in particular) as the descendant of primitive Christianity.[33] After the work of Wheler and Spon, and their illustration of the Parthenon of 1678, published views of Greek architecture were however limited to a few studies. Hooke records in his diary on 23 May 1676 that Wren had seen sketches of Athens.[34] And Chapter 2 noted that Hawksmoor would have known something of Greek architecture through John Struys's *Voyages and Travels* (1681; lot 21). Given the relative absence of illustrations of actual examples of Greek architecture at this time, commentators have remarked that it is possible that Hawksmoor and Carlisle considered their Mausoleum as in some way 'Greek'.[35] Certainly, as has been seen, Carlisle's original request was for a mausoleum which was 'in the form of a Greek Temple' – the Earl thus clearly seeking to identify himself and his lineage with Greek architecture and ideals from the very outset.[36] Indeed it was noted that his daughter's contemporary poem eulogized the Castle Howard landscape by observing 'Buildings the proper Points of View adorn, / Of *Grecian*, *Roman* and *Egyptian* Form'.[37] The poem somewhat ambiguously footnotes these as 'The *Obelisk*, *Temple*, *Mausoleum*, and *Pyramid*', leaving the possibility of identifying either Vanbrugh's Temple or Hawksmoor's Mausoleum as the 'Greek' structure.[38] However Vanbrugh's Temple is an unlikely candidate, based as it was, via the Villa Rotunda, on Palladio's Roman temple reconstructions.[39] Her poem introduces the Mausoleum by observing that 'The Name of Carias noted King it bears', thereby pointing to the archetypal tomb of Mausolus which Hawksmoor had presented to her father as 'the most famous among the Greeks . . . which was calld y[e] Mausoleum'. The very concept of a 'mausoleum' – as a novel building type in England – thus carried Greek associations, to Hawksmoor at least, through its etymology.

Hawksmoor's rejection of an arcade – with its 'Roman' arches – in favour of a colonnade – with its fundamentally 'Greek' post-and-lintel construction – was perhaps intended to give the Mausoleum a more Greek character.[40] It was noted that, reflecting Serlio, he may have considered the colonnade a Greek element following his colonnaded 'Cloister of all S[ouls]. after the Greek'[41] (see Figs 54, 55). But the principal Greek feature of his colonnade – and therefore of the Mausoleum – was, of course, the indispensable 'masculine' Doric Order, the first and most simple of the

Orders of ancient Greece. Indeed it was noted that Hawksmoor firmly rejected its Roman rival in signifying masculine strength and sombre dignity – the Tuscan – for the Mausoleum (although happily using it elsewhere). It should be pointed out here that, like his own Mausoleum columns, he considered the original Greek version of the Doric to have a base, following the model of the Halicarnassus columns that he drew for Wren (see Fig. 22), and he was well aware of the Doric Order's origin and status. As seen in Chapter 2, Roland Fréart de Chambray celebrated the primacy of the Greek Orders (over those of the Romans) and wrote in the introduction to the *Parallèle* that, concerning the arts, 'the Greeks were the first inventors of them'.[42] It was also seen that Hawksmoor owned two editions of Evelyn's English translation of this work (lots 89 and 108) which he used as a source for his design of the Orders, both internally and externally, on the Mausoleum.[43] (Evelyn himself emphasized the 'completeness' of the Greek Orders, observing that 'the *Three Greek Orders* represent those *Three* Species of Building; The *Solid*, the *modest-mean*, and the *Delicate*'.[44]) Concerning the inside of the Mausoleum, it was noted in Chapter 3 that the Roman Composite capital first selected from the *Parallèle* (and matching those of Vanbrugh's hall) was subsequently modified to the Greek Corinthian in the actual building. In rejecting the Roman Tuscan and Composite as inauthentic Orders, at least for the Mausoleum, Hawksmoor appears to have been echoing Fréart's priorities more directly still. Indeed Hawksmoor is at pains to point out to Carlisle the purity of the Doric Order as, together with the Corinthian, an original Greek style, writing that the mausoleum at Halicarnassus 'was Built in the 2d. Year of the Hundreth Olimpiade, which was before the Temple of Diana at Ephesus was built, and in consequence before the Ionick Order was used. so that they had only the Corinthian and Dorick. This was also before Alexander the Great's time'.[45] His need to emphasize this last point to Carlisle is curious, since Shaftesbury believed that the era when the Greeks achieved their ultimate goal of democracy, when all art flourished, was only terminated under the universal monarchy of Alexander the Great.[46] Such associations with Greek democracy might well be a further, expressive reason behind the priority for a Doric exterior and Corinthian interior, and would have followed Vanbrugh's use of customary forms (including the Orders) to signify qualities such as 'strength', 'national history', 'luxury' and so on, at Castle Howard. Indeed although in a more flamboyant form, the Doric pilasters on the main façade were bound up in the narrative of the Whig 'democratic' triumph which was earlier

343 A 'Greek' Mausoleum in a Whig landscape.

identified as structuring the Castle Howard landscape (see Fig. 149).[47]

In the context of the early eighteenth-century battle for the true architectural expression of the new Whig order (a battle which saw the eventual triumph of Palladianism over the Baroque),[48] the Mausoleum can thus be seen as a victory for 'Greek' austerity over 'Modern' Baroque superfluity. This was no doubt partly due to the sombre nature of the building's function, unsuitable for opulent display, but it was also due to the influence of newer tastes for ornamental simplicity. In December 1732 Hawksmoor had suggested to Carlisle that statues or, hardly surprisingly, urns should sit on the entablature.[49] Flaming urns are shown on the basement in one of the arcade schemes, with what look like heraldic shields on the building's body (as with what is thought to be a design for the Duchess of Kent's tomb, with its 'Insignia' (see Figs 195, 345)).[50] But these elements were quickly abandoned. On 20 July 1734 Hawksmoor reported to Carlisle that 'S^r Tho^s Robinson did me the honor of Visit to day and talking over y^e Mausoleum, it was offerd, to stick close to y^e Imitation of y^e Antique, whereupon we agreed to

keep the outside as plain as possible: To finish with the cornice, and have no plinth, upon it'.[51] On 1 August Hawksmoor added that 'Sr Thomas Robinson has half a score papers for your Lordship which I hope he has shewn My Lord Burlington. they concern the Mausoleum'. He was evidently resigned by now to Burlington's influence. Shaftesbury's ideal of antique simplicity, outlined in the *Letter concerning the art or science of design* (1712), was becoming increasingly influential in Whig circles, encouraging the Palladianism of his fellow Whigs, Campbell and Burlington.[52] Burlington, whose education had reflected the new Whig ideology as formulated by Shaftesbury, believed that architecture of a style characterized by unembellished pure forms (such as that recommended for the Mausoleum) was one of the most sophisticated means of exercising the function of government.[53] Good taste produced good morals which in turn produced good government, while the pursuit of luxury led to licentiousness in art and behaviour. Baroque art observed

neither the rules nor the proportions of the ancients, and was therefore both morally and decoratively licentious. This shift in Whig taste is reflected at Castle Howard in the contrast in style between Vanbrugh's main house, whose opulence expressed modern notions of 'luxury', and Hawksmoor's Mausoleum, whose simplicity was due in no small part to the influence of Burlington's politically motivated conception of architectural style. Having worked on both House and Mausoleum, Hawksmoor here again varied his style according to the circumstances of time and place. Indeed the Mausoleum itself fused diverse Whig influences. For the ancient ideals of decorum and 'Greek' simplicity, successfully promoted by certain Whigs and the 'Ancients', were here embraced by Hawksmoor in an effort to monumentalize the rational views of nature and religion cultivated by his patron and by the 'Moderns'. In this sense the building perfectly reflects Hawksmoor's position between the 'Ancients' and the 'Moderns'.

'GOOD FANCY': BETWEEN THE 'ANCIENTS' AND THE 'MODERNS'

NICHOLAS HAWKSMOOR DIED IN 1736. If he ever looked back over his seventy-five years he could only have marvelled at the enormous change in attitude to ancient authority which that period had witnessed – not only in architecture but in philosophy, government and the study of nature. He had seen the decline in Platonic and magical beliefs and the rise of the natural sciences with the founding of the Royal Society in 1662; the fall of the absolutist Stuarts and the rise of constitutional monarchy with the Glorious Revolution in 1688; the growth of speculative freemasonry with Anderson's *Constitutions* in 1723; the advent of British military supremacy with Marlborough's victories under Anne; and, most importantly of all as far as he was concerned, the rise and fall of the architectural movement often termed the English Baroque. Following the publication in 1708 of John James's translation of Perrault's *Ordonnance*, Englishmen could read Perrault's famous warning that 'all those that have wrote of Architecture, vary from each other; so that we cannot find, either in the remains of the Buildings of the *Ancients*, or among the great Number of Architects that have treated of the Proportions of the Orders, that any two Buildings, or any two Authors, agree, and have followed the same Rules'.[1] Perrault had set the tone of the architectural side of the debate between the so-called 'Ancients' and 'Moderns' that dominated the literary world of Hawksmoor's day.[2] Understanding the different sides of this debate must have shaped his own early studies. He was, after all, James's colleague at Greenwich Hospital (from 1705) and on the London churches (from 1717), and he owned a copy of James's 'Perrault' (lot 126) and of Evelyn's 'Account of Architects and Architecture' of 1707 (lot 108) where aspects of this famous quarrel are discussed (which, given the dedication to Wren, he would have read). He left no direct record of what he thought of the various protagonists in this debate, but it echoes in many of his statements on ornament, especially his condemnation to the Westminster Dean

of certain 'Modern Italians' where 'too much liberty is taken'.

This is not to say, however, that he was on the side of the 'Ancients'. By drawing on models both ancient and modern – from Greek and Roman to Mannerist and Gothic, and even ones from exotic cultures – Hawksmoor formulated an expressive ornamental language of quotation and allusion suitable, like all languages, to the circumstances of his era. In seeking to give permanent monumental form, in a variety of stylistic guises, to the fundamental beliefs of his time – in Christianity, monarchy, trade, reason, liberty and freemasonry for example – he became fully aware of his contemporaries' ever expanding scientific and geographic horizons. He studied and then sought to apply the philosophical thinking of his age through what he saw as his unsuperstitious, rational approach to the use of ancient sources, in common with the natural science of his friend and mentor, Wren. There is little evidence – apart from his interest in freemasonry – to support the modern fictional portrait of his churches as diabolical and of their architect as some kind of mystic obsessed with sacrifice.[3] Rather, Hawksmoor's particular interest in the architecture and iconography of death reflected a quasi-rational theory advanced by Blondel and Wren concerning the origins of architectural ornament. He saw his apparently idiosyncratic and eclectic forms as perfectly 'reasonable' and in tune with contemporary values, since they arose from 'Good Fancy', or imagination, combined with a rational design 'method' based on historical precedent. But in other matters Hawksmoor was less rational and more old-fashioned. His evident faith, judging from his library and correspondence, in human progress in the natural sciences was not matched by an equal faith in its advancement in matters of government. He lamented the change in status of the monarchy and the decline of its patronage. He maintained a somewhat archaic attitude to the symbolic power of ancient hieroglyphs and esoteric

forms, while occasionally using ornamental demons and grotesques symbolizing the supernatural world – both tendencies reminiscent of the work of Inigo Jones.[4] The morbid side to his personality was surely a factor in his fascination with the architecture of death: in observing to Carlisle that the Capo di Bove was 'durable', he added as an afterthought 'if anything can be sayd to be so in this world'.[5] Such anxiety was perhaps one reason why he sought to give his churches, in particular, a strong sense of permanence through their monolithic towers and oversized keystones.

This dichotomy in Hawksmoor's character, and indeed work, might be seen as a reflection of an age in which speculative freemasons could promote a rational, Deist non-sectarianism at the same time as cultivating the efficacy of ancient mysteries and signs. Using the terms of this age, Hawksmoor appears to have been neither an 'Ancient' nor a 'Modern' in that for the most part he avoided the excesses of Palladian 'correctness' on the one hand and Baroque experiment on the other.[6] Put another way, he followed the classical ancients but in a modern way. The ambiguity in his style was partly a result of the changing tastes of his time. Whereas in his early years the Whigs had identified with Baroque culture, by the end of his life they had taken up with Palladianism. This evolution in taste limited Hawksmoor's productivity, and clearly had most effect on his final design, the Castle Howard Mausoleum, where the Palladian amateur Sir Thomas Robinson acknowledged how 'reasonable' and 'little prejudiced in favour of his own performances' Hawksmoor was.[7] The influence of the Palladian school would have been at its greatest following its publication of the first volume of Campbell's *Vitruvius Britannicus* and the first book of Leoni's *Palladio*, both in 1715 (lots 131 and 123), followed by Kent's *Designs of Inigo Jones* in 1727 (lot 116).[8] These works were the architectural equivalents of those of the 'Ancients' in the famous 'Battle of the Books'.[9]

Nevertheless examples in Hawksmoor's work of major departures from the Palladian canon date after 1715 – such as the eclectic details of St Mary Woolnoth of 1716–24 – and in 1734 he made plain his distaste for the dominance of the new fashion when dismissing 'Palladios humble Villas'. For it has been shown throughout this book that his attitude to ornament – its extent and type – was principally dependent on relative circumstances such as a building's location, the relevant antique precedent and the character of the patron, rather than any absolute preference for Baroque, Palladian or even 'Gothic' styles. In particular, through using a palate of standard and non-standard ornamental forms, Hawksmoor sought to reflect not only the function of a building, from utilitarian to commemorative, but also the character of its site. His aim was to create a fitting mood, and in so doing reflect the Baroque emphasis on sensory experience. For surely only the contrasting characteristics of the various locations of his churches can account for their equally contrasting moods and 'effects'. All were built at about the same time, with the same denomination and patron and sometimes even the same dedicatee: compare for example the triumphalism of St George in Bloomsbury with the sombreness of St George-in-the-East. They were probably each designed, as Hawksmoor put it concerning rustication at Castle Howard, to 'suit our . . . Situation'. Although as a result he often employed an apparently eclectic vocabulary of ornament, representing a conflicting attitude to antiquity, his approach was perfectly consistent with Serlio's strictures on the requirement for the architect to be imaginative when applying the antique rules of ornamental decorum and licence outlined by Vitruvius. In this way his churches were not isolated experiments as some maintain – *sui generis*, unclassifiable with his other works[10] – but the product of a much more consistent approach to the selection and variation of classical ornament and models.

It has been seen that for Hawksmoor 'good', or 'authentic', architecture was guaranteed by the use of appropriate historical models. As someone 'perfectly skill'd in the History of Architecture' (as his reconstructions of Halicarnassus and Baalbek testify), his design method involved the selection of one or more appropriate models (defined as such by their original use, as Hawksmoor made clear to Carlisle). These were then 'moulded' by embellishment or simplification according to a project's particular circumstances. Thus the same model might be transformed in very different ways; this can be seen with the Tower of the Winds (freely adapted as lanterns on the various towers) and the mausoleum at Halicarnassus (Composite in one location and Doric in another). The model might even be transformed beyond recognition (as with the Egyptian hall used at St Mary Woolnoth). For Hawksmoor, quite unlike the Palladian pedants, outward fidelity in replicating forms and details was much less important than inherent principles.[11] As he remarked on sticking close to the ancients in his designs for the Belvedere, 'I dont mean that one need to Coppy them, but to be upon yᵉ Same principalls'.[12] When understood in these terms – against principles such as architectural decorum that Hawksmoor had studied in his Serlio and the other treatises – his work can be seen as remarkably consistent in reflecting what he boasted was his 'architectonricall method'.

'OUR TASTE RECTIFIED AND MADE SENSIBLE': INDIVIDUAL EXPRESSION VERSUS NATIONAL IDENTITY

Hawksmoor's broken pediments and giant keystones clearly resemble, although do not copy, ornamental forms found in the work of the continental Baroque masters – work which rather than functioning as a form of classicism, as is sometimes claimed,[13] was seen by the Palladians in particular as an 'anti-classical' departure from it. This ornamental 'licentiousness' had served as a sign, to Serlio and other so-called Mannerists, of the creativity of modern architects, and came to parallel the wider aspirations of the 'Moderns' towards superiority over the ancient world in the arts and sciences. For the process whereby ancient mythology was rationalized – a process that promoted the tree trunk over the human body as the columnar model – licensed such unprecedented details as paired columns and even Gothic ornament. In England the correspondence between anti-classical architectural experiment and contemporary ideals – especially of liberty and reason – was, initially at least, made all the more potent when contrasted with the earlier, all'antica architecture of Inigo Jones, and its expression of pre-scientific mysticism and royal absolutism. Following the Glorious Revolution of 1688 and the advent of constitutional government, Whig nobility (Carlisle, Marlborough and Devonshire) built highly decorative, heraldic palaces of mixed and even 'abused' architectural forms. But in their quest to consolidate power after 1710, the Whig peers Shaftesbury and Burlington sought to revive the work of Jones and return to antique canons and a plainness in style as an expression of what Shaftesbury in his Letter (1712) called the 'national taste'. Consequently Campbell cast Jones as the hero of Vitruvius Britannicus, or the British Architect (1715), a work that proclaimed this national ambition through its title and dedication to George I. Whig ideals were thus read into Jones's work, ignoring his Stuart patrons' absolutist values which Shaftesbury identified instead with Wren's buildings.[14] In the face of what Campbell describes as the 'excessive Ornaments without Grace' of continental Baroque, antique rules and Palladian buildings appeared to reflect the Protestant virtue of modesty, and even that of human reason whose exercise distinguished men from beasts. According to this rhetoric, the immoral excesses of Baroque Counter-Reformation architecture – especially that by Borromini who, according to Campbell, 'has endeavour'd to debauch Mankind with his odd and chimerical Beauties' – was clearly visible in its 'affected and licentious', and indeed bestial, forms.[15]

These sentiments encouraged what amounted to a dictatorship by Burlington and his circle in matters of architectural taste – all, somewhat ironically, in the name of British 'Liberty'. Burlington's influence is perfectly illustrated by the debates surrounding the design of the Mausoleum. Not surprisingly, resistance arose, with Hogarth on the attack in his Taste, or Burlington Gate of 1731–2 (Fig. 344) and Pope on the defence in his Epistle to the Right Honourable Richard Earl of Burlington of the same date.[16] At stake was the role of the artist's creative imagination, as Vanbrugh observed in 1721 in lamenting 'Poor Hawksmoor, What a Barbarous Age, have his fine, ingenious Parts fallen into',[17] and as did Hawksmoor himself in defending the role of 'Good Fancy'. The Introduction noted his concern, expressed somewhat sarcastically in 1728, that 'so many of our Noblemen and Persons of Distinction are not only Patrons of Building, but also great Professors of that Science, from whom we may expect speedily to be converted to Truth, and have also our Taste rectified and made sensible: This is mentioned with all imaginable Regard to the Connoisseurs and Criticks'.[18] One such, Campbell, in his attack on Borromini and modern Italians for their 'capricious Ornaments, which must at last end in the Gothick',[19] had clearly intended to imply (if not actually spell out) criticism of the freedom of expression enjoyed by Hawksmoor, Wren and Vanbrugh. The Stepney churches, with their pared down, licentious ornament, and Blenheim, with its imagery recalling Versailles, thus came to be seen as reflecting an unruly foreign style all too easily associated with the Counter-Reformation and with royal absolutism.[20]

In the climate of growing Palladian puritanism, Hawksmoor was evidently keen to avoid the accusation of architectural, and therefore moral, capriciousness. Indeed his deep-seated morality runs from his rejection of the wickedness of London's 'Scoundrell Streets' (as if resembling a modern Babylon or Corinth), through his love of the 'Police Architectonical' and historical 'authenticity', to its expression in the 'most Solemn and Awfull Appearance' of his Stepney churches. His comments to the Dean of Westminster in 1734–5 disapproving of Dietterlin's 'Masquarade' or 'Burlesque Style of Building' speak of his belief in the moral appropriateness of ornamental forms. His disapproval in this letter of the ornamental superfluity of 'the Modern Italians . . . especially Boromini and others' where 'too much liberty is taken' even echoes Campbell's criticisms. Such strictures would obviously have accorded with the values of the more Puritan of his Protestant clerical patrons, especially at Westminster Abbey. This is

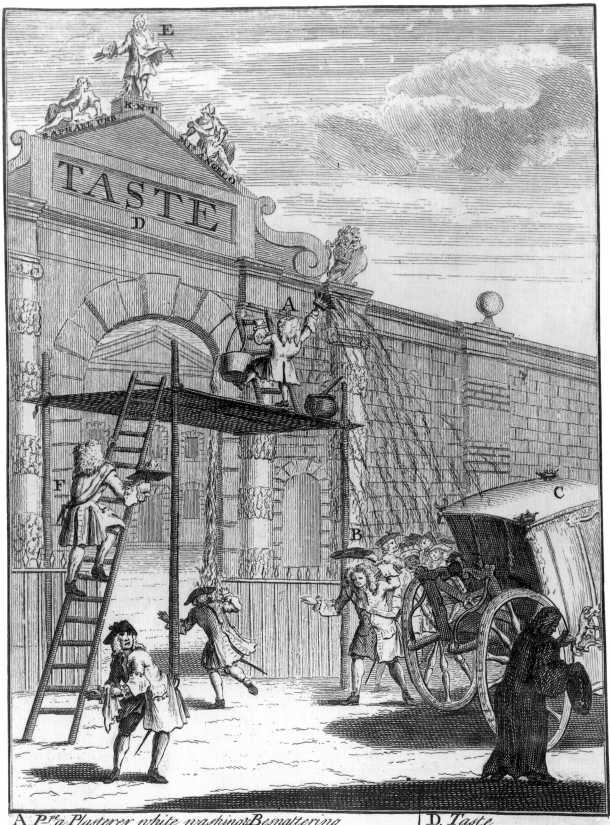

A. Pr.ᵃ Plasterer white washing & Bespattering
B. any Body that comes in his way
C. not a Dukes coach as appears by ye Crescent at one Corner

D. Taste
E. a standing Proof
F. a Labourer.

Price 6ᵈ

344 William Hogarth's *Taste, or Burlington Gate* (1731–2), engraving, 21.5 × 16 cm [British Museum, London].

equally true at the new churches which, through their funereal iconography and combination of canonic and pared down Serlian ornament, appear to warn that the day of judgement is close at hand. Nevertheless, consistent with the antique principles of decorum and magnificence which stressed the need for appropriate displays of wealth, clearly he did not consider shows of ornamental superfluity at Castle Howard and at Blenheim an excess of opulence. Hawksmoor himself highlights this need when criticizing Palladio's country houses for their humility.

Wren was earlier quoted observing that architecture 'has its political Use', for 'it establishes a Nation', 'makes the People love their native Country, which Passion is the Original of all great Actions in a Common-wealth'. These aspirations informed Hawksmoor's solo buildings as much as they animated the work on which he served as Wren's assistant. He was deeply patriotic and pleaded to be able to express, at a fitting scale, Britain's central status in an expanding world. But his use of a range of ornamental vocabularies, including Gothic, and his emphasis on 'Good Fancy' testifies to his complete uninterest in fixing a particular national style, or at least one based on Palladian 'correctness'. For it was in the masonry of the medieval cathedrals of England that Hawksmoor – ever the patriot – traced the expression of a true national style, in which native craftsmen and their clerical patrons had exploited, through constructional developments, the mason's art to the full. It was to honour this past, at both Westminster Abbey and All Souls, that he chose to build in a contextual 'Gothic'. His study of Gothic gave him a predilection for blocks of masonry that, as quoins and keystones, became one of his most consistent details irrespective of a building's style. It is therefore natural enough that it was Hawksmoor's Gothic work, rather than his experiments with foreign styles *all'antica*, which inspired Batty Langley's masonic search for a national style, since for Langley at least 'this kingdom is greatly obliged' to Hawksmoor for his 'strong and magnificent piles'.[21] Thus, somewhat ironically, through Langley's publications Hawksmoor helped pave the way for the stylistic pedantry of the Gothic revival and for the sublime's interest in *terribilità*.

Hawksmoor aimed to build a timeless British architecture based not on any particular style but on the enduring value of historical models, which were adapted to contemporary needs by a combination of human reason ('Strong Reason'), imagination ('Good Fancy') and empirical testing ('experience and tryalls'). Following his reading of Vitruvius, this was what he imagined to have been the rational design method of ancient architects, that is, 'according to the practise of yᵉ ancients'.[22] He reminded Carlisle in 1724, again somewhat moralistically, that, 'if we contrive or invent otherwise, we doe but dress things in Masquerade which only pleases the Idle part of mankind, for a Short Time'. He consequently remained uninfluenced by what he dismissed in October 1732, in the face of direct criticism from Burlington, as 'the Opinion of the Professours of Arts' and 'the many Caprices of the World'. Wren too had earlier sought to look beyond what he termed 'Modes and Fashions' when urging the architect to 'think his Judges, as well those that are to live five Centuries after him, as those of his own Time'.[23] Hawksmoor cannot have failed to receive this instruction from his master, and to have attempted to reflect it through his work. With their very own Solomonic courtyards and chapels, Trajanic columns and arches, his buildings aspired to reflect the qualities of magnificence and order found in the legendary buildings of antiquity, and as such to stand among the greatest architectural wonders the modern world had ever seen.

★ ★ ★

The appeal of a Hawksmoor building is obviously enhanced by appreciating its original design models and the rules employed to determine which type of ornament was to be used where. In referring to his 'reasons and intentions', Hawksmoor himself seems to invite posterity to examine the meaning behind his esoteric forms. But following theories of visual perception advanced most notably by Descartes – whose works Hawksmoor collected – his sketches make clear that his buildings were also designed to be appreciated as sensory experiences. This ambition was achieved through contrasting 'effects' of light and shade, and of mass and void, as well as the use of uplifting and melancholic details. Consequently his buildings can never be fully 'explained' using strictures recorded mainly in private correspondence not intended for publication. These rules were used by Hawksmoor to give his work authority and meaning in an increasingly rationalistic world, but, as he was himself fond of pointing out to his Palladian critics, rules on their own do not produce what he called 'good Architecture'.[24] Through drawing on his 'Good Fancy', Hawksmoor gave a unique signature to his work, daring to build ornamental keystones and lofty mausoleums that defied structural logic and functional purpose. What resulted is a set of haunting buildings which still connect, as powerfully as any Picasso, with our innermost hopes and fears.

A SPECULATIVE RECONSTRUCTION OF HAWKSMOOR'S PRELIMINARY MAUSOLEUM DESIGN OF 1728

HAWKSMOOR PRODUCED A SERIES OF DESIGNS for the Mausoleum at Castle Howard that led to the final, built version. In the absence of surviving preliminary sketches, this process can be traced through his letters to Carlisle, a bill for work submitted by his wife, and surviving drawings of the penultimate, arcade designs (Figs 345, 346).[1] The original conception was for a separate chapel as well as a mausoleum. In his first letter concerning the Mausoleum, on 3 September 1726, Hawksmoor advised that

> Besides the Monument, on the Top of the Mount, I wou'd build at ye foot or ascent of ye sayd hill a Small Chapell with Six Small Rooms, under it, for ye Accomodation of 6 old women (or 6 old men) if you please, to Live in, and A small yearly support, by way of an alms house, and these aged persons should be ye Curators, of ye Monument, to clean, sweep and Lock it up, and shew it to Strangers with many traditions, and accounts concerning it. The Chappell also (but no churchyard or Sepulture) would be for ye use of ye persons that have a claim to a church or chapell at Castle Howard.

This chapel plan was quickly abandoned, however, possibly falling victim to Carlisle's nonconformist attitude to organized religion.

In this letter Hawksmoor promised that the tombs of Porsenna and Halicarnassus 'may be imitated, in Little, as well as at a great Expence, and I will draw up a Scheme for your Lordship accordingly'. Some time before 6 July 1727 Hawksmoor was paid for 'Drawing a Temple or Mosoleum', on 14 July for 'Drawing a New Rotunda to be a Chappel & Sepulcher' and on 20 October for 'Several Drawings of the Church or Mosoleum' and for 'A Mosoleum like the Tomb of King Porsenna'.[2] The drawings are lost, but the appearance of these schemes can be imagined from their design models. Although the rotunda form was eventually adopted, these designs were evidently not acceptable, for three further ones followed: in a letter to Carlisle on 10 November 1727 Hawksmoor mentions 'a Box of sundry Drawings for ye Mausoleum. There are 3 severall designs . . . you will see my Remarks upon each paper'. These sketches were without a scale, for he adds that 'I do not direct your Lordship, what bigness ye fabrick shall be of, or what expence you will be at . . . I only humbly offer you ye fform and Figure of

ye intended structure'. Consequently some time in 1728 Hawksmoor was paid for 'several new designs for a Church or Mosoleum' and for 'Drawings for the Mosoleum & sending them down with larger Explanations annexed'.

One of these designs must have met with a degree of approval, for in a further letter, dated 3 June 1728, Hawksmoor referred to sending a 'Drawing of the Mausoleum' as soon as he (and Carlisle's son, Lord Morpeth) 'can adjust it' (presumably in reference to one of the three previous designs). Once again, this illustrates his 'architectonricall method' in action. The drawings of this 'improved' scheme are also lost. However in his next letter to Carlisle, of 11 July, Hawksmoor gives sufficient detail to reconstruct, albeit tentatively, the design at this stage. He notes that he is sending 'the designe your Lordship, Ld Morpeth, and I last talked of, when you were in London', and although 'but a Scetch' he is careful to distinguish this scheme from his previous 'Sundry Drafts'. He is enthusiastic about the design for he has also been 'drawing it at Large but I will not finish it, till your Lordship sends me your approbation'. He makes clear his new model, for the design is 'upon' the Roman tomb known as the Capo di Bove (Cecili Metella) – as illustrated in Pietro Santi Bartoli's *Gli antichi sepolchri, overo mausolei romani et etruschi* (1697) (see Fig. 339).[3] Although he does not record that this is his source, he quotes from Bartoli's text concerning the tomb's subsequent use as a fortress. Hawksmoor notes that

> ye Square Basement, in which was ye Sepulcral chamber was on each side (if we are rightly informed) 100 fot English and the round part or Tamburo. 90 foot. the whole hight [i.e., of this drum judging from Bartoli] was, 100 foot. I have followed the proportion as near as possible, and I have proposed to make the Square of your Lordships 56 foot on each side, and 32$^f\frac{1}{2}$ high. The round part, or Tambour, is 46 foot diameter and about 48 foot hight. And the whole hight (exclusive of the pineaple on ye Top) is 80 foot, a sufficient hight, and extent for this fabrick.

Hawksmoor goes on to add some further details. Firstly, 'the ascent [to the drum] is on the out side', that is, 'outside' the base if the use of a dogleg stair is assumed – one on each side to preserve symmetry. For if, as in Hawksmoor's final plan, the steps are contained within the base, the width of

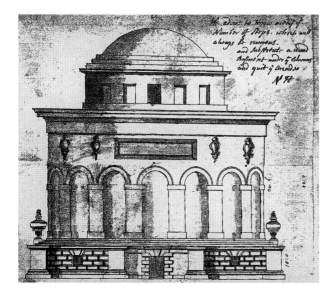

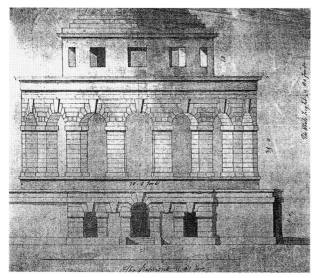

345 and 346 Hawksmoor's penultimate designs for the Mausoleum, drawn with an arcade, c. 1729 [The Castle Howard Collection, Yorkshire].

each flight would be only 2½ feet (the existing external stairs were added after his death).[4] Even though his final scheme would thus have given a strong impression of inaccessibility, initially at least the Mausoleum would have signalled its accessibility through these stairs, given that it was to be visited by 'Strangers' (guided by the elderly custodians). Secondly, in place of the battlements on the Capo di Bove (which he is careful to say are 'Modern'), 'I have placed a Ballustrade'. This difference between the design and its model followed from the fact that the battlements were a later addition arising from the medieval role of the Capo di Bove as a fortress, not its antique one as a tomb. Here again, this adjustment is consistent with Hawksmoor's 'architectonricall method' of selecting and adapting appropriate models. And thirdly, 'I have placed the windows, so, as to enlighten the Chapell, but

not to be seen without door as my Lord Morpeth desired'. To these details might be added the need for an external door into the drum, and a dome as the most logical roof form. The latter is implied by the pineapple finial – which must not only have been visible in itself but, given its purpose, have marked the 'centre' of a visible form – and by the dome of the antique tomb and of the eventual building.[5]

It might be assumed that the '80 foot' specified as the 'whole hight' refers to the drum *plus* its covering (dome or otherwise), following the previous specifications of the antique building. This is because it cannot be in reference to the combined height of the basement ('mausoleum') and drum ('chapel'), which according to the earlier measurements is half a foot greater than this 80 foot dimension. Moreover the measurement must be to the very top since it is to the underside of the crowning pineapple. A zone above the drum of 32 feet results, filled by the dome and its base (with the concealed windows most logically placed behind the balustrade and carried on internal columns or thick walls with niches) (Fig. 347a).[6] This speculative design in its upper form resembles Hawksmoor's drawing for a baptistery at St Paul's (Fig. 348). The external stairs might have taken the form of those illustrated by Serlio for a model temple (Book IV, fols 179r–v, the domed section of which, complete with its pineapple, would easily fit Hawksmoor's description; Figs 349a,b). Alternatively, the 80 foot measurement may have referred to the entire height (ignoring the '½' foot error; Fig. 347b).

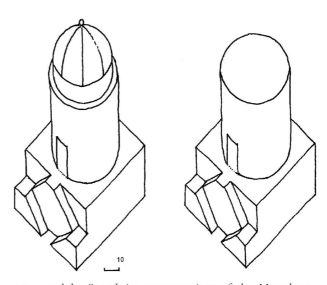

347 a and b Speculative reconstructions of the Mausoleum [author].

Comparing these two possible schemes, the second is very unlikely given that the roof (dome?) and its pineapple ornament would no longer be visible, and the concealed windows become almost impossible to detail. Hawksmoor's drums are invariably domed – of which the built design is the most spectacular example – and the 80 foot measurement is clearly to a centre (the pineapple), not an edge (the drum),

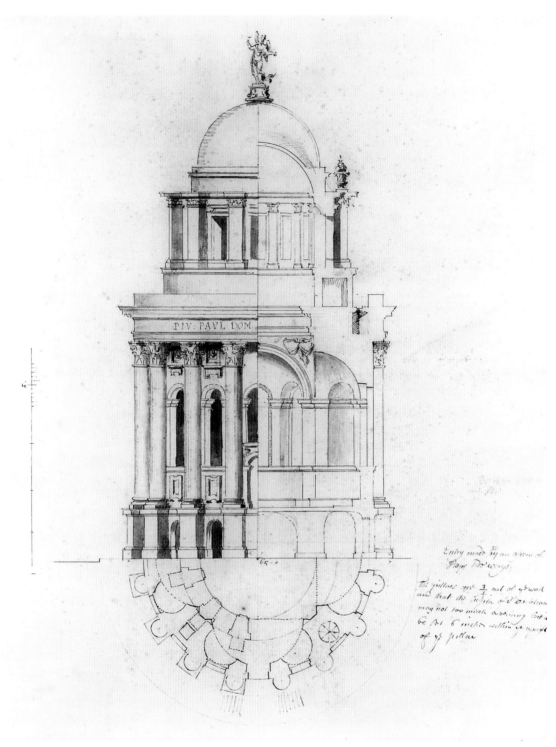

348 Hawksmoor's drawing for a baptistery at St Paul's, c. 1710 [Guildhall Library, London].

implying a dome. Furthermore the overall height of the base-
ment plus the drum can be easily worked out from their indi-
vidual measurements without the need for this additional one
(which in any case is out by the '½' foot). Thus this additional
measurement must logically refer to the drum including its
covering to the underside of the pineapple. Both possible

tower-like designs are clearly very different in silhouette from
the final Mausoleum, although the drum of the building
would resemble the first solution (see Fig. 347a) if the colon-
nade, added in preference to an arcade in the next design
stage, were removed. Drawings survive for these two schemes,
which are both of the same date since arcade and colonnade

solutions. And the final Mausoleum design would have been further justified by resembling – in form if not in Order – Bartoli's conjectural reconstruction of another tomb on the Via Appia, known as the Tomb of Gallienus, as published not long before in Domenico de Rossi's *Romanæ magnitudinis monumenta* of 1699 (see Fig. 341).[7] The next extant letter from Hawksmoor to Carlisle concerning the Mausoleum is dated 29 March 1729, eight months later, by which time reference is made to the colonnade (in preference to the arcade). By

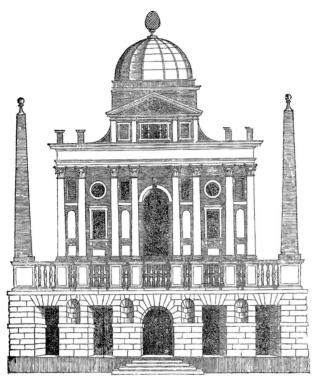

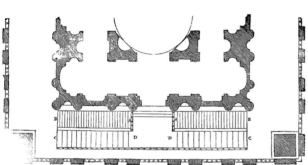

349 a and b Model temple, from Sebastiano Serlio's Fourth Book (*Regole Generali di Architettura*, 1537), fols 179r–v.

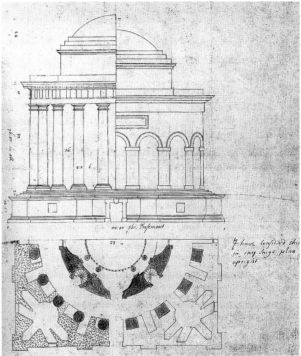

350 Hawksmoor's drawing for the Mausoleum comparing arcade with colonnade, c. 1729 [The Castle Howard Collection, Yorkshire].

are compared in one drawing (Fig. 350). The taller, colonnade scheme clearly resembles the built design. The colonnade added order (and Doric dignity) to the design while retaining the original tower form, virtues absent from the arcade

now the design must almost have been finalized, because some time in 1729 Hawksmoor was paid £7 7s, 'ffor 8 large drawings finish'd of the Mosoleum being Plans, Uprights & sections'.[8]

'I HOPE THE POET M^R POPE
WILL NOT SET HIS SATIR UPON US FOR IT':
BLENHEIM AND THE POETS

VANBRUGH'S AND HAWKSMOOR'S BLENHEIM was not universally well received by their contemporaries, especially by Tories. Upon completion the house was subject to ridicule, on the grounds of Whig extravagance, from the leading Tory satirist of the day, Jonathan Swift. Swift's attacks indicate the politically potent nature of country-house building, particularly the huge architectural statements represented by both Blenheim and Castle Howard.[1] Where the manipulation of architectural scale by Hawksmoor and Vanbrugh was intended to convey magnificence and virtue on behalf of the patron (whether Lord Carlisle or the newly ennobled Duke of Marlborough), in Swift's work such manipulations are made to look ridiculous. This is especially so in his popular masterpiece, *Travels into several remote nations of the world* (1726), or *Gulliver's Travels* as it became known. Concerning Gulliver, the king of Brobdingnag observes 'how contemptable a thing was human grandeur, which could be mimicked by such diminutive insects as I: And yet, said he, I dare engage, these creatures have their titles and distinctions of honour; they contrive little nests and burrows, that they call houses and cities' (II, iii). Swift here draws on the ancient decorum-based notion that a building's scale and expenditure should be appropriate to its practical and symbolic purpose – as indeed Vanbrugh had done in designing Blenheim, except that for the Tory satirist this ambition had got out of hand. Indeed at Blenheim not only its scale but its ornamental opulence invited rebuke.

Contemporaries such as one Signor Carolini, a 'noble Venetian now residing in London' who attempted to decipher *Gulliver's Travels*, identified Vanbrugh's architecture as forming part of Swift's satirical purpose. For in Book III he deciphers 'A New method (perfectly Vanbrughian) for building Houses, by beginning at the Roof, and working downwards to the foundations'.[2] As an integral part of Swift's satire, the book's domestic architecture would have been easily identifiable with actual buildings constructed by contemporaries, especially so since these buildings – notably Blenheim and Vanbrugh's own small house in Whitehall – had been a frequent target of Swift's poetic satire.[3] Book I of the *Travels* features a 'big' house given to Gulliver by the state of Lilliput (Fig. 351). The landscape around this house is seen in terms of an English garden, for according to Gulliver, 'The country round appeared like a continued garden, and the

enclosed fields, which were generally forty foot square, resembled so many beds of flowers' (I, ii). It is often claimed that aspects of Lilliput were meant to satirize England, and, with this in mind, clear parallels can be seen between the circumstances surrounding Gulliver and the Duke of Marlborough. This suggests that Gulliver's large state-run household was read by contemporaries as referring to the primary large state-funded, private household of the time, Blenheim Palace and its associated village, finally completed just two years before publication of the *Travels*. Consider the parallels: in the passage below Swift outlines Gulliver's circumstances (in Book I), which is followed by his comments on those of the Duke at Blenheim (published in the *Examiner* between 16 and 23 November, 1710):

> This great prince . . . created me a Nardac upon the spot, which is the highest title of honour among them. His Majesty desired I would take some other opportunity of bringing all the rest of his enemy's ships into his ports . . . An establishment was also made of six hundred persons to be my domestics, who had board-wages allowed for their maintenance, and tents built for them very conveniently on each side of my door . . . I had three hundred cooks to dress my victuals, in little convenient huts built about my house, where they and their families lived, and prepared me two dishes apiece . . . an hundred [waiters] attended below on the ground, some with dishes of meat, and some with barrels of wine, and other liquors, slung on their shoulders . . . [The treasurer] represented to the Emperor the low condition of his Treasury; that he was forced to take up money at great discount; that Exchequer bills would not circulate under nine per cent below par; that I had cost his Majesty above a million and a half of 'Sprugs' . . . [thus] his Majesty's revenue was reduced by the charge of maintaining [me], which would soon grow insupportable. (I, vi)

> Let us . . . examine how the services of our General have been rewarded; and whether upon that Article, either prince or people have been guilty of ingratitude? . . . I shall . . . say nothing of the Title of Duke, or the Garter, which the Queen bestow'd the General in the beginning of her Reign . . . The lands of Woodstock, may, I believe, be reckoned worth 4,000L. On the building of Blenheim Castle,

351 Illustration of the house for a 'big' man from *Gulliver's Travels* (1727 ed.).

tions were necessary in those who are to be created new lords' (II, vi). Marlborough came to represent the archetypal new aristocrat with, through the Duchess in particular, Whig sympathies. In a description in Book IV of the warfare of England, Gulliver again seems to allude to Marlborough, for 'to set forth the valour of my own dear countrymen, I assured him, that I had seen them blow up a hundred enemies at once in a siege' (IV, v). In the battle of 1704 outside Blenheim in Bavaria, nearly 30,000 of the French and Bavarians were killed or wounded. Never was a victory more eagerly welcomed than this, and never was a conquering leader more rewarded than Marlborough. Named after the battle, Blenheim Palace became the primary architectural symbol of Britannic victory at war which Swift mocks throughout *Gulliver's Travels*, and Gulliver's house and household in Book I is part of this. Both Gulliver and Marlborough are 'giants' in their capacity to breach city walls, and both are rewarded by titles of 'Nardac' (or 'Duke') as a consequence of military action on behalf of the state. Both men subsequently fall out of favour with the court, are accused of treason and flee abroad, for neither country seemed to know quite what to do with such 'extra-ordinary' citizens. In 1692 Marlborough had been thrown into the Tower of London accused of treason and, after Anne stopped all Treasury money for Blenheim in 1712, spent time in 'exile' on the continent. Gulliver's big house and Marlborough's Blenheim were the largest 'domestic' buildings in their respective countries, both symbols of the modern state extravagance and oversized inappropriateness which Book I set out to ridicule.

To Tories such as Swift, Blenheim's extravagant household appeared to contrast with the classical, decorum-based harmony that they imagined had existed in antiquity between house and estate. Alexander Pope emphasized in his *Epistle to the Right Honourable Richard Earl of Burlington* (1731) – which Hawksmoor quoted from in his book on Westminster Bridge – that an 'appropriate' architecture was not dependent on extremes of size, and that gestures of pride looked all the more foolish when mimicked by small things like the 'Individual', or large things like the 'State'.[5] As such they were an offence to common sense, or 'Taste':

> At Timon's Villa let us pass a day,
> Where all cry out, 'What sums are thrown away!'
> So proud, so grand, of that stupendous air,
> Soft and Agreeable come never there.
> Greatness, with Timon, dwell in such a draught,
> As brings all Brobdingnag before your thought.
> To compass this, his building is a Town,
> His pond an Ocean, his parterre a Down,
> Who but must laugh, the Master when he sees,
> A puny insect, shiv'ring at a breeze!
> Lo, what huge heaps of littleness around!
> The whole, a labour'd Quarry above ground.[6]

Pope makes clear in his opening 'argument' that his poem was concerned with what he calls the 'false Taste of Magnificence'. Elsewhere he attacked Blenheim as inhospitable, since 'There are but just two Apartments, for the Master and Mistress, below; and but two apartments above, (very much

200,000L have been already expended, tho' it be not yet near finish'd . . . Here is a good deal above half a million of money, and I dare say, those who are loudest with the clamour of ingratitude, will readily own, that all this is but a trifle in comparison with what is untold.

Swift makes the Lilliputian State look ridiculous through risking bankruptcy in maintaining a citizen for 'glory' in some future war, echoing his earlier attacks on the rewards of the Duke. Indeed the country vanquished by Gulliver, 'Belesfuscu', is often seen as France.[4]

The *Travels* contains many descriptions of bloody battles and warfare obviously intended to remind the reader of the Duke's recent bloody victories against France and his subsequent rewards. In Brobdingnag, for example, the King: 'wondered to hear me talk of such chargeable and extensive wars; that, certainly we must be a quarrelsome people, or live among very bad neighbours, and that our generals must needs be richer than our kings . . . [and wondered] what qualifica-

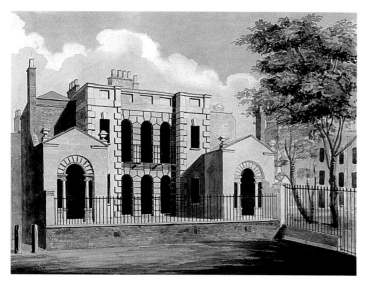

352 Watercolour drawing from the Soane office of Vanbrugh's 'Goose-pie' house in Whitehall, 1700 (demolished) [Sir John Soane's Museum, London].

inferior to them) in the whole House. When you look upon the Outside, you'd think it large enough for a Prince; when you see the Inside, it is too little for a subject; and has not conveniency to lodge a common family'.[7]

Hawksmoor was well aware of the damage to be done by such satires on his and Vanbrugh's work, commenting to Carlisle in 1731 concerning the Mausoleum that he hoped 'the poet Mʳ Pope will not set his satir upon us for it'.[8] Swift's direct attack on the cost of the house, and household, of Blenheim in the Tory *Examiner* had been widely circulated, and was repeated in such works as *A fable on the widow and her Cat* (Queen Anne and the Duke) and *A Satire on the D of M* (1712). In *The History of Vanbrug's House* (1710) — in reference to the diminutive house built by Vanbrugh (as Comptroller of the Works) in Whitehall and nicknamed 'goose-pie' (Fig. 352) — Swift observed

> From such deep rudiments as these
> Van is become by due degrees
> For building famed, and justly reckoned
> At court, Vitruvius the second.
> No wonder, since wise authors show,
> That best foundations must be low.

And now the Duke has wisely taken him,
To be his architect at Blenheim.

> But raillery for once apart,
> If this rule holds in every art,
> Or if his Grace were no more skilled in
> The art of battering walls than building;
> We might expect to see next year
> A mousetrap-man chief engineer.

Indeed it was also to be the fate of Gulliver, the giant of Book I, to be transformed into the 'mouse' of Book II with a suitably scaled house closely resembling Vanbrugh's own 'goose-pie' house — which Swift described elsewhere as 'pretty for a child'.[9]

Hawksmoor's evident faith in human progress — in the natural sciences if not in government — would have set him at odds with Swift and his praise of the 'Ancients'. Modern houses, especially the two produced by the Hawksmoor–Vanbrugh collaboration, became emblematic of individual power rather than the natural order Swift and other Tories identified with antiquity. The scale of both houses stood in opposition to the old established, balanced Tory houses which are symbolized in *Gulliver's Travels* by the ancient estate of Lord Munodi, the doomed paradise encountered in Book III. Indeed, the modern notion of individual power was expressed at Blenheim and Castle Howard not only through ornamental opulence and scale but also through abstract, geometric gardens of the type found at Versailles. Swift ridiculed this form of planning in his famous 'Battle of the Books' within *A Tale of a Tub* (1704), in which a spider's web forms a modern palace and the spider is skilled 'in architecture and other mathematics'. A more charitable view of Blenheim is to be found in Daniel Defoe's *Tour* of 1725, which describes the house as 'a national building, and must for ever be call'd so. Nay, the dimensions of it will perhaps call upon us hereafter, to own it as such in order to vindicate the discretion of the builder, for making a palace too big for any British subject to fill, if he lives at his own expence'. The house was quite simply out of sorts with its intended use, and the status of its user. Accordingly, Defoe predicts that at 'some time or other Blenheim may and will return to be as the old Woodstock once was, the palace of a king'.[10] In so doing he reflects, alongside Swift and Pope, a more modest interpretation of the degree of opulence deemed appropriate to private individuals by the ancient principles of decorum and magnificence.

Notes

PREFACE AND INTRODUCTION

1 For a rare citation of Hawksmoor in the 18th century see Milizia, F., *The Lives of the Celebrated Architects, Ancient and Modern* (1768), E. Cresy (trans.) (1826), vol. 2, p. 288. On past attitudes to Hawksmoor's work see Cast, D., 'Seeing Vanbrugh and Hawksmoor', *J.S.A.H.*, vol. 43 (December 1984), pp. 310–27.

2 *Proceedings of the Architectural College of the Freemasons of the Church* (1847), pt. 2, p. 60.

3 Downes, K., *Hawksmoor* (1959), Preface, p. xv.

4 See e.g. Tinniswood, A., *His Invention So Fertile: A Life of Christopher Wren* (2001), pp. 328–9.

5 The letters (known of in 1959) are catalogued in Downes (1959), Appendix A, pp. 234–61, and references throughout are to this catalogue.

6 The drawings (known of in 1959) are catalogued in Downes (1959), Appendix F, pp. 274–84, and references throughout are to this catalogue; the Oxford drawings are catalogued in White, R., *Nicholas Hawksmoor and the Replanning of Oxford* (1997); a group of drawings for the completion of Westminster Abbey was discovered in 1993 and acquired for the Abbey Library, and Gordon Higgot is preparing a catalogue of drawings in the Soane Museum recently attributed to Hawksmoor (rather than Wren, as was previously thought); for the record of Hawksmoor's site duties for Wren see Bolton, A. T., and H. P. Hendry (eds), *Wren Society Volumes*, 20 vols (1924–43), and letters to Henry Joynes, 1705–13, British Library, Additional MS 19,607; for his library see Watkin, D. (ed.), *Sale Catalogue of Libraries of Eminent Persons* (1975), vol. 4 [Architects], pp. 45–105. On this see Downes, K., 'Hawksmoor's Sale Catalogue', *The Burlington Magazine*, vol. 95 (1953), pp. 332–5. Subsequent lot numbers refer to this catalogue.

7 Obituary transcribed in Downes (1959), p. 8. Michael Wright's *An Account of His Excellence Roger Earl of Castlemaine's Embassy, from His Sacred Majesty James II . . . to His Holiness Innocent XI* (1688), held in Queen's University at Kingston, Ontario. Perrault's *Les dix livres d'architecture de Vitruve* (1684 ed.), held in the Canadian Center for Architecture, Montreal. David Loggan's *Cantabrigia Illustrata* (1688), held at the British Art Center at Yale University.

8 Obituary transcribed in Downes (1959), p. 8.

9 Transcribed in Webb, G. (ed.), 'The Letters and Drawings of Nicholas Hawksmoor Relating to the Building of the Mausoleum at Castle Howard, 1726–1742', *Walpole Society*, vol. 19 (1930–31), p. 140.

10 Marlborough, Sarah, Duchess of, *Private Correspondence* (1838), vol. 1, pp. 263–7 (see Downes, K., *Sir John Vanbrugh*, 1987, p. 354).

11 Transcribed in Downes (1959), Appendix E, p. 272.

12 Quoted in Webb (1930–31), p. 149.

13 Webb (1930–31).

14 On William Benson see Colvin, H., *The History of the King's Works, 1660–1782*, vol. 5 (1976), ch. 5, pp. 57–65. Downes (1987), pp. 387–93 (Benson), pp. 393–5 (Hewett).

15 British Library, Additional MS 61353, no. 240.

16 Webb (1930–31), 28 March 1726.

17 Downes (1959), p. 246, no. 77; see pp. 245–8, nos 77, 80, 82, 83.

18 See Colvin (1976), p. 240.

19 Downes (1959), p. 245, no. 77.

20 Colvin (1976), pp. 52–3.

21 Downes (1959), pp. 246–7, no. 77.

22 Ibid.

23 See Colvin (1976), p. 417.

24 Defoe, D., *A Tour Through the Whole Island of Great Britain* (1725), pp. 361–2.

25 Downes (1959), p. 249, no. 85. In a letter to Carlisle on 4 October 1731 concerning Lord Kingston's stables at Thoresby Hawksmoor wrote that 'I beg Leave to speake of ye Stables at Thorsby the only piece of Building that Sr Thomas Hewett was Guilty of, dureing his being Architect Royall. I knew he was not capable of doing any good, but I never thought he could do so much Mischief for they are ye most infamous that ever was made. We are most of us made of Clay; but that sad wretch was made of *Kennell Dirt* as my Ld Pembroke use to say of sad fellows'.

26 Downes (1959), p. 247, no. 82.

27 Ibid., p. 248, no. 83.

28 Ibid., p. 249, no. 85.

29 Ibid.

30 Webb (1930–31), 3 October 1732.

31 Ibid., 23 October 1733.

32 Vanbrugh writing to Brigadier-General William Watkins in 1721, 'Letters', transcribed in Dobrée, B., and G. Webb (eds), *The Complete Works of Sir John Vanbrugh*, vol. 4 (1928), pp. 137–8. Quoted in Downes, K., *Vanbrugh* (1977), p. 91.

33 Hawksmoor, N., *Remarks on the founding and carrying on*

the buildings of the Royal Hospital at Greenwich (1728), p. 8.

34 See Colvin (1976), p. 128.

35 Webb (1930–31), 17 August 1734. On Ripley's benign attitude to Hawksmoor at Greenwich, see Bold, J., *Greenwich: An Architectural History of the Royal Hospital for Seamen and the Queen's House* (2000), p. 157.

36 Blunt, A., A. Laing, C. Tadgell and K. Downes (eds), *Baroque & Rococo Architecture & Decoration* (1978), p. 156.

37 Colvin, H., 'Hawksmoor', *Biographical Dictionary of British Architects 1600–1840* (1995), p. 474.

38 Downes, K., 'Hawksmoor', in Turner, J. (ed.), *The Dictionary of Art*, vol. 14 (1996), pp. 252–8. See also Downes, K., *English Baroque Architecture* (1966). Timothy Rub commented that 'Hawksmoor's method of design – his handling of detail, and preference for movement, dramatic contrast, and monumental scale – is unquestionably Baroque', adding that the Stepney churches are examples of the 'eclectic' spirit of early 18th-century English architecture, in 'A Most Solemn and Awfull Appearance: Nicholas Hawksmoor's East London Churches', *Marsyas: Studies in the History of Art*, vol. 21 (1981–2), p. 25.

39 Downes (1959), p. 197.

40 Downes (1966), p. 105.

41 Downes, K., 'Hawksmoor', *Macmillan Encyclopedia of Architects* (1982), pp. 341, 343. More recently he judged that the two churches are an 'unhappy compromise between parsimony and fantasy', in Downes (1996), p. 257. He judges that 'Hawksmoor was not afraid to make on occasions quite lamentable designs', in Downes, K., 'Vanbrugh over Fifty Years', in Ridgway, C., and R. Williams (eds), *Sir John Vanbrugh and Landscape Architecture in Baroque England 1690–1730* (2000), p. 3.

42 Colvin, H., quoted in Davies, J. H. V., 'Nicholas Hawksmoor', *R.I.B.A. Journal*, vol. 69, no. 10 (October 1962), p. 375.

43 Downes (1959), pp. 150–1.

44 See also Worsley, G., 'Nicholas Hawksmoor: A Pioneer Neo-Palladian?', *Architectural History*, vol. 33 (1990), pp. 60–70. Worsley, G., '"After ye Antique": Vanbrugh, Hawksmoor and Kent', in Ridgway and Williams (2000), pp. 131–53.

45 Worsley, G., *Classical Architecture in Britain: The Heroic Age* (1995), pp. 61–3. See also Worsley, G., 'Designs on Antiquity, Hawksmoor's London Churches', *Country Life*, vol. 194, no. 42 (18 October 1990), pp. 172–3.

46 Colvin (1995), p. 475.

47 Worsley (1990) talks of a consistent 'style' for Hawksmoor, e.g. p. 61.

48 As stated by Downes (1966), p. 89.

49 See e.g. Cruickshank, D., 'Hawksmoor's First Building? The Portico of All Saints Church, Northampton', *The British Art Journal*, vol. 1, no. 1, (1999), pp. 20–22.

50 See Hart, V., *Art and Magic in the Court of the Stuarts* (1994).

51 See Brooks-Davies, D., *The Mercurian Monarch: Magical Politics from Spencer to Pope* (1983), pp. 180–94.

52 Transcribed in Downes (1959), p. 8.

53 On the role of archetypes in design see Hart, V., 'Carl Jung's Alchemical Tower at Bollingen', *Res*, vol. 25 (1994), pp. 36–50.

54 On Greenwich see e.g. Bold (2000), pp. 18–19, 136. On the Wren City churches, see Geraghty, A., 'Nicholas Hawksmoor and the Wren City Church Steeples', *The Georgian Group Journal*, vol. 10 (2000), p. 2. Generally, see Downes (1959).

55 Webb (1930–31), 10 November 1727.

CHAPTER 1

1 See Webb, G. (ed.), 'The Letters and Drawings of Nicholas Hawksmoor Relating to the Building of the Mausoleum at Castle Howard, 1726–1742', *Walpole Society*, vol. 19 (1930–31), 3 September 1726 and 1735.

2 On the role of Nicholas of Cusa's re-evaluation of the human body in stimulating the Renaissance, see Hart, V., '"Paper Palaces" from Alberti to Scamozzi', in Hart, V., and P. Hicks (eds), *Paper Palaces: The Rise of the Renaissance Architectural Treatise* (1998), p. 6.

3 See Webster, C., *From Paracelsus to Newton: Magic and the Making of Modern Science* (1982). Lindberg, D. C., and R. S. Westman (eds), *Reappraisals of the Scientific Revolution* (1990). Hart, V., *Art and Magic in the Court of the Stuarts* (1994).

4 Hawksmoor had an interest in the science of anatomy. Among his prints are listed 'Eighteen Anatomy Figures' (lot 146). Helkiah Crooke's *Mikrokosmografia . . . collected and translated out of all the best authors of anatomy, especially out of Gasper Bauhinus and Andreas Laurentius* (1615; lot 82). Govard Bidloo's *Anatomia humani corporis* (1685; lot 134). The Royal Surgeon John Brown's *Myographia nova: or, a Graphical Description of all the Muscles in Humane Body, as they arise in dissection, etc.* (1698; lot 72). He also owned Andrew Snape's *The Anatomy of a Horse . . . to which is added . . . the motion of the chyle and the circulation of the blood* (1683; lot 39).

5 Descartes, listed as 'Opera Philosophyca' and 'Meditationes' (lots 22 and 31) in Hawksmoor's collection.

6 See Hart (1998), pp. 18–27. See also Wittkower, R., *Architectural Principles in the Age of Humanism* (1948); Smith, C., *Architecture in the Culture of Early Humanism* (1992).

7 On the rise of geometry, see Hart (1998), p. 27; Pérez-Gómez, A., *Architecture and the Crisis of Modern Science* (1983).

8 See Grafton, A., *New Worlds, Ancient Texts, The Power of Tradition and the Shock of Discovery* (1992); p. 1 notes, 'Between 1550 and 1650 Western thinkers ceased to believe that they could find all important truths in ancient books'.

9 See Padovan, R., *Proportion, Science, Philosophy, Architecture* (1999), pp. 7–8, 253–72. In rejecting the influence of Newton on non-Vitruvian (Baroque) forms, Padovan does not discuss the much earlier threats to Vitruvian canonics posed by science with New World discoveries and, more importantly, by the demise of the Platonic microcosmos theory (and thereby of the body as the ultimate pattern of proportion) with the emergence of science from magical thinking in the 16th century; on which see Webster (1982).

10 See Downes, K., *English Baroque Architecture* (1966), pp. 5, 24–5, 57. Jeffery, P., *The City Churches of Sir Christopher Wren* (1996), pp. 327–8. Du Prey, P. R., *Hawksmoor's London Churches: Architecture and Theology* (2000), pp. 32, 152, n. 61. Soo, L., *Wren's 'Tracts' on Architecture and other Writings* (1998), p. 20. To a lesser extent the new sciences must have influenced the architecture of William Winde, or Wynne, an early Fellow of the Royal Society and architect of Buckingham House, see Downes (1966), p. 68.

11 Drawings for St Paul's and other Wren schemes (at the Sir John Soane's Museum in London and elsewhere) once thought to be by Wren are currently being examined by Gordon Higgot and, for the most part, being reattributed to Hawksmoor and Hooke.

12 On Wren's work in anatomy, see *Parentalia* (1750), p. 187.

13 Wren, Tract I, *Parentalia* (1750), p. 353 [transcribed in Soo (1998), p. 156].

14 Tract II, *Parentalia* (1750), p. 353 [transcribed in Soo (1998), p. 157].

15 Hawksmoor, letter to Carlisle, 3 October 1732, see Webb (1930–31).

16 See Hart (1994).

17 Webb (1930–31), 3 October 1732.

18 Downes, K., *Hawksmoor* (1959), p. 254, no. 136.

19 See Evans, R., *The Projective Cast: Architecture and its Three Geometries* (1995); Pérez-Gómez, A., and L. Pelletier, *Architectural Representation and the Perspective Hinge* (1997).

20 Sale catalogue of Hawksmoor's library reproduced in Watkin, D. (ed.), *Sale Catalogue of Libraries of Eminent Persons* (1975), vol. 4 [Architects], pp. 45–105. See Downes, K., 'Hawksmoor's Sale Catalogue', *The Burlington Magazine*, vol. 95 (1953), pp. 332–5.

21 Evelyn, J., 'An Account of Architects and Architecture', appended to the 2nd ed. of his *A Parallel of the Antient Architecture with the Modern* (1707), p. 4.

22 On the Office of Works see Colvin, H., *The History of the King's Works, 1660–1782*, vol. 5 (1976).

23 Downes (1959), p. 255, no. 147.

24 See Bennett, J., 'Christopher Wren: The Natural Causes of Beauty', *Architectural History*, vol. 15 (1972), pp. 5–22. Bennett, J., *The Mathematical Science of Christopher Wren* (1982).

25 See Watkin (1975). Downes (1953).

26 Hawksmoor's copy of Barbaro's *Vitruvius* was the 1567 Latin edition; his copy of Perrault's *Vitruvius*, the second edition of 1684, is held in the Canadian Center for Architecture, Montreal.

27 Also listed is 'A Book of Leonardi de Vinci' in quarto (lot 49), presumably his treatise on painting. The *Trattato della pittura di Lionardo da Vinci* was published (in folio) in Paris in 1651 and again (in octavo) in 1716. An English translation appeared in 1721 (in quarto). A German edition (in quarto) appeared in 1724.

28 See esp. Webb (1930–31), 3 September 1726: 'the designs of which are published in yᵉ Books of Antiquity, that your Lordship may see at pleasure', reference to Bartoli on 11 July 1728; Vitruvius, Pliny and French treatises on 3 October 1732; and Fréart on 30 October 1733. Perhaps the most notable study of ancient remains in Hawksmoor's collection is that by Desgodets (lot 109). Also listed are an edition of Aegidius Sadeler's *Vestigi delle antichità di Roma* (1606) (lot 161); 'L'Antichit. de Roma' (lot 7) is possibly that by Palladio, a work which was translated into Latin by Charles Fairfax and published by the Clarendon Press in 1709, but equally possibly that by Andrea Fulvio in translation, both works issued in octavo as listed in the sale catalogue: for other candidates see Payne, A., *The Architectural Treatise in the Italian Renaissance* (1999), p. 245, n. 22.

29 Downes (1959), p. 283, no. 468. See Ch. 3 below.

30 While Thomas Archer probably experienced Rome and its Baroque masterpieces at first hand on his travels in Italy, neither Vanbrugh nor Wren visited Rome (both concentrating, if not exclusively, on France) and Hawksmoor never left the British Isles. On Wren's travels abroad, see now Jardine, L., *On a Grander Scale: The Career of Christopher Wren* (2002, forthcoming).

31 Domenico Fontana's *Della trasportatione dell'obelisco Vaticano et delle fabriche di Nostro Signore Papa Sisto V* (1590; lot 104), Carlo Fontana's *Templum Vaticanum* (1694; lot 118), Giovanni Giacomo de Rossi's *Disegni di Vari Alterie e Cappelle nella Chiese di Roma* (1685; lot 120), Giovanni Battista Falda's *Le fontane di Roma nelle piazze e luoghi publici della città* (1691) and his *Il nuovo teatro delle fabriche et edificii in prospettiva di Roma moderna* (1665– ; lots 154 and 155) and Domenico de Rossi's *Studio D'Architettura Civile di Roma* (1702–21; lot 125).

32 Serlio's *Libro Extraordinario* (1663 ed.; lot 102), Montano's *Le cinque libri di architettura* (1636; lot 96), Hendrick de Keyser's *Architectura Moderna* (1631; lot 107) and Francini's *Livre d'architecture* (1640; lot 91).

33 Lowthorp, J. (ed.), *The Philosophical Transactions and Collections, to the end of the year 1700. Abridg'd and dispos'd under general heads . . . By John Lowthorp*, 3 vols (1705).

34 Robert Boyle's *New Experiments Physico-Mechanical* (1660; lot 1), Robert Plot's *De origine fontium, tentamen philosophicum* (1685; lot 1), Isaac Barrow's *Euclid* (1660), *Lectures* (1674) and *Archimedes* (1675; lots 6, 18 and 22), together with Newton's *Optics* (1706; lot 34) and *Principia* (1687; lot 38).

35 Douat, D., *Méthode pour faire une infinité de desseins différens, avec des carreaux mi partis de deux couleurs, par une ligne diagonale; ou, observations . . . sur un Mémoire inseré dans l'histoire de l'Académie Royale des Sciences de Paris, l'année 1704, présénté par S. Truchet* (1722).

36 Bosse, A., *La Pratique du trait à preuves de Mr Desargues, lyonnais, pour la coupe des pierres en l'architecture* (1643).

37 Listed as 'Gassendi Astronomica'.

38 Sammes, A., *Britannia Antiqua Illustrata: or, the antiquities of Ancient Britain* (1676) with a discussion of Stonehenge. Hawksmoor also collected folio works listed as 'Ream's Natural History, and 3 others' (lot 55).

39 Hawksmoor, N., *A Short Historical Account of London Bridge; with a Proposition for a New Stone-Bridge at Westminster* (1736), p. 34, in reference to 'Mr Gautier'.

40 Hawksmoor, N., *Remarks on the founding and carrying on the buildings of the Royal Hospital at Greenwich* (1728), p. 7.

41 See Bennett, J., and S. Mandelbrote (eds), *The Garden, the Ark, the Tower, the Temple: Biblical Metaphors of Knowledge in Early Modern Europe* (1998), no. 17, pp. 57–8.

42 Fréart's work was widely used in England, with masons on the site at St Paul's consulting it, as reported by Evelyn in the 'An Account of Architects and Architecture', appended to the 2nd ed. of his *Parallel* (1707).

43 Plate 32. See Bennett and Mandelbrote (1998), no. 18, pp. 59–60.

44 Meager, L., *The new Art of Gardening* (1697; lot 32); Bradley, R., *A philosophical account of the works of nature . . . To which is added, an account of the state of gardening* (1721; lot 50).

45 See Jacques, D., 'The Formal Garden', in Ridgway, C., and R. Williams (eds), *Sir John Vanbrugh and Landscape Architecture in Baroque England 1690–1730* (2000), pp. 44–6. On the emerging science of estate management see Williamson, T., 'Estate Management and Landscape Design', ibid., pp. 12–30.

46 Downes (1959), p. 244, no. 67.

47 For Hobbes, a 'good fancy' (or imagination) was the virtue of being able to observe likenesses between things of different natures, see ibid., pp. 44–5; Thorpe, C. de W., *The Aesthetic Theory of Thomas Hobbes* (1940). Cast (1984), pp. 315–16.

48 On Wren's other possible travels abroad, see now Jardine (2002, forthcoming).

49 See Levine, J. M., *Between the Ancients and the Moderns: Baroque Culture in Restoration England* (1999), p. 170.

50 Blondel, F.-N., *Cours d'Architecture, enseigné dans l'Academie royale d'architecture*, vol. 1 (1675, lot 146), vols 2 and 3 (1683, lot 90) and possibly all three vols (lot 124).

51 Evelyn discussed the 'Gallic Order' and other French 'Innovations' including Perrault's famous paired columns, 'Account', pp. 46–7, 49.

52 Webb (1930–31), 3 October 1732 and 30 October 1733 (on the Arch of Titus).

53 Downes (1959), p. 275, no. 1. The argument in ibid., p. 1, was revised by him in *Hawksmoor* (1970), p. 17; see also Geraghty, A., 'Nicholas Hawksmoor and the Wren City Church Steeples', *The Georgian Group Journal*, vol. 10 (2000), p. 1. On Hawksmoor's work for Wren, see Bolton, A. T., and H. P. Hendry (eds), *Wren Society Volumes*, 20 vols (1924–43).

54 See Cruickshank, D., 'Hawksmoor's First Building? The Portico of All Saints Church, Northampton', *The British Art Journal*, vol. 1, no. 1 (1999), pp. 20–22.

55 Bodleian Library, Oxford, Bod. MS Rawlinson B. 389, fol. 129. Downes (1959), p. 2. See Geraghty (2000), p. 2.

56 *Wren Society Volumes*, vol. 19 (1924–43), p. 85.

57 On the possibility that Hawksmoor designed the Orangery see Downes (1959), pp. 81–2. See also Colvin (1976), p. 160 (Hampton Court), pp. 190–91 (Kensington Palace). The Orangery is however attributed to the Dutch architect Jacob Roman in Kuyper, W., *Dutch Classicist Architecture* (1980), pp. 123–4.

58 Held in Yale University Center for British Art.

59 *Wren Society Volumes*, vol. 13 (1924–43), p. 33; vol. 15, p. 85. On this see Tinniswood, A., *His Invention So Fertile: A Life of Christopher Wren* (2001), pp. 328–9.

60 On Wren's Tracts, see Hart, V., *St Paul's Cathedral: Sir Christopher Wren* (1995); Soo (1998); Levine (1999), pp. 198–202.

61 See Soo (1998), pp. 15–16, 186.

62 Wren, Tract I, *Parentalia* (1750), p. 351 [transcribed in Soo (1998), p. 154].

63 'Report on Old St Paul's before the Fire', *Parentalia* (1750), p. 275, [transcribed in Soo (1998), p. 50].

64 Wren, Tract II, *Parentalia* (1750), p. 356 [transcribed in Soo (1998), p. 162].

65 Wren, Tract I, *Parentalia* (1750), p. 351 [transcribed in Soo (1998), p. 154].

66 Webb (1930–31), 3 September 1726.

67 On this comparison, see Soo (1998), pp. 146–8.

68 From the English translation by John James, *Treatise of the Five Orders of Columns* (1708), p. x, McEwen, I. (trans.), *Ordonnance for the Five Kinds of Columns* (1993 ed.), pp. 53–4.

69 Wren, Tract IV, *Parentalia* (1750), p. 366 [transcribed in Soo (1998), p. 184].

70 Ibid., p. 365 [transcribed in Soo (1998), pp. 179–81].

71 Tract I, *Parentalia* (1750), p. 351 [transcribed in Soo (1998), p. 154].

72 Ibid., p. 352 [transcribed in Soo (1998), p. 155].

73 See Ch. 4 below.

74 Kerry Downes has recently presented geometry as Hawksmoor's underlying concern in creating 'good effects', in noting his use of a 'rich, eclectic, scholarly and often unconventional vocabulary of detail to make real a feeling for the geometrical abstraction of solids and spaces'. Downes adds that Christ's Hospital is 'in a style that seems to derive from a conception of architecture as a demonstration of solid geometry'. Downes, K., 'Hawksmoor', in Turner, J. (ed.), *The Dictionary of Art*, vol. 14 (1996), pp. 252, 253. Downes noted elsewhere that 'it was Hawksmoor who first, in his plainer buildings, put into practice Wren's emphasis on solid geometrical purity to the exclusion of surface enrichment', in *Sir John Vanbrugh* (1987), p. 345. However in the cases where Hawksmoor excluded surface enrichment, this was less to expose any underlying geometric purity than it was for reasons of decorum. Earlier Downes had noted that Hawksmoor's emphasis on 'fancy', or imagination, owed 'nothing to Wren', in Downes (1959), p. 43. On the Mausoleum, see Appendix 1 below.

75 Wren, Tract I, *Parentalia* (1750), p. 352 [transcribed in Soo (1998), pp. 154, 155–6].

76 Wren, *Parentalia* (1750), pp. 204–5.

77 Tract IV, *Parentalia* (1750), p. 365 [transcribed in Soo (1998), p. 182].

78 Tract I, *Parentalia* (1750), p. 352 [transcribed in Soo (1998), p. 155].

79 Ibid. [transcribed in Soo (1998), pp. 154–5].

80 Ibid. [transcribed in Soo (1998), p. 156].

81 The drawing of All Souls is held at Worcester College, Oxford.

82 Preamble in James's translation of Pozzo's *Perspective* (1707).

83 Letter to Carlisle, Webb (1930–31), 7 January 1724. Minutes of the Commission, Lambeth Palace Library, MS 2724, 4 February 1713. MS 2691, fol. 414 records that on 5 May 1727 it was 'Ordered that at Spittlefields Church the Portico and Entablement be made with wood and brick'. See also Downes (1959), p. 277 drawing no. 144.

84 Webb (1930–31), 18 November 1732.

85 See Cottingham, J., *The Cambridge Companion to Descartes* (1992), pp. 350–58. John Locke had noted that 'We have the ideas of figures and colours by the operation of exterior objects on our senses, when the sun shows them us', quoted in Yolton, J. W., *Perception Acquaintance from Descartes to Reid* (1984), p. 91. On Wren's steeples in this respect, see Geraghty (2000), p. 5. On the importance of architectural 'effect' to Vanbrugh and Hawksmoor, see Cast, D., 'Seeing Vanbrugh and Hawksmoor', *J.S.A.H.*, vol. 43 (1984), pp. 314–15.

86 On the deliberate creation of settings conducive to the melancholic mood, see Strong, R., *The Renaissance Garden in England* (1979), pp. 215–19.

87 Evelyn (1707), p. 9.

88 See Downes, K., 'Baroque: Historical Context', in Turner, J. (ed.), *The Dictionary of Art*, vol. 3 (1996), p. 267.

89 Wren, Tract I, *Parentalia* (1750), p. 352 [transcribed in Soo (1998), p. 155].

90 This was clearly anticipated in the case of the Castle Howard Mausoleum, where his first proposal was to be served by a separate small chapel built at the foot of the hill, with six small rooms for accommodating '6 old women (or 6 old men) . . . by way of an alms house, and these aged persons should . . . shew it to Strangers with many traditions, and accounts concerning it'. Webb (1930–31), 3 September 1726.

91 Ibid., 10 November 1727; 6 May 1729.

92 Ibid., 3 October 1732.

93 Stone terms also feature in a proposed design by Hawksmoor for the Clarendon Building, Oxford. On these forms, see Ch. 3 below.

94 For a mixture of textures representing nature and human work see Serlio's Book IV fol. 133*v*. On these forms see Downes (1966), pp. 128–9.

95 See the Introduction above.

CHAPTER 2

1 See Vesely, D., 'Architecture and the Conflict of Representation', *AA files*, vol. 8 (1985), pp. 28–30. McQuillan, J., 'From Blondel to Blondel: On the Decline of the Vitruvian Treatise', in Hart, V., and P. Hicks (eds), *Paper Palaces: The Rise of the Renaissance Architectural Treatise* (1998), pp. 348–52.

2 It is alleged that during Fischer von Erlach's visit it was Wren who suggested to the Austrian that he write the *Entwurff*; see Aurenhammer, H., *J. B. Fischer von Erlach*

(1973), pp. 11, 30, 153; Harris, E., and N. Savage, *British Architectural Books and Writers 1556–1785* (1990), p. 194. Rykwert, J., *The First Moderns* (1980), p. 154.

3 Wren, Tract V, 'Discourse on Architecture', p. 1; see Soo, L., *Wren's 'Tracts' on Architecture and Other Writings* (1998), pp. 132, 188.

4 In 1687 the French Fellow Henri Justel conveyed news of the discovery of thousands of coloured columns on the coast of North Africa, the remains of Leptis Magna. Reports of a visit to Palmyra in 1691 by Englishmen from Aleppo were presented to the Society in 1695 and published in the *Transactions*. The Society had also sought information on Baalbek from André de Monceaux, another French Fellow of the Society. The antiquities of Greece were noted in the correspondence of Francis Vernon, a Fellow, who spent two months measuring monuments in Athens from about 1675.

5 See Grafton, A., *New Worlds, Ancient Texts, The Power of Tradition and the Shock of Discovery* (1992).

6 See Levine, J. M., *Between the Ancients and the Moderns: Baroque Culture in Restoration England* (1999), pp. 172–4.

7 Pagodas were illustrated in Jan Nieuhoff's *L'Ambassade à la Chine de la Compagnie Orientale des Provinces-Unies vers l'Empereur de la Chine* (Amsterdam, 1665; republished in London, 1669 and 1673, by John Ogilby) and in Athanasius Kircher's *China Monumentis Illustrata* (1667). The 1686 issue of the Royal Society's *Transactions* was entirely dedicated to China. Wren discussed Chinese architecture with Aubrey, see Soo (1998), p. 125. See also Soo, L., 'The Study of China and Chinese Architecture in Restoration England', *Architectura*, forthcoming.

8 Transcribed in Downes, K., *Hawksmoor* (1959), p. 8.

9 They range from 'Blancard's Physical Dictionary' (lot 3) and 'Harris's Lexicon Technicum' (lot 147) to those on Italian (lots 4, 51 and 57), Spanish (lots 4, 26 and 77), Greek (lots 4 and 85), Latin (lots 9, 10, 26 and 97), French (lots 12, 29, 34 and 46), Dutch (lot 31) and even 'Minshal's Dictionary 9 languages – 1626' (lot 95).

10 Webb, G. (ed.), 'The Letters and Drawings of Nicholas Hawksmoor Relating to the Building of the Mausoleum at Castle Howard, 1726–1742', *Walpole Society*, vol. 19 (1930–31), on 3 September 1726 and 3 October 1732. Downes (1959), pp. 255–8, no. 147.

11 See Ch. 1 above, n. 31.

12 Hawksmoor's studies of the fountain in the piazza are at Blenheim, Downes (1959), p. 282, nos 449–50 (Blenheim 13F, 3F). See Ch. 5 below, p. 123.

13 These books, both descriptive and technical, include 'A Description of Holland' (lot 45), 'A Dutch Book of Landskips' (lot 27), Johannus Potanus's *Rerum et Urbis Amstelodamensius historia* (1611; lot 66), Hendrick de Keyser's *Architectura Moderna* (1631), 'Stadt Hay's Van Amsterdam J. Campen 1664' and 'State Houses at Amsterdam Van Campen' (lots 115 and 121), and Hendrik Hondius's 'Dutch Perspective – Hague 1599' (lot 152, but incorrectly dated), plates from which were republished in Joseph Moxon's *Practical Perspective* (1670; lots 71 and 73).

14 On this influence see Mowl, T., 'Antiquaries, Theatre

and Early Medievalism', in Ridgway, C., and R. Williams (eds), *Sir John Vanbrugh and Landscape Architecture in Baroque England 1690–1730* (2000), p. 82.

15 Downes (1959), p. 257, no. 147.

16 Soo (1998), p. 172. On the travel literature in Wren's collection, see ibid., pp. 6–7.

17 On this see Downes, K., 'Hawksmoor's Sale Catalogue', *The Burlington Magazine*, vol. 95 (1953), p. 335.

18 See Lang, S., 'By Hawksmoor out of Gibbs', *Architectural Review* (April 1949), pp. 186–7 (Project II). On the Radcliffe Library, see also Ch. 3 below.

19 Soo (1998), p. 6. Du Prey, P. R., *Hawksmoor's London Churches: Architecture and Theology* (2000), p. 42.

20 See Lang, S., 'Vanbrugh's Theory and Hawksmoor's Buildings', *J.S.A.H.*, vol. 24 (1965), pp. 144; Downes, K., *Hawksmoor* (1970), pp. 107–8.

21 Hawksmoor, N., *A Short Historical Account of London Bridge; with a Proposition for a New Stone-Bridge at Westminster* (1736), p. 31.

22 Downes (1959), p. 277, no. 150.

23 Ibid., p. 276, no. 21.

24 E.g. Greaves, J., *A Description of the grand Signor's Seraglio, or Turkish Emperours Court* (1650).

25 Wren, Tract II, *Parentalia* (1750), p. 357 [transcribed in Soo (1998), p. 163].

26 Hooke, R., *The Diary of Robert Hooke: 1672–1680*, ed. Robinson, H. W., and W. Adams (1935), p. 328.

27 Now in the collection of Queen's University at Kingston, Ontario. See Du Prey (2000), pp. 42–5.

28 Lowthorp, J. (ed.), *The Philosophical Transactions and Collections, to the end of the year 1700. Abridg'd and dispos'd under general heads . . . By John Lowthorp*, 3 vols (1705).

29 Lowthorp (1705), vol. 1, ch. 8 on architecture; vol. 3, pt 2, ch. 2 on antiquities and ch. 3 on voyages and travel accounts (including Egypt, Persia, Turkey and Persepolis). See Soo (1998), p. 125.

30 See Downes (1959), p. 29; Soo (1998), pp. 124, 129; Hooke (1935), p. 328 (17 October 1677).

31 Chardin, J., *Travels into Persia and the East-Indies, the first volume containing the Author's Voyage from Paris to Isphahan*, 2 vols (1686), and *Voyages de Monsieur le Chevalier Chardin en Perse et autres lieux de l'Orient*, 3 vols (1711).

32 Lowthorp (1705), vol. 3, pt 2, ch. 3 p. 530. On Hawksmoor's interest in hieroglyphics see Chs 3 and 5 below.

33 See McQuillan (1998), pp. 344–5.

34 Campbell, C., *Vitruvius Britannicus, or the British Architect* (1715), vol. 1, 'Introduction'.

35 Webb (1930–31), 3 October 1732.

36 See Williams, R., 'A factor in his success. The missing years: did Vanbrugh learn from Mughal mausolea?', *Times Literary Supplement* (3 September 1999), pp. 13–14. 'Vanbrugh's India and his Mausolea for England', in Ridgway and Williams (2000), pp. 114–30.

37 Marot includes a 'Greek temple' among his plates.

38 See Downes (1970), p. 197.

39 See Rykwert (1980), pp. 263–6. Knight, C., 'The Travels of the Rev. George Wheler (1650–1723)', *The Georgian Group Journal*, vol. 10 (2000), pp. 21–35.

40 Struys, J., *Voyages and Travels of John Struys: through Italy, Greece, Muscovy . . .* (1681).

41 This is described by Vitruvius (I.vi.4; lots 70, 111) and illustrated in various (elevated) forms by Fra Giocondo (fol. 9v), Cesariano (fol. XXIVv) and Jean Martin.

42 See Ch. 10 below.

43 Serlio, Book III, pp. C–CI. See Worsley, G., *Classical Architecture in Britain: The Heroic Age* (1995), p. 58.

44 Wheler, G., *An Account of the Churches, or Places of Assembly, of the Primitive Christians* (1689). See Rykwert (1980), pp. 265–6. See also Ch. 6 below.

45 Lambeth Palace Library, MS 2750, nos 16 and 17. For a full discussion of this 'basilica', see Ch. 6 below, pp. 140–42.

46 See Hart, V., *Art and Magic in the Court of the Stuarts* (1994), pp. 50–54; 'Imperial Seat or Ecumenical Temple?', *Architectura*, vol. 25 (1995), pp. 194–213. The original drawing was sent to Hawksmoor's patron George Clarke in Oxford, and (as noted above) is preserved at Worcester College.

47 The original drawing survives at Worcester College, Oxford; Colvin, H. (ed.), *Catalogue of Architectural Drawings of the Eighteenth and Nineteenth Centuries in the Library of Worcester College, Oxford* (1964), 321c. See Du Prey (2000), pp. 101 (Fig. 53), 102, 164 n. 36.

48 Downes (1970), p. 197 (although mistaking the Temple of Bacchus for that to Jupiter); see also Worsley (1995), p. 57.

49 Diary entry for 17 February 1750 from Stukeley, W., *The Family Memoirs of Rev. William Stukeley, M.D.*, vol. 3, published in *Surtees Society Publications*, vol. 80 (1887), p. 9. See Worsley, (1995), p. 56, and Du Prey (2000), pp. 12–14, 114; however Hawksmoor's drawing of Baalbek (correctly) records the Bacchus temple as octastyle while St George's portico is hexastyle. See also Ch. 8 below on the possible influence of the Bacchus temple in Oxford.

50 Found in the R.I.B.A. 'Heirloom' MS copy of *Parentalia* (1750). See Soo (1998), pp. 15–16, 186.

51 Webb (1930–31), 3 October 1732.

52 Wren, C., *Parentalia* (1750), p. 200.

53 Wren, Tract I, *Parentalia* (1750), p. 353 [transcribed in Soo (1998), p. 156].

54 Tract II, *Parentalia* (1750), p. 355 [transcribed in Soo (1998), p. 158].

55 Downes (1959), p. 276, nos 16–18.

56 Wren, Tract III, *Parentalia* (1750), p. 359 [transcribed in Soo (1998), p. 167].

57 Lediard, T., *Some Observations On The Scheme Offered by Messrs Cotton and Lediard* (1738), p. 13. See Harris (1990), p. 232. See also Ch. 9 below.

58 Wren, Tract II, *Parentalia* (1750), p. 355 [transcribed in Soo (1998), p. 158].

59 On these paired columns, see *Parentalia* (1750), p. 288: 'not according to the usual Mode of the *Ancients* in their ordinary Temples'. John Evelyn in his 'An Account of Architects and Architecture', appended to the 2nd ed. of his *A Parallel of the Antient Architecture with the Modern* (1707), discussed this novelty, and concluded that, in opposition to Blondel, 'the *Antiens* did fre-

quently use to Joyne *Columns*, two and two very near to one another upon the same *pedestal*', p. 49.

60 Wren, Tract IV, *Parentalia* (1750), p. 360 [transcribed in Soo (1998), p. 169]. On Villalpando see Hart (1994), pp. 71, 109, 111–12. See also Rosenau, H., *Vision of the Temple* (1979). Rykwert (1980), pp. 9–10, 68, 156–7.

61 Wren, Tract IV, *Parentalia* (1750), p. 360 [transcribed in Soo (1998), p. 169].

62 Tract I, *Parentalia* (1750), p. 351 [transcribed in Soo (1998), p. 154].

63 On Kircher, see Ch. 4 below.

64 Pliny, *Natural History*, XXXVI, 91; Alberti, L. B., *On the Art of Building in Ten Books*, J. Rykwert, N. Leach, R. Tavernor (trans.), (1988), Bk VIII, ch. 3. See Downes (1959), pp. 20–21; Soo (1998), p. 121.

65 Wren, Tract V, 'Discourse on Architecture', p. 14 [transcribed in Soo (1998), p. 195].

66 Hooke also 'Drew a rationall porcenna' (on 18 October 1677) and made sketches in his diary of one of Wren's reconstructions; see Hooke (1935), pp. 317, 320–22. See also Downes (1959), pp. 20–21; Soo (1998), pp. 121–2. The unexecuted, final design of the royal tomb looked quite different, see Wren, *Parentalia* (1750), pp. 331–2 ('resembling the *Temple* of *Vesta*'); Beddard, R. A., 'Wren's Mausoleum for Charles I and the Cult of the Royal Martyr', *Architectural History*, vol. 27 (1984), pp. 36–48. Worsley (1995), p. 50.

67 Reproduced in an undated print by J. Mynde among the Abbey Records, repr. in *Wren Society Volumes*, vol. 5 (1924–43), p. 13.

68 Works Accounts, 5/47, see Colvin, H., *The History of the King's Works, 1660–1782*, vol. 5 (1976), p. 455. Soo (1998), pp. 217, 309 n. 66.

69 Webb (1930–31), 3 September 1726.

70 *Mrs Hawksmoor's Bill*, see Downes (1959), p. 223, Appendix C, p. 266.

71 Wren, Tract IV, *Parentalia* (1750), p. 368 [transcribed in Soo (1998), p. 187].

72 These engravings are thought to be after lost drawings by Wren, see Soo (1998), pp. 14–15.

73 Webb (1930–31), 3 October 1732.

74 The Halicarnassus mausoleum was described in Pliny the Elder's *Natural History* (of which Hawksmoor owned two copies, lots 84 and 99) and in Vitruvius (II.viii). Imaginary reconstructions had been proposed by Antonio da Sangallo and by Cesariano in his *Vitruvius* of 1521 (a non-pyramidal form adapted by Walther Ryff). See Colvin, H., *Architecture and the After-Life* (1991), pp. 30–42.

75 Downes (1959), p. 278, nos. 152–5.

76 See Soo (1998), p. 217.

77 Wren, Tract IV, *Parentalia* (1750), p. 366 [transcribed in Soo (1998), p. 184].

78 Ibid., p. 362 [transcribed in Soo (1998), p. 176].

79 See Addleshaw, G., and F. Etchells, *The Architectural Setting of Anglican Worship* (1948), pp. 52–6.

80 Wren, C., *Parentalia* (1750), p. 320 [transcribed in Soo (1998), p. 115].

81 Serlio's Bk III, p. XXIV, and Palladio's Bk IV, ch. vi.

82 See Hart, V., *St Paul's Cathedral: Sir Christopher Wren* (1995), pp. 9–10.

83 Wren, C., 'Letter to a Friend from Paris', September/October 1665 [transcribed in Soo (1998), p. 104].

84 Wren, Tract I, *Parentalia* (1750), p. 35, [transcribed in Soo (1998), p. 153].

85 Campbell (1715), 'Introduction'. This is despite Inigo Jones's respect for Gothic, for example at St Paul's. Windsor had also been 'modernized' by Hugh May under Charles II.

86 Langley's *Ancient Architecture Restored* (1742), later re-titled *Gothic Architecture Improved by Rules and Proportions*, has the two most eminent freemasons of the period, the Duke of Montagu and the Duke of Richmond, as dedicatees; see Harris (1990), pp. 264–8.

87 Hawksmoor, N., *Remarks on the founding and carrying on the buildings of the Royal Hospital at Greenwich* (1728) p. 9.

88 He also owned a 1665 ed. of Richard Baker's *Chronicle of the Kings of England from the time of the Romans government* (lot 80).

89 Hawksmoor (1736), p. 43.

90 Downes (1959), p. 275, no. 1 (Topographical sketchbook) and p. 284, no. 524 (Welbeck Abbey).

91 Ibid., p. 242, no. 61.

92 Ibid., p. 259, no. 151.

93 Ibid., p. 260, no. 161.

94 See ibid., pp. 214–16.

95 Wren's 'Report on Westminster Abbey' of 1713 to the then Dean, Francis Atterbury, published in *Parentalia* (1750), pp. 295–302, *Wren Society Volumes*, vol. 13 (1924–43), pp. 303–6. See Soo (1998), pp. 4, 34–92 (here quoting from p. 91).

96 Downes (1959), pp. 255–8, no. 147.

97 Ibid., p. 256, no. 147. In reference to Wren's report on the Abbey, noted above.

98 On Wren's 'negative appraisal of the style', see Soo (1998), p. 37.

99 On Ralph's criticism, see Chs 3 and 7 below.

100 Downes (1959), p. 280, no. 315, *Wren Society Volumes*, vol. 8 (1924–43), pls xi–xv. See Colvin (1976), p. 331. Drawings are listed in Hawksmoor's Sale Catalogue, see Watkin, D. (ed.), *Sale Catalogue of Libraries of Eminent Persons* (1975), vol. 4 [Architects], pp. 45–105, lot 224.

101 See Soo (1998), pp. 218–19.

102 Vanbrugh, 'Letters', transcribed in Dobrée, B., and G. Webb (eds), *The Complete Works of Sir John Vanbrugh*, vol. 4, (1928), p. 14; see Lang (1965), p. 136; Downes, K., *English Baroque Architecture* (1966), p. 17; and Downes, K., *Vanbrugh* (1977), p. 48.

103 Pointed out by Downes (1959), p. 216.

104 Drawing dated 21 February 1734, Downes (1959), p. 278, no. 225. All Souls vol. 3, Item 84.

105 On the possible connection with *caulcoles* (*cauliculi*) see Du Prey (2000), p. 103. However the term 'Calceolus' or 'Calceolaria' is defined in the *O.E.D.* as describing 'kinds of plant with flower like ancient slipper'. This terminology follows Wren who notes in his 'Report on Westminster Abbey' (1713), that 'The Angles of Pyramids in the Gothick Architecture, were usually

enriched with the Flower the Botanists call *Calceolus*, Soo (1998), p. 91.

106 Letter to Clarke, at All Souls, 'The Explanation of y*ᵉ* Designes for All Souls' (1715; republished Oxford, 1960). Partly transcribed in Downes (1959), p. 240, no. 58.

107 Downes (1959), p. 260, no. 161.

108 See Du Prey (2000), pp. 93, 104.

109 See Ch. 6 below, pp. 140−42.

110 De Cordemoy's 'Dissertation sur la manière dont les Eglises doivent être bâtie' was first published in *Mémoires de Trévoux* (1712), and then in *Nouveau traité de toute l'architecture, ou l'art de bastir; utile aux entrepreneurs et aux ouvriers* (1714 ed.); see Lang (1965), pp. 144−5; on Hickes's 'Observations', see Du Prey (2000), p. 56. See also Ch. 6 below.

111 On Wren and Aubrey, see Soo (1998), pp. 37−8.

112 See Downes (1970), pp. 163−4.

113 Colvin (1976), p. 410.

114 Hawksmoor's application of Vitruvian principles to Gothic work was in the spirit of Renaissance theories of harmony and of actual practice. Gothic work had been a standard feature of the Vitruvian treatise following Cesariano's famous illustrations of Milan Cathedral. Serlio had harmonized antique models and ornament − principally the column − with, at first, Venetian Gothic in Bk IV (on the Orders) and subsequently French Gothic in Bk VI (on domestic design) − perfectly consistent with the principles of decorum outlined in his text.

115 Félibien's 'Dissertation touchant l'architecture antique et l'architecture Gothique', in *Les plans et les descriptions de deux des plus belles maisons de campagne de Pline le Consul* (1699), pp. 349−50.

116 Subsequent editions (of 1706 and 1707) were 12°.

117 Félibien (1699), (p. 171).

118 Ibid., (pp. 173, 174).

119 Ibid., (pp. 178−85).

120 See Downes (1959), p. 279, no. 291 (see also ibid., Fig. 35a).

121 Transcribed in Downes (1977), Appendix J, p. 264.

CHAPTER 3

1 Webb, G. (ed.), 'The Letters and Drawings of Nicholas Hawksmoor Relating to the Building of the Mausoleum at Castle Howard, 1726−1742', *Walpole Society*, vol. 19 (1930−31), on 3 September 1726.

2 Aristotle uses the term 'architectonic' (*Nicomachean Ethics*, I.i, VI.vii) to denote the ultimate end to which all knowledge was directed and subordinated, that is, virtuous action. Inigo Jones had also used the term, for example, when describing what he saw as the 'universal' geometric scheme embodied by the Roman theatre plan: see Hart, V., *Art and Magic in the Court of the Stuarts* (1994), pp. 131, 203.

3 Webb (1930−31), on 10 November 1727 and 3 October 1732.

4 See Hart, V., 'From Virgin to Courtesan in Early English Vitruvian Books', in Hart, V., and P. Hicks (eds), *Paper Palaces: The Rise of the Renaissance Architectural Treatise* (1998), pp. 297−318.

5 'Explanation of the Obelisk', transcribed in Downes, K., *Hawksmoor* (1959), Appendix B, pp. 262−4; see also pp. 207−10.

6 Inigo Jones, 'Roman Sketchbook', Burlington Devonshire Collection, Chatsworth, Friday 20 January 1614/15, fol. 76r.

7 Palladio, Bk I, ch. xx. For examples of ancient 'licentiousness', including the split pediment at Petra, see Wilson Jones, M., *Principles of Roman Architecture* (2000), p. 146.

8 See Hart (1998); on the Orders as signs of the papacy, to be abused or rejected in favour of astylar façades, see also Carpo, M., 'The Architectural Principles of Temperate Classicism: Merchant Dwellings in Sebastiano Serlio's Sixth Book', *Res*, vol. 22 (1992), p. 149. Randall, C., *Building Codes: The Aesthetics of Calvinism in Early Modern Europe* (1999).

9 Evelyn, J., 'An Account of Architects and Architecture', appended to the 2nd ed. of his *A Parallel of the Antient Architecture with the Modern* (1707), pp. 45, 46.

10 See Hart, (1994). Hart, V., and R. Tucker, '"Immaginacy set free": Aristotelian Ethics and Inigo Jones's Banqueting House at Whitehall', *Res*, vol. 39 (2001), pp. 151−67. Hart, V., and R. Tucker, '"Masculine and Unaffected": Ornament and the Work of Inigo Jones', *Architectura*, forthcoming.

11 He would surely have prized Clarendon's *History of the Great Rebellion* since its publication paid for his Clarendon Building at Oxford. Church conflict also featured in 'Sacheverell's Trial large Paper − 1710' (lot 143), chronicling the controversial impeachment that year by the Whigs of the preacher Henry Sacheverell before the House of Lords. See Watkin, D. (ed.), *Sale Catalogue of Libraries of Eminent Persons* (1975), vol. 4 [Architects], pp. 45−105. Hawksmoor's copy of Michael Wright's *An Account of His Excellence Roger Earl of Castlemaine's Embassy, from His Sacred Majesty James II . . . to His Holiness Innocent XI* (1688) is currently held in Queen's University at Kingston, Ontario.

12 Dugdale, W., *The History of St. Paul's Cathedral in London* (1716 ed.), pp. 115, 148. See Hart, V., 'Imperial Seat or Ecumenical Temple? On Inigo Jones's use of "Decorum" at St. Paul's Cathedral', *Architectura*, vol. 25 (1995), pp. 194−213.

13 Gasparo Contarini's *De Officio Episcopi* (1516) had admonished that the display of luxury was not suitable for buildings commissioned by members of the Church. See Randall (1999). On Calvinist influences on Sebastiano Serlio see Carpo (1992), pp. 135−51.

14 Campbell, C., *Vitruvius Britannicus, or the British Architect* (1715), 'Introduction'.

15 Sphinxes for use at the base of Vanbrugh's 'Temple' are referred to in Hawksmoor's letter to Carlisle of 11 April 1730, in Downes (1959), p. 252, no. 107, and one is sketched in this letter (ibid., p. 283, no. 476) (see Fig.

16 Ibid., p. 252, no. 106.

17 On Serlio see Dinsmoor, W. B., 'The Literary Remains of Sebastiano Serlio', *Art Bulletin*, vol. 24 (1942), p. 75. Onians, J., *Bearers of Meaning: The Classical Orders in Antiquity, the Middle Ages, and the Renaissance* (1988), pp. 280–82. Hart, V., and P. Hicks (trans.), 'Introduction', in *Sebastiano Serlio on Architecture*, vol. 2 (Books VI–'VIII' of *Tutte l'opere d'architettura et prospetiva*, 2001). In the case of two term-like supports for an Ionic fireplace, Serlio created what he described (approvingly) in Bk IV as a 'monstrous, by which I mean a mixed form' (fol. 167r). On mixtures see Fiore, F. P., *Sebastiano Serlio architettura civile, libri sesto, settimo e ottavo nei manoscritti di Monaco e Vienna* (1994), pp. xlviii–xlix. On the tolerant attitude to licentious forms in Bk IV, in contrast to Bk III, see Payne, A., *The Architectural Treatise in the Italian Renaissance* (1999), pp. 120, 140.

18 Lot 540 in the sale catalogue of Wren's books: see Soo, L., *Wren's 'Tracts' on Architecture and Other Writings* (1998), p. 249 n.2.

19 The gates (in order of appearance) are VII (R), XIV (R), VIII (R), XIX (R), XXI (R), XXII (R), XV (D), XXIX (R), XII (D), XXIV (R), XVII (D), *Libro Extraordinario*, pp. 407–32. The unreliable English translation of 1611 had been published without the 'Extraordinary Book'. See *Sebastiano Serlio on Architecture* (2001).

20 Hawksmoor, N., *A Short Historical Account of London-Bridge; with A Proposition for a New Stone-Bridge at Westminster* (1736), pp. 32–3.

21 Clarke transcribed Inigo Jones's annotations into his own copy of Serlio, now at Worcester College; see Harris, J., et al., *The King's Arcadia: Inigo Jones and the Stuart Court* (1973), p. 67.

22 Downes (1959), p. 278, no. 188.

23 Ibid., pp. 130, 177; Downes, K., *Hawksmoor* (1970), p. 154; Worsley, G., *Classical Architecture in Britain: The Heroic Age* (1995), pp. 58, 63, 90, 105. Worsley, G., 'Nicholas Hawksmoor: A Pioneer Neo-Palladian', *Architectural History*, vol. 33 (1990), p. 70. Du Prey, P. R., *Hawksmoor's London Churches: Architecture and Theology* (2000), p. 100.

24 Downes, K., *Vanbrugh* (1977), p. 39.

25 See Carpo, M., *La maschera e il modello: Teoria architettonica ed evangelismo nell'Extraordinario Libro di Sebastiano Serlio (1551)* (1993). But see also Fiore (1994), p. xxv.

26 See *Sebastiano Serlio on Architecture* (2001), 'Glossary', pp. 597–603. This terminology extended the analogy between architectural ornamentation and morality (whether virtue or vice) hinted at by Serlio in Bk III through reference to the 'sacrosanct' nature of Vitruvian rules which only 'architectural heretics' opposed (fol. 69v).

27 'Mr. Van-Brugg's Proposals about Building ye New Churches'. Autograph MS, unsigned and untitled, Bodleian Library, Bod. MS Rawlinson B. 376, fols 351–2; the title is from a contemporary copy Bod. MS

28 Eng. Hist. b. 2, fol. 47; transcribed in Downes (1977), Appendix E, pp. 257–8.

28 See Hart (1998).

29 Campbell (1715), 'Introduction'.

30 Downes (1959), p. 257, no. 147.

31 Ralph, J., *A critical review of the public buildings, statues and ornaments in, and about London and Westminster* (1734), p. 6. On Ralph see Harris, E., and N. Savage, *British Architectural Books and Writers 1556–1785* (1990), pp. 381–5. See also Ch. 7 below.

32 Webb (1930–31), 3 October 1732.

33 Ibid., 12 October 1734.

34 Downes (1959), p. 244, no. 67.

35 Wren, 'Letter to a Friend from Paris' (1665) [transcribed in Soo (1998), p. 104].

36 Downes (1959), p. 257, no. 147. Nevertheless Hawksmoor evidently copied from Borromini, for example in a doorcase in the hall at Blenheim; see Downes (1970), p. 62.

37 Webb (1930–31), 4 October 1731.

38 Downes (1959), p. 257, no. 147, in reference to a great curved frontispiece of three orders of term-like pilasters; see Summerson, J., *Architecture in Britain 1530–1830* (1991 ed.), pp. 54, 78.

39 Downes (1959), p. 244, no. 67.

40 Defoe, D., *A Tour Through the Whole Island of Great Britain* (1725), p. 331.

41 See Ch. 7 below, pp. 183–4.

42 Barbaro's *Vitruvius* (1567), Bk III, ch. 1, p. 115: 'però dico io, che mescolando con ragione nelle fabriche le proportioni d'una maniera, o componendole, o levandole, nè puo risultare una bella forma di mezo'. Hawksmoor refers to 'Vitruvius in the Reverend D. Barbaro' in his letter to Carlisle of 3 October 1732, see Webb (1930–31).

43 Carpo (1992), pp. 135–51. Randall (1999). Hart and Tucker (2001).

44 Cave, W., *Primitive Christianity, or The Religion of the Ancient Christians in the First Ages of the Gospel* (6th ed., 1702), pp. 91–2. On Wren's possible use of this, see Loach, J., 'Gallicanism in Paris, Anglicanism in London, Primitivism in Both', in Jackson, N. (ed.), *Plus ça change . . . Architectural interchange between France and Britain: Papers from the Annual Symposium of the Society of Architectural Historians of Great Britain* (1999), p. 13.

45 Wren, Tract I, *Parentalia* (1750), p. 352 [transcribed in Soo (1998), p. 154].

46 Grelot, describing the piers of Hagia Sophia in 1680, noted that 'Il est difficile de dire de quel ordre ils sont, si ce n'est qu'on leur veuille donner le nom d'ordre Grec gothisé': the English translator renders the order as 'Grecian Gothick'. Grelot, G.-J., *Relation nouvelle d'un voyage de Constantinople* (1680), p. 140 (English ed., 1683, p. 95). See in general Middleton, R. D., 'The Abbé de Cordemoy and the Graeco-Gothic Ideal: A Prelude to Romantic Classicism', *J.W.C.I.*, vol. 25 (1962), pp. 278–320, and vol. 26 (1963), pp. 90–123.

47 On the last (Wiltshire Records Office, 2057/F6/27), dated 1717, see Hewlings, R., 'Hawksmoor's "Brave

Designs for the Police"', in Bold, J., and E. Chaney (eds), *English Architecture, Public and Private: Essays for Kerry Downes* (1993), p. 219. On the Office of Works' 'utility style' employed in this type of building, see Downes, K., *English Baroque Architecture* (1966), p. 112.

48 Webb (1930–31), 20 July 1734. See Ch. 10 below, p. 241.

49 On Jones see Higgot, G., '"Varying with reason": Inigo Jones's Theory of Design', *Architectural History*, vol. 35 (1992), pp. 51–77. Hart and Tucker (2001). On the principle of decorum see Onians (1988), pp. 310–24; Payne (1999); *Sebastiano Serlio on Architecture* (2001).

50 See Curl, J. S., *The Art and Architecture of Freemasonry* (1991), p. 108.

51 Defoe (1725), p. 333.

52 Evelyn (1664), p. 122; (1707), p. 15.

53 'Mr. Van-Brugg's Proposals about Building ye New Churches' (see above n.27).

54 Norberg-Schulz, C., *Late Baroque and Rococo Architecture* (1985 ed.), p. 196. On Vanbrugh's preference for simplicity in the London churches, and the possible influence of René Rapin's note that the 'true Eloquence of the Pulpit should endeavour to support itself only by the Greatness of its Subjects, by its Simplicity and Good Sense', see Lang, S., 'Vanbrugh's Theory and Hawksmoor's Buildings', *J.S.A.H.*, vol. 24 (1965), p. 141.

55 Downes (1977), p. 84. David Cast has observed that what Hawksmoor sought to develop was 'a kind of affective decorum – as when Hawksmoor called for a masculine design that would be proper for "rurall, sylvan shades"', in 'Speaking of Architecture: The Evolution of a Vocabulary in Vasari, Jones and Sir John Vanbrugh', *J.S.A.H.*, vol. 52 (June 1993), p. 187.

56 Webb (1930–31), 5 October 1732.

57 Downes (1959), p. 283, no. 477.

58 Webb (1930–31), 3 October 1732.

59 Jones's *Palladio*, with its famous annotations, was in George Clarke's collection at Oxford. See Higgot (1992).

60 Serlio, Bk IV fol. 183r: the Romans used the Composite 'more for triumphal arches than for any other thing'.

61 Webb (1930–31), 30 October 1733. The Composite Order was used in Vanbrugh's hall in the main house.

62 See Ch. 10 below.

63 Downes (1959), p. 278, no. 217.

64 Ibid., p. 256, no. 147.

65 Wren, C., 'Report on Westminster Abbey' (1713), [transcribed in Soo (1998), pp. 90–91]. See Soo (1998), pp. 214–15.

66 Vanbrugh, 'Letters' transcribed in Dobrée, B., and G. Webb (eds), *The Complete Works of Sir John Vanbrugh*, vol. 4 (1928), p. 14; see Lang (1965), p. 136; Downes (1966), p. 17; and Downes (1977), p. 48.

67 Letter to Clarke, at All Souls, 'The Explanation of yᵉ Designes for All Souls' (1715; republished Oxford, 1960). Partly transcribed in Downes (1959), p. 240, no. 58.

68 Wren to John Fell, 26 May 1681, in Bolton, A. T., and H. P. Hendry (eds), *Wren Society Volumes*, vol. 5

(1924–43), p. 17. See Fürst, V., *The Architecture of Sir Christopher Wren* (1956), p. 51. Soo (1998), pp. 218–19.

69 On this design see Cast, D., 'Seeing Vanbrugh and Hawksmoor', *J.S.A.H.*, vol. 43 (December 1984), pp. 312–13. Downes (1970), pp. 27–8.

70 See Worsley (1990), p. 63.

71 Downes (1970), p. 152.

72 See Downes (1959), p. 86. On other work at the Hospital, see Bold, J., *Greenwich: An Architectural History of the Royal Hospital for Seamen and the Queen's House* (2000).

73 See Bold (2000), pp. 18–19 (esp. on the Standard Reservoir of 1710–11, with its brick arch and pediment; see Fig. 112).

74 Equally, Wren noted in Tract 1 that 'In Things to be seen at once, much Variety makes Confusion, another Vice of Beauty', although 'In Things that are not seen at once, and have no Respect one to another, great Variety is commendable', *Parentalia* (1750), pp. 351–2 [see Soo (1998), p. 154, see also pp. 201–2].

75 Tract 1, *Parentalia* (1750), p. 352 [transcribed in Soo (1998), p. 137].

76 Webb (1930–31).

77 Ibid., 3 October 1732.

78 'Minutes of the Commission for Fifty New Churches', Lambeth Palace Library, MS 2690, fols 42–3 item 5 (repro: World Microfilm Publications, 1980). This ratified the earlier sub-committee meeting, on 11 July 1712, the minutes for which note 'That one General Modell be made and agreed upon for all the fifty new, intended Churches' (MS 2693, fol. 5). See Du Prey, P. R., 'Hawksmoor's "Basilica after the Primitive Christians": Architecture and Theology', *J.S.A.H.*, vol. 48 (1989), p. 43.

79 Smalridge, G., *Sixty Sermons Preached on Several Occasions* (5th ed., 1852), vol. 1, p. 271, undated sermon.

80 Here echoing Perrault's use of the term 'species', in the title of his *Ordonnance*. On the columns as 'species' see Rowland, I. D., 'Vitruvius in Print and in Vernacular Translation: Fra Giocondo, Bramante, Raphael and Cesare Cesariano', in Hart and Hicks (1998), pp. 105–21.

81 Webb (1930–31), 3 September 1726. Downes (1970), p. 184 noted that Hawksmoor's mind 'often worked by association of certain ideas with certain types of building', adding that he 'seems to have been particularly aware of the iconography of commemorative structures'.

82 Evelyn (1707), p. 4.

83 On Wren's manipulation of antique models see Soo (1998), pp. 216–17. See also Sekler, E., *Wren and his Place in European Architecture* (1956), pp. 42–3, 131–7.

84 Soo (1998), p. 217.

85 See Webb (1930–31).

86 See Ch. 10 below, pp. 238–9.

87 See Worsley, G., '"After the Antique": Vanbrugh, Hawksmoor and Kent', in Ridgway, C., and R. Williams (eds), *Sir John Vanbrugh and Landscape Architecture in Baroque England 1690–1730* (2000), pp. 137–9.

88 Hawksmoor would have seen Palladio's reconstruction

of the ancient house illustrated in his copy of Daniel Barbaro's Latin edition of *Vitruvius* of 1567 (lot 70) and in Palladio's *Quattro Libri* (lots 40, 68 and 123), both of which he studied closely (both cited in a letter to Carlisle of 3 October 1732). Perrault also illustrated the ancient house in his 1684 *Vitruvius* (lot 111). Palladio's reconstruction of the ancient house resembles Hawksmoor's project of 1727 to reface the front at Ockham, with its Corinthian portico (minus the pediment) and 'rustic', astylar walls. See Downes (1959), p. 284, nos 495–9, see also pp. 210–14. On these drawings of Ockham, now held in the Canadian Center for Architecture, Montreal, see Harris, J., *Catalogue of British Drawings for Architecture . . . in American Collections, 1550–1900* (1971), pp. 112–15. On the use of the ancient house in the plan at Ockham and at Oxford, see Ch. 8 below, pp. 208–9.

89 Hawksmoor flirted with this four-sided form on an 'attic feature' – Downes (1959), p. 284, no. 559 – although this was essentially purposeless and without an entrance which, if present, would have needed to be emphasized.

90 See Ch. 8 below, p. 219.

91 Downes (1959), p. 284, no. 497.

92 Ibid., p. 257, no. 147.

93 See Ch. 6 below, pp. 151–62.

94 See White, R., *Nicholas Hawksmoor and the Replanning of Oxford* (1997), pp. 72–5: Hawksmoor annotates his multiple sources; the Roman Arch at Saintes in France, the Arch of Constantine, the Pantheon, the Tower of the Winds in Athens, Sangallo's Palazzo Farnese and Inigo Jones's Queen's chapel at St James's. On a drawing for a side elevation of St Mary Woolnoth Hawksmoor annotated 'Cornice Like that in yᵉ Temple of M[ars]. Vindicator', British Library, King's Topographical XXIII. 28.3 (m).

95 Downes (1959), p. 283, no. 468; letter p. 244, no. 67: 'as to yᵉ figure, Barozzi de Vigniole, will justify us by what he has done, without yᵉ Gate of, (Porta del popolo) Rome'.

96 Downes (1970), pp. 196–7. See also Downes (1959), pp. 218–19.

97 See the Introduction above, p. 1; Downes (1959), p. 192.

98 Ibid., p. 282, no. 449–50.

99 See ibid., p. 208 (p. 282, no. 446).

100 Thomas Hearne commented on 1 December 1714 that Radcliffe financed the library project 'not so much out of a principle for doing good, as because he could not tell how to dispose of his money better to gain him a name after his death, he being very ambitious of glory', *Remarks and Collections of Thomas Hearne*, ed. D. W. Rannie, vol. 5 (1901), O.H.S. XLII; see Lang, S., 'By Hawksmoor out of Gibbs', *Architectural Review*, vol. 105 (April, 1949), pp. 184–7; on the tomb archetype for the main designs (III, VI and VII) see p. 187, and *Wren Society Volumes*, vol. 17 (1924–43), p. 82. The use of the plan of Suleiman's mosque in Constantinople for an early, square scheme for the Radcliffe Library was noted in Ch. 2 above (Figs 44, 45).

101 These were present on project IV, and urns also featured on the basement storey of the final design of 1734 (and are on the surviving model of this scheme).

102 Quoted by White (1997), p. 51.

103 See Ch. 2 above, p. 58.

104 See Chs 2 above and 6 below.

105 Downes (1970), p. 190 notes that they are 'architectural forms complete in themselves but elevated from "the cold ground" to the skyline in an unfamiliar context'.

106 Present in the reduced English translation of 1592. Colonna's work was well enough known in a variety of editions in early 18th-century England: William Kent, for example, had two copies; see *A Catalogue of the library of William Kent, Esq: Late Principal Painter and Architect to his Majesty. Which will be Sold at Auction, by Mr Langford, At his House (Late Mr Cock's) in the Great Piazza, Covent Garden. On Tuesday the 14ᵗʰ of February, 1748–9*, Bodleian Library, Oxford, Mus. Bibl. III 8 20, lots 92 and 96.

107 Hawksmoor, N., *Remarks on the founding and carrying on the buildings of the Royal Hospital at Greenwich* (1728), p. 6.

108 See Ch. 9 below, pp. 225–6.

109 Downes (1959), p. 244, no. 67.

CHAPTER 4

1 Bennett, J., and S. Mandelbrote (eds), *The Garden, the Ark, the Tower, the Temple: Biblical Metaphors of Knowledge in Early Modern Europe* (1998).

2 See Rykwert, J., *The First Moderns* (1980), pp. 67, 139; Godwin, J., *Athanasius Kircher* (1979); Hawksmoor may have seen Kircher's works on related subjects in Wren's library. Wren owned Kircher's *Ars magna lucis et umbrae* (2nd ed., 1671; lot 244) and Kircher's *Phonurgia nova* (1673; lot 247), see Watkin, D. (ed.), *Sale Catalogue of Libraries of Eminent Persons* (1975), vol. 4 [Architects], pp. 45–105.

3 In reflecting the zoological priorities of his fellow Royal Society member John Wilkins and of Kircher, according to Wren the Ark contained cisterns and tubs of greens as 'the only food of Tortoises, and some Birds and Insects': Tract V, 'Discourse on Architecture' [transcribed in Soo, L., *Wren's 'Tracts' on Architecture and Other Writings* (1998), p. 189].

4 Downes, K., *Hawksmoor* (1959), pp. 255–8, no. 147.

5 See Hart, V., 'From Virgin to Courtesan in Early English Vitruvian Books', in Hart, V., and P. Hicks (eds), *Paper Palaces: The Rise of the Renaissance Architectural Treatise* (1998), pp. 297–318.

6 On Villalpando see Hart, V., *Art and Magic in the Court of the Stuarts* (1994), pp. 71, 109, 111–12. See also Rosenau, H., *Vision of the Temple* (1979). Rykwert (1980), pp. 9–10, 68, 156–7.

7 Du Prey, P. R., *Hawksmoor's London Churches: Architecture and Theology* (2000), p. 31. On the model of the temple, see Rykwert, J., *On Adam's House in Paradise* (1981), p. 132.

8 Wren, Tract IV, *Parentalia* (1750), p. 360 [transcribed in Soo (1998), p. 169]. See Ch. 2 above, pp. 49–52.

9 Tract I, *Parentalia* (1750), p. 351 [transcribed in Soo (1998), p. 153].

10 Downes (1959), p. 255, no. 147.

11 See Harris, E., and N. Savage, *British Architectural Books and Writers 1556–1785* (1990), pp. 109–13. Summerson, J., *Architecture in Britain, 1530–1830* (1991 ed.), pp. 278–9, 288–9.

12 *Flavius Josephii . . . Opera Omnia Graece et Latine, cum Notis & Nova Versione Joannis Hudsoni . . . Libros, D. E. Bernardi, J. Gronovii, F. Combefish, J. Sibrandae, Hendri Aldrichi . . .* (1726).

13 See Ch. 8 below, p. 196.

14 Harris and Savage (1990), p. 110.

15 Wren, Tract IV, *Parentalia* (1750), p. 360 [transcribed in Soo (1998), p. 169].

16 Tract V, 'Discourse on Architecture', p. 8 [transcribed in Soo (1998), pp. 191–2].

17 On these columns see Rykwert (1981), pp. 123–6.

18 See Downes (1959), p. 199 n. 35.

19 See Virtue, G., 'Virtue Note Books', *Walpole Society*, ed. K. A. Esdaile, vol. 22 (1934), pp. 42, 43, 53.

20 See Soo (1998), p. 122. Du Prey (2000), pp. 15, 17–19.

21 Report by Edmund Halley on 'A Voyage of some English Merchants at Aleppo to Tadmar; by Mr Timothy Lahoy and Mr Aaron Goodyear' and 'An account of Tadmar by Mr William Hallifax', in Lowthorp, J. (ed.), *The Philosophical Transactions and Collections, to the end of the year 1700. Abridg'd and dispos'd under general heads . . . By John Lowthorp* (1705), vol. 3, part 2, p. 518.

22 British Library, King's Topographical XLV. 18. i.

23 Hawksmoor to Carlisle, concerning the Belvedere, 7 January 1724 [transcribed in Downes (1959), p. 244, no. 67].

24 British Library, King's Topographical XLV. 18. h.

25 See Ch. 3 above, p. 85.

26 Transcribed in Downes, K., *Vanbrugh* (1977), Appendix J, p. 265.

27 On the Stuart conception of London as the New Jerusalem, see Hart (1994). On contemporary identifications, see Du Prey (2000), pp. 81–2.

28 British Library, Additional MS 19,607, no. 12: 'My love to Mr Strong, Pesley, Townsend, Bankes and Barton &c' (the masons at Blenheim). See Downes (1959), pp. 11–12.

29 Webb, G. (ed.), 'The Letters and Drawings of Nicholas Hawksmoor Relating to the Building of the Mausoleum at Castle Howard, 1726–1742', *Walpole Society*, vol. 19 (1930–31), on 4 October 1731.

30 Downes notes that these details reflect the 'truth of geometry', in 'Hawksmoor', *Macmillan Encyclopedia of Architects* (1982), p. 346. Although geometric regularity as a basis for the visual perception of beauty appears not to have been as important to Hawksmoor as it was to Wren, his details are clearly permeated with bold geometrical elements based on Euclidean forms. He would have seen these primary forms illustrated first-hand in his editions of Euclid (lots 6 and 76), in the first book of his Serlio, and in his copy of Batty Langley's book on practical geometry (with its freemasonic dedication to Lord Paisley; lot 88).

31 The masons are listed in Lambeth Palace Library, 'Book of Contracts' MS 2703–4, 'Book of Warrents' MS 2705–6, 'Book of Works' 1712–22 MS 2697. See Colvin, H., 'Fifty New Churches', *Architectural Review*, vol. 107 (1950), pp. 195–6.

32 On the cube and its mythology, see Taylor, R., 'Architecture and Magic: Considerations on the Idea of the Escorial', in Hibbard, H. (ed.), *Essays in the History of Architecture Presented to Rudolf Wittkower* (1967), pp. 81–109. Hart (1994), p. 141.

33 While St Alfege is rectangular, the ceiling moulding is a circle set within a square, and cubic central spaces are used at St Mary Woolnoth and St George in Bloomsbury. On St Mary Woolnoth's cubic proportions see Du Prey (2000), p. 106.

34 Wren, Tract IV, *Parentalia* (1750), p. 363 [transcribed in Soo (1998), pp. 178–9].

35 See Gould, J., *The Consise History of Freemasonry* (1903); Knoop, D., and G. P. Jones, *The Genesis of Freemasonry* (1947); Rykwert (1980), pp. 38, 134–5; Stevenson, D., *The Origins of Freemasonry, Scotland's Century 1590–1710* (1988). Ridley, J., *The Freemasons* (1999).

36 Ridley (1999), p. 40.

37 See Knoop and Jones (1949), p. 179.

38 Ibid., p. 212. Batty Langley shows a plan of a Lodge in the frontispiece to *The Builder's Jewel* (1741) (see Fig. 135).

39 On Hawksmoor's use of these forms on his London churches, see Ch. 6 below, pp. 151–62. On the pyramid as a masonic form see Vidler, A., 'The Idea of Type: The Transformations of the Academic Ideal 1750–1830', *Oppositions*, vol. 8 (Spring 1977), Figs 3, 5. See also Curl, J. S., *The Art and Architecture of Freemasonry* (1991).

40 The list appears in G. W. Speth (ed.), *Quatuor Coronatorum Antigrapha* (masonic reprints of the Quatuor Coronati Lodge, No. 2076), vol. 10 (1889–1913), pp. 191–2. On this attribution see Williams, W. J., 'Masonic Personalia 1723–39', *Ars Quatuor Coronatorum*, vol. 40 (1928), p. 42; Ward, E., 'William Hogarth and His Fraternity', *Ars Quatuor Coronatorum*, vol. 77 (1964), p. 11.

41 Downes (1959), p. 1; also in letters from the Duke of Somerset, March 1704–December 1706, see Colvin, H., *A Biographical Dictionary of British Architects 1600–1840* (1995 ed.), p. 476. For the minutes see for example Lambeth Palace Library, MS 2724, fol. 120r.

42 See Knoop and Jones (1949), pp. 176, 210 (Blackerby also became treasurer of the charity of the Grand Lodge in June 1727); Speth, vol. 10 (1889–1913).

43 See Colvin, H., *A Biographical Dictionary of English Architects 1660–1840* (1954 ed.), p. 273.

44 In Hawksmoor's letter to Carlisle of 4 October 1731 he writes 'to thank you for yᵉ kind and generous entertainment I had at Castle Howard and in particular for Mʳ Blackerby, who was a stranger to you, and I only accountable for yᵉ trouble we gave you, how ever he begs his service may be acceptable to yʳ Lordship and

sends a thousand thanks for yᵉ honours he received',
Webb (1930–31). This may well have been his final visit,
see Downes, K., *Hawksmoor* (1970), p. 173.

45 See Ridley (1999), pp. 39, 44. On the London Lodges,
see Curl (1991), pp. 106–14.

46 See Ward (1964). See also Uglow, J., *Hogarth: A Life and
a World* (1977), pp. 108–11, and on Hawksmoor and
Hogarth (both opposed to Burlington) p. 72, (both at
St Bartholomew's Hospital) pp. 282–3. In March 1723
the title-page of the English translation of Sebastian
Le Clerc's *Traité d'Architecture* described the contents as
'Exercises for Free and Accepted Masons' and was ded-
icated to (among others) Hawksmoor and Thornhill.
Thornhill painted the staircase walls at Easton Neston,
the dome of St Paul's and the hall at Greenwich (which
Hawksmoor mentions to Carlisle on 4 January 1732);
he is mentioned by Hawksmoor on one of his draw-
ings for Ockham Park (held at the Canadian Center
for Architecture). See Levine, J. M., *Between the Ancients
and the Moderns: Baroque Culture in Restoration England*
(1999), pp. 191–92.

47 See Colvin, H., *The History of the King's Works,
1660–1782*, vol. 5 (1976), p. 404. On Desaguliers as a
freemason, see James Anderson's *Constitutions* (1723 ed.);
Gould (1903), vols II and III; Ridley (1999), pp. 34–6, 44.
In 1711 Desaguliers published in Oxford a translation of
Jacques Ozanam's *Traité de Fortification* (1694).

48 Desaguliers lived in Channel Row, Westminster, in a
house that had to be demolished when the bridge was
built in 1738–9, and Hawksmoor lived in Millbank,
Westminster – see the *Dictionary of National Biography*
entry for both men.

49 Langley commented on 17 March 1734 (1735 new
style) concerning his Mansion House scheme that 'Mr
Justice Blackerbeee [sic] of Parliamt. Stairs is my near
Neighbour, and who will inform yr Lordship of my
abilities if required', see Perks, S., *The History of the
Mansion House* (1922), p. 165.

50 Speth, vol. 10 (1889–1913). On Roubiliac and Cheere
see Downes (1970), p. 12.

51 Wren's initiation is recorded in Aubrey's MS of the
Natural History of Wiltshire, Bodleian Library, Aubrey MS
2, pt. ii, fol. 72v; see Knoop and Jones (1949), pp.
169–70; Ridley (1999), p. 23. But see now Jardine, L.,
On a Grander Scale: The Career of Christopher Wren
(2002), and evidence in Jacob, M. C., *Living the Enlight-
enment: Freemasonry and Politics in Eighteenth-Century
Europe* (1991), pp. 25, 92.

52 This was performed at the south-east corner facing
sunrise on 25 June 1675, at the curious time of 6.30
a.m. according to the freemason and astrologer Elias
Ashmole, see Ashmole, E., *Elias Ashmole (1617–1692), His
Autobiographical and Historical Notes*, ed. C. H. Josten, vol.
4 (1966), p. 1432. Tradition records that this stone was
laid by Charles II attended by Wren and his masons
(although other records suggest that the 'first stone' was
laid by the Master Mason Thomas Strong senior and
John Longland carpenter). On Charles II's presence see
Conder, E., 'King Charles II at the Royal Exchange,
London, in 1667', *Transactions of the Quatuor Coronati*

Lodge, vol. 11 (1898), pp. 138–52. On Strong and Long-
land, who in any case would have assisted in the cer-
emony (here dated four days earlier), see Hatton, E., *A
New View of London* (1708), vol. 2, p. 456. See also Hart,
V., *St Paul's Cathedral, Sir Christopher Wren* (1995), p. 20.
As an indication of the superstitions surrounding build-
ing foundation, John Flamsteed, the Astronomer Royal
and Fellow of the Royal Society, calculated a horoscope
for 10 August of that year for the founding of Wren's
Greenwich Observatory. Ashmole had calculated one
on 23 October 1667 for the founding of Edward
Jerman's Royal Exchange (attended by the King, see
Conder (1898), pp. 143–4). On Wren and magical prac-
tices see Hart (1995), p. 24 n. 3. On Ashmole and the
Royal Society see Rykwert (1980), p. 131. See also
Hunter, M., *Science and Society in Restoration England*
(1981).

53 See Ch. 10 below, p. 234.

54 Webb (1930–31), 29 March and 1 October, 1729.

55 His tombstone throws no light on this issue, with its
inscription 'PMSL' (*piae memoriae sacer locus*) taken from
ancient epitaphs, see Downes (1970), p. 206.

56 When occasion demanded Hawksmoor was perfectly
capable of such symbolism, as on his design for the
altar canopy at York Minster (British Library, King's
Topographical XLV. 7. ff.2). This has the High Church
symbols of sunburst and reclining angels reflecting
models found in Giovanni Giacomo de Rossi's *Disegni
di Vari Alteri e Cappelle nella chiese di Roma . . .* (1685;
lot 120).

57 Speth, vol. 10 (1889–1913), p. 40. At some point James
bought a property on Croom's Hill, Greenwich, see
Colvin (1995 ed.), p. 537. On James at Greenwich see
Bold, J., *Greenwich: An Architectural History of the Royal
Hospital for Seamen and the Queen's House* (2000), pp. 98,
143 (on their relationship at Greenwich as 'partners but
not collaborators').

58 'Explanation of the Obelisk' [transcribed in Downes
(1959), Appendix B, pp. 262–4; see also pp. 207–10].

59 Leeds City Archive, Vyner MSS: 5742 (245/3). See
Hewlings, R., 'Ripon's Forum Populi', *Architectural
History*, vol. 24 (1981), p. 44.

60 Wren, Tract IV, *Parentalia* (1750), p. 361 [transcribed in
Soo (1998), p. 172]. On the Ionic Order's lunar asso-
ciations, see Rykwert, J., *The Dancing Column* (1996),
p. 249.

61 Emblems of the sun and the moon, together with a
bust of a master mason, each surmount free-standing
columns in Batty Langley's masonic frontispiece to *The
Builder's Jewel* (1741). See also Curl (1991).

62 *St James's Evening Post*, quoted in Malcolm, J. P.,
Londinium Redivivum, vol. 4 (1807), p. 172. Here it was
further described as 'seemingly the most antique struc-
ture of the rural kind that has yet been invented, and
without prejudice doth very greatly exceed every arti-
ficial hermitage, grotto, and cave that has yet been made
or begun in this kingdom'; see Middleton, R., et al.
(eds), *The Mark J. Millard Architectural Collection*, vol. 2
(British Books) (1998), pp. 143–4. Langley manu-
factured these sculptures from artificial stone, and

advertised them in the *Daily Advertiser* on 19 April 1731 and throughout May and June thereafter.

63 See Harris (1990), p. 267, who states that Hawksmoor, like Langley, was a freemason. In an advertisement of 1734 for his *Ancient Masonry, both in Theory and Practice*, Langley promised to illustrate 'the different Modes or Stile of Building, according to . . . Mr. Hawksmore' (again spelt similar to the masonic list). The published work was dedicated to the 'Right Worshipful Masters of Masonry', and including the legendary history of geometry (under 'geometry' in the 'Dictional Index'); plates of Hawksmoor's work were not included however. Langley worked at Castle Howard in 1732 and possibly in 1734, see Hussey, C., *English Gardens and Landscapes 1700–1750* (1967), pp. 129–30.

64 Lambeth Palace Library, MS 2692, 11 February 1731, fol. 52. Montagu had been Grand Master in 1721.

CHAPTER 5

1 The house was described in Bathoe, W., *A Description of Easton Neston* (1758), and Bridges, J., *The History and Antiquities of Northamptonshire*, vol. 1 (1791), p. 289. See Downes, K., 'Hawksmoor's House at Easton Neston', *Architectural History*, vol. 30 (1987), pp. 50–76. But see also Colvin, H., 'Easton Neston Reconsidered', *Country Life*, vol. 148 (1970), pp. 968–71. Downes, K., *English Baroque Architecture* (1966), pp. 73–4.

2 Webb, G. (ed.), 'The Letters and Drawings of Nicholas Hawksmoor Relating to the Building of the Mausoleum at Castle Howard, 1726–1742', *Walpole Society*, vol. 19 (1930–31). (The second Lord Lempster was created Earl of Pomfret, or Pontefract, in December 1721.)

3 Campbell, C., *Vitruvius Britannicus, or the British Architect* (1715), plates 98–100.

4 The Arundel collection, works originally housed in Inigo Jones's famous gallery at Arundel House in London, of around 1615.

5 See Ch. 3 above, p. 79. Theories for this addition, related to Vanbrugh's taste for giant orders, are discussed by Downes, K., *Hawksmoor* (1959), pp. 57–8. Colepepper drawing: British Library, MS Harl. 7588, fol. 512.

6 Serlio, Bk VII, pp. 41, 105. Book VII could well have been included in Hawksmoor's library sale, lot 102 – 'Serlius Architectura – *Venetia* 1663' – since an edition had appeared in Venice in this year, alongside that by the same publisher containing Books I–V and the 'Extraordinary book' which Hawksmoor certainly owned. See Watkin, D. (ed.), *Sale Catalogue of Libraries of Eminent Persons* (1975), vol. 4 [Architects], pp. 45–105.

7 See Ch. 3 above, p. 78.

8 See Hart, V., '"A peece rather of good Heraldry, than of Architecture": Heraldry and the Orders of Architecture as Joint Emblems of Chivalry', *Res*, vol. 23 (1993), pp. 52–66.

9 Wotton, H., *The Elements of Architecture* (1624), pp. 35–6.

10 These statues are now destroyed; see Ch. 6 below, p. 142. At Blenheim his monumental column designs featured the Britannic lion and Roman eagle – see Downes (1959), p. 208 and below n. 70 – and, on another design, heraldic dragon-like monsters – see ibid., p. 282, nos 443, 446, 447 (see above Fig. 119). Hawksmoor's interest in, and knowledge of, heraldry is equally illustrated by his drawing (dated 1728) of a crest with royal lions symbolizing the Royal Hospital at Greenwich, produced as a frontispiece for a planned volume of drawings of the Hospital, reproduced in Bolton, A. T., and H. P. Hendry (eds), *Wren Society Volumes*, vol. 6 (1924–43), p. 17.

11 See Downes (1966), p. 66.

12 See Bold, J., *John Webb: Architectural Theory and Practice in the Seventeenth Century* (1989), pp. 32–3, 167 (Fig. 111), 173 (Fig. 117).

13 See Wren's Tract II, *Parentalia* (1750), p. 356 [transcribed in Soo, L., *Wren's 'Tracts' on Architecture and Other Writings* (1998), p. 159, see also p. 291 n. 44]; according to Evelyn it also had '*Cocks-Feathers and Cocks-Combs*', as well as '*Chains and Ribbons*', in 'An Account of Architects and Architecture', appended to the 2nd ed. of *A Parallel of the Antient Architecture with the Modern* (1707), pp. 46–7.

14 See Downes (1959), p. 85. See also Ch. 9 below, p. 221.

15 Downes (1987), p. 61.

16 Ibid., p. 62; Downes (1959), p. 87 notes that Easton Neston has 'giant rhetorical columns supporting nothing', and 'the elements of classical architecture do not dictate the patterns but are forced into them'.

17 See Ch. 3 above, pp. 75–82.

18 The gallery or *galleria* was a long room in which to stroll, hold festivities and exhibit works of art. It is defined by Serlio in Book VII as synonymous with an 'ambulatory' (p. 44); he also records the link between the French *galerie* and the long upper loggias (often however open) and *salette* over the courtyard in Italian Renaissance palaces (p. 42); *Sebastiano Serlio on Architecture*, vol. 2, Books VI–'VIII' of *Tutte l'opere d'architettura et prospetiva*, V. Hart and P. Hicks (trans.) (2001). See Prinz, W., *Die Entstehung der Galerie in Frankreich und Italien* (1970); Guillaume, J., 'La galerie dans le château français: place et fonction', *Revue de l'Art*, vol. 102 (1993), pp. 32–42.

19 On Ockham see Downes (1959), pp. 210–14. On Hawksmoor's unexecuted design for refacing the old house in 1727, see Chs 3 above and 8 below, p. 84 and 208.

20 Wotton House, *R.I.B.A. Drawings Catalogue*, G-K, 99, see Colvin, H., *A Biographical Dictionary of British Architects 1600–1840* (1995 ed.), p. 478; Thirkleby Park, Yorkshire Archaeological Society's Library, Leeds.

21 British Library, Kings Topographical XXIII. 28. 3t (verso) and 3g. Bedfordshire County Records Office L/33/71–80, 107, 122–3.

22 See Saumarez Smith, C., *The Building of Castle Howard* (1997). One of the first to recognize the importance of Hawksmoor's role at Blenheim was J. H. V. Davies in 'Nicholas Hawksmoor', *R.I.B.A. Journal*, vol. 69, no. 10 (October 1962), pp. 368–76. Downes, K., *Sir John Vanbrugh, a Biography* (1987), p. 200 notes: 'it is clear

from surviving drawings and documents that Hawksmoor performed three functions of which Vanbrugh was as yet incapable; he made most of the drawings, he designed the detailing, and he negotiated rates with the artificers and craftsmen who were to build the house'. On the development of the design and the role of both architects see Downes, K., 'Vanbrugh over Fifty Years', in Ridgway, C., and R. Williams (eds), *Sir John Vanbrugh and Landscape Architecture in Baroque England 1690–1730* (2000), pp. 1–11.

23 Saumarez Smith (1997), pp. 51–3.

24 On Hawksmoor's interest in 'effect', see Chs 1 above and 6 and 7 below. See also Cast, D., 'Seeing Vanbrugh and Hawksmoor', *J.S.A.H.*, vol. 43 (1984), pp. 314–15.

25 Vanbrugh, 'Mr. Van-Brugg's Proposals about Building ye New Churches'. Autograph MS, unsigned and untitled, Bodleian Library, Bod. MS Rawlinson B.376, fols 351–2; the title is from a contemporary copy Bod. MS Eng. Hist. b. 2, fol. 47; transcribed in Downes, K., *Vanbrugh* (1977), Appendix E, pp. 257–8.

26 Ibid.

27 Vanbrugh to Newcastle, 20 August 1723, 'Letters', transcribed in Dobrée, B., and G. Webb (eds), *The Complete Works of Sir John Vanbrugh*, vol. 4 (1928), p. 152.

28 See Worsley, G., '"After ye Antique": Vanbrugh, Hawksmoor and Kent', in Ridgway and Williams (2000), pp. 147–9; on medieval sources see Mowl, T., 'Antiquaries, Theatre and Early Medievalism', in ibid., pp. 91–2.

29 On some (implausible) suggestions as to practical justifications for these walls, see Williams, R., 'Fortified Gardens', in ibid., pp. 49–70.

30 See Dobrée and Webb (1928), p. 14; see Lang, S., 'Vanbrugh's Theory and Hawksmoor's Buildings', *J.S.A.H.*, vol. 24 (1965), p. 136; Downes (1966), p. 17 and Downes (1977), p. 48.

31 See McCormick, F., *Sir John Vanbrugh: The Playwright as Architect* (1991).

32 Wright, J., *Historia Histrionica: An Historical Account of the English Stage* (1699), pp. 10–11. There is no evidence that Vanbrugh designed scenery however, see Downes (1977), p. 42. Frank McCormick has examined the influence of set design, and of perspective scenes and martial vocabulary in particular, on Vanbrugh's architecture, in McCormick (1991), pp. 88–94, 107–31. See also Mowl in Ridgway and Williams (2000), p. 85.

33 'Explanation of the Obelisk', transcribed in Downes (1959), Appendix B, pp. 262–4.

34 Lowthorp, J. (ed.), *The Philosophical Transactions and Collections, to the end of the year 1700. Abridg'd and dispos'd under general heads . . . By John Lowthorp* (1705), vol. 3, pt 2, ch. 3, p. 530. Most recently found in N. Caussin's *De Symbolica Aegyptiorum Sapientia* (1631) and Athanasius Kircher's *Oedipus Aegyptiacus* (1652–4) and *Sphinx mystagoga* (1676).

35 Wren, Tract IV, *Parentalia* (1750), p. 363 [transcribed in Soo (1998), pp. 177–8].

36 Lots 261 and 370, in Watkin (1975), vol. 4.

37 See Saumarez Smith (1997), p. 99.

38 See Hart, V., 'Vanbrugh's Travels', *History Today*, vol. 42 (July 1992), p. 30; see also Appendix 2 below.

39 See Saumarez Smith (1997), pp. 9, 11–12.

40 Cumbria County Record Office, Carlisle D/LONS/L13.

41 See Saumarez Smith (1997), p. 58.

42 Downes (1959), p. 254, no. 136.

43 See Ch. 1 above, p. 26; on Wren see Soo (1998), p. 231.

44 Webb (1930–31).

45 Downes (1959), p. 283, nos 451–7. See Saumarez Smith (1997), pp. 42–4.

46 Serlio, Bk IV, fol. 139r. Serlio notes in Book 'VIII' that 'Doric work is the most austere of all and truly appropriate for a soldier. The entire work is therefore to be Doric but delicate, because of the great Emperor who was such an admirer of architectural beauty' (fol. 18r) in *Sebastiano Serlio on Architecture* (2001).

47 Albeit used without triglyphs in the freeze. Here at Greenwich, as already seen, the Ionic Order was adapted to the building's character. On the simple ornamentation chosen for the soldiers' church in the Hôtel des Invalides, a model for the layout at Greenwich, as a reflection of its purpose following the principles of decorum, see Berger, R. W., *A Royal Passion: Louis XIV as Patron of Architecture* (1994), p. 8.

48 Apparently removed in 1757 because the stucco weathered poorly; see engraving in *Wren Society Volumes*, vol. 19 (1924–43), pl. XL.

49 Serlio, Bk IV fol. 126v. In 'Book VIII' Serlio again makes clear that rustication 'is very suitable' as a symbol of protection and strength (fol. 17v) in *Sebastiano Serlio on Architecture* (2001).

50 Webb (1930–31), 4 January 1732.

51 Downes (1959), p. 254, no. 136.

52 Transcribed in Downes (1977), Appendix J, p. 266; see Saumarez Smith (1997), pp. 69, 156.

53 Downes notes that the idea 'that Castle Howard has an integrated symbolic programme is yet to be proved', in Ridgway and Williams (2000), p. 10.

54 Listed in work carried out between 21 June 1705–15 December 1709, see Saumarez Smith (1997), p. 65.

55 Downes (1959), p. 254, no. 136. Balanced opposites can also be found in the internal iconography of the house, with its vision of Apollo (sun) in the Great Hall contrasted with Diana (moon) in the Grand Cabinet at the west end of the garden front.

56 British Library, Additional MS 61353, no. 91.

57 British Library, Additional MS 61353, no. 252.

58 Ibid. (2 September 1725), 'but all the moldings and other ornam^ts were fully (for y^e Gallery) Drawne', 'Ther's none can judg so well of the designe as the person that composed it, therefore I should beg leave to take a convenient time to slip downe'. On this work see Downes (1959), pp. 202–10.

59 British Library, Additional MS 61353, no. 240.

60 'Letters to Henry Joynes, 1705–13', British Library, Additional MS 19607.

61 See Green, D., *Blenheim Palace* (1951, rep. 1967), pp. 298–9, 315.

62 Shaftesbury, *Letter Concerning the art or science of Design* (published in *Characteristicks*, 5th ed., 1732), pp. 401–2.

63 Aristotle, *Nicomachean Ethics*, IV.ii; see Onians, J., *Bearers of Meaning: The Classical Orders in Antiquity, the Middle Ages, and the Renaissance* (1988), pp. 123-6. See also Stevenson, C., 'Robert Hooke's Bethlem', *J.S.A.H.*, vol. 55 (1996), p. 268. Hart, V., and R. Tucker, '"Immaginacy set free": Aristotelian Ethics and Inigo Jones's Banqueting House at Whitehall', *Res*, vol. 39 (2001), pp. 151-67.

64 British Library, Additional MS 61353, no. 91; see Whistler, L., *Sir John Vanbrugh, Architect and Dramatist, 1664-1726* (1938), p. 237.

65 On this as the main route see Downes, K., *Vanbrugh* (1987), pp. 350-51.

66 Transcribed in Downes (1959), Appendix B, pp. 262-4; see also pp. 207-10. Marlborough had first proposed an obelisk, in 1716, see Downes (1977), p. 74.

67 McCormick (1991), p. 116.

68 British Library, Additional MS 61353, no. 240.

69 Bernini is correct. Hawksmoor's letter to the Duchess of Marlborough of 17 April 1722 (British Library, Additional MS 61353, no. 240) refers to 'the little fountain of Cavalier Bernini'. The sale catalogue lists a sketch by Hawksmoor of the Piazza Navona (lot 295) and his studies of the fountain in the piazza are at Blenheim, Downes (1959), p. 282, no. 449-50 (Blenheim 13F, 3F). In 1724 he commented to Carlisle concerning Vanbrugh's obelisks at Castle Howard that he would 'lift em up yᵉ same sort of Pedestall in Piazza Navona, don by Domnico Fontana', Downes (1959), p. 245, no. 70; see pp. 118, 207.

70 Marlborough was created Prince of Mindelheim by Emperor Joseph I and was entitled to bear his arms on the breast of the Imperial eagle, as they appear on the Saloon doorcases at Blenheim, see Green (1951), p. 208; Downes (1959), p. 208.

71 Downes (1959), p. 282, no. 447.

72 British Library, Additional MS 61353, nos 252 and 255. Downes (1959), p. 282, no. 448 lists Hawksmoor's study at Blenheim of Trajan's Column from an engraving, which formed the basis of his victory column there. Hawksmoor describes the pedestal of Trajan's Column in his obelisk 'explanation' and his sale catalogue lists Pietro Santi Bartoli's *Colonna Traiana eretta dal Senato, e Popolo Romano all'Imperatore Traiano* (1673), as well as Bartoli's *Columna Antoniniana Marci Aurelii Antonini Augusti rebus gestis insignis* (?1672; lots 128 and 159), see Watkin (1975), pp. 45-105. In 1723 Hawksmoor produced a drawing of Wren's design for the Monument, intended for engraving, Downes (1959), p. 284, no. 552 (see Fig. 199).

73 Serlio, Book III, p. CV. This alteration to Corinthian is compatible with Hawksmoor's apparent aversion to the Composite on the Mausoleum exterior at Castle Howard (see Chs 3 above and 10 below). A capital from this arch, as drawn by Fréart, was also proposed for inside the Mausoleum, see Hawksmoor's letter to Carlisle on 30 October 1733, in Webb (1930-31).

74 See Downes, *Vanbrugh* (1987), pp. 287-90.

75 Discussed by Downes (1977), p. 65; Downes, *Vanbrugh* (1987), pp. 309-10.

76 Barbarian captives appear on Trajan's Column and on the Arch of Constantine in Rome, as Hawksmoor would have seen in his copy of Desgodets (lot 109). He refers to the details of this arch on a sheet of details of cornices for Worcester College chapel, Downes (1959), p. 279, no. 264.

77 Palladio, Book IV, ch. vii, pp. 16, 18-19. Wren discusses the temple in Tract IV, *Parentalia* (1750), pp. 364-6 [transcribed in Soo (1998), pp. 179-84].

78 See Downes (1966), p. 80.

79 An early design is discussed in Downes (1966), p. 80. See also Downes (1977), p. 62. Hawksmoor drawings of the Doric south façade – Downes (1959), p. 283, nos 412-14.

80 Vanbrugh in a letter to the Duchess of Marlborough, entitled 'Reasons Offer'd for Preserving some Part of the Old Mannour' (11 June 1709), British Library, Additional MS 61353, no. 66, transcribed in Ridgway, C., 'Rethinking the Picturesque', in Ridgway and Williams (2000), p. 191.

81 On 27 July 1716: Dobrée and Webb (1928), p. 74.

82 Discussed by Bennett, J. A., *The Mathematical Sciences of Christopher Wren* (1982), p. 117. See also Soo (1998), p. 212. Mowl in Ridgway and Williams (2000), p. 86.

83 Everett, N., *The Tory View of Landscape* (1994), pp. 7, 38: 'Daniel Defoe, writing in the 1720s, saw the proliferation of country villas with informal parks and gardens as the best indication of a trading and improving country, the most flourishing and opulent in the world, and luxuriant in culture and commerce'. See *The Blessings of Peace: Queen Anne's speech to Parliament*, published in Dublin in 1713.

84 At the time of Castle Howard's conception, Carlisle was on the threshold of a political career. He served as a minister under William III and, briefly from December 1701, as first Lord of the Treasury (the most important political office in the realm). His political ambitions proved short-lived however, following the death of William III on 8 March 1702 and the accession of Anne. Anne favoured, at least at the start of her reign, the Tories as the 'Church party' over the Whigs whom she saw as political republicans. He was dismissed in May 1702, but he remained a committed Whig and was even briefly reinstated as first Lord of the Treasury in 1715. See Saumarez Smith (1997), esp. pp. 16-17: 'The trajectory of the third Earl's brilliant, but brief, political career as a minister of William III indicates that the plans for Castle Howard were made at exactly the moment when he was looking for promotion at Court. Building a great house was a means of drawing attention to his capabilities, of demonstrating his potential usefulness as an ally of the King'.

85 See Saumarez Smith (1997), pp. 6, 12-17, 38. On the Kit-Cat Club, see Downes (1977), pp. 18-19.

86 See Saumarez Smith (1997), pp. 39, 43.

87 See Downes (1977), p. 33. Although he is sceptical of this interpretation, Saumarez Smith (1997), p. 105, notes that when 'Verrio chose as subject for the Queen's Staircase at Windsor the scene of Apollo giving

Phaeton permission to drive the chariot of the sun, he must have known that it would have been identified in the minds of contemporaries with autocratic monarchy [following Versailles] and the divine right of kings. When, thirty years later, Pellegrini was invited to paint the Fall of Phaeton on the dome of Castle Howard, it could be concluded that contemporaries would have seen it as an image of the collapse of such ambitions, of the detestation of the English for French forms of government and a celebration of the individual liberty established by the Glorious Revolution'. But see also p. 106, where the Great Hall is interpreted as a palace of the sun (although the political overtones are still inescapable and by no means incompatible).

88 Downes (1977), Appendix J, p. 265.

89 William Kent, in the Temple of British Worthies at Stowe (c. 1735), included busts of those who had opposed 'slavish systems' of artistic, political and religious prejudice, fought for the glory of Britannia, or expanded the horizons of exploration and trade (Queen Elizabeth, King Alfred and William III). The Gothic temple was originally dedicated to Liberty. The Greeks Lycurgus, Socrates, Homer and Epaminondas, all honoured in Kent's Temple of Ancient Virtue, were promoters of Virtue, Justice, Liberty and the Welfare of Mankind, see Everett (1994), p. 48. Kent's work makes explicit the emblematic nature of informal gardens of the period, and their meaning as the embodiment of the values of the Glorious Revolution and the subsequent ideal of Whig rule as the most 'natural' form of government known to man. Everett, p. 44, notes that 'writing in 1760, the poetess Anna Seward depicted the improvements at Shugborough as an image of national liberty, since only in 'Freedom's Land' could forms reminiscent of the 'Mandarins' despotic power' be happily combined with 'Grecian domes' and be taken as images of pure delight rather than oppression'.

90 Chatsworth was begun during the 1680s for William Cavendish and was built by the first Duke of Devonshire, a political associate of Carlisle. Lowther Castle in Westmorland was built by John Lowther, Viscount Lonsdale, Carlisle's political ally and rival in the north. For Saumarez Smith, these houses were 'striking monuments to the consequences of the Revolution Settlement' (1997), pp. 22–3.

91 Everett (1994), p. 21, notes that Tory landowners had 'eschewed many fashionable activities, including forms of architecture and gardening which seemed devoted to private opulence, luxury and narrow ideas of possession'.

92 North, R., 'Notes of Building' (1698), ed. Colvin, H., and J. Newman, *Of Building: Roger North's Writings on Architecture* (1981), p. 3. Charles Davenant in his *The True Picture of a Modern Whig, Set Forth in a Dialogue between Mr. Whiglove and Mr. Double. Two Under-Spur-Leathers to the Late Ministry* (1701) noted that 'Now I am at my Ease, I have my Country-House where I keep my Whore as fine as an Empress', p. 31.

93 See Appendix 2 below, and Hart (1992), pp. 26–32.

94 Everett (1994), pp. 7, 38: 'Various attempts have been made in this century, as in the eighteenth, to argue that the style of informal landscape design that seemed to pervade England in the early eighteenth century was a "national style" based on ideas of constitutional liberty expressed in the Glorious Revolution of 1688. This style of improvement is often contrasted with the formality of less fortunate nations, in which nature was suppressed by a "presumptuous art", and topiary, avenues, and parterres could be seen as manifestations of some despotic tendency. In this view, liberty in Britain, together with security of property, created the condition for a rapid increase in national wealth and the general improvement of the landscape'. See Colley, L., *In Defiance of Oligarchy* (1982), pp. 9–10, 85, 99–100, 162–3, 195, 217, 274. See also Downes (1977), pp. 109–10, 'The seventeenth-century formal garden was based on the Cartesian concept of Nature as orderly and regular – Nature as exemplified in the heavenly bodies and the truth of mathematics, so that Wren could identify natural with geometrical beauty. There was a parallel in the minds of men like Shaftesbury or Addison, in the opening years of the eighteenth century, between the Whig liberation of the People from the toils of Absolutism and the liberation of natural forms from the topiarist's shears and the gardener's straight-edge. Vanbrugh was well aware of such parallels'.

95 See Everett (1994), p. 47.

CHAPTER 6

1 Measured drawings of this church were published in the *Builder* on 28 May 1915.

2 British Library, Additional MS 15506.

3 Vanbrugh, 'Mr. Van-Brugg's Proposals about Building ye New Churches', autograph MS, unsigned and untitled, Bodleian Library, Bod. MS Rawlinson B. 376, fols 351–2; the title is from a contemporary copy Bod. MS Eng. Hist. b. 2, fol. 47; transcribed in Downes, K., *Vanbrugh* (1977), Appendix E, pp. 257–8. On 2 November 1714 Vanbrugh submitted two designs for the new church in the Strand, Lambeth Palace Library, MS 2693, fol. 76.

4 See Jeffery, P., 'Originals or Apprentice Copies? Some Recently Found Drawings for St. Paul's Cathedral, All Saints, Oxford and the City Churches', *Architectural History*, vol. 35 (1992), pp. 127–8. Jeffery, P., *The City Churches of Sir Christopher Wren* (1996). Bradley, S., and N. Pevsner, *The Buildings of England. London 1: The City of London* (1997 ed.), pp. 82, 217, 236, 241, 247–9, 260, 265. On the new attribution to Hawksmoor of a handful of unsigned drawings see Geraghty, A., 'Nicholas Hawksmoor and the Wren City Church Steeples', *The Georgian Group Journal*, vol. 10 (2000), pp. 1–14.

5 'Papers of the Commission for Building Fifty New Churches', Lambeth Palace Library, MSS 2690 (minutes)–2729, 2747–2750 (repro: World Microfilm Publications, 1980).

6 Defoe, D., *A Tour Through the Whole Island of Great Britain* (1725), p. 327.

7 See Du Prey, P. R., 'Hawksmoor's "Basilica after the Primitive Christians": Architecture and Theology', *J.S.A.H.*, vol. 48 (1989), p. 42.

8 Lambeth Palace Library, MS 2750, nos 16 and 17. See Ch. 2 above, pp. 62–3. See also Downes, K., *Hawksmoor* (1959), p. 163; Lang, S., 'Vanbrugh's Theory and Hawksmoor's Buildings', *J.S.A.H.*, vol. 24 (1965), pp. 144–5; Rub, T., 'A Most Solemn and Awfull Appearance: Nicholas Hawksmoor's East London Churches', *Marsyas: Studies in the History of Art*, vol. 21 (1981–2), pp. 20–21; Cast, D., 'Seeing Vanbrugh and Hawksmoor', *J.S.A.H.*, vol. 43 (1984), p. 319. See esp. Du Prey (1989), pp. 38–52. Du Prey, P. R., *Hawksmoor's London Churches: Architecture and Theology* (2000).

9 Hawksmoor owned Stillingfleet's *Sermons* (lot 55). Wren also owned copies of Stillingfleet's work to which Hawksmoor could have had ready access, see Loach, J., 'Gallicanism in Paris, Anglicanism in London, Primitivism in Both', in Jackson, N. (ed.), *Plus ça change . . . Architectural Interchange between France and Britain: Papers from the Annual Symposium of the Society of Architectural Historians of Great Britain* (1999), p. 31. Hawksmoor also owned Martin Fotherby's *Atheomastix* (1622; lot 56), Henry Hammond's *Works* (1684; lot 94), Samuel Cradox's *The Harmony of the Four Evangelists* (1668) and *The Apostolical History* (1672; both lot 57), and Jenkin Philipps's *De Atheisme* (1716; lot 5). He owned Cardinal William Allen's *A Defense and Declaration of the Catholike Churchies Doctrine, touching Purgatory, and prayers for the souls departed* (1565; lot 17). See Watkin, D. (ed.), *Sale Catalogue of Libraries of Eminent Persons* (1975), vol. 4 [Architects], pp. 45–105.

10 See Du Prey (2000).

11 See Ch. 2 above, p. 42; and Rykwert, J., *The First Moderns* (1980), pp. 265–6.

12 Du Prey (2000) p. 77.

13 See Ch. 2 above, p. 62.

14 This work included descriptions of the early church buildings at Tyre, the church of the Holy Sepulchre at Jerusalem and the Martyrium of the Apostles at Constantinople, see Loach (1999), pp. 16–17, and on Wren's interests and sources, pp. 11–15. On Wheler's church see also Rykwert (1980), pp. 265–6. Wheler himself addressed the Commission on 16 November 1711 concerning his temporary tabernacle at Spitalfields, see Lambeth Palace Library, MS 2724, fol. 10 [426]. On this see Du Prey (2000), p. 99.

15 Most notably, on Hickes and Bingham see Du Prey (1989), pp. 45–52 and Du Prey (2000), p. 66.

16 Hickes, G., 'Observations on Mr. Van Brugg's proposals about Buildinge the new Churches', transcribed in Du Prey (2000), Appendix 3; on this see Du Prey (1989), pp. 45–6.

17 See Lang (1965), p. 144. See also Ch. 2 above, p. 37.

18 Church Commissioner's minutes for 16 July 1712 recommend 'that the ffonts in each Church be so large as to be capable to have Baptism administered in them by dipping when desired', see Lang (1965), p. 144. See Downes (1959), p. 163.

19 See Du Prey (2000), pp. 83–4.

20 See Rub (1981–2), p. 21.

21 See Downes (1959), pp. 195, 197. Worsley notes that 'No one has ever explained the inspiration behind these buildings, and they remain unique in European architecture', *Classical Architecture in Britain: The Heroic Age* (1995), p. 60; he somewhat implausibly suggests a source for forms (without explaining their meaning) in Du Cerceau's *Quoniam Apud Veteres alio Structurae Genere Templa Fuerunt Aedificata* (1550), a rare collection of prints of Roman temples which there is no evidence Hawksmoor ever saw or owned. Saumarez Smith, C., *The Building of Castle Howard* (1997), p. 170, even notes (without citing evidence) that through the Bloomsbury tower Hawksmoor had 'made himself the laughing-stock of London'. Du Prey (2000), p. 117, suggested that this was a joke on Hawksmoor's part. Hawksmoor's churches have often been studied in isolation, or as an expression of the general ideal of the 'Church Triumphant' made manifest through the combination of the Gothic silhouette and antique temple motifs. See Lang (1965), pp. 144–5; Rub (1981–2), p. 25; Cast (1984), p. 319: 'All the forms of the churches Hawksmoor built could carry associations'.

22 For the design requirements see 'Minutes of the Commission for Fifty New Churches', Lambeth Palace Library, MS 2690, fols 42–3 (repro: World Microfilm Publications, 1980); the sub-committee minutes are in MS 2693, which note for 11 July 1712 'That one General Modell be made and agreed upon for all the fifty new, intended Churches' (fol. 5). See Du Prey (1989), p. 43. See also Bill, E. G. W. (ed.), *The Queen Anne Churches: A Catalogue of the Papers in Lambeth Palace Library of the Commission for Building Fifty New Churches in London and Westminster 1711–1759* (1979), intro. by H. Colvin; Port, M. H. (ed.), *The Commission for Building Fifty New Churches: The Minute Books, 1711–17, a Calendar*, London Record Society, vol. 23 (1986).

23 Lambeth Palace Library, MS 2691, fol. 357, no. 7. The Bloomsbury steeple was paid for by a local brewer and vestryman, William Hucks, who had also financed the new parish workhouse. See Dobie, R., *A History of the United Parishes of St. Giles in the Fields and St. George Bloomsbury* (1834 ed.), p. 153; Clinch, G., *Bloomsbury and St. Giles: Past and Present* (1890), p. 129.

24 Alberti, Bk VIII, ch. 5, see Alberti, L. B., *On the Art of Building in Ten Books*, J. Rykwert, N. Leach, R. Tavernor (trans.) (1988).

25 Wren, in *Parentalia* (1750), pp. 318–21. See Soo, L., *Wren's 'Tracts' on Architecture and Other Writings* (1998), pp. 107–18. In this letter to one of his fellow Commissioners, dated before December 1711, Wren lists eight recommendations. On the towers and steeples by Wren and Hooke see Jeffery (1996), ch. 11, pp. 127–50.

26 'Mr. Van-Brugg's Proposals', see above n. 3. On Vanbrugh's debt to Alberti see Lang (1965), p. 130.

27 British Library, Additional MS 19607, fol. 44.

28 The sale catalogue records the drawings for 'the Tower of St. Michael's Cornhill' (lots 51 and 296) while his bill for models of 6 June 1717 includes 'modells of 2 steeples', Lambeth Palace Library, MS 2724, fol. 3.

29 Downes (1959), p. 258, no. 151.

30 In the above letter he notes 'The Church of Beverly, has 2 noble Square Towers at the West end'. See Du Prey (2000), pp. 107 and 165 n. 46.

31 See Jeffery (1996), pp. 130–31.

32 On ancient tower tombs see Wilson Jones, M., *Principles of Roman Architecture* (2000), pp. 70, 81. There was a traditional association between church towers and tombs, for the burial of master masons in their towers was a well established medieval practice of which Hawksmoor would surely have known.

33 William III: Downes (1959), p. 284, nos 535–43. Kent: ibid. (where it is tentatively identified as such), p. 284, no. 544 (although this drawing is bound with Blenheim drawings in the Bodleian).

34 References in Hawksmoor's letters to Carlisle show that he owned Pietro Santi Bartoli's romantic study of antique funereal monuments, entitled *Gli antichi sepolchri, overo mausolei romani et etruschi* (1697). He owned Giovanni Giacomo de Rossi's *Disegni di Vari Altari e Cappelle nelle chiese di Roma con le loro facciate fianchi piante e misure de piu celebri architetti* (1685; lot 120) and Carlo Fontana's *Templum Vaticanum et Ipsius Origo cum Ædificiis Maximè conspicuis antiquitus, & recèns ibidem constitutis* (1694; lot 118). Christian tombs were illustrated in the works of Domenico de Rossi (lot 125). Alberti had described various sepulchre designs in the eighth Book (on public secular buildings); indeed the 1565 edition owned by Hawksmoor illustrated a stepped mausoleum design. Giovanni Battista Montano's *Le cinque libri di architettura* (1636; lot 96) contained plates illustrating various forgotten crypts and sepulchres.

35 Vitr. IV. i. 9–10. Blondel's plate opens the second part of volume one.

36 Wren, Tract II, *Parentalia* (1750), pp. 356–7 [transcribed in Soo (1998), p. 159]. See Ch. 2 above, p. 49.

37 See Colvin, H., *Architecture and the After-Life* (1991), p. 17. Rykwert, J., *The Dancing Column* (1996), p. 320.

38 As with the Radcliffe Library design (see Ch. 3 above, p. 88), the use of urns here might have been intended to signify the library – at the centre of the new buildings – as a memorial to its benefactor (Sir Thomas Cookes).

39 *Vitruvius* (1684 ed.), pp. 217–19.

40 A statue of Bacchus in the temple at Baalbek stood, according to Hawksmoor's engraving, on an identical altar, and in one of his Halicarnassus-inspired façades he shows an antique warrior on a similar altar to the front of the building, Downes (1959), p. 278, no. 152 (see Fig. 74 (top right)). See also Alberti's description of ancient altars with statues in Bk VII, ch. 13.

41 Soo (1998), p. 217.

42 Item 8, MS 2690.

43 In 1723 Hawksmoor produced a drawing of Wren's design for the Monument, intended for engraving (see Fig. 199 and Ch. 8 below, p. 187), Downes (1959), p. 284, no. 552. His sale catalogue lists Pietro Santi Bartoli's *Colonna Traiana eretta dal Senato, e Popolo Romano all'Imperatore Traiano* (1673), as well as Bartoli's *Columna Antoniniana Marci Aurelii Antonini Augusti rebus gestis insignis* (?1672; lots 128 and 159). While discussing ancient sepulchres in the third chapter of his eighth book, Alberti discussed the design of giant free-standing columns, and Serlio in his third book (fol. 78r) illustrated Trajan's Column, the base of which contained the ashes of the emperor, alongside the obelisks of Rome. On Hawksmoor's column at Blenheim and its sources see Ch. 5 above, pp. 123–4. See also Loach (1999), p. 12.

44 Wren, *Parentalia* (1750), p. 322. A phoenix was also proposed and rejected, see 'Report of Dr. Wren concerning the Monument', 28 July 1675. British Library, Additional MS 18,898.

45 Downes (1959), p. 277, no. 143.

46 British Library, King's Topographical XXVIII. 11, (i) and (e).

47 See Du Prey (2000), p. 75.

48 Lambeth Palace Library, MS 2716, fol. 49 (referring to the non-delivery of a statue of the queen carved in Florence).

49 On this see Lang (1965), p. 133.

50 Bk VIII, ch. 2, see Alberti (1988).

51 Serlio, Bk III, p. LXII. Hawksmoor would also have known of this obelisk through his copy of Domenico Fontana's *Della trasportatione dell'obelisco Vaticano* (1590; lot 104) and his copy of Carlo Fontana's *Templum Vaticanum* (1694; lot 118) with its plates of Roman sepulchres and the Vatican obelisk.

52 See Webb, G. (ed.), 'The Letters and Drawings of Nicholas Hawksmoor Relating to the Building of the Mausoleum at Castle Howard, 1726–1742', *Walpole Society*, vol. 19 (1930–31), 3 September 1726.

53 Hawksmoor, N., *Remarks on the founding and carrying on the buildings of the Royal Hospital at Greenwich* (1728), p. 6.

54 Radcliffe: Downes (1959), p. 284, nos 545–56. Like urns, obelisks as decorative features, sometimes no more than a few feet in height, are a recurring conceit in Elizabethan and Jacobean funereal sculpture.

55 Transcribed in Downes (1977), Appendix J, p. 265.

56 British Library, King's Topographical XXVIII. 11 (d) and (i). See Rub (1981–2), p. 22. They have three interlocked carved frames, similar to those that bind the sacrificial altars together at St George-in-the-East. The pyramid was widely understood as a funereal form in England, Wren recommending to the Commissioners that cemeteries contain 'beautiful monuments', comprising 'a pyramid, a good bust, or statue on a proper pedestal', see *Parentalia* (1750), pp. 318–21 [transcribed in Soo (1998), pp. 112–18].

57 For example Wren used a miniature obelisk on the steeple at St Vedast's, Foster Lane – which may in fact

58 and Jeffery (1996), p. 146 – and used the Tower of the Winds, after the illustration in Cesariano's *Vitruvius* (fol. XXIV*v*), at St Bride, Fleet Street; Hawksmoor's drawings for the tower to the choir school at St Paul's, with its urns and obelisk pinnacles, suggest the design might be by him. On Hawksmoor's obelisk finial details see Geraghty (2000), p. 5.

be by Hawksmoor, see Jeffery (1992), pp. 124, 126, and Jeffery (1996), p. 146 – and used the Tower of the Winds, after the illustration in Cesariano's *Vitruvius* (fol. XXIV*v*), at St Bride, Fleet Street; Hawksmoor's drawings for the tower to the choir school at St Paul's, with its urns and obelisk pinnacles, suggest the design might be by him. On Hawksmoor's obelisk finial details see Geraghty (2000), p. 5.

58 See Jeffery (1996), pp. 142, 143; see also p. 136. The re-cladding of the medieval tower of St Andrew, Holborn, is here credited to Hawksmoor, p. 129. On anonymous and mostly unbuilt designs for the city churches, possibly by Hawksmoor (some with obelisks, altars and urns), held in the Guildhall Library (Gr 2.1.2), see Jeffery (1992), pp. 118–39.

59 Downes (1959), p. 276, nos 19 and 20.

60 On a drawing for the spire of St Edmund-the-King by Hawksmoor in the Tweet Kimball Collection, Sedalia, Colorado, see Geraghty (2000), pp. 10–11. See Jeffery (1996), pp. 141, 144. For St Anne, Limehouse, see Lambeth Palace Library, Book of Works 1712–22, MS 2697, fol. 640.

61 See Appendix 1 below. For the use of the pineapple as a funereal form in Soane's work (on a roof in the form of a giant urn lid), see Summerson, J., 'Sir John Soane and the Furniture of Death', *The Unromantic Castle* (1990), p. 135. On its use in antiquity (synonymous with the 'pine-cone'), see Smith, E. B., *Architectural Symbolism of Imperial Rome and the Middle Ages* (1956), pp. 28–9.

62 Hawksmoor drew urns above the cornice of his Blenheim façade designs, Downes (1959), p. 282, no. 412, and at Castle Howard, Downes (1959), p. 283, no. 461, p. 284, no. 525. Perhaps here too they served a memorial function, equivalent to the inscriptions on gates and the landscape memorials. An urn surmounts the famous Roman rock-cut tomb at Petra.

63 See Ch. 3 above, p. 88.

64 Downes, K., *Hawksmoor* (1970), p. 78. Eggs were a traditional symbol of resurrection, as for example in Piero della Francesca's Brera altarpiece of the Madonna and child with Federico II da Montefeltro.

65 Ibid., pp. 78, 79 (Fig. 65) (see below Fig. 317).

66 See Ch. 4 above, p. 98. Du Prey (2000), pp. 79, 92, links the use of altars to the idea that the primitive Christians built their churches from pagan spolia and *bricolage*. Here the so-called primitive forms are seen, quite simply, as of a primitive Christian 'style' (p. 93). Hawksmoor would have seen the sacrificial purpose of ancient altars discussed in his Alberti, see Bk VII, ch. 13.

67 British Library, King's Topographical XXVIII. 11 (e).

68 Langley, B., *Grub Street Journal*, 11 July 1734.

69 Downes (1959), p. 179, points out that these are quite clearly 'out of their proper context'.

70 Langley, B., *Grub Street Journal*, 11 July 1734.

71 British Library, King's Topographical XXIII. 21.2 (h), (k), (i).

72 British Library, King's Topographical XXIII. 21.2 (a). Pyramid roof drawn on the south elevation, XXIII. 21.2 (e).

73 The spire was rebuilt in the nineteenth century, but on the original spire crockets (as 'flame-like projections') emphasized the obelisk forms: see Downes (1970), p. 141. Du Prey (2000), p. 103.

74 Downes (1959), p. 278, no. 154; see Downes (1970), pp. 141–2; Du Prey (2000), p. 75.

75 British Library, King's Topographical XXIII. 11 (o).

76 Soo (1998), p. 30. This was presented to the Royal Society in August 1678, just before Hawksmoor is thought to have come into Wren's employ.

77 British Library, King's Topographical XXIII. 28.3 (o).

78 The plinth below the columns is ornamented with a funereal plaque of the type found on urns and tombs as illustrated in Bartoli (1697), pls 43, 49, 99 (a work used in the Castle Howard Mausoleum design, see above n. 34).

79 As John Soane later used in his rooftop 'tombs' on the nearby Bank of England, see Summerson (1990), pp. 121–42. Hawksmoor's design for the Provost's Lodging at King's College in Cambridge has broken pediments inspired by those of Michelangelo's famous Medici tombs in the New Sacristy in San Lorenzo, Florence. They were illustrated by Domenico de Rossi (lot 125) and had been used by Philibert de L'Orme on the chimneys of the entrance pavilion of the Château of Anet, illustrated (obliquely) in Androuet du Cerceau's *Livre d'Architecture* first published in 1559 (lot 144).

80 British Library, Additional MS 15506.

81 At Glanum. See Lang (1965), p. 133 and Appendix, p. 151. Wilson Jones (2000), p. 81.

82 Bodleian Library, MS Top Oxon a. 48. fol. 74. See Colvin, H., *Unbuilt Oxford* (1983), p. 29.

83 Held in the Guildhall Library, Gr 2.1.2; see Jeffery (1992), pp. 122–4, figs 9–12.

84 Downes (1977), Appendix E, pp. 257–8.

85 See Chs 2 and 3 above, pp. 42 and 88.

86 The Tower of the Winds formed the basis for the planned lantern at St Alfege as recorded by Jan Kip's engraving of the north façade of 1714 (in the event this lantern was replaced by a 'tempietto' design by James).

87 Such symbolism was held to be relevant to baptism, the sacrament of initiation into the Christian faith, whereby believers pass from death in sin to new life in Christ, and the infinite 'eighth day'. See Davies, J. G., *The Architectural Setting of Baptism* (1962), p. 16. Notable octagonal models were the Florence Baptistery and the Lateran Baptistery in Rome, which Hawksmoor would have seen when studying precedents for the baptistery he designed at St Paul's a few years earlier, around 1710 (which can be read internally as four great niches divided by four piers), (see Appendix 1 below, Fig. 348). On Wren's interest in the Resurrection see *Parentalia* (1750), pp. 201–2.

88 Downes (1970), p. 198.

89 According to Vitruvius (I.vi.4), Andromachus' octagonal tower reflected the planning of Greek cities around the eight winds and the path of the sun.

90 See Downes (1970), p. 121.

91 At Worcester College the chapel's bell tower was probably mirrored on the other side of the court next to

the hall (although this is unillustrated in the surviving drawings), as shown in a reconstruction by Paul Draper in Colvin (1983), p. 76.

92 Hawksmoor's own description, see Webb (1930–31), 4 January 1732.

93 On the 'mixed style' of these forms see Lang (1965), p. 148.

94 Soo (1998), pp. 26, 28, 255 n. 16.

95 Du Prey (2000), p. 92, notes that his churches 'resemble primitive Christian ones as he imagined they must have looked'.

96 See Ch. 2 above, p. 42.

97 The 1712 bill authorizing a second Commission had contained a specific clause forbidding burials inside churches, see Du Prey (1989), p. 43. Surveying suitable sites was one of Hawksmoor's responsibilities. The Commission minutes of 23 April 1725, for example, record that 'Mr Hawksmore & mr Prichd having view'd a piece of ground for a Burying Place for the Parish of St Mary Le Strand and brought in a Plan of same'. In his letter of 18 March 1735 to the Dean of Westminster, Hawksmoor approvingly noted that 'ye paving [is] not Suffered to be dug up for any buryalls whatsoever, at York or Beverly', Downes (1959), p. 259, no. 151.

98 See Williams, R., 'A factor in his success. The missing years: did Vanbrugh learn from Mughal mausolea?', *Times Literary Supplement* (3 September 1999), pp. 13–14. 'Vanbrugh's India and his Mausolea for England', in Ridgway, C., and R. Williams (eds), *Sir John Vanbrugh and Landscape Architecture in Baroque England 1690–1730* (2000), pp. 114–30.

99 In fact the traditional practice of burial in churches continued, see Williams in Ridgway and Williams (2000), p. 121.

100 See Rub (1981–2), pp. 21–2.

101 On the importance of architectural 'effect' to Hawksmoor and Vanbrugh see Chs 1 and 5 above, pp. 27 and 111–14.

102 Breval, J., *Remarks on several Parts of Europe* (1726), vol. 2, pp. 269–70.

103 Wren, Tract II, *Parentalia* (1750), p. 355 [transcribed in Soo (1998), p. 158].

104 On this morbid tendency see Gregg, E., *Queen Anne* (1980), p. 402. The *D.N.B.* entry for Anne notes that in her last years, partly due to her health, she lived so much to herself that her court at times seemed as if it were abandoned.

105 Du Prey (2000), p. 120, notes that 'Mother Nature aided the doomsayers by providing plenty of portents: severe winters that froze the Thames; the bubonic plague; the Great Fire of London and a slightly later one in Southwark; plus hurricanes, comets, and a total eclipse of the sun over London on 22nd April 1715'.

106 A sermon by Thomas Newlin (1688–1743), for example, printed in 1721 was entitled *God's gracious design in inflicting national judgements; a sermon preached before the university of Oxford, at St. Mary's, on Friday, Dec. 16th 1720. Being the day appointed by His Majesty for a general fast . . . for beseching God to preserve us from the plague.* There was an outbreak of plague in southern France in 1720–22, and in Toulouse in particular in 1721.

107 Webb (1930–31).

108 Letters to Carlisle, 10 November 1727 'at present' free from gout; 19 December 1732 'extreamly ill of the Gout'; 17 August 1734 'ill state of my health', see Webb (1930–31).

109 Swift, J., *The Examiner*, no. 42 (24 May 1711), reprinted in *The Prose Works of Jonathan Swift*, ed. H. Davis (1939–68), vol. 3, p. 160. See also Evans, R., 'Hawksmoor's Imposing Churches: An Interpretation', in Hoffman, A. von (ed.), *Form, Modernism, and History* (1996), p. 5.

110 Downes (1977), Appendix E, pp. 257–8.

111 The design is recorded in a set of prints by John Harris around 1713: British Library, King's Topographical XXIII. 28.1 (a), (b), (c).

CHAPTER 7

1 Alberti, L. B., *On the Art of Building in Ten Books*, J. Rykwert, N. Leach, R. Tavernor (trans.), (1988), Bk VI, ch. 13 (p. 183). Serlio, Bk VII, p. 98, see *Sebastiano Serlio on Architecture*, vol. 2, Books VI–'VIII' of *Tutte l'opere d'architettura et prospetiva*, V. Hart, P. Hicks (trans.), (2001).

2 See Chs 3 above, p. 78, and 10 below, pp. 236–40.

3 Du Prey notes that 'all six of the churches employ diverse types of columns. Much like the variation of the steeple designs, the varying of the orders surely connotes an overall design strategy on Hawksmoor's part', in *Hawksmoor's London Churches: Architecture and Theology* (2000), p. 110. The accompanying note 55 (p. 165) describes the Doric at St Alfege as 'enriched' and that at St Anne as 'plain', in reverse of actuality, and while Composite columns are absent from the porticoes, as Du Prey here notes, they are present in the steeples, as noted below.

4 See Onians, J., *Bearers of Meaning: The Classical Orders in Antiquity, the Middle Ages, and the Renaissance* (1988), p. 155; See Hart, V., 'From Virgin to Courtesan in Early English Vitruvian Books', in Hart, V., and P. Hicks (eds), *Paper Palaces: The Rise of the Renaissance Architectural Treatise* (1998), pp. 297–318.

5 Serlio, Bk VII, p. 232, in *Sebastiano Serlio on Architecture* (2001); here paraphrasing Alberti, Bk IX, ch. 2 (1988), p. 294. On this aspect see esp. Onians (1988), pp. 310–14.

6 See *Sebastiano Serlio on Architecture* (2001).

7 Evelyn, J., 'An Account of Architects and Architecture', appended to his *A Parallel of the Antient Architecture with the Modern* (1664 ed.), p. 122; (1707 ed.), p. 45. Ideas current in early 18th-century England on the art of representing human 'character', outlined for example by Lord Shaftesbury in his *Characteristicks of Men, Manners, Opinions, Times* (1711), developed this match between ornament and situation, see Rykwert, J., *The Dancing Column* (1996), p. 45.

8 Morris, R., *Lectures on Architecture* (1734), vol. 1, Lecture

VI, p. 86, 'The first Care in respect to Decoration, is the justly appropriating the Design to the Situation'. See Rykwert (1996), p. 54; see also Leatherbarrow, D., 'Architecture and Situation: A Study of the Architecture of Robert Morris', *J.S.A.H.*, vol. 44 (1985), pp. 48–59.

9 4 January 1732, see Webb, G. (ed.), 'The Letters and Drawings of Nicholas Hawksmoor Relating to the Building of the Mausoleum at Castle Howard, 1726–1742', *Walpole Society*, vol. 19 (1930–31).

10 Downes, K., *Hawksmoor* (1970), p. 121, notes that on the London churches and All Souls (designed around the same time, 1716) 'The basic forms are clothed in a style to fit their context'. See Ch. 3 above, p. 80.

11 On the poor social conditions of Spitalfields in particular see Evans, R., 'Hawksmoor's Imposing Churches: An Interpretation', in Hoffman, A. von (ed.), *Form, Modernism, and History* (1996), esp. p. 5.

12 Timothy Rub first contrasted the 'Corinthian portico of St George, Bloomsbury, with the Tuscan of Christ Church, or St George's richly articulated north façade with the chaste lateral elevations of St Anne. It is not so much the choice of ornament that sets the Stepney churches apart – the rusticated façade and blank niches of St Mary Woolnoth are as wilful and eclectic as anything Hawksmoor designed – but rather Hawksmoor's insistent simplification of ornament, more a difference of degree than of kind'; see 'A Most Solemn and Awfull Appearance: Nicholas Hawksmoor's East London Churches', *Marsyas: Studies in the History of Art*, vol. 21 (1981–2), pp. 21–2. More recently Du Prey has observed that 'for the benefit of different parishioners, the architect sought to vary his language' (2000), p. 118. On the siting of St George, Bloomsbury, bordering an affluent area, see Evans (1996), p. 7.

13 See George, M. D., *London Life in the Eighteenth Century* (1966 ed.), pp. 192–3.

14 These triglyphs are similar to, but not the same as, those used by Vasari on the Uffizi, Florence, in 1560.

15 Downes, K., *Hawksmoor* (1959), p. 174.

16 A wooden model of this was constructed, which is now lost; measured drawings based on it were made in 1826 by C. R. Cockerell; see ibid., pp. 172–3; Rub (1981–2), p. 26 n. 14. The design drawings for St Anne are held in the British Library, King's Topographical XXVIII. 11.

17 Lambeth Palace Library, MS 2724, fol. 173; both designs were approved on 29 July 1714. The interchangeability of elements on their designs is shown by the fact that on a plan for St George-in-the-East, British Library, King's Topographical XXIII. 21. 2 (a), Hawksmoor noted 'If what Mr Groves has provided for Waping Stepney Cannot do us at Limehouse – then we must be content to put it upon Wapping Church'.

18 British Library, King's Topographical XXIII. 21. 2 (k).

19 Suggested by M. J. Craig in Davies, J. H. V., 'Nicholas Hawksmoor', *R.I.B.A. Journal*, vol. 69, no. 10 (October 1962), p. 376.

20 As Hawksmoor notes on a sheet of details for his Worcester College chapel, Downes (1959), p. 279, no. 264.

21 The plainness of both structures would have matched John James's Protestant tastes: in a letter to the Duke of Buckingham of 20 October 1711, James declared his ambition to show 'that the Beautys of Architecture may consist with greatest plainness of the structure', Bodleian Library, MS Rawlinson B. 376, fol. 8.

22 The unpublished drawings for the parsonage are in Lambeth Palace Library, MS 2749 no. 8. See Mowl, T., 'Wholesome Hawksmoor, St John's Parsonage, Southwark', *Country Life*, vol. 184, no. 49 (6 December 1990), p. 166. All the churches were intended to have minister's houses (MS 2690, fol. 16); they were to be inexpensive since on 17 April 1718 it was 'Resolved that 'tis the opinion of this Board that no model of any Parsonage House be received whose Estimate shall exceed one thousand pounds' (MS 2691, fol. 5). At St John the house cost two thousand pounds (MS 2692, fols 109, 110); the vestry at St John was also by Hawksmoor (ibid. fols 83, 88). For an exploratory drawing for the siting of St Luke, Old Street, see MS 2750.

23 See Downes, K., *English Baroque Architecture* (1966), p. 108.

24 British Library, Additional MS 15506.

25 The interior included a Doric arcade and a coffered ceiling which Hawksmoor describes on the drawing (no. 21) as 'The ceiling of ye chancel, this is ye opera Reticulata of ye ancients, done in wood, the Rofes Gilt'.

26 On this area see Uglow, J., *Hogarth: A Life and a World* (1997), pp. 494–500.

27 Detail drawings, British Library, King's Topographical XXIII. 28. 3 (n), (w).

28 British Library, King's Topographical XXIII. 28. 3 (o). On these Jesuit churches, see Harris J., and G. Higgot, *Inigo Jones, Complete Architectural Drawings* (1989), p. 241; on winged cherubim as Jesuit signs, see p. 202.

29 British Library, King's Topographical XXIII. 28. 3 (g, verso).

30 On British Library, King's Topographical XXIII. 28. 3 (l), the only decoration is a bust drawn above the westernmost door.

31 Defined as such in Lambeth Palace Library, Book of Works 1712–22, MS 2697, fol. 719.

32 British Library, King's Topographical XXIII. 16.

33 Du Prey (2000), p. 110.

34 On Stukeley see Ch. 2 above, p. 47. For the early scheme see British Library, King's Topographical XXIII. 16. 2 (b) – with an octagonal dome, a projecting tetrastyle Corinthian portico and twin towers. The towers were a feature of the Pantheon in Hawksmoor's day, as illustrated in his copy of Giovanni Battista Falda's *Il nuovo teatro delle fabriche et edificii in prospettiva di Roma moderna* (1665– ; lot 154) or in Desgodets (lot 109). In the final building this is reflected in the use of a Corinthian portico below two pediments and the fact that during construction the idea of a dome resurfaced. On 13 June 1723 the Committee 'Ordered that ye said Roof be erected with a Cupola in form of ye Sd modell', Lambeth Palace Library, MS 2691, fol. 211. The corbelled cornice was also a feature which Hawksmoor

took from the Pantheon, as he notes on a sheet of details of cornices for Worcester College chapel, Downes (1959), p. 279, no. 264 (see also p. 187). Internally, the Pantheon's perfect form (a sphere) is matched by St George's cube.

35 As argued by Worsley, G., *Classical Architecture in Britain: The Heroic Age* (1995), p. 60.

36 Downes (1959), p. 281, nos 358 (1723) and 359–62 (1728). On 359 (R.I.B.A.) see Bold, J., *Greenwich: An Architectural History of the Royal Hospital for Seamen and the Queen's House* (2000), pp. 105–6. See the plan in Hawksmoor, N., *Remarks on the founding and carrying on the buildings of the Royal Hospital at Greenwich* (1728).

37 On Hawksmoor's familiarity with this plan, see Ch. 8 below, p. 196.

38 This sensitivity to site can be seen to hold true of other churches built by the Commission: consider the rich Ionic and Corinthian pilasters decorating the walls on James Gibbs's St Mary's in the Strand and the Corinthian portico on James's St George, Hanover Square, compared with the more sombre quasi-Doric of Thomas Archer's St Paul, Deptford.

39 Downes (1959), p. 278, no. 154; see Downes (1970), pp. 141–2; Du Prey (2000), p. 75.

40 See Ch. 5 above, pp. 105–10, 117–19.

41 Lambeth Palace Library, MS 2724, fols 120*r–v*. The ornateness of Wren's unbuilt St Mary's (c. 1697) at the centre of the affluent Lincoln's Inn Fields contrasted with Hawksmoor's eventual design for St Giles, for a poorer part of the same parish; see Jeffery, P., 'The church that never was: Wren's St Mary, and other projects for Lincoln's Inn Fields', *Architectural History*, vol. 31 (1988), pp. 136–44.

42 This ornamental scheme clearly impressed contemporaries, see Hatton, E., *A New View of London* (1708), vol. 2, pp. 459–60. See also Defoe's *Tour* of 1725, quoted below, p. 184.

43 See Onians (1988), pp. 264–86; Carpo, M., *La maschera e il modello: Teoria architettonica ed evangelismo nell'Extraordinario Libro di Sebastiano Serlio (1551)* (1993); *Sebastiano Serlio on Architecture* (2001).

44 Du Prey (2000), p. 98, compares the arrangement of these columns on St Anne, Limehouse, to Wren's steeple at St James's Garlickhill in the City (1713–17), but points out that the City church has full-blown Ionic capitals and by such a change Hawksmoor 'may have wished to subtly indicate a difference in tone between the metropolitan location of one building and the suburban site of the other. In addition, the simplification of the orders might render Saint Anne's more accessible to the ship chandlers, rope makers, and mariners of Limehouse, unused to the classical language of architecture but accustomed to medieval towers on ecclesiastical buildings'.

45 See also the design drawing, British Library, King's Topographical XXIII. 21. 2 (f).

46 Lambeth Palace Library, Book of Works 1712–22, MS 2697, fols 627, 629.

47 British Library, King's Topographical XXVIII. 11 (b), (d) and (e). This became an Egyptian cornice in a later

drawing, closer to the built scheme (Victoria and Albert Museum, E.417–1951).

48 Serlio, Bk IV fol. 141*v*. See *Sebastiano Serlio on Architecture*, vol. 1, Books I–V of *Tutte l'opere d'architettura et prospetiva*, V. Hart, P. Hicks (trans.), (1996).

49 This is true even on lantern forms similar to those of Hawksmoor, such as on Wren's St Michael, Paternoster Royal, with its canonic Ionic (free-standing) columns.

50 Ralph, J., *A critical review of the public buildings, statues and ornaments in, and about London and Westminster* (1734), p. 6. See also Chs 2 and 3 above, pp. 60 and 74.

51 Downes (1959), p. 257, no. 147.

52 See Ch. 3 above, p. 74.

53 He uses 'triglyph' capitals (again below urns) on one of his schemes for the Clarendon Building, for example, Downes (1959), p. 279, no. 266, but most of his Oxford schemes use canonic capitals. He is less respectful of canonic proportions in his work; see for example the Ionic 'pilasters' proposed for the Long Library at Blenheim, annotated by him as the 'Attick order' on Downes (1959), p. 282, no. 433.

54 See British Library, King's Topographical XXIII. 11 and CXXIV. 47 and 50.

55 Defoe, D., *A Tour Through the Whole Island of Great Britain* (1725), p. 331.

56 Ibid.

57 Ibid., p. 363.

58 Ibid., p. 331.

59 Ibid., p. 375.

60 Ibid., pp. 332–3.

61 Cawthorn, J., *Of Taste* (1756).

62 Langley, B., *Ancient Masonry* (1734–6), intro., p. 7. This quotes from Morris (1734), Lecture III p. 43 and Lecture V pp. 67–9.

63 Langley, B., *Grub Street Journal*, 11 July 1734.

64 Vanbrugh, 'Mr. Van-Brugg's Proposals about Building ye New Churches', autograph MS, unsigned and untitled, Bodleian Library, Bod. MS Rawlinson B. 376, fols 351–2; the title is from a contemporary copy Bod. MS. Eng. Hist. b. 2, fol. 47; transcribed in Downes, K., *Vanbrugh* (1977), Appendix E, pp. 257–8.

65 Wren, 'Letter to a Friend on the Commission for Building Fifty New City Churches', *Parentalia* (1750), pp. 318–21. See Soo, L., *Wren's 'Tracts' on Architecture and Other Writings* (1998), pp. 107–18.

66 Transcribed in Du Prey (2000), p. 142.

67 See above, n. 34. On a drawing for a side elevation of St Mary Woolnoth, Hawksmoor annotated 'Cornice Like that in y^e Temple of M[ars]. Vindicator', British Library, King's Topographical XXIII. 28. 3 (m).

CHAPTER 8

1 Downes, K., *Hawksmoor* (1959), p. 284, no. 552.

2 See Hewlings, R., 'Ripon's Forum Populi', *Architectural History*, vol. 24 (1981), pp. 39–52. Lang, S., 'Cambridge and Oxford Reformed: Hawksmoor as a Town-Planner', *Architectural Review*, vol. 103 (April 1948),

pp. 157–60. Lang, S., 'By Hawksmoor out of Gibbs', *Architectural Review*, vol. 105 (April 1949), pp. 183–90. White, R., *Nicholas Hawksmoor and the Replanning of Oxford* (1997); on this exh. cat. see Hart, V., untitled review in *Society of Architectural Historians of Great Britain Newsletter* (Spring 1998).

3 Downes (1959), p. 255, no. 147.

4 On this tower see Ch. 6 above, p. 157.

5 'Environs of the Schooles', Ashmolean Museum (GI 7); 'Regio Prima', Bodleian Library, Bod. MS Top. Oxon. a. 26. On the date of these drawings see Lang (1948), p. 159. See also Downes (1959), pp. 121–6.

6 A drawing in the Brasenose collection, Brasenose College B15.1 (s) (White (1997), no. 90), shows the outline of the college rebuilt, with the Radcliffe Library (attached to the Selden End of the Bodleian) and the open space which became Radcliffe Square; see Lang (1948), pp. 159–60. Downes (1959), p. 122.

7 Letter to Clarke, at All Souls, 'The Explanation of yᶜ Designes for All Souls' (1715; republished Oxford, 1960). Partly transcribed in Downes (1959), p. 240, no. 58.

8 British Library, King's Topographical VIII. 44. See Roberts, D., *The Town of Cambridge as it ought to be Reformed. The Plan of Nicholas Hawksmoor interpreted in an Essay by David Roberts* (1955).

9 See Lang (1948), p. 159. White (1997), p. 45. An Act of Parliament of 1720 facilitated the acquisition of the properties required to create Radcliffe Square, work on which began in 1733. On the clearance of sheds and houses next to the city wall, see below, p. 209.

10 See above, n. 8.

11 'The Explanation of the Obelisk', in Downes (1959), Appendix B, p. 264 (Bernini is correct). See Ch. 5 above, p. 123.

12 See Ch. 1 above, n. 31.

13 On Falda and Alexander's work see Krautheimer, R., *The Rome of Alexander VII 1655–1667* (1985).

14 Wren, Tract I, *Parentalia* (1750), p. 351 [transcribed in Soo, L., *Wren's 'Tracts' on Architecture and Other Writings* (1998), p. 153].

15 'Explanation of yᶜ Designes for All Souls', see above n. 7.

16 This laboratory had long been an ambition at Oxford, see Webster, C., *The Great Instauration, Science, Medicine and Reform 1626–1660* (1975), pp. 171–2.

17 Hawksmoor in his 'Report concᵍ sevˡ sites for churches in St Andrews, St Giles delivered to the Committee October 23 1711', Lambeth Palace Library, MS 2724, fols 120r–v.

18 Using Serlio as a possible source, as on the Woodstock arch at Blenheim, Hawksmoor's footprint of the arch on the 'Regio Prima' plan mirrors that of the Arch of Septimus Severus illustrated in Bk III fol. CX.

19 White (1997), p. 88. White interprets the square as only 'partly colonnaded', but it is difficult to see what the pencil lines which align with the colonnade on this south-eastern corner could have indicated other than the logical extension of the colonnade on the other three sides. A hypothetical reconstruction of this arrangement has been shown on the computer model (Fig. 283).

20 Downes (1959), p. 282, no. 448, lists Hawksmoor's study of Trajan's Column from an engraving. Hawksmoor describes the pedestal of Trajan's Column in his 'Explanation' and his sale catalogue lists Pietro Santi Bartoli's *Colonna Traiana eretta dal Senato, e Popolo Romano all'Imperatore Traiano* (1673), as well as Bartoli's *Columna Antoniniana Marci Aurelii Antonini Augusti rebus gestis insignis* (?1672; lots 128 and 159): see Watkin, D. (ed.), *Sale Catalogue of Libraries of Eminent Persons* (1975), vol. 4 [Architects], pp. 45–105. See also Ch. 6 above, p. 147.

21 See Lang (1949), pp. 183–4.

22 These drawings are held at All Souls, Worcester College and the Bodleian Library: see White (1997).

23 Downes (1959), p. 275, no. 1 (sketchbook).

24 White (1997), no. 43.

25 Skyline in Downes (1959), p. 275, no. 1 (sketchbook).

26 The Roman military camp had been an important source for Renaissance studies into antique planning (for example, by Serlio and Palladio). See *Sebastiano Serlio on Architecture*, vol. 2, Book 'VIII' of *Tutte l'opere d'architettura et prospetiva*, V. Hart, P. Hicks (trans.), (2001).

27 Gordon Cullen reconstructed four views of Hawksmoor's Cambridge in Roberts (1955). Hawksmoor's Cambridge is more difficult to model than is his Oxford because of the focus on one college and the outline nature of the overall plan. Cullen's somewhat speculative reconstructions are drawn in the same style as 'artists' impressions' used in contemporary town-planning.

28 Downes notes that the difference between the Cambridge and the Oxford plans is 'that in the latter the main axes are the centre lines of buildings and not of open spaces' which 'resulted in a more "free" sort of planning for Oxford', in *Hawksmoor* (1970), p. 94. However the 'Forum Universitatis' at Oxford (with its central statue) was also on axis with other buildings; at Cambridge Hawksmoor had more space in the town centre to play with than at Oxford. The approach to using axes and vistas remained consistent. Both schemes utilize an existing route redefined by a triumphal arch and square at either end, with a university forum or precinct positioned to one side off this route.

29 This scheme is shown on the overall plan, British Library, King's Topographical VIII. 45, and on a separate plan, British Library, King's Topographical VIII. 58b. A sketch reconstruction of the college is to be found in Downes (1959), pp. 113–15.

30 See preceding note.

31 Facsimile in Conway Library, Courtauld Institute, Hawksmoor box ref. 137/71 (11–12). Printed in Willis, R., and J. W. Clark, *The Architectural History of the University of Cambridge* (1886), vol. 1, p. 556. Downes (1959), p. 278, no. 158–71 (no. 164 for the west block has a Corinthian centrepiece, no. 167 for the north façade of the south block has a full Doric Order with triglyphs).

32 Downes (1959), p. 278, nos 172–80 (no. 180 has astylar walls with a Doric centrepiece). Models of the western (Fellows) block are at King's College.

33 Letter to the Master, Dr Gower, 16 May 1698 [transcribed in Bolton, A. T., and H. P. Hendry (eds), *Wren Society Volumes*, vol. 19 (1924–43), pp. 104–6; Downes (1959), p. 100 (on possible French and Italian models), p. 234, no. 1].

34 British Library, King's Topographical VIII. 57a.

35 Downes (1959), p. 120, places these in the building to the east of King's.

36 Wren's design for a Senate House and Library for Cambridge University, c. 1678 (original drawings in All Souls College, Oxford; facsimile in Cambridge University Library, Broadsides B.92.1). In 1675 the friend and admirer of Wren, Dr Isaac Barrow (the Master of Trinity College), tried to persuade the University of Cambridge to build a counterpart to Oxford's Sheldonian Theatre (1664–9). As formerly at Oxford, at Cambridge University ceremonies took place in the University church, and this was felt by some to be unsuitable. The deceased Bishop of Ely, Dr Benjamin Laney, had bequeathed £500 for a new building, provided it was begun within twelve months of his death (which was in January 1675). When Wren's design of a great hall and library was eventually 'wholly laid aside' by the University due to lack of funds, Barrow 'declared that he would go straight to his college, and lay out the foundations of a building to enlarge his back court, and close it with a stately library, which should be more magnificent and costly than what he had proposed to them'.

37 Item 12 on the key (unmarked) refers to a new Town Hall and Prison while 'S' (unmarked) denotes 'The Courts and Basilica ampli[fic]ata' (i.e., enlarged).

38 Wren's son noted, 'the Exchange [was] to stand free in the Middle of a Piazza . . . from whence the 60 Feet Streets as so many Rays, should proceed to all principal Parts of the City', in *Parentalia* (1750), p. 268. Discussed in Hart, V., *St Paul's Cathedral: Sir Christopher Wren* (1995), p. 15.

39 Hawksmoor, N., *Remarks on the founding and carrying on the buildings of the Royal Hospital at Greenwich* (1728), p. 13. On this reference to the parterre designed by Le Nôtre, see Ch. 9 below, p. 225.

40 Regarded as a deliberate alignment by J. H. V. Davies in 'Nicholas Hawksmoor', *R.I.B.A. Journal*, vol. 69, no. 10 (October 1962), p. 376. Certainly the church could easily have been positioned elsewhere on its open site and, as an inscription records, the lane on axis with the main (west) entrance was not given to the church until 1737, well after construction (the foundations were laid in 1714).

41 Downes (1970), p. 94. He notes in (1959), p. 125: 'The Oxford and Cambridge plans have to be experienced, not seen on paper'.

42 Alberti, L. B., *On the Art of Building in Ten Books*, J. Rykwert, N. Leach, R. Tavernor (trans.), (1988), Bk v, ch. 7.

43 Letter to the Master, Dr Gower, 16 May 1698 [tran-

44 scribed in *Wren Society Volumes*, vol. 19 (1924–43), pp. 104–6; Downes (1959), p. 100, p. 234, no. 1].

44 Downes (1959), p. 278, no. 217.

45 See Chs 2 and 4 above, pp. 49 and 91.

46 These plates were also available on their own; see Du Prey, P. R., *Hawksmoor's London Churches: Architecture and Theology* (2000), p. 31.

47 See Ch. 4 above, pp. 92–3.

48 Wren's Emmanuel College Chapel, Cambridge (1668–73), is situated centrally but is not free-standing.

49 See Ch. 6 above, p. 142. Atterbury was fully aware of the Radcliffe Library scheme, for which Hawksmoor produced various designs, see Lang (1949), p. 183. See Du Prey (2000), p. 51 (Atterbury and Smalridge).

50 See Du Prey (2000), pp. 28–9.

51 Ibid., p. 102.

52 Attributed to Hawksmoor and discussed in Downes (1959), pp. 88–98, p. 280, nos 326–58. See Bold, J., *Greenwich: An Architectural History of the Royal Hospital for Seamen and the Queen's House* (2000), pp. 98–108. See also Ch. 9 below, pp. 221–2.

53 On Libéral Bruant's Hôtel des Invalides see Humbert, J. M., and L. Dumarche, *The Tomb of Napoleon: The Hôtel des Invalides* (1996).

54 An early scheme for All Souls, superseded by January 1714, has the outline of Brasenose rebuilt and extended as two regular quadrangles; see White (1997), p. 65.

55 See Worsley, G., *Classical Architecture in Britain: The Heroic Age* (1995), pp. 105–7. Colvin, H., *Catalogue of Architectural Drawings of the Eighteenth and Nineteenth Centuries in the Library of Worcester College, Oxford* (1964).

56 This was published in William Kent's *Designs of Inigo Jones* (1727; lot 116; and subscribed to by Hawksmoor). On the influence of Villalpando's temple on Whitehall Palace see Hart, V., *Art and Magic in the Court of the Stuarts* (1994), pp. 105–15.

57 See White (1997), p. 75, no. 78. Hawksmoor also produced survey drawings of the Serlian window at the east end of the chapel, Downes (1959), p. 284, no. 549.

58 Downes (1959), pp. 153–4; White (1997), p. 66. See also Ch. 3 above, p. 84.

59 At Ockham the interior changes were to include a new 'lesser' staircase based on the Vitruvian tetrastyle hall described in VI.iii.8, see Downes (1959), p. 211. Hawksmoor calls this the 'Sall de quatre colonnes', suggesting his source was his 1684 edition of Perrault's *Vitruvius*, where the tetrastyle court is illustrated and described as a 'cour . . . a quatre colonnes' (p. 210), and the hall as 'des Salles . . . Tetrastyles', 'A quatre colonnes' (p. 215, in the margin) only a few pages back from the 'Edifice des Tuteles' on pp. 217–19 – on Hawksmoor's reference to which see Ch. 6 above, p. 146. On the resemblance between the refaced front of Ockham and the ancient house after Palladio, see Ch. 3 above, n. 88.

60 See Webb, G. (ed.), 'The Letters and Drawings of Nicholas Hawksmoor Relating to the Building of the Mausoleum at Castle Howard, 1726–1742', *Walpole Society*, vol. 19 (1930–31).

61 Tetrasyle atrium: plan, elevation and section (held at

Worcester College); see Eisenthal, E., 'John Webb's Reconstruction of the Ancient House', *Architectural History*, vol. 28 (1985), pp. 7-18.

62 See Colvin, H., *A Biographical Dictionary of British Architects 1600-1840* (1995 ed.), 'Aldrich', p. 71. Hawksmoor's sale catalogue lists 'L'Antichit. de Roma' (lot 7), possibly that by Palladio.

63 See White (1997), p. 71.

64 Downes (1959), p. 245, no. 74.

65 See Ch. 1 above, p. 16.

66 See Chs 3 and 4 above, pp. 85 and 96.

67 Downes (1970), pp. 196-7. See also Downes (1959), pp. 218-19, and Ch. 3 above, p. 85.

68 Pliny, *Letters* II. 17; see *Sebastanio Serlio on Architecture* (2001), p. 550 n. 227.

69 As Robert Castell was to note in 1728, see Harris, E., and N. Savage, *British Architectural Books and Writers 1556-1785* (1990), p. 152.

70 See White (1997), p. 83; see two letters from Hawksmoor to Dr Clarke (25 March and 11 April 1734), concerning alterations to Holdsworth's scheme, Magdalen College, Oxford, MS 906 (i) and (ii).

71 In fact the Bacchus temple at Baalbek is flanked by fifteen columns, although Hawksmoor's measurements are almost correct.

72 See Ch. 4 above, p. 92.

73 The drawing survives at Worcester College, Oxford, Colvin (1964), 321c. See Du Prey (2000), pp. 101 (Fig. 53), 102, 164 n. 36. See also Ch. 2 above, p. 39.

74 See Ch. 2 above, p. 47.

75 E.g., on his drawing for the garden front at Worcester College, Hawksmoor notes the Roman triumphal arch at Saintes, Charente, which he knew from Blondel's *Cours*, and for mouldings he notes the Arch of Constantine; see White (1997), pp. 73-5.

76 White (1997), pp. 49-50, no. 44.

77 See Ch. 6 above, p. 213.

78 See above n. 5.

79 As Loggan's Roman allusions make clear, academic processions drew on the tradition of the Entry. In projecting a triumphal arch rather than a mere ornamental gate at Oxford, Hawksmoor also referred to the Entry, in which Renaissance monarchs had sought publicly to emulate the archetypes of a Roman emperor entering a newly captured city and of Christ entering Jerusalem. The Triumph was thus an important device in remodelling cities conceived in imperial terms, in which the triumphal arch was the most important physical symbol. Inigo Jones's arch at Temple Bar, copied by Clarke in his proposed elevation of the High Street façade to All Souls, had formed part of a Stuart plan for a royal triumphal route from Westminster to St Paul's. Clarke (who studied Jones's work and purchased most of the architect's library for Worcester College), would surely have been aware of this when copying Jones's arch. Defoe in his *Tour* of 1725 mentions a triumphal entry into London by James I, indicating the popular interest in such processions in Hawksmoor's time. In 17th-century Britain, this form of imperial pageantry had become associated with traditional forms of national procession, including the King's procession to St Paul's from Whitehall and that of the Garter Knight's to Windsor Chapel. Elias Ashmole, founding benefactor of the Ashmolean Museum in Oxford, noted that 'We think it not amiss in speaking of *Processions* to divide them into *Military*, *Civil*, and *Ecclesiastical*: Under the Military may best be comprehended Triumphs, and the *Transuection* of the *Roman Knights*; under the Civil, the pompous *Entries* or *Cavalcades* of *Princes*, into or through any great *City*; and the *Ecclesiastical* are those generally so called, wherein the *Church* proceeds upon a solemn account of *Supplication* or *Thanksgiving*'. See Ashmole, E., *The Institutions, Laws & Ceremonies of the Most Noble Order of the Garter* (1672), p. 552.

80 Now at Worcester College; see Downes (1959), p. 275.

81 See Petter, H. M., *The Oxford Almanacks* (1974), p. 54. Hawksmoor celebrated Oxford as the seat of the muses in his letter to Clarke, and Clarke commissioned the muses on the Clarendon Building, see below, p. 219.

82 'Explanation of y^c Designes for All Souls', see above, n. 7.

83 On these schemes, see White (1997), pp. 38-40; see also Ch. 2 above, p. 42.

84 Hawksmoor's first scheme for the front of King's College in Cambridge has a triumphal arch entrance, here again suggesting the importance of routes and processions to his conception of the university town.

85 Elevations to Propositions 'A', 'I' and 'VI', White (1997), nos 3, 4, and 11.

86 See Downes (1959), p. 136; White (1997), no. 17.

87 White (1997), no. 20.

88 This Gothic design was engraved in 1721 (plan of c. 1717, see Fig. 270), ibid., no. 35a.

89 Downes (1959), p. 279, no. 253.

90 See Massar, P. D., *Presenting Stefano della Bella: Seventeenth-Century Printmaker* (1971), pp. 43-9.

91 Clarke, S., *C. Julii Caesaris, Quae Extant . . .* (1712). Hawksmoor also owned an alternative (unidentifiable) edition of Caesar's commentaries, in quarto (lot 48).

92 Downes (1959), p. 2 (on work c. 1689 at Hampton Court); Downes, K., *Vanbrugh* (1977), p. 44 (on Pellegrini).

93 'Explanation of y^c Designes for All Souls', see above n. 7.

94 David Loggan's *Oxonia Illustrata* (1675); Hawksmoor's copy of Loggan's *Cantabrigia Illustrata* (1688), also listed in lot 119, is held at the British Art Center at Yale University.

95 'Explanation of y^c Designes for All Souls', see above n. 7.

96 White (1997), no. 41; Downes (1959), p. 279, no. 265.

97 See Colvin, H., 'George Clarke', in Turner, J. (ed.), *The Dictionary of Art*, vol. 7 (1996), pp. 378-9.

98 Hawksmoor describes the building as such in a letter to Henry Joynes, British Library, Additional MS 19,607, 21 May 1713. Downes has noted that the surface plainness and restriction of detail in the Clarendon Building is 'appropriate to the industrial side of its character', in Downes, K., 'Hawksmoor', *Macmillan Encyclopedia of*

Architects (1982), p. 339. In Downes (1970), pp. 69, 70, he had suggested that one of Hawksmoor's early designs, where the pediment is enlarged to form a giant gable spanning the whole width of the building (Fig. 322), was 'like the portico to a giant but non-existent building'.

99 Downes (1959), p. 279, no. 268.
100 See Petter (1974), pp. 52–3.

CHAPTER 9

1 Defoe, D., *A Tour Through the Whole Island of Great Britain* (1725), p. 314.
2 See Downes, K., *Hawksmoor* (1959), p. 86. On Hawksmoor's work see also Bold, J., *Greenwich: An Architectural History of the Royal Hospital for Seamen and the Queen's House* (2000), pp. 112–13, 121, 125, 131 (concerning his staircase in the south-east pavilion of the King Charles Building), 134, 136–7, 142–5, 149 (proscenium arch), 157.
3 See Colvin, H., *A Biographical Dictionary of British Architects 1600–1840* (1995) p. 476. For a discussion of Hawksmoor's involvement at Greenwich, see Downes, K., *English Baroque Architecture* (1966), pp. 51–2, and *Sir John Vanbrugh, a Biography* (1987), pp. 372–3. Bold (2000) captions the east range of the Queen Anne Building as by Hawksmoor (p. 154 Fig. 203) and credits Hawksmoor with the design of the façades of the King William Building, under Wren's guidance (p. 135).
4 Downes (1959), p. 281, nos 359–62; Bolton, A. T., and H. P. Hendry (eds), *Wren Society Volumes*, vol. 6 (1924–43), pls XLVII and XLVIII. See Bold (2000), pp. 208–9.
5 Downes (1959), pp. 88–98 (p. 280, nos 326–58).
6 Ibid., p. 280, nos 326–32; *Wren Society Volumes*, vol. 6 (1924–43), pl. XII.
7 Downes (1959), pp. 281, nos 333–47; *Wren Society Volumes*, vol. 6 (1924–43), pls XXXVIII and XXXIX.
8 Downes (1959), p. 280, no. 333.
9 Ibid., p. 281, nos 348–56; *Wren Society Volumes*, vol. 6 (1924–43), pls XIV, XL and XLI.
10 See Hart, V., *Art and Magic in the Court of the Stuarts* (1994), p. 112.
11 Bold (2000), p. 191.
12 Hawksmoor, N., *Remarks on the founding and carrying on the buildings of the Royal Hospital at Greenwich* (1728), p. 5.
13 *Wren Society Volumes*, vol. 6 (1924–43), pp. 17–27.
14 See Chs 3 and 6 above, pp. 89 and 151.
15 See esp. Downes (1966), p. 33.
16 Le Nôtre's plan of c. 1666 (Bibliothèque de l'Institut de France, Paris) is published in Ganay, E. de, *André Le Nostre, 1613–1700* (1962), pl. 156 and in Bold (2000), p. 13; Hawksmoor's notes on a Greenwich Hospital plan of 1723 (at Wilton House) refer to 'The Grand Esplanade by Mons. Le Notre 1666', Downes (1959), p. 281, no. 358. On the attribution of the work to his assistant André Mollet, see Downes (1966), p. 125; but see Bold (2000), pp. 12–14.
17 Downes (1959), p. 255, no. 147. See Ch. 8 above, p. 187.

18 See McEwen, I. K., 'On Claude Perrault: Modernising Vitruvius', in Hart, V., and P. Hicks (eds), *Paper Palaces: The Rise of the Renaissance Architectural Treatise* (1998), pp. 321–37. In his copies of Blondel's *Cours*, Hawksmoor would also have seen that an *ordonnance* might be termed a *columnaison*, a coinage of Blondel's own invention that specifically concerns the column because it is 'the column that gives the rule and measure to everything else', Blondel, F. N., *Cours d'Architecture* (1675–83), p. 4; lots 90, 124 and 146, see Watkin, D. (ed.), *Sale Catalogue of Libraries of Eminent Persons* (1975), vol. 4 [Architects], pp. 45–105. In the following pages of his argument in favour of the work at Greenwich, Hawksmoor echoes this idea of regulating society through architecture, and by implication through the Orders.
19 Vanbrugh writing to Brigadier-General William Watkins in 1721, 'Letters', transcribed in Dobrée, B., and G. Webb (eds), *The Complete Works of Sir John Vanbrugh*, vol. 4 (1928), pp. 137–8. Quoted in Downes, K., *Vanbrugh* (1977), p. 91.
20 Virtue, G., 'Virtue Note Books', *Walpole Society* (ed. K. A. Esdaile), vol. 22, (1934), p. 51. Possibly Samuel Mellish of Doncaster, J.P., see Downes (1959), p. 1. According to Downes, in 1716 Hawksmoor designed a Court of Judicature in Westminster, a timber structure probably demolished around 1739, see Downes (1959), p. 281. See also Colvin, H., *The History of the King's Works, 1660–1782*, vol. 5 (1976), p. 389–90. This experience with the legal profession perhaps inspired what the Duchess of Marlborough described as his 'great honesty', see Introduction above, p. 1.
21 On this see Hart, V., 'On Inigo Jones and the Stuart Legal Body: "Justice and Equity . . . and Proportions appertaining"', in Tavernor, R., and G. Dodds (eds), *Body and Building: Essays on the Changing Relationship of Body and Architecture* (2002), pp. 138–49.
22 See Hart (2002), p. 146.
23 See Ch. 5 above, p. 123. On magnificence, in the context of the Hospital, see Bold (2000), p. 105; Stevenson, C., *Medicine and Magnificence* (2000).
24 Downes (1959), p. 281, no. 357; *Wren Society Volumes*, vol. 6 (1924–43), pl. LIII (Worcester College Vol.[62]); p. 102 notes that this scheme was 'probably quite unofficial'.
25 Hawksmoor (1728), p. 12; all preceding quotations in this chapter, pp. 5–14. On this ceremonial role at Greenwich see Bold (2000), p. 52.
26 Webb, G. (ed.), 'The Letters and Drawings of Nicholas Hawksmoor Relating to the Building of the Mausoleum at Castle Howard, 1726–1742', *Walpole Society*, vol. 19 (1930–31), 17 August 1734.
27 See Butt, J., *The Poems of Alexander Pope* (1963), p. 595, notes to ll. 195–204.
28 Webb (1930–31), 17 February 1736.
29 Downes (1959), p. 261, no. 163 (2 March 1736).
30 R.I.B.A. Drawings Collection, Hawksmoor cat., no. 4. Downes (1959), p. 282, no. 410.
31 Webb (1930–31), 3 October 1732.
32 On Stuart London as a 'New Rome', see Hart (2002).

In the dedication of his English translation of the *Parallèle* of 1664, Evelyn declared that Charles II was a 'paragon' to 'the Great Augustus', to whom Vitruvius dedicated his own treatise; see Harris, E., and N. Savage, *British Architectural Books and Writers 1556–1785* (1990), p. 197. On Sprat's comparison of London under Charles II with Augustan Rome see Soo, L., *Wren's 'Tracts' on Architecture and Other Writings* (1998), pp. 212–13.

33 Hawksmoor, N., *A Short Historical Account of London Bridge; with a Proposition for a New Stone-Bridge at Westminster* (1736), p. 11.

34 See Arnold, D., 'London Bridge and its Symbolic Identity in the Regency Metropolis: The Dialectic of Civic and National Pride', *Art History*, vol. 22, no. 4 (1999), pp. 545–66.

35 Hawksmoor (1736), pp. 5, 21.

36 It had been suggested by the parliamentary committee considering a petition for the new bridge, presented to Parliament on 4 February 1736, that Hawksmoor and Thomas Lediard should assist Thomas Cotton to formalize his scheme for planning improvements in conjunction with the new bridge. See Harris and Savage (1990), p. 232.

37 Defoe (1725), p. 322.

38 See ibid., pp. 355, 364. On Defoe's 'Corinthian' palace, see Downes (1966), p. 47.

39 Downes (1959), p. 280, nos 313–14, see also p. 281, nos 392–400 and pp. 63–6. See also Downes (1966), p. 46, and Thurley, S., *The Lost Palace of Whitehall* (1998).

40 Obituary transcribed in Downes (1959), p. 8.

41 Webb (1930–31).

42 Langley, B., *Grub Steet Journal*, no. 170 (29 March 1732), p. 2.

43 See Colvin (1976), p. 419.

44 Webb (1930–31).

45 Downes (1959), p. 281, no. 390 (Victoria and Albert Museum, E 414–1951).

46 Lediard, T., *Some Observations On The Scheme Offered by Messrs Cotton and Lediard* (1738), p. 13. Harris and Savage (1990), p. 232. See also Ch. 2 above, p. 49.

47 In reference to Palladio's Bk III, ch. xiii.

48 Hawksmoor (1736), p. 25.

49 Letter to Clarke, at All Souls, 'The Explanation of yᵉ Designes for All Souls', (1715; republished Oxford, 1960). Partly transcribed in Downes (1959), p. 240, no. 58. See Ch. 8 above, pp. 193–4.

50 Downes (1959), p. 281, nos 391–400; design for rebuilding the south front of Windsor (1698), no. 315, *Wren Society Volumes*, vol. 8 (1924–43), pls xi–xv. Sale catalogue lot 224, see Watkin (1975).

51 On these criticisms, see Appendix 2 below.

CHAPTER 10

1 See Ch. 5 above, p. 111.

2 See Hook, J., *The Baroque Age in England* (1976), p. 48. Hunter points out that Wren is not easily placed as a Tory or a Whig, in *Science and the Shape of Orthodoxy* (1995), pp. 51–2.

3 See Ch. 5 above, p. 117, and Appendix 2 below.

4 Hawksmoor, N., *Remarks on the founding and carrying on the buildings of the Royal Hospital at Greenwich* (1728), p. 6.

5 See Shaftesbury's *Inquiry concerning Virtue or Merit*, first published in 1699 and then in *Characteristicks of Men, Manners, Opinions, Times* (1711).

6 See Story, T., *A Journal of the Life of Thomas Story* (1747). See also Saumarez Smith, C., *The Building of Castle Howard* (1997), p. 10.

7 See Saumarez Smith (1997), pp. 162–8.

8 Story (1747), pp. 679–80.

9 19 June 1722, 'Letters', transcribed in Dobrée, B., and G. Webb (eds), *The Complete Works of Sir John Vanbrugh*, vol. 4 (1928), p. 147. See Colvin, H., *Architecture and the After-Life* (1991), pp. 160 and 317.

10 For example, as illustrated by Giovanni Giacomo de Rossi, (lot 120). It was noted in Ch. 4 above, n. 56, that Hawksmoor was capable of designing such symbolism, as on the altar canopy at York Minster. In the Mausoleum, the heads of cherubs over the central niche and in the frieze are the only decoration that could be identified with Christian symbolism. This starkness, within and without, mirrors Hawksmoor's Stepney churches.

11 See Saumarez Smith (1997), pp. 167–8.

12 Transcribed in Downes, K., *Vanbrugh* (1977), Appendix J, p. 265.

13 Downes, K., *Hawksmoor* (1959), Fig. 19b captions it as a 'Garden pedestal'. See also p. 283, no. 475.

14 See Colvin (1991), pp. 317–18.

15 Webb, G. (ed.), 'The Letters and Drawings of Nicholas Hawksmoor Relating to the Building of the Mausoleum at Castle Howard, 1726–1742', *Walpole Society*, vol. 19 (1930–31), 5 October 1732.

16 On Morpeth see ibid., 6 May 1727; Downes (1959), p. 250, no. 98, see p. 228. On the masculine character of rustication, see Ch. 3 above, p. 78. On 20 July 1734 Hawksmoor proposed 'to put 2 more courses of Rusticks under the great Basement, which I think may be done, and add much Magnificence and Beauty', Webb (1930–31).

17 Webb (1930–31).

18 Pliny, Bk XXXVI. iv. 30–32. In fact it was Ionic.

19 This was also the spacing of the Doric colonnade around one of the Radcliffe Library schemes, Downes (1959), p. 279, no. 295, see also p. 130.

20 See ibid., p. 229; Saumarez Smith (1997), p. 180.

21 Quoted in Webb (1930–31), p. 133.

22 Quoted in ibid., p. 133.

23 Ibid., 3 October 1732 (p. 135); Barbaro, D., *M. Vitruvii Pollionis de Architectura libri decem* (1567), p. 135: 'si vero Pycnostylon et Monotriglyphum opus erit faciendum; frons adis si Tetrastylos erit, dividatur in partes Decem, et novem et Dimidia, si Hexastylos in partes 29 etc'. Illustrations on pp. 137–8. Hawksmoor notes (Webb, p. 135): 'Vitruvius in the Reverend D. Barbaro gives us (as I said before) a Scheme of it, which I have enclos'd among these papers'.

24 Early English Vitruvian theorists had developed this, for

John Shute's *The First and Chief Groundes of Architecture* (1563), drawing on Cesariano and Philandrer in illustrating a series of five colonnades matched to the various Orders, regularized the Vitruvian progression. Diastyle (3 modules) is given to Doric, and therefore equated with temples to Mars, while pycnostyle is identified with Composite.

25 Webb (1930–31), 3 October 1732. Palladio, Doric Order, Bk I, ch. xv. Palladio's Composite intercolumniation was of one and a half modules (ibid., ch. xviii) and not all his temples are in fact pycnostyle – the temple at Tivoli (Bk IV, ch. xxiii) was systyle although Hawksmoor claims that it too was 'Pictnostyle in its disposition'.

26 See Webb (1930–31), 29 March 1729: 'There must be this precaution had, that thô we can make yᵉ pillars of many small Stones, yet yᵉ Architrave and Entablement will require greater. Now if Mʳ Etty can tell me, how we can find stones in yᵉ Quarry for obviating that difficulty. I am entirely for a Colonade'. See also Appendix 1 below.

27 See Ch. 5 above, p. 125.

28 See Ch. 3 above, pp. 78–9.

29 Webb (1930–31), 3 October 1732.

30 Ibid.

31 Milton, J., *Paradise Regained*, IV, ll. 240–41: '*Athens* [was] the eye of *Greece*, mother of arts/And eloquence, native to famous wits'; from Leonard, J. (ed.), *John Milton: The Complete Poems* (1998), p. 452. On the cultivation of Greek art at this time see Larrabee, S. A., *English Bards and Grecian Marbles* (1943), p. 66; Lang, S., 'Vanbrugh's Theory and Hawksmoor's Buildings', *J.S.A.H.*, vol. 24 (1965), pp. 142–7.

32 Shaftesbury, 'Miscellaneous Reflections', in *Characteristicks* (1711), vol. 3, pp. 140ff.

33 Wheler, G., *An Account of the Churches, or Places of Assembly, of the Primitive Christians* (1689), pp. 63ff. See Lang (1965), p. 144. See Chs 2 and 6 above, pp. 42 and 140.

34 Soo, L., *Wren's 'Tracts' on Architecture and Other Writings* (1998), p. 121.

35 See Downes, K., *Hawksmoor* (1970), pp. 192–200.

36 See Ch. 3 above, p. 83.

37 Transcribed in Downes (1977), Appendix J, p. 264.

38 Certainly concerning his Belvedere design, which was suggested as an alternative to Vanbrugh's temple, Hawksmoor describes the 'apertures' as 'ornaments after yᵉ Greek manner', in a letter to Carlisle of 7 January 1724, Downes (1959), p. 244, no. 67.

39 See Ch. 3 above, p. 84, and Downes (1970), p. 194. The Mausoleum was identified by Hawksmoor as a counterpart to his octagonal temple that housed a statue of 'the Greek Venus Gilt', see Webb (1930–31), 19 July 1735. This open temple of Venus would have contrasted strongly with the enclosed Mausoleum being built at the same time (1731–5), both designs discussed simultaneously by Hawksmoor in his letters to Carlisle. For the temple was dedicated to the goddess of love, rejuvenation and resurrection, as symbolized by its octagonal form and flaming roof-torch in the surviving drawing. Furthermore this was a 'monopteral' temple and the Mausoleum a 'peripteral' one, and as Hawksmoor himself pointed out to Carlisle on 3 October 1732, both thus exemplified, and were an exercise in, the two archetypal circular temples described by Vitruvius (IV.viii.1).

40 Suggested by Downes (1970), p. 199. Downes adds that 'A specific interpretation of the Mausoleum colonnade accords with the meaning of the building: it is the house of the dead', p. 200.

41 See Ch. 2 above, p. 42.

42 Fréart, R. (Sieur de Chambray), *Parallèle de l'architecture antique et de la moderne* (1650), p. 3.

43 In his letters to Carlisle of 3 October 1732: 'Mr Evelyn in his addition to the Paralell of Monsr. Chambrey doth not forbid the Dorick Order, to the Picnostyle disposition'; and on 30 October 1733: 'The capital I wou'd Recommend is that upon the Arch of Titus at Rome, it is in the parrallel of Architecture', see Webb (1930–31).

44 Evelyn, J., 'An Account of Architects and Architecture', appended to the 2nd ed. of his *A Parallel of the Antient Architecture with the Modern* (1707), p. 46.

45 Webb (1930–31), 3 October 1732.

46 Shaftesbury (1711), vol. 3, pp. 140ff.

47 See Ch. 5 above, pp. 127–9.

48 See Hook (1976), pp. 40–51.

49 Webb (1930–31), 4 December 1732.

50 Annotation by Hawksmoor on his drawing possibly for the Duchess of Kent's tomb, see Ch. 6 above, p. 144.

51 Webb (1930–31). Robinson wrote on the same day to Carlisle concerning the alterations, reporting he would 'shew them to Lᵈ Burlington first and let yr Lᵈˢʰᵖ know what he says of it', quoted in ibid., p. 149.

52 Campbell refers to the 'Antique Simplicity' in the Introduction to *Vitruvius Britannicus, or the British Architect* (1715).

53 See Sicca, C. M., 'Burlington', in Turner, J. (ed.), *The Dictionary of Art*, vol. 4 (1996), p. 609.

CONCLUSION

1 Perrault, C., *A Treatise of the Five Orders of Columns in Architecture*, J. James (trans.), (1708), preface, pp. ii–iii.

2 As, for example, in Swift's *A Tale of a Tub: written for the universal improvement of mankind, to which is added, an account of a battle between the ancient and modern books in St James's Library* (1704).

3 As characterized by Peter Ackroyd in *Hawksmoor* (1985).

4 See Hart, V., *Art and Magic in the Court of the Stuarts* (1994).

5 Letter to Carlisle, 11 July 1728: see Webb, G. (ed.), 'The Letters and Drawings of Nicholas Hawksmoor Relating to the Building of the Mausoleum at Castle Howard, 1726–1742', *Walpole Society*, vol. 19 (1930–31).

6 On Wren's 'compromise' between the 'Ancients' and the 'Moderns', see Hart, V., *St Paul's Cathedral: Sir Christopher Wren* (1995), p. 7; Levine, J. M., *Between the*

Ancients and the Moderns: Baroque Culture in Restoration England (1999), pp. xii, 161–209; Soo, L., *Wren's 'Tracts' on Architecture and Other Writings* (1998), pp. 213–14. On the divided nature of 18th century culture, between science and myth, see Pérez-Gómez, A., *Architecture and the Crisis of Modern Science* (1983); Vesely, D., 'Architecture and the Conflict of Representation', *AA files*, vol. 8 (1985), pp. 21–38.

7 See Webb (1930–31), p. 149. See also the Introduction and Ch. 10 above, pp. 241–2.

8 See Downes, K., *Hawksmoor* (1970), pp. 148–9. Worsley, G., *Classical Architecture in Britain: The Heroic Age* (1995), pp. 83, 106. See also Worsley, G., 'Nicholas Hawksmoor: A Pioneer Neo-Palladian?', *Architectural History*, vol. 33 (1990), esp. p. 71.

9 See Levine (1999), p. 204.

10 See Worsley (1995), p. 83. Worsley acknowledges that 'This is not to say that Hawksmoor's architecture can be explained solely by reference to the Antique' (p. 61).

11 Rather than being obsessively concerned with antique reconstruction, as recently claimed in ibid, p. 54.

12 Downes, K., *Hawksmoor* (1959), p. 244, no. 67.

13 See Worsley (1995), p. 71, where the Baroque is described as 'the most ambitious Classical style of all'.

14 See Downes, K., *Vanbrugh* (1977), pp. 77–8; Downes, *Sir John Vanbrugh* (1987), p. 403.

15 Campbell, C., *Vitruvius Britannicus, or the British Architect* (1715), Introduction.

16 See Appendix 2 below.

17 Vanbrugh, writing to Brigadier-General William Watkins in 1721, 'Letters', transcribed in Dobrée, B., and G. Webb (eds), *The Complete Works of Sir John Vanbrugh*, vol. 4 (1928), pp. 137–8. Quoted in Downes (1977), p. 91.

18 Hawksmoor, N., *Remarks on the founding and carrying on the buildings of the Royal Hospital at Greenwich* (1728), p. 8.

19 Campbell (1715), Introduction.

20 See Downes, K., *English Baroque Architecture* (1966), pp. 9, 11.

21 Langley, B., *Grub Street Journal*, no. 237 (Thursday 11 July 1734).

22 Webb (1930–31), 10 November 1727.

23 Wren, Tract I, *Parentalia* (1750), p. 352 [transcribed in Soo (1998), p. 137].

24 Webb (1930–31), 10 November 1727.

APPENDIX 1

1 Letters transcribed in Webb, G. (ed.), 'The Letters and Drawings of Nicholas Hawksmoor Relating to the Building of the Mausoleum at Castle Howard, 1726–

1742', *Walpole Society*, vol. 19 (1930–31), pp. 111–63. *Mrs Hawksmoor's Bill*, in Downes, K., *Hawksmoor* (1959), Appendix C, p. 266. Arcade designs, Downes (1959), p. 283, nos 479–81, arcade and colonnade compared, no. 483. See also Webb (1930–31), pls XVIII–XXI.

2 *Mrs Hawksmoor's Bill*, in Downes (1959), p. 266.

3 See Ch. 10 above, p. 236.

4 See Downes (1959), pp. 229–30.

5 Bartoli's section of the Tomb of Metella indicates a dome. Montano's *Le cinque libri di architettura* (1636; lot 96) gives a reconstruction of the tomb with a dome on an upper drum (Bk III, pl. 33). Downes, K., *Hawksmoor* (1970), p. 198 notes: 'his design, only known from his covering letter, was crowned with some sort of dome and had clerestory windows invisible from outside'.

6 For a consideration of the concealed lighting of the chapel, as a stimulus for the final solution (in which the entablature of the colonnade conceals the clerestory windows), see Downes (1959), pp. 224–5.

7 See Colvin, H., *Architecture and the After-Life* (1991), pp. 317–18.

8 *Mrs Hawksmoor's Bill*, in Downes (1959), p. 266.

APPENDIX 2

1 See esp. Hook, J., 'The Political Framework of the English Baroque', *The Baroque Age in England* (1976), pp. 40–51 (ch. 3).

2 'Carolini', *A Key, or Gulliver Decypher'd* (1727), p. 19 n. IV.

3 See Hart, V., 'Vanbrugh's Travels', *History Today*, vol. 42 (July 1992), pp. 26–32.

4 See Foot, M., 'Introduction' to the Penguin edition of Swift's *Gulliver's Travels*, first published in 1967, p. 27.

5 On the advent of the concept of the 'individual', in the 17th century, see Rykwert, J., 'Privacy in Antiquity', *Social Research*, vol. 68, no. 1 (2001), pp. 29–40.

6 In Butt, J., *The Poems of Alexander Pope* (1963), p. 592, ll. 99–110.

7 From Sherburn, G. (ed.), *The Correspondence of Alexander Pope*, vol. 1 (1956), p. 432. See Brownell, M. R., *Alexander Pope and the Arts of Georgian England* (1978), p. 312.

8 Letter to Carlisle, 4 January 1732: see Webb, G. (ed.), 'The Letters and Drawings of Nicholas Hawksmoor Relating to the Building of the Mausoleum at Castle Howard, 1726–1742', *Walpole Society*, vol. 19 (1930–31).

9 See Hart (1992).

10 Defoe, D., *A Tour Through the Whole Island of Great Britain* (1725), p. 29.

PRIMARY SOURCES

Alberti, L. B., *On the Art of Building in Ten Books*, J. Rykwert, N. Leach, R. Tavernor (trans.), Cambridge, Mass. (1988).

Aldrich, H., *Elementorum Architecturae Pars Prima De Architecturae Civili* [Oxford, ?1708].

Anderson, J., *The Constitutions of the Free-Masons, Containing the History, Charges, Regulations, etc., of that Most Ancient . . . Fraternity*, London (1723, republished 1738).

Aristotle, *Nicomachean Ethics*, J. A. K. Thomson (trans.), London (1976).

Ashmole, E., *The Institutions, Laws & Ceremonies of the Most Noble Order of the Garter*, London (1672).

—*Elias Ashmole (1617–1692), His Autobiographical and Historical Notes* (ed. C. H. Josten), 5 vols, Oxford (1966).

Barbaro, D., [Vitruvius], *M. Vitruvii Pollionis de Architectura libri decem*, Venice (1567).

Bartoli, P. S., *Columna Antoniniana Marci Aurelii Antonini Augusti rebus gestis insignis*, Rome (?1672).

—*Colonna Traiana eretta dal Senato, e Popolo Romano all'Imperatore Traiano*, Rome (1673).

—*Gli antichi sepolchri, overo mausolei romani et etruschi*, Rome (1697).

Bathoe, W., *A Description of Easton Neston*, London (1758).

Bingham, J., *Origines Ecclesiasticae: or, the Antiquities of the Christian Church*, London (1708–22).

Blondel, F.-N., *Cours d'Architecture, enseigné dans l'Academie royale d'architecture*, Paris (1675–83).

Bolton, A. T., and H. P. Hendry (eds), *Wren Society Volumes*, 20 vols, Oxford (1924–43).

Bordino, G., *De Rebus Praeclare Gestis a Sixto V Pont. Max*, Rome (1588).

Breval, J., *Remarks on several Parts of Europe*, London (1726).

Bridges, J., *The History and Antiquities of Northamptonshire*, 2 vols, Oxford (1791).

Burton, R., *The Anatomy of Melancholy*, Oxford (1621).

Calvin, J., *Christianæ religionis Institutio*, Basle (1536).

Campbell, C., *Vitruvius Britannicus, or the British Architect*, 3 vols, London (1715–25).

'Carolini', *A Key, or Gulliver Decypher'd*, London (1727).

Caussin, N., *De Symbolica Aegyptiorum Sapientia*, London (1631).

Cave, W., *Primitive Christianity, or The Religion of the Ancient Christians in the First Ages of the Gospel*, London (6th ed. 1702).

Cawthorn, J., *Of Taste* (1756), in R. Anderson (ed.), *Poetical Works*, vol. 10, Edinburgh (1794).

Clarke, S., *C. Julii Caesaris, Quae Extant . . .*, London (1712).

Clinch, G., *Bloomsbury and St. Giles: Past and Present*, London (1890).

Colonna, F., *Hypnerotomachia Poliphili*, Venice (1499).

Contarini, G., *De Officio Episcopi*, Paris (1516).

Davenant, C., *The True Picture of a Modern Whig, Set Forth in a Dialogue between Mr. Whiglove and Mr. Double. Two Under-Spur-Leathers to the Late Ministry*, London (1701).

De Cordemoy, P. J.-L., 'Dissertation sur la manière dont les Eglises doivent être bâtie', in *Nouveau traité de toute l'architecture, ou l'art de bastir; utile aux entrepreneurs et aux ouvriers*, Paris (1714 ed.).

Defoe, D., *A Tour Through the Whole Island of Great Britain*, London (1725).

De los Santos, F., *Descripción del Real Monasterio de San Lorenzo del Escorial*, Madrid (1681).

De Montfaucon, B., *L'antiquité expliquée, et représentée en figures*, Paris (1719).

Desgodets, A. B., *Les Edifices Antiques de Rome Dessinés et Mesurés tres Exactement*, Paris (1682).

Dobie, R., *A History of the United Parishes of St. Giles in the Fields and St. George Bloomsbury*, London (1834 ed.).

Du Cerceau, A., *Livre d'Architecture*, Paris (1559).

Dugdale, W., *The History of St. Paul's Cathedral in London*, London (1716 ed.).

Evelyn, J., 'An Account of Architects and Architecture', appended to the 2nd ed. of his *Parallel* (1707: see under Fréart), pp. 1–57.

—*The Diary of John Evelyn* (ed. J. Bowle), Oxford (1983).

Félibien, J.-F., *Recueil historique de la vie et des ouvrages des plus célèbres architectes*, Paris (1687).

—*Les plans et les descriptions de deux des plus belles maisons de campagne de Pline le Consul*, Paris (1699).

Fisher von Erlach, J. B., *Entwurff einer historischen Architectur*, Vienna (1721).

Fontana, C., *Templum Vaticanum et Ipsius Origo cum Ædificiis Maximè conspicuis antiquitus, & recèns ibidem constitutis*, Rome (1694).

Fontana, D., *Della trasportatione dell'obelisco Vaticano et delle fabriche di Nostro Signore Papa Sisto V*, Rome (1590).

Fréart, R., (Sieur de Chambray), *Parallèle de l'architecture antique et de la moderne*, Paris (1650); trans. J. Evelyn, *A Parallel of the Antient Architecture with the Modern*, London (1664, 2nd ed. 1707).

Gent, T., *Pater Patriae: Being, An Elegiac Pastoral Dialogue occasioned by the most lamented Death of the Late Rt. Honble and Illustrious Charles Howard*, York (1738).

Gevaerts, J. G., *Pompa triumphalis introitus Ferdinandi*, Antwerp (1642).

Greaves, J., *Pyramidographia: or a description of the pyramids in Egypt*, London (1646).

— *A Description of the grand Signor's Seraglio, or Turkish Emperours Court*, London (1650).

Grelot, G.-J., *Relation nouvelle d'un voyage de Constantinople*, Paris (1680).

Gunther, R. T. (ed.), *The Architecture of Sir Roger Pratt, Charles II's Commissioner for the Rebuilding of London after the Great Fire: Now Printed for the first time from his Note-Books*, Oxford (1928).

Hatton, E., *A New View of London*, 2 vols, London (1708).

Hawksmoor, N., *Remarks on the founding and carrying on the buildings of the Royal Hospital at Greenwich*, London (1728); rep. (with important omissions) in Bolton, A. T., and H. P. Hendry, *Wren Society Volumes*, vol. 6, pp. 17–27.

— *A Short Historical Account of London Bridge; with a Proposition for a New Stone-Bridge at Westminster. As also an Account of some Remarkable Stone-Bridges Abroad, and what the best Authors have said and directed concerning the methods of Building them. Illustrated with proper cuts. In a Letter to the Right Honourable the Members of Parliament for the City and Liberty of Westminster*, London (1736).

Hooke, R., *The Diary of Robert Hooke: 1672–1680* (ed. Robinson, H. W., and W. Adams), London (1935).

— *Diary: 1688–1693* in R. T. Gunther (ed.), 'Life and Work of Robert Hooke (Part IV)', *Early Science in Oxford*, vol. 10, Oxford (1935).

Irwin, A. (Viscountess), *Castle Howard*, London (1732); transcribed in K. Downes, *Vanbrugh* (1977), Appendix J, pp. 263–6.

James, J., *A Treatise of the Five Orders of Columns in Architecture*, London (1708); McEwen, I. (trans.), *Ordonnance for the Five Kinds of Columns*, Santa Monica, Calif. (1993).

King, P., *An Enquiry into the Constitution, Discipline, Unity, and Worship of the Primitive Church*, London (1691).

Kircher, A., *Oedipus Aegyptiacus*, Rome (1652–4).

— *Sphinx mystagoga*, Amsterdam (1676).

Langley, B., *Grub Street Journal*, 11 July 1734.

— *Ancient Masonry*, London (1734–6).

Laugier, M.-A., *Essai sur l'Architecture*, Paris (1753).

Le Brun, C., *Voyage au Levant*, Paris (1714).

Lediard, T., *Some Observations On The Scheme Offered by Messrs Cotton and Lediard*, London (1738).

Loggan, D., *Oxonia Illustrata*, Oxford (1675).

— *Cantabrigia Illustrata*, Cambridge (1688).

Lowthorp, J. (ed.), *The Philosophical Transactions and Collections, to the end of the year 1700. Abridg'd and dispos'd under general heads . . . By John Lowthorp*, 3 vols, London (1705).

Malcolm, J. P., *Londinium Redivivum*, vol. 4, London (1807).

Marot, J., *Le grand oeuvre d'architecture de Jean Marot*, Paris [c. 1665].

Maundrell, H., *A Journey from Aleppo to Jerusalem at Easter, A.D. 1697*, Oxford (1714 ed.).

Milizia, F., *The Lives of the Celebrated Architects, Ancient and Modern* (1768), trans. E. Cresy, London (1826).

Milton, J., *John Milton: The Complete Poems* (ed. J. Leonard), Harmondsworth (1998).

Montano, G. B., *Le cinque libri di architettura*, Rome (1636).

Montfaucon, B. de, *L'antiquité expliquée*, Paris (1722).

Morris, R., *Lectures on Architecture*, London (1734).

Newlin, T., *God's gracious design in inflicting national judgements; a sermon preached before the university of Oxford, at St. Mary's, on Friday, Dec. 16th 1720. Being the day appointed by His Majesty for a general fast . . . for beseeching God to preserve us from the plague*, Oxford (1721).

Newton, I., *Principia Mathematica*, London (1687 ed.).

— *The Chronology of the Ancient Kingdoms Amended*, London (1728).

Ogilby, J., *The Holy Bible*, Cambridge (1660).

Palladio, A., *Andrea Palladio: The Four Books on Architecture*, R. Tavernor and R. Schofield (trans. and eds), Cambridge, Mass., and London (1997).

Pemberton, H., *A View of Sir Isaac Newton's Philosophy*, London (1728).

Pepys, S., *Diary* (ed. W. Matthews and R. Latham), 11 vols, London (1970–83).

Perrault, C. [Vitruvius], *Les dix livres d'architecture de Vitruve*, Paris (1673/84).

— *Ordonnance des cinq espèces de colonnes selon la méthode des Anciens*, Paris (1683); trans. J. James, *A Treatise of the Five Orders of Columns in Architecture*, London (1708); I. McEwen, *Ordonnance for the Five Kinds of Columns*, Santa Monica, Calif. (1993).

Pliny, *Natural History*, D. E. Eichholz (trans.), Cambridge, Mass. (1962).

Pope, A., *Epistle to the Right Honourable Richard Earl of Burlington*, London (1731); see Butt (1963).

Pozzo, A., *Perspectiva pictorum et architectorum*, Rome (1693); trans. J. James, *Rules and examples of perspective proper for painters and architects etc*, London (1707).

Ralph, J., *A critical review of the public buildings, statues and ornaments in, and about London and Westminster*, London (1734).

Revett, N., and J. Stuart, *Antiquities of Athens*, vol. 1, London (1762).

Ripa, C., *Iconologia, or, Moral Emblems*, London (1709 ed.).

Rossi, D., *Romanæ magnitudinis monumenta*, Rome (1699).

Rossi, G. G. de, *Disegni di Vari Altari e Cappelle nelle chiese di Roma con le loro facciate fianchi piante e misure de piu celebri architetti*, Rome (1685).

Sandys, G., *A Relation of a Journey Begun Anno Domini 1610*, London (1615).

Serlio, S., *Architectura di Sebastiano Serlio Bolognese, in sei libri divisa*, Venice (1663); Books I–V and part of the 'Extraordinary Book of Doors'.

—*Sebastiano Serlio on Architecture*, vol. 1; Books I–V of *Tutte l'opere d'architettura et prospetiva*, V. Hart and P. Hicks (trans.), New Haven and London (1996).

—*Sebastiano Serlio on Architecture*, vol. 2; Books VI–'VIII' of *Tutte l'opere d'architettura et prospetiva*; and the *Libro Extraordinario*, V. Hart and P. Hicks (trans.), New Haven and London (2001).

Shaftesbury (Anthony Ashley Cooper), *Characteristicks of Men, Manners, Opinions, Times*, London (1711).

—*Letter concerning the art or science of Design*, in *Characteristicks*, 5th ed., London (1732) [pp. 401–2].

Shute, J., *The First and Chief Groundes of Architecture*, London (1563).

Smalridge, G., *Sixty Sermons Preached on Several Occasions*, 2 vols, Oxford (5th ed., 1852).

Spon, J., *Voyage d'Italie, de Dalmatie, de Grèce, et du Levant, fait aux années 1675 & 1676. Par Jacob Spon & George Wheler*, Lyon (1678).

—*Recherches curieuses d'antiquité*, Lyon (1683).

Story, T., *A Journal of the Life of Thomas Story*, Newcastle upon Tyne (1747).

Struys, J., *Voyages and Travels of John Struys: Through Italy, Greece, Muscovy*, London (1681).

Stukeley, W., *The Family Memoirs of Rev. William Stukeley, M.D.*, vol. 3, in *Surtees Society Publications*, vol. 80, Durham (1887).

Swift, J., *A Tale of a Tub: written for the universal improvement of mankind, to which is added, an account of a battle between the ancient and modern books in St James's Library*, London (1704).

—*Travels into several remote nations of the world*, London (1726).

—*The Prose Works of Jonathan Swift* (ed. H. Davis), 14 vols, Oxford (1939–68).

Theobald, L., *The Mausoleum: A poem sacred to the Memory of her late Majesty Queen Anne*, London (1714).

Villalpando, J. B., *In Ezechielem Explanationes et Apparatus Urbis ac Templi Hierosolymitani*, 3 vols, Rome (1596–1604).

Virtue, G., 'Virtue Note Books', *Walpole Society* (ed. K. A. Esdaile), vol. 22 (1934).

Vitruvius, *De Architectura*, Books I–X, I. D. Rowland (trans.), New York (1999).

Walpole, H., *Anecdotes of Painting in England, with Some Account of the Principal Artists* (collected by G. Vertue), 4 vols, Strawberry Hill, Twickenham (1762–71).

Walton, B., *Biblia Sacra Polygotta*, London (1655–67).

Wheler, G., *An Account of the Churches, or Places of Assembly, of the Primitive Christians*, London (1689).

Williams, W., *Oxonia Depicta*, Oxford (1732–3).

Wotton, H., *The Elements of Architecture*, London (1624).

Wren, C., *Parentalia: Or, Memoirs of the Family of the Wrens*, London (1750).

Wright, J., *Historia Histrionica: An Historical Account of the English Stage*, London (1699).

Proceedings of the Architectural College of the Freemasons of the Church, pt 2, London (1847) [British Library Ac. 4875].

MANUSCRIPTS

Carlisle, 'Essay on God and his Prophets'.

—'A Book of Coates & Crestes' (1699).

Hawksmoor, N., 'The Explanation of yᵉ Designes for All Souls' (1715); republished Oxford (1960); incompletely transcribed in Downes, *Hawksmoor* (1959), pp. 240–42, no. 58.

—'Explanation of the Obelisk', Blenheim, Long Library, 'Inscriptions of Blenheim I', no. 14.F.; transcribed in Downes, *Hawksmoor* (1959), Appendix B, pp. 262–4.

—'Report concᵍ sevˡ sites for churches in St Andrews, St Giles delivered to the Committee October 23 1711', London, Lambeth Palace Library, MS 2724.

—*Sale Catalogue*; facsimile in Watkin (1975).

—'Letters to Carlisle'; transcribed in Webb (1930–31).

—'Letters to Henry Joynes', 1705–13, British Library, Additional MS 19,607.

—'Letters to the Duchess of Marlborough', 1722–5, British Library, Additional MS 61353, nos 240, 252–5b r–v.

Hickes, G., 'Observations on Mr. Van Brugg's proposals about Buildinge the new Churches', Beinecke Library, Yale University, Osborn/Hickes 17.363; transcribed in Du Prey, *Hawksmoor's London Churches* (2000), Appendix three, pp. 139–42.

North, R., 'Notes of Building', (1698) ed. H. Colvin, and J. Newman, *Of Building: Roger North's Writings on Architecture*, Oxford (1981).

Pope, A., 'Letters'; transcribed in Sherburn, G. (ed.), *The Correspondence of Alexander Pope*, 5 vols, Oxford (1956).

Vanbrugh, J., 'Mr Van-Brugg's Proposals about Building ye New Churches', Oxford, Bodleian Library, Bod. MS Rawlinson B. 376, fols 351–2; see also MS Eng. Hist. b. 2. fol. 47; transcribed in Downes, *Vanbrugh* (1977), Appendix E, pp. 257–8.

—'Reasons Offer'd for Preserving some Part of the Old Mannour' (at Blenheim), British Library, Additional MS 61353, no. 66 (11 June 1709); transcribed in Ridgway, C.,

'Rethinking the Picturesque', in Ridgway and Williams, *Sir John Vanbrugh* (2000), p. 191.

—'Letters'; transcribed in Dobrée, B., and G. Webb (eds), *The Complete Works of Sir John Vanbrugh*, vol. 4, London (1928).

Wren, C., 'Tracts I–IV', in *Parentalia: Or, Memoirs of the Family of the Wrens*, London (1750); transcribed in Bolton, A. T., and H. P. Hendry, *Wren Society Volumes*, vol. 19, pp. 126–39, and in Soo, L., *Wren's 'Tracts' on Architecture and Other Writings*, Cambridge (1998), pp. 153–87.

—'Letter to a Friend on the Commission for Building Fifty New Churches', in *Parentalia*, London (1750); transcribed in Bolton, A. T., and H. P. Hendry, *Wren Society Volumes*, vol. 19, pp. 15–18, and in Soo (1998), pp. 112–18.

—'Discourse on Architecture' (Tract v), inserted in R.I.B.A. 'Heirloom' copy of *Parentalia*, with drawing of the elevation of the mausoleum of Halicarnassus by Hawksmoor; transcribed in Bolton, A. T., and H. P. Hendry, *Wren Society Volumes*, vol. 19, pp. 140–45, and in Soo (1998), pp. 188–95.

'Papers of the Commission for Building Fifty New Churches', London, Lambeth Palace Library, MSS 2690 (minutes)–2729, 2747–2750; MS 2750, nos 16 and 17: 'Basilica after the Primitive Christians' (repro: World Microfilm Publications, 1980).

SECONDARY SOURCES

Ackroyd, P., *Hawksmoor*, London (1985).

Addleshaw, G., and F. Etchells, *The Architectural Setting of Anglican Worship*, London (1948).

Amery, C., J. M. Robinson and G. Stamp (eds), *Hawksmoor's Christ Church Spitalfields: Architectural Design Profiles 22*, vol. 49, no. 7 (1979).

Arciszewska, B., 'A Villa fit for a King', *RACAR*, vol. 19, nos 1–2 (1992), pp. 41–58.

Arnold, D., 'London Bridge and its Symbolic Identity in the Regency Metropolis: The Dialectic of Civic and National Pride', *Art History*, vol. 22, no. 4 (1999), pp. 545–66.

Aurenhammer, H., *J. B. Fischer von Erlach*, London (1973).

Beard, G., *The Work of John Vanbrugh*, London (1986).

Beddard, R. A., 'Ecclesiastical and Liturgical Background', in Amery, C., J. M. Robinson and G. Stamp (eds), *Hawksmoor's Christ Church Spitalfields: Architectural Design Profiles 22*, vol. 49, no. 7 (1979), pp. 2–4.

—'Wren's Mausoleum for Charles I and the Cult of the Royal Martyr', *Architectural History*, vol. 27 (1984), pp. 36–48.

Bennett, J., 'Christopher Wren: The Natural Causes of Beauty', *Architectural History*, vol. 15 (1972), pp. 5–22.

—*The Mathematical Science of Christopher Wren*, Cambridge (1982).

—and S. Mandelbrote (eds), *The Garden, the Ark, the Tower, the Temple: Biblical Metaphors of Knowledge in Early Modern Europe*, Oxford (1998).

Berger, R. W., *A Royal Passion: Louis XIV as Patron of Architecture*, Cambridge (1994).

Bernard, T., and J. Clark (eds), *Lord Burlington, Architecture, Art and Life*, London (1995).

Bill, E. G. W. (ed.), *The Queen Anne Churches: A Catalogue of the Papers in Lambeth Palace Library of the Commission for Building Fifty New Churches in London and Westminster 1711–1759*, London (1979), intro. by H. Colvin.

Blunt, A., A. Laing, C. Tadgell and K. Downes (eds), *Baroque and Rococo Architecture and Decoration*, London (1978).

Bold, J., *John Webb: Architectural Theory and Practice in the Seventeenth Century*, Oxford (1989).

—*Greenwich: An Architectural History of the Royal Hospital for Seamen and the Queen's House*, London (2000).

Bradley, S., and N. Pevsner, *The Buildings of England. London 1: the City of London*, London (1997 ed.).

Brooks-Davies, D., *The Mercurian Monarch: Magical Politics from Spencer to Pope*, Manchester (1983).

Brownell, M. R., *Alexander Pope and the Arts of Georgian England*, Oxford (1978).

Butt, J., *The Poems of Alexandar Pope*, New Haven and London (1963).

Carpo, M., 'The Architectural Principles of Temperate Classicism: Merchant Dwellings in Sebastiano Serlio's Sixth Book', *Res*, vol. 22 (1992), pp. 135–51.

—*La maschera e il modello: Teoria architettonica ed evangelismo nell'Extraordinario Libro di Sebastiano Serlio (1551)*, Milan (1993).

Cast, D., 'Seeing Vanbrugh and Hawksmoor', *Journal of the Society of Architectural Historians*, vol. 43 (1984), pp. 310–27.

—'Hawksmoor', *International Dictionary of Architects and Architecture*, Detroit (1993), pp. 374–7.

—'Speaking of Architecture: The Evolution of a Vocabulary in Vasari, Jones, and Sir John Vanbrugh', *Journal of the Society of Architectural Historians*, vol. 52 (1993), pp. 179–88.

Clinch, G., *Bloomsbury and St. Giles; Past and Present*, London (1890).

Colley, L., *In Defiance of Oligarchy: The Tory Party 1714–60*, Cambridge (1982).

Colvin, H., 'Fifty New Churches', *Architectural Review*, vol. 107 (1950), pp. 189–96; 'Mr. Vanbrugg's Proposals', pp. 209–10.

—'Easton Neston Reconsidered', *Country Life*, vol. 148 (1970), pp. 968–71.

—*The History of the King's Works, 1660–1782*, vol. 5, London (1976).

—*Unbuilt Oxford*, New Haven (1983).

—*Architecture and the After-Life*, New Haven (1991).

—'Hawksmoor, or Hawkesmore', in *A Biographical Dictionary of English Architects 1660–1840*, London (1954 ed.).

—'Hawksmoor', in *A Biographical Dictionary of British Architects 1600–1840*, New Haven (1995 ed.), pp. 473–8 (list of executed and unexecuted designs, pp. 475–8).

—'George Clarke', in Turner, J. (ed.), *The Dictionary of Art*, vol. 7, London (1996), pp. 378–9.

—'The Townesends of Oxford: A Firm of Georgian Master-Masons and its Accounts', *The Georgian Group Journal*, vol. 10 (2000), pp. 43–60.

—(ed.) *Catalogue of Architectural Drawings of the Eighteenth and Nineteenth Centuries in the Library of Worcester College, Oxford*, Oxford (1964).

Conder, E., 'King Charles II at the Royal Exchange, London, in 1667', *Transactions of the Quatuor Coronati Lodge*, vol. 11 (1898), pp. 138–52.

Cottingham, J., *The Cambridge Companion to Descartes*, Cambridge (1992).

Cruickshank, D., 'Hawksmoor's First Building? The Portico of All Saints Church, Northampton', *The British Art Journal*, vol. 1, no. 1 (1999), pp. 20–22.

Curl, J. S., *The Art and Architecture of Freemasonry*, London (1991).

Davies, J. G., *The Architectural Setting of Baptism*, London (1962).

Davies, J. H. V., 'Brunelleschi and Hawksmoor', *Colonnade*, vol. 1, no. 1 (1952), pp. 26–36.

—'Nicholas Hawksmoor', *R.I.B.A. Journal*, vol. 69, no. 10 (October 1962), pp. 368–76.

Dinsmoor, W. B., 'The Literary Remains of Sebastiano Serlio', *Art Bulletin*, vol. 24 (1942), pp. 55–91.

Downes, K., 'Hawksmoor's Sale Catalogue', *The Burlington Magazine*, vol. 95 (1953), pp. 332–5.

—*Hawksmoor*, London (1959; 2nd, rev. ed. 1979, additional notes and an appendix on 'The Bow Window Room at Castle Howard').

—*English Baroque Architecture*, London (1966).

—*Hawksmoor* (World of Art Series), London (1970; rep. 1994).

—*Vanbrugh* (Studies in Architecture, eds A. Blunt, J. Harris, H. Hibbard, vol. 16), London (1977).

—'Hawksmoor', *Macmillan Encyclopedia of Architects*, London (1982), pp. 337–47.

—*Sir John Vanbrugh, a Biography*, London (1987).

—'Hawksmoor's House at Easton Neston', *Architectural History*, vol. 30 (1987), pp. 50–76.

—'Hawksmoor', in Turner, J. (ed.), *The Dictionary of Art*, vol. 14, London (1996), pp. 252–8.

—'Baroque: Historical Context', in Turner, J. (ed.), *The Dictionary of Art*, vol. 3, London (1996), pp. 266–9.

Du Prey, P. R., 'Hawksmoor's "Basilica after the Primitive Christians": Architecture and Theology', *Journal of the Society of Architectural Historians*, vol. 48 (1989), pp. 38–52.

—*Hawksmoor's London Churches: Architecture and Theology*, Chicago (2000).

Eisenthal, E., 'John Webb's Reconstruction of the Ancient House', *Architectural History*, vol. 28 (1985), pp. 7–18.

Erskine-Hill, H., 'Heirs of Vitruvius: Pope and the Idea of Architecture', in Erskine-Hill, H., and A. Smith (eds), *The Art of Alexander Pope*, New York (1979), pp. 144–56.

Evans, R., 'Hawksmoor's Imposing Churches: An Interpretation', in Hoffman, A. von (ed.), *Form, Modernism, and History: Essays in Honor of Eduard F. Sekler*, Cambridge, Mass., and London (1996).

—*The Projective Cast: Architecture and its Three Geometries*, Cambridge, Mass. (1995).

Everett, N., *The Tory View of Landscape*, New Haven (1994).

Findlay, D., *Nicholas Hawksmoor's London Churches*, London (1999).

Fiore, F. P., *Sebastiano Serlio architettura civile, libri sesto, settimo e ottavo nei manoscritti di Monaco e Vienna*, Milan (1994).

Fürst, V., *The Architecture of Sir Christopher Wren*, London (1956).

Ganay, E. de, *André Le Nostre, 1613–1700*, Paris (1962).

George, M. D., *London Life in the Eighteenth Century*, Harmondsworth (1966 ed.).

Geraghty, A., 'Nicholas Hawksmoor and the Wren City Church Steeples', *The Georgian Group Journal*, vol. 10 (2000), pp. 1–14.

Godwin, J., *Athanasius Kircher*, London (1979).

Goodhart-Rendel, H. S., *Hawksmoor*, London (1924).

Gould, J., *The Concise History of Freemasonry*, London (1903).

Grafton, A., *New Worlds, Ancient Texts, The Power of Tradition and the Shock of Discovery*, Cambridge, Mass. (1992).

Green, D., *Blenheim Palace*, London (1951, rep. 1967).

Gregg, E., *Queen Anne*, London (1980).

Guillaume, J., 'La galerie dans le château français: place et fonction', *Revue de l'Art*, vol. 102 (1993), pp. 32–42.

Harris, E., and N. Savage, *British Architectural Books and Writers 1556–1785*, Cambridge (1990).

Harris, J., *Catalogue of British Drawings for Architecture, Decoration, Sculpture and Landscape Gardening in American Collections, 1550–1900*, Upper Saddle River, N. J. (1971).

—S. Orgel, and R. Strong, *The King's Arcadia: Inigo Jones and the Stuart Court*, London (1973).

—and G. Higgot, *Inigo Jones, Complete Architectural Drawings*, London (1989).

Hart, V., 'Vanbrugh's Travels', *History Today*, vol. 42 (July 1992), pp. 26–32.

—'"A peece rather of good Heraldry, than of Architecture": Heraldry and the Orders of Architecture as Joint Emblems of Chivalry', *Res*, vol. 23 (1993), pp. 52–66.

—*Art and Magic in the Court of the Stuarts*, New York (1994).

—'Carl Jung's Alchemical Tower at Bollingen', *Res*, vol. 25 (1994), pp. 36–50.

—'Imperial Seat or Ecumenical Temple?', *Architectura*, vol. 25 (1995), pp. 194–213.

—*St. Paul's Cathedral: Sir Christopher Wren*, London (1995; republished 1999).

—'From Virgin to Courtesan in Early English Vitruvian Books', in Hart, V., and P. Hicks (eds), *Paper Palaces: The Rise of the Renaissance Architectural Treatise*, London (1998), pp. 297–318.

—'"Paper Palaces" from Alberti to Scamozzi', in Hart, V., and P. Hicks (eds), *Paper Palaces: The Rise of the Renaissance Architectural Treatise*, London (1998), pp. 1–29.

—Review of Hawksmoor exhibition at the Heinz Gallery, R.I.B.A., London, in *Society of Architectural Historians of Great Britain Newsletter* (Spring 1998).

—'On Inigo Jones and the Stuart Legal Body: "Justice and Equity . . . and Proportions appertaining"', in Tavernor, R., and G. Dodds (eds), *Body and Building: Essays on the Changing Relationship of Body and Architecture*, Cambridge, Mass. (2002), pp. 138–49.

—and R. Tucker, '"Immaginacy set free": Aristotelian Ethics and Inigo Jones's Banqueting House at Whitehall', *Res*, vol. 39 (2001), pp. 151–67.

—'"Masculine and Unaffected": Ornament and the Work of Inigo Jones', *Architectura*, forthcoming.

Hewlings, R., 'Ripon's Forum Populi', *Architectural History*, vol. 24 (1981), pp. 39–52.

—'Hawksmoor's "Brave Designs for the Police"', in Bold, J., and E. Chaney (eds), *English Architecture, Public and Private: Essays for Kerry Downes*, London (1993), pp. 215–29.

Higgot, G., '"Varying with reason": Inigo Jones's Theory of Design', *Architectural History*, vol. 35 (1992), pp. 51–77.

Hook, J., *The Baroque Age in England*, London (1976).

Humbert, J. M., and L. Dumarche, *The Tomb of Napoleon: The Hôtel des Invalides*, Paris (1996).

Hunt, J. D., and P. Willis (eds), *The Genius of the Place: The English Landscape Garden 1620–1820*, Cambridge, Mass. (1988).

Hunter, M., *Science and Society in Restoration England*, Cambridge (1981).

—*Science and the Shape of Orthodoxy*, Woodbridge, Suffolk (1995).

Hussey, C., *English Gardens and Landscape 1700–1750*, London (1967).

Jacob, M. C., *Living the Enlightenment: Freemasonry and Politics in Eighteenth-Century Europe*, Oxford (1991).

Jardine, L., *On a Grander Scale: The Career of Christopher Wren*, London (2002, forthcoming).

Jeffery, P., 'The church that never was: Wren's St Mary, and other projects for Lincoln's Inn Fields', *Architectural History*, vol. 31 (1988), pp. 136–44.

—'Originals or Apprentice Copies? Some Recently Found Drawings for St. Paul's Cathedral, All Saints, Oxford and the City Churches', *Architectural History*, vol. 35 (1992), pp. 118–39.

—*The City Churches of Sir Christopher Wren*, London (1996).

Knight, C., 'The Travels of the Rev. George Wheler (1650–1723)', *The Georgian Group Journal*, vol. 10 (2000), pp. 21–35.

Knoop, D., and G. P. Jones, *The Genesis of Freemasonry*, Manchester (1947).

Krautheimer, R., *The Rome of Alexander VII 1655–1667*, Princeton (1985).

Kruft, H.-W., *A History of Architectural Theory from Vitruvius to the Present*, New York (1994 ed.).

Kuyper, W., *Dutch Classicist Architecture: A Survey of Dutch Architecture, Gardens and Anglo-Dutch Architectural Relations from 1625 to 1700*, Delft (1980).

Lang, S., 'Cambridge and Oxford Reformed: Hawksmoor as a Town-Planner', *Architectural Review*, vol. 103 (April 1948), pp. 157–60.

—'By Hawksmoor out of Gibbs', *Architectural Review*, vol. 105 (April 1949), pp. 183–90.

—'Vanbrugh's Theory and Hawksmoor's Buildings', *Journal of the Society of Architectural Historians*, vol. 24 (1965), pp. 127–51.

Larrabee, S. A., *English Bards and Grecian Marbles*, New York (1943).

Leatherbarrow, D., 'Architecture and Situation: A Study of the Architecture of Robert Morris', *Journal of the Society of Architectural Historians*, vol. 44 (1985), pp. 48–59.

Levine, J. M., *Between the Ancients and the Moderns: Baroque Culture in Restoration England*, New Haven and London (1999).

Lindberg, D. C., and R. S. Westman (eds), *Reappraisals of the Scientific Revolution*, Cambridge (1990).

Loach, J., 'Gallicanism in Paris, Anglicanism in London, Primitivism in Both', in Jackson, N. (ed.), *Plus ça change . . . Architectural Interchange between France and Britain: Papers from the Annual Symposium of the Society of Architectural Historians of Great Britain*, Nottingham (1999), pp. 9–32.

Massar, P. D., *Presenting Stefano della Bella: Seventeenth-Century Printmaker*, New York (1971).

McCormick, F., *Sir John Vanbrugh: The Playwright as Architect*, University Park, Penn. (1991).

McEwen, I. K., 'On Claude Perrault: Modernising Vitruvius', in Hart, V., and P. Hicks (eds), *Paper Palaces: The Rise of the Renaissance Architectural Treatise*, London (1998), pp. 321–37.

McQuillan, J., 'From Blondel to Blondel: On the Decline of the Vitruvian Treatise', in Hart, V., and P. Hicks (eds), *Paper Palaces: The Rise of the Renaissance Architectural Treatise*, London (1998), pp. 338–57.

Middleton, R. D., 'The Abbé de Cordemoy and the Graeco-Gothic Ideal: A Prelude to Romantic Classicism', *Journal of the Warburg and Courtauld Institutes*, vol. 25 (1962), pp. 278–320; vol. 26 (1963), pp. 90–123.

Middleton, R., et al. (eds), *The Mark J. Millard Architectural Collection*, vol. 2 (British Books), New York (1998).

Mowl, T., 'Wholesome Hawksmoor, St John's Parsonage, Southwark', *Country Life*, vol. 184, no. 49 (6 December 1990), p. 166.

Norberg-Schulz, C., *Late Baroque and Rococo Architecture*, New York (1985 ed.).

Onians, J., *Bearers of Meaning: The Classical Orders in Antiquity, the Middle Ages, and the Renaissance*, Cambridge (1988).

Padovan, R., *Proportion, Science, Philosophy, Architecture*, London (1999).

Payne, A., *The Architectural Treatise in the Italian Renaissance*, Cambridge (1999).

Pérez-Gómez, A., *Architecture and the Crisis of Modern Science*, Cambridge, Mass. (1983).

— and L. Pelletier, *Architectural Representation and the Perspective Hinge*, Cambridge, Mass., and London (1997).

Perks, S., *The History of the Mansion House*, Cambridge (1922).

Petter, H. M., *The Oxford Almanacks*, Oxford (1974).

Port, M. H. (ed.), *The Commission for Building Fifty New Churches: The Minute Books, 1711–17, a Calendar*, London Record Society, vol. 23 (1986).

Randall, C., *Building Codes: The Aesthetics of Calvinism in Early Modern Europe*, Philadelphia (1999).

Ridgway, C., and R. Williams (eds), *Sir John Vanbrugh and Landscape Architecture in Baroque England 1690–1730*, Stroud (2000).

Ridley, J., *The Freemasons*, London (1999).

Roberts, D., *The Town of Cambridge as it ought to be Reformed: The Plan of Nicholas Hawksmoor interpreted in an Essay by David Roberts*, Cambridge (1955).

Rosenau, H., *Vision of the Temple: The Image of the Temple of Jerusalem in Judaism and Christianity*, London (1979).

Rowland, I. D., 'Vitruvius in Print and in Vernacular Translation: Fra Giocondo, Bramante, Raphael and Cesare Cesariano', in Hart, V., and P. Hicks (eds), *Paper Palaces: The Rise of the Renaissance Architectural Treatise*, London (1998), pp. 105–21.

Rub, T., 'A Most Solemn and Awfull Appearance: Nicholas Hawksmoor's East London Churches', *Marsyas: Studies in the History of Art*, vol. 21 (1981–2), pp. 17–26.

Rykwert, J., *The First Moderns*, Cambridge, Mass., and London (1980).

— *On Adam's House in Paradise*, Cambridge, Mass., and London (1981).

— *The Dancing Column*, Cambridge, Mass. (1996).

— 'Privacy in Antiquity', *Social Research*, vol. 68, no. 1 (2001), pp. 29–40.

Saumarez Smith, C., *The Building of Castle Howard*, London (1990; republished 1997).

Sekler, E., *Wren and his Place in European Architecture*, London (1956).

Service, A., *The Architects of London*, London (1979).

Sheppard, F. H. W. (ed.), *London County Council: Survey of London*, vol. 27: *Spitalfields and Mile End New Town*, London (1957).

Sherburn, G. (ed.), *The Correspondence of Alexander Pope*, 5 vols, Oxford (1956).

Sicca, C. M., 'Burlington', in Turner, J. (ed.), *The Dictionary of Art*, vol. 4, London (1996), p. 609.

Smith, C., *Architecture in the Culture of Early Humanism*, New York and Oxford (1992).

Smith, E. B., *Architectural Symbolism of Imperial Rome and the Middle Ages*, Princeton (1956).

Soo, L., *Wren's 'Tracts' on Architecture and Other Writings*, Cambridge (1998).

— 'The Study of China and Chinese Architecture in Restoration England', *Architectura*, forthcoming.

Speth, G. W. (ed.), *Quatuor Coronatorum Antigrapha* (masonic reprints of the Quatuor Coronati Lodge, no. 2076), 10 vols, London (1889–1913).

Stevenson, C., 'Robert Hooke's Bethlem', *Journal of the Society of Architectural Historians*, vol. 55 (1996), pp. 254–75.

— *Medicine and Magnificence*, New Haven and London (2000).

Stevenson, D., *The Origins of Freemasonry, Scotland's Century 1590–1710*, Cambridge (1988).

Strong, R., *The Renaissance Garden in England*, London (1979).

Summerson, J., 'St. George's in the East', *Architectural Review*, vol. 90 (1941), p. 135.

— *Architecture in Britain, 1530–1830*, London (1991 ed.).

— 'Sir John Soane and the Furniture of Death', in *The Unromantic Castle*, London (1990), pp. 121–42.

Taylor, R., 'Architecture and Magic: Considerations on the Idea of the Escorial', in Hibbard, H. (ed.), *Essays in the History of Architecture Presented to Rudolf Wittkower*, London (1967), pp. 81–109.

Thorpe, C. de W., *The Aesthetic Theory of Thomas Hobbes*, Ann Arbor (1940).

Thurley, S., *The Lost Palace of Whitehall*, London (1998).

Tinniswood, A., *His Invention So Fertile: A Life of Christopher Wren*, London (2001).

Uglow, J., *Hogarth: A Life and a World*, London (1997).

Vesely, D., 'Architecture and the Conflict of Representation', *AA files*, vol. 8 (1985), pp. 21–38.

Vidler, A., 'The Idea of Type: The Transformations of the Academic Ideal 1750–1830', *Oppositions*, vol. 8 (Spring 1977), pp. 30–42.

Ward, E., 'William Hogarth and His Fraternity', *Ars Quatuor Coronatorum*, vol. 77 (1964), pp. 1–20.

Watkin, D. (ed.), *Sale Catalogue of Libraries of Eminent Persons*, London (1975), vol. 4 [Architects], pp. 45–105.

Webb, G. (ed.), 'The Letters and Drawings of Nicholas Hawksmoor Relating to the Building of the Mausoleum at Castle Howard, 1726–1742', *Walpole Society*, vol. 19 (1930–31), pp. 111–63.

Webster, C., *The Great Instauration, Science, Medicine and Reform 1626–1660*, London (1975).

— *From Paracelsus to Newton: Magic and the Making of Modern Science*, Cambridge (1982).

Whistler, L., *Sir John Vanbrugh, Architect and Dramatist, 1664–1726*, London (1938).

— *The Imagination of Vanbrugh and his Fellow Artists*, London (1954).

White, R. (ed.), *Nicholas Hawksmoor and the Replanning of Oxford*, Oxford and London (1997).

Williams, R., 'A factor in his success. The missing years: did Vanbrugh learn from Mughal mausolea?', *Times Literary Supplement* (3 September 1999), pp. 13–14.

Williams, W. J., 'Masonic Personalia 1723–39', *Ars Quatuor Coronatorum*, vol. 40 (1928), pp. 30–42, 126–38, 230–40.

Willis, R., and J. W. Clark, *The Architectural History of the University of Cambridge*, 4 vols, Cambridge (1886 ed.).

Wilson Jones, M., *Principles of Roman Architecture*, London (2000).

Wittkower, R., *Architectural Principles in the Age of Humanism*, London (1948).

Worsley, G., 'Nicholas Hawksmoor: A Pioneer Neo-Palladian?', *Architectural History*, vol. 33 (1990), pp. 60–70.

— 'Designs on Antiquity, Hawksmoor's London Churches', *Country Life*, vol. 194, no. 42 (18 October 1990), pp. 172–4.

— *Classical Architecture in Britain: The Heroic Age*, New Haven and London (1995).

Yolton, J. W., *Perception Acquaintance from Descartes to Reid*, Oxford (1984).

Exhibition Catalogues

Arts Council Gallery, *Hawksmoor*, London (1962).

R.I.B.A. Heinz Gallery, London, and the Ashmolean Museum, Oxford, *Nicholas Hawksmoor and the Replanning of Oxford* (ed. R. White), Oxford and London (1997).

Whitechapel Art Gallery, *Hawksmoor* (ed. K. Downes), London (1977).

Photograph Credits

Institutions currently holding drawings illustrated in this book are cited in the captions. Unless otherwise credited, the photographs of Hawksmoor's work are the author's own.

Illustrations were used from the following sources:

Alison Shepherd [from: John Summerson, *Georgian London*, 1945 ed.], 133

Ann Nutkins, 113

Ashmolean Museum, Oxford, 44, 120, 314

Bath University Library, 40, 41, 42, 88, 89, 103, 122, 143, 160, 174, 176, 342

Bodleian Library, Oxford, 53, 119, 121, 173, 276

British Architectural Library, R.I.B.A., London, 80, 114, 287, 333

British Library, London, 16, 108, 117, 129a,b, 130, 131, 139, 184, 189, 190, 191, 192, 193, 202, 203, 213, 214, 215, 217, 231, 236, 258, 264, 266, 289

Castle Howard Collection, Yorkshire, 90, 337

Cleveland Museum of Art, Cleveland, 31

Conway Library, Courtauld Institute of Art, London, 55, 56, 73, 74, 75, 76, 109, 116, 194, 195, 197, 205, 228, 249, 271, 273, 290, 294, 295, 296, 297, 304, 306, 307

David Roberts [from: *The Town of Cambridge as it ought to be Reformed*, 1955], 278

Guildhall Library, Corporation of London, 348

Lady Hasketh, 141

Lambeth Palace Library, London, 60, 329

Leeds City Archives, 134

London Metropolitan Archives, London, 186, 220

Magdalen College, Oxford, 311

Mark Wilson Jones, 224

Mary Courtman-Davies, 227

National Monuments Record (Swindon), 115, 154, 155, 175; (London), 105

Prints and Drawings Department, British Museum, London, 201, 234, 235, 344

Queen's College, Oxford, 9, 298

By courtesy of the Trustees of Sir John Soane's Museum, London, 352

Victoria and Albert Museum, London, 127, 161, 335

Walpole Society Volumes, 233, 345, 346, 350

Westminster Archive Centre, London, 46

Wiltshire Records Office, 107

Wren Society Volumes, 8, 22, 28, 29, 47, 63, 68, 69, 84, 132, 140, 141, 199, 280, 302, 326, 327, 328, 331

Yale Center for British Art, New Haven, Paul Mellon Collection, 21

Index

Figures in *italics* refer to illustration numbers